EARLY GEORGIAN INTERIORS

# Early Georgian Interiors

John Cornforth

PUBLISHED FOR THE PAUL MELLON CENTRE FOR STUDIES IN BRITISH ART
BY YALE UNIVERSITY PRESS, NEW HAVEN AND LONDON

Picture research by Emma Lauze
Designed by Sally Salvesen
Typeset in Garamond in India
Printed in Italy

LIBRARY OF CONGRESS CATALOGING-IN-PUBLICATION DATA

Cornforth, John, 1937–2004
Early Georgian interiors / John Cornforth.
p.   cm.
Includes bibliographical references and index.
ISBN 0-300-10330-1 (cl : alk. paper)
1.  Interior decoration–Great Britain–History–18th century. 2.  –Great Britain–Georgian style.
3.  Architecture, Domestic--Great Britain–18th century. 4.  Architecture, Georgian–Great Britain.  I. Title.
NK2043.A1C67 2004
747´.0942´09033–DC22
                    2004002599

ILLUSTRATIONS

HALF TITLE PAGE: *Part of a plate from Pozzi's* Artis Sculptoriae Paradignata *(Fulda, 1708).*
*One of a number of prints that belonged to Italian stuccadores working in Ireland.* Irish Architectural Archive.

TITLE PAGE: *Detail of a table made by Matthias Lock for the Tapestry Drawing Room at Hinton St George, Wiltshire, mid-1740s.*
Victoria and Albert Museum.

PAGE VIII: *The Chinese wallpaper in the White Dressing-Room at Felbrigg, Norfolk.*

# Contents

*Editor's Note*

By the time that John's last illness took hold, he had finished most of his work on this book. He had answered all the queries. The text was in galley proof. He had worked long and hard collecting, selecting and monitoring the quality of the reproductions. And he had discussed his hopes and objectives for its appearance. But he did not have time to complete the acknowledgements, a task that would have given him enormous pleasure. The people who continue to live in houses that have been in the possession of their families for centuries; the custodians who care for historic houses on behalf of the National Trust and other institutions; and the scholars and experts, young and old, famous and not yet well-known, with whom he shared his interests were central to his life. John loved to discuss his latest discoveries with this broad spectrum of like-minded colleagues, friends and acquaintances. Those who benefited from John's intellectual generosity have been equally generous in their support and encouragement for the completion of his book.

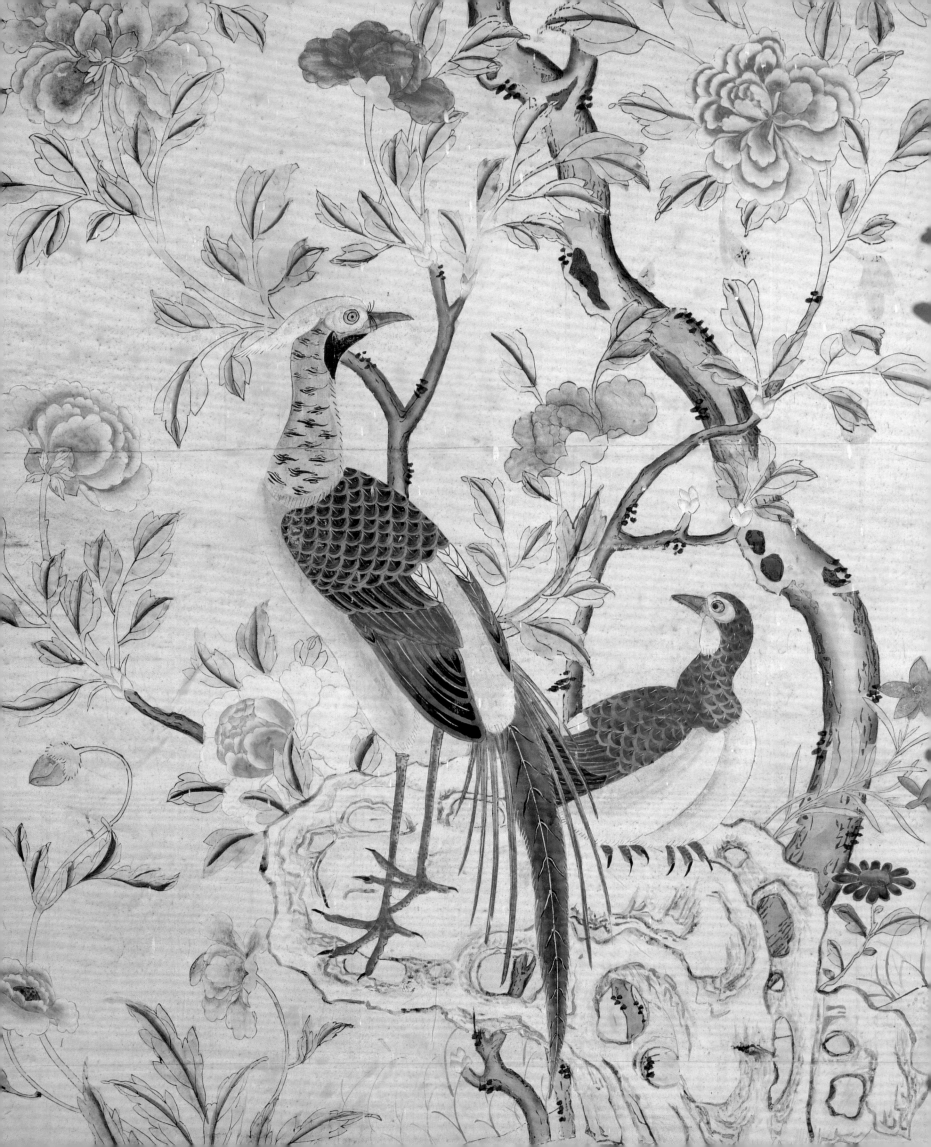

# *Preface*

In the late 1960s and early 1970s I worked with John Fowler on a book that we called *English Decoration in the 18th Century*. Our aim was to provide the Historic Buildings Representatives of the National Trust with a basic introduction that would help them in their work of looking after country houses. We both knew that the project was a race against time that might not be completed, because John had undergone two operations for cancer, and our intention was to set down on paper what he knew before it was too late. John had immense knowledge built up through years of looking and teaching himself how things were done and made; but, apparently because of the medical treatment he underwent, I found after a time that he often did not remember why he knew facts and expressed his ideas with such authority. We proceeded with John talking round the topics we had planned and then, prodded by me, dictating preliminary drafts that I wrote down. Then I sought for the examples to support what he had said. Thus, gradually, we worked up the drafts together. What was uncanny was the way that I found the necessary supporting evidence. The result was a book in which certain old friends of John said that they could hear him talking.

The book remained in print from 1974 until the late 1980s, by which time so much new material had come to light that the text was embarrassingly out of date. But since John had died in 1977, I did not want to revise it, because I knew that I would lose the sense of him talking.

It seemed better to start again, but how? I wanted to include more about the relationship between planning, decoration and furnishing and certain subjects like the significance of silver, the taste for tapestry and needlework, and the role of chinoiserie, which we had not included. Restrictions on space, however, meant omitting others such as staircases and bedrooms, chimneypieces and picture frames, which I would have liked to include, and a few discussed in the first book such as Ladies' Amusements and mourning decorations, which particularly appealed to John. Also, I have left out carpets, because I have so few examples to add to Sarah Sherrill's *Carpets and Rugs of Europe and America* (1996); and I have said less about colour because of Ian Bristow's two volumes on *Architectural Colour in British Interiors 1615–1840* and *Interior House-Painting Colours and Technology 1615–1840*, published in 1996.

In the end, I decided to reduce the period to the years 1685 to 1760, starting with William Talman at Chatsworth, Derbyshire, concentrating on William Kent as an architectural decorator and ending before Robert Adam began his most productive decade as a designer of interiors, because that was to be the subject of a book by Eileen Harris that I knew would transform our understanding of the 1760s and 1770s. Her book appeared in the autumn of 2001, shortly after I had completed my text.

Shortening the period was also suggested by the denseness of the ground to be covered: it could not be packed into a single volume and make the study useful to the greater number of people working on historic interiors and to students in search of an introduction. When John and I started, the Historic Buildings staff of the National Trust consisted of a handful of people: now it has grown into a regiment, and there is an army in the wider field.

When we began, the literature was minimal, but the amount of material published since 1974, much of it in specialist articles, has been overwhelming. So often I have felt that I was about to drown in other people's footnotes. Ironically, that has made it much harder to write a general book than twenty-five years ago.

As I worked on, I realized that I was trying to understand the conventions that underlay so much of the decoration and furnishing of rooms in the period and that I was aiming to reconstruct a grammar of decoration. It meant taking note of many details new to me that I felt worth including as pointers for the collection of evidence that could be useful in the restoration of interiors. Any restoration project raises an unbelievable number of queries, and one of the difficulties is to know where to start looking for comparative evidence on which to base decisions. Thus, although I see this book as a successor to *English Decoration in the 18th Century*, it is only another step along the road on which others will travel further in the future.

The emphasis on planning and social life and their relationship to decoration and furnishing as seen through inventories, plans and descriptions of visitors has brought home the rarity of entities, of complete rooms, of apartments and of houses, and how much has been lost since country-house photography got going in the early years of the last century.

After I retired from full-time work at *Country Life* in the autumn of 1993, I began to think about a book that attempted to draw as much of this material together as possible. Then, in the summer of 1995, I inflicted a course of lectures about the period 1720–70 on a group of students at the Bard Graduate Center for Studies in the Decorative Arts in New York. Not only did it get me started, but it taught me even more, prompting many questions that were new to me and making me aware of gaps in my thinking. After that, I became involved in the British Galleries at the Victoria and Albert Museum, which opened at the end of 2001, and that project raised many more questions as well as introducing people to pester with questions.

In approaching the subject, Houghton Hall in Norfolk has been of crucial importance, and I have been singularly fortunate in having gone there on numerous occasions over the past thirty years; every time I have learned something that has not only helped me to understand it better but has stimulated my thinking about other houses. It is the only great house of the 1720s and 30s to have been completed by one man in less than fifteen years and to have retained most of its decoration and furniture. So not only is it a demonstration of country-house planning and the fullest expression of William Kent's brilliance as an architectural decorator, but it makes it possible to look both backwards over the preceding forty years to the more sophisticated houses of Charles II's later years, such as Belton in Lincolnshire, and forwards to the completion of Holkham, also in Norfolk, at the end of the period under review here.

William Kent (1685–1748) was the hero of my New York course, because I felt then, as I still feel, that he is an underestimated figure as an architectural decorator. At the same time, I also realized that there was more research to be done on William Talman (1650–1719) as an architectural decorator and that more recognition should be given to James Gibbs (1682–1754) as the key planner of houses and designer of interiors and the first fully trained British architect to design furniture. Also, it seemed important to bear in mind the contributions of Henry Flitcroft (1697–1769), whose modified version of Kent's style for interiors in the 1730s was the basis of formal classicism in England until the late 1750s, and of Thomas Ripley (c.1683–1758), who developed ambitions as an architectural decorator. However, what makes comparisons difficult is that there are no major unaltered domestic interiors by Gibbs, Flitcroft or Ripley that retain their original furnishings.

Nor are any of Lord Burlington's rooms intact, and there is remarkably little evidence as to what they looked like. He never became a fluent draughtsman, and so he approached the process of design through quotations from antiquity, the Renaissance and the drawings of Inigo Jones, which he had copied, adapted or rearranged by a professional draftsman. He was clearly fascinated and excited by the relationship of rooms of different shapes and sizes, as can be seen at Chiswick House, Middlesex, but at the same time, the overall results seem curiously dry, perhaps because his rooms have lost most of their original finishes and upholstery as well as their pictures and sculpture.[1]

One major distortion that cannot be cured is the imbalance between the lack of satisfactory visual evidence about London interiors and the relative plenty for country houses. That is serious, because many fashions must have started in London and spread to the country. Yet today it is impossible to sense what was considered suitable for town and what for the country and the differences between them.

The very richness of the *Country Life* archive and other collections has made the selection of images a testing matter and there has had to be severe pruning, with many desirable ones omitted. Many, however, are relatively familiar and can be found elsewhere, even if that means the committed reader is left with a good deal of chasing up references to where they may be found. I have also included as many plans as possible because discussion of decoration is usually divorced from planning.

Absences also partly explain why I have compiled as full a bibliography of post-1975 publications on individual country houses as I can, so that illustrations can be tracked down. It cannot be complete, but the only running index for England that I know is that kept in the Furniture Department at the Victoria and Albert Museum, with an Irish index kept by the Irish Architectural Archive in Dublin and a Scottish list by the Royal Commission on the Ancient and Historical Mounuments of Scotland in Edinburgh.

Another difficulty is that we tend to ignore the economics of interiors, but then, as now, patrons probably combined extravagance and meanness and were always on the look-out for ways of achieving the maximum effect from the minimum expenditure. Many individual prices are known, and a few are given here, but it is not easy to put them into a sensible perspective that relates expenditure on, let us say, upholstery to silver or pictures and that helps to explain the differences in attitudes and expenditure on the different arms of house decoration between a great nobleman of ancient family like the 6th Duke of Somerset at Petworth in Sussex and an *arriviste* figure like the Duke of Chandos at Canons, Middlesex, or a country squire like Sir John Chester of Chicheley Hall, Buckinghamshire and a London barrister and new owner like John Meller of Erddig in North Wales.

Yet another of my concerns has been what to do about Irish and Scottish interiors: whether or not to include them, and if so, how. They have different characters as a result of their political, economic and social histories. On the other hand, the English perspective cannot be correct if the contributions of Sir Edward Lovett Pearce and Richard Castle to Ireland and of William Adam to Scotland are completely ignored. All three are original figures in the age of James Gibbs; and there may well have been links between Adam and Gibbs that are not yet understood and raise the question of Scottish influence on English planning in the 1720s and 30s. Also, many leading Scottish patrons continued to shop in London, as they had done since 1603, and some of the most illuminating documents and examples relating to English furnishings occur in Scottish records and houses. So there are a few references to Irish and Scottish interiors, even though they do not amount to proper consideration of them.

Above all, I became increasingly unhappy about the way we tend to approach interior design, decoration and the decorative arts of the period in the British Isles. Art history here has concentrated on the history of style in painting and sculpture and to a slightly lesser extent in architecture, with the decorative arts tending to be regarded as second class in the ladder of studies and still largely ignored. As a result, the history of interiors is seen as architect-driven, and yet at the same time there is little discussion of architects' interests in interiors and the planning of houses. Here, Vanbrugh, Hawksmoor and Gibbs particularly suffer. Surely that is a distortion of the situation at a time when the priorities of patrons were crucial and their patterns of expenditure so significant. The reasons for design and decoration and the grammar of decoration which architects had to absorb and develop need to be explored. Only then is it possible to pursue the architects' approaches.

*One of William Kent's etched vignettes in Pope's translation of Homer's* Odyssey *published in
1725. This side table is one of his earliest representations of furniture based on his memory of
Roman tables and realized in a table formerly at Devonshire House (Fig. 167)*

I

*Aspects of Early Georgian Fashion and Taste*

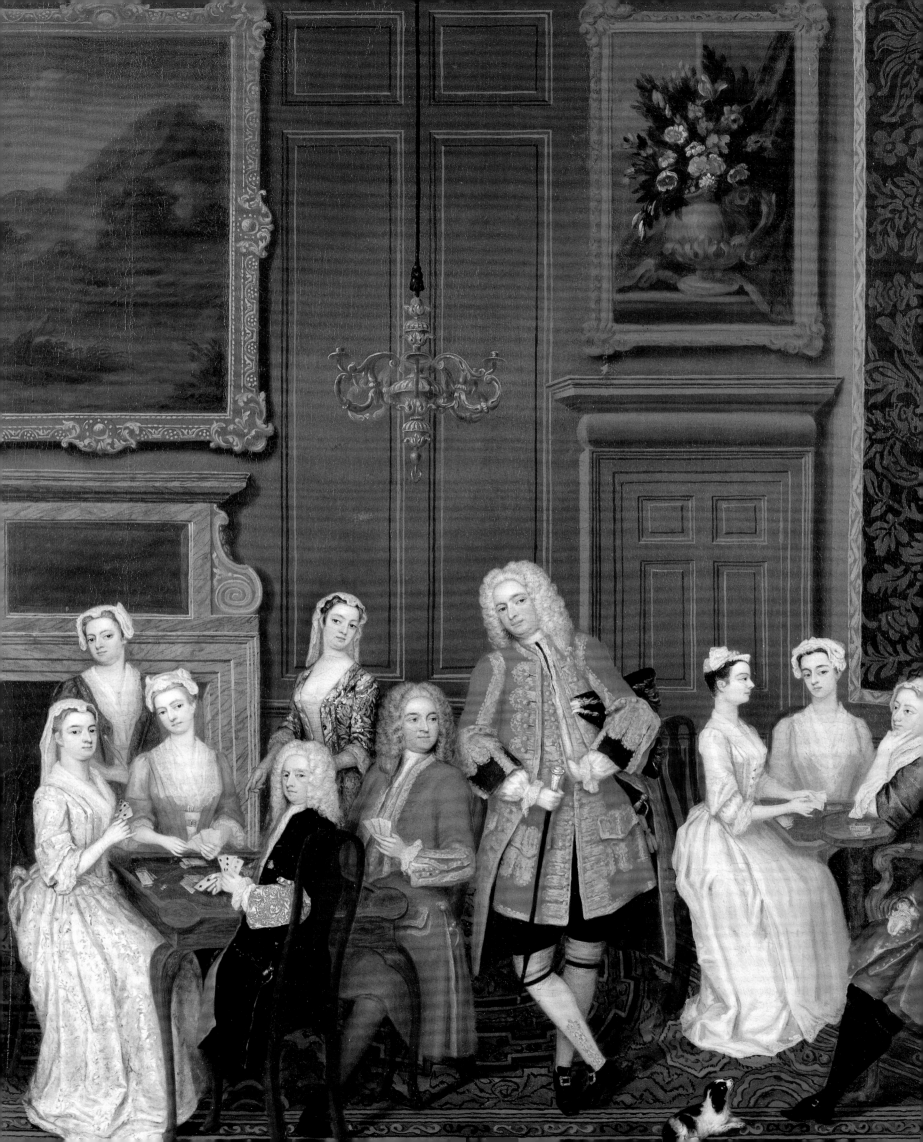

The twentieth century's concern with the history of style in painting and architecture and its desire to arrange it in a succession of tidy periods has caused particular problems with interiors in the first half of the eighteenth century. Not only have the general phases, Baroque, Palladian, Rococo and Neo-Classical, required constant reconsideration, revision and qualification, but a corresponding interest in the history of furniture and upholstery, textiles and dress, silver and colour, as well as social history and manners, have made the study of interiors of that time infinitely more complex. As a result, interiors seem less dominated by architects.

The problems are well brought out in Giles Worsley's *Classical Architecture in Britain* (1995), the key book in recent years, where he only comes to 'The Palladian Interior' in chapter 10 and then combines it with 'The Importance of Garden Buildings'.

> As an architectural style Palladianism concerned itself with exteriors and with planning, not with the decoration of interiors. In the *Quattro libri* Palladio's villas are illustrated with a ground-plan and an elevation, and while some of the palazzi have sections, none provides much lead on decoration . . . Each generation of Palladians had to create its own interiors in the shell which a Palladian design provided. Unlike the best Baroque buildings, interior and exterior do not necessarily have to form an integrated design. This gave Palladianism a flexibility which helps to explain its long survival at the heart of English architecture, for interiors could react to changing fashions while the architectural framework remained little altered.[1]

However, it is not really satisfactory to brush interiors aside in that way, because they presented a whole range of challenges, not least the demand for a style to work in a new political as well as a new architectural situation; and that involved a host of responses to non-architectural aspects of life. Also, by their very nature and the use of so many transitory materials, interiors and decoration tend to respond more quickly than buildings to changes in fashion and to the conscious and unconscious desire of patrons to get ahead of each other.

Thus the responses go far beyond architects' plans and drawings for walls and ceilings, which became increasingly sophisticated and seductive in this period, the relationship of theories of harmonic proportion and the search for fundamental truths in the architecture of Antiquity. They relate to the continuous evolution of a way of life that was strongly traditional and conservative in its roots and yet was demanding new rooms and new furnishings as well as changing relationships between rooms and appropriate settings for growing collections of works of art. The challenge lay in how to fit what were essentially non-architectural requirements into a highly formal architectural framework, often inspired by Palladian precedents, in which symmetry in planning was valued for its own sake.

The increasing interest taken by gentlemen in architecture was significant, and it is no accident that the first six decades of the eighteenth century were an age of amateur architects, most of whom were bound by a language of architectural quotation from the past. However, just as important but less noticed was the growing influence of wives on the way life was conducted. Today, most people approach their houses primarily through their exteriors and elevations, but in the eighteenth century most houses grew out of their plans. Palladio provided suggestions rather than solutions for houses in Britain, as can be seen in the original form of Stourhead, Wiltshire, as illustrated in *Vitruvius Britannicus* III, which was more closely modelled on a Palladian plan than most English villas but had to be considerably altered and enlarged to make a workable country house for the second generation of occupants.

On the other hand, it is surprising that, while sectional drawings were made and prints of them (Fig. 25) were included in books from *Vitruvius Britannicus* onwards, no one in England took up Daniel Marot's perspective prints of rooms (Fig. 93), and the first designer to make 'laid out' or 'exploded' drawings of rooms showing the appearance of all four walls so that they could be folded up to line a box was William Kent (Fig. 11). He also appears to have been the first to make use of colour in designs for interiors, as is recorded in payments to him and the proposal for the library at Holkham, Norfolk (Fig. 439). Architectural designs for interiors became much more sophisticated in the 1740s, but even so, little use of colour was made until the 1750s. And drawings of interiors such as *A Couple Taking Tea in Front of a Fireplace* by J. Poitvin (Fig. 1), of about 1710, are exceedingly rare. Among the few other examples are drawings by William Stukeley of his rooms in his house at Grantham starting in 1728, and the watercolour of Sir Roger and Lady Newdigate in the classical library at Arbury Hall (Fig. 88) in Warwickshire in 1751 by his sister-in-law, Mary Conyers. Idealized rooms appear in conversation pictures from the early 1730s onwards, but usually they are as stiff as the figures posed in them. Thus, although patrons and architects were fascinated by proportion and the relationship of spaces, rooms were arranged in a two-dimensional way, with furniture

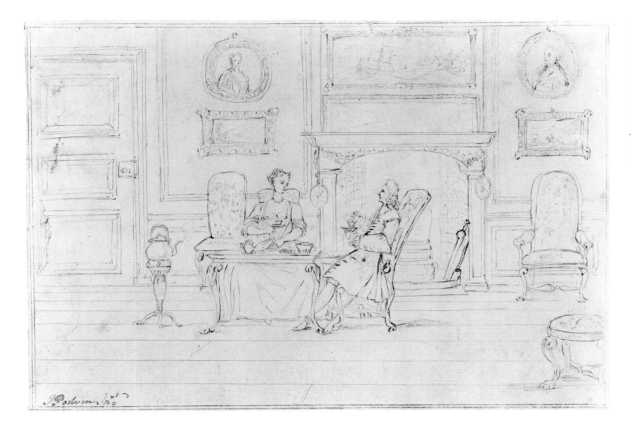

1. A Couple Taking Tea in Front of
a Fireplace *by J. Poitvin, about 1710. A
rare early eighteenth-century drawing of a
interior, it shows many details of furnish-
ing, such as upholstered arm- and side
chairs, a tea table with a kettle on stand
beside it and fire irons standing in the
fireplace. It also shows how the skirt of
the man's coat flows over the chair.*
National Galleries of Scotland.

always planned in relation to walls rather than spaces, hardly ever
being designed to be free-standing in a room.[2]

There is an argument for considering dress, both male and
female, before interiors, because that had such a profound effect on
the style of life, on the way people looked at things and how they
moved and sat. Court dress, formal and informal dress were all
significant, because they involved types and patterns of materials,
line and cut, and ornament; and in a period when the upholsterer
was the dominant figure in the furnishing of interiors, what was
happening in dress almost certainly anticipated developments in
upholstery. There is a certain affinity between the elaboration of the
working of the headboards of beds associated with Marot and
Francis Lapierre in the late 1690s and early 1700s (Fig. 101) and the
complexity of dresses such as the mantua in a bizarre pattern of
salmon-pink damask brocaded in green and yellow silk as well as
gold thread (Fig. 4) thought to date from about 1708 (now in the
Metropolitan Museum, New York).[3]

As far as fine materials are concerned, brocades, velvets and
damasks were expensive, and, since patterns for dress changed
every season and materials were woven in short lengths to maintain
their exclusivity, their choice involved training the eyes of their
wearers in a way that has virtually disappeared with modern ready-
to-wear clothes. Thus a high proportion of well-to-do ladies and
gentlemen were aware not only of the materials they wore and saw
other people wearing, as is apparent from the carefully observed
descriptions in letters of the time, such as those of Lady de Grey,
but surely also those they saw used to furnish houses. That comple-
mented the training of their eyes through reading and looking at
sets of prints and engravings in books, which had as crucial an
influence on the way people looked at things as, first, black and
white photography and, more recently, colour photography had in
the late nineteenth and twentieth centuries.[4]

Full dress and undress clothes for everyday wear affected
peoples' lives through the way their cut controlled their movements

and, particularly, the way they sat. Very broadly, over the century the
clothes of both sexes became less formal and more comfortable,
involving the use of less material, less formal, smaller patterns and
lighter cloths. Suits for men, introduced in the 1660s, were often in
plain woollens and in sober colours, browns and greys, with the
coat, breeches and waistcoat matching, but occasionally in a bright
colour, like the red suit worn by 'Lord Clapham', the doll of about
1690, who sits with his wife in the Victoria and Albert Museum. A
later example of a man's suit is to be seen in Devis's portrait, painted
in 1759, of Sir Roger Newdigate wearing a frock suit with a coat of
dark blue cloth trimmed with gilt buttons and a narrow gold braid as
precise as the nailing on the splat-back chair on which he sits in his
library at Arbury, with matching breeches and waistcoat.[5]

On formal occasions a man might wear a contrasting and more
decorative waistcoat, as can be seen with the silver brocade one
worn by 'Lord Clapham' and in the portrait of Arthur Vansittart
painted by Dahl in 1718, now at Lyme Park, Cheshire (Fig. 132).
However, whereas a suit of the second decade of the century con-
sisted of a long coat with a full skirt and stiffened pleats and had
what Aileen Ribeiro has called 'a Baroque fullness', by the middle of
the century both the coat and waistcoat were shorter and there was
less, and often no, stiffening in the pleats.[6]

This development was influenced by the adoption for sporting
activities and then for everyday wear of the frock coat, which had a
small turn-down collar, no stiffened side pleats and small closed
cuffs or slits. Originally a working-class garment, it began to be
adopted by gentlemen in the 1720s, because it was loose-fitting and
comfortable. An early idea of this can be seen in Knyff's portrait of
the 3rd Viscount Irwin with his shooting dog (Fig. 324), painted
about 1700, that provides the visual and historical key to the gallery
at Temple Newsam, at Leeds, Yorkshire.[7]

Englishwomen preferred more fitted clothes than the French,
and remained loyal to the hoop from about 1710 until the 1760s. As
Baron de Pollnitz, an admirer of English women, wrote in 1733:

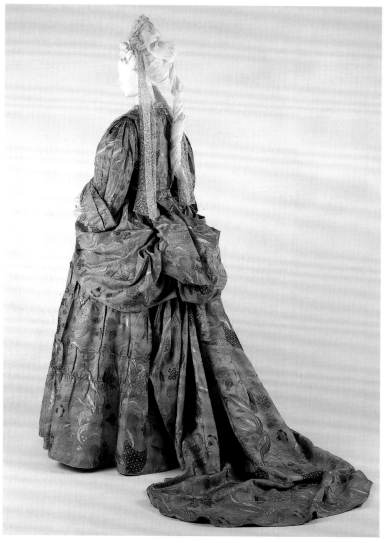

*The relationship between upholstery and dress.*

2. *A bed of about 1700 in two-coloured damask of the 'artichoke' pattern with an elaborately draped and fringed head cloth. Formerly at Wroxton Abbey, Oxfordshire and now in store at Aston Hall, Birmingham.*

3. *A detail of the two-coloured damask on the Wroxton bed. The 'artichoke' pattern was favoured about 1700, as can be seen at Hampton Court Palace.*

4. *The back view of an English mantua and petticoat of bizarre salmon-pink silk damask brocaded in green, yellow and gold, about 1708.* Metropolitan Museum, New York.

Most of the *English* women are handsome; they have the finest Hair in the World, and are only obliged to pure Nature for the Beauty of their Complexions. 'Tis a Pleasure to see them blush. They are commonly very richly dressed, but not altogether in the Taste of the *French* Ladies, which is the only Fault that I find with 'em. They seem to affect Dressing to their Disadvantage. Their Gowns so close before, with strait Sleeves, which don't reach beyond the Elbow, make them look as if they had no Shoulders nor Breasts. And what is worse than all, they have broad flat Rumps to their Gowns, and Hoop-Petticoats, narrow at the Top, and monstrous wide at the Bottom. They are always laced and 'tis as rare to see a Woman here without her Stays on, as it is to see one at *Paris* in a full dress.

The hoop reached its largest size in the 1740s and 50s, but by then

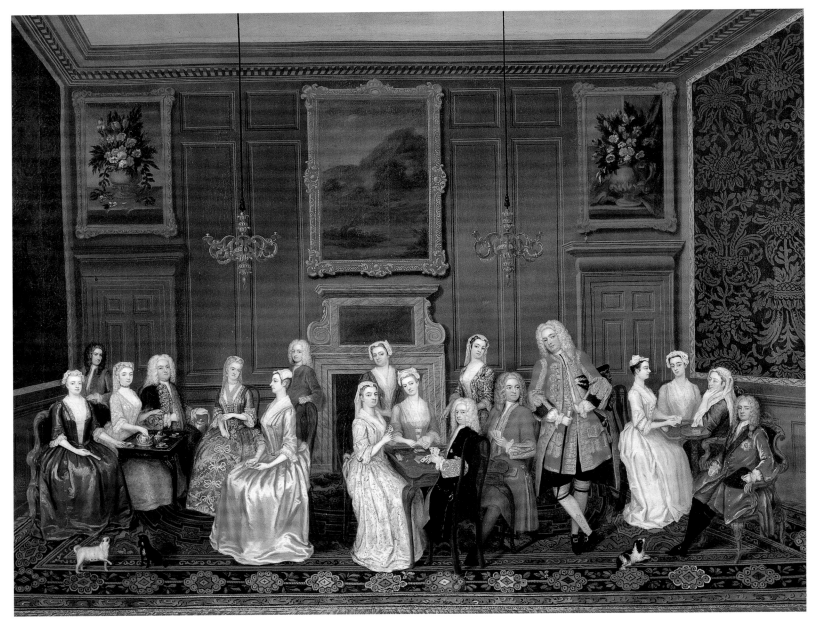

5. Tea Party at Lord Harrington's House *in London by Charles Philips, 1739.*
*The company includes several ladies connected with houses mentioned in the book: first*
*on the left, Lady Betty Germain; fifth from the left, the Duchess of Montagu, wife of*
*the 2nd Duke; seventh from the left, the Duchess of Dorset, wife of the 1st Duke;*
*next to her at the card table, Henrietta, Countess of Suffolk. They are shown tightly*
*laced in the English fashion.*

*The partly panelled room, presumably fitted up about 1720, is painted a stone*
*colour and the boldly figured hangings have a carved and gilt fillet. The simply*
*moulded marble chimneypiece incorporates a looking-glass. Its landscape overmantel is*
*balanced by a pair of flower pictures. The pair of carved and gilt chandeliers hang on*
*cords with tassels and have no candles. The floor is largely covered with an oriental car-*
*pet.* Yale Center for British Art, New Haven.

some chose not always to wear it, and after that it declined in size and use.[8]

It was Englishwomen's liking for being tightly laced that gave them that very stiff, upright appearance in many pictures, such as the *Tea Party at Lord Harrington's House* in London painted in 1739 by Charles Philips (Fig. 5) and in many by Devis. They liked to sit on side chairs with fairly straight backs so that their skirts over hoops had the freedom to fall on either side. It is easy to understand Lady Hertford writing in 1740: 'Few unmarried women appear abroad in robes, or sacques; and as few married ones would be thought genteel in anything else. I own myself so awkward as to be yet unable to use that dress, unless for visits of ceremony; since I do not feel at home, in my own house, without an apron; nor can endure a hoop that would overturn all the chairs and stools in my closet.'[9]

With those restrictions, it is not surprising that both men and women set a great deal of store by their informal clothes and,

indeed, often chose to be painted in them, as were the young Lord Burlington and the young Thomas Coke (Fig. 436). Wrapping or nightgowns were worn by men and women in the mornings, women regarding them as informal dress, to be worn with an apron. They were made of a wide range of materials and, not surprisingly, since their cut was originally influenced by the kimono, many of them were of silk, sometimes painted, or of chintz imported from the east. These in turn encouraged the taste for chinoiserie and its association with informality in dressing-rooms and bedrooms. The quality of some of these gowns can be judged by the miniature versions belonging to 'Lord and Lady Clapham', the splendid toilette that the 2nd Lord Dysart bought in Paris (on view at Ham House, Surrey) and the dressing-gown at Newhailes, Midlothian associated with Sir James Dalrymple and made of a grey silk with a white figure recorded in a design by Anna Maria Garthwaite in 1742 and lined in plain green silk.[10]

However, the development of fashion cannot be considered through treating male and female clothes as separate, albeit parallel, subjects, because the balance between male and female clothes began to change in the middle of the century, with men's clothes becoming less eye-catching. That in turn suggests a more fundamental change in the balance of life that is reflected in the design of houses and interiors and the nature of the Rococo.

What makes the relationship between dress and decoration so difficult to follow is that it is hard to visualize what was worn in and around a country house in the first half of the century and how formal clothes would have been for dinner in the Great Parlour or the dining-room or when parade rooms were used. There are few revealing remarks like that of Lady Kildare writing in November 1762 to her husband from Castletown, her sister's house in Co. Kildare: 'We are mightily quiet and comfortable, live all day long in one room, muddle and dress in the morning for all day.' That was unusual, because generally people were fairly formally dressed by the middle of the day.[11]

Yet how people dressed at home is just as significant for decoration and furnishing as all the Palladian propaganda. Moreover, as we shall see, there were links between the patterns used for clothes (Fig. 4) and upholstery (Fig. 3), and, since patterns and colours of rich dress materials for formal clothes changed every season, they must have influenced materials used for hangings and seat furniture, although, of course, the latter changed more slowly. Certainly the passing of boldly figured designs in dress brocades and damasks and their replacement by more flowing designs in lighter materials was important for upholstery. On the other hand, changes in style were slow-moving, and even the well-to-do kept their clothes for years; and there are many examples of eighteenth-century dresses in expensive materials that were altered or remade later. But just as everyday clothes have seldom survived, the simple materials used in houses are rare: it is the richer materials that sometimes remain *in situ* in parade rooms because they were little used and carefully looked after.

Deportment was also important, and eighteenth-century attitudes involved a complicated code of training by the dancing master on how to stand, move, bow and curtsey, as can be seen in the plates in *The Rudiments of Genteel Behaviour* by F. Nivelon, originally published in 1737 (and reprinted by Paul Holberton in 2003). What was involved can be gathered from '*The Dancing Master* done from the *French* of Monsieur RAMEAU by J ESSE *Dancing-Master*', whose profusely illustrated book appeared in 1728: 'Dancing here in *England* has been very much advanced withine this twenty years' and he considered it of importance because 'since 'tis by what we behave ourselves so gracefully in the World, and our Nation is so much distinguished'. He described how to walk well, how a man should take off his hat and put it on again, 'of Honours of different kinds' – that is to say, how to bow forwards, to left and right and backwards – 'Of the Manner how Women ought to Walk and appear gracefully' and 'of the Honours used in Entering a Room, or in an Assembly'. The key lay in the 'Manner of carrying the Head; which is, that a Woman, how graceful so ever she may be in her Deportment, may be differently judged of: For example; if she holds it upright, and the Body well disposed, without Affectation, or too much Boldness, they say there goes a stately Lady'.

That was a visual expression of a highly ordered society that encouraged a sense of looking up, not only metaphorically but literally: it applied to how people looked at each other and also how they looked at rooms. Eighteenth-century rooms were designed, perhaps unconsciously, to be taken in at eye level and upwards, rather than at eye level and down. That can be seen in such points as the way pictures were hung high, portraits were so composed as to read best when looked up to rather than at eye level as they are so often today, and attention was concentrated on entablatures, cornices and the coves of ceilings.

Today, not only do people dress and carry themselves in a much more relaxed way, but their rooms are almost always strongly horizontal in emphasis, and that can make them find more vertical eighteenth-century rooms uplifting and challenging, even daunting. Thus an understanding of deportment as well as dress has to be borne in mind when thinking about eighteenth-century decoration.

Silver was also more significant in the look of rooms than is generally realized today, because it was such an important statement of prestige as well as a way of building up a realizable asset. Like rich materials for clothes, it helped to develop taste through concentrating the eye and the mind of the patron. It often seems to have been one of the first fields for considerable expenditure when a young man came into his inheritance. Examples of both will be cited later. On the other hand, it is important to take note of the converse, particularly in squires' plate lists, where show-pieces such as epergnes, tureens and dinner services are absent and total values are modest.

New ideas about style and ornament must often have been encountered through making purchases of plate. So it is no accident that the first manifestations of the Rococo in England appeared in silver in the early 1730s, and by 1736 Lamerie's Rococo style had matured. Only after that did it occur in printing, then in silk designs for clothes, and after that in carving, as in Paul Petit's gilt frame with sporting motifs for Frederick, Prince of Wales's painting of *The Shooting Party* by John Wootton in 1742, and in plasterwork, as can be seen in the dining-room at Kirtlington, Oxfordshire (Fig. 399) and the saloon at Honington, Warwickshire (Fig. 81).[12]

For most of the period, the upholsterer was the principal figure in the fitting-up of interiors, but possibly in the mid-1740s and certainly by the early 1750s that began to change as a result of developments in furniture. These included not only the increasing use of mahogany from the late 1730s and the way that wood lent itself to carving, but also the introduction of new forms, the growing sophistication of established ones, in particular chair and settee frames and the way they were stuffed, and the desire for more elaborate sets of furniture. Thus Thomas Chippendale on the title page of his book *The Gentleman and Cabinet-Maker's Director* in 1754 described himself as 'Cabinet-Maker and Upholder'. However, the picture of the English furniture world has been complicated by a tendency to date pieces optimistically early: many need to be placed at least a decade later. It is particularly difficult to follow developments in chair design, as forms were developed for different rooms and purposes, and new rooms produced new requirements. This diversification and specialization led to the cabinet-maker taking over leadership in the furnishing trades from the upholsterer, who was already finding less demand for hung rooms, richly worked materials and complex displays of trimmings.

Yet another thread was provided by the increasing importance of ladies, and particularly heiresses, in social life and their influence on houses and taste. They had an impact on the growth of informality and comfort, particularly the privacy of bedrooms, which in turn

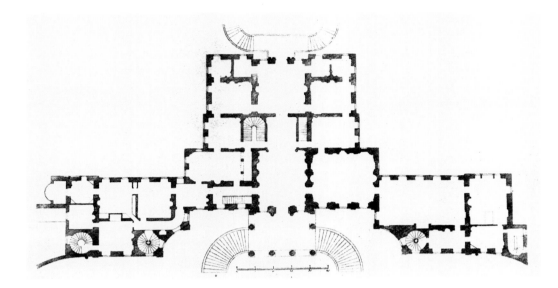

6. *The plan of Hopetoun House, Midlothian. This shows how in 1721 William Adam planned to add a grand new front range to the smaller late seventeenth-century house, with an apartment for Lord and Lady Hopetoun to the left of the hall and the Great Apartment to the right. That was to have a Great Dining-Room with pilasters and a buffet niche and a five-bay Great Drawing-Room (Fig. 123), with a bedroom beyond. The decoration and furnishing of the rooms to the right was only completed in the 1760s. The private dining-room was to have a screen of columns masking access to the service stair.*

encouraged a new spirit of experiment in decoration and furnishing. What is less clear is when that started.

In ladies' letters and journals there are often references to visits to shops, particularly mercers for materials – Lady Anson in 1753 wrote to her sister-in-law: 'I have turned over all Carr's and Swan's shops two or three times, and I will mention as well as I can what I think most likely to suit your Ladyship.'

Little at present, however, is known about shops and dealers in luxury goods and works of art and their role in creating fashions. Some idea of what shops were like can be gathered from trade cards. That for The Blew, or Blue, Paper Warehouse of about 1720 (Fig. 111) shows an elaborately designed shop with an inner arcade and behind it a lady seated at a counter. James Wheeley's trade card, probably dating from the 1760s, shows a fashionably dressed couple discussing a bold flowered wallpaper that has been unrolled for them by a young assistant standing by one of the senior figures in the shop.[13]

The history of style has also led to a concentration on new houses at the expense of old ones that were enlarged and modernized. Yet the way houses were altered and rooms were given new names and contents often provide revealing evidence about how ways of life were changing and why alterations were carried out. Roger North is particularly illuminating about this in his *Treatise on Building*, evidently written in the mid-1690s after he had altered and enlarged Rougham Hall in Norfolk:

> And the more desirous a man is of large accommodation, the more reason he hath to decline the new, and take to the reforming part. For an old house will have much room convertible to uses, which a man will not allow him self in new, where extent multiplys charge intollerably . . . I cannot but add, that a new fabrick is so chargeable, that it is usually thrift pinch't in the dimensions so as to be very inconvenient.[14]

The emphasis on new work and progressive thinking in modern writing has also meant that insufficient attention has been devoted to the strong thread of conservatism in country houses, whose owners tended to take a long view of time, often looking backwards and forwards simultaneously and being as concerned with the past as the present and the future. That is particularly apparent in the prominence given to heraldry in many houses and the way that it was turned to decorative purposes. Today, so few people can read

arms that crests and complete achievements tend to evoke little response, but it is worth registering the range of their uses in the first half of the eighteenth century. Apart from on plate, for which there were a number of specialist engravers, including William Hogarth as a young man, and on Chinese export porcelain services, coats of arms or crests appear (or appeared) in plaster on the ceilings of the halls at Houghton and Raynham, both in Norfolk (Figs. 193, 225); in overmantels in the halls at Ombersley Court, Worcestershire and Buxted Park in Sussex; as the theme of Lady Betty Germain's tapestries formerly at Drayton House, Northamptonshire and on the borders of tapestries at Blenheim Palace, Oxfordshire (Fig. 358) and Stowe, Buckinghamshire; on a range of looking-glasses, engraved at Chatsworth, carved and gilt-framed at Blenheim (Fig. 355) and Bowhill, near Selkirk, in Scotland; in *verre églomisé* at Drumlanrig Castle, Dumfriesshire and Penshurst Place, Kent; on Italian scagliola table tops like that with Lord Lichfield's arms from Ditchley, Oxfordshire, now in the Victoria and Albert Museum; on lacquer chairs at Osterley Park, Middlesex (Fig. 351) and in *verre églomisé* on chairs from Sutton Scarsdale, Derbyshire (Fig. 134); on a looking-glass table top at Erddig in Clwyd, North Wales (Fig. 366); in needlework on chairs at Berkeley Castle, Gloucestershire (Fig. 273); on a carpet at Aston Hall, Birmingham; and with crests used for the legs of side tables at Holkham (Fig. 457) and at Spencer House in London (Fig. 244).[15]

What is also often forgotten is how long it usually took to complete a new house. Many were never completed by their initiators, and changes of generation through early deaths followed by minorities often led to changes of mind about planning, decoration and furnishing. Thus modern figures for new country-house building in the first half of the eighteenth century have to be viewed with caution. Sir John Summerson, following up Vanbrugh's observation to Lord Manchester in 1708 that 'All the World are running Mad after Building, as far as they can reach', was concerned to discover the pace of building and produced impressive figures for it, but, of course, they are for the start of work and do not take into account completion – or non-completion or major alterations. He made a list of 150 large country houses built in England between 1710 and 1740: it showed twenty-one and twenty-two respectively were begun in the years 1710–14 and 1715–19; after that, the numbers rose to no less than fifty in 1720–4, and then twenty-two, twenty-one and eleven in the three five-year periods after that. However, of the fifty

7. *Stanford Hall, Leicestershire.. The entrance front on the left in stone and the east front in brick. The house was begun in 1697 by Sir Roger Cave and designed by William Smith the elder and completed three owners later by Sir Roger's younger grandson, Sir Thomas Cave, in 1745. The stables were added by Francis Smith for Sir Thomas in 1737.*

begun in the early 1720s, most would have been fitted up in the years after 1725; and it is worth bearing in mind what happened to some of the most important houses that took a very long time to complete.[16]

At Castle Howard, Yorkshire, the 3rd Earl of Carlisle began building in 1700, but never succeeded in finishing the house (Fig. 21). His son, the 4th Earl, who inherited in 1738, made considerable changes to the furnishing of the Great Apartment in the south front. Then, in 1753, he began the west wing to a new design by Sir Thomas Robinson, but died in 1759 before its interior was finished. That was only finally completed in the early nineteenth century and according to yet another plan.

Blenheim was begun in 1705, but building stopped between 1712 and 1716, when Vanbrugh resigned. Then, without Vanbrugh's involvement, it resumed, and in 1719 the Duke and Duchess were able to move into the private apartments (see pp. 275–9). The Duke died in 1722, but the Duchess went on working on the house although she never completed the furnishing, as can be seen from the inventory she compiled in 1740, by which time much of it, as well as the plan, seemed old-fashioned. That can be gathered from the descriptions of the way materials were worked, and not surprisingly in 1752 the Duchess of Northumberland thought 'The furniture of the House in general is both old fashioned & shabby'.

A neighbouring house in Oxfordshire, Ditchley, built by the 2nd Earl of Lichfield, was less ambitious (see pp. 291–6). It was begun in

1720, but even so there were distinct changes in style between, first, the Baroque plasterwork in the saloon and the Kentian decoration in the hall done in the mid-1720s, and then again in the dining-room fitted up by Flitcroft in the late 1730s; and some rooms were still unfinished when Lord Lichfield died in 1743. And at the end of the decade, changes were made to the plan.

Holkham took about forty years from its conception by Thomas Coke, later 1st Earl of Leicester, and Lord Burlington about 1726; the family wing was completed with help on decoration from William Kent in 1741, but the main block was not fitted up until the 1750s; and Lord Leicester continued to respond to new architectural ideas, making changes to the interior right up to his death in 1759 (see pp. 313–24). The house was completed by his widow in 1764. So, stylistically, the architectural decoration of the house runs from early Palladianism to early Neo-Classicism.

In Scotland, one of the few ambitious projects of the 1720s was the 1st Earl of Hopetoun's refronting of Hopetoun House, near Edinburgh, and the fitting-in behind it of extended suites of parade and family rooms (Fig. 6). The front elevation of nineteen bays was designed by William Adam in 1721 as a Scottish answer to Canons, the Duke of Chandos's house at Edgware, but the great portico had not been started when the earl died in 1742. It was abandoned by his successor, who employed the younger generation of Adams to complete the interior in the 1750s; and the 2nd Earl only obtained the final furnishings in the late 1760s.

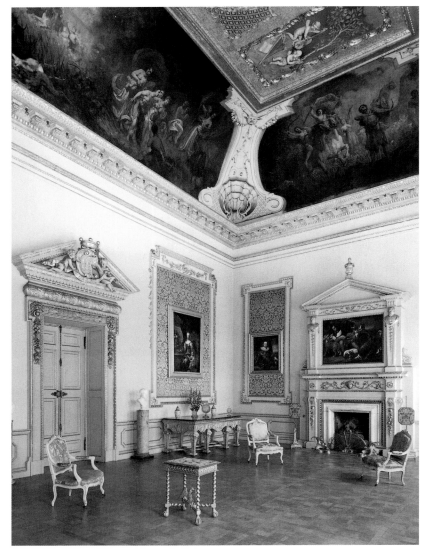

8. *Stanford Hall, Leicestershire. The double-height saloon with a deep coved ceiling completed in 1745 by William Smith the younger for Sir Thomas Cave in place of Sir Roger's single-storey hall. The painted decoration was added in 1880.*

If noblemen and those who had made large fortunes found it difficult to complete great houses, many squires of moderate means found it even harder to finish what they had begun. Stanford Hall in Leicestershire is an excellent example (Fig. 7). Building started in 1697 but was only completed by the fourth owner in descent in 1745, and by the third member of the Smith family to work on it. However, it takes time to digest how it was altered in that period and ended up a rather different house from that planned in the 1690s by Sir Roger Cave, the 2nd baronet, with William Smith (1661–1724) as architect and builder. They conceived it as an H-shaped house with its main elevation of nine bays in stone facing down a straight avenue and all its other elevations, including its east front of seven bays, in brick. Sir Roger died in 1703 at the age of forty-nine before completing the main part of the interior.[17]

His son, Sir Francis, fitted up the Great Parlour, presumably the room at the south-west corner of the house now called the Green Drawing-Room, but again he died before finishing the house, in 1719. With the aid of Francis Smith (1672–1738), William's brother and Sir Roger's grandson, Sir Verney, put in the main staircase about 1730 and planned other work, but died young and unmarried in 1734.

So it was left to Sir Verney's brother, Sir Thomas, to finally complete but also revise the design of the house. In 1737 he built a large stable block set back to the north so that it did not obstruct the view from the family rooms in the east front. This encouraged him to create a new entrance in the centre of the east front at first-floor level, over an existing one at ground level that must have been used by the family as well as servants. Moving the entrance also led to rethinking the original concept of the single-storey entrance hall filling the five central bays of the south front. This was finally made into a double-height Great Room or saloon (Fig. 8), by William Smith the Younger (1705–47), the son of Francis. Then, presumably, the Great Parlour became the drawing-room and the two other related rooms in the west front the principal bedroom and dressing-room. At the same time, the original apartment at the north-east corner of the house was made into a dining-room. Thus the whole house evolved as it was completed.

These examples suggest that what we like to think of as period houses and period rooms need to be looked at with caution. Very few were ever complete entities, built, decorated and furnished from scratch at one time. Most made use of some pictures and furniture and even fittings that were inherited or came from earlier houses, while everyday rooms must always have been subject to modifications of arrangement to suit changes in family life. What is striking is how many families lived with the builders for so many more years than would be acceptable today and recognized that some jobs would have to be left to the next generation – and might even have left them quite deliberately, to bind their heirs to the house and discourage them from altering it. Therefore it is only possible to attempt to recreate a theoretical framework to living two hundred and fifty years ago.

At Inveraray, in Argyllshire, a particularly remote place, the project took forty-five years and three generations to complete. It started with Vanbrugh's first sketch for a castle-style house about 1720, in the time of the English-orientated 2nd Duke of Argyll, but building was only begun to Roger Morris's design by the 3rd Duke in 1745. Then there was a major revision of the plan; and finally in the 1780s decorations were carried out by the 5th Duke in a version of the Louis Seize style associated with the young Prince of Wales at Carlton House.

In Ireland, the greatest of the houses, Castletown in Co. Kildare, was begun by William Conolly about 1720 but was left unfinished when he died in 1729. Work was only resumed in 1759, when the staircase was decorated in the Rococo style, and the house was finally completed in the mid-1770s when the painting of the gallery was carried out in a Pompeian manner.

*The Uses of Rooms and Changing Social Practice, 1685–1760*

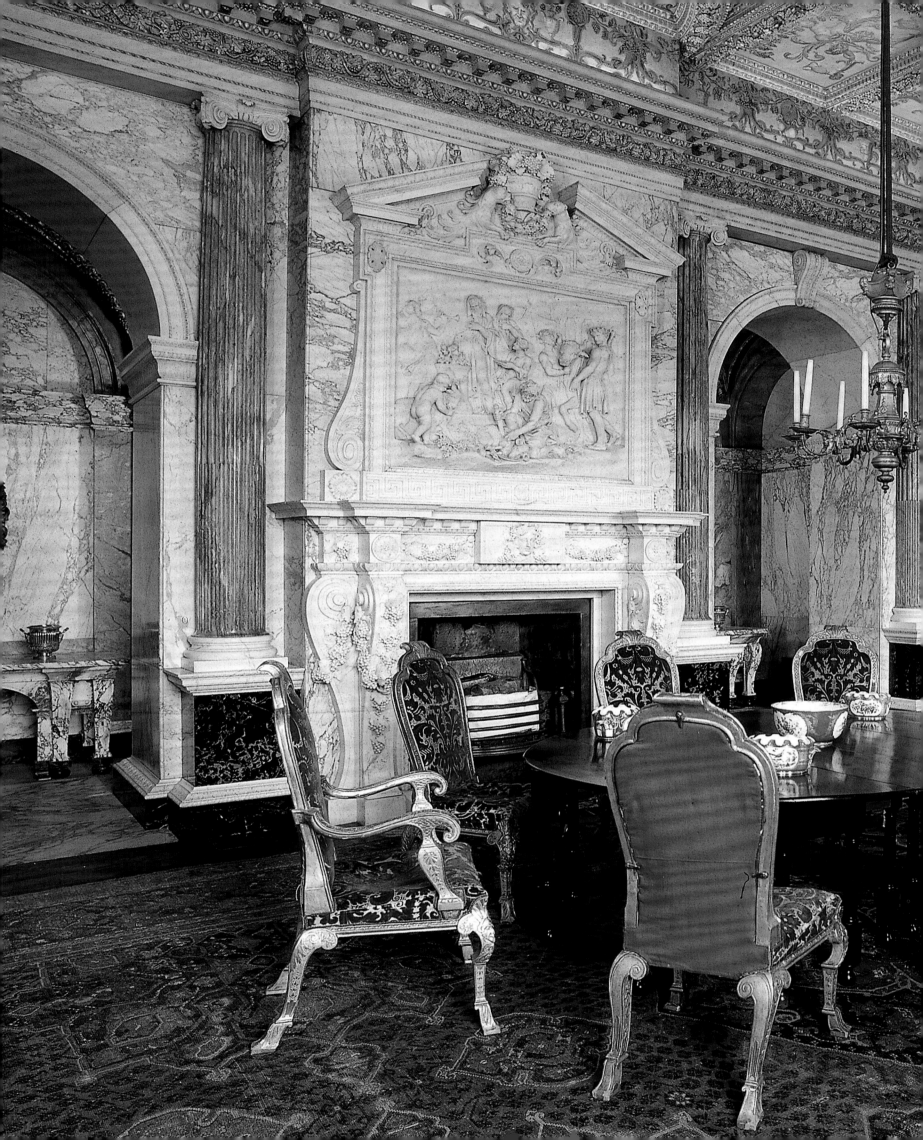

## THE MEANING OF STATE

In recent years, planning of eighteenth-century houses has been considered as a largely architectural matter, with attention concentrated on great apartments from the late seventeenth century onwards and the villa in the second and third quarters of the eighteenth century. But there has been no detailed study of planning, use, size of rooms and their relationship with decoration and furnishing in the first three-quarters of the eighteenth century; and, in fact, so few rooms with their contents survive intact that it is surprisingly difficult to provide a picture of rooms by type and by decade in this period. Also, little has been written about the decline of the great apartment in the mid-century, or about the move away from the processional plan in a great house, with its climax in the bedroom, to a balanced relationship between rooms used for different purposes at different times of the day. The extended linear plan of Blenheim, with its twin great apartments (Fig. 354), had no successors except for Wanstead (Fig. 25), and, although both Houghton (Fig. 188) and Holkham (Fig. 437) had what were in effect double great apartments, the attitudes of George I and George II to England did not encourage their aristocratic subjects to plan for royal visits of the kind that are implicit in the Jacobean arrangement of Hatfield House, Hertfordshire. The provision of private rooms and family apartments has also to be borne in mind, as can be seen when those at Blenheim are compared with those projected for Hopetoun, and provided at Houghton and Holkham.

An immediate problem arises through the past and present uses of the word 'state' in connection with rooms and beds. It has become more used through the opening of houses to the public and the showing of rooms that often have not been lived in even on an occasional basis for a long time; and it has become wrongly associated in people's minds with 'royal', because of state apartments in royal palaces, where the word is correctly used. In recent architectural history it has received attention following Hugh Murray Baillie's seminal article on 'State Apartments in Baroque Palaces' in *Archaeologia* in 1967.

It is its meaning of dignity and pomp that needs emphasis, because many rooms and apartments that are now usually called 'state' were in the past referred to as 'great' or 'rooms of parade' or 'apartments of state'. Roger North, for instance, referred to parade rooms and also used the word 'state' – 'If the house be of very great state', 'an apartment of state' and 'a state bedchamber'. And he distinguished between houses belonging to noblemen and private gentlemen. In most houses, particularly those of private gentlemen, parade rooms, while inspired by or modelled on arrangements in royal palaces, were not reserved for royal visitors but were intended as statements of family dignity and to honour special guests as well as impress visitors. As the Duchess of Marlborough wrote to Mrs Clayton about Blenheim, 'there is 20 apartments with all sorts of convenience fit to lodge anybody, but upon the principal floor there are three that are really so fine that they are too good for any body to make use of except their R Highnesses & the Dear Prince William'.[1]

However, as the years passed in those houses where fine beds of the Baroque period survived, they became objects symbolic of the past to be admired and preserved rather than used, not least because they were in inconveniently placed and uncomfortable apartments; and the description 'state' became attached to them. Mrs Delany, for instance, writing of Lord Guilford's prospective visit to Bulstrode in Buckinghamshire, suspected 'that the good Earl would find himself more comfortable if he was not honoured with the great apartment'. The pressure to preserve them can be seen at Powis Castle, in Wales, where in 1772 T. F. Pritchard recommended to the Earl of Powis that 'This whole apartment has a most Elegant appearance, and shou'd be preserved to keep up the Stile and Dignity of the Old Castle'. In 1770 Horace Walpole added on to Strawberry Hill the Great North Bedchamber (Fig. 306), which he described as a state bedchamber, although it was primarily a room to complete a tour and show off more objects to visitors. Similarly at Cotehele in Cornwall, the bedrooms were arranged for show, not use (Fig. 290).[2]

On the other hand there are a few rooms in country houses whose names do recall royal visits, like the old state bedroom at Petworth, which in the first half of the eighteenth century was called the King of Spain's Room; the King William Room at Castle Ashby, Northamptonshire, which is the former Great Chamber renamed to mark William III's visit in 1695; and the Queen's Rooms at Sudbury, Derbyshire and at Belton, which commemorate the visits of Queen Adelaide, the widow of William IV. The Best Bedchamber at Aston Hall, Birmingham, was called the King's Chamber by Sir Lister Holte in the mid-eighteenth century to commemorate the family's royal service in the Civil War and the siege of Aston in 1643.[3]

*The Marble Parlour, Houghton* (see Fig. 217)

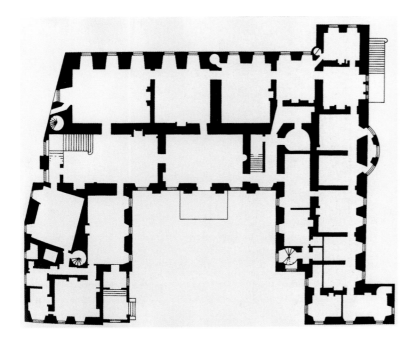

*Dalkeith Palace, Midlothian*

9. *A plan of the ground floor of the remodelled house shows Anne, Duchess of Buccleuch's early eighteenth-century arrangement of the Great Apartment on the north side of the house meeting the private apartment in the east range in the two corner closets. The Great Dining-Room, later the gallery, was on the first floor over the hall and part of the staircase hall, and it led through to a drawing-room flanked by two more important bedrooms on the north side.*

10. *The overmantel in the Picture Closet, at the north-east corner, with a carved marble frame and looking-glass painted in the manner of Marot by Bogdani in 1701 for the Duchess of Buccleuch at Moor Park, Hertfordshire, but soon removed to Scotland.*

Chatsworth, in Derbyshire, is revealing. While it has one of the few great apartments suited to a prince, indeed considerably grander than William III's palace at Het Loo after he extended it in the early 1690s on becoming King of England, the first room was originally called the Great Chamber, taking over the name from its Elizabethan predecessor; and later it was sometimes referred to as the Great Dining-Room. The complete run of rooms was called the State Apartment, but by 1764, the date of the earliest inventory, when the rooms were already thought of as archaic, only the dressing-room and bedchamber were given the prefix 'state'. Moreover, by the late eighteenth century and at least up to the mid-nineteenth the names of the rooms had completely dropped out of use and, like those of the same period at Boughton, Northamptonshire, they were merely numbered. The emphasis on 'state' only developed in the late nineteenth and twentieth centuries, with the State Music Room being a fiction that takes its name from the *trompe-l'œil* violin painted on an inner door brought from Devonshire House.[4]

Dalkeith Palace, Midlothian, makes an instructive comparison with Chatsworth, because Anne, Duchess of Buccleuch, as the widow of the Duke of Monmouth, regarded herself as being close to royal rank. She replanned Dalkeith on the grandest lines in the opening years of the eighteenth century, with a Great Apartment at right angles to her own and rooms for daily living on the ground floor (Fig. 9); over the hall was a Great Dining-Room that led to a drawing-room on the far side of the house flanked by a pair of handsome bedrooms. The first and largest room of the Great Apartment was called the Great Ante-Chamber and was simply furnished as an eating room with black-framed chairs with black leather seats. Then followed the Great Drawing-Room and the tapestry-hung Queen's Room, called after its marble-framed overmantel portrait of Mary of Modena, the wife of the dethroned James II – not Queen Anne – and with a yellow damask rather than a crimson bed, which would be the more usual choice in that position. Could the choice of colour have a significance that is lost on us? Only later was the room called the State Bedroom, perhaps after it was used by King George IV on his visit to Edinburgh. Beyond it were three small, richly fitted, intercommunicating rooms, the Blue Dressing-Room, the Picture Closet, with its Marotesque glass painted by Bogdani set in a marble frame, which was on the corner of the house (Fig. 10), and the Great Closet, with its marble chimneypiece topped with a relief by Grinling Gibbons and marble-framed glass with its applied decoration of the Duchess's coronet and monogram framed by sprays of leaves. These little rooms could also be used in combination with the Duchess's bedroom in the east range.[5]

Given the notoriety of the Duke of Chandos's Canons at Edgware in Middlesex as a symbol of extravagance and splendour, it is revealing to find the word 'state' not used in the 1725 inventory. Instead, the contents of the Best Dressing-Room and Best Chamber are given. On the other hand, in the Duke of Chandos's house in St James's Square the most richly furnished room was called the State Chamber, but, instead of a crimson bed, it had one of 'flowered Turkey damask'.[6]

At Houghton, when Isaac Ware produced his folio volume on the house in 1735, the word 'state' was not used at all. However, at Holkham Matthew Brettingham refers in his book, first issued in

11. *William Kent's 'exploded' or 'laid out' design for the decoration of Viscount Cobham's North Hall at Stowe, with its painted cove and ceiling, about 1730. This shows how he worked up an outline drawing set out by a draughtsman.* The Paul Mellon Centre for British Art at Yale.

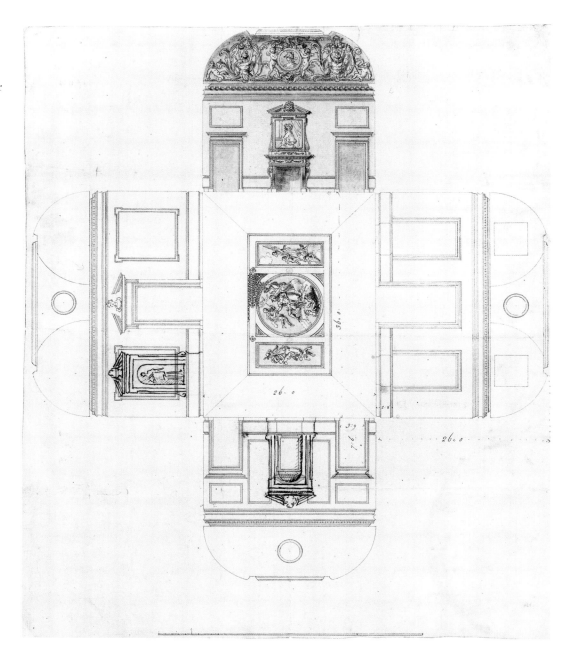

1761, to the State Bedchamber Apartment, to the drawing-room as the State Ante-Chamber, the Landscape Room as the State Dressing-Room and to the State Bedchamber and North State Bedchamber.[7]

At Stowe, the earliest version of the guidebook describing the interior, bound into a copy of the 1756 garden guidebook, refers to the State Apartments, the State Bedchamber, State Dressing-Room and Closet, and State Gallery (Fig. 12). By then Stowe had been a show-place for some forty years – the New Inn for visitors had been built in 1717 – but Earl Temple, the nephew of Viscount Cobham, who had inherited the property in 1752, was keen to publicize it, and it is conceivable that he deliberately played up the character of the interior as part of that.[8]

Lord Cobham, who had served in the Marlborough wars and been made a major-general in 1709, had been happy to continue to call the enlarged centre room of the south front by its old name of the Great Parlour, although he gave it a heroic character by hanging it with a set of *Art of War* tapestries bearing his arms and motto. The tapestries were woven in Brussels between 1706 and 1712. In about 1730 he employed Kent to design the hall, as can be seen from his

'exploded' design (Fig. 11), and to paint the ceiling with a central roundel of *Lord Cobham receiving a Sword from Mars* in grisaille on a mosaic ground (Fig. 13), as well as set up a marble relief by Veyrier of *The Family of Darius Before Alexander*. In the 1740s, he formed the adjoining gallery hung with Brussels tapestries of *The Triumph of the Gods*. However, it was Lord Temple who in the 1750s formed the rooms beyond, including the new State Bedroom. Its showy bed designed by Borra and completed in 1759 (now in the Lady Lever Gallery) must have been primarily a theatrical prop to impress visitors rather than a bed to be slept in; and it is conceivable that the use of 'state' in connection with it and all the related rooms was an ancestor of modern marketing language.[9]

The terms 'state bedchamber' and 'state bed' were certainly used at Woburn when that house was remodelled in the 1750s. Norman's bill for the bed calls it the Grand State Bed. But that was in a ducal house that was deliberately conservative. Similarly in the inventory for Castle Howard taken on the death of the 4th Earl of Carlisle in 1758, the rooms of the original Great Apartment are called State Drawing-Room, State Bedchamber and State Dressing-Room while the 3rd Earl's bedroom had become the Second State Bedchamber.[10]

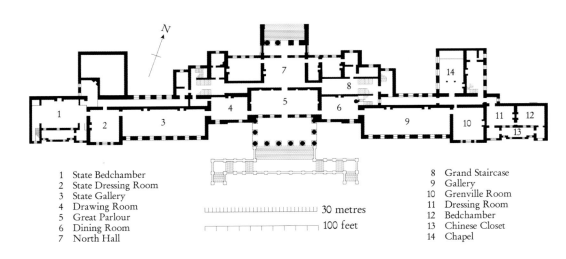

1 State Bedchamber
2 State Dressing Room
3 State Gallery
4 Drawing Room
5 Great Parlour
6 Dining Room
7 North Hall

8 Grand Staircase
9 Gallery
10 Grenville Room
11 Dressing Room
12 Bedchamber
13 Chinese Closet
14 Chapel

30 metres

100 feet

*Stowe, Buckinghamshire.*

*12. A plan of the principal floor in 1763. To the original nine-bay seventeenth-century house, with its enlarged, five-bay, Great Parlour in the centre, two extended apartments with seven-bay galleries were added in the 1740s but only completed in the 1750s. The state apartment with its dressing-room and bedroom lay on the far left and Earl and Countess Temple's rooms on the far right.*

*13. Part of the ceiling and cove of the North Hall at Stowe as painted in grisaille on a golden mosaic ground by Kent with a central roundel of* Lord Cobham receiving a sword from Mars *and ornament in the cove. It can be compared with the decoration in the saloon at Houghton (Fig. 195).*

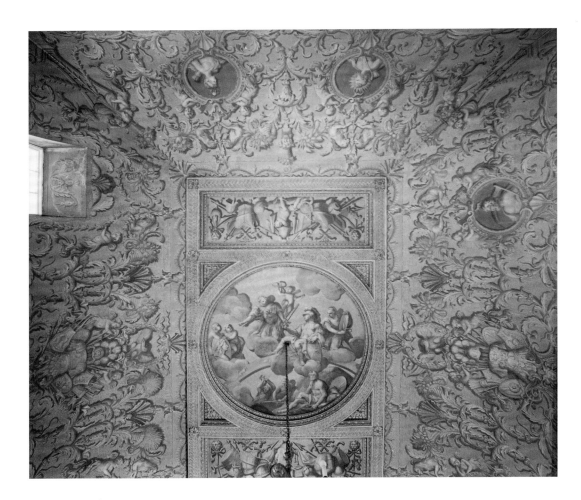

*14. The interior of the doll's house at Nostell Priory, Yorkshire, presumably made about 1740 by the craftsmen working with James Paine on the new house. It illustrates on a miniature scale many contemporary ideas about decoration and furnishing.*

Bottom left and centre: *the Common Parlour and hall. The panelled Common Parlour is furnished as an eating room with splat back chairs that have leather seats. The grey marble of the chimneypiece is also used for the top of the pier-table, which has wrought-iron brackets; over the chimneypiece is a landscape glass and painting framed together; and the room retains its original lustring curtains, pelmet cornices and valances.*

*The marble chimneypiece in the hall, like others in the house, is copied from plates in Gibbs's* Complete Book of Architecture. *The set of hall chairs is a fairly early example.*

*On the middle storey are the principal rooms, with, on the right, the drawing-room. Here the architectural detail is carved and gilded; the walls are decorated with cut-out prints; the curtains are of crimson velvet; the treatment of the overmantel echoes full-scale examples in York houses. The idea of crimson velvet and architectural gilding is continued in the central bedroom, while the chimneypiece is of finer white marble. The unusually bold paper in the dressing-room on the left is a reminder of the growing fashion for Chinese wallpapers in bedrooms and dressing-rooms in the early 1740s.*

*On the top floor are the Yellow Taffeta and Chintz Bedrooms. The chairs have upholstered seats and backs covered to match the bed. The bed and window curtains in the adjoining room are of imported chintz, which makes it the earliest surviving example of such a room; the bedspread is quilted, and the chairs are of ivory.*

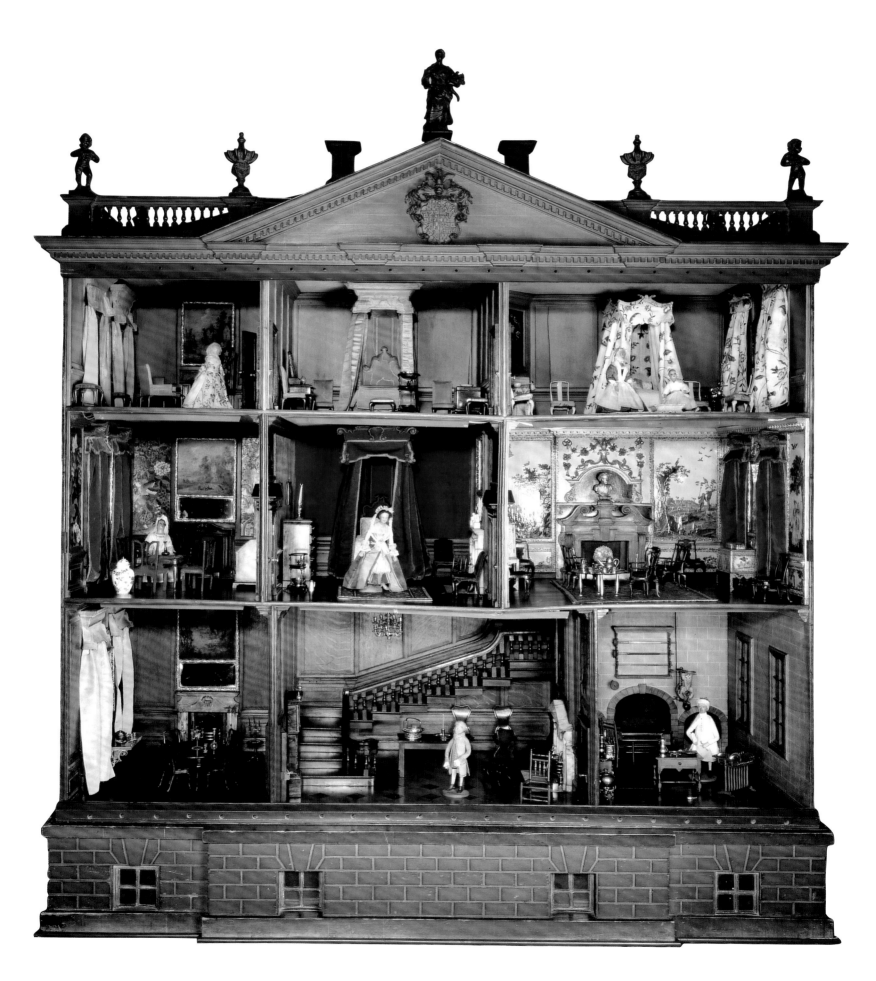

Unfortunately there are very few accounts of royal visits to houses that describe how such illustrious guests were received, but it has to be remembered that neither George I nor George II showed any interest in getting to know their kingdom, and, unlike William III and, later, George III, they saw no need to honour their leading subjects with visits. Thus one of the few accounts is of King Carlos of Spain's visit to Petworth, where he was received by Prince George, the husband of Queen Anne, on 28 December 1703:

The Prince was at the door before his Majesty alighted, and waited on him directly to his own apartment, and there left him about half an hour, after which he sent to visit him, and was received at the door of his bed-chamber by his Catholic Majesty, and seated in an arm-chair opposite to his own; the ceremony was short, and the prince had not been long returned to his quarters, before the King sent to return to the visit, and was received at the top of the stairs, and conducted to the Prince's bed-chamber. After he had been there a little while, he signified to the Duke of Somerset his desire of seeing my Lady Duchess; whereupon the Prince, the two Dukes, etc waited upon him at her Grace's apartments, who came forward several rooms, even to the bottom of the stairs, to meet the King, and making a very low obeisance, she received a kiss from him, as also the two young ladies, her daughters, whom she presented to him. After that he accompanied her to a little drawing room, where he staid three or four minutes, and then was carried by the Prince to see the house, and presently after to supper, which was served up with so much splendour and profusion, yet with so much decency and order, that I must needs say I never saw the like.[11]

Even lesser royal visitors caused a stir, as Mrs Delany found when Princess Amelia, one of the daughters of King George II, paid a visit to the Duchess of Portland at Bulstrode, Buckinghamshire, in 1772, which 'made some little disturbance even in this palace', she wrote. 'All the comfortable sophas and great chairs, all the piramids of books (adorning *almost every chair*), all the tables and even *the spinning wheel* were banish'd for that day, and the blew damask chairs set in prim form around the room, only one arm'd chair placed in the middle for her Royal Highness'.[12]

That the word 'state' did not have a royal connotation can be seen most clearly in Scotland, where there was no likelihood of a royal visit throughout the period. Yet at The Drum, a William Adam house of the mid-1720s in Midlothian, the plan of the upper floor, which is devoted to the Great Apartment, is called 'the state floor' in *Vitruvius Scoticus* (Fig. 40). Similarly, in John Douglas's scheme for Archerfield, East Lothian in 1747, the plan is inscribed 'Principal or State Floor'. It consisted of a central vestibule with a larger flanking dining-room and drawing-room, with two apartments and a parlour at the back of the house, but has none of the processional character of a late seventeenth or early eighteenth-century plan with the bedroom as the climax. And James Winter's mid-eighteenth-century plan of the top floor at Blair Castle is inscribed 'A plan of the State Floor or 3rd Storie'. The distinctive Scottish use of the word can also be seen in Sir John Clerk of Penicuik's poem 'The Country Seat', begun about 1726, in which he wrote: 'Three kinds of Structure then shall be my Theme/ And each adapted to a Country Life. The first may be defined a House of State;/ The second for Convenience and use;/ The third a little villa . . .'.[13]

This suggests that the word 'state' needs to be used with caution, and it should be checked when it was first used in a particular house and what it meant then. In England, at least, it seems to become more common from the late 1750s onwards.

It also appears that certain colours and materials might not have conveyed the idea of 'state' as opposed to 'best' in the opening decades of the eighteenth century and that crimson was always the colour of state, as will be explained later.

That is now a remote way of thinking, but certainly in the first half of the eighteenth century there was a strong sense of hierarchy, grading and order in the way houses were arranged, furnished and used, with the parade rooms much less rarely used than we like to imagine today.

The use of orders in interiors needs to be considered in a similar way, because complete sets (as opposed to pairs of pilasters flanking a chimneypiece or supporting a screen) were rarely used in decoration, even in Baroque houses. At Chatsworth, exceptionally, they were found in five rooms, the first-floor dining-room and former Breakfast Room (now the Duke's Room), the chapel and gallery (both Ionic) and the centre saloon on the first floor of the west front that is now the Centre Bedroom. They are found in a few halls, as at Wanstead (Fig. 26) and Langleys in Essex, Barnsley in Gloucestershire, Sudbrook Park (Fig. 27), Richmond, Wentworth Castle in Yorkshire, Ombersley, Raynham (Fig. 225), Castletown in Co. Kildare, Arniston in Scotland, and Clandon in Surrey; and occasionally in Great Parlours, even if some are now called saloons, as at Ditchley (Fig. 387), Stoneleigh in Warwickshire, Badminton (Fig. 49) in Gloucestershire, Ombersley and Lyme in Cheshire. The only saloon with an order seems to be at Powerscourt (Fig. 70), Co. Wicklow; the only dining-room the Marble Parlour at Houghton (deatil, p. 13); and the only Great Dining-Room at Beningbrough, Yorkshire (Fig. 61). Apart from them, there are a handful of special cases like the Balcony Room at Dyrham (Fig. 140) in Gloucestershire, the Cupola Room at Kensington Palace (Fig. 173), Sir Robert Walpole's bedroom at Houghton (Fig. 224) and the Painted Parlour at Canons Ashby, Northamptonshire (Fig. 46).[14]

One way of approaching the sense of grading and order in design, decoration and furnishing is through the simplified form of the Nostell Priory Doll's House (Fig. 15). This appears to have been designed about 1740 by an architect, possibly James Paine, who was working at Nostell in Yorkshire from about 1737, and executed by many of the specialist craftsmen of the York School working on the main house. It shows within the confines of a building conceived in inches rather than in feet (it measures $83\frac{1}{2}$ inches high by $75\frac{1}{2}$ inches wide and 30 inches deep) many of the ideas discussed in this book. It was commissioned by Sir Rowland Winn, who had begun the new house in the early 1730s, and was intended for his wife, who died in 1743. On the ground floor in the centre is an entrance-cum-staircase hall, still the largest room in the house, with a parlour to the left and a kitchen to the right. On the first floor the spaces are differently arranged, with a traditional great apartment of a drawing-room leading into a principal bedroom with a dressing-room beyond. On the top floor are two more handsome bedrooms and a dressing-room that are a reminder that 'attic' in the eighteenth century did not have the derogatory meaning that it has today.[15]

In the rather old-fashioned panelled hall and the other rooms, the chimneypieces are copied from Gibbs's *Complete Book of Architecture* of 1728, which was the most influential of all architectural publica-

tions in the eighteenth century. The balustrade is of mahogany, which had become a fashionable wood for architectural use in the 1720s, and it has a strongly scrolled end that is often found in Yorkshire houses of that time. Over the white marble chimneypiece is an overmantel picture of the family dog in the manner of Wootton, and the overdoors are sporting subjects, a much reduced idea of, say, the hall at Badminton (Fig. 238). The room contains a set of hall chairs, which were then a comparatively new fashion.

To the left is a common parlour, the everyday room of the house until the middle of the century, and it is panelled in oak with a chimneypiece of a suitably underplayed grey marble, which is also used for the top of the pier-table, a match that was often seen in houses. Above the chimneypiece is a landscape glass with a classical subject; over that another gilt frame. The draw curtains with matching pelmet cornices and valances, a rare survivor often recorded in inventories but seldom seen in houses, are of a plain pale blue silk taffeta or lustring, a material much used for curtains at that time and the choice of colour according to the evidence in inventories. The chairs have well-shaped seats covered in leather, as was usual in a parlour.

On the first floor are the three rooms of parade and, as might be expected, they are decorated in a more elaborate style. In the drawing-room all the architectural mouldings, including those on the doorcases, are carved and gilded, while the overmantel with its gilt bust is reminiscent of those found in certain York houses, including the Treasurer's House in York. The walls are painted yellow and decorated with panels of cut-out prints, but it is not clear what they are intended to suggest – painting, painted toiles as in the bedroom at Houghton, pictorial tapestry after Teniers, or a particularly smart handpainted wallpaper like the later one in the Van Rensselaer Room in the Metropolitan Museum, New York. On the floor is a fine needlework carpet. As befits a formal drawing-room, the curtains together with their cornices and valances are in red velvet, which would have been an extravagant choice at the time because of the cost and its impracticality for seat furniture, but which is used here to continue the idea of the bedroom next door and suggest 'best' or 'state'.

The Crimson Velvet Bedroom is slightly earlier in feeling, with its velvet bed and matching wall hangings, but here there is no carving or gilding. A plain velvet bed in 1740 would have been unusual, and the hangings would probably have been of tapestry. However, velvet works better than damask on a miniature bed, and a damask bed might well have had matching hangings.

Next to it is the dressing-room, which is given a fashionable Chinese character, with the fields of the panels filled with a bold design that could be intended to suggest lacquer rather than wallpaper, as in the dressing-room at Newhailes (Fig. 334). The sense of unity in the apartment is created by the continuity of red velvet for the curtains and chair seats.

On the top floor, the panelling is all painted a serviceable grey-blue rather than being varnished oak or painted white, which would have been an extravagance because it would have gone off, and the main bedroom and dressing-room are both done in yellow silk, with a yellow bed, curtains, cornices and valance, and chairs with upholstered seats and backs, yellow being a less grand colour than crimson or green. The chairs are particularly well shaped, as if done by a professional upholsterer interested in line. The last bedroom is done in chintz, of which an enormous amount was imported, and

has a bed with a more up-to-date cornice and matching curtains along with ivory furniture. It is perhaps the earliest surviving example of a complete chintz room.

## ARRIVAL AT THE HOUSE

One of the surprises of late seventeenth- and early eighteenth-century houses is how seldom the main door appears to have been used: family and most guests invariably entered through a lesser door, usually at the side or at a lower level. That was a matter of both external and internal planning. It meant that the forecourt was not disturbed by the sounds and smells of horses and the marks of coach wheels: they were invariably banished to the side of the house nearest the stables and away from the windows of the principal rooms. As far as internal planning was concerned, that was also convenient because it gave more direct access to the everyday and working parts of the house, leaving the parade rooms undisturbed.

How that worked can be seen in a number of late seventeenth- and early eighteenth-century paintings. A huge naïve view of Belton House (Fig. 15), which was begun in 1685, probably to the design of William Winde, and occupied in 1688, shows Bug, the porter, standing staff in hand at the gates of the forecourt, ready to welcome guests arriving in a coach, which will have to stop there so that they can alight and walk across the forecourt ornamented with statues to the steps up to the front door. However, that entrance was only used on special occasions: most of the time, the west door was used by the family. By 1751, when the bird's-eye view attributed to J. F. Nollekens (Fig. 16) was painted for Viscount Tyrconnel, who had finally inherited Belton in 1721, the forecourt had been greatly extended and the statues removed so that coaches could drive to the foot of the steps; and another turning circle had been laid out in the west forecourt, serving the west door.[16]

A number of other contemporary paintings show coaches approaching recently formed forecourts but not actually within them, their layouts making them unsuitable or impossible for use on a regular basis. In the views of Longleat, Wiltshire, by Siberechts, there is a broad paved walk from the gates to the steps up to the door, but it would have been impossible for a coach to drive in or turn round. At Cheveley in Cambridgeshire, a coach is seen turning outside the forecourt some way from the entrance front of the house, while the stable court is close to the side of the house. At Denham Place in Buckinghamshire, the forecourt to a house built between 1688 and 1701 was laid out as an elaborate garden with statues.[17]

To drive right up to the main entrance to a house was obviously unusual, because in 1697 Celia Fiennes described so carefully the earlier arrangement surviving at Burton Agnes, in Yorkshire: 'We enter under a Gate house built with 4 large towers into a Court, which is large, in the middle is a Bowling green palisado'd round, and the Coaches runns round it to the Entrance which is by 10 stepps up to a Taress, and thence a pavd walke to the house.'[18]

Roger North had a good deal to say about the habit of closing forecourts:

> I must differ from the comon practise in England, which is to keep company from the fore-court, and decking it like a garden, using the same curiosity of planting, mowing, weeding, rolling, as if there were to be no other. And for this reason it is kept close shutt, least doggs, horses, etc, happen to come in and con-

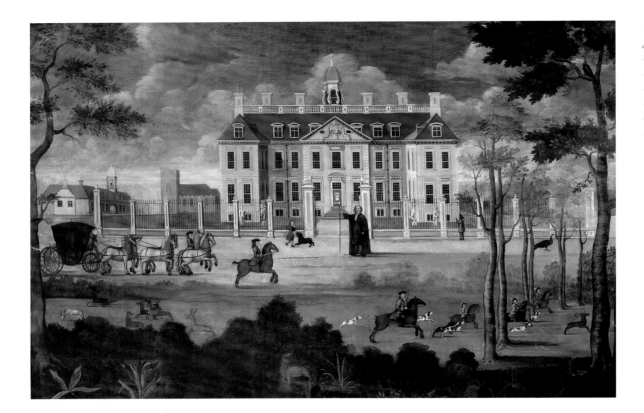

15. *Guests arriving in a coach at the gates to the original forecourt of Belton House, Lincolnshire, where the porter with his staff waits to conduct them to the front door. Coaches could not enter the forecourt. An anonymous painting about 1700.* The National Trust, Belton House.

taminate the neatness of it; so that a stranger who is to come to the house, seeing the front, which is a notorious direction to the entry, goes on but finds all close, and then is to seek and must enquire which is the way in to that house . . . Therefore in my judgement it is fitt the forecourt should be so layd out as to endure comon using, according to the intent of it. And if it happens to be fouled or disorderd, it is well worth the care to clean continually, and returne it to that reasonable decorum it is capable of.'[19]

He also explained about other entrances: 'a house ought to have a back entrance, as well for the comon servile part of the family, and buisseness to make constant use of, as also for the master at ordinary time to pass by'. 'Therefore this back entrance should not be like that of a vault, hollow and dark, altogether unpleasant, as I have seen some, but somewhat cheerful, and aiery, which the best of family at private times may with comfort make use of.'

Writing in the 1690s, before the Palladian idea of a main block with flanking wings had become fashionable, North did not comment on the advantages of being able to site the kitchen and its related offices in one wing, such as safety from fire. That became a feature of houses in the 1720s, as can or could be seen at Ditchley, Raynham, Houghton, Chicheley and Antony. It also meant the servants' entrance could be well away from the family entrance. Indeed, it demonstrates a practical – and unintellectual – reason for the popularity of the Palladian idea.

The use of side entrances for the family is well illustrated in three Norfolk houses, Raynham (Fig. 17), Houghton and Wolterton. Raynham is particularly interesting, because of the way the seventeenth-century house was altered by the 2nd Viscount Townshend, for the first time evidently soon after 1700 and then again in the mid-1720s, with Thomas Ripley as architect and William Kent as architectural decorator of the principal rooms. About 1700, Lord Townshend altered both main elevations, replacing the twin entrances on the west front with a central door into the double-

height hall, which he reduced in length, and also closing the two entrances on the east front. It seems that there was always a side door at a lower level on the north side of the house, and either then or in the 1720s, when the kitchen wing was built and the north court formed, it was made more important, with a pillared sub-hall leading to the foot of the principal staircase of the house. That led up to the everyday rooms at the north end of the house, with the Common Parlour at the north-west corner, in what had been the upper part of the original kitchen; next to it in the middle of the north side was its withdrawing room, and at the north-east corner of the house the dining-room, with Kent's triumphal arch.[20]

The design of Houghton is a more complicated matter than used to be thought, because the claim made by Colen Campbell in *Vitruvius Britannicus* has been challenged by the discovery of a well-thought-out plan by James Gibbs (Fig. 188) that appears to pre-date the laying of the foundation stone in 1722. Judging by surviving dated drawings Campbell was involved between 1723 and 1726, by which time he in his turn had been ousted by William Kent as architectural decorator; and all along Thomas Ripley had been in charge of building. Thus it is to Gibbs that credit should be given for the ingenious plan with its horizontal and vertical division into family and parade rooms and also the way Sir Robert could use the Arcade or lower hall for rumbustious political entertaining. That concept was expressed in the four original entrances: up the steps to the hall door on the east front, for use on special occasions; within the steps directly into the Arcade, which has been the main as well as the everyday entrance since the steps were removed in the late eighteenth century; the modest door on the south side with the inscription over it commemorating the building of the house, now scarcely used but the original family entrance that led to the small rooms at the south-east corner of the house and the staircase up to Sir Robert Walpole's rooms; and the servants' entrance through the kitchen court.[21]

Wolterton was designed from scratch by Ripley when he was

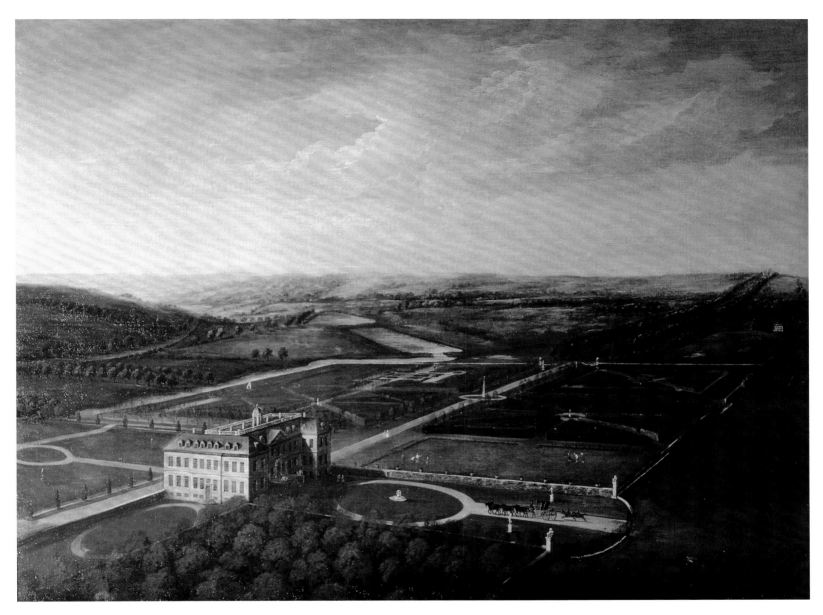

16. *A bird's-eye painting of Belton in 1751 attributed to J. F. Nollekens. This shows the forecourt enlarged and the statues removed by Viscount Tyrconnel to allow coaches to make a circle to the front steps and also the west court between the stables and the everyday entrance to the house on the west side.* The National Trust, Belton House.

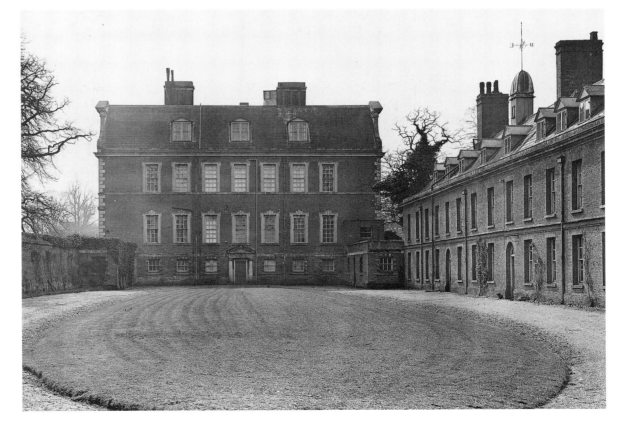

17. *The north side of Raynham Hall, Norfolk, with the end of the seventeenth-century house, the back court and kitchen wing built by Thomas Ripley in the 1720s. The centre door, which was the everyday entrance, opens into a low hall. The main staircase leads out of it, past the original everyday family rooms on the first floor facing north.*

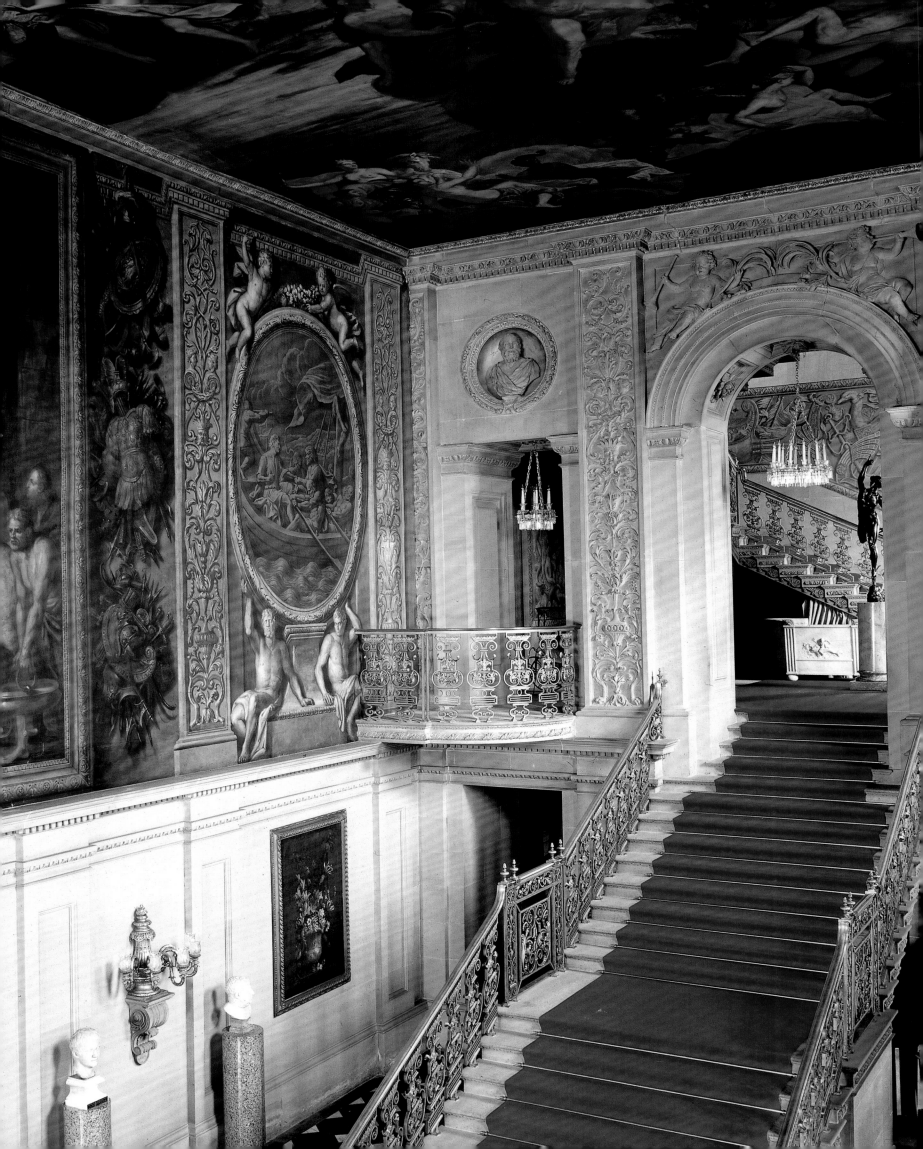

working on both Raynham and Houghton and it was built between 1726 and 1741 for Sir Robert Walpole's brother, Horatio, Lord Walpole, who sat in the House of Commons for forty-five years and served twice as Secretary to the Treasury and as ambassador to France from 1725. As Agneta Yorke wrote in 1764, 'The house is extremely convenient without being grand.' Originally there was a flight of steps up to the door into the hall on the piano nobile, but, as at Houghton, that has been taken away and a new door made below it. The everyday door was always on the east side facing the stables and, again as at Houghton, there is an inscription commemorating the building of the house placed above it. It leads into what used to be called the Common Hall, a much better space than at Houghton, that connects with the everyday rooms of the house. As Philip Yorke wrote in 1750, 'The family live in the rustic, where are 4 good plain rooms, the dining parlour, the drawingroom, the study (which has an arcade before it) and the breakfast room. The rest are for servants.'[22]

At Chicheley, which was built in the early 1720s, there was a forecourt with gates in front of the main elevation flanked. There was on one side, by the stables range, a central arch through which coaches could be driven, while the west court has always been the everyday approach to the house (Fig. 373). To the north lay a kitchen wing, balancing the stables. It appears that those coming to see Sir John Chester on estate business could use a door under the stairs on the north side of the house close to his dressing-room on the ground floor next to the Gentlemen's Drawing-Room.[23]

Antony in Cornwall can be compared with Chicheley, because a bird's-eye view of the house, painted soon after it was completed in the mid-1720s, shows the main block of stone with its flanking wings of brick looking on to an enclosed forecourt with a turning circle for coaches – which must have been very rarely used because of the spreading nature of Plymouth Harbour that limited access by land. The painting gives no clue of the eastern forecourt with its gate piers, which must have marked the family entrance a storey below the main floor, connecting with the original line of the east staircase. That would have been quite separate from the servants' entrance into the east wing, containing the kitchen, which had its own link to the main house in the corridor behind the arcade.[24]

When Erddig in Clwyd was extended at about the same time, Badeslade's bird's-eye engraving of the 1740s (Fig. 359) shows that a forecourt with gates was provided in front of the main block of the house and that was flanked by two enclosures in front of the wings, that on the right connecting with the kitchen and providing a servants' entrance, and what appears to be the everyday family entrance in the left wing. That connected with the bottom flight of the staircase in the main block leading up to the everyday rooms and continuing up to the bedroom floor.[25]

A related aspect of planning, now usually forgotten, is the matter of access to stables, particularly when they were linked to a house,

as at Earnshill in Somerset, an early villa with massive wings completed in 1731 by Henry Combe, a Bristol merchant. The entrance front has an everyday entrance on the ground floor, contrived within the structure carrying the steps up to the main door into the hall. However, what struck Christopher Hussey in 1938 was being able to go down a secondary staircase from the sitting-room, perhaps the original Common Parlour, straight into the stables to inspect a horse.[26]

By the 1720s, forecourts of existing houses tended to be larger and simpler, and paintings show coaches in them, as in those of Ledston Hall, Yorkshire of about 1728, of Carton, Co. Kildare in about 1730 and of Calke Abbey, Derbyshire in about 1734. The last includes the new steps added by James Gibbs about 1727–8 so that on formal occasions visitors could go straight up to the double-height hall on the main floor. These paintings can be compared with the arrangements shown in some of Badeslade's and Rocque's engravings that form volume IV of *Vitruvius Britannicus*. The view of Kiveton in Yorkshire has the porter opening the forecourt gates so that a coach could drive through them; in that of Wentworth Castle, also in Yorkshire, the carriage approach went round the forecourt and up the slopes to the terrace in front of the house. However, that arrangement did not last long, because a painting by Thomas Bardwell in 1752 shows the slope below the house grassed over and the terrace in front of the house planned for viewing the landscape rather than accommodating carriages and horses, with a drive apparently coming in from one side.[27]

New houses begun in the 1720s, particularly those with a raised piano nobile, and therefore steps and possibly a portico, tended to have no forecourt, and it became possible to drive up to the foot of the steps and use either the main entrance at the top or an everyday entrance below. That can be seen not only in the designs of Houghton, but also those of Wanstead, Wentworth Woodhouse in Yorkshire, Nostell Priory and Kirtlington, where there were doors beneath the steps that led into lower halls.

Indeed, it was the desire for two such entrances that could contribute to a house being turned round. At Newhailes, for instance, when the late seventeenth-century house was extended in the late 1730s, it was also rearranged so that the east rooms, which had been on the entrance side, overlooked the garden running towards the sea; and a new forecourt was made on the west side so that it was possible to drive in, with horseshoe steps leading up to the new entrance door into the new hall and the everyday door below. Thus access and approaches were a key part of planning.[28]

## DOUBLE- AND SINGLE-STOREY ENTRANCE HALLS

The use of the side door obviously increased the impact of the hall when it was only used as the entrance on special occasions and gave it a thrill that has been destroyed for us by familiarity – and photography. The English seem to have been very reluctant to give up the idea of the Great Hall, which for centuries had been the heart of the house and the symbol of family dignity and hospitality. Indeed, more of that feeling seems to have been carried on into the late seventeenth- and eighteenth-century house than is often realized, and so the entrance hall should be regarded as a traditional idea classicized as much as a classical idea inspired by sixteenth-century Italian theorists. This can be seen in the pull between the two-storey and single-storey hall, which developed in the last quarter of the

18. *Chatsworth, Derbyshire. The southward view in William Talman's Painted Hall, begun in 1687 and completed in 1694, shows the Edwardian staircase leading up to the original stone screen with the slightly earlier Great Stair to the second floor seen through the centre arch. The ceiling is painted with* The Apotheosis of Julius Caesar *and the east wall with* Julius Caesar offering sacrifice before going to the Senate, *both painted by Laguerre in 1691–4.*

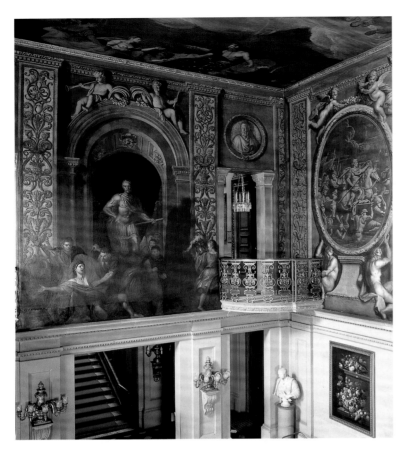

19. *Chatsworth, Derbyshire. The north wall of the Painted Hall, decorated in* trompe-l'œil *to reflect the stone screen, with the murder of Julius Caesar in its centre arch. The opening below has been enlarged.*

architecture, the risers of the original stairs being of alabaster and blue john and Tijou's wrought-iron balustrade in blue and gold rather than all gilded as it is today. Through the arch and its side openings there is a view of the landing and the cantilevered Great Stair – then a striking novelty – set against stone walls painted with *trompe-l'œil* grisaille reliefs that are part of Verrio's scheme added in 1691. At ground level the doorway between the arms of the staircase led through into the pillared grotto supporting the landing for the Great Stairs.[30]

At the north end of the hall similar effects were achieved in paint, with a *trompe-l'œil* screen to match the stone screen. *The Murder of Julius Caesar* bursts through its centre arch, while above on the ceiling *Death Aiming her Spear at the Attributes of Regal Power* points down to Julius Caesar, the choice of Caesar being a pointed parallel to that of William III. Originally there was a narrower doorway below, balancing that to the grotto. The upper, painted part of the long east wall is divided into five sections, with a main 'picture' in a 'frame' of *Julius Caesar Sacrificing Before Going to the Senate* hanging between two painted trophies suspended on ribbons from rings in the ceiling (they reflect the painted trophies between the windows on the west wall and the carved stone trophies outside on the east wall of the court). These are flanked by large oval grisailles of an equestrian statue of Julius Caesar and *Caesar Crossing the Rubicon* set between painted pilasters that repeat the ornament and gold ground of the stone pilasters of the screen.

The whole illusion must have been made more dramatic by Talman's lighting: he provided no windows at ground-floor level in the hall – they were pierced in the early nineteenth century – and so light only came in through the first-floor windows on the west wall. The recent cleaning and restoration of the complete scheme has brought out the imaginative quality of Talman's conception, his skill in solving tricky problems, and his control over the painters and carvers that is confirmed by the unexpected amount of time he spent at Chatsworth in the early years.

At Stoke Edith, Herefordshire, the entrance and hall were particularly carefully thought out (Fig. 20), but their handling seems too sophisticated to be the work of the property's owner, Paul Foley, which is the tradition. Building began in about 1696, three years before his death, and it was finished in 1701 by his son, Thomas, who lived until 1737. The house, demolished after a fire in 1927, was skilfully sited on a sloping site so that on the north, entrance, side it appeared as a three-storey house of nine bays. The three-storeys allowed for a low ground floor with small windows in the stone-faced 'dado' and two rows of big windows above. The three-bay centre was emphasized by its stone facing, giant order of pilasters and pediment. Here, a staircase on a horseshoe plan led up on to a bridge that crossed over a covered way to the front door leading into the double-height hall, while the covered way sheltered the lower everyday entrance. The author of a *Country Life* article in 1909, sounding like Celia Fiennes, wrote of the main door as 'a seldom-used mode of entrance reserved for princely visitors, the usual ingress being through the door into a lower hall'.[31]

The lower walls of the hall were panelled and painted, apparently by Issac Bayly in 1705, with rockwork landscapes. After that, Thornhill painted the upper walls with allegorical scenes framed by a *trompe-l'œil* order and with the chimney breast carried up as painted architecture framing a *trompe-l'œil* statue of Liberty with painted architecture curving behind the chimney breast, and figures of

seventeenth century and produced some of the most dramatic interiors found in English houses. It ended with the virtual victory of the single-storey hall in the mid-eighteenth century.

Although most houses built in the reign of Charles II had single-storey halls, which were usually wholly or partly panelled, there were a few exceptions, among them those at Kingston Lacy, Dorset, begun in 1663 (remodelled later), and at Ragley Hall, Warwickshire, begun in 1679 but not completed until the 1750s.[29]

The two-storey hall, however, became one of the features of the Baroque house. An example can be seen at Chatsworth, where in the early 1690s Talman gave it a novel form (Fig. 18); and it is proof of his imaginative skill that he produced such a dramatic solution to the problems caused by the 1st Duke of Devonshire's stage-by-stage approach to planning. Having first rebuilt the south range in 1687–8, with the Great Apartment on the top floor, as it had been before, and the Great Stairs starting at first-floor level in the southeast corner of the court between the old hall and the new Great Chamber, Talman was then asked in 1688 to rebuild the rest of the east range, including the Elizabethan Great Hall. So he had to devise a way of providing both a new hall and a staircase up to the start of the Great Stairs. As in the chapel, he had the ceiling and upper walls painted by Laguerre, who completed them in 1694, and the lower walls panelled, giving them movement and interest through broad flat pilasters and marbling (instead of the stone facing of the 6th Duke's time). At the south end he laid out the stairs in a French-inspired horseshoe shape, with the two curling flights meeting in front of the centre arch of the stone screen, designed in the form of a triumphal arch, again apparently an idea derived from French

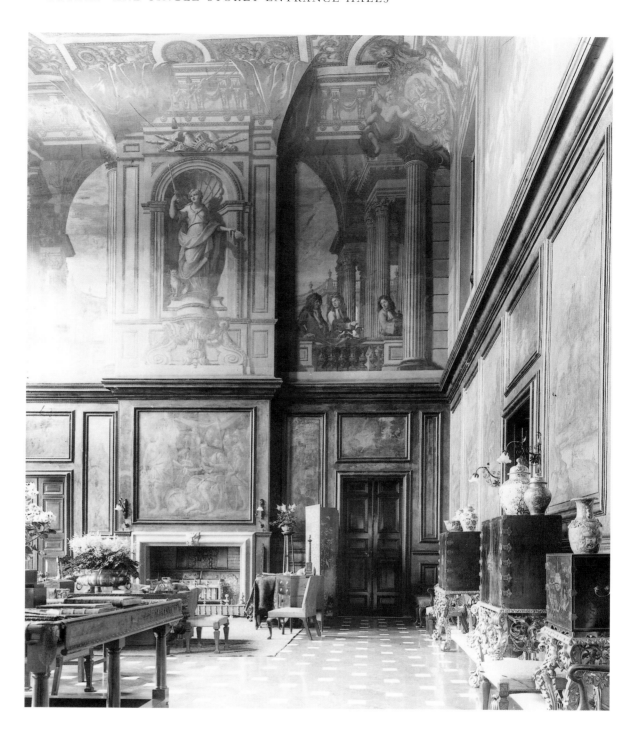

20. *The hall at Stoke Edith in 1909. The panelled lower walls were painted in a combination of low-toned grisaille to look like stone reliefs and 'rock stone'. The painting of the upper wall and ceiling in 1705 was one of James Thornhill's first important commissions and showed how effective he was as a painter of architecture and figures.*

Thomas Foley and the artist looking down over the balustrade. The ceiling he filled with *Cupid and Psyche Received in Olympus*.[32]

About the same time, Easton Neston in Northamptonshire was achieving its final form, and Hawksmoor's hall, as is known from a nineteenth-century photograph and the plan in *Vitruvius Britannicus* I, was a spatially complex design. It was in three parts, with a double-height central area and single-storey side sections, marked off by piers and columns. The entrance door led into the lower, left-hand, section and then continued ahead into the spinal corridor through the centre of the house; and the first section of the corridor formed an ante-room with a curved wall facing the door to the Great Staircase, which was placed at right angles to it.[33]

It was Vanbrugh, excited by the possibilities of space and light in architecture, who really developed and encouraged the idea of a the-atrical hall, as can be seen in his great stone halls at Castle Howard (Fig. 21) and Blenheim, conceived in the early years of the century, and then at Kings Weston, Gloucestershire, about 1710, Seaton

Delaval in Northumberland, about 1720, and Grimsthorpe, Lincolnshire, about 1722. What he did at Castle Howard was to take ideas that could be achieved in painted canvas in a theatre, as in Thornhill's design for *A Room of State with Statuary & Bustoes* for *Arsinoe, Queen of Cyprus*, an opera performed in London in 1705 that he had seen in Talman's Painted Hall at Chatsworth (Fig. 18), and carry them out on a giant scale in stone. He cut back through the side walls to the spaces containing the twin staircases, creating dramatic perspectives that exploit the fall of light. At the same time, in 1709, he brought in Giovanni Antonio Pellegrini, who had only recently been brought to England by Lord Manchester, to paint the dome and other parts of the interior, and apparently for the first time in 1711 used the Italian stuccadores, Giovanni Bagutti and Plura, to create the overmantel.[34]

Evidently the intention was to use the hall for dining on formal occasions, because facing the chimneypiece is a marble niche, now occupied by a statue and crowned with a pair of busts and another

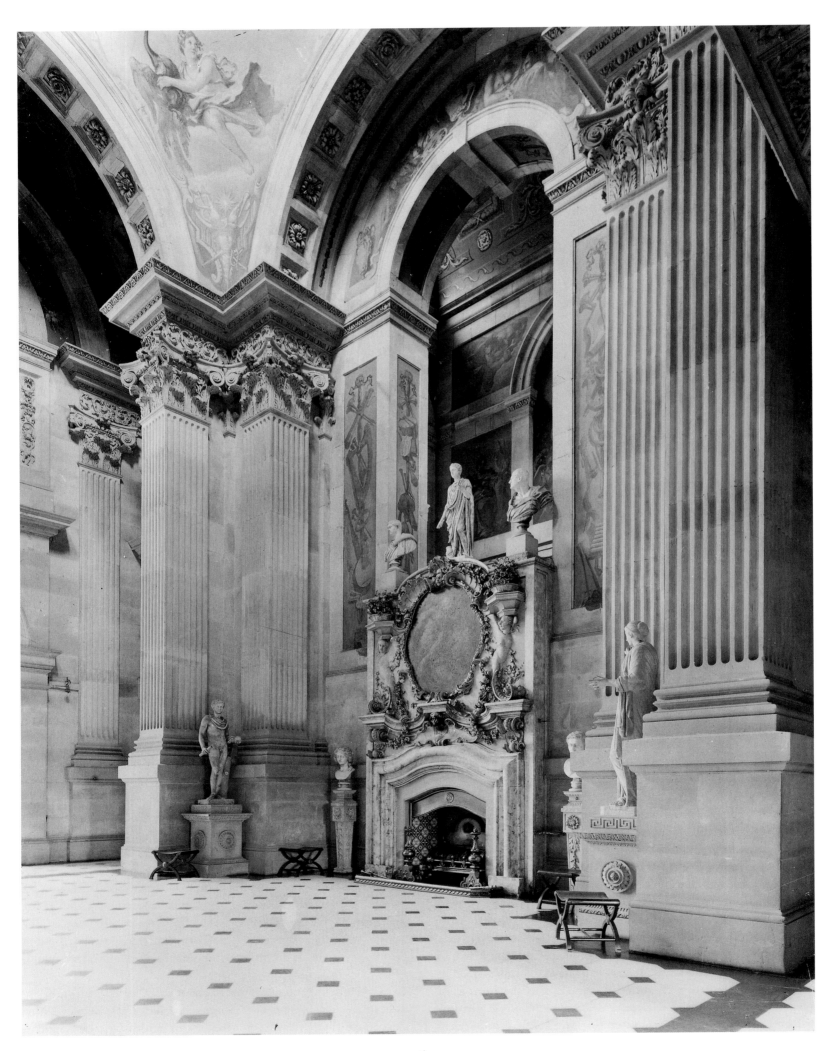

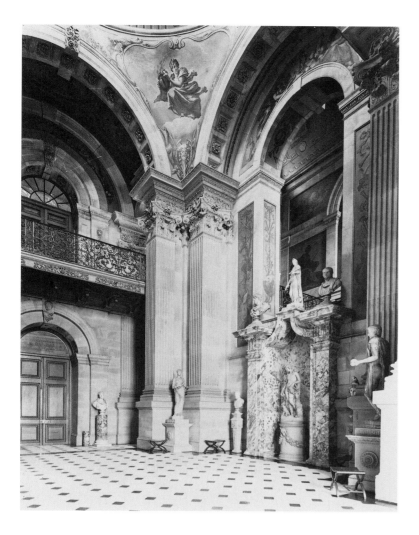

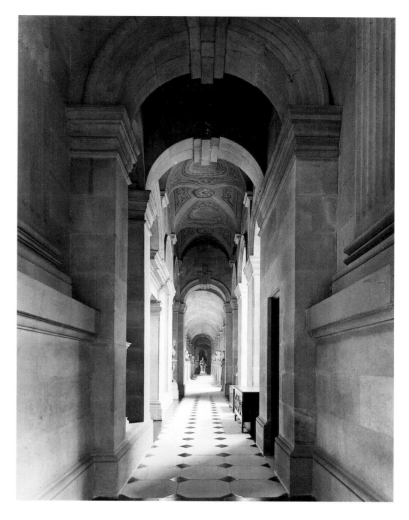

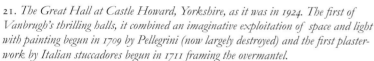

21. *The Great Hall at Castle Howard, Yorkshire, as it was in 1924. The first of Vanbrugh's thrilling halls, it combined an imaginative exploitation of space and light with painting begun in 1709 by Pellegrini (now largely destroyed) and the first plaster-work by Italian stuccadores begun in 1711 framing the overmantel.*

22. *The niche facing the fireplace in the Great Hall, Castle Howard. In 1732 this was described as a buffet niche, suggesting that the hall was intended for dinner on special occasions.*

23. *The north corridor at Castle Howard in 1924.*

24. *The hall at Beningbrough Hall, Yorkshire. The house, begun by John Bourchier a few years after his trip to Rome in 1704–5 and completed about 1716, displays many signs of Roman influence. The idea of the vaulted hall may come from Rossi's* Studio d'Architettura Civile *(1702). Through the door lies the original single-storey Great Parlour.*

statue (Fig. 22), but which was described as a buffet by John Loveday in 1732. Then it would have probably displayed the plate described on p. 44.[35]

Not surprisingly, this hall was influential in Yorkshire, where a great deal of country-house building was going on. That can be seen first at Bramham (*c.*1703–10), then Beningbrough (completed about 1716, Fig. 24), Duncombe (begun 1713) and Gilling (1715–25). Castle Howard, however, was not the sole influence in the area. Lord Bingley, the builder of Bramham, was an amateur architect. John Bourchier, the builder of Beningbrough, was in Italy in 1704–5 and when he came to build his house a few years later, he gave it a strong Roman flavour, not only in its shape and its external detailing, but in the design of the hall with its giant order of pilasters standing on a stone base and carrying a vault that, like so much of

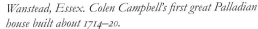

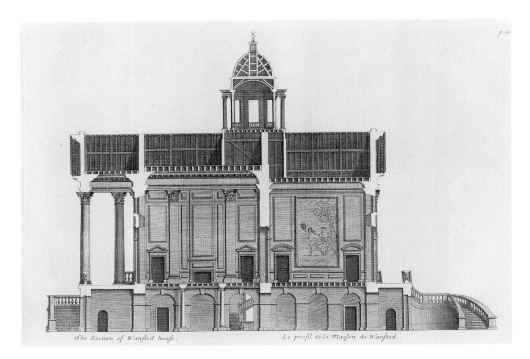

*Wanstead, Essex. Colen Campbell's first great Palladian house built about 1714–20.*

25. *The section from* Vitruvius Britannicus I *shows the hall with its giant order of pilasters and the panelled saloon, suggesting a Baroque rather than Palladian interior.*

26. *The plan of the principal floor from the second scheme in* Vitruvius Britannicus I *shows the huge hall with a still moderate-sized saloon flanked by two complete apartments, as at Blenheim (Fig. 354). There were four more apartments, including those of Lord and Lady Castlemaine, on the ground floor.*

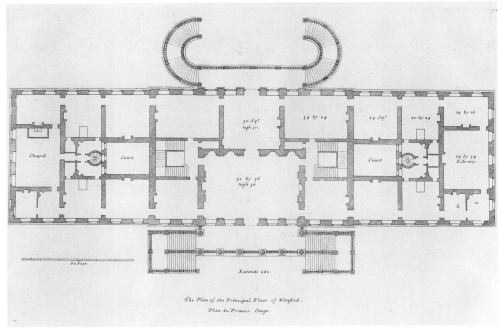

the external detail, is derived from plates in Rossi's *Studio d'Architettura Civile* (1702) (Fig. 24).[36]

The first Palladian hall in England is at Wilbury, in Wiltshire, a villa designed as early as 1710 by William Benson (1682–1754), who became Surveyor of the King's Works in 1718–19. According to the plates in *Vitruvius Britannicus*, the nine-bay house with its three-bay portico had a five-bay hall measuring 31 by 21 by 21 feet high, flanked by two rooms, one presumably a parlour and the other a drawing-room; behind that was a deep room measuring 20 by 31 feet that was presumably a Great Parlour rather than a saloon, and it was flanked by two bedrooms. As built, the hall or great room is of three bays with a deep cove, and the chimney breast and chimney-piece are presumably original, like the plasterwork framing the bed of the ceiling and the oval garland within it. The wall treatment as well as the papier-mâché decoration dates from the mid-eighteenth century, when the house was turned round and the room became a saloon.[37]

In Colen Campbell's second scheme for Wanstead, he provided a huge double-height hall (Fig. 26). It was his first great house, built about 1714–20 for Sir Richard Child, the grandson of a highly successful East India merchant, created Viscount Castlemaine in 1718 and Earl Tynley in 1733. Despite the Palladian intentions of the exterior, the hall, measuring 52 by 36 by 36 feet, was closer to the Baroque tradition with its giant order of Corinthian pilasters; but that order was not completely in tune with the rather old-fashioned panelling scheme of tall, narrow panels between the dado and the string at the base of the capitals and smaller panels above, or the slightly projecting chimneypiece with its bolection moulding and a long, thin panel above.

Not surprisingly, given Gibbs's Roman background, he took up the double-height hall, apparently for the first time, at Sudbrook, the 2nd Duke of Argyll's villa (Fig. 27). There, in 1715–19, he built what he described as a 30 foot Cube Room, which as the only large room in the house was surely intended as a combination of a hall and a

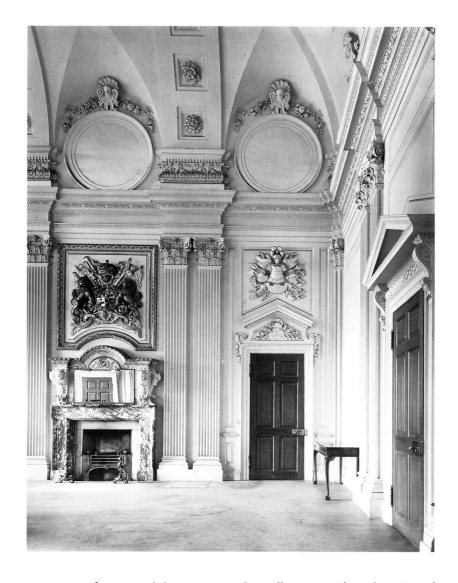

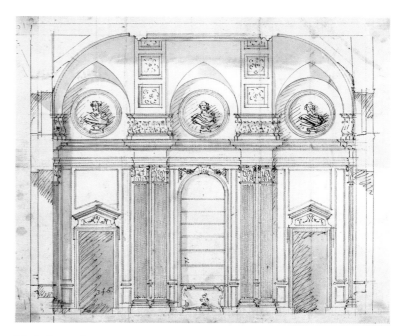

*The hall at Sudbrook Park, Surrey.*

27. *The principal room in the villa built in 1715–19 by James Gibbs for the 2nd Duke of Argyll, it was unusually architectural, with its paired pilasters, vaulted ceiling and side doorcases inspired by Rossi prints. The martial ornament alludes to the Duke's military career.*

28. *Gibbs's sketch for the facing wall. The niche has shelves, presumably for the display of plate at formal dinners, and beneath it an early architectural side table. One of the few free drawings in the Gibbs collection apparently in his own hand rather than a draughtsman's (Fig. 79).* Ashmolean Museum.

room for entertaining company. Its walls are paced out by pairs of composite pilasters that disappear in the corners; they support coffered ribs and a system of vaulting with framed *œils-de-bœuf* in the attic storey that become windows on the outer wall.[38]

The pedimented doorcases with scrolls on the end walls are taken from Rossi's plates, while military trophies in their tympana and above them allude to the Duke's military career that had seen him rise to being a full general in 1711. In the overmantel is a splendid display of the Duke's arms, while below, at the top of the overmantel mirror, they are engraved behind the glass.[39]

A preparatory drawing for the room apparently in Gibbs's own hand (Fig. 28), rather than a draughtsman's like most of those in the Gibbs collection in the Ashmolean Museum, and sketched over a drawn-out framework, envisaged a simpler scheme of decoration, with a buffet niche with seven shelves and a side table with curling legs below.[40]

One of the most exciting and richly decorated double-height halls is found at Barnsley Park, Gloucestershire, a puzzling, anonymous house in the Baroque manner seemingly begun about 1719 by Henry Perrot and completed about 1731. The two storeys are clearly defined by the double screen of arches at the inner end, with the lower order of Corinthian pilasters continuing round the hall in a system of single and paired pilasters and niches and above simpler pilasters without capitals and deeper niches. The plasterwork includes an overmantel full of movement like those at Hall Place, Maidenhead, and reliefs on the upper walls and ceiling; and it is

probably by leading Italian stuccadores such as Artari and Bagutti.[41]

In the 1720s and 30s, the idea of a double-height hall was taken up outside the circle of metropolitan designers, particularly by Francis Smith of Warwick and his son William, as can be seen at Chicheley, Ditchley and Ombersley in the 1720s. In them there is a fusion of Baroque, Gibbsian and Palladian thinking. As will be explained later, both at Chicheley and Ditchley the Smith designs appear to have been the subject of early changes of mind. At Chicheley (Fig. 374), the double-height hall may reflect the intervention of William Kent with Henry Flitcroft, while at Ditchley it seems that Flitcroft came in as designer of the hall, with Kent as decorative painter (Fig. 385). At Ombersley, on the other hand, Francis Smith was working on his own for Samuel Sandys, created Lord Sandys in 1743: building began in 1723 and was completed in 1730. As will be explained later, the room was evidently used for dinner, at least on occasion.[42]

Among the handsomest halls of the mid-1720s are those at Houghton (Fig. 191, to be discussed later), and formerly at Wricklemarsh, at Blackheath, Kent, which was built by Sir Gregory Page, who had a great fortune thanks to his trustees' prompt sale of his father's South Sea stock in 1720. Immediately he came of age, he commissioned a design for a new house from James Gibbs, which is published in *The Complete Body* (plate 48), but after his marriage and purchase of the property, he went to John James, showing him the earlier proposal. As can be seen from the plate in *Vitruvius Britannicus* IV (Fig. 29), James designed a double-height hall with a

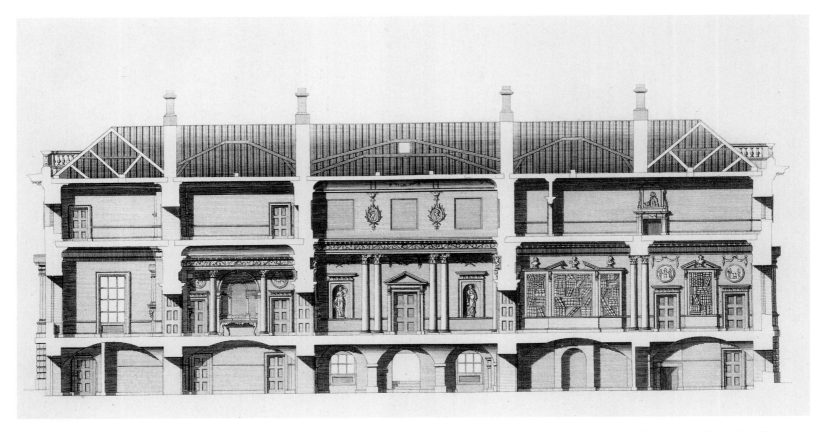

29. *The section of* Wricklemarsh, Blackheath, Kent *from* Vitruvius Britannicus *IV. It shows the house designed by John James and built in the mid-1720s. In the centre is the double-height hall with its screen of coupled columns and statues in niches. To the left lies the dining-room with a screen of columns framing a mirrored niche for a sideboard and display of plate and access to the service staircase behind; and a gallery* *for pictures fills the end of the house. On the right is a double library linked by a screen of doubled columns, with an early pedimented breakfront bookcase in the first section and circular reliefs over the doors in the second. The principal bedroom behind has a screen of coupled columns.*

screen of columns supporting a closed gallery, and the walls were decorated with large and small reliefs by Rysbrack and busts on consoles. Despite the speed of building – the roof is supposed to have been on by the end of 1725 – it seems unlikely that the decoration was complete before 1727. So it was close in date as well as style to the halls at Ditchley and Houghton, the last being complete by the time Sir Matthew Decker visited the house in July 1728.[43]

In Scotland, elaborate double-height halls were proposed by William Adam in 1721 for Hopetoun, and realized in about 1726 in a complex Vanbrughian form at Arniston, Midlothian, where he remodelled a tower house (Figs. 30, 31). His thrilling solution must be based on either direct or indirect continental experience: also it parallels Vanbrugh's handling of space and cutting through solid walls. Adam provided an inner frame with an outer shell: the central area, three bays wide and two deep, is defined by a giant order of pilasters, with half-columns in the corners, from which spring a groined vault; behind the pilasters at ground-floor level are arches opening into side aisles, while the centre arch between the pair of fireplaces leads past the staircases to a Great Parlour on the south front, which Adam formed out of two rooms in the old house. The ceiling and vault are richly decorated with remarkably free plasterwork attributed to Joseph Enzer, a Dutch or German craftsman, who was at Yester in East Lothian in 1736–9, and so was possibly added a few years after the hall was first fitted up.[44]

In Ireland, the noblest double-height hall is at Castletown, Co. Kildare, which might be regarded as the Irish Houghton in terms of the ambitions of its creator, William Conolly, who had become one of the richest men in the country and Speaker of the House of

Commons in the Irish Parliament. The conception of the house is far from clear: in 1719 John Molesworth, a diplomat who served in Italy and had persuaded the Florentine architect Galilei to come to Britain, wrote to him: 'Mr Conolly is going on with his designs and no doubt would be glad of your advice now and then. And truly of all your Employers had shown himself most generous.' In July, 1722, however, Bishop Berkeley wrote to Sir John Perceval, 'The most remarkable thing now going on is a house of Mr Conolly's at Castletown . . . The plan is chiefly of Mr Conolly's invention, however, in some points they are pleased to consult me.' In September he wrote, 'you will be surprised to hear that the building is begun and the cellar floor arched before they have agreed on any plan for the elevation or facade. Several have been made by several hands.'[45]

The plan is, in fact, a fusion of ideas, several of which have English parallels, particularly in the way it apparently originally divided, with family rooms to the left of the hall. However, the closest English comparison is with Beningbrough, with its double-height hall, staircase hall to one side and its first-floor Great Dining-Room. At Castletown there is a similar arrangement, with the hall and staircase hall linked, originally a panelled Great Parlour in the centre of the garden front (now the Green Drawing-Room) and over it the exceptional gallery that seems to be part of the palazzo form of the house while also corresponding to a Great Dining-Room. The relationship of the hall and gallery suggests that the former was always intended as a double-height space and was probably designed by Sir Edward Lovett Pierce in the mid-1720s after his return from Italy.

It is both monumental and festive, because of the combination

*Arniston, Midlothian.*

30. *The hall with its complex handling of space and light, with double arcades and two chimneypieces, a giant order and a vaulted ceiling. The arch on the right leads past the hidden oval staircase and the principal staircase to the Oak Room. The plasterwork is by Joseph Enzer.*

31. *The plan of the main floor from* Vitruvius Scoticus *shows how in the mid 1720s William Adam designed a dramatic double height hall and an 'L'-shaped staircase that was to lead to a Great Apartment within an existing structure. He enlarged the space behind the hall into a panelled Great Parlour, now the Oak Room, and placed the library (Fig. 89) on the second floor over the hall. The incomplete right-hand end of the house was replanned in the 1750s by John Adam, who suppressed the first-floor Great Apartment and formed a drawing-room and dining-room on the main floor.*

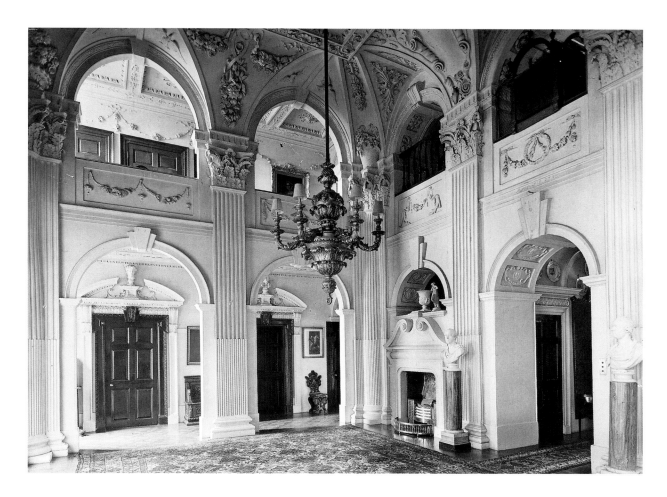

of the Ionic order for the ground floor, with its bold half-columns supporting a complete entablature and screen of full columns carrying the cross gallery, and, instead of an upper order, an upper row of tapering pedestals with baskets of flowers supporting a carved frieze and cornice that suggests a lighter, almost open-air structure above the solid architecture below, a concept without parallel in the British Isles. Facing the chimneypiece of simply moulded black Irish marble without any decorative carving is an arch through to the staircase hall.

Of all the surviving early Georgian halls, that at Moor Park, Hertfordshire, is the most richly decorated (Fig. 36), but it is untypical in that it combines an architectural conception going back to the hall at the Queen's House at Greenwich and restated at Houghton with a Venetian approach to decoration involving an unusually lavish use of marble for the dado and doorcases, richly gilded plasterwork by Giovanni Bagutti and the Artari, and glorious painting by Giacomo Amiconi. The last, completed in 1732, created a more joyful mood than Sir James Thornhill, acting as both architect and painter, had envisaged about 1724.

Thornhill was working within the shell of the late seventeenth-century house that his patron, Benjamin Styles, had bought in 1720, and evidently the intention was to outshine both Wanstead and Houghton as well as challenge Gibbs and Kent. In July 1725, he signed an agreement with Styles to paint eight scenes of *Heroic Virtues,* and several of his surviving drawings (Fig. 32) show how he proposed to combine his own painting and the stuccadores' detailed proposals for the decoration of the walls with trophies like those painted by Kent in the Cupola Room (Fig. 173). One shows slightly

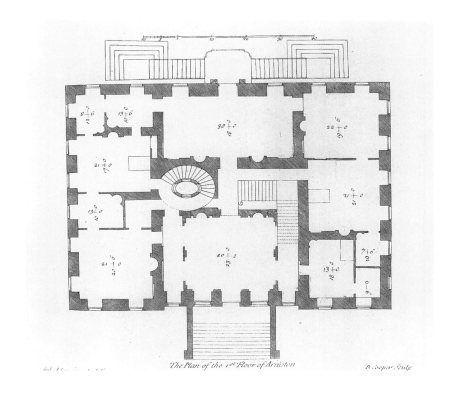

*The Plan of the 1st Floor of Arniston*

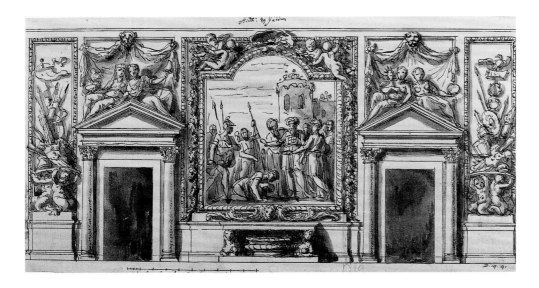

*Moor Park, Hertfordshire.*

36 (facing). *The most richly decorated of the double-height halls of the 1720s, it was fitted into an existing house by Sir James Thornhill, who designed it round a set of his own canvases of* Heroic Virtues, *plasterwork by Giuseppe Artari and Giovanni Bagutti, and unusually generous use of marble for the doorcases and dado. About 1730 replacement canvases were commissioned for the lower walls with four finer canvases of the story of* Jupiter and Io *by Giacomo Amiconi. The upper walls were painted by Francesco Sleter.*

32. *One of Thornhill's alternative Corinthian and Doric proposals for the wall treatments on the ground floor of the hall, 1725. They show how he incorporated the stuccadores' own designs into his schemes with his paintings. He also planned one of the first monumental tables for a hall with sphinx supports and a cistern that suggests occasional use for dining. Victoria and Albert Museum.*

33. *The hall ceiling with illusionistic painting by Giacomo Brunetti framed in plasterwork by Giuseppe Artari and Giovanni Bagutti originally designed in relation to the Thornhill scheme.*

34. *A design for a ceiling at Gubbins, Hertfordshire, probably 1720s, by Giuseppe Artari (died 1769). Artari was one of the principal Italian stuccadores working in England from 1720, particularly for Gibbs, who owned this fluent drawing and to whom it used to be attributed. Gibbs's office designs for decoration are much drier. This drawing suggests that stuccadores often made their own designs. Ashmolean Museum, Oxford.*

35. *An ornament print by Giacomo Brunetti, published in 1736. He was a painter of architecture who also worked in the theatre, and his prints were the first to be originated and published in England. They show how close his ornament was to that of the Italian stuccadores.*

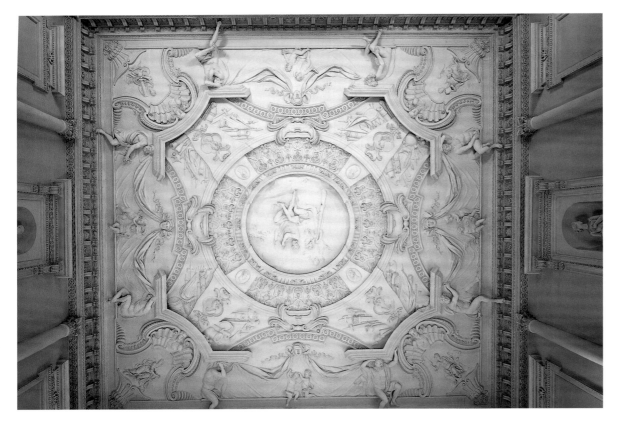

37. *The hall ceiling at Clandon Park, Surrey, probably late 1720s. The false perspective with a central open 'dome' suggests the influence of prints like Pozzi's and parallels the work of painters, as at Radnor House, Twickenham (Fig. 38). The central relief of* Hector and Iole *is after an engraving of a painting by Annibale Carracci in the gallery of the Palazzo Farnese in Rome. There is no evidence that it was ever painted in more than a single white to heighten the illusion of recession and create a contrast between structure and open sky as at Orleans House (Fig. 153).*

38. *A painted parallel to plasterwork. A ceiling by an unknown painter at Radnor Lodge, Twickenham, now destroyed. It has been dated about 1743 and attributed to Francis Hayman.*

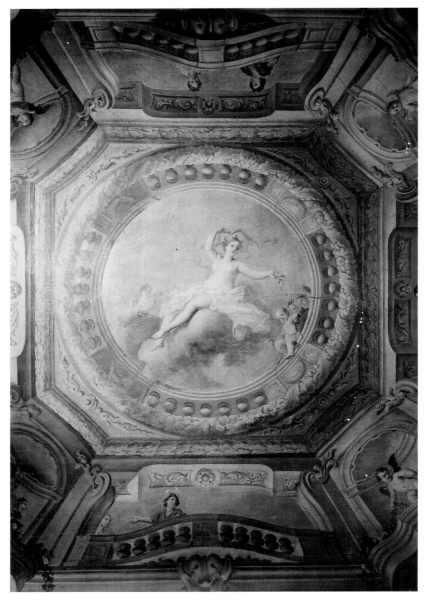

projecting bases for the main pictures on the end walls and one of the earliest architectural pier tables in England supported by crouching sphinxes with a cistern beneath. A drawing for the ceiling shows how he proposed to combine his own figurative painting in differently shaped central and corner panels with the designs of the stuccadores, whose trophies were executed in the middle of each side.[46]

He concentrated on his canvases in 1726 and 1727, but after Styles refused to pay any more, they went to court in 1728 and 1730. Again, as at Kensington Palace, this may not have been a straightforward artistic disagreement, because Vertue records:

> a strong party at Court being all of the office of Works. Mr Kent's friends & interest, no doubt endeavourd, to foment this difference & slurr the reputation of Sr James tho it was the true oppinion of the several Artists Judges in this case that Sr James had excelld in this work. particularly as he designed it to Rival all his competitors. But what is Merit when envy joynd with power to oppose it.[47]

The identification of Bagutti and the Artari as the stuccadores depends on two documents, one a particularly fluent drawing of a ceiling at Gubbins in Hertfordshire, formerly attributed to Gibbs, which is addressed on the back to Bagutti at Moor Park (Fig. 34); the other is Sir Edward Gascoigne's note of the Artaris' names on his visit in 1728. The playing boys with garlands round the frames with the paintings of the *Story of Jupiter and Io* by Amiconi and supporting medallions on top of the upper doorcases are very close in spirit as well as date to the decoration in the cove of the Stone Hall at Houghton (Fig. 193).[48]

Styles must have been left with an incomplete scheme for a year or so, because Amiconi only arrived in England in 1729. But by 1732 his four canvases were known to Vertue, who noted '7 or 8 Stories to place in his hall in lieu of those Sr James Thornhill did – & no doubt intended as a mortification to him'. They are arguably the finest cycle of decorative painting of the period in England (Fig. 36).[49]

For the upper walls, Francesco Sleter painted pairs of *trompe-l'œil* statues in niches in grisaille. The ceiling painting is by Giacomo Brunetti (Fig. 33), whom Vertue describes as a 'painter of architectur and ornaments', but is now better known for his set of ornament prints, the first to have been published in England in 1736 (Fig. 35). He had already worked with Amiconi on Lord Tankerville's house in St James's Square and painted scenes for the opera. He painted the *trompe-l'œil* dome in a steep perspective that recalls *The Cupola of the Ninetieth Figure with its Light and Shade* in Carlo Mario Pozzo's *Artis Sculptoriae Paradigmata*, published in Fulda in 1708, and also the *trompe-l'œil* balustrades in the corner 'openings' of the ceiling.[50]

The whole concept of the ceiling with stucco figures of slaves and trophies in the centres of all four sides leads on to the remarkable ceiling in the hall at Clandon Park, Surrey (Fig. 37), with its *gnudi* lying on the cornice and supporting sections of moulding from which spring a cross vault and arches that in turn carry an inner dome open to the sky with a central relief of *Hector and Iole* (copied from an engraving of Annibale Carracci's painting in the gallery of the Palazzo Farnese in Rome). That playing with space, which is even more elaborate than in the ceiling of the Octagon at Orleans House, Twickenham (Fig. 153), could have been influenced by Pozzi's plates. These were certainly known to the Italian stuccadores in Ireland and could easily have been acquired by Giuseppe Artari when he was in Germany. Photographs inevitably flatten the sense of false perspective, as does the single white in which the ceiling is painted. No trace of colour has been found, but could the stuccadores have intended it to be tinted to strengthen the illusion, as was discovered in the Octagon? Vertue noted, apparently in connection with the hall, 'stuccos painting guildings & most rich and costly'. Thus it is tempting to see the ceiling as the stuccadores' equivalent of the painted ceilings formerly at Radnor House, Twickenham (Fig. 38) and surviving on the stairs at 8 Clifford Street, London.[51]

It is unclear whether the Clandon ceiling followed or preceded that at Moor Park; and again, as with that at Barnsley, it is not known whether it was the work of Bagutti and the Artari working together or separately, or in some other combination, as at Ditchley. Clandon was designed by Giacomo Leoni for the 2nd Lord Onslow, and the traditional starting date of 1731 seems too late. In the Addenda to the first book of Defoe's *Tour,* which came out in 1724, he wrote 'Since the Closing of this Volume there are several Great and Magnificent Buildings begun to be Erected, within the Circuit of these Letters which however, not being finish't, cannot now be fully described': the second one he mentions is 'Lord Onslow's seat, re-edifying near Guildford'. So if work began on rebuilding the old house about 1723–4, its decoration could have been under way by 1728 and Frederick, Prince of Wales entertained in 'the great room' upstairs in 1729. Lord Onslow died in 1740, before the house was finished.[52]

One of the puzzles of the hall is how Lord Onslow came to commission from Rysbrack the two exceptional continued chimneypieces, all of marble, with their emblems of Diana and Bacchus and their superb reliefs of *Sacrifices,* which must be contemporary with the one in the Stone Hall at Houghton (Fig. 191) and precede by several years that in the Marble Parlour (Fig. 217). Not only are they superbly carved, but the selection of the different white marbles with the stronger grey demonstrates a marvellous eye for the

subtleties of the shading and the veining of the material. Unfortunately, there is no record of the year they were installed or what they cost.[53]

The double-height hall remained fashionable until the early 1740s, but then rapidly went out of fashion in new houses for a combination of reasons. There was no sense in having an ice box in the middle of a house, particularly when it took up space needed for bedrooms as the number of visitors increased with the improvements in roads. Also, it may have been felt that the relationship of a double-height hall to a single-storey saloon or Great Parlour behind created a sense of anticlimax, as can be experienced at Beningbrough, Ditchley and Clandon.[54]

Many houses, both new ones and those remodelled, had single-storey halls, as can be seen at Wentworth Castle, Stoneleigh, Sutton Scarsdale and Antony; and their variety is considerable, particularly when the hall is linked to the staircase hall. The hall at Antony is simpler than the others discussed here in being completely panelled in oak and, although carefully and subtly detailed, it involves no carving or any decorative plasterwork. What is so satisfying is the sober way it balances the saloon and drawing-room; but after nearly 300 years the woodwork in all three rooms has considerably darkened. The main staircase has also been reconstructed: originally it had a more dramatic start in the centre arch and then immediately turned south to climb in three flights to the first floor.[55]

At Wentworth Castle, where the grand new entrance range, designed about 1708 by Jean Bodt for the Earl of Strafford who met him while ambassador in Berlin, is at right angles to the earlier house, the entrance hall is below the gallery that fills the whole of the first floor. So it was designed as a sub-hall with four Ionic columns standing in the centre of the room and pilasters around the walls supporting the ceiling beams, with extra pilasters introduced for decorative effect. The walls are panelled and the moulded architraves to the doors are of marble.[56]

On plan, Sutton Scarsdale appears as an old house remodelled and disguised by two grand new fronts designed by Francis Smith of Warwick for the 4th and last Earl of Scarsdale, a man of evidently flamboyant taste. Work began in 1724, and old photographs of the hall suggest that the Italian plasterers Artari and Vassalli took over the design, as also appears to have happened in the saloon at Ditchley (Fig. 387). There were two chimneypieces with sculptural overmantels combining reliefs and putti, like those at Barnsley, Clandon and Hall Place, Berkshire, and round the walls there was a system of rather weakly drawn pairs of pilasters with single ones in the corners. The wall panels were filled with ornament that appears dark in photographs, and the recent discovery of gilding on the staircase at The Drum (Fig. 39) raises the possibility that here, too, the plasterers added gilding.[57]

At Davenport, begun about 1726, Francis Smith's hall and staircase halls are treated as closely linked spaces, the walls of both plastered to resemble channelled masonry and perhaps originally painted a stone colour. In the hall the chimneybreast and facing arch to the staircase hall are framed by pilasters, while the Gibbsian side doorcases with their rustication contrast with the columns and pediment of the saloon doorcase. Here, all is architecture, with no contribution from the Italian stuccadores. At Mawley, probably also built by Francis Smith but, according to Horace Walpole in 1743, largely designed and executed by its owner, Sir Edward Blount, and perhaps begun about the same time as Davenport, the hall has three

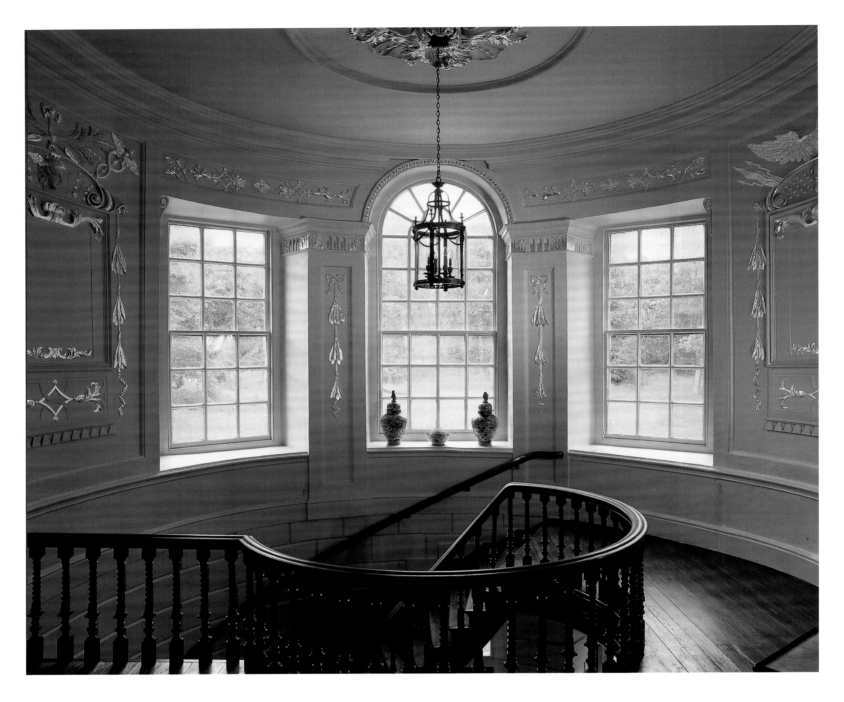

arches leading to the staircase hall, reviving the Chicheley idea. Here, both the plasterwork by the Italian stuccadores and woodwork by an unknown master are unusually fanciful.[58]

At the Drum (Fig. 40), which William Adam originally conceived about 1726 as a villa with two flanking pavilions, one of which was the existing house, he devoted the centre of the main house to the hall, with an arch leading through to an oval staircase hall that projects beyond the north wall into what was at that time a most unusual bay. Presumably the architectural treatment of the hall with its order of pilasters and half-columns was part of the first phase of building and decorating in the late 1720s, whereas the Marotesque trophy of arms above the chimneypiece with the arms of Lord Someville and his second wife, whom he married in 1736, the vigorous scrolls over the doors and the vases over the doorways in the thickness of the arch and all the ornament on the upper walls of the stair well, now once more stone colour and parcel-gilt, were added by Thomas Clayton about 1740.[59]

How these halls were furnished is not known, but it appears that specifically designed furniture only began to be introduced in the mid-1720s. In England, the form of the hall chair goes back to the painted shell-back chairs formerly at Holland House (one is now in the Victoria and Albert Museum) that are thought to have been designed by Francis Clein about 1630 and derive from Italian *sgatelli* of which examples were imported about that time, as can be seen at Petworth. A few late seventeenth- or early eighteenth-century hall chairs are recorded, like a set of painted chairs with unusually high backs that are supposedly from Holme Lacy in Herefordshire (one of which is now at Beningbrough) and another from Wentworth Castle, again not definitely dated. However, sets of hard chairs with shaped backs bearing a crest or coat of arms only seem to have come into fashion about 1730. The one at Ham House is supposed to be the set of '18 Hall Chairs Painted and Varnisht' at £1 each charged for by George Nix on 1 August 1730. At Grimsthorpe, there is a set of chairs painted stone colour with the colourful arms of the 2nd Duke of Ancaster, who inherited in 1723 and died in 1742.[60]

Such chairs are associated with servants waiting, but it is not clear whether that means servants of the house or the servants of visitors and there appear to be no enlightening descriptions of such chairs

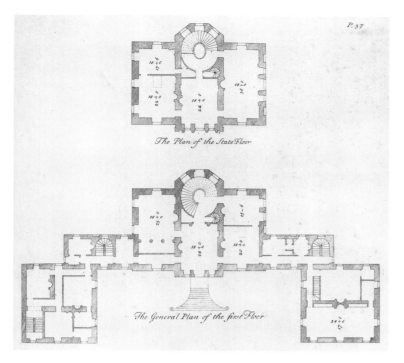

The Drum, Midlothian, designed by William Adam about 1726.

39. *The upper part of the stone-coloured oval staircase. The recent gilding of the plasterwork and the sky-blue ceiling follow evidence that was found.*

40. *Plan of the main floor and first floor or 'Floor of State' from* Vitruvius Scoticus. *The ceiling of the Great Dining-Room on the upper floor is illustrated in Fig. 62.*

in use. However, one of the instructions for the Groom of the Chambers at Burley-on-the-Hill was 'You are to attend in the Hall when there is Company, and also at other times, but in this last you shall be relieved by the footman in their turns.'[61]

Hall benches with panelled backs appear in three patterns at Houghton, in the arcade, on the staircase and in the Stone Hall (Fig. 191), where they slot in under the brackets for the busts as part of Kent's contribution; the last are mentioned by Sir Matthew Decker as not yet having arrived in July 1728. Kent seems to have adapted them from the form of seventeenth-century garden seats of the kind found at Ham House rather than from the richly carved benches found in the halls of Dutch houses. Indeed, at Houghton the painted benches used outside on the west front are similar to those in mahogany in the hall. Presumably the pair in the hall at Raynham (Fig. 225) are contemporary, but there is no reference to them in James Richards's account for carving. The set of mahogany seats (Fig. 250) now at Boughton from Montagu House, Whitehall, a house designed by Flitcroft for the 2nd Duke of Montagu, were supplied by George Nix in 1728, which shows how early Kent's influence was felt. The Ditchley benches (Fig. 358) may have been added a few years after the hall was completed, when Flitcroft was working on the rooms to the west, because there is a reference to them being gilded in 1738; also their cresting interferes with Kent's frames, which suggests a change of mind. Those of about 1740 in the hall at Badminton (Fig. 238) relate to the set of picture frames attributed to John Boson.[62]

Special side tables for halls also appear to be an innovation of the 1720s, as can be seen in Thornhill's design for the hall at Moor Park (Fig. 32). The earliest examples surviving *in situ* appear to be by Kent, the single painted one at Ditchley carved in the Roman man-

ner by James Richards in 1726 (Fig. 389), and the pair of carved mahogany tables that flank the statue of Laocoön in the Stone Hall at Houghton (Fig. 191). In the hall at Raynham is a set of half-octagon tables of mahogany (Fig. 225), presumably the four mentioned in Richards's account for carving.

Another splendid example in Kent's Roman manner, but not associated with him, is the painted table originally from Longford Castle, where it probably stood in the hall when that was refitted in the early 1740s (later at Coleshill and now in the Victoria and Albert Museum). Its pendant was made to fit the curve of the White Parlour at Longford (Fig. 286), where it remains, a nice illustration of the relationship of the hall and parlour as alternative places for dinner. Whether other tables in that manner, originally painted but now gilded, started their lives in halls is impossible to tell.[63]

Most people would have had simpler tables such as the mahogany pair in the hall at Ham House or the four marble-topped tables – two large and two small – listed in the hall at Antony in 1771, and these could have been used as side tables equally happily in dining-rooms and perhaps also suggest the continuing tradition of dining in the hall.

The unexpectedly late date for hall chairs may be explained by their only coming in when people ceased to dine in their halls and began to use dining-rooms all the time. Certainly there is some evidence for dining in halls even in the third quarter of the eighteenth century, particularly in the summer, and using chairs with leather seats like those in common parlours. That can be seen at Belton, where the first (1688) inventory listed in the marble-floored hall a dozen rush armchairs and two marble cisterns with brass cocks; by 1698 there were three tables as well as twelve high-back chairs. In 1737 there were two large oval wainscot tables, two marble slabs on blue and lacquered frames and twenty black leather seated chairs.

At Hanbury Hall, Worcestershire, which was begun in or about 1701 – the date recut over the hall door – and probably completed soon after 1710, when Thornhill painted the staircase and ceilings, the hall was evidently used as the principal dining-room: the 1721 inventory listed an oval table, two sideboard tables, a dozen black leather seated chairs and, as well as a large 'Turkey workt' carpet, two mats, which might have gone under the sideboards.[64]

That is suggested by the 1732 inventory for Ombersley, listing in the hall 'two large painted cloth to dine on, and two painted cloth for ye sideboards'. Also there were twelve walnut-tree chairs with black leather seats, and there were more of them in the Common Parlour. The two marble tables presumably fitted in the recesses of the inner wall and would have doubled up as sideboards. There are similar entries for evidently interchangeable chairs in the Erddig inventory of 1726, and two of these survive.[65]

At Felbrigg in Norfolk, the Great Hall was still used as the Common Eating Parlour in 1734, as is noted on one of William Samwell's plans for the house from the mid-1670s; and that was distinct from Samwell's dining-room, which is the predecessor of the present drawing-room.

There is also the silent evidence provided by niches in halls, with one of the first being that in marble in the hall at Dalkeith. Certainly that at Castle Howard (Fig. 21) was described as a buffet in 1732 and Gibbs indicates one in his design for the hall at Sudbrook (Fig. 27).[66]

As late as 1756, Ware wrote of the hall: 'It serves as a summer-room for dining; it is an ante-chamber in which people of business, or of the second rank, wait and amuse themselves; and it is a good

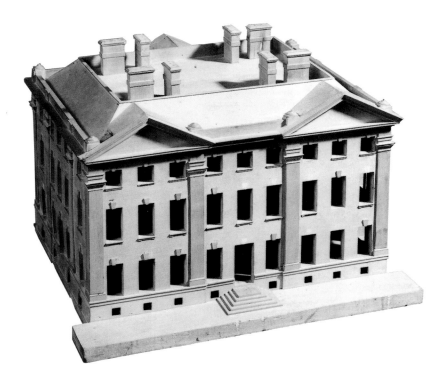

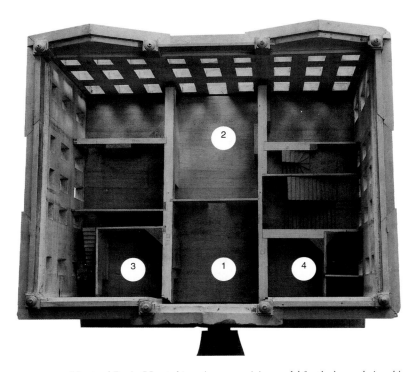

41, 42. *Herriard Park, Hampshire. A rare surviving model for the house designed by John James and a view on to the ground floor. Building began in 1703 after many alternative plans had been considered. 1, hall. 2, Great Parlour, later called the saloon. 3, probably Little Parlour later the Business Room. 4, bedroom apartment.*

apartment for the reception of large companies at public feasts.' Five years later, when Sir James Dashwood entertained the Corporation of Oxford to dinner at Kirtlington, he not only recorded the menu but the fact that they ate in the hall, eighteen at a long table and four at a side table.[67]

While there appear to be no descriptions of such occasions in England, Mrs Delany gives two accounts of life in Irish halls. In 1732 and 1733, she stayed at Dangan in Co. Meath:

The house is very large, handsome, and convenient. . . . We live magnificently, and at the same time without ceremony. There is a charming large hall with an organ and harpsichord, where all the company meet when they have a mind to be together, and where music, dancing, shuttlecock, draughts, and prayers, take their turn. Our hours for eating are ten, three, and ten again . . . We meet at breakfast about ten; chocolate, tea, coffee, toast and butter, and caudle, etc, are devoured without mercy. The hall is so large that very often breakfast, battledore and shuttlecock, and the harpsichord, go on at the *same time* without molesting one another.

When she went to Mount Usher in Co. Wicklow in 1752, she found a similar arrangement:

The house is a very good one, old fashioned, convenient, and comfortable, the hall *very large*, in which is a billiard-table and harpsichord, and a large desk filled with books; within it a large parlour, where we dine; and within that a drawing room, but the spacious hall and the amusements belonging to it make us give it the preference to all the other rooms.[68]

### COMMON PARLOURS, GREAT PARLOURS, DINING-ROOMS AND GREAT DINING-ROOMS

*Common parlours*

When visiting a large, early Georgian country house open to the public today, it is tempting to imagine arriving as an honoured guest at the front door two hundred and fifty years ago and moving from the hall to the sequence of parade rooms beyond, giving little thought to the Common or Little Parlour. However, there is a strong argument for considering the Common Parlour first, after the hall but before the parade rooms, because its situation was of key importance in a house. Also, the parlour seems to have gradually changed its use in the course of the first six decades of the century, from being an everyday living-room in which people sat as well as ate, but which had no comfortable chairs with upholstered seats and backs, to being almost entirely a sitting-room, as at Felbrigg in the early 1750s (see pp 307–11), and even disappearing altogether in new houses in the 1740s and 50s, as at Kirtlington and Hagley.

Roger North wrote:

For the common parlor, this for economy sake must be layd neer the offices, and back entrance, but yet I would not have it ly remote from the hall, or downe stairs, or to be come at thro windings and turnings, as I have seen many, but to have an immediate door from the hall, for the principall entrance, and a back way to the comon servants' passage door, and also another door, that leads partly clear of both towards the back stairs . . . This room must not be great, but neat and pleasant, and posted so as to view the front and back avenues to the house; for, being the place of general pastime, it is not amiss from it to see all the movements that happen neer the house.[69]

He explained the arrangement of his own house, Rougham Hall, in Norfolk:

Then at one end (of the hall) a great parlor, and a pair of stairs,

*Belton House, Lincolnshire.*

43. *The original Great Parlour of the 1680s, now the saloon, as it was in 1964. The panelling and principal portraits are original, as is the carving framing the overmantel. The rest of the carving has been brought in and the ceiling is nineteenth century.*

44. *Plans of the main floor with some of the names of rooms used in 1737.*

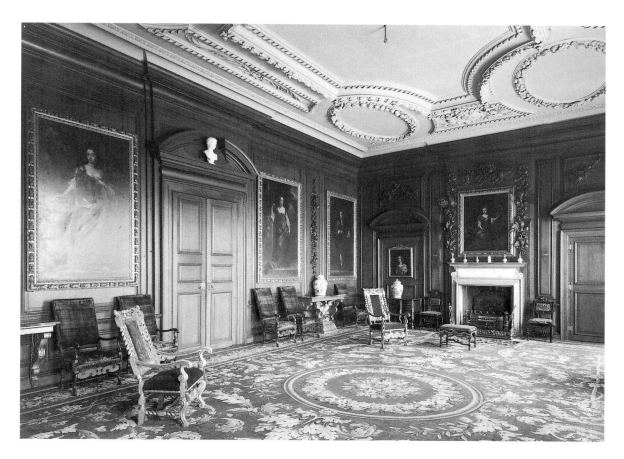

called also great, and a door into the garden, and at the other end, buttery pantry kitchen, and a litle parlor, for every day eating. It is but late that servants have left their eating in the hall. This in my time was done in my father's house. But since it has bin usuall, to find a room elswhere for them, and the master, in summer especially, leaves his little parlor to eat there.[70]

What he does not mention is the matter of warmth, but keeping a large house warm and dry must have been a major consideration; and even the richest people had to accept that most of the time they had to live in fairly restricted spaces.

One of the best later descriptions of such a room in use is at Moreton, an evidently old-fashioned manor house in Dorset, written by Mary Frampton, a daughter of the house, in her diary covering the years 1779 to 1846. She described what an earlier generation would have called a Common Parlour: 'To show the progress of luxury, I must mention that at that time my father, with a fortune of £4000 a year, with an excellent house, &, lived entirely in one of the worst rooms in it, where we breakfasted, dined and supped; and even with company in the house, excepting on the rare occasions of a large party. We used to go out of the room for a short time after dinner, and return to it again after tea.'[71]

Life in such a room brings to mind the references to 'commons' in the Purefoys' letters about their life at Shalstone in Buckinghamshire. No doubt guests were asked to dinner, but in winter that depended on a clear sky and moonlight to go home by. It seems that they were also entertained more informally, to what was called Commons, a phrase still in use at Trinity College, Dublin, where Fellows say 'I'm dining on Commons to-night' when they mean that they are dining in hall. 'Commons' at Shalstone was presumably the midday family meal. In 1749 Henry Purefoy asked James Gibbs (a friend, not the architect) to 'take a Commons with mee'; and 'Since you are so oblidging to give us an Invitation wee intend to come &

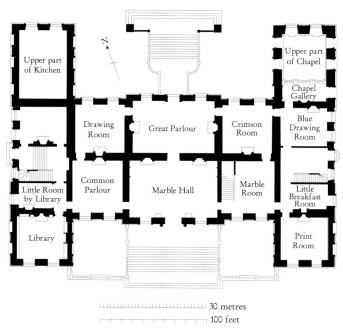

take a commons with you tomorrow about one a clock & hope wee shall have your good company.' Presumably they would have eaten in the Common Parlour.[72]

Today, very few common parlours survive in unaltered form, but with the aid of plans and inventories and a rare model like that for Herriard Park, Hampshire (Figs. 41, 42), it is possible to imagine them and see how they related to halls and great parlours. The Herriard model must have been made shortly before Thomas Jervoise began building his new house in 1703 and finally made up his mind after considering a number of plans showing variant arrangements of rooms produced by John James. It illustrates more graphically than any plan the way the block-like house was to be

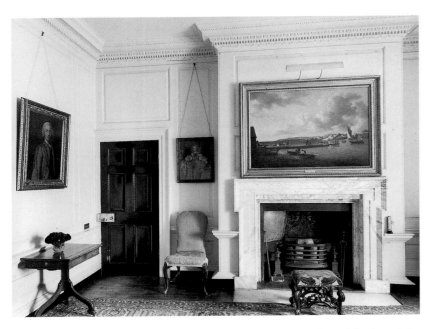

45. *One of the everyday ground-floor rooms at Houghton Hall, Norfolk. Part of the original panelled Supper Room at the south-east corner of the house. It was one of three panelled rooms used for regular meals. The main series of plates of the house are Chap 5.*

divided up and the modesty of the smaller spaces, including the Common Parlour. The view on to it has the hall in the centre of the entrance front, with a slightly shallower panelled room behind it showing the character of a great parlour (later called the Saloon); to the left was a small room with more modest panelling, which was probably the Little Parlour, while to the right was a small bedroom apartment.[73]

The Herriard model can be compared with the more generous plan of Belton, in many ways the classic example of a late Charles II house (Fig. 44). There, the *de facto* common parlour was the room to the left of the hall and in 1688 already called the 'Dineing Room' (now remodelled as the Tapestry Room). Then, it had two cane chairs with arms, fifteen single cane chairs, a child's chair, two sideboard tables, two oval tables and a cedar table. By 1737 it had been refurnished with twelve cane chairs with leather bottoms, an oval walnut table and a large mahogany table. In 1743 it was called the Common Parlour; and evidently it was still used as an everyday eating room in 1754, when it had twenty walnut chairs with leather seats, a large blue and white marble cistern and two sets of flowered cotton curtains. One of the few references to a common parlour in use occurred here in 1760, when Lady Cust wrote to her son about the visit of 'Lord B': 'I and my three daughters were in the Common Parlour, when he first came . . . we talked upon indifferent subjects & my Lord looking very much about ye room.'[74]

Probably the most accurate record of such a room is the drawing of the parlour in William Stukeley's house at Grantham that he made in 1726. That was a more modest bachelor house than any discussed here, but he had sophisticated, up-to-date ideas and his wall elevations show how he scaled them down to suit his purse. Thus, in the parlour he placed a bust on a bracket above the tripartite chimney glass and a tall walnut glass above a tea table of vaguely oriental form, with china set out on it. The curtains had pelmet cornices and decorated valances. The splats of the chairs were a little more elaborate than those in the dining-room. Indeed, the difference between

the two rooms suggests that the parlour was becoming a sitting-room associated with tea, while the dining-room was furnished more boldly with gilt-framed portraits hung high, just below the cornice and above the lower panels, with bold pelmet cornices to the curtains. The stiffness of Stukeley's drawing probably echoes the spirit of the room: certainly it is similar to the atmosphere of rooms in early conversation pieces and the interiors of eighteenth-century museum houses in New England.[75]

Arguably the most complete arrangement exists at Houghton. To the right of the south door is a small room, called the Little Parlour in 1745, that Sir Robert used for breakfast and seeing people who came on estate business. Next to it on the south-east corner of the house was the room for supper, which was hung with family portraits (Fig. 45). Between it and the Arcade in the east front is the Hunting Room, which remains the everyday dining-room, named after Wootton's *Hunting Piece* with Sir Robert, Thomas Turner and Charles Churchill (formerly in the Hermitage Museum and now lost and only known through an engraving). The room has a stone floor, a Gibbsian chimneypiece and stone-coloured panelling behind its late eighteenth-century Chinese wallpaper. To the right of the Arcade is the Coffee Room, as it has always been called, where Sir Matthew Decker drank tea after dinner in 1728; it remains the everyday sitting-room. These rooms were all simply furnished, with no less that forty-eight walnut chairs with leather seats in the first three rooms and twenty-two chairs and a settee in the Coffee Room. There were no curtains in the first room.

In the late seventeenth and early eighteenth centuries, parlour chairs invariably had cane or rush seats and backs; and in the second quarter of the eighteenth century seats of black leather are often mentioned, with the same chairs also being used in the hall, as at Erddig and Ombersley. In 1737–8, when Thomas Coke was thinking about furnishing the family wing at Holkham, he wrote to Brettingham that he believed he would have black leather chairs for what he called the rustic dining-room, on the ground floor of the family wing and still the family dining-room.[76]

In the 1740s the parlour started to disappear from new houses, as can be seen in the plan of Kirtlington (Fig. 395), and by the 1750s it was evidently out of fashion, as can be seen in the plan of Hagley (Fig. 406) and in the new houses of James Paine. Paine does not use the term at all in connection with his published plans of Gosforth, Belford in Northumberland, Serlby, Bywell or Axwell, but provides a 'common-sitting room' at Gosforth in 1754 and a 'common-eating room' at Axwell in 1760.[77]

### Great parlours

Today the difference between the terms 'common' and 'great' parlour means little, but it is quite clear that they did have different characters, as Roger North explained: the great parlour generally lay on the far side of the hall from the common parlour, or possibly back to back with the hall in a double-pile house, and it invariably had a withdrawing room next to it.

A great parlour, like a common parlour, seems to have been invariably panelled, a custom that arose from the antipathy to using rooms hung with tapestry or material for meals. Occasionally, particularly in the houses of Francis Smith of Warwick, it was given the special dignity of a complete order, as can be seen at Stoneleigh and Badminton and possibly Ombersley and Mawley. However, in many

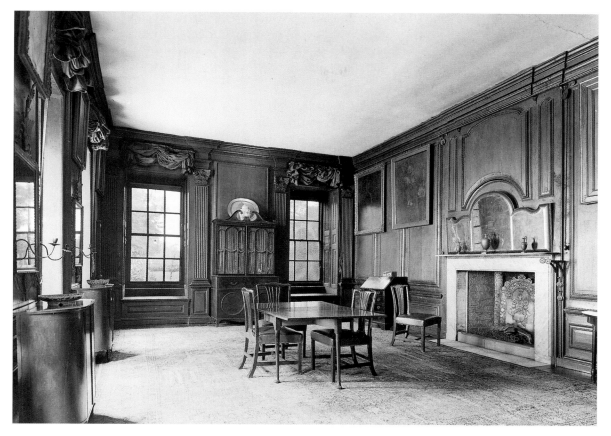

46. 'The Right-Hand Parlour' at Canons Ashby, Northamptonshire, as it was in 1921. It was probably fitted up in 1710 as the Great Parlour and, unusually, given pilasters on the end wall to frame the windows with the capitals rising above the tops of the windows to frame the festoon curtains in the dead light. Although the chimneypiece was altered later, it retains its original overmantel whose walnut frame is shaped to complement the panelling over it. The portraits are hung high.

47. One of the original walnut chairs acquired for the parlour. The 1717 inventory lists twelve chairs, of which six survive, and a settee. The bended back is the earliest documented example of its type and is based on a Chinese design like that of Fig. 350.

houses, when a dining-room was formed later, the great parlour confusingly became a drawing-room or saloon, but still retained its panelling, as can be seen at Belton, Stoneleigh, Chicheley and Mawley.[78]

At Belton, although the fitting-up of the Common and Great Parlours has been considerably altered, the gradual enrichment of their furnishing can be followed from the early inventories. In 1688 the Great Parlour had eighteen rush chairs, two large glasses, japanned tables, presumably below the glasses on the window piers, sarsnett curtains, but no big tables. Ten years later, it had twenty-four Dutch chairs, which were probably of the simple type used in eating rooms, the pier-tables and glasses, with four stands, all japanned to form sets, but the curtains had been changed to singles of silk.

By 1737 the room had evidently ceased to be used for meals and had become the principal drawing-room of the house (although it was not known as the Saloon until the nineteenth century), because it had '10 wrought (presumably needlework) chairs backs and seats stuffed', four stools of red flowered silk, a pair of large pier-glasses with three brass sconces, a pair of large marble tables, two small pier-glasses in gilt frames with a pair of glass sconces, two pairs of satin plush curtains with valances, and it was lit by an unusually large 'lustre with 16 brass sconces', which had been exchanged for one of glass by 1754.

From the start, the room was evidently hung with family portraits, because four large or very large pictures and two ovals are mentioned in 1688. The four are the full-lengths on the south wall

of Sir John Brownlow, the builder, and his wife, Alice Sherard, and his brother and successor, Sir William and his wife, Dorothy Mason, by John Riley and John Closterman.

A good example from the early eighteenth century is the room at Canons Ashby, Northamptonshire, to the south of the great hall, originally called 'the Right Hand Parlour' and now the dining-room (Fig. 46), and the other side from the Winter Parlour, which probably continued in use as the common parlour. It was handsomely panelled by Edward Dryden in 1710 and still retains its original tripartite overmantel glass with an arched centre section that answers the shape of the overmantel panel and narrow side panels, while the windows at the west end are framed by pilasters. The room still looks much as it did in the 1921 photograph, which shows the portraits hung high and festoon curtains drawn up into the dead light above the windows and fitting neatly into the design of the pilasters; and it retains its pair of contemporary marble cisterns. Recently it has been pointed out that six of the original twelve walnut chairs with cane seats that were *en suite* with a settee and a marbled-top sideboard according to the 1717 inventory survive in the house (Fig. 47). The chairs are the earliest English examples with a bended back, an idea thought to have been adapted from a Chinese original.[79]

At Compton Place, Sussex in the late 1720s, Colen Campbell designed an eating room with a screen of columns (Fig. 48), a continued chimneypiece and unusually elaborately carved panelling by James Richards that incorporated small portraits and tabernacle glasses in the design. Instead of being called a dining-room in the 1743 inventory, it was still called the Great Parlour. It then had four-

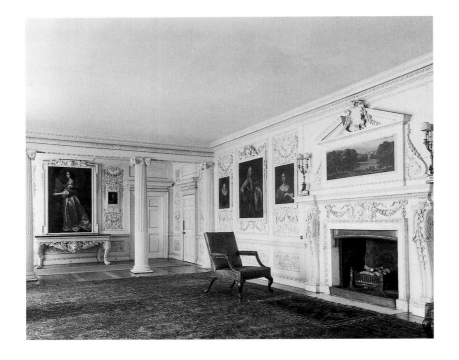

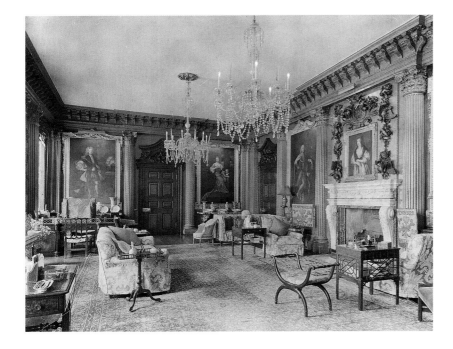

teen walnut chairs with matted seats, a walnut table frame and four glasses in painted 'tabernacle frames'. At that date the room evidently did not have the nearly contemporary painted pier and side tables that appear on the end wall in the *Country Life* photographs taken in 1935.[80]

One of the last panelled great parlours may be that at Badminton (Fig. 49), designed by Francis Smith for the 3rd Duke of Beaufort in the years after 1729. Conceived as a Baroque room for a patron with strongly Italianate but not Palladian tastes, it has a more complex system of half-columns and pilasters than is usual in a Smith house: half-columns frame the doors on the end walls and the chimney-piece, with the deep bracketed entablature stepping forward on each occasion, and with pilasters in the corners of the room and framing the doors on the long wall; and all the doorcases are derived from plates published by Rossi. Over the chimneypiece is a trophy by Gibbons, which is echoed by Edward Poynton's carvings in the overdoors.[81]

The term 'great parlour' rather than dining-room still occurred at Dunham Massey at the end of the 2nd Lord Warrington's lifetime, as can be seen from the inventory almost certainly taken after his death in 1758. It was furnished with twenty-four walnut chairs with crimson silk damask seats and red frieze case covers. No dining-table is listed, but there was a mahogany stand for the large silver cistern.[82]

None of the parlours or great parlours before 1730 seem to have had any comfortable-sounding upholstered chairs or settees. Those started to appear in the 1730s.

Arguably the last new great parlour was that at Strawberry Hill, which Horace Walpole added on in 1754 and often called the Refectory (Fig. 50). It was hung with portraits of family and friends, but given a gothic gloss in its chimneypiece, cornice, stained glass in the upper lights of its window and Hallett's black chairs with what Walpole called 'matted bottoms' and looking-glasses in black frames. Horace Walpole, in his part-serious, part-teasing way, gave it its name that played on the past: yet at the same time he furnished it more as an up-to-date sitting-room than as an eating room, with a pair of newly fashionable settees that appear in check case covers in John Carter's watercolour of 1788, an early eighteenth-century lacquer bureau and no side tables (unless they were on the wall behind the artist).[83]

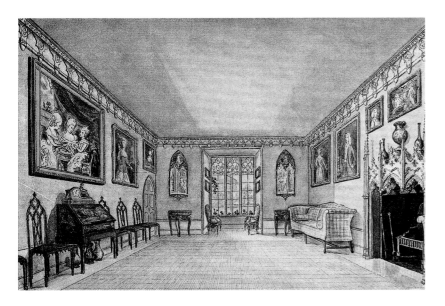

*48. The Great Parlour, later the dining-room, at Compton Place, Sussex, fitted up by Colen Campbell in the late 1720s. It is an early example of the use of a screen of columns in an eating room. The only parallel to the carving of the fields of the panels is in the Great Room at Fairlawne (Fig. 74).*

*49. The 3rd Duke of Beaufort's Great Parlour at Badminton, Gloucestershire, designed by Francis Smith after 1729, as it was in 1939, when it was a drawing-room. Smith liked to use an order in a Great Parlour, but this is an unusually rich example for a patron with Roman rather than Palladian taste, incorporating a reused Grinling Gibbons overmantel and doorcases after a Rossi design with Gibbonsesque carving of the Smith period.*

*50. The Great Parlour or Refectory at Strawberry Hill, Twickenham, Middlesex, added to the house in 1754 and as recorded by John Carter in 1788. Always eclectic in his tastes, Walpole hung it with portraits of family and friends and he included an early eighteenth-century japanned or lacquer desk, a modern French clock and gothick chairs made by Hallett. The two settees of the 1750s have red and white check case covers. Lewis Walpole Library, Farmington.*

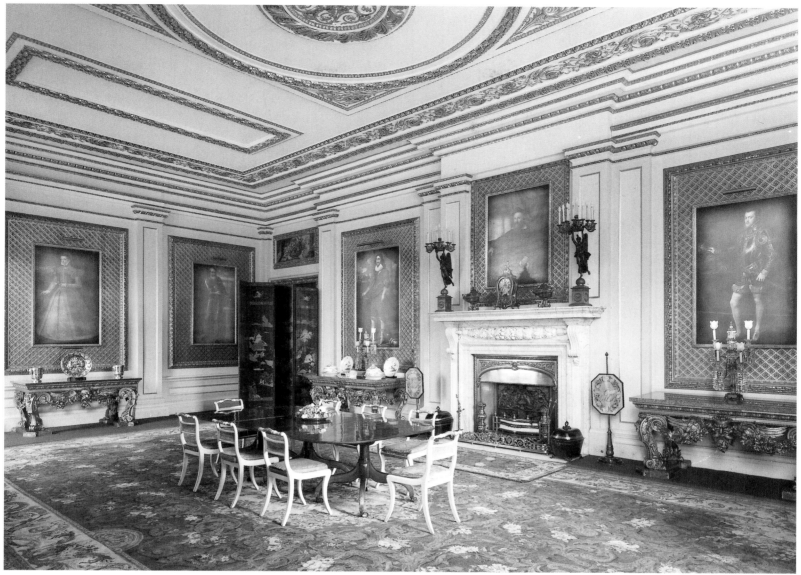

51. *The dining-room on the first floor at Chatsworth and the first room of that apartment. Although altered by the 6th Duke of Devonshire, the complex panelling scheme with its recessions and complete order of pilasters together with its chimneypiece and* *carved frames to the panels are all part of William Talman's subtle design for the 1st Duke.*

## Dining-rooms

The use of the word 'dining-room' throughout most of the period is inconsistent. Before the mid-1730s, it is not often found, and as late as 1755 Mrs Delany could puzzlingly write from her house in Spring Gardens, Westminster, of 'My "*dining room*", vulgarly so called is hung with mohair cafoy paper, (*a good blue*)'. In the early part of the period the most usual pattern for a large country house was to have a common parlour, a great parlour and a great dining-room, which will be discussed next, but on occasion the term 'dining-room' was found earlier.[84]

One of the earliest identified uses of the term 'dining-room' is at Ham House. There, the central room of the private apartments of the Duke and Duchess of Lauderdale on the garden front, which has a marble floor and was always hung with leather, was called the Marble Dining-Room in the 1677, 1679 and 1683 inventories. In the new wing at Felbrigg in the mid-1670s William Samwell provided a dining-room between his new principal staircase and a smaller drawing-room, and evidently it was used on more formal occasions than the Great Hall. The 1688 inventory for Burghley House, Northamptonshire, describes the room to the east of the

Marble Saloon, the central room on the south front, as the Dining-Room, but, since it was hung with crimson figured velvet, it cannot have been the everyday room; it is more likely that the Gilt Leather Dining-Room, hung with gilt and blue Spanish leather, which was in the east range, was more generally used. At Belton the Little Dining-Room was evidently the common parlour.[85]

One of the handsomest dining-rooms of that time is by Talman at Chatsworth (Fig. 51). It is the room opening off the Great Staircase on the first floor and preceding the drawing-rooms in the south front and has been the family dining-room through most of its history. Although altered by Wyattville, it retains Talman's complex scheme of panelling in three planes and its complete order of Doric pilasters that marks the subtle advances and recessions of the planes. In this it has been clearly worked out by the same mind who planned the wainscot in the chapel and that in the gallery recorded in an early nineteenth-century watercolour.[86]

The 1727 inventory for Kiveton in Yorkshire suggests that the dining-room was one of the simpler rooms: it had a dove-coloured marble chimneypiece, its pictures were in black and gold frames, its drapery curtains with cornices and valances were of scarlet hara-

52. *Colen Campbell's design for a dining-room for the 2nd Earl of Bute's house in Great Marlborough Street, London, 1722. One of the earliest uses of tabernacle frames for glasses on window piers and comparable with those in the saloon at Burlington House (Fig. 165).* British Architectural Library.

teen, an inexpensive material, and it had fourteen Spanish leather chairs with two large and two smaller marble sideboard tables.[87]

The formalizing and elaboration of dining-rooms may well tie up with a series of interrelated developments that need to be considered separately. The first is increasing size, so that in noblemen's houses it could be used for public days. This may have encouraged the introduction of the screen of columns at the service end that framed the sideboard and display of plate. At about the same time, the silver dinner service became established, with the fashion for *service à la française*, with elaborate dishes for each course set out on the table and the company helping each other. Then later, in about 1740, came the introduction of mahogany as opposed to walnut chairs. The design and size of tables was also probably significant, with the tradition of using convivial oval tables and having more than one in a room, as Mrs Delany described at Castletown.

It is also possible that whereas the Great Parlour implied a panelled room, from the early 1720s a 'dining-room' suggested a room with stucco walls painted a light colour.

At Blenheim, Vanbrugh did not provide a dining-room as one of the main run of rooms, and perhaps envisaged the saloon being used on special occasions, although that probably never happened in the lifetime of the 1st Duke of Marlborough. However, on the

family side of the house, as is first shown on a plan of about 1705 in Sir John Soane's Museum (Fig. 353), there was to be a dining-room with an unexecuted screen of columns overlooking an internal courtyard; and that must have been in use from about 1719. The space still survives with its carved cornice, and, according to the 1740 inventory, it was furnished with 'Hangings of Lead Colour and Gold Leather; 3 scarlet cloth curtains; 2 marble cisterns; two walnut tree folding tables; 4 walnut tree stands; One arm chair of Caffoy; Two Velvet chairs; Twelve Yellow Leather Chairs; A wanscot Table to set the side board plate on; Marble Shelves in the Beaufet; In the Round Room where the Desert used to stand.'[88]

The leather hangings can be compared with their earlier use at Ham and Burghley and with simple chairs at Dalkeith Palace. In 1701 the Duchess of Buccleuch wrote to Lord Melville 'to order some guilt leather Hangers for the dining room and some such plain chairs as is used for eating rooms I mean Kane or some sort that has no stuff on them'.[89]

How Vanbrugh's feeling for spatial planning developed can be seen in his proposals for Eastbury. First came the unexecuted plan at Worcester College where the Greek-cross hall with its central piers and columns was to be flanked by a circular staircase and an octagon room, which in turn was to lead into two balancing rooms, one with niches flanking the door that was presumably to be an eating room. His arrangement of the dining-room in *Vitruvius Britannicus III* shows an unusually long room – 45 by 22 feet – lit by a Venetian window and with a screen of columns and a bay beyond that with more columns against the end wall framing a central apse for a buffet and a jib door leading through to a servery and service stair.[90]

One of the first architectural designs for a formal dining-room is that by Colen Campbell in 1722 for the 2nd Earl of Bute's house in Great Marlborough Street in London (Fig. 52), but this may not have been carried out, because Lord Bute gave up the house the following year. For the piers on the window wall, Campbell proposed tabernacles or pedimented glasses like those in the saloon at Burlington House, and these would have been among the earliest examples, only rivalled by Gibbs's use of them in the Great Room at Fairlawne in Kent (Fig. 73).[91]

That Gibbs was interested in the idea of dining-rooms in the early 1720s can be seen in the plan for Ditchley (Fig. 383), where the saloon was originally intended to be a dining-room measuring 31 feet 6 inches by 23 feet, and in the first plan for Houghton (Fig. 184), which includes the general idea of the Marble Parlour with its two arches and the service door connecting with the north staircase hidden behind the chimney breast, although the fitting-up and decoration of the room is due to Kent in the early 1730s, as explained on page 151.

One of the first illustrations of a screen of columns in a dining-room is Marot's frontispiece to his *Nouveau Livre d'Apartements* of 1703, which shows his surviving dining-room constructed in the early 1690s for William III at Het Loo. A balustrade in the side sections between the columns demarcates the service area from that for eating, while the centre opening gives a clear view of the buffet set against the sculptural decorations as if it was an altar dedicated to Bacchus.[92]

A screen of columns occurs in Vanbrugh's 1705 plan for Blenheim (Fig. 353), in William Adam's early 1720s plan for Hopetoun, as we have seen (Fig. 6), in Campbell's late 1720s remodelling of Compton Place (Fig. 48), in Lord Pembroke's proposal for White

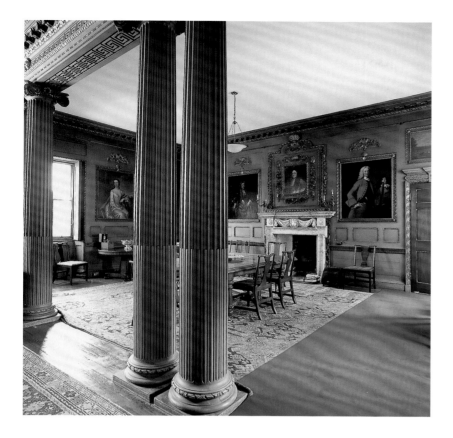

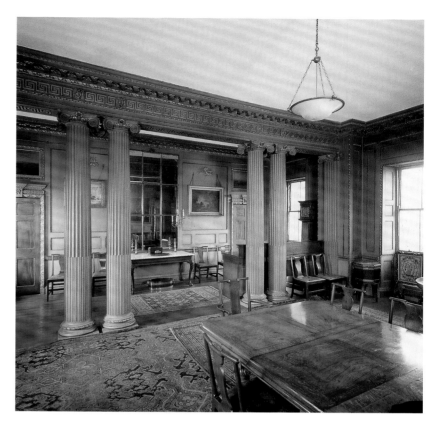

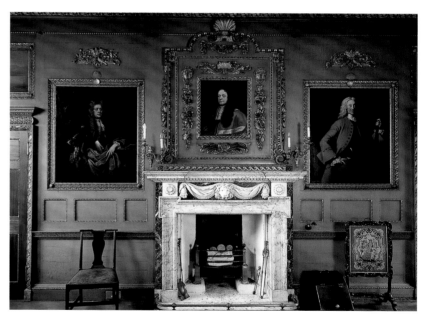

*Newhailes, Midlothian.*
53. *The dining-room was formed as part of the new principal apartment in the late 1730s by Sir James Dalrymple when he enlarged the late seventeenth-century house, it has a screen of Ionic columns marking the junction between the old and new building and also the service area.*

54. *The false 'window' of looking-glass above the serving table in the dining room at Newhailes. To the right is a door into a vestibule at the head of the stairs down to the kitchen.*

55. *The chimneypiece wall. The marble chimneypiece was sent from London by Henry Cheere. Evidently the red clothes in the three portraits were considered in relation to the olive colour of the panelling first painted in 1739.*

Lodge, Richmond in 1727, and in the form of a triumphal arch at Raynham (Fig. 227). There is an elaborate version at The Drum, where the marble architraves to the main doors and the ceiling attributed to Samuel Calderwood are original, with the walls enriched about 1740 by Thomas Clayton. In planning terms, the arrangement is ingenious, because outside the door behind the screen is space for organizing the serving of the food at the head of a secondary staircase leading up from the kitchen on the ground floor.[93]

Certainly by the mid-1720s the screen was a current idea, and it was sometimes combined with the buffet, as at Wricklemarsh (Fig. 29). The section of the house in *Vitruvius Britannicus* IV shows the dining-room with a screen of columns, and behind it a deep arched recess with a blind Venetian window, which may have had a large built-up looking-glass, and a side table on which plate could be set out. Vertue noted a 'plain neat dineing room – really (the cloth laid) – the Covers the beaufat of plate adornd with various vessels of wrought silver between marble Collumns – and all a propper neat and rich. and gave a pleasure to think their was the appearance of plenty and decency'.[94]

Occasionally a dining-room was fitted up with two screens, as at Spencer House, where in 1755 John Vardy proposed them as part of

a complex design with pilasters all round the room (Fig. 239). Later the room was given its present form by Holland. Once more, it has its original gilt side tables with the Spencer wyvern for legs designed by Vardy in 1758 (Fig. 224): although always intended as a pair, there are differences in their details, as if one was made by John Vardy's brother, Thomas, a noted carver, and the other by another craftsman, perhaps after Vardy had lost the commission.[95]

In the 1730s there seems to have been a desire for larger dining-rooms. Thus when Sir James Dalrymple, one of the Scottish landowner–lawyers who sat in the House of Commons, enlarged Newhailes, the late seventeenth-century house that his father had extended, one of his aims was to have a larger dining-room (Fig. 53) as the first room of his new principal apartment. He formed it out of a two-bay room to the west of the new central hall in the old house with an extra bay in his extension, the junction being marked

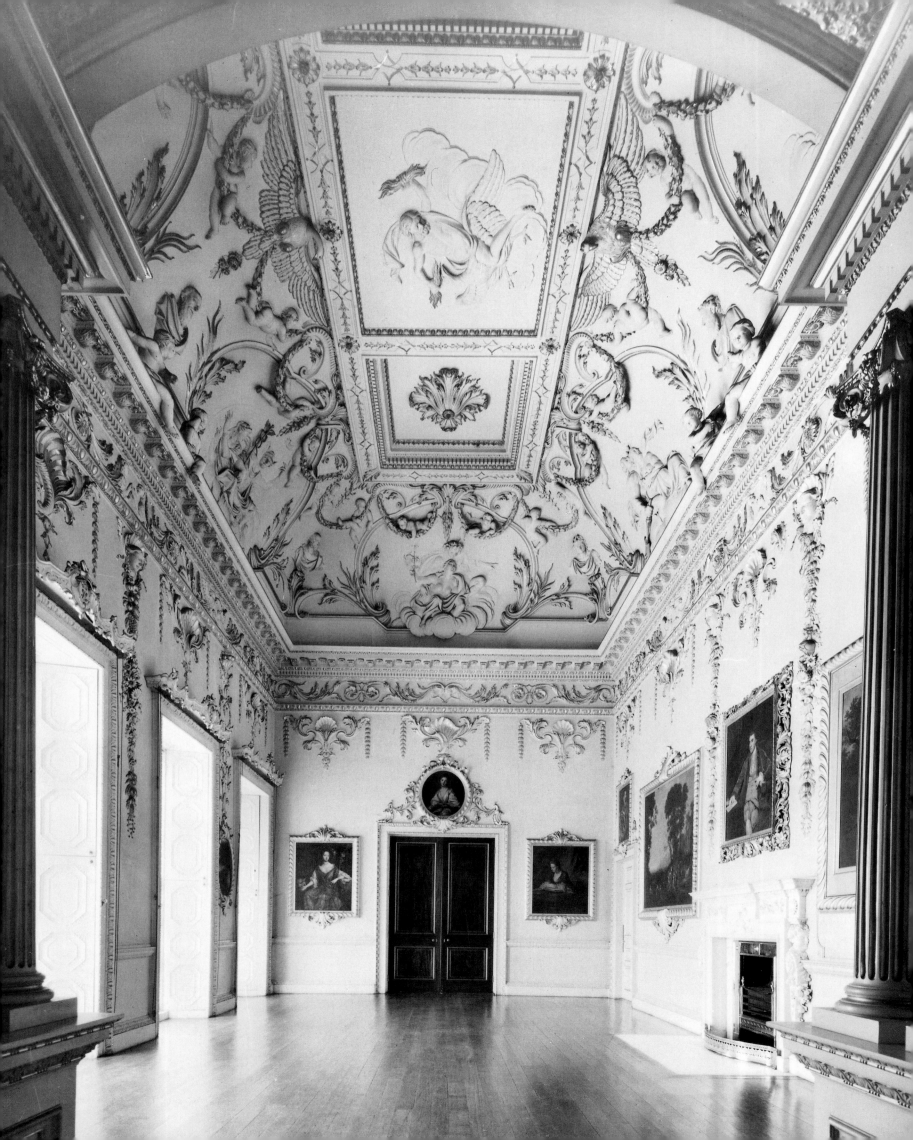

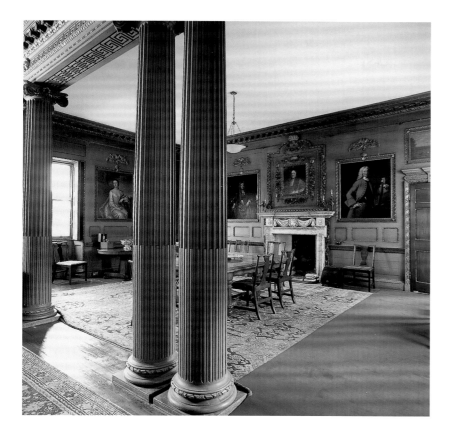

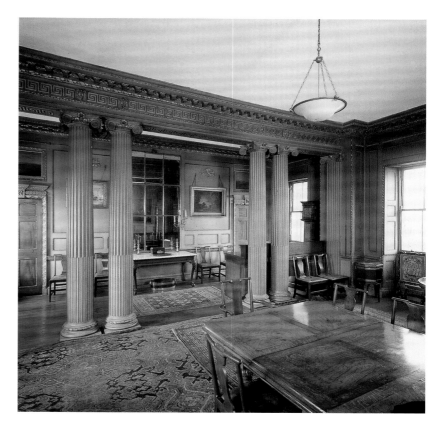

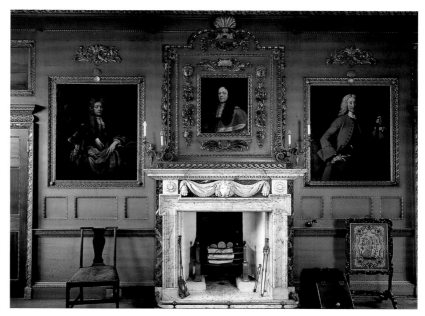

*Newhailes, Midlothian.*

53. *The dining-room was formed as part of the new principal apartment in the late 1730s by Sir James Dalrymple when he enlarged the late seventeenth-century house, it has a screen of Ionic columns marking the junction between the old and new building and also the service area.*

54. *The false 'window' of looking-glass above the serving table in the dining room at Newhailes. To the right is a door into a vestibule at the head of the stairs down to the kitchen.*

55. *The chimneypiece wall. The marble chimneypiece was sent from London by Henry Cheere. Evidently the red clothes in the three portraits were considered in relation to the olive colour of the panelling first painted in 1739.*

Lodge, Richmond in 1727, and in the form of a triumphal arch at Raynham (Fig. 227). There is an elaborate version at The Drum, where the marble architraves to the main doors and the ceiling attributed to Samuel Calderwood are original, with the walls enriched about 1740 by Thomas Clayton. In planning terms, the arrangement is ingenious, because outside the door behind the screen is space for organizing the serving of the food at the head of a secondary staircase leading up from the kitchen on the ground floor.[93]

Certainly by the mid-1720s the screen was a current idea, and it was sometimes combined with the buffet, as at Wricklemarsh (Fig. 29). The section of the house in *Vitruvius Britannicus* IV shows the dining-room with a screen of columns, and behind it a deep arched recess with a blind Venetian window, which may have had a large built-up looking-glass, and a side table on which plate could be set out. Vertue noted a 'plain neat dineing room – really (the cloth laid) – the Covers the beaufait of plate adornd with various vessels of wrought silver between marble Collumns – and all a propper neat and rich. and gave a pleasure to think their was the appearance of plenty and decency'.[94]

Occasionally a dining-room was fitted up with two screens, as at Spencer House, where in 1755 John Vardy proposed them as part of

a complex design with pilasters all round the room (Fig. 239). Later the room was given its present form by Holland. Once more, it has its original gilt side tables with the Spencer wyvern for legs designed by Vardy in 1758 (Fig. 224): although always intended as a pair, there are differences in their details, as if one was made by John Vardy's brother, Thomas, a noted carver, and the other by another craftsman, perhaps after Vardy had lost the commission.[95]

In the 1730s there seems to have been a desire for larger dining-rooms. Thus when Sir James Dalrymple, one of the Scottish landowner–lawyers who sat in the House of Commons, enlarged Newhailes, the late seventeenth-century house that his father had extended, one of his aims was to have a larger dining-room (Fig. 53) as the first room of his new principal apartment. He formed it out of a two-bay room to the west of the new central hall in the old house with an extra bay in his extension, the junction being marked

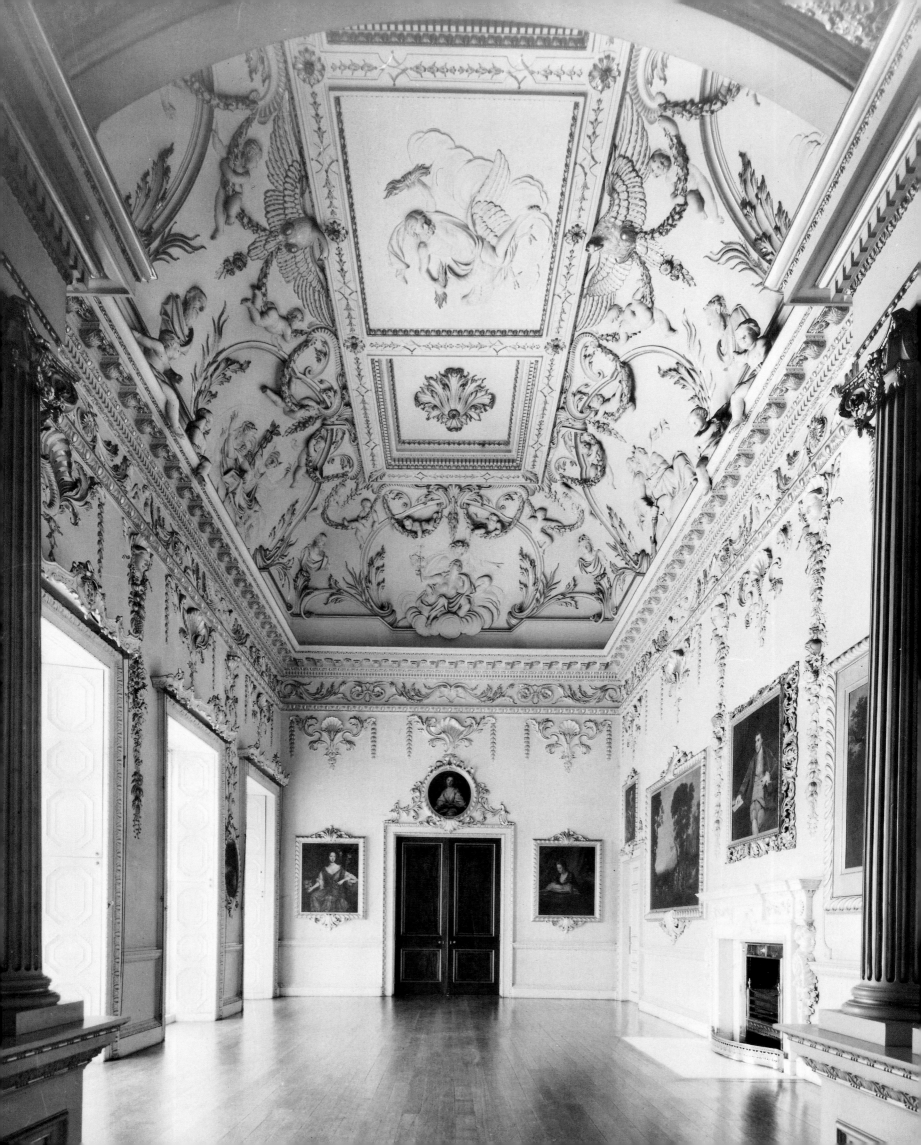

by the screen of paired columns. The screen also defined the service area, with one door to a small vestibule that communicated with a staircase leading down to the kitchen. In the centre of the new west wall he placed a large pier-glass of nine bevelled panes set in a finely made metal frame, evidently a unique way of a creating a *trompe-l'œil* window echoing the real windows while also reflecting any plate set out on the table below it.[96]

The room has always been an olive colour since it was painted by James Norrie in 1739, but there are no payments recorded for architectural gilding, so at least some may have been added in the early nineteenth century, as happened elsewhere in the house. Certainly the room was repainted in its original colour by Moxon in 1872.

Sir James hung the room with portraits of his immediate family. Over the marble chimneypiece, ordered from Henry Cheere in London in 1739–40, he placed a small portrait of his grandfather, the 1st Viscount Stair, by Sir John Medina. To the left is his uncle, the 2nd Viscount and 1st Earl of Stair, also by Medina, which he bought in 1739, and to the right is his first cousin, the 2nd Earl and Field Marshal, painted by Ramsay and paid for in 1745. In these three the notes of red are important in enlivening the decoration of the room, and presumably Ramsay was asked to bear that in mind when he painted the 2nd Earl. The panelling was planned round the half-length portraits in inset Greek key-pattern frames, which are placed fairly high, with three small recessed panels with distinctive beading set between between the portraits and the dado rail.

More memorable dining-rooms of the 1740s and 50s survived into the age of photography than drawing-rooms, perhaps because they depend more on architectural decoration and less on the work of upholsterers. Among them are those at Carton in Co. Kildare (Fig. 56), Kirtlington (Fig. 399), St Giles's House in Dorset (Fig. 57), Felbrigg (Fig. 427) and Nostell Priory, the last two by James Paine (Fig. 58), and finally that at Holkham (Fig. 458).

The grandest surviving room, albeit somewhat altered in its wall treatments, is that at Carton, formed in the late 1730s by Richard Castle for the 19th Earl of Kildare (died 1744), who regarded himself as the first nobleman in Ireland. The successor to the hall of the late seventeenth-century house, it is a double-height room with a deep coved ceiling (Fig. 56) decorated by Paolo and Filippo Lafrancini soon after they moved to Ireland in 1739, with one of the most extravagant displays of Baroque plasterwork in the British Isles, which cost the huge sum of £501.[97]

At St Giles's House, the 4th Earl of Shaftesbury (1710/11–71) carried out a major alteration between 1740 and 1744, with Henry Flitcroft forming a new entrance hall, later the Tapestry Room, a dining-room next to it and, beyond, a music room, later the White Hall. The double-height dining-room (Fig. 57) is one of the finest of its day, and, if it had been placed on axis with the hall, would surely have been thought of as a saloon. As it was, it appears to have always been a dining-room that doubled up as a great room, which may explain the presence of its splendid carved and gilt chandelier that is otherwise surprising to find over a dining table in a mid-eighteenth-

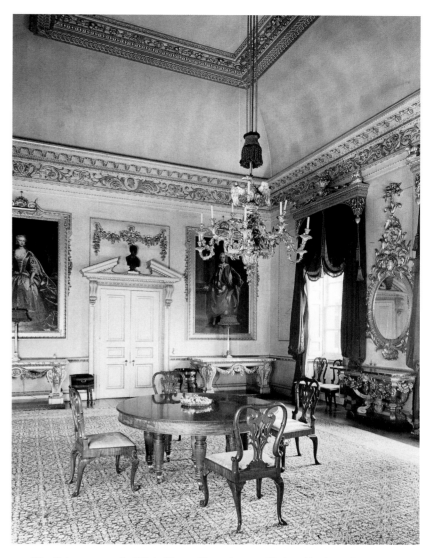

57. *The dining-room at St Giles's House, Dorset in 1943. Designed in the early 1740s by Henry Flitcroft, it is shown here with one of its original pair of gilt pier-glasses and tables and side tables, and the portraits of the 4th Earl and Countess of Shaftesbury painted by Joseph Highmore in 1744 in their related frames. The contemporary gilt wood chandelier appears to be original to the room. The set of chairs is attributed to Hallett (see also Fig. 400).*

century room. The treatment of the room is strongly architectural, with its entablature, deep cove and Jonesian pattern of beams on the bed of the ceiling. Everything fitted in with that: the continued chimneypiece, the tables at the end of the room, the massive pier-tables and splendid oval pier-glasses between the windows, the white and gold frames with scrolled and broken pediments to the set of full-length portraits that include the 4th Earl and his first wife painted by Highmore in 1744, itself evidently a fashionable idea for a dining-room in the 1740s. The room also contained a particularly fine set of carved mahogany chairs attributed to Hallett.[98]

The taste of the early 1750s is particularly well represented by Paine's dining-room at Nostell Priory (Fig. 58). It is about the same size as the Marble Parlour at Houghton – 31 by 24 feet as opposed to 32 by 24 feet – but it has to be imagined without Zucchi's grotesque panels, introduced by Robert Adam. Here, Paine appears an architect in the Palladian tradition but with a strong feeling for Rococo ornament in carved wood and plaster, particularly on the ceiling with its central relief of Ceres. The white marble chimneypiece with its overmantel framing a picture of Roman ruins is balanced by portraits by Henry Pickering of Sir Rowland Winn, the

56. *The former dining-room at Carton, Co. Kildare. The grandest room of its kind in the British Isles when it was formed. The ceiling decorated by Paolo and Filippo Lafrancini at a cost of £501 in 1739. The figurative groups of gods and goddesses in the cove are based on an engraving of Lanfranco's* Council of the Gods *in the gallery of Villa Borghese in Rome.*

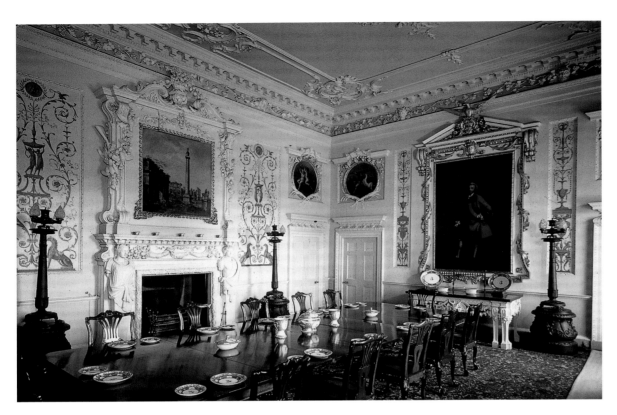

*Nostell Priory, Yorkshire.*

58. *The dining-room designed by James Paine in the early 1750s, with arabesque painting added by Robert Adam. The portraits on the end walls by Henry Pickering of Colonel Edmund Winn, 1746, and Sir Rowland Winn, the builder of the house, 1752, have white and gold frames, the first with the mask of Minerva, goddess of war, and the second, that of Mercury, god of trade and commerce. The colours of the portraits are significant in the overall balance of the room.*

59. *Paine's design for the white-painted side tables beneath the portraits in Fig. 56. They are the most elaborate pieces of furniture known to have been designed by him.*

60. *The marble buffet and cistern in the panelled dining-room at Ledston Hall, Yorkshire, about 1730.*

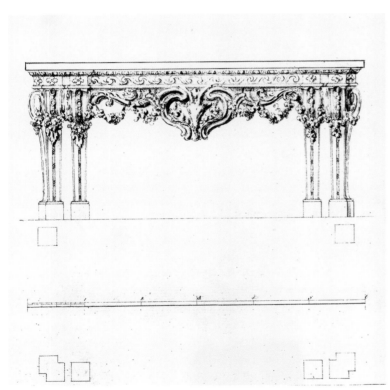

4th Baronet and builder of the house, painted in 1752, facing that of his brother, Colonel Edward, painted six years earlier, which are in splendid carved and parcel-gilt frames. Beneath them are a pair of white-painted rather than gilded side tables, which are the most elaborate pieces of furniture known to have been designed by Paine (Fig. 59). The strict limitation in the amount of gilding reflects the taste of the time, while, as at Newhailes, the colours in the portraits are important in the colour balance of the room.[99]

While the dining-rooms of the 1740s and 50s that have survived are almost all strong, formal architectural interiors, there appears to have been a fashion for less formally decorated eating rooms. At Rokeby in Yorkshire, Cassiobury, Russell Farm and Marble Hill, for instance, they were decorated with prints pasted on paper. The first is the only one of the four to survive as well as being the earliest example of a print room, dating from the mid-1750s with some of the borders being published in 1754.[100]

Today, one of the objections to eating in a hall is the hardness and chill of a marble or stone floor, as at Ham and Belton, but that does not seem to have occurred to early eighteenth-century builders. The memorandum for the building of Antony says 'That the Hall, Dining-room and passage to the stairs be paved with what Stone Sir William pleases'. And the Hunting Room, the everyday dining-room, at Houghton still has a stone floor, but with a carpet on it.[101]

In the first half of the century, large tables like that at Houghton

(Fig. 217) were exceptional, and sometimes people sat at two oval tables. When King Carlos of Spain supped at Petworth in 1703, the table was a very large oval. The King sat in the middle and the Prince of Denmark almost at the end. What is thought of as the characteristic English dining-table, a long rectangle with removable leaves, is a post-1760 development, as is the side table with flanking urns and the sideboard with drawers. At Castletown in 1752, as Mrs Delany recorded, old Mrs Conolly dined at 3 o'clock and 'generally had *two tables* of eight or ten people each; her own table served with *seven* and *seven* and *a dessert*, and two substantial dishes on the side table. As soon as dinner was over, she took the ladies to the drawing-room, and left the gentlemen to finish as they pleased . . . Tea and coffee came exactly at half an hour after five, she then waked.'[102]

The mahogany dining chair, which is often regarded as one of the archetypal pieces of eighteenth-century English furniture, was another significant development. However, the form seems to have become established rather later than might be imagined, with walnut most generally used until the late 1730s. The earliest Hallett bill sent to the 6th Viscount Irwin in 1735 lists chairs of mahogany as well as walnut: twelve mahogany chairs costing 10s. each, which suggests that they did not have stuffed backs and could have been for an eating room, and eighteen walnut chairs with upholstered seats and backs that cost 23s. each. These parlour chairs still survive, but the pair of settees that went with them have disappeared. In a letter of the same year to his nephew, Lord Irwin asked him 'to look at the frames of the chairs for the parlours and dining rooms'.[103]

The earliest surviving mahogany design seems to be that formerly in the dining-room at Ditchley (Fig. 393), furnished by William Bradshaw in the late 1730s. After that comes the set of about 1744–5 formerly at St Giles's House attributed to Hallett (Fig. 57), to whom large payments were made in 1745; the chairs have what appear to be characteristic pierced backs based on complex interlacing patterns. Close to them in date is the set originally at Kirtlington and also evidently by Hallett (Fig. 400).[104]

Gradually during the century, the hour of dinner was set back, with more modest squires' houses, like Dudmaston in Shropshire, still continuing to eat at 1.00 in the middle of the century. According to a copy of a contemporary diary, 'Dinner was ready every day at one o'clock for twenty persons, and when the Bell rang any neighbouring Farmers out working in their fields were welcome to come and any friends of the family who chose to partake of the plain hospitable dinner provided. Those who came in time sat down with the Colonel (Weld) and his sister Lady Woolridge [*sic*], those who were late partook with the servants.' Although called 'Dinner', that sounds more like Commons. The Duke of Portland dined at 2.00 at Bulstrode in 1740. When Mrs Delany stayed at Cornbury, in Oxfordshire, in 1746, she noted: 'We return home at two and spruce out, dinner at half an hour after two.' By the last quarter of the century the hour had gone back to 4.00, as at Euston, Suffolk, in 1784, and even an hour later in the shooting season in the country. In a fashionable London house, dinner was invariably later.[105]

The hour of dinner was significant, because on occasion it influenced the siting and aspect of the room. The Duchess of Marlborough, annotating a plan of Wimbledon House in Surrey, which Lord Pembroke and Roger Morris built for her in 1732–3, wrote on the north-west corner room: 'this room will be very agreable for a constant eating room because the sun never comes upon it at dining time'. While on the great parlour or saloon in the south

front she noted: 'This Room the sun will be upon at the Dining time; and besides it ought to be kept all ways clean and therefore not proper to eat in.' Her reaction was confirmed a generation later, in 1752, when Lord Lyttleton wrote about plans for Hagley: 'I think it is sufficient if the Drawing room windows open to the east prospect as that is the room we shall sit in the most. For the Parlour or Eating Room a north view will be best.' As built, the dining-room faced west, getting the view and the afternoon sun.[106]

The light and time of dinner also influenced the ordering of silver and the laying of the table, because few candlesticks were provided as part of early silver dinner services. They tended to be added when the hour of dinner became later; and also they tended to increase in height.

It cannot be chance that the rise of the dining-room coincided with that of the matched silver dinner service (and also the armorial service of oriental china). However, that is hard to judge today, because not only do so few early services survive, but nowhere in Britain is one set out as it would have been. Either they were sold to pay debts and provide portions for children, or they were turned in when larger services were needed.[107]

The silver dinner service was part of a change in emphasis on plate for use on the table as opposed to display on the sideboard and buffet. An English buffet is hard to visualize today, because so few contemporary drawings survive. In Bodt's design for the interior of Wentworth Castle and in John Talman's design for the hall at All Souls, as well as in his drawing for a display of plate, they appear as vertical constructions.[108]

Probably the best survivor is in the panelled dining-room at Ledston Hall (Fig. 60), which must date from about 1730, when the house belonged to Lady Elizabeth Hastings. A carved wooden architrave frames an arched recess with shelves that is marbled to match the marble cistern.[109]

At Canons, the unusually grand dining-room (as opposed to the eating room to the left of the Great Hall) was divided into three parts: there was a three-bay main section, 45 feet 8 inches long, with a painted ceiling of the *Five Senses*, two chimneypieces and openings at each end, one into a single-bay music room, 12 feet long, and a wider one to a single-bay buffet, 10 feet 6 inches long and again with a painted ceiling. The latter communicated with the pantry and still-room and must have served as a serving room as well. Macky wrote of it: 'the Dining Room, very spacious; a nobler Side Board of Plate than most Sovereign Princes have; and at the End of it, a Room for his Musick, which performs, both Vocal and Instrumental, during the Time, he is at Table; and he spares no expense to have the best'. Yet at the same time the furniture was surprisingly simple, with the eighteen caned chairs being valued at only £1 each and the two wainscot tables at £1 10s. the pair.[110]

At Castle Howard, the 3rd Earl of Carlisle had two sets of plate for display on the sideboards at each end of the room used for dining, one silver and one gilt. The former consisted of a silver cistern and fountain flanked by a pair of ewers and dishes, three pairs of cups with covers and seventeen waiters for the servants. The gilt plate at the other end included a pair of ewers made by Pierre Harache in 1697–8 and valued at 6s. an ounce in 1730 (now at Temple Newsam), a gilt cup and cover made by Harache in 1701 (now part of the civic plate at Carlisle), and also one large round and four square salvers, a large dish, a large ewer, two large chased jars, two bellied chased jars and two pairs of cups. It is hard to say how

usual such an arrangement was in a nobleman's house at that date and how firm the convention of separating silver and silver gilt. But by the middle of the century such a display must have been out of fashion, because the cistern and fountain were melted down in 1749 and 1750.[111]

The buffet also seems to have been used for the serving of wine, because the Baron de Pollnitz described how, when the ladies retired after dinner, the men remained at the table; 'upon which, the Cloth being taken off, the Footmen place a Bottle of wine, or more, if all the Guests don't drink the same Sort, with Glasses well rinsed, and then they withdraw, only one waits at the Beaufet. The Bottle now goes round; every one fills his glass as he pleases, and drinks as much, or as little as he will, but they always drink too much, because they sit too long at it.'[112]

Possibly there should be some distinction between buffets in great parlours and those those in common parlours, where there was probably little or no plate, like that described by Celia Fiennes in 1702 in Mr Routh's house at Epsom, which appears on the plan in *Vitruvius Britannicus II*: 'on the left (of the entrance) to a little parlour wanscoted, white in veines and gold mouldings, a neat booffett furnish'd with glasses and china for the table, a cistern below into which the water turn'd from a cock, and a hole at bottom to let it out at pleasure'.[113]

Quite modest houses had cisterns – Canons Ashby had a pair of marble cisterns listed in the Great Parlour in the 1717 inventory – and how they were used can be gathered from *The Household Book of Lady Grisell Baillie*, with its instructions for servants written down by her mother in 1743. No. 8 for the Butler was: 'Stand at the Sideboard and fill what is cald for to the other servants that come for it, and never fill, nor let any other do it in a duty glass, but as soon as a glass is drunk out of, rinse it directly in the brass pail which you must have there with water for that purpos, then wype it.'[114]

In Scottish houses a number of dining-rooms retain buffet niches. At Pollok House, near Glasgow, where building was begun in 1747, there was a balancing dining-room and drawing-room either side of a small garden hall, and the dining-room has a handsome niche. At Glendoick, a small but well-fitted house in Perthshire built about 1746–50 by Roger Craigie, Lord Glendoick, there is a particularly elaborate buffet niche set into an Ionic frame with two pairs of pilasters, the inner pair being crowned with a broken swannecked pediment. Originally the niche was fitted with shelves and sliding doors.[115]

Indeed, the concept seems to have lasted longer in Scotland, where even in the late 1740s one was planned in the new Great Dining-Room at Blair Castle; and the niche survives although the room was completed as the drawing-room, with the dining-room on the floor below.[116]

The Blair example might have been a revival as opposed to a survival, because the buffet niche returned to fashion again in certain English houses in the mid-1750s, when old silver was displayed as a mark of ancient lineage. The apse in the dining-room at Holkham (Fig. 458) must have been always planned for the display of plate, but by the time the room was nearly finished in 1755 that idea must have returned to fashion.

It may have been the Holkham apse that gave Sir Nathaniel Curzon the idea for a buffet of old and new plate in his new dining-room at Kedleston, which he first discussed with James Stuart about 1757–8. The latter, in his design for a state room, proposed a cistern

under a side table, which looks very like the one of Sicilian jasper supplied by Richard Hayward in 1758. Presumably Sir Nathaniel inherited the pair of wine fountains and cisterns, which Ralph Leeke had developed from an earlier French fountain in 1698, and then he had them slightly altered again to make them relate better to his new dinner service bought from Phillips Garden in 1758–9. When Robert Adam took over the designing of the house about 1760, Sir Nathaniel asked him to combine all these elements together with an incense burner designed by Stuart in an advanced Neo-Classical style. Recently the arrangement shown in Adam's drawing of 1762 has been recreated by the National Trust, partly using copies of elements no longer in the house.[117]

An impressive display of plate was required for the public day, an event about which so far little evidence has come to light, but which almost certainly influenced the size and treatment of dining-rooms in the houses of the greater aristocracy (earls and above). Their purpose was to maintain local goodwill and political support, and so neighbouring gentry and some clergy were welcome to dine without invitation on set days when the family were in residence.

The earliest known reference to this practice is in 1690–1, when the 2nd Earl of Warrington of Dunham Massey wrote to his brother, Henry Booth, in January 1714–15: 'I have seen my father several times the year before the Revolution fall aweeping at the greatness of his debts . . . and they were increased at the Revolution. When my mother dyed [1690–1] my father took that opportunity to leave off keeping a publicke day in the house, and dined on the Bowling Day at the Ale House in Dunham Town to save charges.'[118]

The next mention of one is in 1710 at Deene Park, Northamptonshire, the seat of the 3rd Earl of Cardigan: Sir Justinian Isham, who rode the twenty-two miles from Lamport Hall, recorded in his journal: 'We set out for Lord Cardigan, whose day it was.'[119]

Mrs Delany commented on public days when she stayed with the Duchess of Portland at Welbeck Abbey, Nottinghamshire, in 1756 after the death of Lady Oxford, the Duchess's mother: 'The Duke, Duchess, and the young ladies dined at Lord Scarborough's; it was their public day'. In the same letter she mentioned going to dine with a Miss Sutton and 'the Duchess has desired her to come on a private day.' A couple of weeks later, at Welbeck, she wrote: 'On Thursday (the public day) we had no company but men; the constant service is 12, 16, and 20, the dessert; the side table 7 and nine. On Friday ye duke of Devonshire and Lord George Cavendish dined here, and then the same number of dishes as on the public day.'[120]

When Horace Walpole went to stay at Chatsworth at the end of August 1760, he wrote to Lady Ailesbury that we 'make our entry to the Public Dinner, to the disagreableness of which I fear even Lady Mary (Coke's) company will not reconcile me'. The 4th Duke of Devonshire held public days twice a week when he was there in the summer. At the time of the Duke's death in 1764, the dining-room, the present private dining-room on the first floor, had a large set of twenty-four chairs; and when the room was redone by the 5th Duke, a new set of thirty-six chairs was acquired. In 1783 the Duchess wrote to her mother, Lady Spencer, that they had sat down thirty-nine on their first public day. The following year, Dr Johnson attended one when he was staying at Ashbourne with Dr Taylor, who had been the 4th Duke's chaplain, and there he met Edmund Burke. At Alnwick Castle in Northumberland in the 1760s, the Duke and Duchess of Northumberland had public days twice a

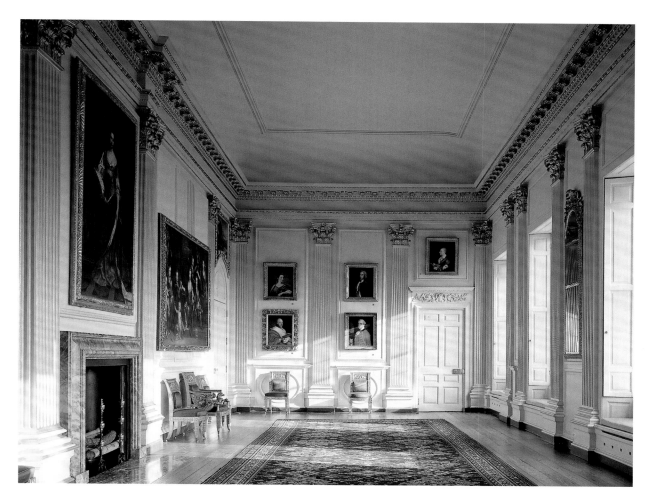

*61. The saloon at Beningbrough, probably originally intended as a Great Dining-Room, about 1715. It has an unusually complex panelling scheme as well as a complete, if eccentrically placed, order of pilasters that argue against a full complement of pictures, pier-glasses and side tables.*

week during the six weeks they spent there from the end of July. In 1768 the Duchess noted that on the first six days there were twenty-five, fifteen, nine, twenty-one, twenty-three and sixteen people.[121]

While plate was generally ordered for use in London, it was taken to the country for these days. Thus the weight of the Duke of Northumberland's plate in its chests accounted for half the total of all the baggage taken the three hundred miles from London to Alnwick, in Northumberland, and then back again.[122]

*The puzzle of great dining-rooms*

The great dining-room as distinct from the dining-room or great parlour is one of the most puzzling rooms in a late seventeenth- or early eighteenth-century English country house. It was invariably on the first floor and as far as possible from the kitchen; and there are no descriptions of one in use. It was the descendant of the Elizabethan and Jacobean great chamber and probably the earliest grand example, although never so called, is the Double Cube Room at Wilton, which Evelyn called the 'Dineinge room' in 1654; though it only achieved its present form in the time of the 8th Earl of Pembroke, who inherited in 1683 and died in 1733. It was he who brought from Durham House in London the set of Van Dyck portraits and adjusted the panelling to take them, and, although the precise date is not known, it cannot have been long before the room was illustrated in *Vitruvius Britannicus* II (1717), the first interior to be included in the publication. Writing in 1724, Macky called it 'the richest Room in *England*, and perhaps Europe'.[123]

At Drayton, when Lord Peterborough refitted the old Great Chamber early in the Restoration period, he called it the King's Dining-Room and hung it with a series of full-length family por-

traits, some of which he had made up. At Chatsworth, the first of the state rooms on the second floor is in the same position as the earlier Great Chamber and it was so called in the accounts and the plan in *Vitruvius Britannicus* I, only later being called the State Dining-Room, but never used as such. At Doddington Hall, Lincolnshire, the big room on the first floor over the hall must have been the Great Chamber and in the 1753 and 1760 inventories it was still called the Long Dining-Room, soon after that being redecorated as a drawing-room and hung with flock paper. There was also a Great Dining-Room at Ham House, where it dated from the 1630s. It survived throughout the Lauderdale period but then was swept away some time between 1698 and 1728, when the centre of its floor was cut away to create a double-height hall.[124]

At Kiveton, a new house begun in 1697, the Great Dining-Room was on the upper floor and was evidently an ante-room to the Great Drawing-Room and Bedroom. Four bays long, it was hung with tapestry of *Horses*, which had plenty of gold and silver thread, and it had eleven inlaid walnut 'banquits' covered with crimson velvet (presumably stools) with two easy chairs to match, mantua silk curtains, and five marble statues on pedestals.[125]

That suggests that the large room on the first floor at Beningbrough, now called the Saloon, was intended as a great dining-room (Fig. 61). The panelling scheme with its order of pilasters is unusually complex, in the tradition of Talman's rooms at Chatsworth, and appears to be complete in itself and not intended to take many pictures. On the end walls there are two complete pilasters and two half-pilasters in the corners. On the long wall facing the windows the chimneypiece is emphasized by a pair of pilasters standing forward; and behind them are half-pilasters that answer the pairs of complete pilasters flanking the doors, which have arched heads with

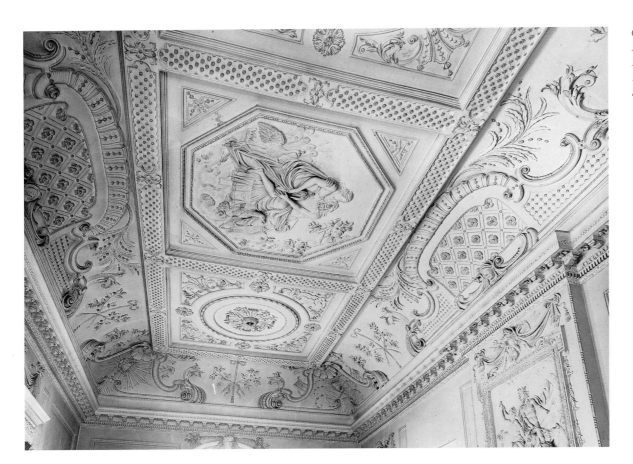

62. *The ceiling in the former Great Dining-Room on the first floor at The Drum. It was evidently completed about 1740 when Thomas Clayton carried out the plasterwork.*

shaped overdoor paintings, as at Castle Howard, with half-pilasters in the corners of the rooms. On the window wall, the piers between the windows are not all the same width, so that while each window is flanked by pilasters, only the central pair of piers is wide enough to take glasses. There are places for large pictures over the chimney-piece and on the second and fifth panels on the flanking wall: the first and third, and fourth and sixth panels are more boldly treated, as if they were not intended to be hidden.[126]

In a number of new houses built in the second and third decades of the eighteenth century, a great dining-room on the first floor continued to be an important part of the plan, as can be seen at Chicheley and Clandon, which was planned before 1724. The use of the last for a banquet given to Frederick, Prince of Wales in 1729 seems to be the only known reference to one. It is placed above the saloon in the east front; and to the south lies the Prince Regent's Room, the original principal bedroom. Its decoration never seems to have been finished, because it lacks any plasterwork by the Italians active below, and it was apparently hung with a crimson flock wallpaper of the same pattern as that partly surviving in the adjoining bedroom (Fig. 121).[127]

In Scotland, the great dining-room seems to have had a separate history, possibly growing out of direct French influence in the sixteenth and seventeenth centuries, with the low halls and high halls found above each other being derived from the *salle basse* and *haute salle*, rather than from the English great hall and great chamber. Thus Melville House, Fife, which grows out of the vertical Franco-Scottish tradition, has a Great Apartment, with a Great Dining-Room on the upper floor. At Dalkeith, the Great Dining-Room was above the hall, on the floor above the principal apartment: later, it became the gallery. That idea was still followed in a smaller house of the 1720s like The Drum, where there was also a dining-room on the

main floor. There, the oval staircase leads up to a Great Apartment (Fig. 39), with what must have been originally intended as a great dining-room leading to a drawing-room and bedroom. The decoration of the first room, including the reliefs in the overmantel and in the centre of the ceiling, appears to have been added by Thomas Clayton about 1740 (Fig. 62), making it one of the finest rooms of its date in Scotland.[128]

On the other hand, a great dining-room might also be found on the principal floor, as at The House of Dun in Angus, where it was the main room of the house (Fig. 71).[129]

Possibly the last great dining-room was that planned at Blair Castle when it was restored after its sack in 1745. The original idea seems to have been to devote the top floor to it, hence the buffet niche in what was completed as the Great Drawing-Room in the late 1750s. Then it was decided to form a dining-room on the floor below, with elaborate stucco decoration. The change of mind represents the passing of the old idea and the increasing importance attached to the drawing-room.[130]

### THE ELABORATION OF DRAWING-ROOMS

Fewer drawing-rooms than dining-rooms have survived intact from this period, because their decoration was more dependent on hangings and upholstery and an appropriate display of pictures other than portraits. It is also worth considering whether, as they became larger, they became more formal as sets of seat furniture increased in extent and were less used except for the display of elevating subject pictures. This could also have been influenced by the library developing as the room in which men and women sat together in relative comfort and informality.

Drawing-rooms always had a different character from parlours

and great parlours in being hung either with tapestry or material as a background to pictures; and they were invariably more richly furnished, with finer frames for the seat furniture and more expensive upholstery, even if they continued the colours of the flanking rooms, or had highly valued needlework covers (Fig. 382). But they hardly ever had an order of pilasters, as is occasionally found in a hall, great parlour or great dining-room: rooms with an order now called drawing-rooms started out with a different purpose.[131]

In late seventeenth- and early eighteenth-century plans, drawing-rooms had two principal relationships, one to parlours and the other to bedrooms. As far as the first is concerned, often a common parlour had a drawing-room and so did a great parlour, both drawing-rooms being smaller in size. Ladies withdrew to these rooms before the gentlemen after dinner for tea and coffee. That is well demonstrated in the plan of Belton (Fig. 44), where the present Red Drawing-Room was originally used with the Common Parlour and the present Tyrconnel Room with the Great Parlour.

In grand houses with a number of principal bedroom apartments, like Wanstead and Ditchley, each apartment required a drawing-room. That meant that they ended up with an excessive number of rooms that not only absorbed space and needed expensive fitting-up but were little used and did not leave enough space for a spacious dining-room and library that were becoming essential requirements. Moreover, by the third quarter of the century people seem to have disliked walking through rooms arranged in apartments in the course of daily life (as opposed to viewing houses) and preferred to have fewer and larger adjoining rooms.[132]

In the first quarter of the century, few drawing-rooms were large, and some now seem inconveniently small, but gradually, as they were reduced in number, they were made larger so as to be in proportion to dining-rooms; and by the early 1740s they matched them in size. At Castle Howard, one of Vanbrugh's early plans shows the two ante-rooms flanking the saloon being 22 feet long by 21 feet deep with two windows, and the west drawing-room beyond being only 21 by 20 feet and also of two bays. Then he proposed enlarging them, and the next plan shows the flanking rooms 27 by 22 feet, and the west drawing-room 27 by 21 feet. At Houghton, the Green Velvet Drawing-Room and the other three balancing rooms, including the Marble Parlour, are all a generous 31 by 21 feet (Fig. 188), with chimneypieces on the long walls. At Ditchley, on the other hand, Gibbs's plan shows the two drawing-rooms to the left of the hall and saloon measuring only 23 by 20 feet (Fig. 383), with chimneypieces and doors on the short end walls, which must have made sets of furniture with settees difficult to arrange. In Sanderson's plan for Kirtlington of the early 1740s (Fig. 395), both the Great Drawing-Room and dining-room were to be unusually large, 36 by 24 feet and with three windows; and the deep coved ceilings make them seem even larger.

The increase in size must have been partly influenced by the fashion for pairs of matching gilt pier-glasses and tables with marble tops, which developed in the course of the 1720s: they created a sense of greater light by day and a more glittering effect by night. Three bays also made a room seem broader, because a chimneypiece against a chimney breast did not line up with a pier-table, so creating a narrow waist in a room. Later, in the late 1740s and early 50s, greater length was needed for upholstered seating, particularly pairs of long settees flanking a chimneypiece. The larger and more comfortable settee with a serpentine line to the top of the back and float-tufted stuffing seems to have been introduced in the late 1740s and developed in the 1750s (Fig. 412).

The idea of balancing drawing-rooms and dining-rooms was soon taken up in plans for new Scottish houses like Archerfield and Dumfries House, Ayrshire, and in the way that Blair Castle was finally completed with the Great Drawing-Room with four windows over the Great Dining-Room (Fig. 253).[133]

The restriction of early drawing-rooms can be seen in the way life in certain houses has evolved, with changes of name not necessarily leading to changes in the style of fitting-up. At Antony, the tapestry-hung drawing-room is not only small but has the Gibbsian marble chimneypiece and a doorcase on the side wall; it must have soon proved inconveniently small, and life moved next door, to the saloon. Similarly at Chicheley, the partially hung Lady's Drawing-Room (Fig. 378), which was also fitted up by Thomas Eborall in 1725, is so small that it has become a less formal sitting-room, while the panelled Great Parlour (Fig. 379) has become the drawing-room of the house.[134]

Yet the panelling includes elaborate veneering in elm grained to simulate walnut, limewood carving and a grained and parcel-gilt cornice, so that there was a close relationship between this room and the set of walnut and parcel-gilt seat furniture with needlework covers originally in the room. I have come across no other example of a similar connection between panelling and seat furniture at that date, but it raises the possibility that there was a similar relationship in the drawing-room at Mawley Hall, Shropshire.

Mansley Hall has the most elaborately fitted up drawing-room dating from the second quarter of the eighteenth century. It probably dates from the 1730s and owes its exceptional character to its owner, Sir Edward Blount, who appears to have had Francis Smith as his builder and provider of most of the craftsmen. To the left of the hall are two rooms both now called drawing-room, but the larger one on the corner of the house, which is fully panelled and has an Ionic order of half-columns and pilasters, was probably originally the great parlour: the smaller room between it and the former principal bedroom on the other corner would have been the original drawing-room. The difference in mood between them is expressed not only in their architectural treatment but in the different languages of their two chimneypieces. There is a rather high one mostly in *porto venere* marble but with a carved white marble frieze and heads to the terms in the first room, and a much lower one using more white marble in the second. In the drawing-room, where there is no order, there is an exceptional veneered walnut wainscot designed to frame panels of material and incorporating the monograms and arms of Sir Edward and his wife, Apollonia Throckmorton. Its principal doorcase, taken from a Rossi print like those at Badminton, has inlay in brass and ivory, which recalls the work of the Channon circle and in particular the Powderham bookcases; and above the door there is a panel of marquetry repeating the design used in the saloon at Davenport. The room has an exceptional parquetry floor.[135]

One of the few rooms to have retained its hangings and chairs is the circular drawing-room (Fig. 63) adjoining the gallery on the first floor at Longford Castle, which has probably survived because it was difficult to reach and must have been rarely used for its intended purpose, always being a picture room. It is hung with a splendidly bold cut velvet, which cost 24s. a yard in 1743; and with it are a set of massive armchairs with carved and parcel-gilt mahogany frames

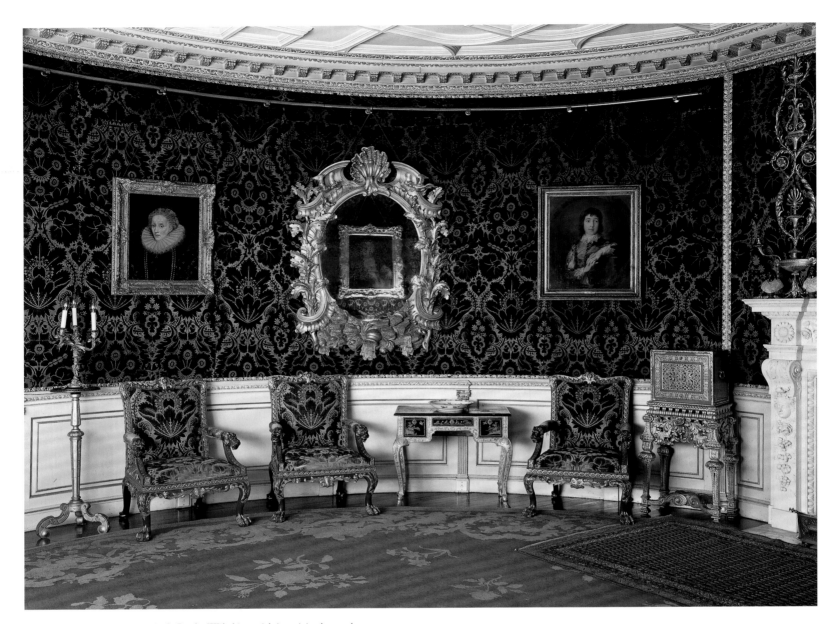

63. *The drawing-room at Longford Castle, Wiltshire, with its original cut velvet hangings and carved and parcel-gilt mahogany chairs attributed to Giles Grendey. The cut velvet was bought at a cost of £1 4s. a yard in 1743.*

(but no settees, presumably because they could not be made to fit the curved walls) attributed to Giles Grendey and covered in the same velvet. Both the colour of the velvet and the parcel-gilt mahogany continue themes in the gallery. Conceivably parcel gilding was decided on as being one down from gilding, just as green was one down from crimson in the hierachy of colours, and both reflected Lord Folkestone's response to the old house and to the proportions of its rooms.[136]

Since a drawing-room was used for tea and coffee after dinner, perhaps the use of silver should be borne in mind. That could explain the fashion for silver gesso furniture in certain drawing-rooms. Today, only at Erddig do the settee and side chairs, pier-table and pier-glass all survive (Fig. 366), but in conversation pieces there are a surprising number of silver tables. One of elegantly simple form dating from the third decade of the eighteenth century, bearing the arms of the 2nd Earl of Oxford with the Harley supporters and seventy-two quarterings, was in the collection of the Duke of Portland. But, apart from the silver table-top at Chatsworth engraved for the 2nd Duke of Devonshire by Blaise Gentot in Paris about 1710, the only ones apparently recorded in inventories were at

Canons, where two were listed among the tea plate in the drawing-room as silver tables upon silvered frames and valued at only £33, which suggests very little silver. Could they have been silver trays on wooden frames, as survive at Dunham Massey, or silver trays on silver gesso stands?[137]

The connection between tea, silver and silver gesso also appeared in the Greenwich house of John Crowley, a prosperous London merchant and alderman with rich tastes evidently not unlike those of John Mellor of Erddig. The inventory of about 1728–31 lists in the drawing-room two pairs of India blue damask curtains and damask hangings, six (carved?) and silvered backstool chairs covered with silver and gold brocade, a settee and two stools, a Persian carpet, a carved and silvered frame for a tea table, a table for a tea kettle, a small ebony cabinet inlaid with silver on a black claw, a pier-glass in a carved and silvered frame with snake branches and a chimney glass.[138]

The reference to the silvered frame for a tea table brings to mind a table formerly in the possession of the late Ronald Lee that consisted of a contemporary silver gesso frame with a silvered brass tray. He also owned a silvered brass kettle stand, which, because of

64. *The White and Gold Room at Petworth House, Sussex. It was designed by Matthew Brettingham about 1754–5, shortly after he had obtained a book of French ornaments, as the principal drawing-room of the house and preceding the room with the bed of Fig. 114.*

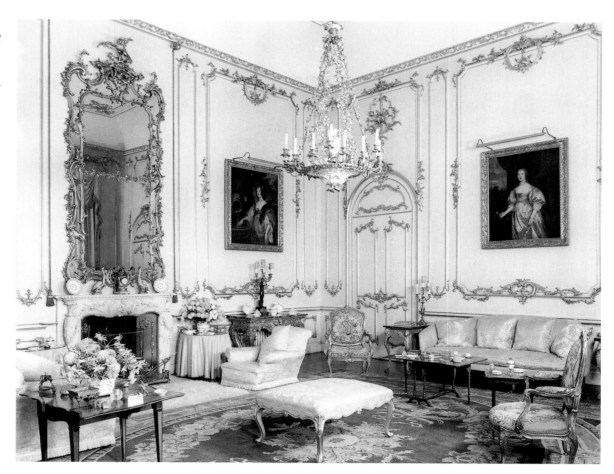

its weight, would be a great deal more stable than a much more expensive and rarer silver kettle on stand.

What is surprising about drawing-rooms of the 1720s and 30s is that they were planned to seat so few people. At Houghton (see pp. 150–69), for instance, where there were between thirteen and seventeen chairs in each of the three parlours on the ground floor, twenty-two in the Coffee Room, and twenty-four in the Common Parlour on the main floor, the saloon and the two flanking drawing-rooms each had a pair of settees and twelve armchairs, with four stools in the saloon and Velvet Drawing-Room and no side chairs. Apart from the seat furniture in the latter – and twenty-seven pictures – there was the pier-glass and table, a 'brass chandelier', and four large silver sconces with two branches each, but no tea table or pedestals. Guests can only have walked through the room to admire the pictures and the ensemble: certainly they were not expected to sit on the impressionable green silk velvet covers of the chairs.

Round about 1740, it became fashionable for drawing-rooms to acquire a certain French character. That idea is familiar from the rooms of the 1760s and early 1770s hung with Gobelin tapestries and related seat covers, as formerly existed at Croome Court, Worcestershire (now in the Metropolitan Museum) and still survive at Newby Hall, Yorkshire and at Osterley, Croome room being inspired by the Tapestry Drawing-Room at Hagley (Fig. 412) fitted up in the late 1750s on Croome Court. However, the first documented example appears to be at Ditchley, where about 1740 a set of English carved walnut chairs in the French taste with related tapestry covers were supplied for the drawing-room (Fig. 393).[139]

Another early example appears to have been at Wolterton, where Lord Walpole, remembering his time as ambassador in Paris, seems to have given both his saloon and drawing-room a French character through his use of tapestry hangings and tapestry or needlework

covers on French-style chairs. According to the 1859 sale catalogue, the Saloon was hung with three tapestries depicting the Battle of Solebay with the Walpole crest (now at Hampton Court Palace) and a set of carved walnut chairs, conceivably English like the set at Ditchley, with *Aesop's Fables* covers, which are mentioned in the house in 1764; and in the overmantel was a portrait of Louis XIV. In the drawing-room there appears to have been the (still present) set of Teniers tapestries with French-style borders, which may have been a gift from Cardinal Fleury.[140]

The most ambitious example of an English drawing-room of the 1750s panelled in a French style is the White and Gold Room at Petworth (Fig. 64), which was seemingly, if surprisingly, designed by Matthew Brettingham about 1754–5. It was planned as the drawing-room of the principal apartment on the ground floor and was the room preceding the King of Spain's Bedroom with its remarkable Rococo bed attributed to Samuel Norman and James Whittle, which they may have supplied in 1756 (Fig. 114). Whereas at Norfolk House the introduction of the French note into the Music Room was a revision by Borra of Brettingham's original scheme, here he seems to have been the designer, and it may be relevant that in 1755 Lord Leicester wrote to him: 'I am glad you have purchased so good a book of French ornaments & I am impatient to see it let it come by the next carrier.' It seems that the decoration of the room has been simplified, which would explain its sparseness, but the surviving ornaments have the lack of conviction and timidity that comes from an English carver copying unfamiliar prints. Perhaps the room was originally furnished with chairs in the French taste by Paul Saunders, who supplied sets in two sizes that remain in part at Petworth.[141]

There is no evidence that the Petworth chairs had tapestry covers, but that was the most usual way of giving a room a French character. Thus in 1745 Sir Edward Gascoigne tried to persuade the

65. *An early twentieth-century photograph of three chairs with mid-eighteenth-century English parcel gilt carved mahogany frames in the French taste made to take French tapestry covers. They are thought to have come from Grimsthorpe Castle, Lincolnshire. A pair of the chairs are now in the Metropolitan Museum but without gilding or tapestry.*

66. *Ham House, Surrey. One of the oval pier-glasses and tables in the drawing-room supplied by Bradshaw and designed to live with the panels of partly rearranged seventeenth-century gilt carving above them.*

67. *One of the monkey doors in the original Great Drawing-Room at Norfolk House, St James's Square, London, designed by Borra and carved by Cuenot, early 1750s. The monkey motifs relate to the tapestries originally in the room (Fig. 69). One of the doorcases is now in the Victoria and Albert Museum.*

7th Viscount Irwin to have French tapestry covers for his new gallery at Temple Newsam. He wrote from Cambrai: 'I think ye Tapestry-work Chairs here do look very well, & even not unworthy a place in ye handsommest Apartment in England, such as I think yt you are furnishing.'[142]

How unusual it would have been to order French tapestry covers and put them on English frames in the 1740s and 50s is hard to say. Certainly documented examples are rare, but there are pointers to the practice, albeit ones with complicated histories. One involves a set of fine English carved mahogany chairs in the French taste in the Metropolitan Museum: they appear to have come from Grimsthorpe, so are associated with the 3rd Duke of Ancaster, and an old photograph shows them with parcel-gilt frames and French tapestry covers that would have made them much more suitable as drawing-room chairs (Fig. 65) than their present ungilded state and damask covers.[143]

That tapestry or needlework was fashionable for chairs in the French taste in the 1750s is confirmed not only by one of Chippendale's designs for them (plate 20: 'Both the Backs and Seats must be covered with tapestry, other Sort of Needlework') but by the set of gilt chairs with tapestry covers signed by Danthon illustrating *Aesop's Fables* now in the saloon at Uppark.[144]

The earliest surviving example of hanging English tapestry in a French style in a drawing-room is at Ham House, where the 4th Lord Dysart formed a new drawing-room on the first floor in 1744

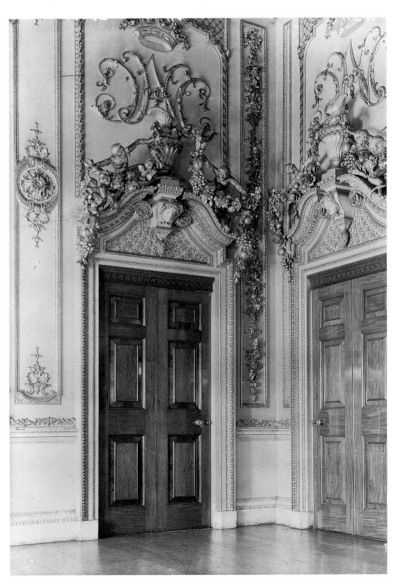

68. *Ham House, Surrey. The 4th Lord Dysart's new drawing room formed in 1744 was hung with a set of tapestries in the French taste based on prints after Watteau, Lancret and Pater woven by Bradshaw. The simple chairs acquired about 1730 are upholstered in their origi-nal cut velvet.*

69. *One of a set of* Nouvelles Indes *tapestries woven by Neilson after designs by Desportes originally ordered for the Great Drawing Room at Norfolk House. One panel is dated 1754.* Arundel Castle, Sussex.

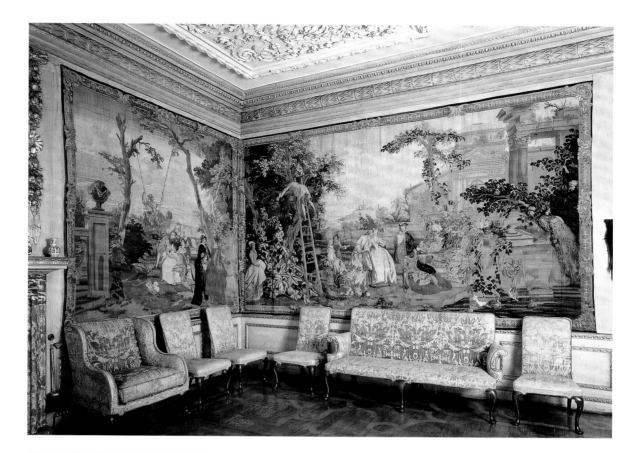

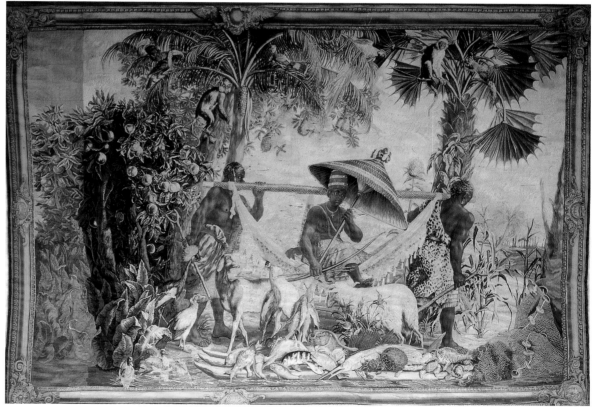

and hung it with a set of tapestries based on prints after Watteau, Lancret and Pater, woven by Bradshaw (Fig. 68).[145]

A decade later, new French tapestries were ordered for the Great Drawing-Room at Norfolk House, St James's Square. When the 9th Duke of Norfolk and his Duchess, who was evidently interested in the French style, as can be gathered from her fourteen prints after Meissonier published in 1749, fitted out their new house in the early 1750s, they decided to hang that room with a set of *Nouvelles Indes*

tapestries woven by Neilson after designs by Desportes (Fig. 69). Two of the panels are dated 1754. It was the presence of monkeys in the tapestries that must have suggested the figures of monkeys carved by Cuenot to perch on the doorcases designed by Borra (Fig. 67). With the tapestries went a set of eighteen elbow chairs and as many as five settees with carved and gilt (as opposed to parcel-gilt) frames upholstered in crimson velvet to underline the grandeur of the room. There were curtains to match and two glass lustres, both

of twenty-four lights. Sadly, the room only lasted a few years, because when Worksop in Nottinghamshire was rebuilt for a second time after a fire, the tapestries were adapted for use there.[146]

When Lord Dumfries was furnishing Dumfries House, Ayrshire, in the late 1750s, he wrote to Lord Loudon: 'The Drawing room in the new House is to be furnished with tapestrie Hangings which are here. I shall want eighteen Elbow chairs, tapestrie backs and bottoms and two setees to hold three people each, by the two sides of the fire.' The hangings seem to have been a set of four large Gobelin panels; and in the end, in 1759, he ordered fourteen mahogany armchairs and a pair of settees covered in blue damask and a pair of card tables from Chippendale.[147]

The taste for French chairs came in rapidly, as can be seen at Castle Howard, where the 4th Earl of Carlisle not only increased the amount of tapestry in the principal rooms but introduced new chairs in that taste. Thus he ordered mahogany chairs covered in crimson flowered velvet to go with the French Royal tapestries of about 1700 that he bought for the Tapestry Drawing-Room, and mahogany chairs upholstered in crimson flowered damask to match the bed in the principal bedroom.[148]

While a complete drawing-room in the French taste, with tapestry hangings and gilded chairs with covers of tapestry or needlework, was always exceptional, a modified English version soon developed. That combined a French note to the shape of the chairs with the taste for mahogany, which lent itself to carving. That can be seen in the mahogany suite at Nunwick in Northumberland, which was supplied by William Gomm. That consists of a long settee, six side chairs and four square stools, together with a pair of card tables, two pole screens and two torchères, the seat furniture being made to take the needlework covers worked by Lady Allgood. Gomm was clearly a more significant cabinet-maker than can be judged from the present handful of references to him that include supplying furniture to Richard Hoare at Barn Elms in the early 1730s, to Stoneleigh in 1763–4 and his book of designs at Winterthur.[149]

Few such complex suites survive, and that gives special importance to the carved and gilt set in the gallery at Temple Newsam (Fig. 322) made in the mid-1740s by James Pascall, a little-known carver, gilder and picture-frame-maker rather than a cabinet-maker, whose complete account was settled in 1746. As will be shown later, it consisted of twenty chairs, four settees and a day bed, all covered in needlework, as well as pairs of console and side tables, eight torchères and the flamboyant pair of girandoles.[150]

### THE ROLE OF SALOONS, GREAT ROOMS AND GALLERIES

Today, the tendency is to exaggerate the grandeur and size of early eighteenth-century country houses, and underplay their good sense and moderation. That is particularly to be seen in the way owners approached the matter of a large room for company in addition to the hall. In a number of houses they had saloons or great rooms, and the difference in name usually seems to have depended on the overall plan and how they were placed in relation to the hall. A few had galleries that were neither old rooms remodelled nor primarily intended for the display of pictures or sculpture, but were long rooms for company provided instead of, or in addition to, saloons. Evidently there was a good deal of overlap, but today it is often difficult to discover the subtle differences through their furnishing.

The term 'saloon', however, is as fraught with difficulty as 'par-lour' or 'dining-room', because it was a room in transition in the first three decades of the century, while different ideas of decoration were tried out, as can be seen from designs and rooms that survive. In a number of country houses the term has been adopted long after the room was fitted up: sometimes an entrance hall was renamed, as at Castle Hill in Devon and Stoneleigh; and sometimes a great parlour, as at Belton (Fig. 43).[151]

But an attempt must be made to provide a definition for the 1720s and 1730s. In Chambers's *Cyclopedia* of 1728, a salon or saloon is described as 'a very lofty, spacious Hall, vaulted at Top, & sometimes comprehending two Stories, or Ranges, of Windows . . . Ambassadors and other Great Visitors, are usually received in the Saloon'. As well as being double-height, Chambers also seems to have envisaged it as a picture room, and therefore usually hung with material; and although he does not say so, a saloon was invariably placed centrally, either on the axis of the hall or occasionally over the hall, as at Buckingham House, Canons and Burlington House (where, incidentally, it had no chimneypiece). In smaller town houses, such as 44 Berkeley Square in London (Fig. 235) or 85 St Stephen's Green in Dublin, it often filled the whole of the front of the house on the first floor.[152]

The Duke of Buckingham wrote to the Duke of Shrewsbury of his room:

> I am oftener missing a pretty gallery in the old house I pulled down than pleased with a *Salon* which I built in its stead, tho' a thousand times better in all manner of respects . . . the *salon*, which is 35 ft high, 36 ft broad, and 45 ft long. In the midst of its roof a round picture of Gentileschi, 18 foot in diameter, represents the Muses playing in a concert to Apollo, lying along a cloud to hear them. The rest of the room is adorned with paintings relating to Arts and Sciences, and underneath divers original pictures hang, all in good lights, by the help of an upper-row of windows which drown the glaring.[153]

That was large by the standards of the time: the saloon shown in the plan for Wanstead was to be 30 feet square, with two flanking rooms 34 by 24 feet. What became the Saloon at Ditchley Gibbs shows as being 31 feet 6 inches by 23 feet; while at Houghton it is the largest room in the house, measuring 40 by 30 feet and double height, and at Wricklemarsh it was 32 feet 8 inches by 24 feet 4 inches.

Ware in 1756 wrote a definition of a saloon that might have had the rooms at Houghton and Holkham in mind:

> A great room intended for state, or for the reception of paintings, and usually comprehending two stories or ranges of windows. Its place is in the middle of a house, or at the head of a gallery, and it is a kind of magnificent hall, spacious, and continued with symmetry on all its sides, and cov'd at the top. It may be square, oblong, or octagonal, or of other regular forms. The *salon* at *Blenheim* house is a very fine one: the purpose for which these rooms were originally contrived was the reception of great visitors.

But that suggests the latter concept was already out of date.[154]

What contemporary definitions do not say is that there was an increasing demand for large rooms, particularly in London houses, to receive more people. Writing in March 1741, Lady Hertford noted that

Assemblies are now so much in fashion, that most persons fancy themselves under a necessity of inviting all their acquaintance three or four times to their houses, – not in small parties, which would be supportable, but they are all to come at once: nor is it enough to engage married people; but the boys and girls sit down as gravely to whist tables, as fellows of colleges used to do formerly ... I am to have one of these rackets next Wednesday.

A few years later, the word 'drum' came in. Mrs Montagu wrote: 'by the word Drum we understood a polite assembly, and by Rout, only an engagement of hoop petticoats'; and the following year Smollett wrote: 'a riotous assembly of fashionable people, of both sexes, at a private house, consisting of some hundreds; not unaptly stiled a drum, from the noise and emptiness of the entertainment'. Writing in 1750, Madame du Bocage noted 'Routs, which begin at seven o'clock and end at eleven, conclude the pleasures of the day. The *English* lately borrowed this custom from the *Italians*; but they have not like them, spacious palaces; and this occasions great constraint to their company.'[155]

The effect of that can also be seen in country houses, where the demand for a great room led to a surprising number being enlarged or turned round so as to provide one. Among good examples are Stanford (Fig. 8); Wallington in Northumberland (Fig. 277), where in the early 1740s the house was turned round in a similar way and the old hall became a saloon; and Stourhead, where again in the early 1740s the house was enlarged and a great room designed by Flitcroft added.[156]

Saloons seldom occur in late seventeenth-century houses, partly because great apartments tended to be on the floor above the hall and opened off the great staircase. One early reference is in the 1688 inventory to Burghley that describes the panelled central Marble Hall on the ground floor of the south range between the drawing-room and dining-room as the 'Marble Salloon Roome'. The term, however, seems to have come in with the new century, as at Castle Howard, Blenheim, Buckingham House and for the centre rooms on the west front at Chatsworth. It is interesting to try to unravel the development of thinking about its character between those first examples and the full expression of the idea at Houghton a quarter of a century later.

At Chatsworth, the name was used for the centre rooms on the first and second floors of the West front, designed and built after Talman's departure. These were originally ante-rooms open to the corridors linking the west staircase to the west front apartments. The upper room was painted by Thornhill and is now the Sabine Bedroom, and the lower room, which is panelled unusually with a complete order of Corinthian pilasters, is now the Centre Bedroom.[157]

At Castle Howard, the saloon was a single-storey panelled room measuring 33 feet square and, like the saloon at Burghley, it had the character of a garden hall rather than a great reception room. It was paced out with an order of Ionic pilasters and was wainscotted above the dado with a system of tall main panels and shallow upper panels that left little space for furniture. The chimneypieces and doors with their marble surrounds on the end walls were close together, because of the stepping back of the wings and the need for the doors to line up to create the great enfilade from one end of

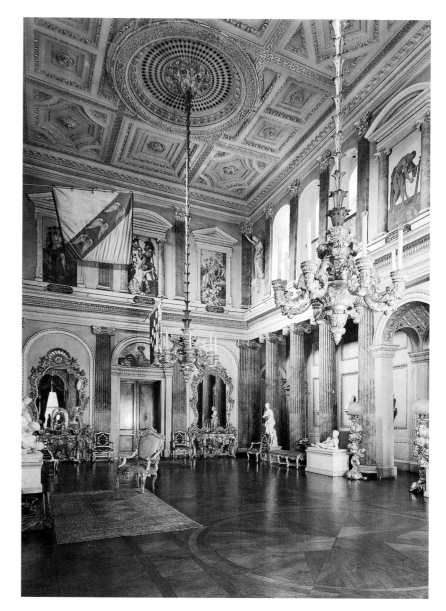

70. *The first-floor saloon at Powerscourt, Co. Wicklow, as it was in 1946. Slotted in between earlier ranges of building in the 1720s by Richard Castle, it was the grandest room of its kind in the British Isles. It was embellished in the nineteenth century and burnt in 1974.*

the house to the other; and they were further emphasized by the overdoors shaped to go over them. Its character was partly dictated by the creation over of it of a double-storey festive saloon with huge wall paintings by Pellegrini, a room close in conception to a great room in a grand continental palace and found nowhere else in England.

From the start, a double-height saloon was proposed for Blenheim, but the different schemes for its decoration (Fig. 357) suggest that Vanbrugh had not seriously considered either its function or its relationship to the hall and flanking apartments when he planned it. After his departure, it was finally turned into a painted hall by Laguerre.

For Eastbury, as can be seen in the drawing in the Victoria and Albert Museum (but not in the engraving in *Vitruvius Britannicus* III), Vanbrugh proposed a tripartite saloon with two screens of columns. He suggested a similar room 67 feet long and divided into three sections by screens of coupled columns to run the length of the garden front at Seaton Delaval. He also proposed one for

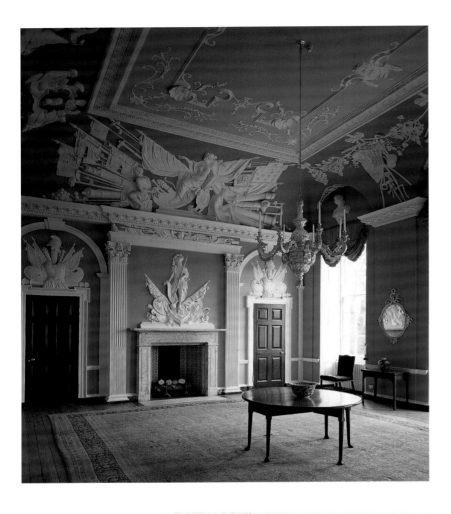

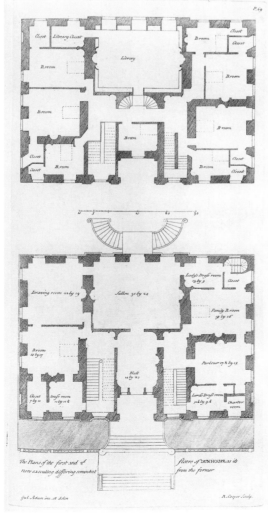

Inveraray. Even on plan, these read as exciting spaces, as saloons-cum-galleries; and not surprisingly, they were copied and adapted by other architects, like William Wakefield at Duncombe Park.[158]

The saloon at Canons sounded rather solemn and Gibbsian. A double-height room on the first floor over the entrance hall, it had three sash windows with three circular windows over them and it was wainscotted in walnut and mahogany with pilasters and an entablature, all valued at £843 18s. in 1725. The ceiling, valued at £500, was painted by Thornhill with *Apollo and the Muses with the Seven Liberal Arts* and set in plasterwork valued at £250 with gilding worth £155. The marble chimneypiece was valued at £208 17s. 8d., and over it appears to have been a stucco overmantel of *Charity and Chastity* valued at only £15 and completed with £3 of gilding. On the walls were four copies of Raphael cartoons valued at £700, but these were not after the *Acts of the Apostles* and were obtained by Henry Davenant in Genoa in 1720. They seem to have related to Raphael's *Creation* series in the Vatican. The room was lit by two silvered chandeliers valued at £90, but no furniture is listed. The whole room was valued at £2,399 15s. 8d.[159]

Architecturally, the most dramatic saloon of the 1720s was that at Powerscourt in Co. Wicklow (Fig. 70), created for Richard Wingfield, 1st Viscount Powerscourt (1697–1751) by Richard Castle. This was slotted in on the first floor between two earlier ranges of building and consisted of a double-height space, 55 by 41 feet and nine bays by three. On the main floor were long side screens of Ionic columns with arches in the centre bays and pilasters on the end walls supporting an entablature. The upper storey had Corinthian pilasters, and aedicules with triangular and segmental pediments on the end walls and arches opening into galleries on the long walls.[160]

Occasionally saloons are found in relatively modest houses like the House of Dun (Fig. 71), a villa finally designed by William Adam for David Erskine, Lord Dun in 1730–2. Erskine discussed the design by Alexander McGill with his kinsman, the 6th Earl of Mar, the exiled former Secretary of State for Scotland and amateur architect, who had used McGill at Alloa House in the early years of the century, and Mar's comments influenced the final form of Adam's house. Indeed, Mar may well have made the first design as early as 1719, when he began to work on villa designs as well as the surviving plans for the House of Dun dated 1731, the year before he died. As built and illustrated in *Vitruvius Scoticus*, the plan (Fig. 72) divided into unequal thirds, with a wider centre devoted to a narrow hall flanked by a pair of staircases and beyond it a saloon 30 by 24 feet and a storey and a half high. To the east lay the original great apartment and to the west the rather cramped family apartment. The idea of devoting so much space to the saloon, or Great Dining-Room as it was also called, was Mar's: he said that in McGill's plan there would be scarcely a tolerable room in the house and that was not right 'for a Gentleman's seat in the Country, which is to go from father to son

*The House of Dun, Angus, an early villa by William Adam begun about 1730 and completed in 1742.*

71. *The saloon or Great Dining-Room was the one large room. It has plasterwork by Joseph Enzer.*

72. *The plans of the main and second floors. They show Adam's ingenuity in the allocation of space on the main floor, with a family and best apartments either side the saloon, and, according to Scottish custom, a large library on the second floor over the saloon.*

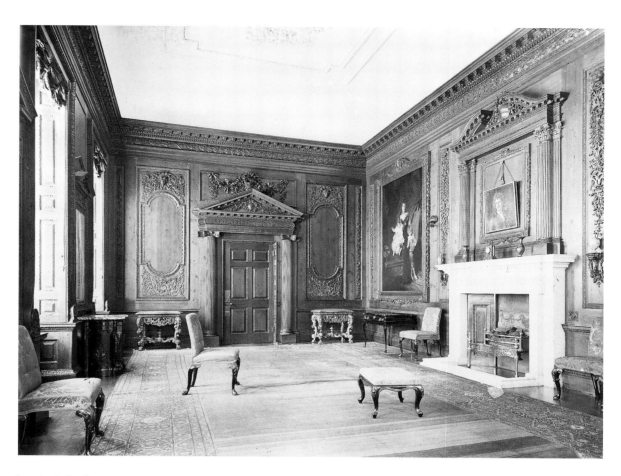

73. *The Great Room at Fairlawne, Kent, in 1918. The room was probably designed by James Gibbs before the the death of the 1st Lord Barnard in 1723. The panelling, exceptionally richly carved like that at Compton Place (Fig. 48), was probably originally painted but stripped about 1900. The design and the original ceiling are illustrated in Figs. 74 and 75.*

as is hoped for many generations who tho' the house may not be large nor great appartments in it yet ought to have one or two handsome & tolerable larger rooms for the Master to entertain his friends upon occasion & where some Copels of young folks may dance when they have a mind to divert themselves at peaceful & high times'. Apart from its size, the most striking feature of the room is its plasterwork, carried out in 1742 by Joseph Enzer at a cost of £216.[161]

Despite what Chambers wrote, the name 'saloon' was often given to single-storey rooms in the 1720s and 30s, and that related to pictures and furniture as much as architectural decoration, as can be seen at Erddig and Antony. At Erddig the room has been enlarged, but it always had simply moulded panelling and its status as a saloon seems to have been expressed in the difference in quality between its furniture and that in the adjoining drawing-room: walnut chair frames with crimson caffoy and yellow silk covers in the first room (Fig. 365) were followed by silver gesso frames with covers of crimson silk velvet in the drawing-room (Fig. 368). There was a similar situation at Antony: again, the room called the Saloon in the 1771 inventory is a completely panelled room with the character of a great parlour, but what justified its name was the combination of large subject pictures and the upholstery. Here were 'Two Pieces of the Duke of Marlborough's Battles, Two Pieces of Venus, two of Wild Beasts, Fowls etc large, Two Scripture Pieces and portraits of Sir Thomas Moore [*sic*] and his Lady', as well as fourteen small pictures. Thus it had a quite different character from the other rooms, such as the hall and common parlour, where portraits predominated. The seat furniture, which is possibly the walnut set now in grey stamped velvet, was then in crimson velvet that would have established the formal character of the room; and that led to seat furniture with tapestry covers in the adjoining drawing-room. Between the windows of the saloon were a pair of gilt gesso tables

with marble tops, which are still there, and over them a pair of glasses, possibly those with pediments now in a bedroom rather than the finer ones there today.

Although a single-storey room, the Clandon Saloon has probably always been so called – certainly since the 1778 inventory. It has a fine ceiling by the same Italian stuccadores who worked in the hall. The walls are lined with simple plaster panelling, and the coarse marble chimneypiece has an ebullient Italianate plaster overmantel incorporating a relief similar to those at Barnsley and Hall Place, Berkshire. The marble floor, which makes it unbearably cold for most of the year, gives it the feeling of a garden hall rather than a drawing-room.[162]

What may be the earliest surviving great room is at Fairlawne (Fig. 73) in Kent, which was built shortly before the death of the 1st Lord Barnard in 1723 by James Gibbs. It is also his earliest surviving grand country-house interior to survive (Sudbrook was a villa) and shows how he tackled such spaces just after Campbell formed and Kent completed the saloon at Burlington House (Fig. 165) and at the moment when Kent was turning to architectural decoration at Kensington Palace. In scale and style it could be regarded as a saloon, except that it was an addition to an existing house and did not have an axial relationship to the hall. It is completely panelled with a handsome pedimented doorcase of the Ionic order at the entrance and a marble chimneypiece with a related overmantel topped with a broken pediment. Flanking the door are two tall panels with plain central fields framed in rich acanthus carving, incorporating plumed masks and shells and shaped into curves at the top and bottom, a use of ornament only paralleled in the dining-room at Compton Place (Fig. 48), carved a few years later by James Richards. The chimneypiece is flanked by two huge architrave frames with small broken pediments and bands of Greek key carving that are answered in the carved and gilt pier-glass designed to fit

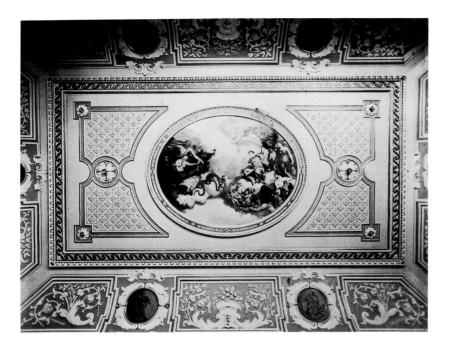

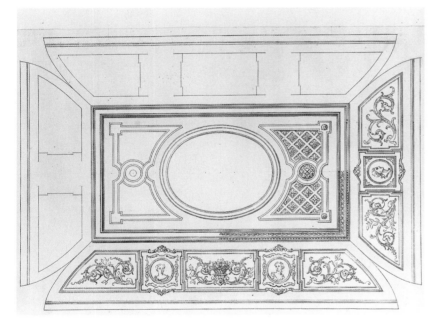

74. *The Great Room at Fairlawne, Kent, in 1918. The original ceiling of the Great Room combining decorative painting and Italianate plasterwork as it was before its destruction at the end of the nineteenth century. It is impossible to tell whether it was originally gilded.*

75. *Gibbs's design for the ceiling. The tight style of his office drawings should be compared with the fluency of drawings by the Italian stuccadores (Fig. 34). Ashmolean Museum, Oxford.*

76. *Two of Gibbs's designs for the Great Room that are perhaps the earliest to show glasses in detail in the elevation of a room. A similar glass with a swan-neck pediment was made for the east wall. Ashmolean Museum, Oxford.*

between the window architraves on the end wall, a rare idea at that time. The piers on the window wall have rather simpler tabernacle frames also designed to fit the panelling.[163]

Edwardian photographs show the room in a wood colour, as if it had been stripped, but originally it was probably painted. It has lost its original coved ceiling, which in an older photograph had stucco cartouches with painted panels in the cove and a painted oval in the centre of the ceiling framed by Italianate plasterwork, a grander version of the ceiling surviving in Gibbs's Henrietta Street room in the Victoria and Albert Museum. Gibbs's design for the ceiling is much tighter and simpler than those done by the stuccadores (Fig. 34).

One of the earliest paintings of what appears to be a real great room, or at least based on one, is Hogarth's *Wanstead Assembly*, painted between 1728 and 1731. This room was an alteration to the plan, being formed out of the library and two adjoining rooms at the end of the house and given a painted ceiling, though apparently not by Kent, who painted the hall ceiling. Hogarth shows a room with an entablature and a Jonesian beamed ceiling with painting on the bed and probably stucco figures and ornament in the deep cove, and a continued chimneypiece with scrolled pediment to the overmantel. He also showed tapestries on either side, one of which was a Brussels panel bought by Lord Castlemaine between 1724 and 1728. Among the other furnishings was a silver table for tea and an unusually large chandelier with two rows of lights, with a servant attending to it.[164]

The room at Wanstead can be compared with the Great Room on the first floor at Marble Hill, Twickenham (Fig. 77), the villa built by Henrietta Howard, Countess of Suffolk. The very particular idea of the house goes back to a design of about 1723 by Colen Campbell and his published engraving in *Vitruvius Britannicus* III. However, its final form is due to Roger Morris and Lord Pembroke, with the active involvement of Lady Suffolk, whose understanding of architecture was respected by her friends. The Great Room, which is a 24-foot cube, three bays wide and deep, with an entablature and deep cove, is the most elaborately decorated interior in the house; and it suggests that Lady Suffolk wanted an imposing room overlooking the river, as in a garden temple, in which she could entertain friends coming from the city.[165]

The handling of the room has a certain stiff correctness that suggests the directing hand of an amateur like Lord Pembroke, who was a man of taste but not a draughtsman, and a stronger sense of verticality than Campbell's interiors. Its panelling scheme is inspired by that in the Double Cube Room at Wilton, and the fact that it is not hung with material suggests that it was used for dinner on formal occasions as well for receiving company, rather than as a drawing-room. The entrance wall has a central doorcase with a broken pediment and is flanked by two large panels that slightly advance from the wall plane, and they are balanced by another panel on the wall facing the chimneypiece. Originally the first two were hung with large copies of paintings after Van Dyck and Rubens in frames, which must have been made for the room. On the window wall there are a pair of tabernacle glasses with earred frames and broken pediments similar to those in the saloon at Burlington House (Fig. 165) and shown by Campbell in his design for Lord Bute's dining-room (Fig. 52); and above them are carved and gilded ornaments presumably by James Richards, who worked in the house in 1726.

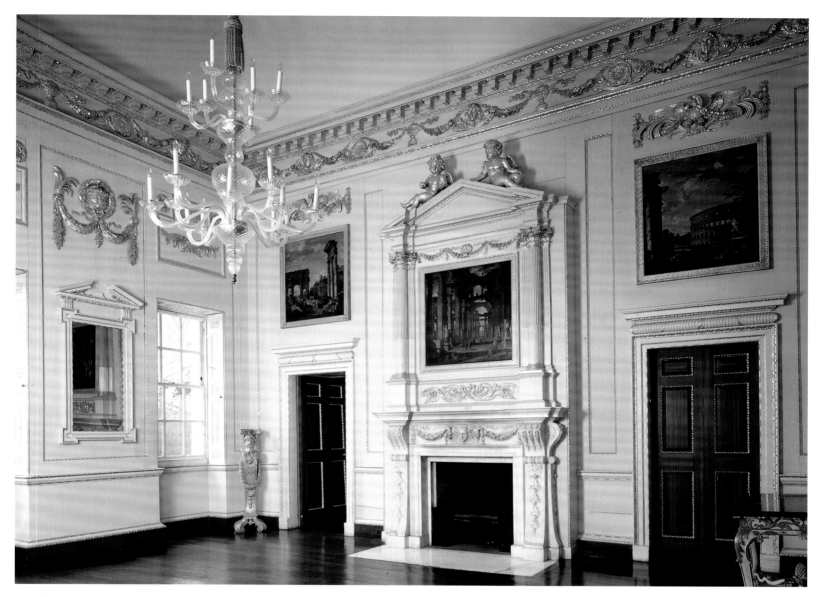

77. *The Great Room at Marble Hill, Twickenham, Middlesex. Although originally designed for Lady Suffolk by Colen Campbell about 1723, the final form of the house was due to Lord Pembroke and Roger Morris, and this room overlooking the Thames was intended for the entertainment of company from London, presumably for dinner.*

*So its walls were panelled rather than hung with material, and it had early tabernacle glasses on the piers between the windows. Two pairs of side tables were soon added, and a set of five paintings for the overmantel and overdoors by Panini acquired in 1738.*

The marble chimneypiece, whose frieze centres on Apollo's head with eagles' heads either side, has a carved wooden overmantel with more eagles' heads in the base panel and putti at the top. That contains an architectural capriccio that was one of five commissioned for the room from Panini in 1738. These were removed in 1902, but the overmantel was bought back in 1984 and two of the overdoors in 1988.

Another recovery for the room, in 1987, is one of a pair of large and two smaller tables with white marble slabs and white and gold frames centring on a peacock with its tail fanning out round him, in the manner of William Kent. Presumably the smaller pair went below the glasses on the window wall, but the projection of the panels below the pictures suggests that the tables might not have been part of the original design of the room, but might have been early afterthoughts executed by Richards working in the style of Kent.

In 1741, Henry Hoare II finally took over the villa at Stourhead that his father had built in the early 1720s and his mother had lived in until her death that year. As can be seen from the two plans in *Vitruvius Britannicus* III, neither Campbell's original scheme, which

was one of the closest to a design by Palladio, in this case the Villa Emo, nor his father's alteration to it, had been very happy. So about 1744 he called in Henry Flitcroft to turn the villa into a larger country house, making a number of changes to provide a series of rooms for entertaining, including a new Great Room with a coved ceiling that forced him to rebuild the whole west end of the house. While in Italy in the late 1730s, Hoare had acquired a number of fine pictures, many of which remain in the house, but they would not clothe the walls of a Great Room and, as was usual in England, he had to rely on copies of famous pictures in rich frames. The appearance of the room is recorded in a watercolour by Buckler and in a nineteenth-century photograph.[166]

Another example of a great room of the 1740s is at Shugborough, in Staffordshire, where Thomas Anson built on two wings, probably to the design of Thomas Wright. The north wing is devoted to a double-height room hung with a set of large stage-set-like paintings of classical architecture in tempera attributed to an obscure Bolognese artist, Pietro Paltronieri, which were first mentioned by Philip Yorke in 1748. On that visit he did not comment on

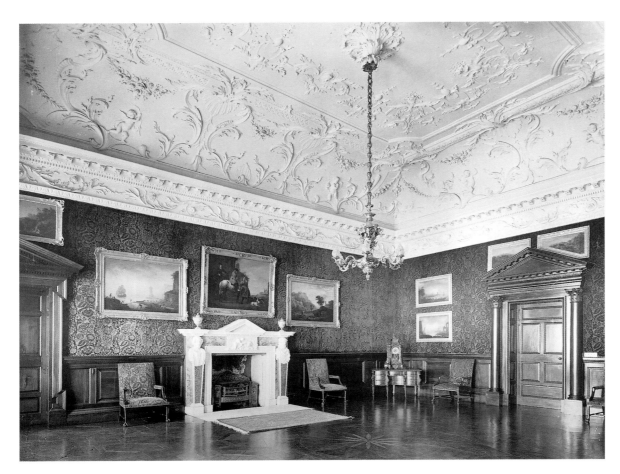

78. *The saloon at Russborough, Co. Wicklow, in 1937. The walls are hung with a stamped wool velvet in a mid-eighteenth-century pattern, but apparently a nineteenth-century replacement, with the original seat furniture upholstered to match. The chimneypiece is probably by Carter and imported from London. The plasterwork is attributed to Paolo and Filippo Lafrancini working in the 1740s and the pictures appear to have been part of the original Milltown collection formed in the mid-eighteenth century and now in the National Gallery of Ireland.*

the deep coved ceiling with its central plaster relief after Guido Reni's painting of *Apollo and the Hours preceded by Aurora* in the Palazzo Rospigliosi in Rome, one of the most admired paintings at that time. So it was possibly added between 1748 and 1763. The room became a dining-room in 1794, when some alterations to its doors and the paintings were made.[167]

One of the best mid-century saloons survives at Russborough, Co. Wicklow (Fig. 78). The house was designed by Richard Castle for Joseph Leeson, the son of a succesful Dublin brewer who died in 1741 and left him able to establish himself as a member of the landed class. In 1742 he bought the property at Blessington, and presumably he began to build the new house about 1743–4, while he went to Italy, where he is recorded in 1744 and 1745 and was one, if not actually the first, of Batoni's British sitters. By 1748 a traveller described Russborough as 'a noble house forming into perfection'. In 1750 Leeson went to Italy again, and the house seems to have been complete by 1754.[168]

The saloon was evidently planned to take Leeson's pictures purchased in Italy, and so its walls and, according to early twentieth-century photographs, and those of the two adjoining rooms, were all hung with the same material. This is currently a crimson stamped wool velvet in a Rococo pattern that is similar in texture to the caffoy at Houghton (Fig. 202) and Holkham (Fig. 443) and the stamped velvet at Knole, Kent (Fig. 124), and, while its width suggests that it is a nineteenth-century replacement, it may convey the spirit of the original. All the woodwork in the room, including the dados, is mahogany, and the rich brown wood with the dense coloured material have a smouldering quality. The glorious coved ceiling was decorated by the Lafrancini. The chimneypiece seems to have been supplied from London by Carter, with the dark marble relating to the tone of the dado.

Unfortunately there are no photographs that show the room before Lady Milltown gave the collection to the National Gallery of Ireland in 1902, and so it is impossible to know how it looked with its Grand Tour pictures, simple but unusually generous mahogany seat furniture upholstered to match the walls, and its extravagantly carved and gilt pier-glasses. If the chairs, which remained in the house until the early 1950s, had been lined up against the dado, their wide backs would have given a sense of the pattern of the hangings continuing downwards, with the single row of nails of the hangings being reflected in the nailing on the chairs. The pier-glasses appear to be the pair with eagles at the top, cherubs' heads on the sides and a bearded mask at the bottom (Fig. 79), now in the National Gallery. Below them presumably went gilt pier-tables with scagliola tops by Pietro Belloni, which survive in the National Gallery. They were apparently complemented by an exceptional landscape-shaped frame that could have framed a picture over Carter's chimneypiece (Fig. 80). The frames are documented, but they are distinctly Irish essays in the manner of Lock.[169]

Among the most original saloons of the early 1750s is the Octagon at Honington (Fig. 81), which was evidently designed by John Freeman of Fawley Court and built on to the house by William Jones, who had constructed the famous Rotunda at Ranelagh and was also working near by on the completion of Edgecote. The Honington room, however, is much more richly decorated than any interior at Edgecote and a skilled draughtsman must have drawn out all the ornament. A glorious room a storey and a half high, it has a deep cove to the ceiling framing a painting by Luca Giordano set in a band of suitably festive vine and grape ornament that reflects the friezes of the doorcases and trophies of plasterwork on the walls and in the cove. Also there are huge pier-glasses in parcel-gilt plaster frames in the recesses facing the side windows in the bay. It is

79, 80. *One of a pair of pier-glasses and the probable overmantel frame from the saloon attributed to the Dublin carvers, John Houghton and John Kelly.* National Gallery, Dublin.

81. *The octagonal saloon at Honington Hall, Warwickshire, designed by John Freeman, an amateur architect, and built by William Jones in the early 1750s. The identity of the stuccadore is unknown, but the trophies in the angles of the room and the dome are exceptionally spirited, as are the white and gold plaster frames to the glasses unusually placed on the inner walls of the room.*

superbly finished down to the carving and parcel gilding of the glazing bars.[170]

The long trophies of naturalistic ornament on the ceiling and walls have an unusual density to them that is reminiscent of the decorations at Ranelagh, designed by Michael Moser, who was principally a chaser of metal and used to working on a small scale. Could he have been involved again? The architectural gilding was also superbly planned and 250 years later the room has a remarkable sparkle.

Woburn has one of the last big saloons of this period. It was formed for the 4th Duke of Bedford by Henry Flitcroft, who had to accept the Duke's insistence on keeping the courtyard form of the old house, which meant the ranges were not deep enough to provide a truly splendid sequence of spaces. The principal entrance was a pillared hall in the centre of the west front directly below the saloon, but there was nowhere to fit in a grand staircase. So a pair of simple staircases were placed at each end of the range, and these lead up to

82. *The saloon on the first floor of Provost's House, Trinity College, Dublin. A double-height space with two screens of columns and a deep coved ceiling completed in the early 1760s, with plasterwork by the Dublin stuccadores, Patrick and John Wall.*

a broad corridor overlooking the courtyard. This corridor was given screens of columns at each end to make it a more convincing gallery for early Russell portraits. The centre point is the door to the Saloon, which was inspired by that at Holkham, with its coffered ceiling based on the same source in Desgodetz; but, as Horace Walpole said, it is too high and narrow. Its Rysbrack chimneypiece has lost its original overmantel so and the room now lacks a vertical architectural focus and a balance to the splendid doorcase. Originally the room and all the others in the Great Apartment were hung in the same blue damask, but none of the original material survives, so it is impossible to envisage the effect of its figure and weight of colour in the rooms.[171]

It is furnished with a pair of large, richly carved and gilt settees and four armchairs, a pair of sumptuous pier-glasses supplied by Whittle and Norman in 1756 at a cost of £129 10s. with another £142 10s. for the plates, three pelmet cornices that call for elaborate draped valances whose form is not recorded, and an eighteen-light carved wood chandelier made by William Hollingsworth in 1758 for £86. According to the 1771 inventory, the contents of the room were valued at £548 11s.

In Scotland, the finest Great Room or saloon and only finally

completed in the early 1760s is that at Yester, East Lothian (Fig. 322). The house had been begun by the 2nd Marquess of Tweedale soon after he inherited in 1697, but it was only half finished when his grandson, the 4th Marquess, inherited as a minor in 1715. The latter lived until 1762, but he only managed to complete it just before his death, perhaps because he was so deeply involved in Scottish affairs in London, serving as Secretary of State through the years of the Jacobite rising. In the 1730s he consulted William Adam about the projected Great Dining-Room on the first floor, and it was Adam's idea to raise the attic storey so that it could become a double-height room with a deep coved ceiling. However despite attempts to revise the scheme in 1751 and 1756, building was only finally resumed in 1759–61 by John Adam, probably with some contribution from his brother, Robert, newly returned from Italy, who may have suggested the coffering of the cove based on that in the Basilica of Maxentius in Rome and some of the ornament. It was in 1761 that William Delacour, who was working in Edinburgh, painted the large ruin pieces for the walls. John Adam recorded in a later memorandum dated October, 1764: 'I agreed with Delacour for the landskips in the Great Room at Yester by the Slump at one hundred guineas & for the plain painting by the yard superficial at

15*d*. being fleck white and nutt oyl, and for the gilding round the pictures frames at 9*d*. per foot running.'[172]

The last Great Room to be considered here is that in the Provost's House at Trinity College, Dublin (Fig. 82), which is the climax to that house and the reward for climbing one of the most remarkable staircases of its generation. It fills the whole of the five-bay entrance front of the house begun for Provost Andrews in 1759 and is two storeys high, with a central section of three bays and a deep coved ceiling and extra bays behind the screens of columns at each end. As Edward McParland has written, 'The management of scale and of the orders is complex and adept. Three Corinthian orders, at doorway, windows, and either end of the room, each appearing in both pilaster and columnar form, are dexterously handled and subtly modulated. And complementing this intellectual control of architectural members is the plasterwork, equally controlled but also, as is fitting, lighter in touch, frivolous and gay.' The plasterwork is by the Dublin stuccadores, Patrick and John Wall.[173]

A gallery is not usually thought of as an early eighteenth-century form of room, and Vanbrugh was one of the first architects to become interested in the idea, as he was in the long saloon. His first was at Blenheim, where, asked by the Duke of Marlborough to provide one for pictures, he devoted the whole of the west wing to it, dividing it into five sections to create a space of great splendour and variety, emphasized by the use of white marble pilasters on black marble bases. It was still unfinished in 1722 when Hawksmoor wrote to the Duchess that it 'will be a room of distinguished Beauty if rightly managed'; and he then completed it with the aid of Isaac Mansfield, who did the ceilings. The centre section is aligned on the great marble doorcase framing the doors at the end of the cross corridor through the palace from the Bow Window Room. It is flanked by a pair of narrower sections, each of three bays; and beyond the arches are broader and loftier square spaces with groin-vaulted ceilings.[174]

Obviously the provision of galleries was related to the growth of collections of pictures and sculpture, and the English liking for works of art in the rooms in which they lived rather than in galleries, as was more usual on the continent. So the number of galleries primarily for works of art was always limited. One of the first after Blenheim was that proposed by Bodt for Wentworth Castle, where it runs the complete length of his new range. It was only completed, more simply, by Gibbs in the early 1720s. It still survives, although now shorn of its pictures. Among others are or were those at Chiswick, Houghton, Holkham, Longford, Petworth, Wricklemarsh, Knowsley in Lancashire and Wimpole.[175]

Campbell designed two, one at Mereworth (Fig. 83) and a second at Compton Place, as well as proposing them in his designs for Lowther and Lord Cadogan. At Compton Place the gallery was a carefully articulated handling of a seventeenth-century first-floor cross gallery, as at Erddig and Frogmore House at Windsor. At Mereworth, like Inveraray, it was really an elongated saloon with a central doorcase and two chimneypieces. So was Flitcroft's gallery at Wimpole (Fig. 85), which was formed in 1742 out of three rooms and given two screens of columns, two chimneypieces and a set of upholstered seat furniture. Another undocumented example is at Stratfield Saye in Hampshire, which round about the middle of the century was formed out of a series of rooms on the ground floor of the body of the seventeenth-century house and given a screens of Ionic columns at each end.[176]

In planning terms, one of the most remarkable early eighteenth-century galleries is that at Castletown, which seems to have always been part of the design. Set on the first floor, at the head of the great staircase, it occupies a similar position to the so-called Saloon at Beningbrough, but it is more like a Roman gallery in its dimensions. However, it seems only its ceiling was in place by the time William Conolly died in 1729, and there is no evidence about how it was intended to be used or that it was planned for works of art. On the other hand, in the 1770s, before its present scheme of decoration was completed in the following decade, Lady Louisa Conolly wrote vivid a description: 'In the gallery where we live, 'tis the most comfortable room you ever saw, and quite warm; supper at one end, the company at the other, and I am writing on one of the piers at a distance from them all.'[177]

How exceptional – and how Irish – that degree of informality was at that time is unclear. Did it perhaps grow out of the use of the Jacobean Long Gallery at Holland House in the 1750s by Lady Caroline Holland, one of Lady Louisa's elder sisters?

Today, the best example of a mid-eighteenth-century picture gallery-cum-great drawing-room or great room is that at Temple Newsam (Fig. 322), which was the Long Gallery of the Jacobean house redesigned in the 1740s. How the walls at Temple Newsam were clothed with pictures and how they dictated much of the rest

83. *The gallery at Mereworth Castle, Kent, as it was in 1920. The ceiling and cove painted by Amiconi and Sleter set off by dark painted architectural detail and possibly original green velvet hangings. This suggests the importance of dark tones in the original balance of the decoration.*

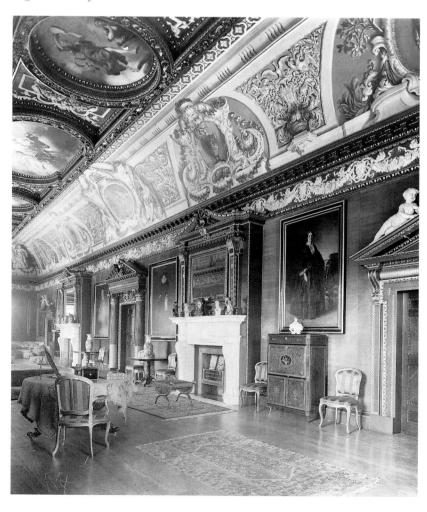

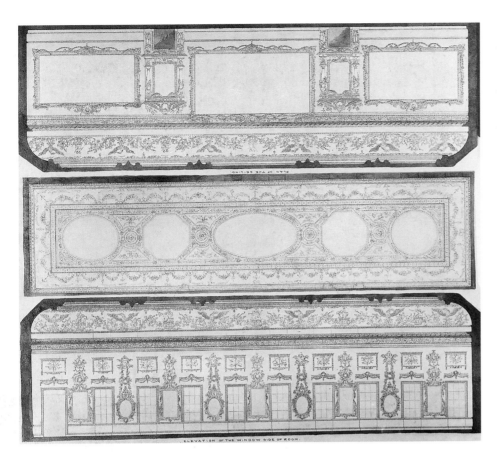

84. *Mid-nineteenth-century measured drawings of the gallery at Northumberland House, London, designed by Daniel Garrett about 1750 (but completed after his death in 1753 by James Paine in the years 1754–7) as a room of assembly. It was hung with huge copies of famous Italian masterpieces and decorated with plasterwork by the Lafrancini. One of the chimneypieces and overmantel frames by Benjamin Carter is now in the Victoria and Albert Museum.* The Duke of Northumberland.

of the decoration is discussed on page 249, but it has an unusually large set of gilt furniture that combined the idea of a drawing-room and a gallery suite; and all the seats were covered in needlework, which was a drawing-room idea. Unfortunately, there are no early descriptions of life in the room, but nineteenth-century water-colours and photographs show how it became the living-room of the house.

The gallery had a distinguished ancestry going back to the long gallery, where it was possible to take gentle exercise and commune with ancestors and heroes on the walls. Thus it had associations with dignity and grandeur. That was the point of the gallery at Woburn formed in the 1750s to display Russell portraits. A similar spirit inspired Horace Walpole to add on his gallery at Strawberry Hill (Fig. 305), but surely that was also a great room for company.[178]

However, there were also a number of galleries that were not primarily for the display of pictures or sculpture. Two that come to mind from the 1750s are those at Hagley (Fig. 420) and Northumberland House (Fig. 84), while others were formed in that decade at Stowe (Fig. 11), where they were essentially for show. Others were proposed and presumably provided in Roger Morris's scheme for a house for Thomas Wyndham at Hammersmith and perhaps realized by Servandoni, and in Sanderson's house for the Duke of Bedford at Stratton Park, Hampshire.[179]

In the early 1740s a convention developed of furnishing galleries with long stools and sometimes these were on the scale of large day beds with curled ends, as at Longford (Fig. 319), formerly at Wimpole (Fig. 85) and at Temple Newsam (Fig. 325), in the last two cases being parts of sets of seat furniture with settees and chairs. At The Vyne there are a set of unusually early gothick stools supplied by William Vile in 1753.

At Northumberland House (Fig. 84), the gallery, which is discussed more fully on page 247, was added to provide a room of assembly in one of the grandest and oldest of London houses, which lacked a room large enough to accommodate a large company. That, too, was furnished with great settees and long stools with carved and gilt frames and crimson damask covers.[180]

### LIBRARY–LIVING-ROOMS

'The most recent modern custom is to use the library as the general living-room: and that sort of state room formerly called the best parlour, and of late years the drawing-room, is now generally found a melancholy apartment, when entirely shut up and opened to give the visitors a formal cold reception.' So wrote Repton in 1816, and, while that always used to seem convincing, it is probably not true: the idea of the library as a living-room seems to go back to before the middle of the eighteenth century.[181]

Although the English became collectors of books before pictures, it would appear that before the 1720s country-house libraries were seldom treated as architectural interiors or regarded as being among the principal rooms of a house. However, one admirable model was Marot's print of the small room that William III had fitted up at Het Loo after the death of Queen Mary. There, the shelves are given architectural form by narrow sections stepping forward as if they are pilasters, an idea quite often imitated. It is possible that there were several early architectural libraries in the houses of passionate book collectors comparable with that of Lord Sunderland, whose splendid London library was designed in 1719 by Thomas Hewett. Indeed, it is possible that the library as a large and prominent room started in and around London, and was taken up in country houses later. A library, for instance, does not appear in the plans of Castle Howard, Blenheim or Ditchley.

Probably the earliest connoisseur's library to survive is at Narford, Norfolk, which Sir Andrew Fountaine inherited in 1706 and

15*d*. being fleck white and nutt oyl, and for the gilding round the pictures frames at 9*d*. per foot running.'[172]

The last Great Room to be considered here is that in the Provost's House at Trinity College, Dublin (Fig. 82), which is the climax to that house and the reward for climbing one of the most remarkable staircases of its generation. It fills the whole of the five-bay entrance front of the house begun for Provost Andrews in 1759 and is two storeys high, with a central section of three bays and a deep coved ceiling and extra bays behind the screens of columns at each end. As Edward McParland has written, 'The management of scale and of the orders is complex and adept. Three Corinthian orders, at doorway, windows, and either end of the room, each appearing in both pilaster and columnar form, are dexterously handled and subtly modulated. And complementing this intellectual control of architectural members is the plasterwork, equally controlled but also, as is fitting, lighter in touch, frivolous and gay.' The plasterwork is by the Dublin stuccadores, Patrick and John Wall.[173]

A gallery is not usually thought of as an early eighteenth-century form of room, and Vanbrugh was one of the first architects to become interested in the idea, as he was in the long saloon. His first was at Blenheim, where, asked by the Duke of Marlborough to provide one for pictures, he devoted the whole of the west wing to it, dividing it into five sections to create a space of great splendour and variety, emphasized by the use of white marble pilasters on black marble bases. It was still unfinished in 1722 when Hawksmoor wrote to the Duchess that it 'will be a room of distinguished Beauty if rightly managed'; and he then completed it with the aid of Isaac Mansfield, who did the ceilings. The centre section is aligned on the great marble doorcase framing the doors at the end of the cross corridor through the palace from the Bow Window Room. It is flanked by a pair of narrower sections, each of three bays; and beyond the arches are broader and loftier square spaces with groin-vaulted ceilings.[174]

Obviously the provision of galleries was related to the growth of collections of pictures and sculpture, and the English liking for works of art in the rooms in which they lived rather than in galleries, as was more usual on the continent. So the number of galleries primarily for works of art was always limited. One of the first after Blenheim was that proposed by Bodt for Wentworth Castle, where it runs the complete length of his new range. It was only completed, more simply, by Gibbs in the early 1720s. It still survives, although now shorn of its pictures. Among others are or were those at Chiswick, Houghton, Holkham, Longford, Petworth, Wricklemarsh, Knowsley in Lancashire and Wimpole.[175]

Campbell designed two, one at Mereworth (Fig. 83) and a second at Compton Place, as well as proposing them in his designs for Lowther and Lord Cadogan. At Compton Place the gallery was a carefully articulated handling of a seventeenth-century first-floor cross gallery, as at Erddig and Frogmore House at Windsor. At Mereworth, like Inveraray, it was really an elongated saloon with a central doorcase and two chimneypieces. So was Flitcroft's gallery at Wimpole (Fig. 85), which was formed in 1742 out of three rooms and given two screens of columns, two chimneypieces and a set of upholstered seat furniture. Another undocumented example is at Stratfield Saye in Hampshire, which round about the middle of the century was formed out of a series of rooms on the ground floor of the body of the seventeenth-century house and given a screens of Ionic columns at each end.[176]

In planning terms, one of the most remarkable early eighteenth-century galleries is that at Castletown, which seems to have always been part of the design. Set on the first floor, at the head of the great staircase, it occupies a similar position to the so-called Saloon at Beningbrough, but it is more like a Roman gallery in its dimensions. However, it seems only its ceiling was in place by the time William Conolly died in 1729, and there is no evidence about how it was intended to be used or that it was planned for works of art. On the other hand, in the 1770s, before its present scheme of decoration was completed in the following decade, Lady Louisa Conolly wrote vivid a description: 'In the gallery where we live, 'tis the most comfortable room you ever saw, and quite warm; supper at one end, the company at the other, and I am writing on one of the piers at a distance from them all.'[177]

How exceptional – and how Irish – that degree of informality was at that time is unclear. Did it perhaps grow out of the use of the Jacobean Long Gallery at Holland House in the 1750s by Lady Caroline Holland, one of Lady Louisa's elder sisters?

Today, the best example of a mid-eighteenth-century picture gallery-cum-great drawing-room or great room is that at Temple Newsam (Fig. 322), which was the Long Gallery of the Jacobean house redesigned in the 1740s. How the walls at Temple Newsam were clothed with pictures and how they dictated much of the rest

83. *The gallery at Mereworth Castle, Kent, as it was in 1920. The ceiling and cove painted by Amiconi and Sleter set off by dark painted architectural detail and possibly original green velvet hangings. This suggests the importance of dark tones in the original balance of the decoration.*

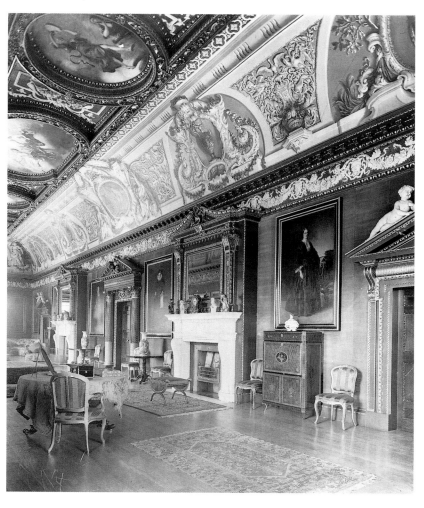

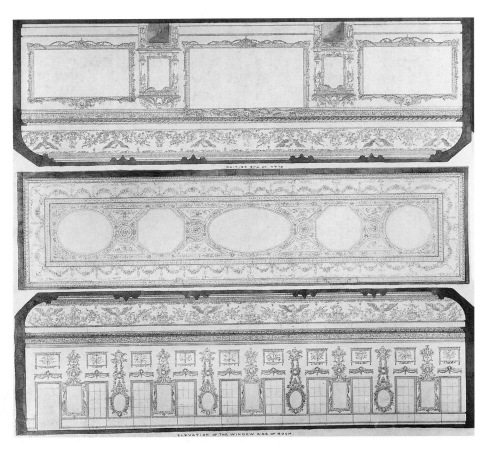

84. *Mid-nineteenth-century measured drawings of the gallery at Northumberland House, London, designed by Daniel Garrett about 1750 (but completed after his death in 1753 by James Paine in the years 1754–7) as a room of assembly. It was hung with huge copies of famous Italian masterpieces and decorated with plasterwork by the Lafrancini. One of the chimneypieces and overmantel frames by Benjamin Carter is now in the Victoria and Albert Museum.* The Duke of Northumberland.

of the decoration is discussed on page 249, but it has an unusually large set of gilt furniture that combined the idea of a drawing-room and a gallery suite; and all the seats were covered in needlework, which was a drawing-room idea. Unfortunately, there are no early descriptions of life in the room, but nineteenth-century watercolours and photographs show how it became the living-room of the house.

The gallery had a distinguished ancestry going back to the long gallery, where it was possible to take gentle exercise and commune with ancestors and heroes on the walls. Thus it had associations with dignity and grandeur. That was the point of the gallery at Woburn formed in the 1750s to display Russell portraits. A similar spirit inspired Horace Walpole to add on his gallery at Strawberry Hill (Fig. 305), but surely that was also a great room for company.[178]

However, there were also a number of galleries that were not primarily for the display of pictures or sculpture. Two that come to mind from the 1750s are those at Hagley (Fig. 420) and Northumberland House (Fig. 84), while others were formed in that decade at Stowe (Fig. 11), where they were essentially for show. Others were proposed and presumably provided in Roger Morris's scheme for a house for Thomas Wyndham at Hammersmith and perhaps realized by Servandoni, and in Sanderson's house for the Duke of Bedford at Stratton Park, Hampshire.[179]

In the early 1740s a convention developed of furnishing galleries with long stools and sometimes these were on the scale of large day beds with curled ends, as at Longford (Fig. 319), formerly at Wimpole (Fig. 85) and at Temple Newsam (Fig. 325), in the last two cases being parts of sets of seat furniture with settees and chairs. At The Vyne there are a set of unusually early gothick stools supplied by William Vile in 1753.

At Northumberland House (Fig. 84), the gallery, which is discussed more fully on page 247, was added to provide a room of assembly in one of the grandest and oldest of London houses, which lacked a room large enough to accommodate a large company. That, too, was furnished with great settees and long stools with carved and gilt frames and crimson damask covers.[180]

### LIBRARY–LIVING-ROOMS

'The most recent modern custom is to use the library as the general living-room: and that sort of state room formerly called the best parlour, and of late years the drawing-room, is now generally found a melancholy apartment, when entirely shut up and opened to give the visitors a formal cold reception.' So wrote Repton in 1816, and, while that always used to seem convincing, it is probably not true: the idea of the library as a living-room seems to go back to before the middle of the eighteenth century.[181]

Although the English became collectors of books before pictures, it would appear that before the 1720s country-house libraries were seldom treated as architectural interiors or regarded as being among the principal rooms of a house. However, one admirable model was Marot's print of the small room that William III had fitted up at Het Loo after the death of Queen Mary. There, the shelves are given architectural form by narrow sections stepping forward as if they are pilasters, an idea quite often imitated. It is possible that there were several early architectural libraries in the houses of passionate book collectors comparable with that of Lord Sunderland, whose splendid London library was designed in 1719 by Thomas Hewett. Indeed, it is possible that the library as a large and prominent room started in and around London, and was taken up in country houses later. A library, for instance, does not appear in the plans of Castle Howard, Blenheim or Ditchley.

Probably the earliest connoisseur's library to survive is at Narford, Norfolk, which Sir Andrew Fountaine inherited in 1706 and

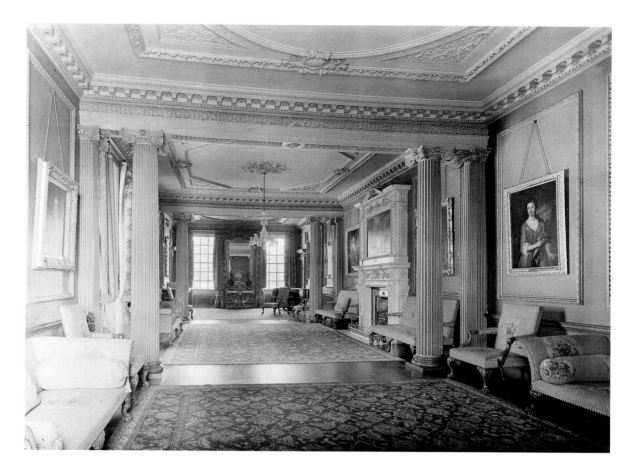

85. *The picture gallery at Wimpole Hall, Cambridgeshire, as it was in 1927. It was formed for Lord Hardwicke out of three rooms in 1742 by Henry Flitcroft, who inserted the screens of columns. In 1927 it retained its original set of seat furniture comprising day beds, settees and large armchairs as well as the pier glasses and tables still at each end of the room.*

86. *The Arniston library designed by William Adam about 1726 as depicted in* Vitruvius Scoticus, *showing the full effect of the glazed bookcases with busts over them.*

may have designed himself soon after he returned from Italy in 1716. The top of the bookshelves line up with the head of the door-case and have a row of portraits of great men and poets above, and over all floats a coved ceiling painted in the Baroque style by an unknown Italian painter.[182]

Compared with that, the 2nd Lord Warrington's library at Dunham Massey, probably fitted up between 1706 and 1716, is unexpectedly simple, with shelves from skirting to moulded cornice and no architectural carving. Its only enrichment is Grinling Gibbons's early panel of *The Crucifixion* after Tintoretto, which Lord Warrington bought for the overmantel. It seems that it was mainly for Lord Warrington's own use, with a room furnished as a study next to it and beyond that a dressing-room that also appears to have been his.[183]

In Scotland there was an earlier tradition of creating book rooms on upper floors, but the library on the second floor at Arniston seen here in the plate from *Vitruvius Britannicus* (Fig. 86) is the earliest to be treated as an architectural interior. Designed by William Adam about 1726, it is five bays long and has an Ionic order of pilasters defining the bays and framing the bookshelves while carrying the entablature from which springs the vaulted cove of the ceiling. There is no known room of that date to rival it in England, but what no illustration can convey is the way it is sited to enjoy the great view north towards Arthur's Seat.[184]

As with other early William Adam projects, the question arises as to whether he had contact with James Gibbs; but at present there is no evidence. Certainly Gibbs had been involved with the design of private libraries early on, with his first thoughts for a college-like room for Edward Harley, the future 2nd Earl of Oxford, at Wimpole dating from 1713, the year that he married Lady Henrietta Cavendish, the Newcastle heiress. That came to nought, but in the 1720s he built there one of the first large architectural country-

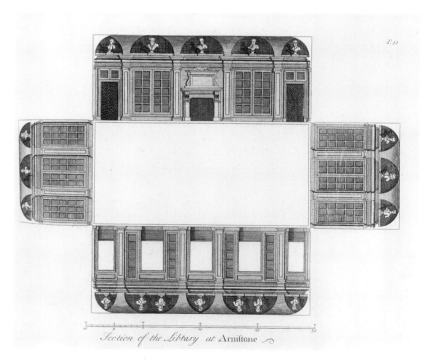

*Section of the Library at Arniston*

house libraries and that survives in part, albeit altered both by Flitcroft and Soane.[185]

Thus Gibbs, as in so many other ways, seems to have been the crucial figure, and his design for the library at Kelmarsh, Northamptonshire, of about 1728 is significant not only because it shows all the shelving but because it is apparently the earliest recorded example of a library treated as one of the principal rooms of a house opening off the entrance hall and thus convenient for daily living. Gibbs continued to suggest libraries placed like that, as can be seen in his plans for Kirtlington of about 1740.[186]

At Wricklemarsh, the library (Fig. 29) designed by John James

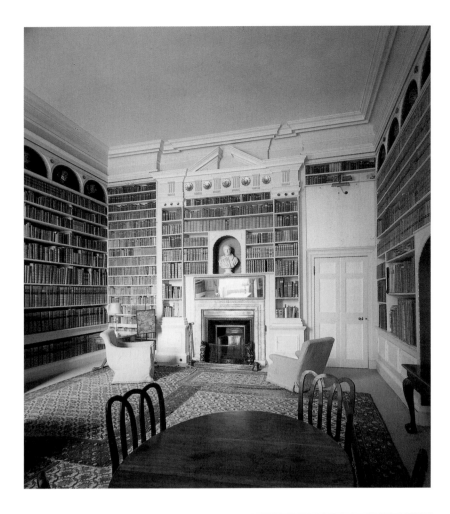

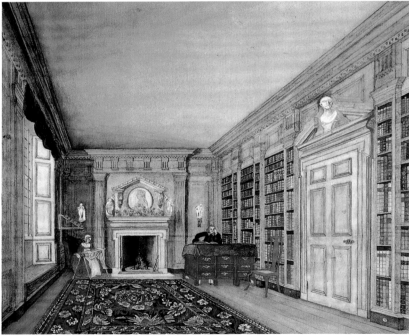

87. *Lord Tyrconnel's library at Belton fitted up between 1721 and 1737. Great care was taken with the original arrangement of the books, with dummies hiding the vertical supports for the shelves and empty spaces filled with joke titles on the spines of the books. The set of gilt busts is original.*

88. *The classical library at Arbury Hall, Warwickshire. A watercolour painted in 1751 by Lady Newdigate's sister, it is an exceptionally rare kind of view showing Sir Roger at his desk and Lady Newdigate doing her embroidery, but both off the oriental carpet. The design of the room suggests a date in the 1730s, so an unrecorded early commission from Sir Roger, who was converted to the gothick style in the late 1740s.*

filled all three bays to the right of the hall, being divided into two sections by a screen of paired columns. According to the plate in *Vitruvius Britannicus*, the back wall in the first section was filled with a tripartite pedimented bookcase, which must be one of the earliest of its type, while in the second section, between the doorcases was a narrower pedimented bookcase, both being close to the manner of William Kent.[187]

Kent's fitting-up of Sir Robert Walpole's study at Houghton (Fig. 223) is the earliest surviving, highly architectural room of its kind in England, combining a complex design with ingenious use of the limited space. In the 1730s Kent designed a large library at Devonshire House, London, of which little is known except for its centre tables, now at Chatsworth. At about the same time, he designed two of his finest rooms, the library for Lord Leicester's own use at Holkham (Fig. 440) and Queen Caroline's library at St James's Palace, only recorded in his designs and later views. Indeed, the Holkham library is the earliest one to survive intact that explains why such a room was favoured for living in by men and women. The rows of leather bindings providing the warmest and most calming of backgrounds even when one is not drawn to browse among them. Kent's last recorded library is that added at Rousham, a double-height room that retains its gothick ceiling, chimneypiece and overmantel (Fig. 223) but not its bookcases. It has the character of a great room, and in this it invites comparison with the library at Newhailes.[188]

There, the library wing, which had been added on to the house by Sir David Dalrymple in 1719–20, was not finished when he died in 1721, and it was left to his son, Sir James, to embellish it and make it into the great room of the house in the early 1740s. In 1743 Sir James installed a new marble chimneypiece and plaster overmantel by Thomas Clayton to frame Medina's portrait of his father and himself when young, new doorcases and overdooors, and the same year he bought one of the earliest documented library desks from Sam Smith in London.[189]

Another intriguing library was formed at Powderham in the late 1730s by Sir William Courtenay, later 1st Viscount Courtenay. He had inherited in 1735 at the age of twenty-five and soon began to plan alterations that included the library and the new staircase with its extravagant plasterwork. The room still survives, but it has lost its original ceiling put up between June and November 1739, and its only features *in situ* are the continued chimneypiece in brown and gold that frames a bolection moulding and a strange screen over a pair of doors. Now in another room are the spectacular of pair of bookcases made of padouk wood with carved and gilded decoration and brass inlay that are dated 1740 and signed by John Channon, to whom payments were made that year. The great broken pediments and columns are without parallel in English furniture, but, just as Channon looked at Berain prints for some of the inlaid ornament, he may have adapted the pediments from one of Rossi's prints.[190]

A contemporary library not by a London designer is Lord Tyrconnel's in the family part of the house at Belton (Fig. 87), which was fitted up between 1721 and 1737. Country work, it was probably originally painted a dull green or green stone colour quite close to what exists today, and at the top of the east and west walls of books are rows of eight arched openings containing gilt busts listed there in 1737. Great care was taken with the arrangement of the books, with dummy spines hiding the vertical supports of the shelves. Philip Yorke noted in 1755: 'in order to fill up the vacant spaces on

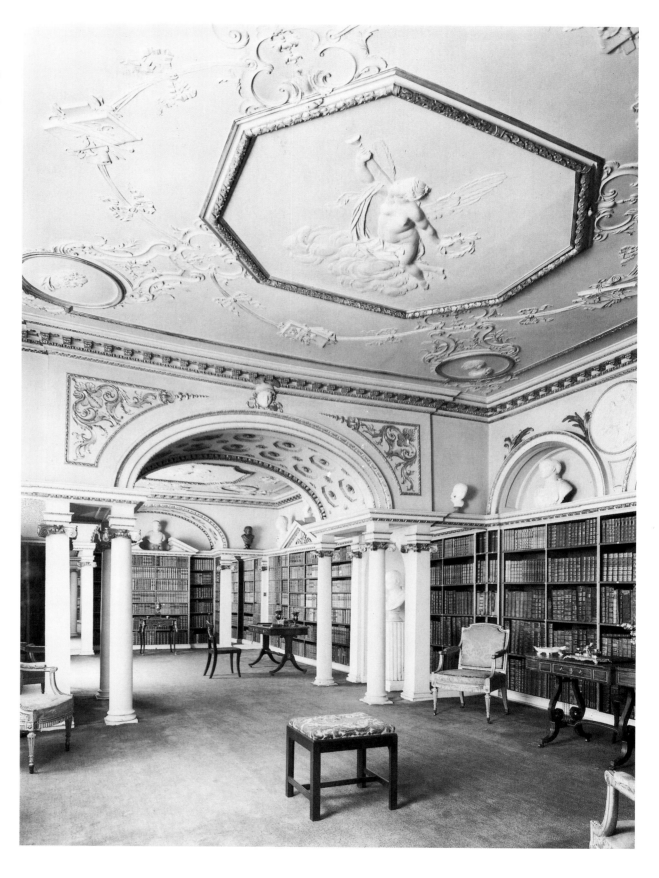

89. *Thomas Anson's library at Shugborough, Staffordshire, as it was in 1954. A bachelor dilettante's sanctum formed out of two rooms in the mid-1740s. Opening off the entrance hall, it was probably always the favourite sitting-room of the house. The plasterwork appears to be by Francesco Vassalli.*

the shelves he has invented titles for books that are carved in wood, as Standstill's *Travels*, Block's *Thoughts*, *Short Procedings in Chancery*, Dennis on the *Dunciad* etc'.[191]

That room can be compared with the contemporary classical library at Arbury painted by Mary Conyers in 1751 (Fig. 88). That has an entablature and pilasters with shelves for books as seen in Marot's print of William III's library at Het Loo and at Badminton, which suggests it may have been designed by Francis Smith of

Warwick (died 1738); but with a Gibbsian chimneypiece and overmantel that have the look of London work. Sir Roger Newdigate is shown reading at a sloping-topped desk like the one in Devis's later portrait of him in his gothick library; and the desk is placed at right angles to the bookshelves, off the carpet. Lady Newdigate is seated in a wing chair, doing her needlework, as if the room was their everyday sitting-room, and she, too, is off the carpet. The placing of the furniture means that the carpet had to be placed off-centre in

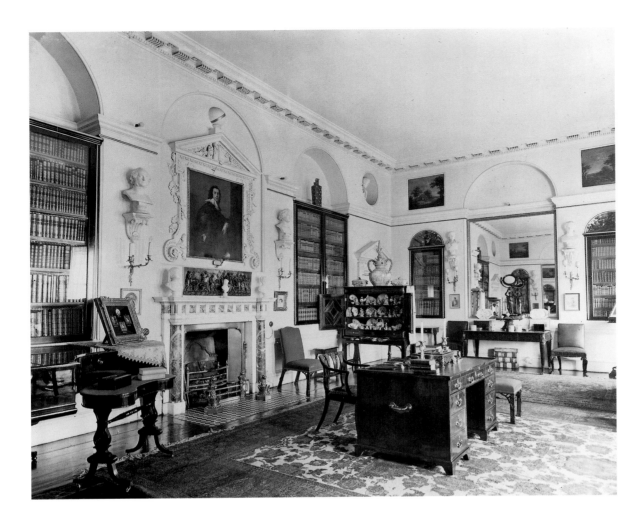

90. *Harleyford Manor, Buckinghamshire, a villa designed by Sir Robert Taylor in 1755. The library, as it was in 1910, was the largest of the rooms and evidently planned as the everyday sitting room of the house.*

91. *Harleyford Manor, the plan of the main floor showing the relationship of the library, drawing-room and dining-room.*

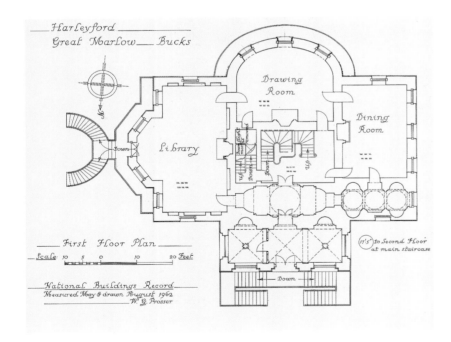

the room: that appears to be deliberate, not a weakness of drawing, and raises the question as to how important it was thought to reveal the complete design of an oriental carpet and not subject it to concentrated wear.[192]

The library at Temple Newsam is rather out of the way at the end of the north wing beyond the gallery, but for that reason was probably designed in the early 1740s by Daniel Garrett to make a final powerful architectural statement. It has a bold Corinthian order

standing on an oak dado and with a complete entablature articulating the room, three-quarter columns framing the two deep window reveals and the fireplace, and half-columns dividing the bookcases into bays. Bronzed plaster busts are shown standing on the entablature over the three-quarter columns. In the centre stands the double-sided library table attributed to William Hallett, which makes it among the early examples *in situ*.[193]

Two other contemporary libraries are at Kirtlington (Fig. 405), designed by John Sanderson, and at Lydiard Tregoze, Wiltshire, which has so many parallels that it is tempting to suggest that Sanderson provided the design. Both open off halls and appear to have been library–living-rooms. The Lydiard room is equally architectural, with a continued overmantel over the chimneypiece flanked by blocks of shelves made in three parts, the centre sections with broken pediments framing busts advancing like breakfront bookcases so as to give subtle movement to the room.[194]

The design of the bookshelves can be compared with those in the library at Shugborough (Fig. 89), which was completed before 1748 for Thomas Anson, apparently to the design of Thomas Wright. He balanced the north wing containing the great room with another for Anson's own use, with the library as the link with the main house. It is in two sections, one part occupying the space to the left of the entrance hall in the old house and the other in the link to Anson's own rooms. The join was imaginatively disguised by the deep coffered arch carried on two pairs of Ionic columns and pilasters. The arch, only 8 feet high, is repeated at half the depth at the south end of the room, where it frames a bookcase. The complex room has the feeling of a scholar's sanctum, as befitted its

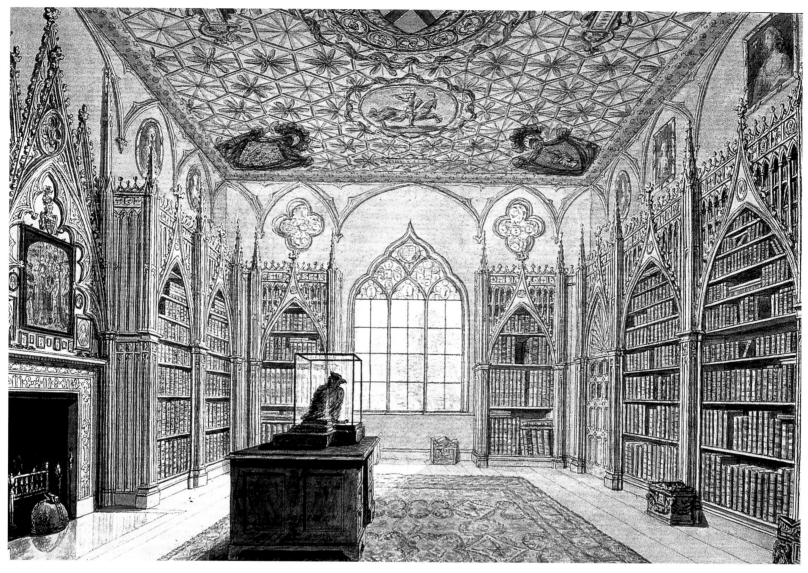

92. *The library at Strawberry Hill as recorded by John Carter in 1784. The original design by Richard Bentley was refined by John Chute and the room was decorated in 1754. The heraldic ceiling was painted by Andien de Clermont and the bookcases were originally a stone colour.* Lewis Walpole Library, Farmington.

creator, a bachelor of scholarly tastes who belonged to the Society of Dilettanti, but it, too, could have been a library—living-room.[195]

The increasing importance of the library as a living-room is well brought out in Sir Robert Taylor's plan for Harleyford (Fig. 91), a Thamesside villa in Buckinghamshire that he designed for Sir William and Lady Clayton in 1755. On the main floor are three principal rooms, a centrally placed drawing-room with a shallow bow on the central axis of the house, a dining-room at one end, and at the other a considerably larger library with a big canted bay and steps down to the garden. Presumably that was the main sitting-room of the house. Photographs taken in 1910 bring out the contrast in mood between the drawing-room, with its pictures in delicate Rococo frames over the chimneypiece and doors and rich plaster trophies on the tall panels, and the library (Fig. 90), with its subtle system of arched recesses of different depths and circular recesses for busts.[196]

As might be expected, the gothick style was adopted for libraries, but usually as studious places for the owner rather than as living-rooms of the house, as can be seen with Paine's library on the first-floor at Felbrigg that adjoined William Windham's bedroom, the

first-floor library at Malmesbury House, Salisbury, fitted up at an unknown date for the philosopher James Harris, the library at Strawberry Hill and the library at Arbury. The Strawberry Hill library (Fig. 92) was added on by Horace Walpole in 1754 in the upper part of the extension containing the Great Parlour, and its elaborate concept and fanciful detail was typical of the Committee of Taste's approach to design: it was John Chute's refinement and simplification of Bentley's earlier drawings based on Hollar's illustration of the choir screen in Sir William Dugdale's *History of St Pauls* (1658). The chimneypiece was based on a combination of the fourteenth-century canopied tomb of John Eltham, Earl of Cornwall in John Dart's *Westmonasterium* (1742) and from the tomb of Thomas, Duke of Clarence in Dart's *The History and Antiquities of the Cathedral Church of Canturbury* (1726). Yet in a typical Walpole way, the ceiling drawn out by Bentley with a display of Walpole heraldry devised by Horace Walpole was based on a newly published print from Wood's *Palmyra* and painted by Andien de Clermont, better known as a painter of *singeries*. The bookcases and chimneypiece are now painted white and the walls dark green, but that is contrary to Walpole's intention of both being stone-coloured, close in tone to

the colour of the painted ribs of the ceiling, thus creating a gothick unity. Sir Roger Newdigate was able to draw on his knowledge of that room when he came to design his own new library at Arbury in 1755, but he had the advantage of being a talented architectural draftsman who could make his own graphic notes of details of King Henry VII's Chapel at Westminster Abbey.[197]

The idea of the library table seems to have developed during the 1730s. In the library at Houghton is a special big double-sided mahogany writing table with drawers that is an English adaptation of a French form of bureau. For Lord Burlington, Kent produced a free-standing centre table indebted to the form of a triumphal arch, and for Lady Burlington a pair of related commodes (Fig. 248) in parcel-gilt mahogany with central recesses and drawers that look like two halves of a centre table but are also influenced by the idea of the bureau dressing-table. They were designed with pier-glasses to stand against the wall of her Garden Room and were carved by John Boson in 1735. These, however, are exceptional pieces, and by the early 1740s the form had become standardized, as can be seen from the library tables at Newhailes bought in 1743 and at Temple Newsam.[198]

Lady de Grey's letters describe living in such a room at Wrest in Bedfordshire soon after she married in 1740 and they appear to be the earliest references to one being lived in informally. At the age of eighteen she had married Philip Yorke, the son of the 1st Earl of Harwicke, who bought Wimpole from Lord and Lady Oxford, and two weeks later she succeeded her grandfather, the Duke of Kent. On 30 October 1744 she wrote: 'But my time in *devouring* (as you call it) is the long Evenings . . . In this last Week we have passed very quietly alone & sat every Evening mightily comfortably by the library

Fire.' Another letter written the same month describes how 'Our Residence is fixed in the library, & you may imagine us if you please, for Tea (that is for the Time is dark) till Supper, sitting on each side of the great Table with a Competent quantity of candles, Books & Papers upon it, & looking most profoundly Wise.' Catherine Talbot, who stayed with Lady de Grey 3in May 1745, wrote in her journal: 'Tea in the library Everybody reading or writing or Sleeping, just as they pleas'd.'[199]

Lady de Grey's description of sitting on each side of the great table leads on to the late eighteenth-century habit of sitting round a table in the middle of a room to share the light. That practice was to have a profound effect not only on the furnishing and planning of sitting-rooms, as can be seen in late eighteenth- and early nineteenth-century illustrations, but of all rooms by making people want a central focal point and often making them uneasy with large areas of empty space in rooms.

Obviously the history of individual room types should include bedrooms and dressing-rooms, and the subject could easily be expanded to fill a book, but even an outline chapter provides a basis for considering aspects of upholstery and decoration. That is done in chapters three and four. However, rooms also have to be looked at in sequences to show how their decoration and furnishing was designed to create both unity and variety. That is considered, first, in connection with parade rooms at Houghton designed by William Kent, in the second section of chapter five, and in eight other houses as a concluding chapter to the book. They show how use, or purpose in the case of parade rooms, underlay all the other decisions about decoration and furnishing in a much more ordered way than is current today.

# 3

*The Primacy of Upholstery*

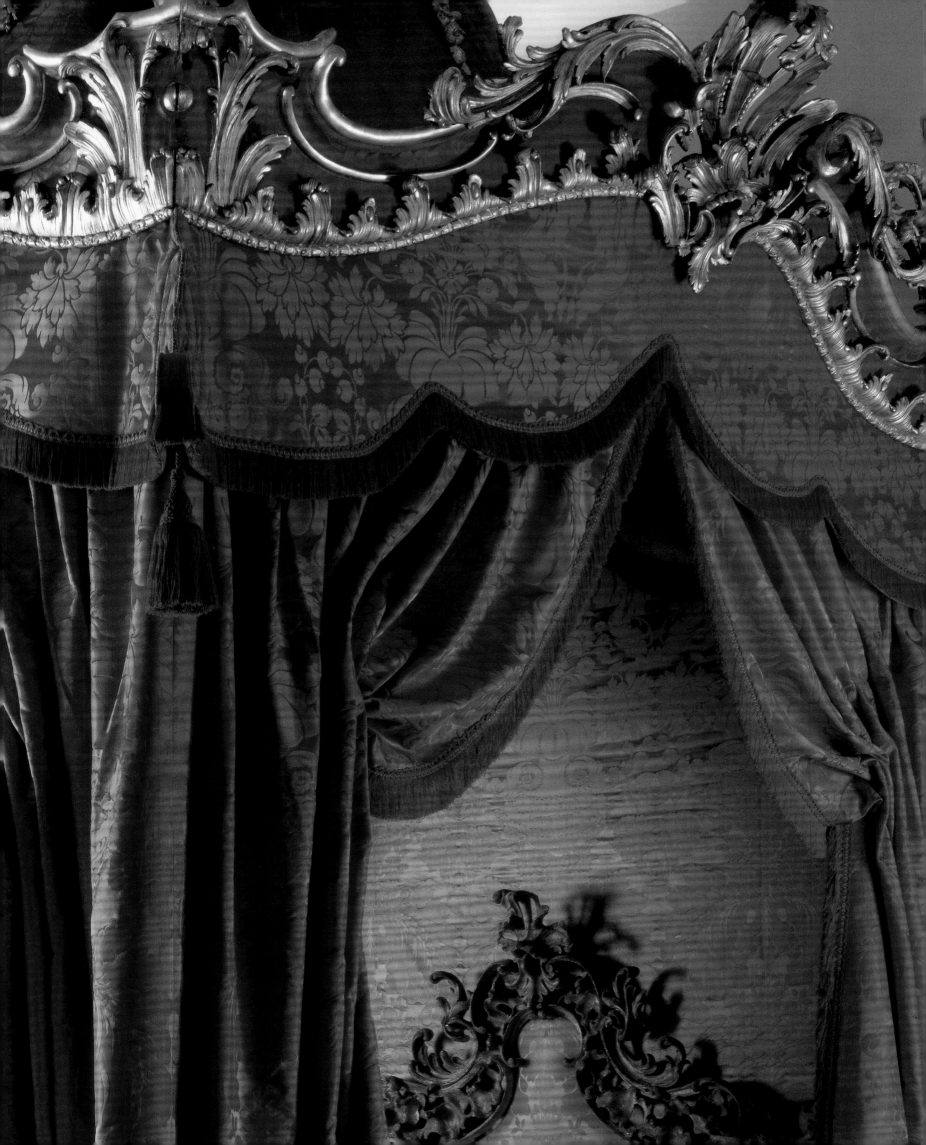

If the promoters of Baroque or Palladian architecture had to find a way of designing interiors and creating a new synthesis out of stated or implied orders, chimneypieces and doorcases, and of giving an architectural character to furniture placed against walls, that was only part of the challenge they faced. They also had to come to terms with the division in houses between essentially architectural spaces – halls, staircases and corridors – and rooms where upholsterers had established a dominant hold through the elaboration and costs of their work and needed to be brought under control.

If some of the rooms furnished about 1700 sound over the top today, the thoroughness of their planning is impressive and suggests that there must have been a degree of still undocumented collaboration between an architect like William Talman and an upholsterer like James Moore the elder, who played a crucial role in the completion of Blenheim. Both must have been familiar with Daniel Marot's approach to interiors, as demonstrated in his suites of prints such as *Nouveaux cheminées*, *Nouveaux livre d'apartments* and *Nouveau livre d' orfeuverie*, all published in 1703.

Talman is a particularly elusive figure, but at Chatsworth it is possible to sense his control over architectural design and decoration and his appreciation of sequences of spaces that otherwise can only be glimpsed in designs such as those for the halls and staircase in his unrealized ground plan for Kiveton.

Marot's prints provided a new kind of vocabulary of designs for decoration that did not have a comprehensive successor until Robert Adam produced the first volume of *Works in Architecture* in 1773. However, Marot, despite his appointment as *Architecte de sa Majesté Britannique*, remains the *éminence grise* of English interiors in the 1690s and early 1700s because, although he came over with William III a few years after he had fled from France, there is remarkably little documentary evidence of his work on interiors for the King and Queen or their circle, or contacts with French craftsmen in England, like Lapierre, and none with Talman. And he only emerges from the shadows in a handful of drawings such as those connected with the painted panels from Montagu House and now at Boughton and those relating to a set of narrow embroidered panels now at Hampton Court Palace. Yet prints like Fig. 93 and a design for a state bed like that in the Biblioteca Comunale degli Intronati in Siena suggest direct contact with Lapierre concerning beds like that from Melville House (Fig. 101), while the print of a dressing-room

(Fig. 330) suggests that he may have been involved with the conception of Vanderbank's chinoiserie tapestries (Fig. 331).[1]

Marot seems to have introduced a sense of control that went beyond upholstery and furniture to choices concerning the marbles used for chimneypieces and table tops and even to the material of andirons. Reading an inventory like that of 1727 for Kiveton, which must have been furnished when it was built in the years 1697 to 1704, is like following a musical score, with each room not only building up into a movement but forming part of a melody running through a whole apartment.[2]

It also brings out the relationship between materials and furniture in a grand house and the way colours, weaves and textures were considered in sequences of rooms. In the four-bay Great Dining-Room at Kiveton, where the chimneypiece was of purple marble and the walls were hung with tapestry, the inlaid walnut stools were covered in crimson velvet. Next, in the two-bay Great Drawing-Room, where again there was a purple marble chimneypiece and hangings of tapestry, there was a black and gold table with a purple marble top, and the black and gold seat furniture was covered in flowered velvet. That presumably included the settee illustrated by

93. *An engraved perspective of a state bedroom by Daniel Marot, about 1712. The treatment of the bed recalls that of the Melville bed (Figs. 101 and 102). The wall hangings with their flounced valances and vertical ruffles are exceptionally elaborate and the set of silver sconces hanging against them is unusually large, although comparable numbers are recorded at Castle Howard and Dunham Massey.*

94. *Cut velvet on a settee with a black and gold frame about 1700–5, photographed at Hornby Castle, Yorkshire, c.1900. It appears to be identifiable in the tapestry-hung Great Drawing-Room in the 1727 inventory for Kiveton.*

Percy Macquoid in *The Age of Walnut* as Plate VI (Fig. 94). Third came the two-bay Great Bedchamber, where the chimneypiece was white marble and there were more tapestry hangings. The bed was of green damask trimmed with silver, with carved and gilded seat furniture to match, and also a carved and gilt pier-glass and table. Thus the materials were not only considered in relation to the furniture in each room but as a sequence in the run of rooms.

However, as will be seen later, it was only in the mid- to late 1720s that William Kent, with his training as a painter, his study of Roman Baroque interiors and his understanding of ornament, achieved a new balance between architecture and decoration in England. Architects had to accept the continuing taste for tapestry, not only for its own sake but as a substitute for pictures. They also had to consider the increasing use of boldly figured wall hangings, often in sequences, particularly as picture collections grew. They had to bear in mind the great importance of principal beds, the increasing attention paid to window curtains and the taste for needlework. All were part of the role of upholstery in creating a sense of unity as well as richness of texture, pattern and colour.

At the same time, there was a belief in symbolism and a strong sense of hierarchy in the fitting-up of houses that is hard to appreciate today. While it is most obviously seen in the subjects chosen for painted decoration, as with all the Williamite allusions in the Painted Hall at Chatsworth (Fig. 18), it could be carried through into materials and colours, as is explained in the next chapter, into beds made out of canopies of state, as was the case at Kimbolton (Fig. 333), Blenheim, where according to the 1740 inventory the state bed was made out of 'two states one King Wm Arms the other Queen Anne', and Raynham (Fig. 95), where the bed is presumably made out of the 2nd Viscount Townshend's canopy provided when he was ambassador to the congress at The Hague in 1709–11. It also occurs in the placing of tapestries with military subjects as at Blenheim (Fig. 358) and Stowe.

In 1747, Campbell still wrote in *The London Tradesman*:

I have just finished my House, and must now think of furnishing it with fashionable Furniture. The Upholder is chief Agent in this Case: He is the Man upon whose Judgment I rely in the Choice of Goods; and I suppose he has not only Judgment in the Materials, but Taste in the Fashions, and Skill in the Workmanship . . . though his proper Craft is to fit up Beds, Window-Curtains, Hangings and to cover Chairs that have stuffed Bottoms: He was originally a species of the Taylor; but, by degrees, has crept over his Head, and set up as a Connoisseur in every Article that belongs to a House. He employs Journeymen in his own proper Calling, Cabinet-Makers, Glass-Grinders, Looking-Glass Frame-Carvers, Carvers for Chairs, Testers, and Posts of Beds, the Woolen-Draper, the Mercer, the Linen-Draper, several Species of Smith, a vast many Tradesman of other mechanic Branches.[3]

Like a successful decorator today, he had to be a dictator and dominate his customers. Lady Cust experienced that in 1743: 'I have been at a great upholsterer's to-day – he sais he has not made any furniture of mohair this year, so I believe I shall be afrayed to buye it but when my horses come I will go about more.'[4]

Her reference to mohair is a reminder that the upholsterer supplied the finer woollen materials of which a very broad range were used in the early eighteenth century. They started with damasks and mohairs and went down the scale to moreens and harateens, calimancos, camlets, serges and tammys, as can be seen in the Canons inventory; and these cheaper plain materials were often glazed, watered or embossed with a pattern. However, upholsterers did not have sufficient capital to invest in more expensive silk materials, which were bought by patrons from mercers, who needed a great deal of capital for their businesses. The amount can be gathered from Campbell saying that while an upholsterer required £100 to £1,000, a carver of chairs £50 to £200 and a cabinet-maker £200 to £2,000, a mercer needed £10,000.[5]

Campbell wrote: 'The Mercer is the Twin Brother of the Woollen-Draper, they are as like one another as two Eggs . . . The Mercer deals in Silks, Velvets, Brocades, and innumerable Train of expensive Trifles, for the Ornament of the Fair Sex.' Ordering such materials from weavers has always been a complicated business, particularly if they are made abroad, and risky for someone not experienced in the trade. An unusual insight into that is provided in one of Lord Manchester's letters to the Duchess of Marlborough:

My Lord Rivers has two pieces making of yellow damask. he sent the pattern from England drawn upon paper. The only difference is that when it is a new pattern they must be paid for setting up the loom. If I might advise your Grace, I should think the best way would be to have several colours which you will have plain painted upon paper, with the breadth and quantities specified that will be wanting for each room and what ever you will have figured, and with several colours, the whole design must be sent, as it is always done, and then it will be made exactly as to your own mind.[6]

Today there is very little evidence about the relationship between owner, mercer and upholsterer, let alone the architect if he had to be considered as well. So it is impossible to tell who established the sequences of materials that were so important in setting the pace of great apartments in the first half of the eighteenth century, as can be

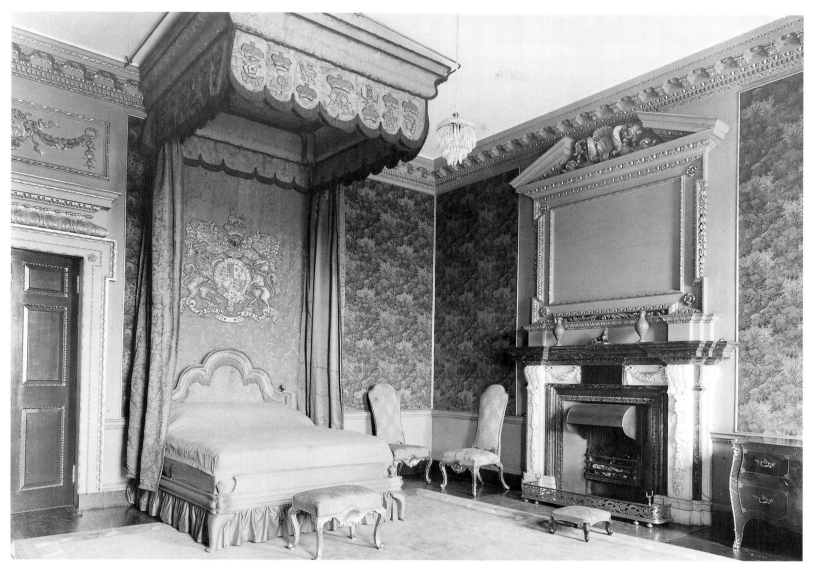

95. *The state bed at Raynham made out of the 2nd Viscount Townshend's canopy. Other examples of the reuse of canopies are recorded at Blenheim and could be seen at* *Kimbolton (Fig. 333) and still are at Scone Palace, Perthshire, Blickling Hall, Norfolk, and Knole, Kent.*

gathered from the inventories for Canons and Kiveton and what survives at Boughton, Houghton, Erddig and Holkham.

The dyer is a forgotten figure, but he has always been significant, because it is his eye for consistency of tone that explains why even today a specialist supplier's materials can have a distinct character. Campbell explained: 'In *London* there are Dyers of all Sorts; some dye only Wool, others Silk; some confine themselves to particular Colours, such as Scarlet and Blues; the Scarlet Dyer is by much the most ingenious and profitable Branch of the Dying Business; the best Dyes that are struck of that Colour are done upon the River *Severn*.'[7]

The cabinet-maker played second fiddle to the upholsterer until shortly before the middle of the century. That is a particularly striking feature of the Canons inventory, where in the principal rooms the upholstery was immensely expensive, as were the painted ceilings, the architectural gilding and certain kinds of imported furniture such as *pietra dura* tables. But even in the Duke and Duchess's own bedroom the furniture was of modest value: a pier-glass at £18, a japanned cabinet on a frame also £18, and a japanned chest £15, with a japanned card table at £3 and a pair of stands at £2 10s.; while in the Duchess's Dressing-Room a dressing bureau with drawers was valued at £3.[8]

Despite the researches of Geoffrey Beard and the rich documentation he published in his *Upholsterers and Interior Furnishing in England 1530–1840* (1997), English upholsterers in the early eighteenth century remain obscure figures because so little of their work exists today; Thomas Roberts, for instance, is only known through his surviving accounts of work for Sir Robert Walpole in his various houses in the late 1720s and early 1730s.

Three furniture-makers that are particularly tantalizing are the two James Moores, the elder (*c.*1670–1726) and the younger (*c.*1690–1734), and William Bradshaw (recorded 1728–75). In the case of the Moore the elder, what is significant is the way that he worked at Blenheim from 1705 and then at Marlborough House in London; and, remarkably, managed to satisfy that demanding and contrary woman over so many years. Initially supplying the glass for Blenheim in 1705, he was entrusted with the completion of the house after the dismissal of Vanbrugh in 1716. So he was more than an upholsterer and cabinet-maker and must have acted as an architectural decorator, fitting up rooms, as he also did at Harcourt House in London. Today that is hard to grasp, but there seems to have been a similar connection in the fitting-up and furnishing of the Lady's Drawing-Room at Chicheley, which will be discussed later.[9]

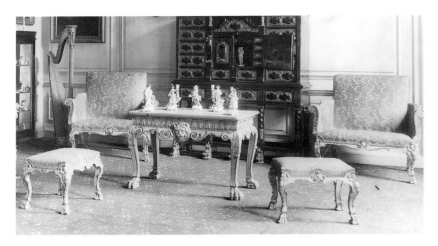

96. *A gilt gesso suite of seat furniture with brocade covers in a pattern of gold, silver and pink of about 1720 photographed at Glemham Hall, Suffolk, in 1910. The set was later recovered in a copy of the material by the Victoria and Albert Museum and is now loan to Ranger's House at Blackheath.*

97. *One of a set of twelve mahogany chairs with tapestry covers supplied by William Bradshaw to Chevening, Kent, in 1736–7.*

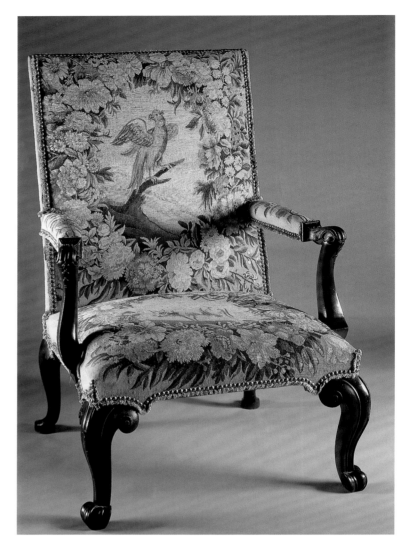

Moore is first recorded in partnership with John Gumley, the looking-glass seller, in 1714, and is particularly associated with elaborately carved and gilt gesso side tables and stands made early in George I's reign. As well as examples in the Royal Collection, there are closely related tables made between 1714 and 1718 for Stowe (now in the Victoria and Albert Museum) and formerly at Glemham Hall, Suffolk (now on loan to Ranger's House at Blackheath, London, Fig. 96), three designs of originally differently finished pier-tables at Blenheim (Fig. 355), including one with a Vitruvian scroll frieze, and, among other attributions to him, the Bateman (now Victoria and Albert Museum), Boughton, Port Eliot, Stowe and Treasurer's House, York chests (the former also in the Victoria and Albert Museum).

He also supplied a number of grand gilt chairs like those at Blenheim, illustrated by Percy Macquoid in *The Age of Mahogany*, Fig. 30. They have a distinctive profile to the front legs, with a pronounced upper curve, an exaggerated sweep to the back legs and a subtle curling 'S' and twist to the arms. That can also be seen in the gilt gesso seat furniture relating to the Glemham table, now covered with a copy of the original sumptuous brocade with two kinds of gold thread on a salmon-pink ground which must have been woven between 1717 and 1723. Comparable details are found on other special chairs of the time, like the set thought to have belonged to the Duke of Chandos and now in the Marble Parlour at Houghton (Fig. 221) and a set of parcel-gilt walnut chairs upholstered in crimson velvet that were originally in the Best Bedchamber at Stoneleigh and are more likely to have been supplied by the younger Moore. Two other groups of related chairs are probably from Harcourt House, Cavendish Square, London and at Berkeley Castle, Gloucestershire (Fig. 273). Thus the Moores' name is associated with a number of key pieces of furniture that suggest the nature of the grand style in England just at the moment when William Kent became interested in the challenge of furnishing parade rooms. At present it is difficult to separate their work, because James Moore the younger was appointed cabinet-maker and chairmaker to Frederick, Prince of Wales in 1732 and died two years later.[10]

William Bradshaw seems to have covered most branches of the trade, upholstery, cabinet-making and tapestry weaving; and it is probably not chance that he is first recorded when he moved into the workshop of the tapestry weaver Joshua Morris in Frith Street in 1728: within a decade, he was established as one of the leading figures in his field. His earliest recorded commission was at Chevening, Kent in 1736–7, where as well as supplying furniture (Fig. 97), he organized joiners, painters and japanners. In the late 1730s and early 1740s he seems to have been responsible for much of the furnishing of the Family Wing at Holkham, including completing a set of Vanderbank tapestries for the Family Bedchamber and the furnishing of the rooms of parade at Ditchley (Fig. 393).[11]

Little, however, is known about how he and other upholsterers employed special carvers like James Richards, John Howard, John Boson and Matthias Lock and chairmakers like William Hallett on furniture commissions. In the mid-1740s Bradshaw was involved with the new Tapestry Drawing-Room at Ham House (Fig. 68), providing not only the tapestries, which he signed, but a pair of carved and gilt pier-tables with marble tops and oval glasses with detail in harmony with the seventeenth-century garlands reset at the top of the panels. He also put up the new hangings and made paper hangings to go over them, as well as crimson lustring scarves for twelve chairs and two settees. At Longford in the years 1737–50 he seems to have collaborated with or worked alongside Benjamin Goodison, who was first recorded working for James Moore the elder in 1720.[12]

Matthias Lock is a particular mystery, because, although he is

98, 99. *A pier-glass and table made by Matthias Lock for the 2nd Earl Poulett for the Tapestry Drawing Room at Hinton St George, Wiltshire, mid-1740s. It is not known whether Lock was working directly for Lord Poulett or, more likely, as a subcontractor for an upholsterer like Bradshaw. Both pieces were originally water gilt, but then refinished in the Regency period and are now oil gilt.* Victoria and Albert Museum.

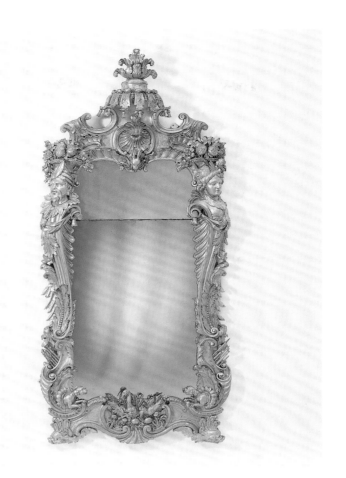

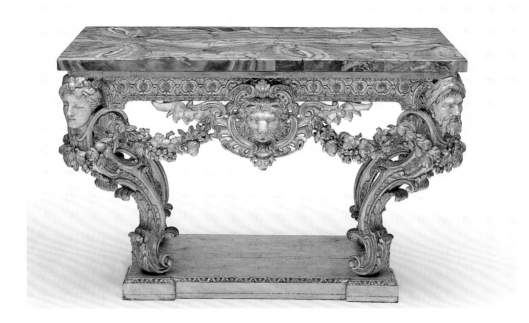

known through his trade card and his published designs, which start in 1740 with *A New Drawing Book of Ornaments,* very few payments to him have been found. Through his surviving sketches he first appears, probably working for Bradshaw, on the carving of the side tables for the dining-room at Ditchley (now at Temple Newsam) that were designed by Flitcroft in 1741.[13]

Then he emerges as an independent artistic personality in his spirited carving of the glass and pier-table (Fig. 98, 99) and the related pair of stands made for the Tapestry Room at Hinton St George in Wiltshire for the 2nd Earl Poulett, who inherited in 1743. It is not known what Lord Poulett paid for them, or who supplied

them to him, but Lock's sketches record the amount of time spent on their carving and its cost; though he does not mention the gilding, which may have been done by another specialist. The original carving of the glass frame cost £34 10s. and took 138 days' work, with Lock himself doing twenty days. The table only cost £1 5s. 5d. for the joiner's contribution, but £21 for the carver's, with Lock working on it for fifteen out of the eighty-nine days. All four pieces have a Baroque exuberance to their conception that is unrivalled in England, while their detail shows his debt to French engraved designs.[14]

With his designs for *Six Sconces* of 1744 and for *Six Tables* in 1746,

Lock became the key Rococo designer in England, anticipating the work of Chippendale; and his influence can be seen in the work of Houghton and Kelly in Ireland (Figs. 79, 80) and in Gideon Saint's book (Fig. 266). Indeed, his designs of the 1740s and early 1750s continued to be reissued in the late 1760s.

Paul Saunders (1722–71) is also a shadowy figure as an upholsterer, chairmaker and tapestry weaver. He seems to have made some good contacts in his late twenties when he was working for the Duke of Somerset at Petworth, and seems to have been the moving spirit in his firm, but in 1756 he ended his partnership with George Smith Bradshaw, an uncertain connection of William Bradshaw. However, he continued weaving tapestry, attempting to make a success of new designs and styles, as well as being a specialist in elegant chair frames and doing upholstery. He is not recorded supplying elaborate carved and gilded glasses and tables, like Linnell, Chippendale, Whittle and Norman. For instance, at Hagley he supplied the French chairs with tapestry covers for the Tapestry Drawing-Room (Fig. 414), but not the glasses and pier-tables that go with them (Figs. 416, 418). In the mid-1750s he supplied not only tapestry to complete the set in the state bedroom at Holkham (Fig. 451) but also the sets of carved mahogany and parcel-gilt seat furniture for the sculpture gallery (Fig. 453) and the dining-room (Fig. 458). Thus he continued to combine a variety of trades.[15]

The connection between an upholsterer and a supplier of looking-glasses has also to be born in mind, but there is not a great deal of evidence about it. The earliest surviving example of a series of glasses in a great apartment is that by Gerrit Jensen, dating from about 1697–8, in the King's Rooms at Hampton Court Palace, where they play their part in creating a sense of increasing richness. A similar progression might be expected in the state rooms at Chatsworth, but they are not found there; nor is there any record of where the 1st Duke of Devonshire placed the two great single glasses with his arms in their arched tops that were supplied by Gumley in 1703.[16]

The first group of glasses in a great house that could give a sense of a sequence are those at Blenheim associated with James Moore and supplied before and after 1720 for the private rooms and Great Apartment (Fig. 355); but they have been moved around in the house so it is difficult to work out how they were originally arranged and which were fully and which parcel-gilt. However, the idea can be seen in the sequence of glasses bought for Erddig in the early 1720s (Figs. 363, 366).

The development of the pier-glass also needs to be related to that of the pier-table. At Hampton Court, sets of carved and gilt tables, with and without stands, were supplied by Pelletier to go below the glasses against the window piers in the King's Rooms, but they are not related to them in design. The earliest glasses and tables with related carved and gilded frames are those at Blenheim.

Among Gibbs's drawings in the Ashmolean Museum (Fig. 28), there are a few for glasses and tables, as for the Great Room at Fairlawne, but in the early 1720s they were still rare. At Erddig, for instance, the gilded glasses in the saloon had walnut tables below them, and the silver gesso glass bought for the drawing-room had its table added later (Fig. 366). Yet at Houghton (Fig. 199), furnished only a few years later, all the principal rooms have related gilded pier-glasses and pier-tables.

Thus carvers and gilders appear to have been a step behind japanners, because there are sets of japanned, lacquer and other fan-

cily finished glasses and tables and stands dating from the 1680s and 90s. At Belton, for instance, by 1698 there were glasses and tables with japanned frames and matching stands in the Great Parlour, but they must have disappeared into the shadows of the window piers on the north wall; and understandably they were exchanged for gilt-framed glasses by 1737.

At Kiveton, glass frames were finished not only to match table frames but also those of the seat furniture and/or upholstery. In the Best Dressing-Room, the chimney glass had a red and gold japanned frame that related to the crimson and gold upholstery. In the Best Closet, which may have had an oriental character because of its 'Indian Sattin' hangings and upholstery, the chimney glass had a black and gold frame to match the mouldings to the hangings and also the frames of a large couch and four stools. Similarly, in the Best Dressing-Room at Canons the silver gesso frame of the glass presumably echoed the silver ground of the crimson flowered velvet used for the hangings and the silver lace used to trim the covers of the chairs.[17]

The desire for unity also extended to the way verre églomisé was sometimes used, with the borders of crimson, green, yellow and blue glass being considered as part of schemes of decoration. Again the Kiveton inventory of 1727 provides rare evidence: verre églomisé are listed in the South-East Drawing-Room, on the second floor close to the Great Apartment, and in the North-East Drawing-Room on the first floor. In the South-East Drawing-Room there was a looking-glass in a green and gold glass frame, and green caffoy was used for the wall hangings and seat upholstery, with the festoon curtains being of green persian. In the North-East Drawing-Room there was a startling scheme in purple and gold, with three large glass sconces and a looking-glass with purple and gold glass frames, six panels of purple and gilt leather hangings and purple and gold velvet cushions on the ten cane chairs.[18]

References to the use of coloured japanned furniture are equally rare. Little survives in situ or is even documented, so it is hard to relate examples to schemes of decoration. However, once again the Kiveton inventory provides an example with the red japanned chairs in the Best Dressing-Room: they related to a fixed chimney glass in a red and gold frame, four pieces of crimson tabby hangings with eight panels of crimson and gold damask, and curtains of red sarcenett. Perhaps they provided strong contrasts of colour, as at Canons and Erddig (see pp. 270–1).

Black japanning was more common, but even so unified schemes are hard to pin down. In the Best Closet at Kiveton there was a chimney glass in a black and gold japanned frame, a couch and four large stools with black and gold japanned frames, and similarly treated mouldings to the panels of Indian satin on the walls.

Such a scheme would have involved London suppliers, but big country houses were remarkably self-sufficient as far as upholstery was concerned. At Burghley in the late seventeenth century, Thomas Stretch was house steward and tradesman upholsterer, and he arranged everything with Lord Exeter while his master was abroad. Samples of materials and trimmings winged their way back and forth across Europe. In 1701, Anne, Duchess of Buccleuch took her London upholsterer, Benjamin Sydney, when she went to live on her Scottish estates and remodelled Dalkeith Palace. There, he acted as groom of the chambers and was paid £15 a year, ranking after the steward with £50, the cook with £25 and the clerk of the kitchen with £20, but above the butler, who got £10. The 2nd Lord

Nottingham's instructions for servants at Burley-on-the-Hill said of the groom of the chambers: 'You must be carefull of the furniture, brushing and cleaning every morning that wch is in constant use, and the rest also once in the week or oftener if need be. . . . He is no other use than to take upon him the business of upholsterer. Unless he has been brought up to that trade I think he can know but little of the matter.' At Canons, the upholsterer ranked considerably higher than the cabinet-maker: he ate at the table of the senior members of the household in the dining-room, while the cabinet-maker ate in the servants' hall.[19]

## BEDS AND CURTAINS

The greatest challenge to upholsterers was in the devising and execution of beds; and it is astonishing how many survive in whole or part from the late seventeenth and first half of the eighteenth centuries in historic houses or museums in Britain, but conversely how rare are simple beds hung in woollen materials and cotton. Indeed, the grander ones provide a marvellous picture of the achievement of upholsterers, particularly when they retain their original related seat furniture.

The valuations put on some of these beds was huge, as can be gathered from the Canons inventory of 1725. That unusually full document gives a unique insight into the priorities of expenditure, not only on the furnishing of rooms but their fitting-up and on pictures; it also shows how expenditure was concentrated in a very few rooms. The difference between the Best Bedchamber and Dressing-Room, and those of the Duke and Duchess of Chandos and of their son and daughter-in-law, Lord and Lady Carnarvon, are striking, as is the gap between them and the lesser bedrooms in the house.

The Best Bedchamber had a bed hung with rich crimson flowered velvet on a gold ground, and two pairs of window curtains, presumably of the same stuff, bordered with rich green and gold brocade and trimmed with a rich green and gold fringe. There were also four elbow chairs, eight back stools and two square stools upholstered to match. Together with the bedclothes and quilt embroidered in gold, they were put down at £844. The room was hung with three pieces of tapestry with gold and silver thread measuring 90 ells, and at £5 an ell this was listed at £450. It also contained a large pier-glass at £80, a large chimney glass at £55, and a mosaic, table, presumably *pietra dura*, with a gilt frame at £250, all very large figures. There were silvered covings to the hearth, a steel hearth, but silver dogs, tongs, shovel and brush. The total, including the fittings and painted ceiling, came to no less than £2,358 4s. 6d.[20]

The Best Dressing-Room was done in crimson flowered velvet on a silver ground, with window curtains matching the hangings, and it contained ten chairs, a sofa and two stools trimmed with silver. These were valued at £650. There was a pier-glass in a silvered frame, put down at £110, another mosaic table at £250 and an India cabinet with a gilt frame at £50; and with the display of silver valued at over £970 and the fittings, the total for the room came to £2,616 8s.

After that, there was a big step down to the Duke and Duchess's Chamber, where there was a white satin, wrought bed bordered with 'attlas', which Florence Montgomery describes as a silk-satin from the East Indies. This was lined with green mantua silk. There were three pairs of window curtains, and also, unusually, three door curtains, together with hangings. The furniture consisted of six back

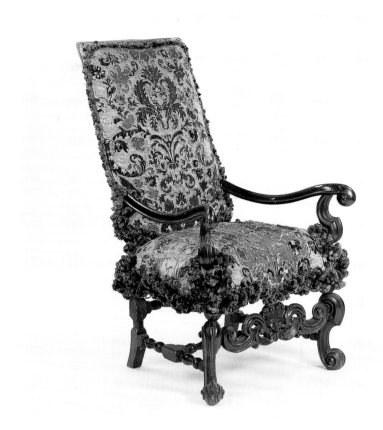

100. *A five-colour cut velvet on an arm chair formerly at Burley on the Hill, Rutland, about 1690. It was part of the furnishings of the state bedroom, now dispersed. The bed with one pair of the original chairs and stools are at Het Loo in Holland and another pair of chairs is in the Metropolitan Museum.*

stools, two elbow chairs and two square stools; and all that came to £400. The Duchess's dressing-room was done in yellow damask and had six japanned chairs, and was put down at £50, while in her closet was a red japanned secretaire with glass doors valued at £12. The Duke's dressing-room was also in yellow damask, valued at £60, and it had eight walnut chairs with inlay and banister backs and yellow damask pincushion seats at £26. It also had another large japanned secretaire with glass doors, valued at £25.

In Lord Carnarvon's Bedchamber, the bed was of chintz, presumably imported from India, and that, together with the bedclothes, window curtain and six chairs, was valued at £194. But, apart from a looking-glass and pair of sconces at £20, the rest of the furniture was valued very low: a walnut table and stands at £3, two matted stools at 8s., and a red japanned card table at £1 5s. On the other hand, the contents of his dressing-room were valued at £426 11s., partly because of the gold and silver embroidered hangings and curtains valued at £80, six silver sconces at £69 15s. and portraits of the Duke and Duchess of York by Lely at £70. Lady Carnarvon had a rich needlework bed, with matching hangings and four pairs of window curtains put down at £145; but again the other furniture was modest, with a card table at £2 and four square stools at £3 12s.

Below them in value came the Tapestry Chamber, with a crimson and green paned bed listed at £11; and the Green Damask Room, with a green damask bed with hangings and curtains at £32.

These descriptions and values help to put into perspective the range of fine materials that survive on beds. Among the most elaborate cut velvets are the once green and gold material trimmed in what was originally scarlet and white on the Venetian Ambassador's

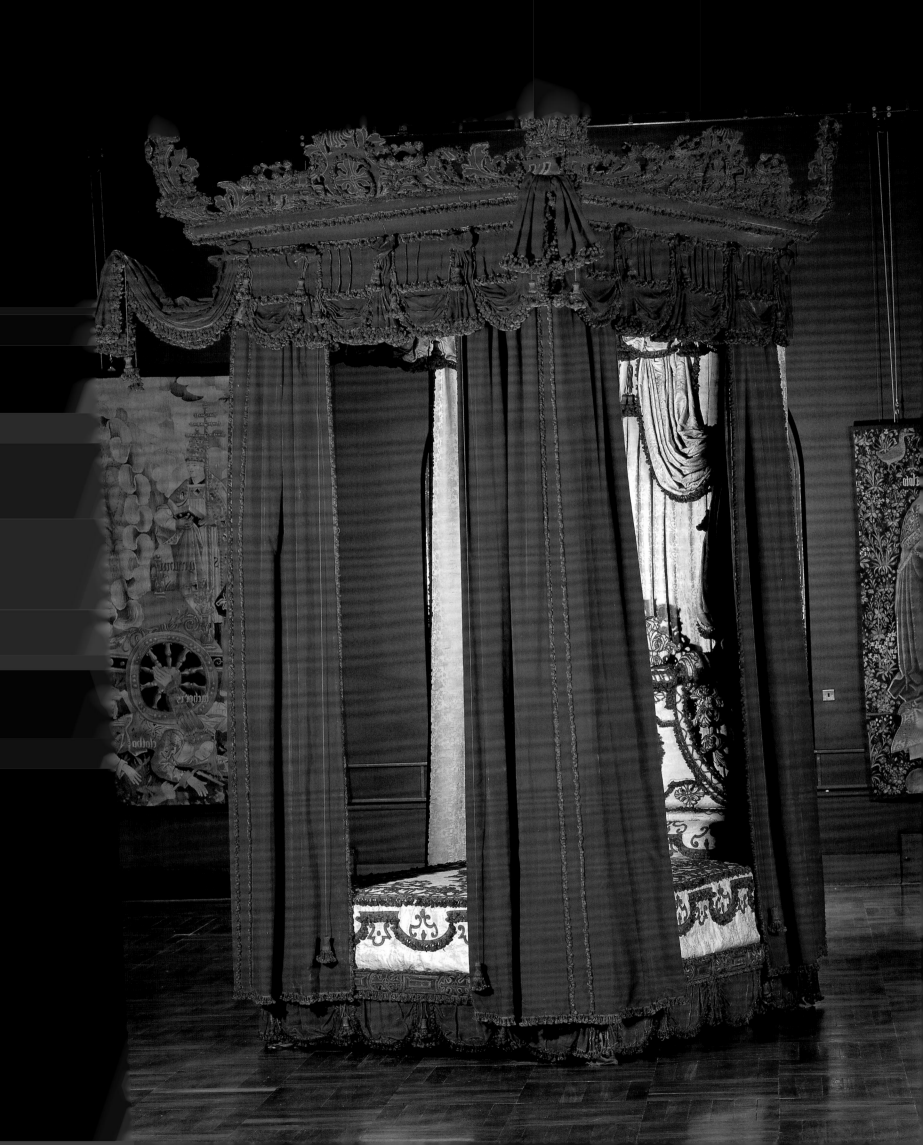

102. *A detail of the cornice showing the complexity of the pattern of the* passementerie *with its many widths of braid and tassel fringing.*

101. *The bed of crimson velvet lined with ivory Chinese damask of a trailing design of small flowers probably made by Francis Lapierre for Melville House, Fife, in the late 1690s. The tapestries that originally hung with the bed are illustrated in Fig. 332.* Victoria and Albert Museum.

Bed at Knole, made by Jean Paudevin for James II in 1688; the five-colour material with a white ground that is arranged with the stronger, darker colours in the centre of the design and yellow towards the edges so that it reads as a rich stripe on the bed formerly at Burley on the Hill, Rutland and now at Het Loo (Fig. 100), thought to have been used for the Countess of Nottingham's accouchement at Nottingham House, Kensington in 1693; and the crimson and gold on white satin supplied by John Johnson, a mercer, at 42s. a yard in 1714 as part of an order of 321½ yards for Queen Anne's bed, formerly shown at Hampton Court Palace.[21]

Among plain velvets, arguably the finest is the crimson velvet bed from Melville House, Fife, now at the Victoria and Albert Museum (Fig. 101). Standing 17 feet, 6 inches high, it is marvellously theatrical with its contrasts of still-unfaded crimson velvet and the now white but originally ivory lining of a Chinese damask in a trailing design of small flowers. It is curious how roughly the frame is made and how crudely the drapery of the head cloth and the false festoons on the valances are cut. On the other hand, the *passementerie* is dazzling, and it must have been a complicated task to draw out the design on the white damask, which had to be done at an early stage in order to calculate how much of the many different kinds of fringe and gimp needed to be made and how much silk had to be dyed for them. Unfortunately, no references can be found to the bed in the papers relating to the building of the house, one of the key new houses in Scotland in the late 1690s and early 1700s. Nor is there even a definite date for it. Recently, Tessa Murdoch has attributed its design to Marot and its making to Lapierre, suggesting that it was delivered in 1700, the same year as the tapestries (Fig. 331) were supplied.

Inevitably, little brocade of the period has survived on beds in country houses and there are few contemporary references to them except in the series of inventories for Boughton starting in 1697 that describe the earlier, possibly French, bed that Ralph Montagu reused there when he fitted up the Great Apartment in the late 1680s and early 1690s. The *trompe-l'œil* painting as opposed to carving of the cornice mouldings in those rooms suggests that they were fitted up with an eye on a combination of economy and speed, unlike those at Chatsworth, so it was not surprising he did not order a new bed but used one possibly twenty years old. On the other hand, the sequence of materials in the Great Apartment was carefully planned. Compared with beds associated with Marot and Lapierre, the form of the Boughton bed, which has recently been returned to the house, on loan from the Victoria and Albert Museum (Fig. 147), is simple and all the emphasis is on the sumptuous material, which is probably Italian. The complex pattern in gold brocade complements the figure in the crimson damask in a subtle way, and the material is skilfully cut, particularly in the tester, where it lines curved surfaces. That is now the best-preserved section of the bed, but inevitably, through decay and alterations over the centuries, the overall effect of the material is a ghost of what it was 300 years ago (Fig. 148).[22]

Among two-colour damask beds are those at Chatsworth and Wroxton (now in store at Aston Hall, Birmingham). The former replaced the original state bed by Lapierre, of which parts now survive in the gallery at Hardwick, and is thought to date from about 1730 and to be a perquisite of the 4th Duke of Devonshire as Lord Chamberlain to George II. It is lined in a matching plain silk and the valances are decorated with a gallon but no fringing.

Fine single-colour damasks appear on two beds hung in the 'artichoke' pattern, from Hampton Court, Herefordshire, now at Het Loo and the Metropolitan Museum, and on the Prince of Wales's bed at Hampton Court Palace, where again the damask was supplied by John Johnson, but in two widths, one of 24 inches at 28s. and one of 23 inches (Fig. 100). A remarkable sunflower pattern (Fig. 103) with an 82-inch repeat survives from the Leeds Castle bed, which

103. *A yellow damask with a sunflower pattern in a 6-foot repeat on the bed formerly at Leeds Castle, Kent, supplied between 1710 and 1719. The same pattern was used in a bedroom at Houghton in the mid- to late 1720s.* Victoria and Albert Museum.

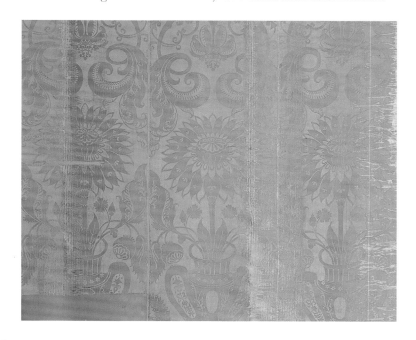

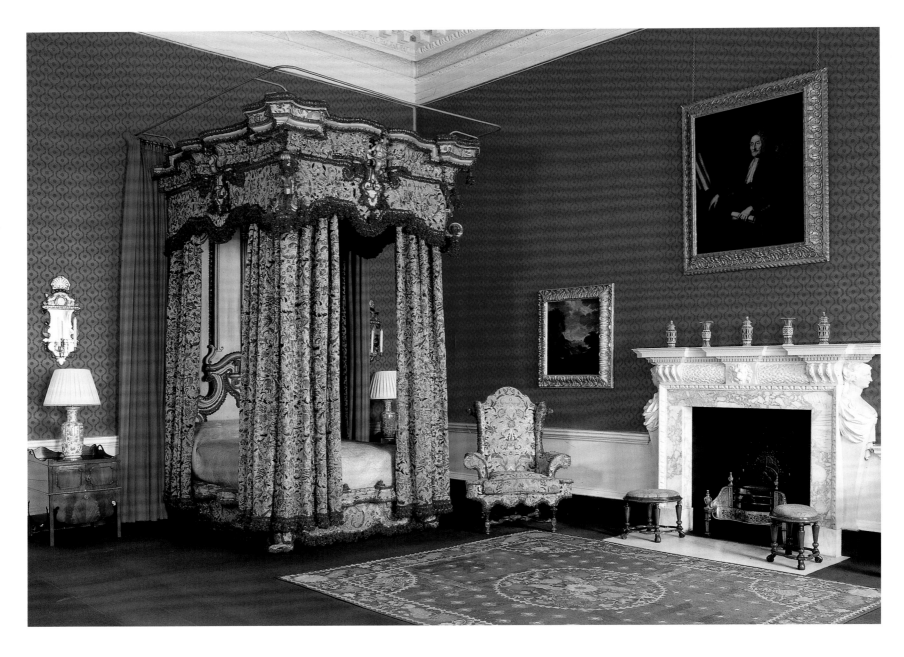

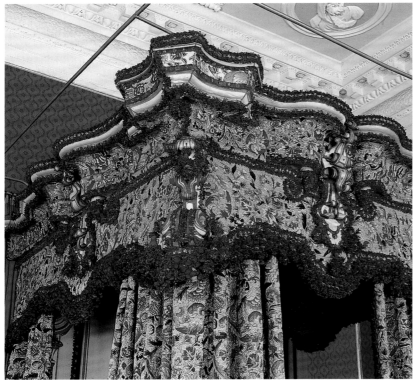

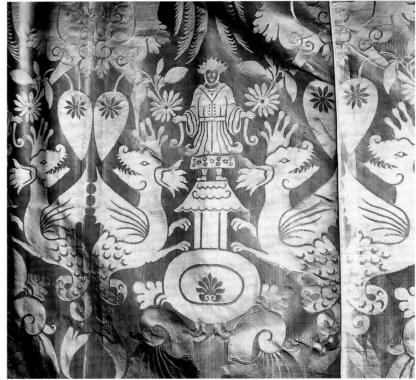

was supplied between 1710 and 1719 (now in the Victoria and Albert Museum), and is also recorded at Houghton, where it was originally used in one of the four principal bedrooms on the second floor.[23]

Among needlework beds, the finest today are those at Drayton and Clandon. The former was ordered for the mid-seventeenth-century state bed by the Duchess of Norfolk in 1700, when two needlewomen, Rebkeah Dufee and Elizabeth Rickson, agreed to make over 60 yards of embroidery for the bed at a rate of six shillings a yard. The bed itself, which was completed in 1701, is a surprisingly restrained design now attributed to Etienne Penson, and has green velvet curtains paned with panels of the embroidery and lined in yellow. Originally there were six chairs as well as a settee covered in similar embroidery. The Clandon bed (Fig. 104) presumably dates from about the same time and is entirely covered in embroidery, with lavish crimson tassel fringing, but no photograph can convey the extraordinary glow of its golden herringbone ground: it is as if it was embroidered on cloth of gold. With the bed go two large armchairs, six side chairs and also the original pair of pelmet cornices, without their valances.[24]

A special point about a tall bed hung in damask was that it provided an opportunity to show off a pattern with a long repeat that was recognizably expensive. A good deal of the cost of a new pattern arises from the time spent in setting up a loom in preparation for weaving, as Lord Rivers explained to the Duchess of Marlborough. That can be imagined with the elaborate chinoiserie design with a 9-foot repeat on the blue damask bed now at Milton (Fig. 106) and the 5-foot design in crimson originally used on the Hatfield bed (Fig. 107), which was supplied by Henry Strudwick in 1711 at a cost of 19s. a yard, coming to a total of £458 7s. 9d. A somewhat similar design, now in a faded green, survives at Newhailes, as patterns in panels in a dressing-room (Fig. 108) but surely originally used for a principal bed.[25]

The Newhailes pattern relates to a group of 'pillar and arch' designs that occur in different kinds of material, as can be seen with Queen Anne's cut velvet and the green cut velvet on the Londesborough bed now at Hardwick (Fig. 109), which is difficult to date because the cornices appear later than the design of the velvet. A version appears on the trade card of the Blew Paper Warehouse about 1720 (Fig. 111) that relates to a flock paper that appears paned with leather in a fragment from Ivy House, Worcester, now in the Victoria and Albert Museum, where it is dated about 1680 (Fig. 112), and also in a wool velvet or caffoy on chairs now in the Philadelphia Museum (Fig. 113).[26]

Sizes of repeat always have to be carefully considered when ordering materials for beds, wall hangings and curtains, to avoid cutting to waste; and measuring a room for hangings is skilled work. Little historical evidence about this survives, and the only contem-

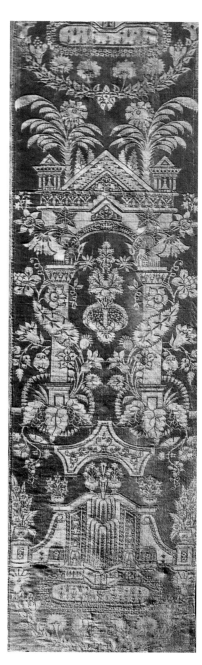
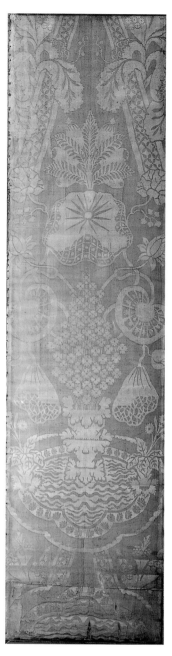

107. *A crimson damask version of a 'pillar and arch' pattern with a repeat measuring over five feet supplied for the bed at Hatfield House, Hertfordshire, made in 1711.*

108. *A faded damask of a related pattern surviving in a dressing-room at Newhailes but probably originally used for a bed, about 1715–20.*

porary reference is in connection with the hangings for the Cabinet at Felbrigg in Norfolk (Fig. 433), which, apparently unusually, were supplied ready-cut (see p. 312). At Houghton the calculation survives for the plain green velvet required:

> In the drawing room about 66 foot Compass of Hangings which will take about 38 breadths of Velvet 4 yds and ¼ deep. (161½ yards) Over the 2 doors 6 breadths 6 foot 6 deep over ye windows (13 yards) 12 breadths of window Curtains 5 yds Long. (60 yards) for the two window Vallans (17 yards) 12 chairs and two Settees', bringing the total to 280½ yards. The total for all the rooms was estimated to be 521¾ yards, and Sir Robert was told he needed another 316¾ yards; and 'The pieces run about 50 yds each'.[27]

Today it is rare to see old curtains or seat furniture trimmed with

104. *The needlework bed at Clandon with one of its pair of large armchairs. With it are six side chairs and pair of pelmet cornices. Presumably the bed made for the predecessor of the present house and treated as a historical relic from about 1770 when it was brought downstairs from the principal bedroom with the wallpaper in Fig. 121.*

105. *Detail of the Clandon bed showing the relationship of the coloured needlework to the golden ground.*

106. *The interior of a bed formerly at Wentworth Woodhouse, Yorkshire, and now at Milton, Northamptonshire. Detail of the blue damask with oriental motifs in a nine-foot repeat, about 1715–20.*

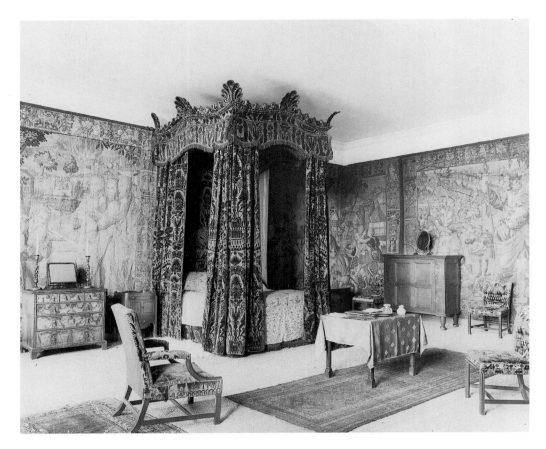

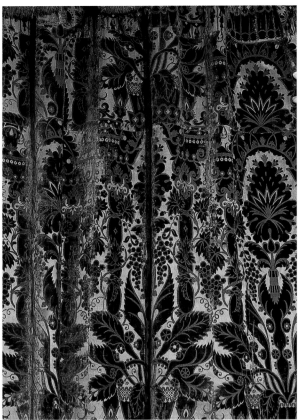

109. *The green cut velvet bed from Londesborough Hall, Yorkshire, now at Hardwick Hall, Derbyshire. While the pattern appears to date from the early eighteenth century, the style of the cornice and shape of the valances and the enriched knotted fringe suggest that the bed was made up for Lord Burlington in the 1740s.*

110. *A detail of the 'pillar and arch' pattern of the green cut velvet. The material has been much cut about leaving few complete repeats.*

111. *The trade card of the Blew Paper Warehouse, about 1720. The design on the left suggests a 'pillar and arch' pattern.*

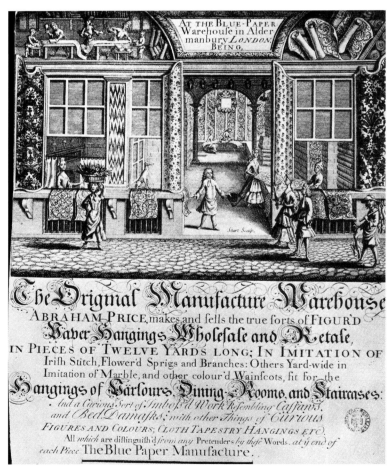

gold or silver lace that still has any sparkle, and the best example is in the Green Velvet Bedroom at Houghton, where the trimmings from Turner, Hill and Pitter used on the bed are itemized in detail and cost the huge sum of £1,219 3s. 11d. At Temple Newsam, the combination of crimson damask and gold lace can be seen in the tester of the Hinton bed, where the 'artichoke' pattern is combined with three widths of gold lace. The bed, which was ordered about 1710 by the 1st Earl Poulett, who was Lord Steward of the Royal Household from 1711 to 1714, originally had curtains and valances of crimson velvet enriched with gold lace and was lined with damask in the 'artichoke' pattern in a matching colour.[28]

There is similar scrolling in yellow silk braid rather than gold lace and combined with rich tassel fringing on the valances of the Dyrham bed. There, the curtains are made up with panels of yellow velvet set into shaped frames of crimson velvet.[29]

By George III's reign, such beds had gone out of fashion, as can be seen from Caroline Yorke's description of Wimpole in 1781: 'Most of it furnished in old style, for example Mama's & my rooms are brown wainscot, & the bed curtains & hangings damask laced with gold most dreadfully tarnished.'[30]

It is difficult to tell what was considered suitable for a man and what for a woman or a husband and wife. A rare exception is the

Duchess of Marlborough's choice of scarlet velvet for the Duke's bed and blue damask for her own. Similarly, at Wanstead, Lord Castlemaine's apartment was done in rich formal materials and had a bed in crimson damask, while Lady Castlemaine's was much lighter, being in '*China* Paper' and 'China silk'.[31]

Today, bed curtains are usually presumed to have been of the draw type, but by the 1750s there was a fashion for drapery or reefed curtains, as can be seen in Chippendale's plates and in a design for a bed for Hopetoun. They are now only seen in restorations, as on the Petworth bed (Fig. 114) and the bed in the Crimson Room at Nostell, which follows a drawing of the Paine period. The unusually fanciful Petworth bed with its carved, pierced and gilded cornices and gilded outline to its dome, thought to have been supplied by Samuel Norman and James Whittle in 1756, was made for the King of Spain's Room: it was hung with a crimson damask that had an 8-foot repeat bought from Robert Carr. In the 1764 inventory, the curtains were described as being 'to draw up'. When the bed was restored, evidence of the pulley wheels and cloak pins was found.[32]

Careful consideration was given to the linings of beds in schemes of decoration. Often they were of the same colour as the bed hangings, as with the Hinton bed, and, if different, they sometimes matched the window curtains. But they could also contrast in material, colour and scale of pattern, as with the white Chinese damask lining the crimson velvet Melville bed (Fig. 101). On occasion, when a bed had hangings of needlework, the window curtains matched the lining of the bed curtains. This is recorded in 1726 in the second bedroom on the first floor at Erddig, where the worked bed was lined with green satin that matched the window curtains and window seats. Similarly, the 1753 inventory for Narford taken on the death of Sir Andrew Fountaine lists in the tapestry-hung Red Bedchamber a red mohair bed lined with red silk, red silk draw-up window curtains, red upholstery and, unusually, a red silk *portière* to one of the doors; and 'all the Furniture is ornamented with silver lace round it'. In another room, the 'work'd Bed in worsted' was lined with green silk, and all the upholstery and window curtains matched that. It seems usual for the lining of a fine bed to have been in silk, and so sometimes more expensive than the outer curtains. The 1792 inventory for Houghton describes the bed in the Needlework Bedroom on the second floor as being lined with yellow silk, with yellow case curtains and yellow silk linings to the needlework window curtains. Similarly, the bed in the Painted Taffeta Bedroom was lined with green silk persian. (The bed curtains have been

*112. A red flock wallpaper of a similar pattern. It is paned with gilt leather and was found at Ivy House, Worcester.* Victoria and Albert Museum.

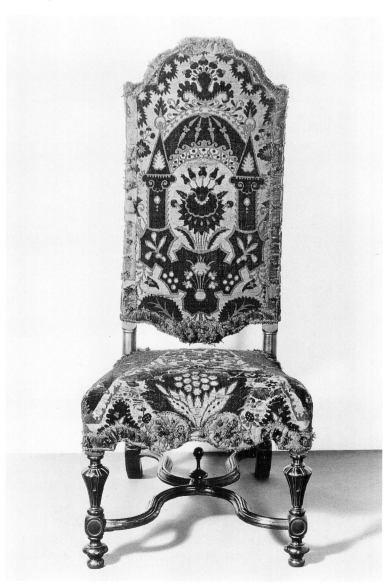

*113. A version of the pattern in a caffoy-like material on a chair of about 1715.* Philadelphia Museum of Arts.

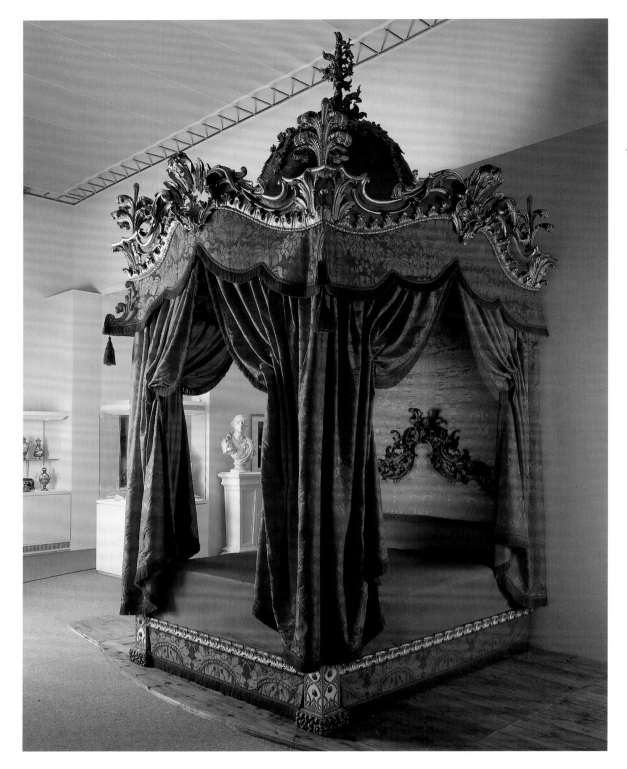

114. *The bed provided for the King of Spain's Room at Petworth House, Sussex, which adjoined the White and Gold Room (Fig. 64). Probably supplied in 1756 by Samuel Norman and James Whittle, a noted carver, it has an unusually elaborate carved and gilded canopy. It was originally hung in a crimson damask with an eight foot repeat and the curtains were reefed. The same pattern was used at Kedleston (Fig. 122).* Lord Egremont.

restored but the tester is presumably the original green silk.) Originally it had green case curtains and the window curtains were also lined with green silk.[33]

The frequent use of green for linings and curtains is striking and raises again its symbolic association with Venus and sleep.

The sense of grammar in linings can also be gathered from a letter sent by Paul Saunders to Lady Carlisle in 1753, when he was making a set of tapestries for the London house: 'The chairs cannot be finished till the window curtains are determined as the backs of the former as to colour must be governed by the latter as must also the fringe if any should be approved.'[34]

At Felbrigg, in the Green Bedchamber, where the bed was of green and red damask, possibly a mixed damask or a wool damask woven in Norwich, and the wallpaper was described as 'green

flowered', the lining of the bed was in green silk and the window curtains were of green lustring. Could it be that the bed hangings and wallpaper were of the same pattern? There are no documented examples of a damask and a wallpaper matching, but it seems likely that the flock paper of about 1740 in the state bedroom at Christchurch Mansion (Fig. 120) was chosen to match the original bed hangings.[35]

Invariably, valuable beds were protected by case curtains, as can be seen in Marot's design for a state bed in Siena and in the Houghton inventory of 1745, and formed part of the plan for a room. Usually they were of the same colour as the bed and window curtains, or sometimes of the same colour as the lining of the bed but in a cheaper material. Thus in the Green Velvet Bedchamber at Houghton, where the rod (often gilded in the early eighteenth cen-

tury) for the case curtains round the bed can still be seen in the 1920 *Country Life* photographs, they were of green silk. The bed in the Needlework Bedchamber also had case curtains of green silk, which matched the lining of the bed, while in two bedrooms on the second floor the case curtains matched the colour of the linings of the beds but were not silk.

The bed of 'Flowered Turkey damask' in the State Chamber in the Duke of Chandos's house in St James's Square was lined with buff-colour mantua silk, and there were buff silk case curtains and case covers on the chairs.[36]

One way of putting these beds into context is to consider sequences of materials listed in the bedrooms of certain houses, bearing in mind that 'attic' did not then have the pejorative meaning that it has today. In the mid-1720s, when the Duchess of Marlborough was going to Blenheim for ten days or a fortnight, she wrote: 'I shall almost fill the Attick Story with Friends.' At Houghton, Sir Matthew Decker wrote of the second floor: 'The atticq story is almost entirely finished, and clean and neatly furnished; all the rooms are 14 feet high; here are twelve good handsome bedchambers, four of which are pretty large. To ten of the bedchambers is a little room for a servant which makes it all compleat commodius, besides many closets for woods and other necessaries.' That account can be filled out from the 1745 inventory that shows how the rooms were graded in size, detailing and furnishing, with seven beds being thought worthy of case curtains. These were a bed in 'work't chints', one in yellow damask (of the Leeds Castle pattern, Fig. 103) at the south-west corner and, in one of the four principal rooms on that floor, a 'White Work't India Bed' of which fragments survive, one with 'work't hanging', the 'Painted Taffaty' bed that is still in the north-east corner room, a 'chints' bed and one of red damask in the room with 'Painted Dimothy' hangings (Fig. 127) on the west front. After them came beds of red mohair and calico, which had no case curtains and a number of smaller rooms where only the colours and not the materials are specified. Of Stretton Hall, the Conollys' Staffordshire house, Lady Louisa wrote in 1759 'there are three very good bed chambers, besides our own, upon the middle (floor) to put any body in, and in the garret you may almost put anybody, it is so comfortably furnished'.[37]

At Compton Place in 1743 there were two bedrooms on the ground floor, but the main ones were on the first floor, opening off the gallery. At its south end on the west side was the Green Damask Room, later called the State Bedroom (Fig. 115) and famous for its plasterwork attributed to Charles Stanley. It has a recess for the bed, with closets either side. The room had three panels of tapestry, six walnut chairs and two stools in green damask relating to the bed, all valued at £139 3s. 6d. Its dressing-room (Fig. 116) was hung with four pieces of Brussels tapestry of the story of *Don Quixote,* bought in 1730 by Lord Wilmington, and, because of them, the contents of the room were valued at £159 15s. 6d. That was balanced by the Yellow Mohair Room, later called the Duchess's Bedroom, where the contents were valued at only £61. There was also a Chintz Bedroom and a Yellow Damask Bedroom, whose contents were put down at £58 16s. and £36 6s., while in Lord Wilmington's own rooms there was only blue camlet and the contents were valued at £34 18s.[38]

These can be compared with the materials used in the bedrooms at Erddig. After the bed of oriental embroidery (Fig. 369) in the principal bedroom and the bed of crimson damask in the second

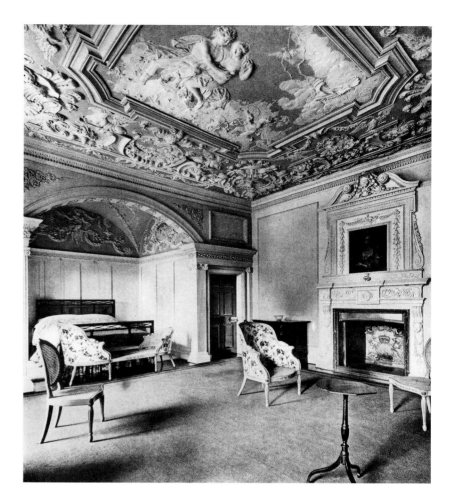

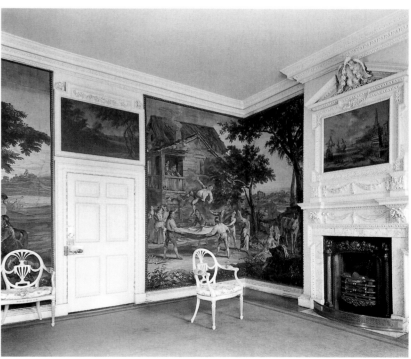

115. *Compton Place. The principal bedroom formed about 1728–9 and originally called the Green Damask Bedroom, as it was in 1916. The plasterwork was evidently by John Hughes who employed three 'Germans' to do the decorative elements, one of whom appears to have been Charles Stanley, an Anglo-Dane. The doors either side the recess for the bed led to closets.*

116. *The dressing-room to the principal bedroom hung with Teniers tapestries after Don Quixote, which Lord Whitworth bought when he was ambassador in Brussels and sold to Lord Wilmington in 1730.*

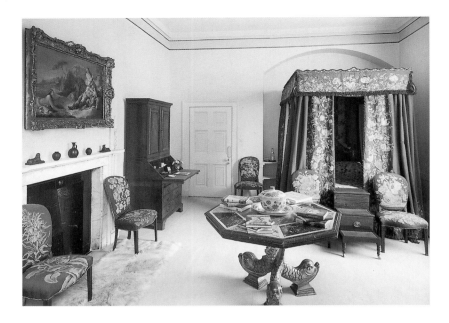

117. *The needlework bed at Weston Hall, Northamptonshire. It was worked about 1731, together with the covers of six related chairs by Sarah Jennens, the mistress of the house.*

118. *A detail of the embroidery on the head cloth.*

bedroom on the main floor, on the first floor on the west or entrance side there were two large rooms called the Worked Room and the Blue Mohair Room, which contained a scarlet lacquer bureau (Fig. 372). Both had dressing-rooms and closets. On the east or garden side of the house to the north of the gallery were the Yellow Mohair Room and the Scarlet Room, which had a dressing-room and study beyond it. To the south of the gallery was another bedroom and the breakfast room, and beyond, in the new wing, three evidently lesser rooms, the Yellow Cloth, the Green Cheney and the Yellow Cheney Room.[39]

There was a somewhat similar sequence at Ditchley, where on the first floor the values attached to the contents of the bedrooms varied between £51 3s. and £26 6s. There were beds in blue mohair; yellow silk damask trimmed with silver lace, and with yellow callimancoe hangings and curtains and quilted callimancoe for the seats and backs of chairs; green silk damask with green lustring curtains; yellow damask; crimson stuff damask; and, most tantalizing of all, crimson caffoy on a yellow ground lined with yellow lustring, with yellow lustring curtains and 'red flock hangings on canvas and gold ground', a technique otherwise unrecorded in a country house but known from earlier, coarse fragments.[40]

None of these schemes survive, even in fragments, and probably the only example of a complete wool bed is that dating from the early 1730s formerly at Zeals Manor, Wiltshire, and now at Hanbury. Beds with needlework hangings are now also great rarities. At Doddington there is a bed with hangings worked in a spirited design of huge curling feathers in red and orange on a white linen ground. At Weston Hall, Northamptonshire, there is a bed and six matching chairs embroidered with flowers on a brown wool ground in about 1731 by Sarah Jennens, who had gone to live in the house as a young widow in 1714 and for whom it was bought in 1721 (Fig. 117).[41]

Clearly bed hangings were influenced by the fashion for wallpaper as opposed to woven hangings. As so often, Mrs Delany pro-

vides insights. In 1750 she wrote of bedrooms at Delville: 'I have stripped down old stuff beds . . . and in their stead am putting up *blue and white linen* and blue and white paper hangings.' And a little later: 'I have done up a little apartment, hung it with blue-and-white paper, and intend a bed of blue-and-white linen – all *Irish Manufacture*.'[42]

A full description of a bed hung with cotton occurs in a bill from William Greer for furnishings supplied to the Hon. George Bowes for Gibside, Co. Durham, in 1743. The bedstead with mahogany foot pillars and carving on the knees and feet cost £8 15s., and 106 yards of fine furniture cotton were provided for the bed, counterpane, three pairs of window curtains, and cases to the six walnut chairs, easy chair and pair of stools: at 7s. 6d. a yard, that came to £40 7s.½d. In addition, 68 yards of fine white cotton at 2s. 6d. were supplied for lining the bed at a cost of £8 10s. 7½d. There was also a charge of £1 9s. 2d. for 'stiffening and glazing the above printed and white Cotton'.[43]

As in so many aspects of decoration, Marot provides the best introduction to curtains, and in his famous print he shows a mixture of valances with false and working festoon curtains and festoon curtains on their own. Not surprisingly, no complete examples of window curtains, either draw or festoon, have survived from the period, although there are references to curtains 'to draw up in festoons' in Lapierre's account with the Duke of Montagu; and Roger North, when writing about galleries, observed 'And if great curtaines are hung in the strait range, and drawne up with great blobbs, it hath a strange aspect of grandure'. On the other hand, a few examples of pelmet cornices with valances for windows survive alongside those for beds, as with the needlework bed at Clandon (without valances), the state bed from Holme Lacy now at Beningbrough, the blue bed at Belton (recovered), the state bed at Holkham (Fig. 450) and in the Nostell Dolls' House (Fig. 14). In all these cases the wood cornice is covered to match the bed. Two out

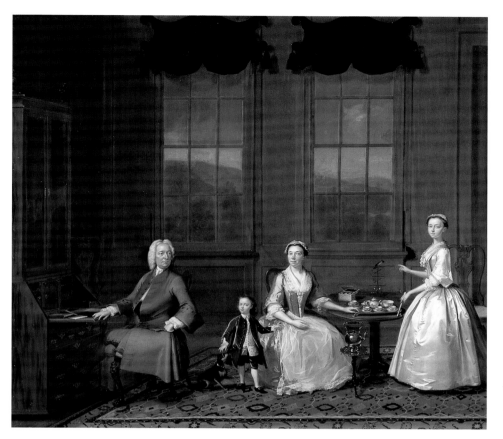

119. Sir Henry Gough and his Family *by William Verelst, 1741. It shows pelmet cornices covered in the same material as the drawn up festoon curtains.* Private collection, on loan to the Victoria and Albert Museum.

of the original three cornices with valances made of crimson caffoy and yellow silk from the saloon at Erddig (Fig. 364) survive, although at present not on display. At the end of the Cartoon Gallery at Knole, draw curtains have been cobbled up out of festoon curtains made of the stamped velvet used for the hangings and upholstery in the room, and they are lined with a watered woollen material that originally matched the colour of the velvet.[44]

There is an excellent illustration of covered cornices in William Verelst's conversation picture of Sir Henry Gough, a lawyer and director of the East India Company, with his wife and children (Fig. 119), painted in 1741. It shows a pair of shaped pelmet cornices covered in the same blue material as the curtains, which are fully drawn up so that two, not three, festoons only just break into the top panes of the windows, and the cords can be seen running down the outer edges of the window architraves. The stone, rather than light, colour of the walls and the presence of the glass-fronted bookcase suggests that the room is a parlour rather than a drawing-room, but the silver kettle on its waiter placed on a low wooden stand beside the tea table with its service set out suggests a drawing-room.[45]

Examples of carved and gilt cornices survive in the Round Drawing-Room at Longford, and in the drawing-room and principal bedroom at Dumfries House, while others from the dining-room at St Giles's House and the saloon at Croome are also recorded. There is also a fine set in white and gold that goes with the pier-glasses and tables in the Tapestry Drawing-Room at Hagley (Fig. 415). One of the best contemporary illustrations of a set is Steward Mackenzie's design for the Great Drawing-Room at Blair (Fig. 253). Another is in William Gomm's elevations of the four walls of a drawing-room dated 1761 (in the Henry Francis Du Pont collection at Winterthur, Delaware), where that for the window wall shows a pair of chinoiserie tables with glasses over them, cornices over the three windows and reefed rather than festoon curtains.[46]

How often drapery, which presumably means reefed, curtains were made in the early eighteenth century is not clear, but they are mentioned in Lapierre's account with the Duke of Montagu – curtains 'to draw up in drapery'. They also existed at Kiveton, in the South Closet, where there was a 'strip'd Dimothy Drapery' window curtain; in the Dining-Room, which had three scarlet harateen drapery window curtains; and in the South-East Closet, which had a damask drapery window curtain.[47]

Most rooms, however, had simple draw curtains, as can be seen in the painting of *Wanstead Assembly* and in the payments relating to the new curtains in the dining-room at Temple Newsam in 1735. There were two gilded brass pulley rods and matching hooks to hold up the rods, and the curtains were drawn on '9½ onsis of crimson InGrain Silk Rainwork Line' with two large brass pulleys; and were hung on thirty-six gilt brass rings, with four small brass hooks and twelve small brass rings put on the bottom of the curtains to hang them up when the room was cleaned.[48]

While it was usual in the late seventeenth and early eighteenth century for curtains to match the rest of the upholstery in a room, contrasting white curtains were also used. They can be seen in the three state rooms between the Guard Room and the Bedchamber on the King's side at Hampton Court, followed by crimson damask laced with gold to match the bed; and there are references to them in the inventories of Ham House, Burghley, Belton and Boughton. At Belton in 1698 the drawing-room next to the Great Parlour, now the Tyrconnel Room, had chairs 'Bottomed with green damask' and two green silk window curtains, while the Chapel Drawing-Room with the Vanderbank tapestries and blue woodwork had white damask curtains. They can be effective when the walls are darker, either because they are panelled or because of the paint colour, and also by day the light from behind can throw up the pattern if they are only thinly lined. The 1727 inventory for Kiveton lists curtains of crimson silk mantua with friezes (cornices) and valances to match in

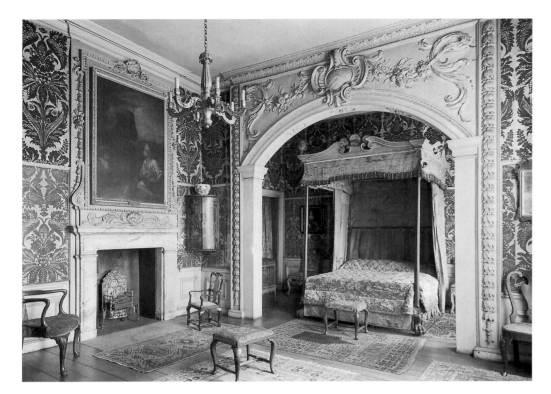

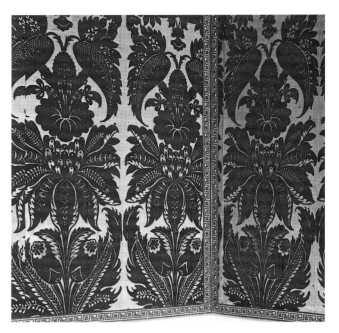

120. *The principal bedroom at Christchurch Mansion, Ipswich, Suffolk, with its recess for the bed. The bold flock wallpaper, a version of the archetypal pattern for damask and wallpaper for the period, appears to be contemporary with the fitting up of the room, about 1740. The mid-eighteenth-century bed from Belhus, Essex, shown here before it was rehung, was in a damask of the same pattern. The hangings of the original bed are likely to have matched the pattern and colour of the wallpaper.*

121. *A version of the same design in flock wallpaper with its border surviving in part in the original principal bedroom, later the Prince Regent's Bedroom at Clandon, probably about 1728–30. Here the colour has virtually fled from the glazed ground, so creating a two-tone effect. Unusually there is limited use of a second printed ground colour to create shading, a detail copied in the new wallpaper at Temple Newsam (Fig. 324).*

the Great Dining-Room, where the long inlaid-walnut stools were in crimson velvet and had cases of red serge; curtains of green tabby with friezes and valances to match the bed in the Great Bed-chamber, where the upholstery was of green damask; and of red sarcenett with a frieze and valance in the Best Dressing-Room, where the hangings were of tabby with panels of crimson and gold damask. But in the Great Drawing-Room, where the upholstery was of flowered velvet in unspecified colours, the curtains were white damask. By the 1720s, when upholstery in general had calmed down, curtains invariably matched the colour of the rest of the upholstery, but there were still exceptions, as can be seen from the 1744 inventory for Blenheim, which lists white curtains in the incomplete west apartment. However, the reason for their choice is not clear.[49]

The fashion for uniformity was followed by that for festoon curtains, and they were made in a variety of materials. Some were velvet, as in the drawing-room at Erddig and the Great Drawing-Room at Norfolk House, but these must have been heavy for the cords that drew them up and the material bruised easily. In the Velvet Bedchamber at Dunham Massey, where the bed was of crimson velvet, the curtains were of crimson damask. Damask also soon looks crushed. So, not surprisingly, it became usual to retain uniformity of colour but use a lighter plain silk such as lustring or taffeta. Again, there appear to have been differences of degree between rooms with damask curtains and those with lustring. At Blenheim, for instance, the Duke had damask upholstery but lustring curtains in his dressing-room, while in the more important Grand Cabinet both hangings and curtains were of damask. In the Music Room at Norfolk House, the festoon curtains of green damask matched the covers of the stools.[50]

In the drawing-room of the Duke of Cumberland's apartment at Hampton Court in 1736–7, the armchair and stools were covered in crimson mohair and the draw-up curtains were in crimson Florence taffeta; and in the Bedchamber the wall and bed hangings were in blue mohair and the window curtains were of Florence taffeta. It is likely that the mohair was glazed and so had a look of silk.[51]

There was also a relationship between the style of curtain and the height of a room. A festoon curtain, whether or not it has a cornice, works best when there is plenty of dead light above the top of the window to take the bunched-up material, as can be seen in the old photograph of the 'Right-Hand Parlour' at Canons Ashby (Fig. 46); and it is clear that when a number of rooms were designed, the form of the curtains was taken into account. When a room intended to have festoon curtains now lacks them, the design of the window wall may be upset, as happens in the Kirtlington dining-room in the Metropolitan Museum. However, there does not appear to be documentary evidence suggesting when festoon curtains were made with two and when with three festoons.

The style of curtain was also considered in relation to the degree of enrichment of a window architrave. A festoon curtain drawn up into the dead light leaves the architrave clearly visible and so justifies expensive carving and even gilding in a grand room, as can be seen in the Great Room at Marble Hill (Fig. 77). There, not only is the moulding carved and gilded but the fields of the panels of the shutters are enriched with ornament. Conversely, there was no point in carving or gilding a window architrave that would be hidden by a draw curtain. In the Balcony Room at Dyrham, while the central architrave is both carved and gilded, the side architraves are not carved at all.

Curtaining a Venetian window has always presented a problem, and when the National Trust decided to restore one based on a Chippendale plate in the State Bedroom at Nostell Priory, it found that it had to be cut like a huge sail.[52]

The only extant example of evidence about how curtains were originally hung can be found in the Great Room at 85 St Stephen's Green in Dublin, where within the arch of the centre window there are still broad rings for the cords. Evidently they posed a problem at the time, because Elizabeth Anson wrote to Lady de Grey from Shugborough, illustrating the effect, in 1750: 'The Window-Curtain in the Bow Window, I promise an account of is divided as I thought – comma ca and these points hang down as low as the surface in the space between the two cornishes as ornaments & festoons of stucco.'[53]

The rise of the fashion for hung saloons and drawing-rooms in England – rooms hung from cornice to dado in one material other than tapestry – was almost certainly a response to the growth of picture collections and was tied up with a reaction against panelling, which absorbs light, kills crimson or green damask and whose mouldings make large pictures difficult to hang. Materials (velvet, whether cut, plain or stamped, caffoy and damask), the designs chosen for weaving and colours were influenced by their suitability as a background for pictures in gilt frames, which themselves only began to be widely used in the last quarter of the seventeenth century. Thus, hung rooms need to be looked at in relation to the pictures that they contained, and inevitably after two and a half centuries it is exceedingly unusual for a room to retain both its hangings and its arrangement of pictures unaltered. The Cabinet at Felbrigg (Fig. 429), which retains its original hangings, and the Landscape Room at Holkham (Fig. 448), which retains most of its pictures but has had its hangings renewed, are rarities.

It is only with the growing number of restoration schemes in the last twenty-five years that the relevance of the width of cloth and the height of the repeat of a damask design has become apparent. For commercial reasons, most old patterns in England measuring 21 inches wide were redrawn in the late nineteenth and early twentieth centuries to suit power looms 48 inches wide. So not only did they have to be doubled but they also had to be pulled out laterally to make up the width. At the same time, some patterns, like that found on the Petworth bed, were reduced in height, from, say, 6 to 3 feet, with complete motifs omitted, to make them more saleable. That, however, makes them unsuitable both for hangings in eighteenth-century rooms and the upholstery of eighteenth-century furniture, because the patterns are now often too short for hangings and too wide to sit comfortably on a chair.[54]

The Felbrigg pattern is often thought of as the archetypal design of the eighteenth century, and certainly its swirling leaves seem to work well as a background for history picture in gilt frames. Several versions are woven today in different sizes ranging from 3 feet 6 inches to 9 feet, or made in wallpaper. Almost certainly Italian in origin, perhaps the earliest version is the wallpaper used in William Kent's Privy Council Offices, of which a fragment survives in the Victoria and Albert Museum. Other contemporary examples are the flock paper in the state bedroom at Christchurch Mansion (Fig. 120) and in the Prince Regent's Bedroom at Clandon (Fig. 121),

where the colour has so fled from the ground that it now reads as a two-tone paper, but where there there was in any case some overprinting of the ground in a darker shade to create an effect of two tones of flocking. Unfortunately, none of these can be dated precisely, though all date from round about 1740.[55]

The difference between a silk, silk and wool, and wool or worsted damask (and now cotton) are now usually thought of mainly in terms of cost, but in fact they have very different characters, particularly when new. With a new silk damask, the figure stands forward from the ground, and the effect may be too lustrous for English picture rooms. With a wool and silk damask, there is a contrast between the matt figure in relief and the satin ground, and it can give an effect not unlike a material with a pile.

Often a mixed damask was used. Arthur Young described a 'silk and worsted' damask in the drawing-room at Wallington and a worsted damask survives in the Cabinet at Felbrigg, while William Greer charged 5s. 9d. for best yellow silk and worsted damask and 3s. 9d. for best crimson worsted damask for Gibside. The temptation when reading an eighteenth-century inventory is to presume that a reference to damask is to a silk or part-silk material, but that is often an inflation, especially in an inventory compiled by an upholsterer, who would distinguish between a damask and a silk damask.[56]

A dramatic illustration of a wool and silk damask can be seen in the drawing-room at Kedleston (Fig. 122), which has been recently rehung with a copy of the original material hung in the 1760s and taken down in 1870. Sir Nathaniel Curzon wanted a very large repeat because of the height of the room, choosing a design of about 9 feet that is also found on the Petworth state bed (Fig. 114) and that filled the space between the dado and cornice in almost two repeats. He also wanted the effect of a bolder figure than a silk damask, comparable with a brocatelle or caffoy. However, what cannot be certain is that the reweaving exactly recaptures the original balance of the two blues. Perhaps there was not a great choice of up-to-date patterns available and he chose one originally woven for bed hangings rather than walling, which tended to have strong horizontals that need to be broken up by pictures. He used the same pattern in blue silk damask in the state apartment, where it appears as mostly a 1973 reweaving in a wide width, and there the pattern is much less insistent. It is interesting to see how he continued the colour and pattern but changed the weave.

There are few references in archives to the skill and care required in calculating the amount of cloth needed for hangings, nor apparently to where hanging should start in a room and whether it should be centred on the chimneypiece. First, when a pattern is being chosen, the length of its repeat has to be considered in relation to the height of the wall between the dado rail and the cornice so that there is not a lot of cutting to waste, leaving unusable short lengths. In 1708 Lord Manchester wrote to the Duchess of Marlborough:

> It is always best to have rather more than less than you shall want, for in the measuring of the rooms they may be mistaken. beside, there must be chairs, window curtains, and for the doors, according to the manner in Italy, which looks very handsome, and is cheap as anything, I think can be made of silk. The height of the hangings for the rooms I must know; else there will be great loss when they come to be cut and to know the figures join right, for they can be made to what height you please.

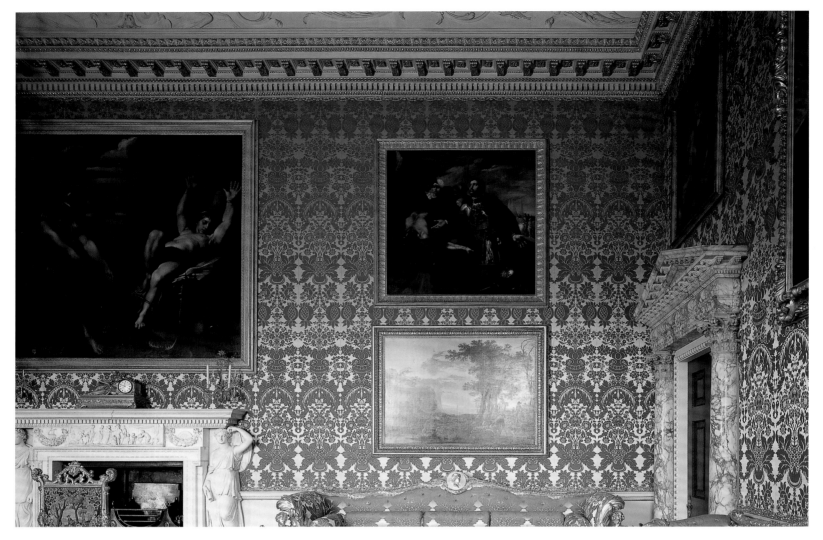

122. *A silk and wool damask recently woven for the drawing room at Kedleston Hall, Derbyshire, based on fragments of the original material hung in the early 1760s. It seems that Sir Nathaniel Curzon wanted a bold effect comparable with the caffoy and* *cut velvet he had seen at Holkham (Figs. 443–5) but in a cheaper material. He also used the same design in silk damask in the state bedroom apartment.*

Some of Lord Manchester's own materials survived into the age of photography, as on a set of chairs (Fig. 168) and the hangings in the state bedroom at Kimbolton, where panels of crimson silk velvet were bordered with strips of Chinese embroidery (Fig. 333).[57]

Slight differences between different weavings of a pattern are probably explained by a patron telling the mercer the height of the drop and the weaver then calculating any adjustments to the size of the repeat to make it fit as economically as possible and avoid cutting to waste. A weaver using a draw loom or jacquard (but not a power loom) can add in extra throws of weft as he goes, probably adding up to 18 inches on a 7 feet 6 inches repeat.

Minor variations can also be explained by slight changes of pressure by the weaver, and with material woven on a draw loom by equally slight ones made by the draw boy pulling the cord. A pattern could be deliberately drawn out or compressed so that the repeat could be adjusted to the drop.

Quantities could be huge, as can be seen in the Duchess of Marlborough's order for Blenheim, the lengths required for Holkham in the mid-1750s, and with the Red Drawing Room and related rooms at Hopetoun (Fig. 123). In 1755 James Cullen, a London upholsterer who had moved to Edinburgh in 1752, provided an estimate of the amount of damask needed for all the rooms of the Great Apartment, but the cost was so great that Lord

Hopetoun did nothing more for eleven years: a visitor recorded that the drawing-room was temporarily finished with plain paper. For the first room, completed as the dining-room and therefore not hung, 72 yards 1 foot 6 inches was required for the three festoon curtains, which were 14 feet 6 inches long and with five breadths in each. For the drawing-room the total came to no less than 434 yards – 272 yards 2 feet 6 inches for the hangings, but with a characteristic saving of 34 yards 2 feet 3 inches where the material would not be put under the big pictures; 100 yards for the five festoon curtains, which were 15 feet long with four breadths in each; and the rest for the sixteen elbow chairs and two sofas. For the bedroom, 349 yards were needed and for the dressing-room 134 yards, bringing the total to over 990 yards. In 1766 Cullen wrote to his patron again: 'If you have not furnish'd yourself with the crimson silk damask for the grand apartment I have an opportunity of getting a quantity for you now much below the markett price. There is about 800 yards & has been offered me at 13*s.* 6*d.* per yard. It was brought from abroad by a Nobleman who is going back & at present has not use for it.' Finally, after a lot of difficulty, including avoiding customs duty, the material was acquired and sent up to Scotland – where it remains in the drawing-room and the bedroom.[58]

If hangings of caffoy, cut and plain velvets are familiar from Houghton and Holkham, eighteenth-century stamped wool velvet

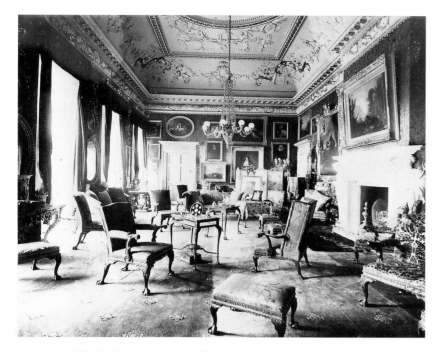

123. *The Red Drawing Room at Hopetoun House, about 1900. Intended as a great room and for pictures from the early 1720s, it was finally fitted up in the 1750s and 1760s, with plasterwork by Thomas Clayton (about 1754), a chimneypiece by Rysbrack (delivered in 1758) and crimson damask for the hangings measured in 1755 but not bought until 1766.*

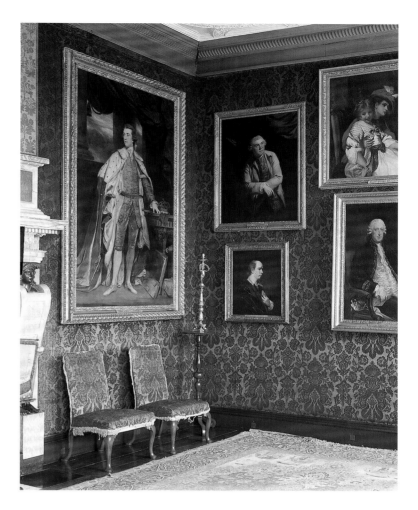

124. *A stamped wool velvet used for hangings and upholstery in the Reynolds Room, formerly the Drawing Room, and other rooms at Knole, Kent, probably introduced by the 1st Duke of Dorset in the mid-1720s at the time decorative painting was carried out in neighbouring rooms.*

125. *An unfaded sample of the stamped wool velvet at Knole always hidden from the light.*

is less so. The best example is now to be seen in the Cartoon Gallery and Reynolds Room at Knole, where it is also found on the simple walnut seat furniture. It cannot be dated precisely, but it appears to be part of the alterations carried out by the 1st Duke of Dorset that included decorative painting by Mark Anthony Hauduroy in 1723–4. Clearly a vast amount of material that was not too expensive was needed for the house. Inevitably it has faded a great deal, but the strength of the original colour and the contrast of the matt figure to the lustrous ground can be seen on the hidden parts of the cushions on the settees, which also retain their original watered lining unfaded (Fig. 125).

Another material used for hangings was mohair, which has been a puzzle in recent years, because no examples have been found in houses, although it is frequently encountered in documents. Recently the Victoria and Albert Museum commissioned from Angus Weavers a reconstruction of mohair for wallhangings for the Henrietta Street Room on the basis of an unused dress-weight sample of what was believed to be mohair in its collection; the weaver had copied a sample twelve years earlier for a German client. It was woven with a worsted warp from Suffolk sheep and pure Turkish mohair weft, which was spun in Yorkshire; and the worsted had to be dyed to live with the mohair because they take colour differently. Then the cloth was scoured and glazed wet by passing it though a heated calendering machine: at the third pass, the cloth starts to show the effect of glazing and this cloth had six passes. That gave it a lustre with the look of a heavy plain silk. This immediately explained why it was used so much in the eighteenth century as a material one grade down from a figured silk damask for wallhangings, beds and upholstery. Like many woollens, it was often watered in formal or informal patterns, as opposed to be being glazed, and it was even rewatered after cleaning, as is recorded in Thomas

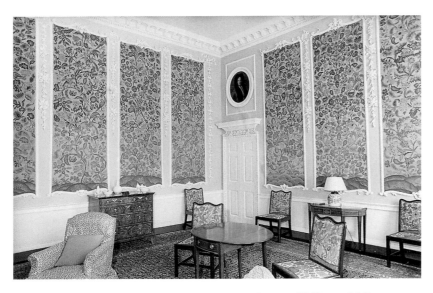

126. *Three panels in the Needlework Dressing-Room at Wallington Hall, Northumberland. They are part of a set of hangings completed in 1717 by Julia, Lady Calverley for the drawing room at Esholt Hall, Northumberland, and brought to Wallington in 1757 by her son who gave them a Rococo setting.*

127. *Part of a set of painted hangings imitating tapestry in a bedroom at Houghton, probably late 1720s. They appear to be based on French prints, and are listed in the 1745 inventory as painted dimothy. They are probably the only set still in situ in England.*

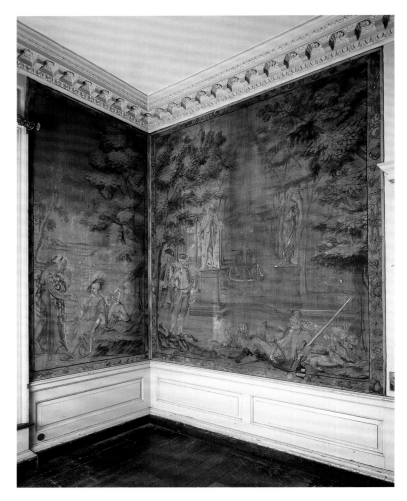

Roberts's account for upholstery work in Sir Robert Walpole's houses in the late 1720s.

At Ditchley, green mohair was used in the everyday drawing-room; and at Compton Place the second bed was in yellow mohair. At Stoneleigh, crimson mohair was used for the window curtains in the Great Parlour, the first room of the Great Apartment and the first of three crimson rooms: the cushions on the walnut chairs were of crimson velvet. It was also used for the curtains in the adjoining drawing-room, where there were hangings of crimson velvet and needlework chairs. In the Duke of Cumberland's rooms at Hampton Court in 1736–7 crimson mohair was used for the upholstery in his Withdrawing Room and blue mohair for his bedroom, both as hangings and for the bed. At Leicester House in 1742, when it was being prepared for the Prince and Princess of Wales, all four parade rooms were hung in conventional state-room crimson, with the first two-bay room, which only had walnut stools, being in mohair; then followed two three-bay rooms furnished with gilded furniture and hung in damask; and at the end the principal room, with a damask canopy and state chairs. Mrs Delany used it in crimson for curtains and seat furniture in her drawing-room in Dublin in 1744, and then crimson damask in the bedroom; but she also recorded that she refused to hang a room in mohair that she wanted to cover with pictures, and used wallpaper instead. It seems to have cost 6s. 10d. a yard in 1712.[59]

Much more tapestry was used in the first half of the eighteenth century than is recognized today, particularly in bedrooms and dressing-rooms. Owners of houses continued to buy it new or second-hand, like Sir Robert Walpole and Lords Leicester and Lyttleton; and numerous weavers tried to keep the tradition going or revive it in new ways, as with Bradshaw, Paul Saunders, Danthon and Peter Parisot. Great prestige was still attached to it, and it was still used for official and diplomatic gifts, as at Blenheim; at Wolterton, where a set of Gobelin *Venus and Adonis* tapestries are supposed to have been given by Cardinal Fleury to Lord Walpole when he was

ambassador in France; and at Chevening, where there is a set of arabesque tapestries woven in Berlin, which was given to General James Stanhope, later 1st Earl Stanhope, by Frederick of Prussia in 1708.[60]

There were obvious reasons why several of the Duke of Marlborough's generals ordered sets of tapestries depicting *The Art of War*, as can be seen at Cliveden in Buckinghamshire, Stansted in Sussex and formerly at Stowe, for which they were woven between 1706 and 1712. However, the last grand use of tapestry seems to have been at Castle Howard, where the 4th Earl of Carlisle, the son of the builder, bought a set of what were then called *Roman Triumphs* but in fact were former French royal tapestries telling the story of *Artemis and Mausoleus*, which he placed in the first room of the Great Apartment between 1745 and 1751.[61]

It is not known whether Lord Carlisle bought the *Roman Triumphs* because they were French, but there was a demand for French tapestries or tapestry in a French style, as there was for pictorial tapestries after Teniers designs. The former is represented by the set of tapestries woven after French prints by Bradshaw, still to be seen in the drawing-room at Ham House (Fig. 68), which were altered in 1744; in the French tapestries originally ordered for the Great Drawing-Room at Norfolk House in the mid-1750s (Fig. 69); and in the drawing-room at Dumfries House as that was fitted up in the late 1750s. Teniers tapestries were acquired for the east gallery at Stowe in the 1740s, for bedrooms at Longford Castle and Mereworth Castle (now at West Wycombe) and the dressing-room at Compton Place (Fig. 116).[62]

Needlework hangings are much rarer than tapestry. Indeed, they are hardly ever seen in country houses. Perhaps the only pair of hangings still in their original location are those completed by Mary

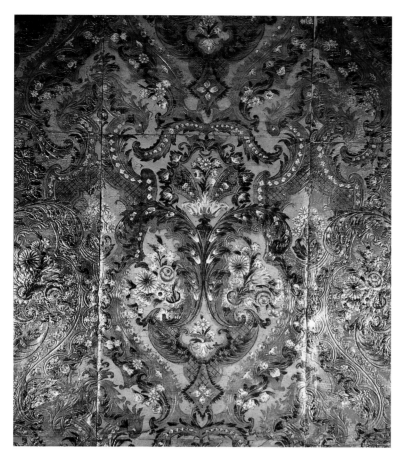

128. *Part of the conserved section of the set of leather hangings in the former saloon at Rathfarnham House, near Dublin, apparently about 1730. The bold figure is similar to the Houghton caffoy (Fig. 202).*

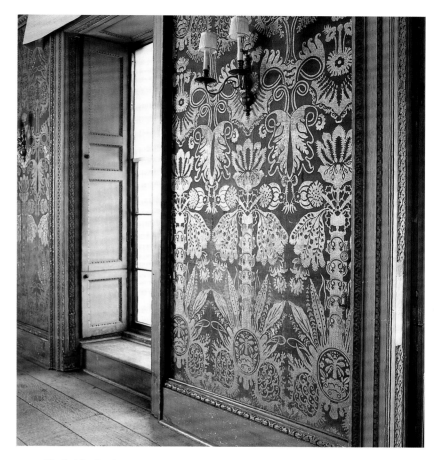

129. *Flocked leather hangings in the former dining-room at Compton Place, probably about 1730. Apparently a unique survivor.*

Holte in 1744, when she was sixty years old, for the Best Bed-chamber at Aston Hall, where they line the bed recess, with the second panel curiously designed to fit around the window. They could have been inspired by Joshua Morris's grotesque tapestries, but their design was probably based on a late seventeenth-century French ornament print revolving round a central panel that Mary Holte filled with views of Aston and Brereton Hall, Cheshire. The drawing is rather naïve, but what it lacks in sophistication is made up for in the spirited rendering of the figures and animals.[63]

At Wallington there is a set of ten panels of tree of life designs (Fig. 126) completed by Julia, Lady Calverley in 1717 for the drawing-room at Esholt Hall, Northumberland. It was to the great pride of her husband, who recorded: 'My wife finished the sewed work in the drawing room, having been three years and a half in the doing. The greatest part has been done with her own hands. It consists of ten panels.' When her son, Sir Walter, sold Esholt, he took them to Wallington in 1755 and arranged them in a delicate Rococo setting in a dressing-room.[64]

The finest of these hangings is the pair of panels formerly in the Green Velvet Bedroom at Stoke Edith and now in the Victoria and Albert Museum. They are among the most evocative pictures of a Baroque garden, but no one knows who worked them or when; and they may have been hung with the bed when that became an object of historical curiosity and not made to go with it.

A cheaper alternative was to have painted hangings. Today, probably the only set *in situ* is that in a bedroom at Houghton (Fig. 127), which is lined with a set of painted toiles after French prints that recall Bradshaw's tapestries at Ham and are listed in the 1745 inven-

tory as painted dimothy. The only other survivor is the now-divided set from Syon House painted by Andien de Clermont for the pre-Adam house (Fig. 268). There may have been more, because in the Dunham Massey inventory of 1758 the closet to the tapestry-hung Yellow Damask Bedchamber contained three pieces of painted dimothy hangings and there were three more pieces in what may have been Lord Warrington's room.[65]

Undisturbed gilt leather hangings *in situ* have become such a rarity that it is a surprise to find how often they were mentioned in late seventeenth- and early eighteenth-century inventories. Most of the early examples are thought to have been imported from Holland, but in the late seventeenth century they were produced in Scotland by Alexander Brand and recently it has been established that a good deal were made in England and even exported to Holland. Brand supplied them to Sir William Bruce for Kinross House and to the Duchess of Buccleuch for the dining-room at Dalkeith and may have been responsible for the panels at Prestonfield House near Edinburgh. Another good example in Scotland used to be in the ante-room at Melville House, unusual for its borders of Marotesque urns. Leather was extensively used at Dyrham, as can be seen in the 1710 and 1742 inventories, and in the dining-rooms at Ham, Burghley and Blenheim.[66]

Two interesting eighteenth-century examples are to be seen in the saloon at Loreto Abbey at Rathfarnham, Co. Dublin and the library at Compton Place. The former (Fig. 128) appears to have been installed in about 1730, when house was built, and at first sight seems an unusual choice for such a room. But with its gold decoration on a blue ground, heightened with sprays of flowers in yellow,

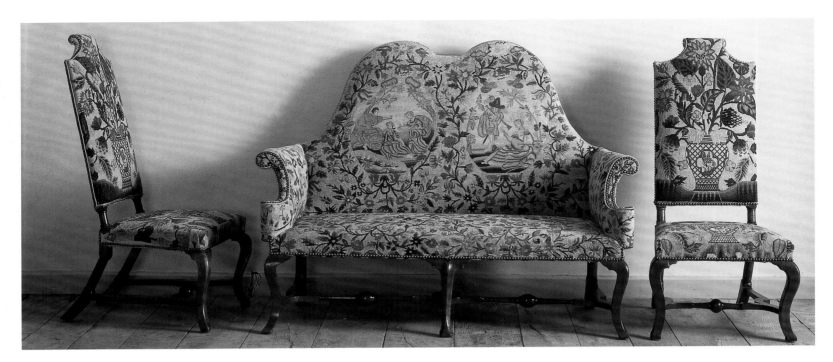

130. *Part of a set of needlework chairs 'in the newest fashion' at Canons Ashby supplied by Thomas Phill in 1714. They are the earliest documented English chairs to have a cabriole leg.*

red and white, it must have been more colourful and glistening than a woven material. Old photographs taken when the set of hangings was complete show how striking it must have been. At Compton Place the walls of the former dining-room were hung at about the same time with gilt leather patterned in green flock in a huge repeat, a technique not recorded anywhere else (Fig. 129).[67]

Decorative fillets in a variety of materials hid the nails securing hangings, as can be seen from the gilt borders to panels in a number of conversation pictures such as the *Tea Party at Lord Harrington's House* (Fig. 5); but most of the surviving examples appear to date from after 1760. The most expensive were in carved and gilt wood (and very occasionally silvered, as in Lady Hilsborough's room described by Mrs Delany), and they cost a great deal in a large room because of the length required. But soon they were imitated in gilded papier mâché or cast lead, as in the drawing-room at Hope-toun, where they are only used horizontally. The convention seems to have been to choose a thinner fillet for verticals, if one was used, and a heavier one for horizontals. So the generous Greek-key fillet in the gallery at Longford suggests that it may have been renewed in the mid-nineteenth century. In the first half of the eighteenth century, it seems that a lace dyed to match the hangings was often thought enough, as can be seen in the saloon at Houghton. Or sometimes in grand rooms a single or double line of broad gold lace might be put up, as can be gathered from Duchess Sarah's careful annotation of the Blenheim inventory. In the Cabinet at Felbrigg, William Wyndham economized with a gilt cord (Fig. 432). Gilt-brass-headed nails were used, sometimes as a single row as in the saloon at Russborough (Fig. 78), sometimes in a double row as for the leather hangings at Rathfarnham House and the damask in the gallery at Corsham Court, Wiltshire, where they match the nailing on the seat furniture.[68]

Fillets, sometimes of related paper, but also of other materials such as papier mâché, were invariably used for wallpaper, especially when it was hung in the same way as material, in order to hide the

tacks, as can be seen in the Prince Regent's Bedroom at Clandon (Fig. 121).

## SEAT FURNITURE

The history of chairs is usually written in terms of the development of the style of frames, with upholstery and covers regarded as being of secondary importance, but the first half of the eighteenth century saw a major change of emphasis. At the beginning of the period, most chairs cost remarkably little – about £1 or £2 for a walnut chair without upholstery – and their prices only went up if they had covers of rich materials or needlework and plenty of trimming. In Lord Carnavon's dressing-room at Canons six walnut chairs covered with green mohair were valued at £9 and six walnut chairs with red linen and crimson serge covers in the Ante-Room were valued at £12, while twelve chairs with brocade false cases and loose serge cases in his drawing-room were valued at £44. Such richly upholstered chairs were only used in the principal bedrooms, dressing-rooms and drawing-rooms of grand houses: chairs in halls, parlours, eating rooms and secondary bedrooms were invariably simpler.[69]

In the opening years of the century, the emphasis was on materials and the way they were used for show covers, with contrasts of textures and colours. That can be seen with the yellow and crimson velvet on the chairs that match the Dyrham bed, or the even more complex design of crimson velvet on a set of chairs and day bed at Drumlanrig Castle. Another approach was to draw attention to the shape of a chair by the contrast between relatively plain covers and rich fringing, sometimes worked in scallops, as on a chair at Lyme and another formerly at Rushbrooke Hall, Suffolk, or following the line of the chair as in the example formerly at Hampton Court, Herefordshire and now at Hampton Court Palace.[70]

The armchairs and side chairs – two of the armchairs are now in the Metropolitan Museum – that went with the state bed at Burley-on-the-Hill were covered in the same pattern of cut velvet as the

bed and had rich scalloped fringing (Fig. 100). Some of the most richly decorated and upholstered chairs were supplied to Kiveton, where carved, gilt and japanned frames were covered in handsome cut velvets, like the settee and day bed now at Temple Newsam. There, the 1727 inventory suggests that natural wood frames for chairs were not considered suitable for the principal rooms. Another settee of particularly good shape from Hampton Court, Herefordshire, now in the Victoria and Albert Museum, is covered in cross-stitch embroidery in a damask pattern in red on a light-yellow ground, imitating a two-colour damask, and doubled in width to fit the back. There is no record where it was placed originally and no related chairs survive.[71]

During the second decade of the century, the line of frames became more sophisticated and the upholstery of both settees and chairs tended to be better shaped, so that the two pulled together in a new way, as can be seen with the settee and set of six chairs, all with needlework covers, recently restored to Canons Ashby. For many years they were in the principal bedroom, but they are not mentioned in the 1717 inventory and there is no evidence as to their original situation. They seem more likely to have been in a drawing-room. They were supplied to Edward Dryden by Thomas Phill, Upholsterer to Queen Anne, George I and George II, who charged £7 7s. in February 1714, for '6 wallnuttree back chairs, frames of ye newest fashion, Stufft up in Lynnen' and 'for making ye needlework covers and fixeing ym on ye chaires' (but there is no mention of the related settee). The description 'newest fashion' is significant, because recently Adam Bowett pointed out that they are the earliest documented English chairs to have a cabriole leg.[72]

At the same time, not only did the number of upholstered chairs increase in a house but they were also found in more rooms. For important bedrooms, it was usual to provide a fully upholstered armchair. Some of these have strongly sculptural shapes with elaborately scrolled arms and sides, like the chair in blue brocade at Boughton or another at Castle Howard. In neither case have their beds survived, but at Hatfield there is still a chair in crimson damask that relates to Thomas How's state bed, while at Clandon there is a fine one still retaining its original needlework that goes with the bed.[73]

How early upholstered settees were found in bedrooms is hard to say, but it is striking that at Houghton all four important bedrooms on the corners of the second floor had pairs of settees evidently *en suite* with the chairs. On the *piano nobile* there were single settees in Sir Robert's bedroom and the Blue Damask or Family Bedroom and its dressing-room.[74]

The 1720s might be regarded as the golden age of the walnut chair in terms of line and shape, whether with pierced or upholstered backs, as can be seen with the second set of chairs with green velvet covers at Houghton (Fig. 215) and those with needlework covers formerly at Chicheley (Fig. 382). Often they are particularly elegant in side views, which bring out the relationship between the swell of the upholstery and the slope of the back and the kick of the back legs. When chairs retain their original covers of figured material, the skill displayed in the cutting of the material is striking, and sometimes it seems as if chairs were shaped to suit the figure of their covers, although there does not appear to be any contemporary evidence of this.

Occasionally frames were parcel-gilt, a fashion that appears to

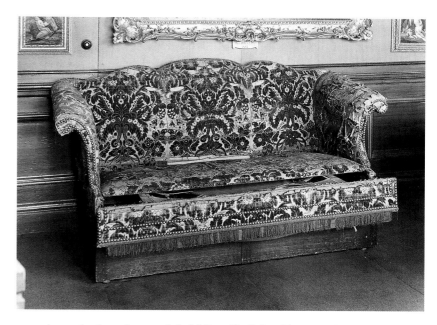

131. *A cut velvet formerly on a sofa bed delivered by Robert Tymperon of Stamford to Burghley House, Lincolnshire, in 1750. The sofa bed is of similar shape and design to one in the state bedroom (Fig. 449) at Holkham. It is also a good example of nailing.*

have started with water gilding of gesso on walnut about 1715 and then spread to oil gilding on mahogany. The first is particularly evident on the Houghton and Chicheley chairs.

Nailing could be important in the emphasis of line, complementing the picking-out of highlights of carved mouldings in gold. A remarkable range of effects could be achieved. The two basic forms were close nailing, which forms an even line, and space nailing, with gaps between them, as on the backs of the chairs in the saloon at Houghton (Fig. 204) and in Vardy's plates. But there were many subtleties, depending on the size of the nails, which ranged from big flat-headed studs as on a chair at Castle Howard, down through a middle size that looks large to us, as on Kentian chairs at Rousham and a set of needlework chairs on loan to Lyme (Fig. 133), to fine, small ones formerly on a sofa bed at Burghley (Fig. 131), where they emphasized the shape of the ends and were combined with a fringe at the base. There is particularly complex nailing on the principal set of chairs from Devonshire House at Chatsworth that have been recovered but appear to follow the original plan. Precision was important, as can be seen in the nailing so carefully recorded on the chair in Dahl's portrait of Arthur Vansittart dated 1718, which is now at Lyme (Fig. 132). On occasion, the nailing on seat furniture was related to the way wall hangings were secured, as in the single line of nails in the saloon at Russborough and the double line in the gallery at Corsham. Their impact depended on whether or not they were gilded, and also whether gold or silver lace or coloured gimp or fringe was used behind the nails, as is still to be seen on the set of seat furniture made by Thomas Welsh for the Red Drawing-Room at Hopetoun in 1767–8 (Fig. 123) and a chair formerly at Cusworth.[75]

Houghton provides the best illustration of the triumph of the chair, because there are so many of different designs from about 1715 to 1735, and according to the 1745 inventory there were quantities of chairs on the ground, first and second floors, of which many had upholstered seats and backs. In Thomas Roberts's account for upholstery for Houghton in 1729, which is mainly

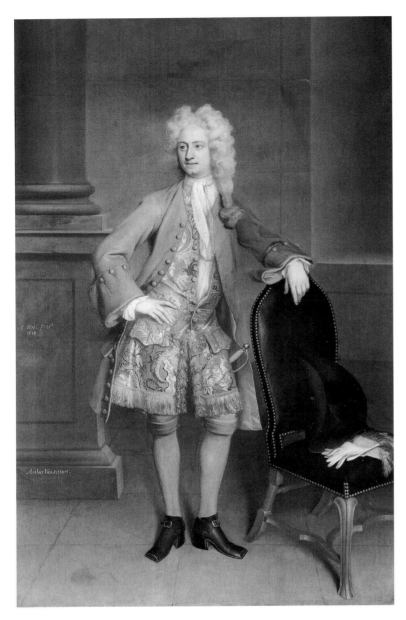

132. Arthur Vansittart *by Dahl. The portrait dated 1718 shows him wearing a plain coat over a lavishly trimmed brocade waistcoat. That makes a deliberate contrast with the simple chair covered in black leather whose line is emphasized by the precision of the gilt nailing.* The National Trust, Lyme Park.

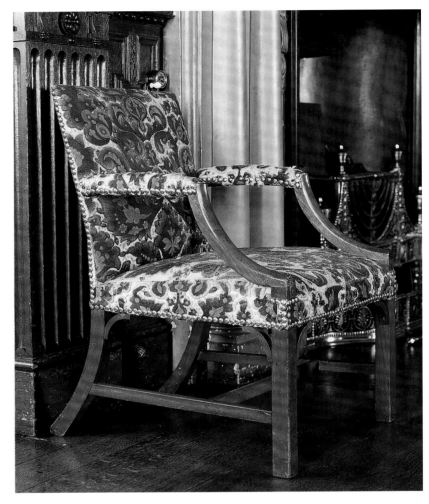

133. *One of a set of mid-eighteenth-century mahogany chairs with needlework covers in imitation of cut velvet, bright gilt nailing and original watered wool backs from Lyme Park, Cheshire, and recently loaned back to the house.*

concerned with non-parade rooms, he charged £30 for a set of twelve walnut chairs and gave a detailed description of them: '12 fine Wallnuttree Chair Frames with Compass Seates a Carved Shell on the Feete a Fine Compass India back vener'd with the finest Grenople Wallnuttree & vener'd Pedestals Girts bottoms Curl'd hair linnen to stuff in and work stuffing and covering them with your own Damask'. A matching settee cost £6 6s.[76]

Covers of tapestry or needlework were so highly valued that they were generally put on the best frames in a house, often fully or parcel-gilt. This can be seen with the walnut and parcel-gilt set of one armchair and six back stools made in about 1725 and listed in the drawing-room at Stoneleigh Abbey in 1738, where they were valued at £60. They have fine needlework covers, evidently professionally made and designed for another set of frames with arms, even though the existing frames were specially made for them with the arms and coronet of the 3rd Lord Leigh (died March 1737–8)

picked out in colour. In the saloon of the Duke of Chandos's house in St James's Square in 1725 there were twelve japanned back stools covered with red linen and with needlework cases that were valued at £96; but the twelve elbow chairs varnished black with banister backs and seats covered in figured velvet were only put down at £12.[77]

Needlework chairs were often chosen for drawing-rooms with tapestry or needlework hangings, and, if they were not available, it seems material with a pile was often used in preference to damask. That can be seen in the drawing-room of Sir William Stanhope's house in Albemarle Street, London, in 1733, where there were '3 pieces of fine historical Tapestry 12 feet 2 Pairs of crimson Velvet Window Curtains Five Chairs carv'd and gilt frames cover'd with Crimson Velvet backs and seats and false cases and an Arm Chair ditto'. Similarly, in the Tapestry Drawing-Room at Castle Howard as refitted by the 4th Earl of Carlisle and described in the inventory

134. *A walnut and parcel gilt chair from a set originally at Sutton Scarsdale, Derbyshire, about 1728 and attributed to Thomas How. It is unusual because of the cast gilt lead mounts in place of carved and gilt detail and the panel of blue ground* verre églomisé *with the arms of Lord Scarsdale inset in the back that suggests the covers may have been blue.* Temple Newsam, Leeds.

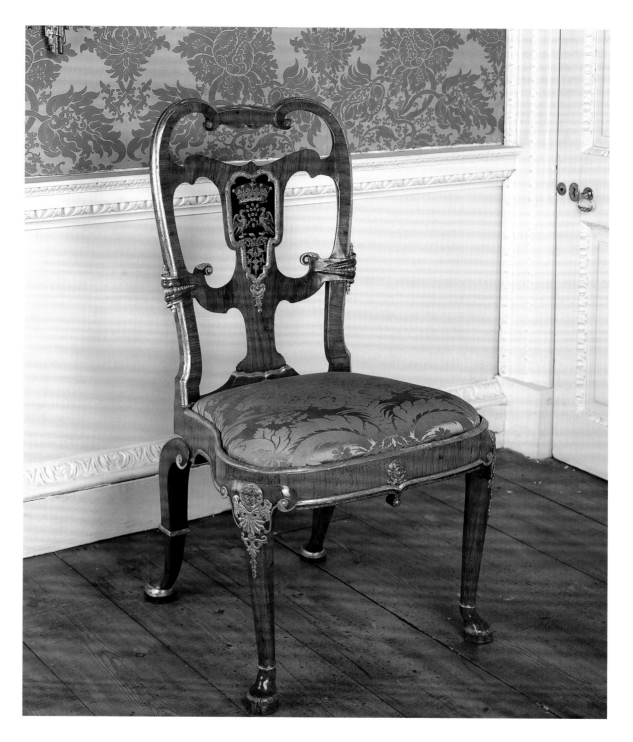

taken in 1758 on his death, there were four pieces of seventeenth-century French tapestry described as *Roman Triumphs* (sold from Naworth Castle, Cumberland, in 1999); and with them were eight mahogany French elbow chairs with stuffed backs and seats covered in crimson flowered velvet; the curtains were damask. The state bedroom was furnished in a similar manner.[78]

Recently a set of six mid-eighteenth-century side chairs and two armchairs have been lent back to Lyme (Fig. 133). These have unusual covers worked as if they were intended to imitate cut velvet, with the needlework raised above the linen ground.[79]

When expensive materials were used for covers, they were not used on the backs of chairs, and the convention was to use a simpler woollen material in the same colour as the show stuff and matching the colour of the curtains. That was often watered and sometimes impressed with a pattern complementary to that of the show materials, as on the saloon chairs at Houghton (Fig. 202). Today it is

rare to come on a set of chairs that have kept their original watered material, as have the needlework chairs at Lyme and those in the gallery at Temple Newsam (Fig. 325), but velvet or damask on the back of an upholstered chair appears to have been a solecism.

One of the most curious sets of seat furniture is that originally consisting of twelve side chairs, two settees and two pedestals from Sutton Scarsdale (Fig. 134), and so presumably dating from the late 1720s or early 1730s when the new house was being finished. They are attributed to Thomas How, the upholsterer whose name appeared on the foundation plate of the house commemorating its rebuilding by the 4th Earl of Scarsdale. The line of the parcel-gilt walnut frames with splat backs is rather stiff compared with the Houghton chairs, and, instead of being carved, the frames are decorated with gilt lead mounts that originally balanced the burnished water-gilt mouldings. Most unusually, the backs are inset with panels of the Scarsdale arms in *verre églomisé* with a blue ground framed in

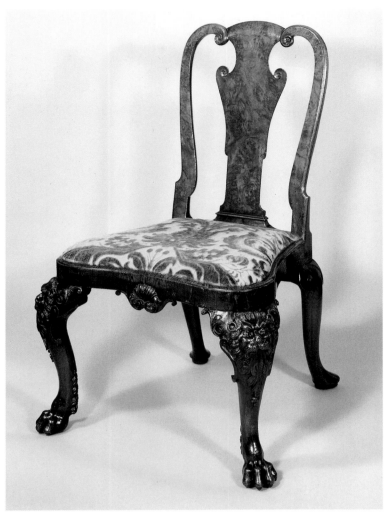

135. *One of a set of walnut chairs supplied by Thomas Moore to Dudley Ryder in 1734. Walnut seems to have remained the preferred wood for parlour and dining chairs until the late 1730s.* Lady Lever Gallery, Port Sunlight.

gilt lead; that suggests the upholstery was probably blue in colour. The pedestal has similar inserts and the mouldings at the base also show traces of parcel gilding.[80]

The rapid increase in the importation of mahogany was to have a considerable effect on furnishing, and its plentiful use at Houghton was not the great extravagance it used to be thought. In 1721 the Naval Stores Act was passed to promote the production of naval stores in the North American colonies that were essential for the British Navy and mahogany from the West Indies was free from duty. That year, the value of mahogany imported was recorded at £100. In 1723 it was nearly £700; in 1724, £1,200; in 1725, £3,100; and by 1728 it had reached £4,000.[81]

That may explain why one of mahogany's early architectural uses could be found in the house of Thomas Goldney, a Bristol grocer who was both a Quaker and a privateer. At Goldney House, Clifton, the room called 'the Mahogany Parlour' in an inventory of 1768 is panelled in mahogany. With its complex order of Tuscan pilasters and walnut inlay in the frieze, Baroque outline to its marble fireplace surround and Gibbonsesque overmantel, it is hard to date, but it is thought to have been fitted up about 1720.[82]

However, it took a surprisingly long time for mahogany to drive out walnut as the wood most favoured for chairs. At Houghton, for

instance, it is striking how many walnut chairs there were, and the only mahogany chairs in the main rooms were the carved and parcel-gilt set in the saloon. In William Hallett's earliest recorded bill, sent to Lord Irwin in 1735, there is mention of a set of eighteen carved walnut chairs at 23s. each, coming to £20 14s. (sold at Sothebys in 1999), and two now-missing settees at £4 18s. the pair; they have carved shells on their knees and claw and ball feet. There were also twelve mahogany chairs at 10s. each; four more walnut chairs at 16s. 6d.; six chairs with matted seats at 8s. 6d.; and twelve matted chairs at 2s. 6d.[83]

Those eighteen walnut chairs can be compared with a set of ten walnut chairs (Fig. 135), eight of which are now in the Lady Lever Art Gallery, supplied by Thomas Moore to Dudley Ryder in 1734. These were described in the bill as having 'broad banister Backs cutt in a Shape with scrole tops finneard with very good wood, loose Compass seats stuft in white Hessings with rich carved forefeet with Lyons faces on ye knees and Lyon Paws & Oge back feet with scroles and carved shells to ye fiore rails'; and they cost just over £2 16s. each. A second set of ten 'french wallnuttree' chairs similarly carved were supplied at the same price. Next on the account came a pair of carved and gilt frames for marble slabs with lionsheads and paws to the legs at £18 and a pair of 'carved scrole pediment pear frames with new glasses to Do finely gilt in burnished gold' at £10 10s.[84]

Thus in the mid-1730s it was considered correct to combine walnut chairs with gilded pier-glasses and tables. That was evidently a fairly recent change, because when the saloon at Erddig was furnished in the early 1720s both chairs (Fig. 365) and table frames were walnut, and only the glasses (Fig. 363) had gilded frames.

In the late 1730s and early 1740s an increasing number of carved mahogany chairs could be found. Examples include a single chair at Holkham with heavily carved legs and arms ending in lions heads, which may be the pattern chair for which Hallett was paid £3 5s. in 1738, a time when Thomas Coke was furnishing the Family Wing; the set of massive leather-covered chairs supplied to the Treasury about 1739; the long set of large parcel-gilt and boldly nailed chairs with upholstered seats, backs and arms presumably supplied for the new drawing-rooms at Kent's Devonshire House and now at Chatsworth; the parcel-gilt chairs also by Kent at Rousham, which are unusual at that date because their detailing ties up with that of a marble-topped table; and the set of parcel-gilt chairs still upholstered in their original cut velvet in the drawing-room at Longford Castle (Fig. 63) attributed to Giles Grendey.[85]

The change-over from walnut to mahogany was still going on in the early 1740s. In 1743, for instance, William Greer supplied a dozen very large mahogany chairs with stuffed seats, backs and elbow and covered in yellow silk and worsted damask at a cost of £43 4s. for the drawing-room at Gibside, Co. Durham. For the bedroom, which he furnished with a cotton bed, he supplied six walnut chairs with leaves carved on the knees and scrolled toes and covered in green glazed linen for £12 15s. However, it may not be quite a straight comparison, because it could be that the glazed cotton was preferred on walnut rather than mahogany frames.[86]

Handsome sets of dining chairs in mahogany seem to date from the late 1730s and early 1740s onwards, as is known from Ditchley (Fig. 392), St Giles's House (Fig. 57) and Kirtlington (Fig. 400).

Until after the mid-century, it seems to have been the custom to stretch the material tight over the seats and backs of chairs so that

nothing interrupted the figure. It is hard to find evidence for tufting of backs or seats; and Chippendale does not indicate it in his plates. However, after 1760 good examples of tufting are found, as on the damask-covered seat furniture in the gallery at Corsham and on the leather seats of the library chairs at Osterley; and it is also indicated in engraved designs.

## CASE COVERS AND FALSE CASES

Good upholstery was so highly valued that throughout this period chairs covered with velvet, damask or needlework were invariably fitted with case covers, but there is very little evidence as to when they were taken off and the good upholstery exposed. One of the few references comes from Mrs Delany, on the visit of the Lord Lieutenant of Ireland to her house in October, 1745: 'Yesterday we were honoured with a visit from our Viceroy and Queen; they sent over early in the morning to know if we were disengaged, as they would breakfast. To work went all my maids, stripping covers off the chairs, sweeping, dusting, etc, and by eleven my house was as spruce as a cabinet of curiosities, and well bestowed on their Excellencies.'[87]

Another reference of the same year came during a tour describing a visit to Blenheim, when the author wrote that they were fortunate 'to see that place to advantage, as the Duke of Marlborough was there, and the furniture uncovered and shewn to everybody'. Clearly that was unusual, because the 3rd Duke had only come into the place after the death of Duchess Sarah in 1744.[88]

The convention was to have loose rather than fitted case covers of the same colour as the good upholstery but in a cheaper, more hard-wearing plain material, or in a check that matched the colour of the show material. Thus at Canons, chairs covered in crimson damask had case covers of crimson shalloon.

But there were many variants recorded in inventories. The needlework chairs in the Lady's Drawing-Room at Chicheley had cases of green serge fringed all round, the colour relating to the green lustring curtains. For Milton in Northamptonshire in 1710 a set of eight walnut back chair frames costing 19s. each had damask covers, and green printed stuff for loose covers was also supplied. At Erddig, the 1726 inventory lists many case covers in white stuff. In John Crowley's house in Thames Street, six India back walnut chairs with mohair covers had printed linen case covers, the same idea as at Milton; while Henry Shelley, a draper in St Paul's, Covent Garden, had in his Great Dining-Room in 1736 nine walnut chairs covered with needlework (most unusual in such a room) and they had leather cases. At Ham in 1744, Bradshaw provided 'scarves' of crimson lustring for the velvet seat furniture in the drawing-room, but they could not have been expected to last.[89]

Check case covers can be seen on the settees in the Refectory at Strawberry Hill in John Carter's watercolour of 1788 (Fig. 50), but whether Horace Walpole had them when the settees were new is not known. Certainly checks were in use by the middle of the century, because William Greer provided cases of 'fine Cotton Cheque' at 1s. 6d. a yard for the mahogany chairs in the drawing-room at Gibside in 1743.[90]

On occasion a different approach was adopted, and it was the show covers, or 'false cases' as they were sometimes called, that were made to slip on and off. This was logical when houses were only occupied for short periods in the year and there were servants

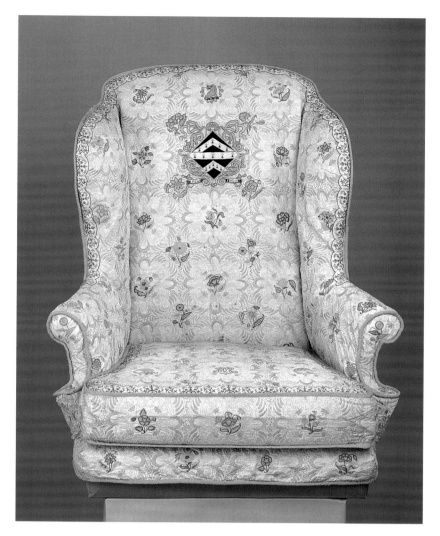

136. *A finely embroidered, evidently tight-fitting 'false case' or loose cover for a wing chair with the arms of a widow of the Holden Family.* Victoria and Albert Museum.

to make the changes. Covers were made to go on an existing set of chairs at Dyrham so that they would match the principal bed, and caffoy covers survive in the Saloon at Erddig (Fig. 365). Similarly, the covers of crimson velvet on a gold ground on the gesso chairs now in the Marble Parlour at Houghton were also originally made to come off rather than be fixed as they are today. At Boughton, the 1718 inventory lists eight upholstered walnut armchairs with loose cases of crimson velvet trimmed with gold galloon in the drawing-room of the Great Apartment, and six upholstered chairs with cases of crimson damask flowered with gold and trimmed with gold fringe. Some of the material appears to survive on the chairs in the room, but it has been reworked over the years and is now fixed to the frames. However, the pattern is quite different from that of the material used on the bed and must have been obtained to convey the idea of crimson and gold. Several of the other rooms had chairs with case covers of the show upholstery. At Canons, Lord Carnavon's tapestry-hung drawing-room had twelve walnut back stool chairs with brocade false cases valued at £44 to match the two pairs of brocade window curtains also valued at £44 and loose serge cases; and in the saloon of the London house the twelve back stool chairs covered in red linen had needlework case covers that raised their value to £96.[91] That reference calls to mind

an exceptional 'false case' cover for a wing chair in the Victoria and Albert Museum (Fig. 136). Intended to fit, it is of very fine professional embroidery, mainly in yellows with a band of crimson embroidery, edged with a yellow tape and lined with a watered yellow wool. On the chair back are the arms of Holden set in a widow's diamond and framed in ornament reminiscent of engraving on silver or a bookplate of about 1725. Nothing is known of its history, but the fact that it was for a wing chair suggests that it might have been intended for a principal bedroom with related bed hangings lined in yellow and possibly yellow window curtains. The fineness of the embroidery suggests a room only used on special occasions.[92]

Another route could be seen in a bedroom at Gibside, which was done in cotton in 1743. The walnut chairs covered in glazed green linen had loose covers in printed cotton for show. At Cotehele, there is a rare set of slightly later knotted 'false cases'.[93]

How usual it was to have different case covers for winter and summer is hard to say, but records seem to indicate that at Delville Mrs Delany had summer covers of French blue linen finished with garlands of husks and oak leaves and bows in knotted white linen thread. Could it be that the rare embroidered linen case covers on the set of chairs at The Vyne, which may possibly have been supplied by Vile in 1753, were intended for use during the summertime?[94]

# 4

## *Aspects of Display*

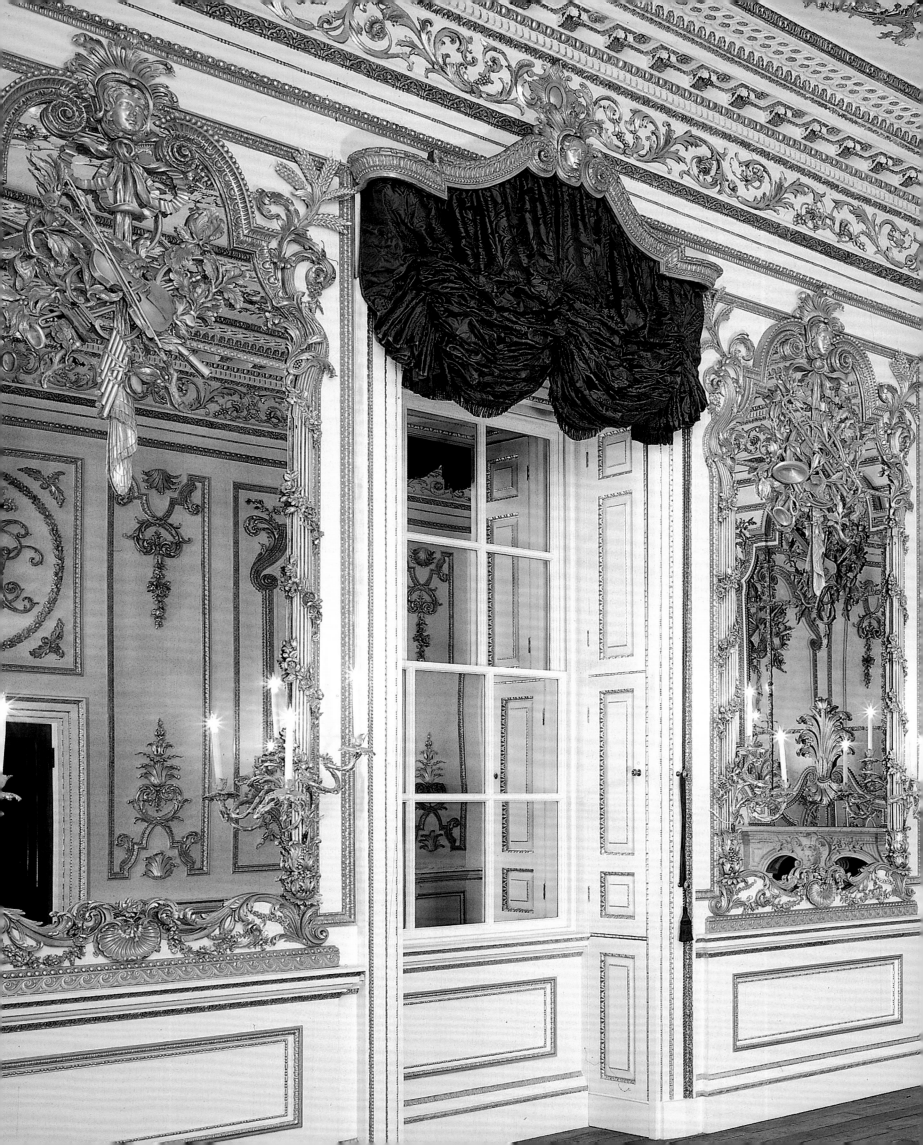

In approaching early eighteenth-century interiors from a twenty-first-century point of view, almost the hardest aspect is their emphasis on display, not only in terms of architectural concept and planning, with the number of rooms in a sequence, but the way expenditure was concentrated on a comparatively small number of rooms to achieve the maximum impact. That concentration tended to be diluted later, when people expected to live in more of their houses more of the time.

Plate was particularly important, but comparatively few collections of early eighteenth-century silver and silver gilt survive, and those that do are rarely shown. Gilding was also significant, but today most people are frightened of it, quite apart from being put off by the expense involved in its renewal, and feel more at ease if it is 'antiqued' or left untouched and lifeless. Thus it seemed important to include plate to make a bridge to the usual approach to silver specialists, who tend to consider individual pieces in terms of style, maker and date and are less interested in use and impact in an interior. Good contemporary descriptions are hard to find and illustrations are even rarer.

Another forgotten aspect of display was the significance of light in an age of candles. Since light was expensive and complicated to organize, it was both a compliment to guests and a symbol of hospitality, and even occasionally of unnecessary extravagance. Too little was thought mean; too much was considered vulgar.

However, the use of silver, the frequency of gilding and the amount of light used may well have had different connotations in London and country houses in the early eighteenth century that we now find hard to pick up. There might have been more of all three in London, but that is now hard to prove.

## THE SIGNIFICANCE OF SILVER

The importance of a fine display of plate in an early eighteenth-century nobleman's house is hard to sense today, because only at Dunham Massey, Ickworth in Suffolk and Woburn are large eighteenth-century collections on show, with a smaller display recently arranged in the dining-room at Kedleston. What it meant at the time can be gathered from the reaction of John Collis, the Mayor of Hastings, when he dined in 1735 with the 2nd Duke of Richmond at Goodwood in Sussex, soon after the latter became Master of the Horse. Collis noted:

There were twenty seven Sussex Gents among the rest; the Duke of Newcastle, Earl of Wilmington, Lord Abergavenny, Lord Ossulton who is the Earl of Tankerville's son. The Entertainment vastly splendid and served all in plate, Dishes & all, and a fine desert; there were twenty four footmen waiting at Table, & as he is Master of the Horse to the King 16 of them in the King's livery & the rest in his own, which is very handsome. In short, the Dinner Side-board, Desert, and grandeur surpassed everything I ever saw, & the house vastly fresh finished. We tarried till 12 o'the clock, dining at half an hour after 4.[1]

An even grander occasion was the dinner given for Prince Eugene of Savoy by the 2nd Earl, later 1st Duke of Portland, at his house in St James's Square in 1711. Seventeen noblemen dined at 6.00, waited on not by servants but by gentlemen:

The Linen and the Plate is the finest in England, the buffet for the gilt and silver plate is as rich as any and for the china dishes and plates, none in England come near my Lord's. The dinner consisted in twenty six dishes, the centre and four corners, which were soups, being afterwards taken up and relieved by five others, so made it thirty one for the first course. The second course was thirty three dishes. The fruit was all served on china, forty three dishes large and set up in pyramids. It was a perfect garden to see, and like a beautiful landscape, the variety of fruit colours, glasses, and the gold and red and other colours of the china adding a new lustre to the whole.[2]

Usually a collection of plate was formed gradually over many years, indeed often over more than one generation. Acquiring silver was regarded as a good way of building up a reserve of easily realizable cash that could be called on if necessary or used to settle debts or help with the portions of younger children. Even so, it is surprising how long it took to complete sets of cisterns, coolers and fountains – the fountain for water to rinse glasses after use, the cistern to catch the water and also any dregs in glasses after use, and the larger cooler for ice to stand on the floor – that were fashionable in the first three decades of the century and of which over twenty-five examples are known. At Burghley, for instance, it was probably the 6th Earl of Exeter who acquired the great cistern, which was made by Philip Rollos in 1710; but only in 1728 did his younger son, the 8th Earl, who succeeded in 1722 at the age of twenty-one and married in 1724, acquire from Thomas Farren a wine fountain and

smaller cistern. The 2nd Earl of Warrington, who inherited Dunham Massey in 1694 and married in 1702, acquired his great cistern from Philip Rollos in 1701, but it was not until 1728 that he ordered the fountain from Peter Archambo; and the following year the smaller cistern.[3]

The finest surviving – indeed, only complete – set of fountain, cistern and cooler (now in the Victoria and Albert Museum) is that made for Thomas Parker, the 1st Earl of Macclesfield and Lord Chancellor from 1718 to 1725, by Anthony Nelme in 1719–20 (Fig. 137). Together, the three pieces weigh almost 2,500 ounces, and the cost of the Britannia standard silver without workmanship would have been about £1,200. As a comparison, the Duke of Chandos's fountain of 285 ounces was valued at £135, his small cistern of 662 ounces at £314, and large cistern of 2,158 ounces at £1,025 – that is to say, totals of 3,105 ounces and £1,474.[4]

Only the richest people could afford a silver cistern, and even some peers had to content themselves with one of silvered brass. Among the rare survivors are those made about 1715 with the arms of the Earl of Grantham (Fig. 139), which would pass for solid silver in a display, or the simpler one with the arms of the 4th Earl of Cholmondeley, but probably ordered by the 1st Earl, who died in 1724.[5]

The passing of the fashion for fountains and cisterns after 1730 and the rising taste for epergnes in the 1720s marked the switch in emphasis from the buffet and display plate on the sideboard to plate on the table. The earliest known epergnes in Britain are those by Edward Feline dated 1730, made for a member of the Williams family of Bodelwyddan in Flintshire, (Fig. 138, now in the National Museum of Wales) and that by David Willaume II and Anne Tanqueray of about 1731–2, which was acquired by Cholmley Turner (1685–1757) of Kirkleatham, Yorkshire, some twenty years later (and is now at Temple Newsam). The latter is more complex, consisting of a stand, a tureen, six branches, two triple caster stands and vase-shaped casters, two cruet frames and four short curved branches with four smaller dishes and an oval dish to replace the tureen cover. It weighs 438.9 ounces.[6]

It is not surprising to find that the Duke of Chandos had what was described as a 'new silver machine' with twenty-seven pieces weighing 532 ounces and valued at £252 in 1725. When Lady Grisell Baillie dined at Canons on 12 April that year, she noted 'A Duson at Table' and 'ane Eparn in the Midle' of the table. Epergnes were the most expensive pieces in their day, and George Wickes, who seems to have specialized in them, made thirty-nine between 1735 and 1747.[7]

A silver dinner service represented a huge outlay and very few early ones survive. The finest is that ordered by the 20th Earl of Kildare, later 1st Duke of Leinster, from George Wickes and supplied in 1745–47. Out of the original 190 pieces, no less than 170 survive, with nineteen out of the original thirty serving dishes, and fifty-nine dinner plates and eighteen soup plates out of ninety plates. There were ten sauce boats and spoons, four fish plates, one large and ten smaller waiters, four pairs of candlesticks, twenty-two dish covers, two tureens with dishes and ladles, two oval and four round boxes and two cruet boxes, an epergne with a basket, plateau and base. The epergne weighed 427 ounces 16 pennyweights and cost £360 11s.[8]

The fullest account of tea plate is that at Dunham Massey, where there was a special Tea Room, a small room with one window, a fireplace, no seat furniture and only a marble slab on a mahogany frame on which the silver was presumably set out. There was a large silver tea kettle with a lamp and stand, which presumably stood on the ground like those made by Simon Pantin for the Bowes family of Gibside and Streatlam Castle, Co. Durham (now in the Metropolitan Museum, New York) and by Augustine Courtauld in 1725 with the arms of the Earl of Hertford, later 7th Duke of Somerset, belonging to the Duke of Northumberland. Only five are now known, but one is to be seen in a painting of a tea party in the Victoria and Albert Museum. There were also two lesser tea kettles and lamps on mahogany waiters, four gilt tea canisters, a silver chocolate pot, two silver coffee pots on two waiters and four silver teapots. The pair of silver waiters or tables made by David Willaume with their specially fitting mahogany tables are described as for tea and coffee in the 1758 inventory.[9]

The tea plate in the drawing-room in the Canons inventory was valued at £208: it included a kettle, stand, lamp and trivet valued at £80 2s. 4d., and two silver tables upon silvered frames valued at only £33 0s. 6d., which may have been silvered brass like the chandeliers or silver waiters on gesso frames.[10]

In certain grand houses, a display was also to be found in principal dressing-rooms. At Canons there was £970 worth of silver on display including two large chased silver bottles, one of 445 ounces valued at £200 and one of 443 ounces valued at £199. The silver was evidently regarded as part of the scheme of decoration because the hangings were of crimson flowered velvet on a silver ground, the hearth was done in silver and a large pier-glass had a silvered frame valued at £100. Today, the only place where that kind of display can be seen is in the King's Chamber at Knole, where the silver furniture, dressing set and jars on the ebony cabinet have probably complemented the richly brocaded bed since the early eighteenth century and have survived as part of the showing of the house.

A number of families had silver or silver gilt toilet services, sometimes built up over a number of years with pieces by different makers or sometimes ordered at the time of a marriage. An early one, now in the Victoria and Albert Museum and formerly at Sizergh Castle, Westmorland, is decorated in a distinctive chinoiserie style that is akin to etching. At Dunham Massey there is a twenty-eight-piece set mostly made by Magdalen Feline in 1754 for Lord Warrington's only child, Mary, who married the 4th Earl of Stamford. However, although Hogarth depicted one in *The Countess's Levee* in *Marriage à la Mode*, there are puzzlingly few descriptions of them by visitors to houses and they show little sign of wear, as if only set out on special occasions.[11]

Silver was also used for sconces, which tended to be used only in drawing-rooms and important bedchambers, and occasionally for chandeliers, as is explained on p. 134.

The importance attached to plate can be seen from the way a young man of means often started to buy plate as soon as he inherited, came of age or married. In 1718 Thomas Coke, newly returned from Italy, plateless and recently married but not yet hit by his losses in the South Sea Bubble, bought nearly £3,000 worth of silver from Paul de Lamerie. That was more than the £2,917 19s. he spent on works of art on his grand tour. His order included five dozen plates, which, with 4s. a plate for their engraving, came to £364 9s. 9d.; twenty-one dishes for £454 16s. 9d.; forty-eight knives at 5s. each, forty-eight spoons and forty-eight forks at 3s. each. He ended up with 758 ounces of gilt plate and 9,270 ounces of silver, including

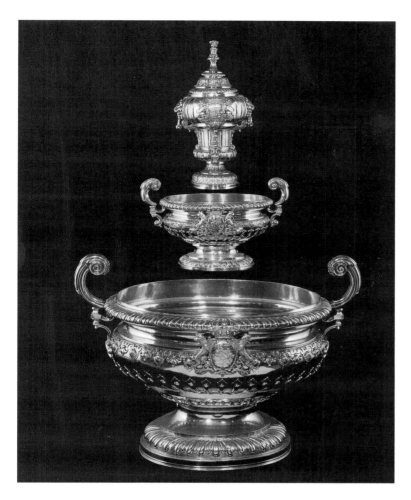

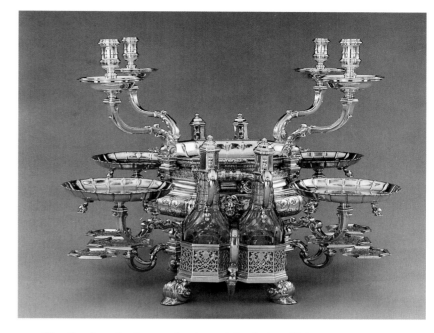

137. *The silver fountain, cistern and cooler made by Anthony Nelme in 1719–20 for the 1st Earl of Macclesfield. The only complete set known to survive.* Victoria and Albert Museum.

138. *The earliest known English silver epergne made by Edward Feline, 1730, for the Williams family of Bodelwyddan, Flintshire.* National Museum of Wales.

139. *A silvered brass cistern with the arms of Henry d'Auverquerque, 1st Earl of Grantham, about 1715. Much more use was made of silvered brass than is realized today, particularly for sconces and chandeliers.* Private collection.

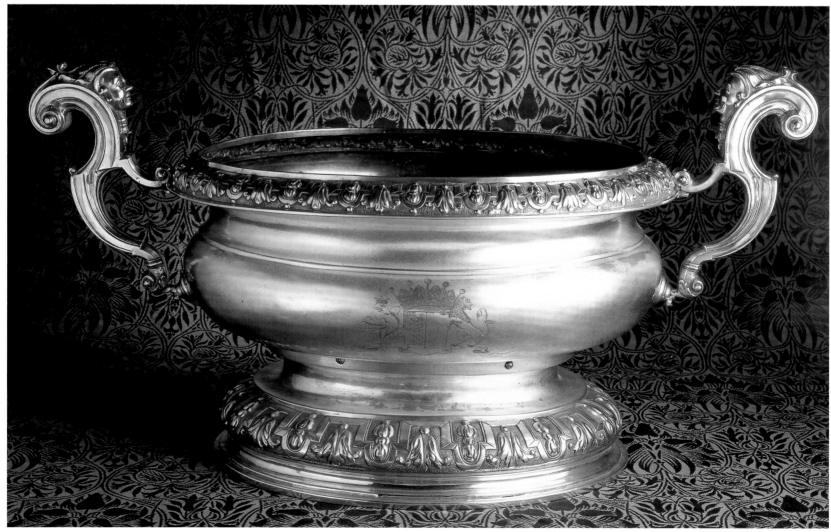

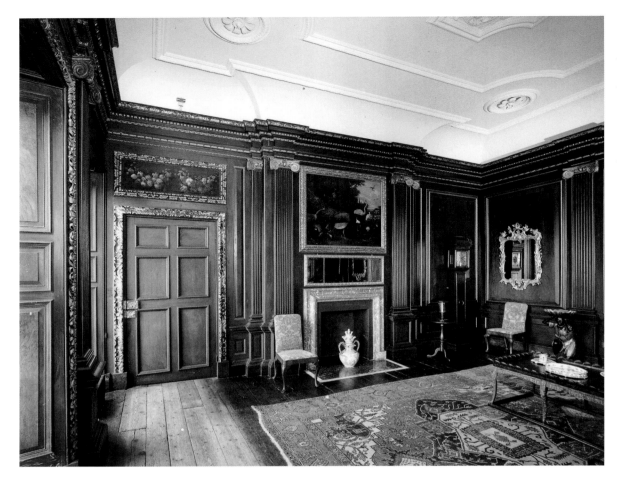

140. *The Balcony Room at Dyrham Park, Gloucestershire. An unusually elaborate panelling scheme in the Hauduroy part of the house with a complete order of pilasters first painted and gilded in 1694.*

141. *Ian Bristow's reconstruction drawing of the original marbling, painting and gilding scheme in the Balcony Room. Only the gilding has continued to follow the original intention.*

ninety-six gadrooned plates and thirty-six plain ones. That can be compared with the Duke of Portland's purchases of plates from Crespin over the years: in 1734–5 he bought eighteen, with one about 1740 and four in 1742–3, and then forty-nine in 1743–4, followed by 120 with different arms in 1756–7.[12]

If the number of plates seems very large, it has to be remembered that they were used all the time, as can be gathered from a postscript to one of the Burley-on-the-Hill letters of about 1718: 'I hope you have your plate out and do not put the ladies to eat off pewter.'[13]

Purchases of plate often coincided with building, with the former sometimes absorbing funds really needed for the latter. In 1745 Lord Kildare, who had succeeded his father at the age of twenty-two in 1744, and later became 1st Duke of Leinster, began Leinster House in Dublin and ordered his great service from Wickes. The year before, Wickes had copied for him a pair of figurative candelabra after designs by Thomas Germain that were remarkably close in spirit to the recently completed ceiling in the dining-room at Carton (Fig. 56). A little later, Nathaniel Curzon bought an epergne costing £525 15s. to commemorate a win by his horse Jason, and, as soon as he inherited, he ordered from Philips Garden a dinner service with six dozen plates and twelve gilt plates that in 1759 cost £2,918 6s. 7d., a huge sum, particularly in view of his plans for Kedleston. The epergne and some of the plates are to be seen on the table as part of the display of plate in the dining-room there.[14]

Silver purchases can be revealing of an emerging patron's taste. One of the earliest identifiable objects bought by Sir Robert Walpole is a pair of silver wine coolers by William Lukin with hallmarks for 1716–17 (Fig. 222, now in the Metropolitan Museum). Another example is the epergne (now in the Victoria and Albert Museum) that was made by de Lamerie and given as a wedding pres-

ent to Sir Roger Newdigate in 1743, several years before he showed any interest in the gothick style, but which parallels his classical library.[15]

Silver can also conjure up the splendour of a house that has lost its contents or even disappeared. Plate with the arms of Thomas Wentworth as Lord Raby and later Earl of Strafford, for instance, brings alive his ideas for Wentworth Castle that were never fully realized. He served as ambassador to The Hague and Berlin and as a result was granted plate with the Royal arms, including a ewer and basin by Philip Rollos dated 1705–6 that is now in the Victoria and Albert Museum. That represents another once quite common thread of splendour in old English plate collections, because so many people who served the monarch benefited from such loans that often became grants.

The list of plate in the Canons inventory can help to create a sense of the richness of the house. By 1725 the Duke of Chandos had £7,519 worth of silver and silver gilt in his Plate Room, and the compiler of the inventory got tired of adding up the weights. In addition, there were sconces in some of the principal rooms, silver fireplace furniture in some rooms as well as silver set out on the tea table in the drawing-room, the Best Dressing-Room and the Duke's Dressing-Room, which took the total value to over £8,000.[16]

That figure can be compared with the value put on Lord Warrington's plate, which is one of the most extensive collections of its time partly surviving in its original house. Much of it is in a restrained taste that parallels the way he handled the house, in particular the mood of his library and chapel. It consists not only of dinner plate, but tea plate, sconces, dressing plate and chapel plate. In his early years, when he was short of money, he bought a few exceptional pieces like the Philip Rollos wine cooler in 1701 and chapel plate, but he only started to buy on an extravagant scale in 1728. When he

revised the list of his plate in 1754, he noted that he had 26,589 ounces, which at a melt-down value of 5s. 6d. an ounce, represented £7,300. That was probably an exceptional amount for someone of his means, who was neither a great office holder nor a diplomat.[17]

That the Warrington plate was exceptional is suggested by comparison with the collections of the 4th Duke of Bedford, the 2nd Earl of Lichfield, the 3rd Earl of Carlisle and the 1st Earl of Leicester. The Duke had 20,000 ounces at the time of his death in 1771. Lord Lichfield, the builder of Ditchley, built up a more modest but probably more typical collection of plate weighing 5,253 ounces, valued at £1,488 7s. 9d. at the time of his death in 1743, whereas the rest of the contents of his still not quite complete new house were put down at £1,489 5s. Between 1726 and 1733, years when he was involved with building and furnishing, his accounts record a steady flow of payments to Lamerie, usually of £50 but sometimes less and occasionally up to £55, as if he was paying in instalments. Sadly, none of it can be traced today, but the most valuable pieces were a large gilt dish weighing 154 ounces and 5 pennyweights, a tureen and cover at 148 ounces 10 pennyweights, four large carved sconces with single branches weighing 291 ounces 5 pennyweights and 'a circuit compleat' (evidently an epergne) at 478 ounces 15 pennyweights.[18]

## ASPECTS OF COLOUR

More research has been carried out on paint and colour than on any other aspect of decoration in the past thirty years, and the subject has become so technical that it is difficult to treat it helpfully in a book of this kind. Ian Bristow has taught us to adopt a questioning attitude to any paint scheme that claims to be a survivor from the late seventeenth or eighteenth century, because he has overturned so many assumptions. He and others have also provided a historical

framework, even if there can be endless arguments about shades of colour and how to relate new paint to surviving aspects of earlier schemes of decoration, in particular gilding, hangings and wallpaper. Invariably, any new paint colour has to be modified to live with old work, with whites, in particular, knocked back. Very rarely is it possible to do a complete scheme of decoration in a historic interior with new paintwork, gilding and upholstery. This is important to remember, because Ian Bristow has provided confirmation of the strength of colours used in this period that parallels the evidence of unused textiles and wallpapers.

Less attention has been devoted to tone, texture and contrasts in rooms, and in particular to how panelling and carving have darkened. A start was made in the Grinling Gibbons exhibition at the Victoria and Albert Museum in 1998 that brought out the original lightness in colour of his limewood carvings and the way they related to grounds that were much paler in colour than they are today. Similarly, the recent cleaning of the painted ceilings in the state rooms of Chatsworth has drawn attention to their close relationship to the design of the wall treatments that had been partly lost through the darkening of all the woodwork and its luxuriant carving. However, what finally brought out the importance of changing tone was the presence of a specially made chest of drawers in the style of 1690, veneered in olive and holly and varnished in 'Best White Varnish', which was made for an exhibition about the London furniture trade in the late seventeenth century at the Geffrye Museum in the winter of 2001–2, and the coincidence of the exhibition about French marquetry at the Wallace Collection that showed how quickly marquetry loses its pristine balance. The blond character of the holly on the edges of the drawers and the dark oyster cuts of olive wood on the Geffrye piece provided unexpectedly vivid evidence of how important the original contrasts of light and dark were in the woods; and how much current views are influenced by a romantic haze of time and generations of careful polishing that have totally changed the appearance of objects.[19]

Many panelled rooms must have been much lighter in tone than we realize and it is worth remembering how after fifty or sixty years they were thought to be gloomy. At Chatsworth, for instance, the state rooms struck Horace Walpole as *triste*, which must reflect both time and darkening through treatment – and clearly the panelling has received a great deal of attention over the years. Similarly, when Jane Austen's mother stayed at Stoneleigh Abbey in 1806, she found that the combination of crimson upholstery and oak panelling installed about 1730 in the principal rooms was gloomy, presumably partly because the panelling must have darkened. Originally these rooms were probably close in weight to the panelling of the Great Hall at Boughton installed in 1910 and still quite light.[20]

Thus, when thinking about colour in the first half of the eighteenth century, it has always to be considered in relation to overall tone, and the love of strong colour has to be related to much lower levels of artificial light than are usual today. There was also a liking for contrasts of texture and colour that is to be seen in the way panelled rooms were painted, the way materials of different textures were combined in upholstery, gilded stands were used to show off lacquer cabinets and cut velvets used on chairs with gilt gesso frames.

The late seventeenth-century approach can be seen at Dyrham, where in the late 1970s Ian Bristow's examination of the Balcony Room, the centre room of the west front designed by Samuel

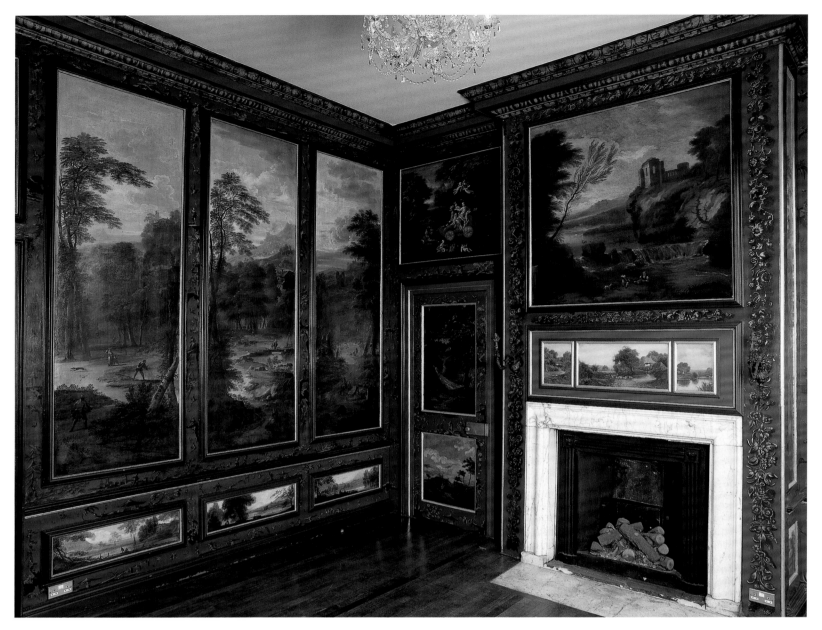

142. *The Painted Room at Carshalton House, Surrey, about 1710. The framing is a red brown as if to suggest red lacquer and the stiles and rails are painted in a chinoiserie style by a different hand to the landscapes. The moulded cornice is in* trompe-l'œil *and the overmantel is framed with* trompe-l'œil *garlands imitating gilded carving.*

Hauduroy, led to the discovery that the existing scheme of graining and gilding, which had always been taken to be original (Fig. 140), was almost a reversal of the original intention. The entablature, pilasters, the framing of their bases, the dado rail and skirting mouldings and the mouldings to the main panels were painted to resemble porphyry; the main areas of the panelling were marbled an orange-pinky colour and the skirting marbled grey (Fig. 141). The existing gilding more or less follows the original idea, with the mouldings of the entablature, the capitals, some of the base mouldings, the main and subsidiary panels and the dado panels all picked out. It was expensive: the entry below that in the account for painting the room was for 199 books of gold at 2s. each that came to £19 18s.[21]

The painter was probably Mark Anthony Hauduroy, the brother or son of the architect, and in 1694 he charged 3s. a yard, nearly three times the 1s. 2d. for oak and walnut graining elsewhere in the house: the revised measure for the room came to 147 yards, and the cost to £22 1s. He is recorded later, carrying out grisaille painting in the King's Chamber and on the Second Painted Staircase at Knole in 1723–4.[22]

The first forty years of the century saw major changes in the ways houses were painted, with a move towards simpler techniques, lighter colours and flat rather than glossy finishes, 'dead' colour as it was usually called. Taking off the shine considerably altered the colour, as Patrick Baty showed in samples done as trials before the repainting of the Norfolk House Music Room. This corresponded with the decline in wood panelling left in its natural state or varnished. The panelling of late seventeenth-century rooms not carried out in oak was invariably painted to imitate or suggest a finer wood or marbling, or on occasion a combination of contrasting materials, with some gilding of mouldings. A number of good examples survive, as at Ham, or can be seen in old photographs like those of the hall at Stoke Edith, while at Erddig in 1692 the agent wrote to Joshua Edisbury: 'The drab roome I thinke is painted very well the panells are resembling Yew, the stiles to prince Wood, and the mouldings a light colour. The Doctor's chamber is pretty well don sum what like Ash, I think; and vained very much like the Hall. The other roome, either a dark brown or somewhat like Simnimone in colour.'[23]

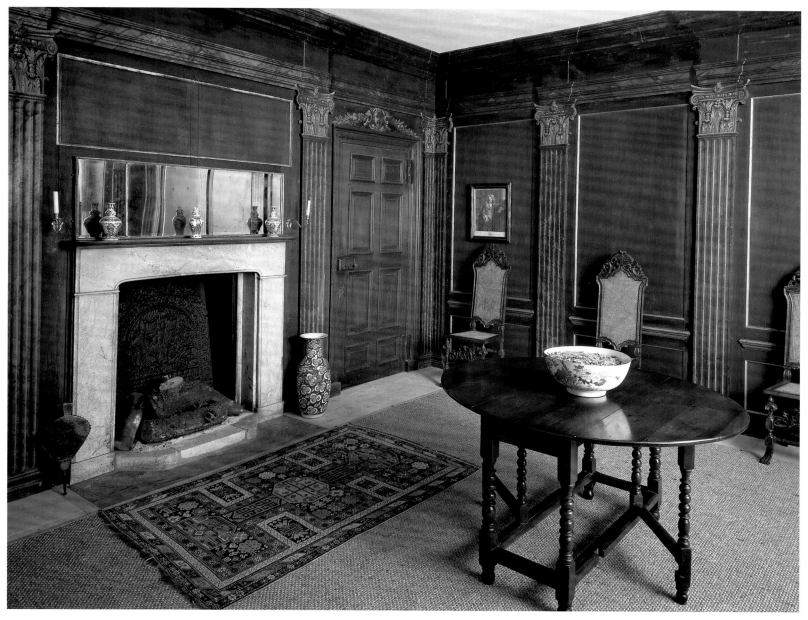

143. *The Painted Parlour at Canons Ashby. An unusually complex room with a simple order of cut-out pilasters with fluting and capitals painted in* trompe-l'œil.

*The painting was almost certainly done about 1715 by Mrs Elizabeth Creed, a cousin of Edward Dryden. The landscape glass and the pair of single sconces are original.*

Over the years a number of examples in other houses, several relatively modest, have been illustrated. Among them are Great Hundridge Manor in Buckinghamshire, Swangrove, at Badminton in Gloucestershire, the Parsonage at Stanton Harcourt, Oxfordshire, the White House at Suckley in Worcestershire, Hill Court, Herefordshire and Carshalton House, Surrey (Fig. 142). At Great Hundridge, which was built in 1696 by a London apothecary, there are three decorated rooms. The parlour has the fields of its panels grained to suggest walnut, with marbled mouldings and the stiles and rails imitating lacquer with pilasters flanking the bolection moulded fireplace. One bedroom has yellow sienna marbled panels with walnut stiles and a marbled black and gold fireplace; the main panels in the other are painted with rock stone in umber, burnt sienna, ochre and indian red.[24]

In the parlour at Stanton Harcourt, the fields of the panels simulate walnut veneer, the mouldings are marbled green and the stiles and rails imitate porphyry. In an upper room at Swangrove, a *maison de plaisance* on the edge of the park at Badminton built about 1703 for the young 2nd Duke of Beaufort, the panels are marbled white

and the doors, stiles and rails are japanned. At the White House, which appears to be two thirds of a house that was built about 1700 and never completed, there is good graining and marbling in a bedroom and, even more remarkable, a marquetry closet. At Hill Court, the panelling of the principal room on the first floor is painted to imitate rock stone, the mouldings are marbled and the stiles and rails are freely painted in a chinoiserie style. The work may have been done by Isaac Bayly who worked in the hall at Stoke Edith in 1705.

Some idea of the costs can be gathered from Bayly's letter about Hill Court, and these figures can be compared with Hauduroy's charges at Dyrham quoted on the previous page. He charged 1s. a yard for cedar colour and walnut; 1s. 6d. for black and white marble; 2s. for green stone; 3s. 6d. for rock stone; and 5s. for lapis lazuli.[25]

One of the most remarkable examples of fancy painting and colour is the Painted Parlour at Canons Ashby (Fig. 143), which almost certainly painted by Mrs Elizabeth Creed (1642–1728), a cousin of Edward Dryden and responsible for painted family

144. *Detail of the grisaille panels based on Marot prints with the arms of the 2nd Duke of Montagu and his Garter conferred in 1718. Now at Boughton House, Northamptonshire.*

monuments in north Northamptonshire. It is not known when work began, but the room was not yet furnished at the time of Edward Dryden's death in 1717. It is a country version of a Talman panelled room with an order, where colour is used to complement the architectural design. The colour and grain of the simple moulded pinky-grey marble chimneypiece suggested the marbled finish of the pilasters, which are cut out and painted with *trompe-l'œil* flutes, the architrave mouldings and the cornice, and the colour of the main fields of the panels and the dado panels. The cut-out capitals are also painted in *trompe-l'œil* to suggest white or grey-white marble, and the framing of the panelling and the frieze is painted a dull blue. The doors and architraves are in tone with the fields of the panels and above it is a little *trompe-l'œil* carving. The mouldings round all the panels are gilded and match the frame of the horizontal chimney glass.[26]

This approach to painting went out of fashion during the 1720s, but it is based on similar principles to the design of the Marble Parlour at Houghton (Fig. 217), where all the architectural elements are expressed in a range of marbles. However, it is hard to find other examples of colour in paint being used to convey the architectural grammar of a room in the 1720s and 1730s.

In 1747 *The London Tradesman* observed:

> When it was the Taste to paint the House with Landskip Figures, in Imitation of varigated Woods and Stone, then it was necessary to serve an Apprenticeship to the Business, and required no mean Genius in Painting to make a compleat Workman; but since the Mode has altered, and Houses are only daubed with dead Colours, every Labourer may execute it as well as the most eminent Painter.[27]

Even in the 1720s and 1730s, the main rooms in some Smith houses, including Chicheley (Fig. 374), Ombersley, Davenport and Mawley, were still lined in wainscot, but in the 1720s came the change from wood to stucco and so from browns to painting in stones, olives or even whites on special occasions. At Kensington Palace, when the King's Gallery, which had been fitted up by Wren for William III with oak panelling and velvet hangings, was remodelled by Kent, he painted the existing panelling white to go with the new crimson damask hangings (Fig. 181). Indeed, it may be the earliest visible example of a grand room treated in that particular way.

Such a use of white was a statement of extravagance, because the oil in it tended to discolour it, and there are a surprising number of references to rooms being stone colour or olive, which are based on earth colours that do not change. This can be seen at Boughton, where the panelling in the Great Apartment is all painted a drab colour. It can also be seen on the set of panels at Boughton (Fig. 144) based on engravings by Marot and painted with the 2nd Duke of Montagu's arms with the Order of the Garter, which he received in 1718, that were in store at Montagu House, Bloomsbury, according to the 1735 inventory. The ballroom at Wanstead was an olive colour, as it appears in Hogarth's painting, and that is confirmed in Mrs Lybbe Powys's description in 1781. So was Vanbrugh's saloon at Eastbury, Dorset, and the rooms at Houghton, according to Mrs Lybbe Powys. In 1744 Mrs Delany wrote that she had her English room 'painted a sort of olive, somewhat lighter than my brother's, for the sake of my pictures, and because the room is very light'. However, that only lasted six years, because in 1750 she wrote that she had hung her 'dressing room (which was painted olive-colour before) with a dove-colour flock paper'.[28]

Inevitably, few original paint schemes survive after 250 years, but in the 1930s the original suede-brown colour was revealed in the saloon at Ditchley, and it makes an effective ground for the reliefs but also suggests sober panelling in a great parlour. Old photographs of the gallery at Mereworth, where the ceiling is dated 1732, show it hung with plain green velvet and the woodwork painted brown and parcel-gilt (Fig. 83). One of the best examples is at Newhailes, where there are references to James Norie's use of olive–stone colour in several of the rooms in his bill of 1739; but it is not clear how old the present finishes are, or the present balance of olive to gold in the dining-room (Fig. 53). It may be that some of the gilding dates from the early nineteenth century and the olive colour has been renewed in the past.

Throughout this period, halls, staircases and circulation spaces tended to be in stone colour because it was hard-wearing and cheap. How that works can be seen in real stone in the halls, staircases and corridors at Castle Howard and Blenheim, and in stone and plaster at Beningbrough. When it was decided in the late 1970s to clean the paint off the stone dado in the hall at Beningbrough, it was revealed to be a beautiful cream colour, as at Castle Howard, and that provided a clue to the painting of the hall and corridors. A grisaille scheme on a grey stone ground can still be seen on the Second Painted Staircase at Knole, painted by Mark Anthony Hauduroy in 1723–4, and, while it is not surprising there, surely it is more unexpected to find similar painting in the very richly furnished King's Chamber. Stone colour can also be found at Houghton: on the ground floor, the stone colour of the Arcade continued into the original paint colour seen recently on the panelling in the Hunting Room when the Chinese wallpaper was taken down for conserva-

*The sequence of furnishings in the 1690s in the Great Apartment at Boughton*

145. *The First State Room with four of the probably original simple japanned chairs with gilt finials and feet which had cushions covered in crimson damask in 1697.*

146. *Crimson velvet armchairs with Mortlake tapestries of the Acts of the Apostles in the adjoining drawing-room. Originally the chairs in the room had false cases of crimson velvet, not fixed upholstery as here.*

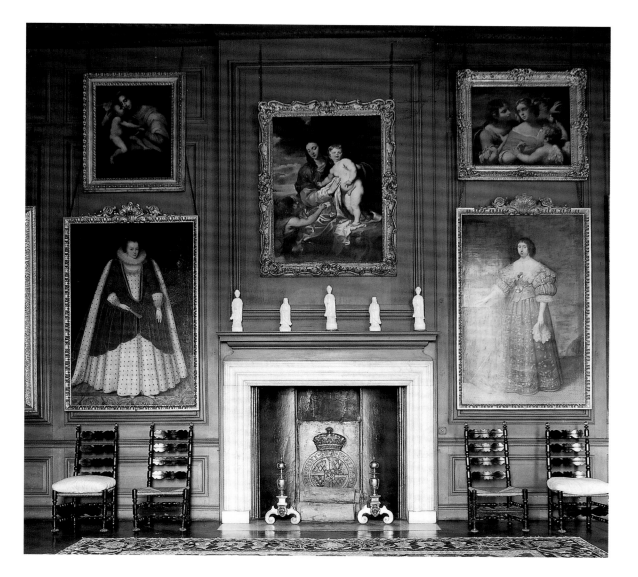

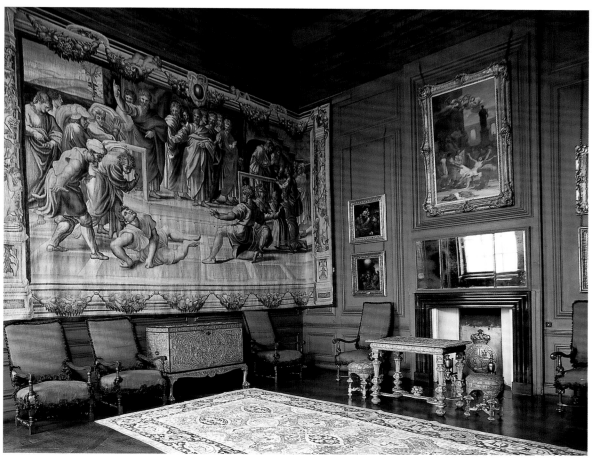

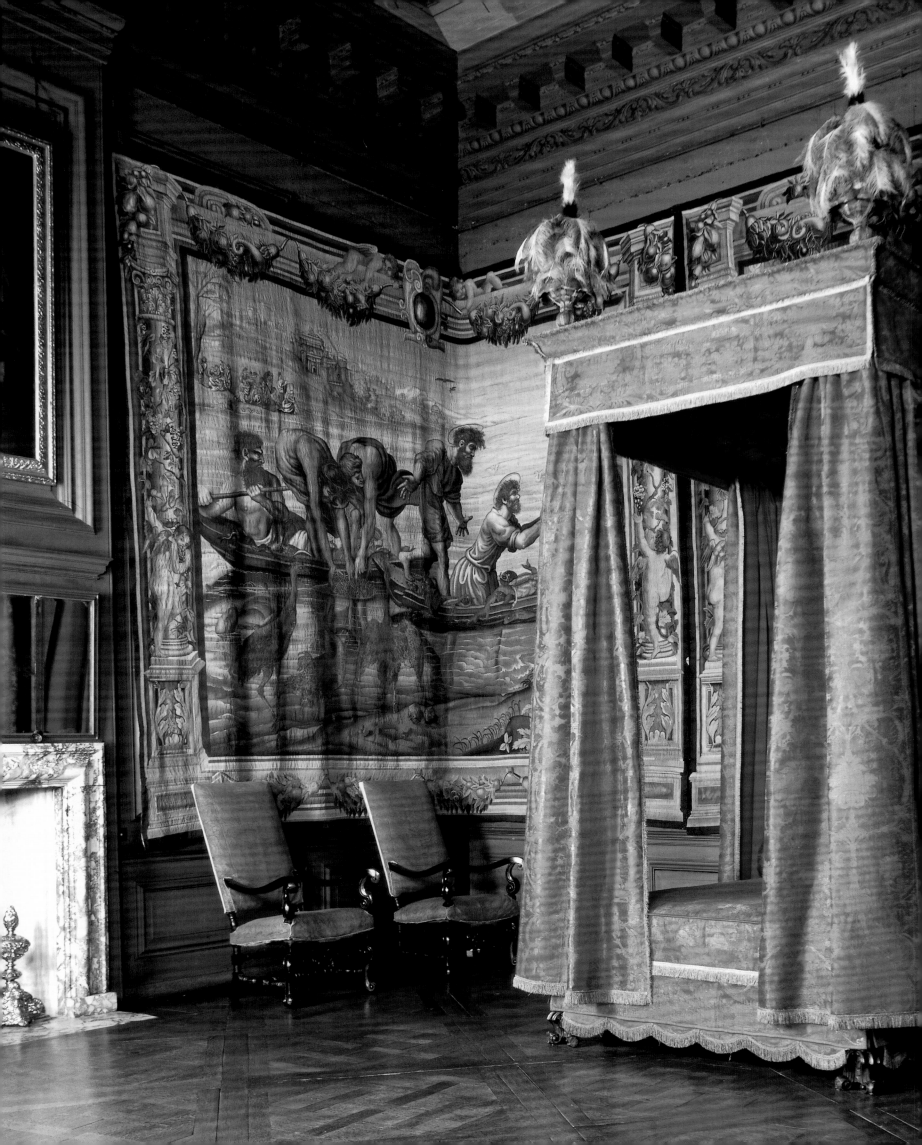

148. *The tester of the bed showing the subtle cutting of the pattern to suit the curved shape.*

149. *A detail of the crimson and gold material on the chairs in the state bedroom. While the design does not match that of the material on the bed, it continues the idea.*

147 (facing page). *The original state bed at Boughton, in crimson damask brocaded in gold, possibly French about 1670. It was been recently returned to the room on loan from the Victoria and Albert Museum.*

tion, on the walls of the balancing Stone Staircase and, of course, in the Stone Hall (Fig. 191). It makes the impact of the rich textures and warm colours of the parade rooms all the more dramatic. Another version is seen in the ground colour of Kent's Painted Staircase at Kensington Palace.

What emerges is that there was a hierarchy of colours that was partly a matter of association, but was also influenced by price. Thus in 1734 Salmon in *Palladio Londonensis* included a list of prepared colours sold by Alexander Emerton, the London colourman, which Ian Bristow suggests were sold in paste rather than liquid form. They consisted of best white lead colour at 4*d.* a pound; pearl colour, lead colour, cream colour, stone colour, and wainscot or oak colour at 4*d.* and 5*d.* a pound; chocolate colour, mahogany colour, cedar and walnut-tree colour at 6*d.* a pound; gold colour at 8*d.* a pound; olive colour, pea colour, fine sky blue mixed with Prussian blue at 8*d.* to 12*d.*; orange colour, lemon colour, straw colour, pink colour, blossom colour at 12*d.*; fine deep green at 2*s.* 6*d.*[29]

However, association was more important, and red, crimson or scarlet was always the principal colour. In Randle Holme's *Academy of Armoury*, first published in Chester in 1688, he wrote of the 'Signification of the Colours Used in Arms' and of red being the colour of Mars: 'Thus colour *Vermillion*, or *Red*, is the chief amongst colours, forasmuch as it representeth the Fire, which of all the other Elements is the most lightsome, and approaches nearest to the quality of the Sun: In regard whereof it was ordered, that none should bear this Colour but Persons of noble Birth and Rank, and Men of special desert, for it signifyeth Dignity.'

In decoration and furnishing, crimson always seems to have had the grandest associations; and certainly state apartments in royal

palaces were all done in crimson until George IV's time. That explains the choice of crimson, whether in velvet, brocade or damask for the grandest beds, and is confirmed by the use of crimson canopies of state for beds at Raynham (Fig. 95), Scone Palace, Perthshire, and Blickling in Norfolk. The use of crimson can be followed through in the fitting-up of great apartments, as at Boughton. There, according to the 1697 inventory, in the first completely panelled room were a pair of armchairs and twelve back stools with matted (i.e. rush) seats and they had crimson quilted damask cushions with valences trimmed with matching galloon, and also two crimson damask chairs trimmed with gold fringe. In the drawing-room hung with *Acts of the Apostles* tapestry there were eight walnut chairs with stuffed backs and seats that had false cases of crimson velvet trimmed with gold galloon (Fig. 146). In the bedroom there was the bed of 'crimson damask flowered with gold' (Fig. 147), six stuffed elbow chairs covered in what was described as the same material and six matted chairs with matching cushions. Then there was a change to blue in the dressing-room.[30]

Recently, with the return of the newly conserved bed on long loan from the Victoria and Albert Museum, it has become possible to see how that sequence worked. Four of the five surviving simple black japanned chairs with gilded finials and feet and rush seats, but without their damask cushions, have been placed either side of the chimneypiece in the first room. In the adjoining drawing-room, armed chairs with old red velvet upholstery from three slightly different sets have been replaced; while the chairs that go with the bed are covered in a much cut-about and decayed crimson and gold material that echoes but does not attempt to match it. Without the bed, they read as crimson damask, but its arrival makes the gold

ground more visible and so makes the whole build-up work in a most unusual way (Fig. 149).

Clearly weave and texture have an important role in this sequence, and this idea continued on occasion until the end of the period under consideration here. In particular, it seems usual to have used a bolder and less expensive material in a saloon than in a drawing-room, as can be seen at Erddig (Fig. 368), Houghton (Fig. 202) and Holkham (Fig. 447), with caffoy preceding velvet, cut at Erddig and Holkham and plain at Houghton.

That can also be seen with the use of crimson in all three rooms of the Great Apartment at Stoneleigh, which must have been fitted up in the late 1720s or early 1730s. In the first room, the Great Parlour, the walnut chairs had crimson velvet cushions and the curtains were of crimson mohair. Then in the drawing-room, where there were chairs with particularly fine needlework covers, the wall hangings were of crimson velvet and again the curtains were of crimson mohair. Finally, in the Best Bedroom there was a bed of crimson velvet valued at £300 in 1738, seat furniture of parcel-gilt walnut with velvet covers that could be by James Moore the younger, and window curtains of crimson silk. Thus there was both unity and a steady build-up in richness of effect.[31]

Antony was more simply furnished than might be imagined today, but again it is interesting to see where crimson materials were used. The 1771 inventory, which appears to show the house largely unaltered since the death in 1744 of Sir William Carew, the builder, lists eight chairs and a settee of red velvet in the saloon, but only one – not the expected three – pairs of window curtains of rose-coloured 'Hallakeen', presumably haratteen. The principal bedroom, above it on the first floor and still called the Red Room as in 1771, had a bed of 'velvet cavoy' or caffoy. The design of the wainscot on the piers between the windows suggests that the contemporary gilt gesso pier-tables with marble tops were not anticipated, and nor were the pier-glasses over them.

Conversely, at Chicheley, which was furnished at the same time, Sir John Chester had no crimson upholstery, perhaps suggesting that he thought it too grand for his house. It would be interesting to find evidence suggesting that while crimson was associated with splendour, it was considered not very happy to live with and people preferred other colours as backgrounds for living as well as for pictures. It may also have been thought that crimson materials absorbed light and were difficult to bring alive without candles.

So while green came second in the hierachy, it was thought a more agreeable colour for furnishing, and, since it was associated by Randle Holme with Venus, felicity and pleasure, it was often chosen for best beds, as can be seen at Kiveton, Drayton, Houghton (Fig. 213) and Compton Place. In the Great Bedchamber at Kiveton there was a 'Rich green Damask Bed lin'd with Tabby compltd trimm'd with Gold, Silver, & silks lace, fringe, Lines, Tossles & Roses wth embroider'd Cyphers, Stars & Coronetts in Gold and Silver'; and it had green case curtains hanging from a gilded rod. With it went twelve large chairs with frames carved and gilded with cyphers and coronets and covered and trimmed like the bed, and four green tabby window curtains.[32]

Green seems to have been particularly liked as a background for pictures in the 1730s, as could be seen at Houghton in the drawing-room, and in the 1740s in damask in the gallery and cut velvet in the drawing-room at Longford Castle (Fig. 63). When the Duchess of Northumberland went there, she particularly admired 'the taste in

the Apartments dressed with Green, of which there are several furnish'd with different manufacture & various hues of this pleasing colour'. The Round Drawing-Room still retains the velvet that she saw, and, although the adjoining gallery has been rehung, the damask is probably a repetition of the original pattern. It was used in flock wallpaper in the gallery at Temple Newsam, where it has been replaced in recent years (Fig. 324).

It is also noticeable that rooms with green upholstery tended to be more important than those with blue. That can be gathered from the Chicheley inventory and that for Doddington Hall, Lincolnshire, where in 1760 the drawing-room overlooking the garden had ten chairs covered in green flowered velvet and green camlet curtains, while the parlour, now the library and overlooking the forecourt, had curtains of blue camlet.

Blue seems to have come third in the hierarchy. Randle Holme called it Jupiter's colour and said it 'signifyeth Piety and Sincerity'. Thus the bed of blue damask in the artichoke pattern from Hampton Court now in the Metropolitan Museum was probably in a less important room than the crimson damask bed from the same house now at Het Loo. The inventories for Canons, Houghton and elsewhere suggest that in the first four decades of the century, blue was often the colour chosen for upholstery in everyday rooms, and, when used for woollen materials, the effect must have been sober on dull days.[33]

On the other hand, there were exceptions. One of the best examples of painting is the Blue Drawing-Room at Belton, which appears to be related to the borders of the Vanderbank tapestries (Fig. 331). Another was the use of blue velvet or caffoy used in the principal drawing-room at Castle Howard and the blue cut velvet bed at Wolterton, of which only a fragment remains of the material. Another is the combination of blue cut velvet and blue paint in the corner room at Chiswick, which is a complete restoration with the pattern of the velvet from the caffoy at Houghton.

The growth in the use of blue was partly due to the discovery of Prussian blue during the first decade of the century. It was first advertised in 1710 and by the time Kent was working on the Cupola Room at Kensington Palace one of the criticisms of it was that he had not used the more expensive ultramarine as was required. By the 1730s, Prussian blue was cheap enough to use in house painting.[34]

That probably explains its use as a smart colour for decoration from about 1730 to about 1760 and its use in plain and patterned wallpapers. All the state rooms at Woburn were hung in blue damask in the late 1750s; Lord Dumfries chose blue damask for the drawing-room furniture for his house; and Mrs Delany hung her dining-room 'with mohair cafoy paper, (a *good blue*)' in 1755. Traces of blue paint have been found at The Vyne in the saloon and dining-room, where they appear to antedate the inventory of 1754.[35]

During the 1750s there seems to have been a new fashion for plain papers consisting of small sheets that were pieced together and then painted, the net of vertical and horizontal joints creating a subtle rhythm that is not found with a length of modern plain paper. No complete examples have survived from the eighteenth century, but recently parts of a verditer paper dating from the late 1770s were found in the Great Drawing-Room at Burton Constable, while modern recreations have been made for Mrs Child's Bedroom at Osterley and for the Lee Priory Room at the Victoria and Albert Museum. Smaller fragments of a sugar-bag blue paper survive on the backs of prints originally in the south link corridor at Kedleston.

In the Chinese Drawing-Room at Carton (Fig. 347), Lady Kildare reused blue paper as a ground for panels of Chinese paper. These can be compared with the unfaded example of a decorative wallpaper of about 1760 at Doddington Hall (Fig. 150), which appears very similar to one in the principal bedroom at Grimsthorpe described by Arthur Young: 'the blue damask bedchamber is elegant, it is hung with blue paper upon which are painted many different landscapes in blue and white with representations of frames and lines and tassels in the same'.[36]

Horace Walpole was an early user, with a plain blue paper in the first-floor Breakfast Room, seemingly a red one in the Red Bed Chamber, which had the chintz bed in which his father died and crimson Norwich damask chairs, and a plain purple paper in the Holbein Room (Fig. 304), where it matched the colour of the cloth bed. In 1758 Mrs Delany noted the Duchess of Portland's dressing-room in her London house as being new hung 'with plain blue paper the colour of that in my closet'. Two years later, when the Duchess of Northumberland went to Bulstrode, she saw another one used by the Duchess of Portland: 'the Room next the Hall hung with plain light Blue paper: this room is large & well proportioned. It has five windows on two sides'.[37]

Yellows do not seem to have been part of that hierachy, and they are notoriously difficult get right in flat paint, needing to be glazed. Also, there may have been an antipathy to yellow as a background to bright gilt frames. So early references tend to be to hangings, as in King William III's Little Bedroom at Hampton Court Palace in 1701, where it was in succession to and contrast with crimson in the parade rooms. There may be a point to it being used for rooms like the Queen's Bedroom at Dalkeith and the original principal bedroom at Castle Howard that is lost on us. At Leeds Castle, Kent, what survived as the principal bed in the early years of the century was an angel bed made in about 1710–20 and hung in yellow damask in the sunflower pattern (Fig. 103). The same pattern was recorded in a second-floor bedroom at Houghton, where the Family Drawing-Room was done in yellow caffoy, but yellow was not used in any of the principal rooms. In 1731 Mrs Delany described the three principal rooms in Mrs Clayton's house in St Stephen's Green in Dublin as being done in gold-coloured damask. The 1743 inventory for Compton Place describes the second principal bedroom as being all in yellow mohair. The Hon. George Bowes seems to have had a particular penchant for yellow in his houses. When he refurnished his drawing-room at Gibside in 1743, William Greer provided yellow silk and worsted damask for hangings, curtains and chair covers at 5s. 9d. a yard.[38]

References to rooms being painted yellow before the 1740s are uncommon, although recently three tones of yellow have been found in the Kirtlington dining-room and recreated by the Metropolitan Museum, with a slightly stronger colour as the ground to the frieze and then one slightly lighter on the ceiling. These can be compared with James Mackay writing to Patrick Duff in 1755: 'These ornaments painted white, upon a deep yellow ground of the ceiling has a good Effect, or all white both are in fashion here.'[39]

Mrs Delany described a scheme in yellow in a London house in 1756: 'I was yesterday at Lady Hilsborough's assembly; she has a very good house, furnished all with yellow damask, with an open border of burnished silver that edges all the hangings, and many other pretty decorations of japan and china, but *no pictures*.' That sounds like an early example of the fashion for rooms in three-

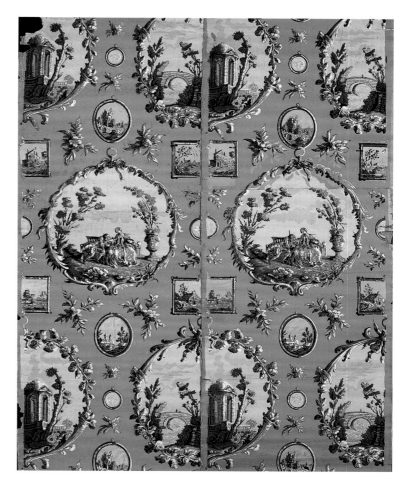

150. *An offcut of wallpaper at Doddington Hall, Lincolnshire, about 1760.*

colour damasks with large glasses but no pictures that was sometimes mentioned in the early 1760s. Although the combination of yellow with silver seems to anticipate a scheme by Chippendale at Harewood House in the late 1760s, it may have been a convention, because there are earlier references to yellow damask with silver lace in a bedroom at Ditchley in 1743.[40]

While there was a strong sense of sequence in colours in paint and upholstery, there was another that took into account the colours and veining of marbles for chimneypieces. More dark marbles were used in the late seventeenth and early eighteenth centuries, particularly when chimneypieces were moulded rather than carved; and as the years passed colours became lighter as the amount of carving increased and motifs became smaller in scale. At Kiveton, for instance, one way the importance of the room was expressed was in the marble chosen for the chimneypiece. Thus there was purple in the Great Hall, Great Dining-Room and the Great Drawing-Room, and then white in the Great Bedchamber and Egyptian marble in the Best Dressing-Room; but only Plymouth in the Best Closet. The grading continued downward with dun-coloured marble in the North-East Closet and Plymouth in the North-East Bedchamber, the everyday drawing-room and the vestibule; and dove-coloured marble in the dining-room.

Halls generally had chimneypieces of stone, while those in saloons would probably be of a less fine marble than those in drawing-rooms. That also related to the amount of carving desired, and Ware pointed out: 'In general the rule by which (the ancients) guided themselves was this, where they intended a great deal of ornament, they employed a plain marble; and where they proposed

less workmanship, they allowed the most variegated kinds.' 'Therefore for all sculpture and ornament, the best material is that which is one simple colour.'[41]

It was also the convention for the tops of pier-tables to be of the same marble as the chimneypiece. The colour of the marble could thus become an integral part of the colour scheme of a room, as can be seen in the Painted Parlour at Canons Ashby (Fig. 143) and the Tapestry Drawing-Room at Hagley (Fig. 412).

In the twentieth and twenty-first centuries, as part of the pursuit of light, doors are often painted white or light colours, but originally they were dark, being made of mahogany or oak, grained or painted a dark colour. The painting of doors in a light colour may have been introduced in the 1750s, but more evidence is needed. The painted doors in the hall at Ditchley (Fig. 385) are one puzzle, while another old but probably not original example can be seen in the dining-room at Felbrigg (Fig. 427): there, dark doors and the portraits were surely part of the original counterpoint of light and dark in the room. Against that, the doors in Paine's contemporary design for the dining-room at Gopsall appear to be light in tone, like the walls.[42]

It is also not clear when glazing bars began to be painted white, but at Houghton, where they are of oak and on an unusually bold scale, they all remain in their natural state, as do the carved glazing bars at Blenheim. It is conceivable that the fashion for painting them came in when glazing bars became thinner and panes of glass larger, which transformed the appearance of sash windows from inside as well as outside. Occasionally they were not only carved but painted white and parcel-gilded, as in the saloon at Honington, decorated in the early 1750s (Fig. 81).

Today, pre-Adam ceilings are invariably painted white, and so Robert Adam's claim that it was his idea to paint them in colours is accepted. However, in 1759 William Chambers wrote:

> When the profiles, or other parts of a room are gilt, the ceiling must likewise be so; and that, as profusely as the rest. The usual method here, is to gild all the ornaments, and to leave the grounds white, pearl, straw colour, or light blue, or any other tint proper to set off the gilding and ornaments to the best advantage: but I have frequently seen that practice reversed with more success, by gilding the grounds, and leaving the foliages white, particoloured, or streaked with gold.[43]

It is not known how early this habit started, but, as was explained earlier, it seems likely that the Italian stuccadores planned the tinting and gilding of their ceilings. Physical evidence of tinting, however, is hard to find because it would have been done in distemper, which has been washed off over the years. In support of this, however, is the point that distemper could have been used immediately by stuccadores, while oil paint would have been left for a year or so and would have had to be applied by a painter.

Contemporary documents rarely provide that kind of evidence. One of the few found by Ian Bristow relates to the ceiling by John Baptist St Michele in the Governors' Court Room at St Bartholomew's Hospital, London, in 1738, which is described as 'done in Stucco, of three different colours'. A visitor to Ditchley describes the hall walls as cream-coloured stucco with lead-coloured ornaments. Another account dates from 1752, when Lady Luxborough wrote to William Shenstone: 'I must now beg the favour of you to instruct me about the ceiling of my bed-room, which I would have

adorned a little with papier mache and the ground painted a colour.' He recommended: 'The whole Cove (except the Moulding) should be washed with Oker.' And at Norfolk House in 1756 the painter charged for painting the ceilings of the dressing-room and state bedroom, which had elaborate ornament in the French style, 'in party colours'.[44]

At present there are a few examples based on modern, scientifically based evidence, like that found for tinting in light blue and for more generous gilding in the Octagon at Twickenham that made much more sense of its architectural design. Otherwise, all that can be done is to cite examples that appear to be old, like the pale blue on the bed of the ceiling in the hall at Houghton (Fig. 193). Similarly, the tinting of the figurative plasterwork in the principal bedroom at Compton Place (Fig. 115) makes good sense, as if an old tradition has been always adhered to. In the saloon at Wallington (Fig. 278), the cove of the ceiling is painted a delicate shade of blue to throw up the Lafrancini plasterwork. There is no record of it having been done, but even if the present colour is not original, it may well repeat an original idea.[45]

Patrick Baty found clear evidence of pink in the entablature and on the ceiling in the gallery at Temple Newsam (Fig. 324), which was obtained by tinting the white distemper with red ochre. As repainted, it takes any glare off a white ceiling, but to modern eyes looks rather odd with the soft white of the dado and architraves. However, it raises a question about whether the balance of pink and green anticipates Robert Adam's fondness for the combination in the 1760s.[46]

About the same time, Lord Chesterfield described how the panelling and ceiling of his study were painted a beautiful blue, with much carving and gilding. These seem to tie up with the Premnay reference to yellow grounds mentioned a little earlier. A visitor to Heythrop in 1756 described 'a handsome dining room the whole Room Stuccoed and the Ceiling very neatly ornamented with Birds and festoons of flowers on a Buff coloured ground'. And Arthur Young described the Best Dressing-Room at Hagley with 'The ceiling white ornaments in stucco on a lead coloured ground'.[47]

On occasion, ornament was evidently painted naturalistically, as can be gathered from Dr Pococke's description in 1754 of the interior of the recently built Belvedere, attributed to Flitcroft, in Windsor Park: 'The hexagon is most beautiful, the sides are adorned with festoons and flowers and fruits hanging down from them on each side of the doors and windows in stucco, and painted in their natural colours.' That idea is familiar from French Rococo boiserie, but perhaps it was more usual in English decoration that is supposed today.[48]

## QUALITIES OF OIL GILDING

Much less has been written about gilding than colour and paint, and it remains a mysterious subject, partly because so few gilding schemes are carried out in eighteenth-century rooms when they are restored today, largely for reasons of cost. Architectural gilding was always expensive – as Lord Lyttelton wrote to Sanderson Miller: 'Do you reflect, my good Friend, how much the Beauty of Hagley might have been improved by two Hundred pounds? . . . It could have gilt me two or three Rooms, or bought two fine pictures for my Salon.'[49]

The English tradition was to oil gild architectural ornament, and today that is usually presumed to be inferior to the more complex and expensive process of water gilding, which involves laying thin

coats of gesso over parchment size, carving the dry gesso, sizing it and polishing it, before applying gold leaf that can be burnished to create a high sheen. That technique was used for architecture as well as seat furnishing. However, as always, comparisons are not as simple and direct as that, and it is not reasonable to compare gilding in an English country house with that in a French royal palace or a sophisticated Parisian building like the Hôtel Soubise. In fact, there was little gilding of architecture or boiserie in houses outside Paris, which may have been in part a practical matter, because water gilding is delicate and soon deteriorates in a damp atmosphere, a problem in France as well as England. It may also have been a matter of perception, because burnished gilding creates a great sense of brilliance and richness, and on occasion it was considered a relief to get away from it.

The comparison between English and French practice is even less straightforward, because after 1725 there was very little panelling of parade rooms in England. Instead, they were stuccoed or hung from cornice to dado with material or wallpaper, which would justify no more than a gilt fillet. So there was usually only limited scope for architectural gilding beneath the entablature or cornice, except in the rare panelled rooms of the late 1740s and 1750s in the French taste, like the Music Room from Norfolk House (Fig. 154) and the White and Gold Room at Petworth (Fig. 64).

On the other hand, English carving was often finer than French, as the French admitted, and, since oil gilding did not involve a layer of gesso requiring a second bout of carving, it only needed a thin coat of oil-based size as a base for the gold leaf; and when the carving was part of a painted architectural scheme, it needed only a thin layer of paint before the size was laid on. The carving gave the gilding life and stopped it going solid, while at the same time oil gilding created an even effect that was admired.

Those planning gilding were skilled in balancing the gilding of flat mouldings with the highlighting of carved ones. Where there are broad bands of gilding, as in the frieze of the Green Drawing-Room at Clandon (Fig. 151), it is not actually solid, because the carving of the bay leaves breaks it up. They seem to have avoided bands of it at eye level.[50]

The brightness of oil gilding is influenced by the length of time it takes for the size to dry – the slower the size, the brighter the effect – and the colour of the gold is not only dependent on the shade and purity of the gold leaf but whether it is laid on white or on earth colour and the colour of the size. Thus, the colour direction of the gilding may have been planned in relation to the colour of the upholstery in a room. A good deal can be done to create contrasts of brightness and mattness, which are easy to achieve with water gilding, by using tinted glazes, but inevitably old ones have been wiped off over the years.

As with painting schemes, very little eighteenth-century architectural gilding survives unaltered. In some places it has been painted over, in others renewed or added later, sometimes with additional ornaments, as at Blenheim. What can be disagreeable is when old, damaged and discoloured gilding without any sparkle is retained, and renewed white paint is too bright and contrasting as well as crudely cut in. It makes the gilding even deader. Cutting-in is a delicate task, and is the reverse of the original technique of gilding over the colour.

Certainly it is difficult to provide a set of rules on how to gild architecture at different dates in the period considered here. So

151. *The frieze of the Green Drawing-Room at Clandon. The gilding was probably added in the 1740s when the original wallpaper (Fig. 254) was covered with damask and the overmantel was installed.*

much depended on what an owner was prepared to spend, on understanding how far to go and when to stop – difficult then as now – and on the judgement of the craftsmen involved. There were probably differences between practices in London and country houses, with more gilding in London interiors.

Surprisingly, in late seventeenth-century parade rooms like those at Chatsworth and Boughton there is no architectural gilding, and the same is true of the King's Rooms at Hampton Court, where there is also very little carving, with only the entablature in the King's Bedroom enriched.

One of the best examples of late seventeenth-century architectural gilding is in the Balcony Room at Dyrham (Fig. 140), where, as Ian Bristow has shown, the gilding more or less follows the original scheme, whereas the rest of the room has totally changed its character. The mouldings of the entablature are picked out in gold, but there is none on the straight mouldings; the capitals to the pilasters are gilded, as are the mouldings to their bases, and the mouldings of the panelling scheme are lined out in gold.[51]

It would appear that William Kent, presumably as a result of his experience in Italy, introduced a more generous approach to architectural gilding than had been usual hitherto in England; but by then there was already an excellent understanding of the possibilities. That is well illustrated by the set of painted panels at Boughton (Fig. 144) after engraved designs by Marot: they bear the arms of the 2nd Duke of Montagu with the Order of the Garter conferred on him in 1718. However, a camera has difficulty picking up the underpainting in aubergine-brown, with lining-out in black and touches of red ochre in some panels. Over the aubergine colour, the solid parts of the design are laid in solid gold, which can only be detected where it comes through the top glaze that dulls down its brightness, with the detail hatched or done with fine brushstrokes.

Kent must have had a thorough understanding of that kind of painting and the use of oil as opposed to water gilding on carving, and how to work with it to create contrasts of effect. Some people, like Lord Oxford, who admired Gibbs, thought Kent used too

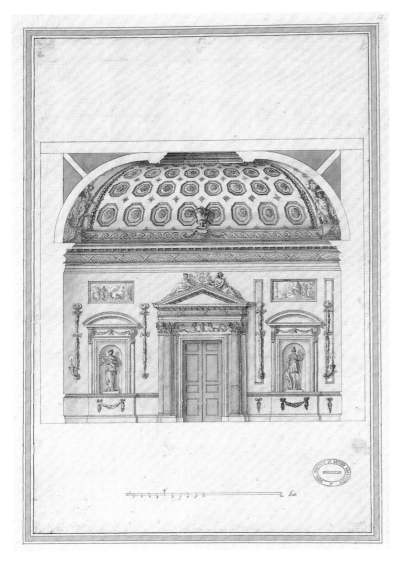

152. *Henry Flitcroft's drawing of a 'Side of a Cube Room' with rare guidance for gilding that conflates Kent's Cupola Room at Kensington Palace (Fig. 173) and the hall at Ditchley (Fig. 385) but evidently done for the engraving in William Kent's* Designs of Inigo Jones, 1727. *RIBA Drawings Collection.*

have sand-gilt grounds to throw up the ornament, an idea familiar in mirror frames.[52]

The architectural gilding at Houghton can be compared with that at Chiswick, where it is more dominant because in the small rooms it is close to the viewer as well as being considerably renewed. It is even overpowering in the richly ornamented gallery and tribunes and in the Blue Velvet Room, where the dado and skirting are carved and gilded. However, in general the combination of picking out mouldings and edging with colour and the gilding of flat edges appears correctly balanced; and in Ian Bristow's view, the gilding on the ceiling of the Red Velvet Room is original, as are the upper parts of the Blue Velvet Room. The designs of both are thought to be based on drawings by Flitcroft following instruction from Lord Burlington and perhaps similar to Fig. 152. The latter is interesting because of its relationship to Kent's painted decoration and in particular the relationship of the gold mosaic grounds to his painted panels.[53]

Those rooms invite more thought about the King's Gallery at Kensington Palace (Fig. 181), where the combination of crimson, white and gold seems a natural palace style, but was, in fact, a novelty at the time. A reference to white and gold also occurs about the same time in Sir Matthew Decker's description of the dining-room at Narford.[54]

In the mid-1740s there seems to have been a decline in the taste for gilding, as Campbell wrote in *The London Tradesman* in 1747: 'But as Gilding at present seems to be out of Fashion, there is Employment but for few Hands, who do not understand Carving.' That would fit with Mrs Powys in 1756 finding the effect at Houghton too much: 'the cornishes and mouldings of all the apartments being gilt, it makes the whole what I call magnificently glaring'.[55]

At Honington (Fig. 81), where the saloon dates from the early 1750s, the gilding was planned to create a lighter effect. It is striking that there are no solid bands or straight lines of gilding, or gilding of flat mouldings, so there is less underlining of the architecture. The gilding reads as highlights on mouldings, cut in along the outer edges so that they seem to be almost serpentine and often lying in front of subsidiary ornament left in white. The parcel gilding of the capitals of the doorcases is particularly subtle, with the spines of the acanthus leaves, their edges and the edges of the turned-back tips of the leaves all gilded. Parcel gilding continues in the plaster frames of the pier-glasses, the shutters and, unusually, the carved glazing bars.[56]

Documentary evidence for gilding schemes is rare, because few early eighteenth-century drawings indicate gilding. One such is Flitcroft's version (Fig. 152) of the original drawing for the 'side of a Cube Room' in Kent's *Designs of Inigo Jones*, which shows gilding of the statues in the niches and, rather oddly, the reliefs over the niches, and some gilding of the drops-cum-candle-holders flanking the niches as well as the coffers in the ceiling. The design seems to be a conflation of the Cupola Room at Kensington Palace and the hall at Ditchley (Fig. 385), but the architectural gilding does not seem to be well planned.[57]

That raises the question as to who planned gilding, because by its nature it is closer to painter's work than an architect's. However, the role of the upholsterer must not be forgotten, because there was usually a relationship between architectural gilding, the frames of seat furniture and tables, and the covers of seat furniture and wall hangings, and they were planned to give a sense of build-up to

much: at Raynham in 1732 he noted: 'The rooms are fitted up by Mr Kent, and consequently there is a great deal of gilding.' Vertue did not care for the gilding of the statues in the niches of the Cupola Room at Kensington Palace (Fig. 170).[52]

The most extensive and the most skilfully planned example of gilding to survive is at Houghton. In the saloon (Fig. 194), all the architectural elements that are carved are picked out in gold, and the seat furniture (Fig. 202) is treated in a similar way. The gilding gives a sense of understanding where to pull out all the stops, where to be restrained and where not to gild at all. Only the highlights of mouldings are gilded, but at the same time there is plentiful gilding of flat edges to emphasize the structure, as can be seen on the saloon doorcase, where the outer moulding of the architrave to the door, the moulding immediately between the frieze and the outer mouldings of the pediment are all gilded. The columns of the doorcase (Fig. 202) are gilded, but the flutes left plain, while the leaves of the capitals are only parcel-gilt. There are the additional comparisons at Houghton between the way mouldings are gilded and the way the trimmings on the Green Velvet Bed (Fig. 213) are worked to create an architectural effect and also the way the legs of the gilded chairs

153. *The Octagon at Orleans House, Twickenham, in 1944. It appears that Gibbs's original design for the walls was elaborated in the early 1720s by the Italian stuccadores, who devised not only the modelling of the ornament in the dome but its original painting and gilding scheme suggesting it was a structure with openings to the sky, like the hall ceiling at Clandon (Fig. 37).*

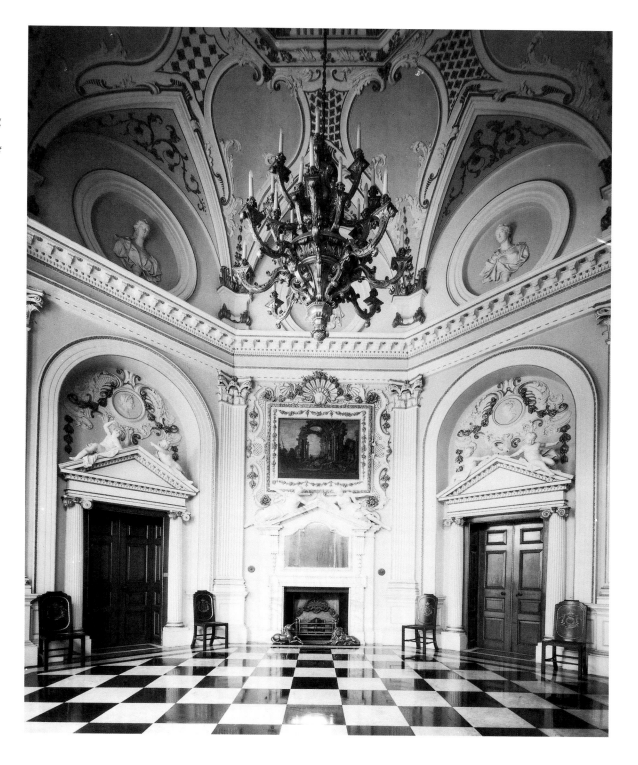

a climax in a drawing-room and bedroom. There was a correlation between materials made of silk and the use of gilding: gilding would generally not be found in a room done in woollen materials. In the case of the architectural framework, it would be logical for the architect to make the basic plan, but when it came to decoration, the detail may well have been worked out by the craftsmen on the spot as the work proceeded, with only general guidance provided on working drawings. It would be interesting to know more about James Moore's practice, because it is evident that he was much more than a provider of gilded furniture: he could plan upholstery and the fitting-up of rooms, so it would be reasonable to presume that he could organize architectural gilding as well. Kent was probably unusual in that, being trained as a painter, and with his particular talent as an ornamentalist, he had a special feeling for effects of gilding; whereas Gibbs, with his more restrained

approach to decoration, probably had less confidence and seldom let himself go.

The recent restoration of the staircase of The Drum (Fig. 39) is illuminating. The plasterwork on the stone-coloured staircase, presumably executed about 1740 by Thomas Clayton, links up with Philip Yorke's description in 1755: 'the rooms Stuccoed and gilded expensively'. Restoration revealed evidence of gilding of the ornament on the upper walls of the staircase well and of the ceiling rose, while the bed of the ceiling had a band of blue. This echoed descriptions of contemporary plasterwork at Mavisbank. Gilding was also found on the mouldings of the doors and the glazing bars of the windows.[58]

That, in turn, brings to mind certain English parallels, among them the ceiling of the Octagon at Orleans House, Twickenham (Fig. 153), which needs to be tinted and more generously gilded

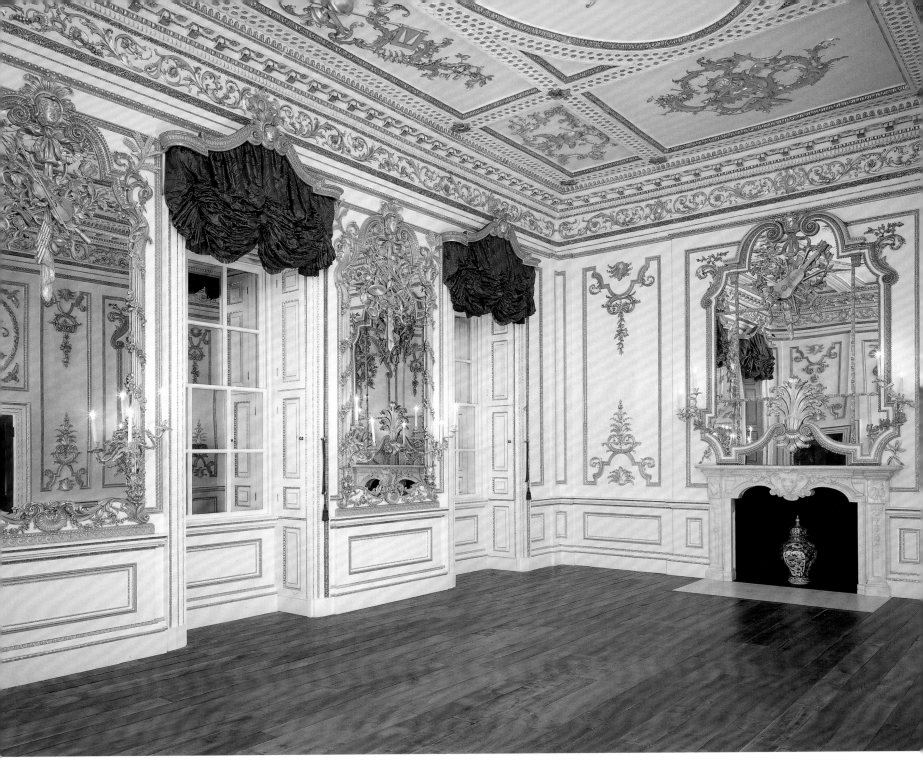

154. *The Music Room from Norfolk House, St James's Square, London. The room as recently resited in the Victoria and Albert Museum. The panelling has been repainted and the gilding cleaned and in part renewed. The basic design of the room with its dado, entablature and beamed ceiling appears to be by Matthew Brettingham*

*and completed by 1751. Then all the decoration in the French style between the dado and the cornice was added by G. B. Borra, with the carving and gilding done by John Cuenot. The ornament between the beams of the ceiling was also an addition, but the stuccadore is not identified.*

following the evidence mentioned on p. 122 to make full sense of the design of the room and the plasterwork in particular. When Sir John Clerk of Penicuik saw it in 1727, he commented on 'finely finished within stucco work and gilding, according to the old mode revived'. He also noted that the saloon at Wanstead was 'a fine room well finished in stucco, the roof painted by Kent (a very indifferent piece of work) and the ornaments above are gilded. All the roofs are ornamented with flowered work in stucco and gilding'.[59]

The high costs of gilding stucco are brought out in the valuations of the ceilings of Canons, where Bagutti and Artari worked in 1722, the figures presumably being the original cost, because it had no value once done. In the saloon, the plasterwork of the ceiling was valued at £250 and its gilding at £155; and the staircase ceiling

was put down at £115 and its gilding at £100. In the chapel, the fret-work ceiling by Bagutti was valued at £210, and the gilding at £350; with Belluchi's paintings at £490, the ten painted glass windows by Price at £500 and the organ at £730.[60]

However, just as a number of ceilings by the Italian stuccadores which were originally parcel-gilt have been painted in a single white, particularly in great houses, there must be many pre- and post-1760 rooms that have had architectural gilding added later, particularly when gilt seat furniture was introduced. The comparison between the planning of the gilding at Houghton and Holkham suggests that all the rooms at the latter have been regilded, with gilding carried through into rooms that surely originally were not picked out. In the Family and Strangers' Wings, for instance, where the doors are oak

rather than mahogany with carved mouldings, the gilding of the ceilings feels *de trop*, and the sense of build-up to the parade rooms is lost.

Certainly the proportion of eighteenth-century furniture that is now gilded is almost certainly higher than it was originally, but it is not easy to sense when it was used and how it related to architectural decoration. There seems to have been a distinction between gilded pier-tables and pier-glasses and gilded seat furniture. The first two do not seem to have demanded gilded seat furniture or architectural gilding, whereas gilded or parcel-gilt seat furniture generally seems to have called for architectural gilding and conveys a strong sense of parade. Similarly, a scheme of architectural gilding generally seems to call for gilded seat furniture. Of course there are exceptions, like the gallery at Temple Newsam, where there is a complete set of richly carved and gilded furniture of the 1740s but no architectural gilding; and there must have been many more felicitous relationships, as between the decoration and furnishing of the Lady's Drawing-Room at Chicheley more fully discussed on p. 289.

Parcel gilding of furniture is particularly subtle, but untouched examples are rare and it is even rarer to see unrestored examples of a white and gold finish still *in situ*, such as the glass at Felbrigg (Fig. 432). The original tables in the Bow Window Room at Blenheim were described as brown and gold, which presumably means parcel-gilt walnut, rather than all gold (Fig. 355). The glasses in the Great Dining-Room at Hopetoun were painted white (and gilded later) to create a sense of build-up to the Great Drawing-Room with its gilded glasses. The spectacular set of three glasses and pier-tables supplied by George Cole in 1763 for the Great Drawing-Room at Blair at a cost of £43 for the tables and £168 for the glasses were originally white and gold and then gilded in the nineteenth century. Much late eighteenth-century furniture that was painted became shabby and was then gilded in the nineteenth century.[61]

There is little mention of different colours of gold in eighteenth-century documents, although Robert Dossie in *The Handmaid of the Arts* wrote about the choice of gold leaf in 1758: 'the fitness of the colour, to any particular purpose, may be distinguished by the eye. The full yellow is certainly the most beautiful and truest colour of gold; but the deep reddish cast has been of late most esteemed from the caprice of fashion.' One reference is in Cuenot's account for carving and gilding at Norfolk House in 1753–6: there, he described the Red Drawing-Room as 'the third Red Room green guilt', but he did not enlarge on that. William Farington, who wrote a long description of the opening of the house, commented on the 'the grounds coloured and the ornaments gilt'; and in the Duchess's Bedroom, later the state bedroom, he noted that 'the Carvings & Gerandoles in this Room are all Gilt with Pale Gold, wch was vastly admir'd, but to me looks like tarnish'd silver'. Cuenot, however, makes no reference to that in his bill. Few examples of different colours of gold survive from the mid-century, but they can be seen on the headboard and canopy of the Badminton bed in the Victoria and Albert Museum.[62]

The main survivor from Norfolk House is the Music Room (Fig. 154), now in the Victoria and Albert Museum, which is full of contradictions arising from its complicated history. The basic design of the room is by Matthew Brettingham, the architect of the house, and to him can be attributed the conventional Palladian beam pattern of the ceiling, which follows that of the Whitehall Banqueting House, the entablature, the door architraves, the dado rail and the

skirting, which were complete by 1751. Then, presumably at the insistence of the Duchess of Norfolk, who owned prints by Meissonier, the enrichment of the panelling between the entablature and the dado rail was developed as a second phase by G. B. Borra, an architect, draughtsman and architectural decorator from Turin, with the carving done by John Cuenot, an obscure but brilliant craftsman of French descent who is also recorded in one of the other great rooms of the 1750s, the gallery at Northumberland House (Fig. 84). At the same time, the gilded trophies were added to the beamed ceiling.[63]

Happily, Cuenot's long and detailed bill survives for all the carving, gilding and related painting carried out between 1753 and 1756 in no less than twelve rooms, a higher number than would be found in a French house. The total cost came to the huge sum of £2,643 3s. 8½d.: the Music Room came to £645 7s. 3d.; the adjoining Green Damask Room to £421 2s. 1¼d.; the third, Red, Drawing-Room to £382 8s. 4d.; and the Great Drawing-Room to £495 0s. 6½d. It is not possible to separate entirely the costs of carving and gilding, because in some items they are combined, but the gilding of the ceiling of the Music Room cost £35 7s., the cornice and architrave £28 5s. and the six large trophies of music £20 15s.[64]

The figures also disguise the build-up in the principal rooms, where the architectural gilding and the furnishing need to be considered together. At the head of the stairs was a small ante-room that led into the Music Room, which was the first of the three big rooms overlooking St James's Square. That it was panelled rather than hung with material reflects the fact that it was for music, but the idea of panelling the first of a run of large rooms went back to the late seventeenth-century way of treating a great apartment, as can be seen at Chatsworth and Boughton. The idea of furnishing it only with stools followed royal practice; they were green and gold with green damask covers. Then followed two drawing-rooms for pictures, the first hung in green damask and furnished with gilt chairs rather than stools, and the second in crimson damask. Behind the Red Drawing-Room was the larger Great Drawing-Room, which was hung with specially woven French tapestries (Fig. 69) and had carved and gilt seat furniture upholstered in crimson velvet. Thus there was a build-up to that climax. Although all the rooms were altered later and underwent several bouts of regilding, originally there was a strong sense of overall control over the way the painting and gilding was done, with the principals presumably laid down by Borra and the detail probably worked out by Cuenot, but it is worth considering whether their mouldings were not better suited to being water gilt than oil gilt.

The mouldings that form part of the Brettingham design seem to call for the usual treatment, with only the highlights gilded, as seen at Houghton and Honington, but the evidence points to them having always been gilded solid. Similarly, there is no lining-out of the mouldings or of the edges of the ceiling beams as might be expected. That has a certain logic, because Borra and Cuenot wanted the heavier Brettingham mouldings to match their own; and it appears to follow the evidence of the way the room was painted, with the beams a slightly lighter colour than the bed of the ceiling in an attempt to make them disappear and make the trophies appear stronger.

How well the Music Room worked originally is impossible to tell, but William Farington, who was suitably impressed with the house, commented that 'there is a vast Profusion of Gilding & great Shew

155. *A detail of the Norfolk House Music Room, showing new oil gilding alongside evidence of the state of the gilding before its recent restoration.*

156. *One of the white and gold pier-glasses and tables supplied in 1759 by Vile and Cobb for the saloon at Croome Court, Worcestershire.* Temple Newsam, Leeds, on display at Lotherton Hall, Leeds.

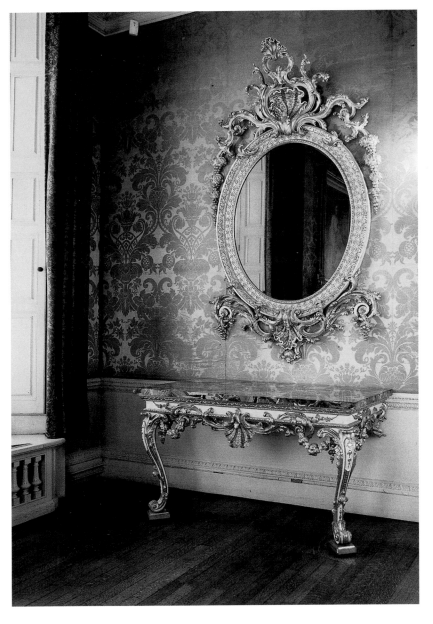

of Magnificence through ye whole'. Perhaps, unlike other guests, he had not been intimidated by the Duchess, seated in the Music Room to receive company, and he appreciated that 'every one endeavour's to make themselves fine', except for Lady Rockingham, who was thought uncivil to wear no diamonds. Decoration and dress went together.[65]

To English eyes, the Music Room appears to be French, but if a French panelled room were compared with it, there would be many more vertical mouldings, both curved and flat, not only to panels between dado and cornice but framing doors, pier-glasses and over-mantels. And, unlike English mouldings that tend to recede, they project (here, of course, the Borra mouldings are applied to the surface of the wooden lining and not incorporated into it), giving movement to a room that is enhanced by the way the gilding catches the cross light. Such gilding would call out for contrasts of light and shade, and so of burnishing, that is possible with water but not oil gilding (Fig. 155). English rooms, on the other hand, usually aim for calm and have very few vertical mouldings. It is their horizontal elements of entablatures and dados that are more important, and those do not catch the cross light. While in theory it is logical to balance the gilding of the entablature with that of the dado and skirting mouldings, it was often considered unnecessary, because it would be unnoticed in a room full of people, and so only the upper mouldings were gilded. Indeed, in the Marble Parlour at Houghton, Kent picked out the dado mouldings in ochre paint, a trick he had doubtless picked up from Roman palace decoration.

Not only are the proportions of the Music Room English, rather than French, but there were also far fewer looking-glasses than in an equivalent French room, and so again less framing to be gilded.

At first sight, a surprising example of oil gilding can be found on the set of chairs designed by Adam and made by Chippendale for the drawing-room at 19 Arlington Street, London, which were invoiced on 9 July 1765 as being 'Carv'd in the Antick manner & Gilt in oil gold stuff'd and cover'd with your own damask'. The reason for their style and finish was presumably that they were intended to go into a gilded room of the early 1740s where water gilding would have looked inappropriate.[66]

Little attention has been devoted to the taste for parcel gilding in white and gold or a colour and gold in the 1740s and 50s, probably partly because it is now rare to find good examples of frames for tables, glasses or pictures that have not been redone, and even references are sparse. When they are found, like the mirror at Felbrigg (Fig. 432), they have a special elegance, and these are a reminder that the look seems to have been thought particularly suitable for bed-rooms. However, probably the most extensive example surviving is the Tapestry Drawing-Room at Hagley (Fig. 412). Another example, not far away, was in the saloon at Croome Court, Worcestershire (Fig. 156), where in 1759 Vile and Cobb supplied a pair of oval glasses and a pair of pier-tables to go with them, all 'part painted, and Gilt in Burnish'd Gold'. There was a set of similarly treated pelmet cornices and a complete set of full-length and half-length picture frames. The chairs in the elaborately gilded Palm Room at Spencer House were also finished in white and gold (Fig. 242).[67]

The stools in the Norfolk House Music Room appear to be the earliest recorded in a colour and gilded, but by the early 1760s the fashion was established, as can be seen with the chairs in the water-colour of the Round Drawing-Room at Strawberry Hill and the table attributed to Gideon Saint (Fig. 267). Another example occurs

in Arthur Young's description of what he called the 'breakfasting closet' at Grimsthorpe (Fig. 343): it was 'hung with *India* paper, the ceiling in arched compartments, the ribs of which join in the centre in the gilt rays of a sun . . . shutters, doors and the front of the drawers (let into the wall) all painted in scrolls and festoons of flowers in green, white and gold; the sofa, chairs, and stool frames of the same'.[68]

What appear to be early examples of the combination of black and gold are the frames of the glasses from the Refectory at Strawberry Hill (Fig. 50), one of which is now at Wolterton; the tables and stools by Vile seen in early views of the gallery at Strawberry Hill (Fig. 305); and the gothick pier-glass and pier-table in the Further Drawing-Room at The Vyne, which are thought to date from about 1760. In all these cases, the intention was to suggest the past, as it was on black and gold picture frames.

The taste for parcel gilding should probably be related to the decline of architectural gilding and the great success of English carvers in the 1740s and 50s as producers of pier-glasses and tables that were usually water gilt like picture frames. To a mid-eighteenth-century eye, the juxtaposition of a highly burnished water gilt frame and an oil gilt entablature might have been uncomfortable, and clearly gilding of a glass frame at eye level provided better value for money. There was therefore a distinct swing away from architectural gilding, except in the grandest houses like Holkham and Woburn. When there was gilded seat furniture and no architectural gilding, as in the gallery at Temple Newsam (Fig. 324), it had the effect of pulling the eye downwards.

Compared with gilding, there are few mentions of silvering in decoration in this period, and among the survivors are a few pieces of silver gesso furniture from the drawing-room at Erddig (Fig. 368), the similar chairs in the state bedroom at Powis, and the glass with the Bowes arms from Streatlam Castle or Gibside in Co. Durham (now on loan to the Bowes Museum). Another example is on the frame and cresting of a pier-glass with blue ground *verre églomisé* borders in the Victoria and Albert Museum. These do not give any suggestion of the silver having a clear, integrated role in decoration other than through the association of silver with tea as explained earlier, but presumably there were others, like the silver gesso frame to the glass in the Best Dressing-Room at Canons that related to the flowered velvet and silver hangings and upholstery and the display of silver in the room. In the 1750s George Lucy of Charlecote Park, Warwickshire rejected the idea of picking out doors and a cornice in silver, because he thought it would tarnish if fires were not kept burning all the time. At the end of the 1750s, Mrs Delany noticed a silvered fillet to the yellow damask hangings in Lady Hilsborough's drawing-room (see p. 121).[69]

Among references to silvering are those to oval sconces silvered at £8 each in the King's Gallery at Kensington Palace, supplied by Gumley and Turing in November 1727, and a pair of 'very large hanging glasses silvered' at £150 each. Benjamin Goodison's account for furnishings supplied for the use of the Prince and Princess of Wales at Leicester House, London in 1742 mentions in the state bedchamber a silvered rose in the ceiling and carved and silvered frames to the overmantel glass and also the state chairs and stools.[70]

One major problem that has developed over time in apparently untouched eighteenth-century rooms is that water gilding and oil gilding tend to have reacted differently, so that it is very rare to see

architectural gilding, gilt furniture and picture frames – and pictures – all in balance. Architectural oil gilding goes dull and needs cleaning, but stands up to changes in temperature, whereas damp and cleaning tends to damage water gilding, with picture frames particularly being rubbed and thus losing their contrasts of matt and burnished areas. Moreover, while pictures tend to get cleaned, often less is done to their frames, and so they get out of step with each other. Then they pull against the gilding of the furniture and the architecture, and it is exceedingly difficult – and expensive – to make them all work together in a harmonious way.[71]

An unusually successful example of this can be seen at Kedleston, where the cleaning of both pictures and frames has created a new harmony with the decoration, both in the painted stucco Music Room and the drawing-room recently hung with a strong-blue silk and wool damask.

## LIGHT AND HOSPITALITY

Electricity has destroyed the sense of wonder at a display of light within a building, and the idea of light being an aspect of hospitality and a compliment to company. That is brought out by Sir Thomas Robinson recording that when the Duke of Lorraine was entertained at Houghton in 1731, the hall was lit by 130 wax lights and the saloon by fifty, and 'the whole expense in that article being computed at fifteen pounds a night'.[72]

Some idea of what that meant could be seen in an experiment the Victoria and Albert Museum carried out in the Norfolk House Music Room in 1999 to show how it might look if lit only by twenty-four candle bulbs in the original candle branches round the room, but without the looking-glasses in position. What was remarkable was how well the spread of light illuminated the upper walls and ceiling, but 25 watt candle bulbs needed to be dimmed. That done, the balance of the trial white paint and the cleaned but unrestored gilding was happy. Since then, the system has been refined, but what came across strongly was the unexpected relationship between eighteenth-century decoration and the way it was lit. Clearly there was no need for chandeliers, which create a sense of darkness below them. It was also a reminder that twenty-four candles in a room was an extravagant amount of light, making sense of Sir Thomas Robinson's remarks about Houghton and also the reaction to the lighting of the gallery at Northumberland House when it was opened in 1757: four large crystal chandeliers, each of twenty-five lights, were thought to light the room 'even more brilliantly than is necessary'.[73]

Wax candles were usually white, but could be coloured – in natural green wax from America, or dyed red, green, yellow or black. They were sold by weight – so many candles to the pound – and that way of measuring them lasted until recently. Thus they were 4*s*., 6*s*., 8*s*., 10*s*. and 12*s*. to the pound, with the 4*s*. being the longest and thickest (now the measures refer to the length, a twelve being 12 inches long). The choice of the size of the candle used was influenced by the expected length of the event: thus in 1830 it was reckoned that a 4*s*. burned for eleven hours, and so when an evening was expected to last about five hours, 4*s*. would last for two evenings; 6*s*. were recommended for an evening of about six or seven hours and used only once.

Certain great houses made their own candles. At Canons, for instance, the housekeeper was expected to keep 2,400 lb of white,

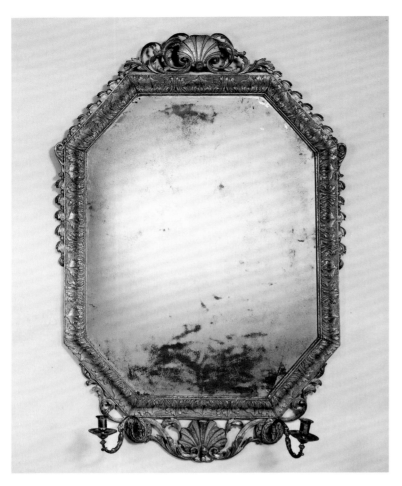
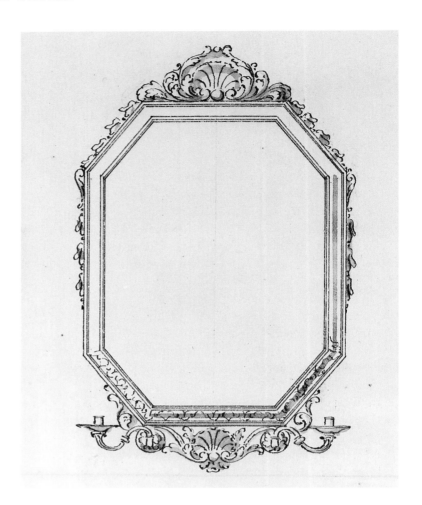

157 *and* 158. *A carved and gilt sconce and Gibbs's design for it, about 1725. One of the earliest furnishings for which the design by an English architect survives.* Temple Newsam and Ashmolean Museum.

green and yellow wax in stock, enough for two candlemaking sessions; at five to the pound, 140 pounds of wax made 700 candles at 1*d.* each in wax.[74]

However, not all candles were wax, and there were social distinctions involved in who was given wax candles and who tallow dips. The latter were for servants and children, but on occasion there were doubts as to whether someone qualified for one or the other.

It seems that candles were only placed in the sockets of sconces and chandeliers when they were going to be lit, and then removed afterwards, but there appear to be no references to cleaning either. Contemporary illustrations invariably show chandeliers that were not in use without candles.

The number of candles required to light a room could influence the way it was decorated. Isaac Ware wrote in 1756: 'After the consideration of heat comes that of light; and this ought to be much regarded in chusing the kind of room best adapted to the place and purpose. Other considerations being equal, a wainscoted room, painted in the usual way, is the lightest of all; the stucco is the next in this consideration, and the hung room the darkest.' Thus it would take six candles to light a wainscot room, eight for a stucco room and ten for a hung room. When Lord Hardwicke was thinking of repainting a room at Wimpole in the early 1780s, he wanted to have it an ash or olive colour, because that was more durable; but Lady Hardwicke said that the fashionable French white would be cheaper in the end, because that would enable them to light the room with two instead of four candles.[75]

It is hard to visualize how little light people lived by and the restrictions it placed on them. Mrs Delany, for instance, wrote: 'my candlelight work, is finishing a carpet in double-cross stitch, on very coarse canvas, to go round my bed'.[76]

Halls, corridors and staircases must have been particularly challenging, not only because of their scale but because of draughts. Obviously hanging lanterns were used, like the unusually large one on the Queen's Staircase at Hampton Court, which was supplied by Benjamin Goodison in 1729–30. Also special glazed wall lanterns were devised, as still survive in the halls at Ditchley (Fig. 385) and Frampton Court, while at Houghton the carved and gilt wooden arms supporting glass bowls still stand on the newels of the principal staircase (Fig. 187).[77]

It is not easy to imagine how a spread of light was achieved in a room other than through candlesticks that could be moved about at will. One of the simplest ways was to magnify their reflective power by combining them with a looking-glass. However, as has been explained, the English could not make large plates in the early eighteenth century, and there are no Georgian drawing-rooms or cabinets of mirrors with candles reflected into infinity. Instead, pairs of swivelling glass or brass arms were placed at either end of, or attached to, narrow looking-glasses placed above chimneypieces, as still survive at Boughton. Apparently similar glass ones were valued at £1 a pair at Canons. Pairs of arms in glass or metal could be attached to small gilt-framed looking-glasses or sconces like the one designed by Gibbs (Fig. 157, now at Temple Newsam). In the

159. *A pair of silver sconces from a set of six by Archambo made for the 2nd Earl of Warrington for Dunham Massey, Cheshire, in 1730–1. Lord Warrington was exceptionally keen on silver sconces and this was part of the finest set used in the principal bedroom.* The National Trust, Dunham Massey.

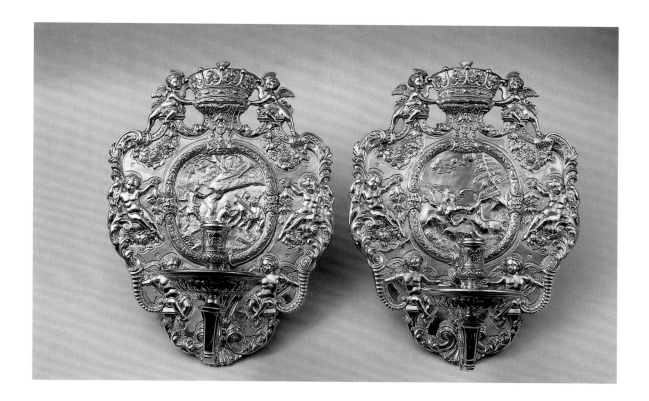

seventeenth century, candles were often placed on pairs of stands that stood either side of a table and matching glass against a window pier, but they must have been dangerous because of the risk of curtains blowing into them while they were alight. By the 1720s, candleholders were attached to pier-glasses for reflection as well as safety.[78]

Carved and gilded sconces such as the Kentian set in the Ballroom at Knole (Fig. 231) and the huge Rococo pair in the gallery at Temple Newsam (Fig. 157) look spectacular, but they cannot have been effective sources of light.

Smaller sconces were made to stand on brackets, like those of two lights in the form of winged dragons that stood on brackets of carved wood supported by eagles in the dining-room at St Giles's House. A number of architectural designs for interiors dating from the 1740s and 50s show decorative brackets in use in this way, as in one of Sanderson's designs for the dining-room at Kirtlington that shows both a single candlestick and a candelabra.[79]

Stands continued to be made, like the set of eight originally in the gallery at Temple Newsam and the fanciful ones in the gallery at Hagley (Fig. 422), and it seems that they were often placed in the corners of rooms.

It is also possible that the taste for oval glasses in the 1740s and 1750s, as incorporated in the plasterwork of the saloon and dining-room at Wallington and in the dining-rooms at Kirtlington (Fig. 398) and Felbrigg, was influenced by the desire to create reflections round a room and spread light.

In the last quarter of the seventeenth century, there was a fashion for silver sconces in drawing-rooms and principal bedrooms, as can be seen in Marot's prints (Fig. 93) and in the copies recently made for the King's Rooms at Hampton Court Palace, where they make sparkling highlights against the dark colours and dense textures of tapestries. They continued to be used in country houses in the first quarter of the eighteenth century. Writing in 1732, John Tracy Atkins described the drawing-room at Castle Howard as 'a room hung with blew velvet, in it are fourteen very large silver sconces',

which must have made a very brave show. At Canons in 1725 there were six silver sconces in Lord Carnavon's drawing-room weighing 199 ounces and valued at £69 15s.; and there were two pairs in the drawing-room valued at £30.[80]

However, the taste for them faded after that, and Lord Warrington seems to have been one of the last enthusiasts: he had as many as fourteen in the gallery at Dunham Massey, as well as a pair of six-light chandeliers and four small silver branch candlesticks on gilt brackets for three candles each. The room was hung with fine old tapestry and had three settees, four stools and five pairs of window curtains, all in yellow damask, and eighteen chairs covered in Irish stitch. There were a pair of sconces and a pair of branches for four candles in the drawing-room, where the upholstery was in crimson silk damask. And there was a pair from the finest set of six made by Peter Archambo in 1730–1 (Fig. 159) in the Velvet Bedchamber.[81]

Although Marot included designs for chandeliers as well as sconces, these were always rarer than might be imagined from the evidence of early conversation pieces like Hogarth's *Wanstead Assembly*, which shows an unusually large one with two rows of candles being attended to; *The Wollaston Family*, which shows a silver chandelier; or *The Tea Party at Lord Harrington's* (Fig. 5) with its Philips pairs in gilded wood. Not only are they seldom found in houses today, but there are surprisingly few references to them in inventories: the reason must be that while they looked impressive as objects, they were ineffective sources of light in a large room. At Kiveton in 1727 the only rooms where there were lines for chandeliers, or 'schandeleer's as they were called, were the Great Dining-Room and Great Drawing-Room, the first having crimson silk line to go with crimson upholstery, a tassel and balance weight, and the second having gold-colour silk line and tassel (perhaps to relate to the black and gold furniture). At Houghton there were five chandeliers apart from the lantern in the Stone Hall, a pair of gilt metal ones for eight lights in the saloon and single ones in the flanking drawing-rooms, and a large one of unspecified material in the Family Parlour. The three survivors appear to be French gilt brass or bronze (Fig. 160) and

160. *One of three gilt metal chandeliers at Houghton. Listed in 1745, they may be of gilded brass, then called French plate, and have been supplied by William Hubert.*

161 (facing page). *The Great Parlour at Sudbury Hall, Derbyshire. It became the dining-room in the 1740s and is now called the saloon. The pair of six light carved and gilt chandeliers with their original spring balances were installed either then or in the early 1750s, at the time when the room was altered and the contemporary full length portraits in Van Dyck dress were installed in the partly new white-painted panelling.*

were supplied by William Hubert, probably a Huguenot, who repaired French metal branches and girandoles for Sir Robert in 1730. In 1735, when Hubert gave up his business, he advertised a 'great Choice of very curious Bronze Lustres, Girandoles, Andirons, and Branches, gilt and repaired in the finest French taste'.[82]

One early set of gilt wood chandeliers is in the Great Hall at Grimsthorpe, where there are five, a centre one of eighteen lights and four of six lights, which must have provided an exceptional amount of light. Related to them through the design of their carved and gilt finials with ducal coronets are a pair of eight light chandeliers in a combination of glass and carved and gilt gesso with gilt metal mask mounts in the French style that are dated about 1730. These hang in the galleries off the hall, but they are such exceptional objects that surely they must have been intended for a drawing-room.[83]

The same pattern of gilt mount occurs on a fine gilt gesso chandelier with eight lights of about 1720 from Holme Lacey in Herefordshire (now in the Metropolitan Museum, New York), and that has a marvellous soft sparkle because the burnished gesso is still bright. A variant of the idea can be seen on an exceptionally large contemporary gilt gesso chandelier in the same museum that has four metal mounts at the top and then two circles of eight lights

with gilt bronze arms springing from gilt lead masks. Unfortunately it has no provenance, and, since no references to comparable examples appear to be recorded in inventories, it is hard to visualize its original location.

The pair of carved and gilt six-light chandeliers of about 1740–50 at Sudbury Hall in Derbyshire (Fig. 161) are a rare survivor because they have kept their pulleys, cords, tassels and counter weights. They probably date from the time when the 1st Lord Vernon installed full-length portraits by Vanderbank, Seeman, Kneller and Hudson (the last of which is dated 1741) and made the original Great Parlour into a dining-room (now called the Saloon).[84]

Until recently, a splendid carved and gilt chandelier of the mid-1740s hung over the table in the dining-room at St Giles's House in Dorset (Fig. 57). And, if that seems an unlikely position, given the custom of having tables that could be carried in and out, it appears to be confirmed by the dining-room at Hopetoun, where the list of furniture required for the room in 1755 lists lines and tassels for a glass chandelier or lustre, as it was called.[85]

The especially elaborate carved and gilt wood chandelier in the Stone Hall at Houghton (Fig. 191), which replaced the original big lantern hung by Sir Robert, was bought in 1748 by the 2nd Lord Orford at the sale of the possessions of his brother-in-law, Lord Cholmondeley, who must have acquired it for a great room, not a hall.

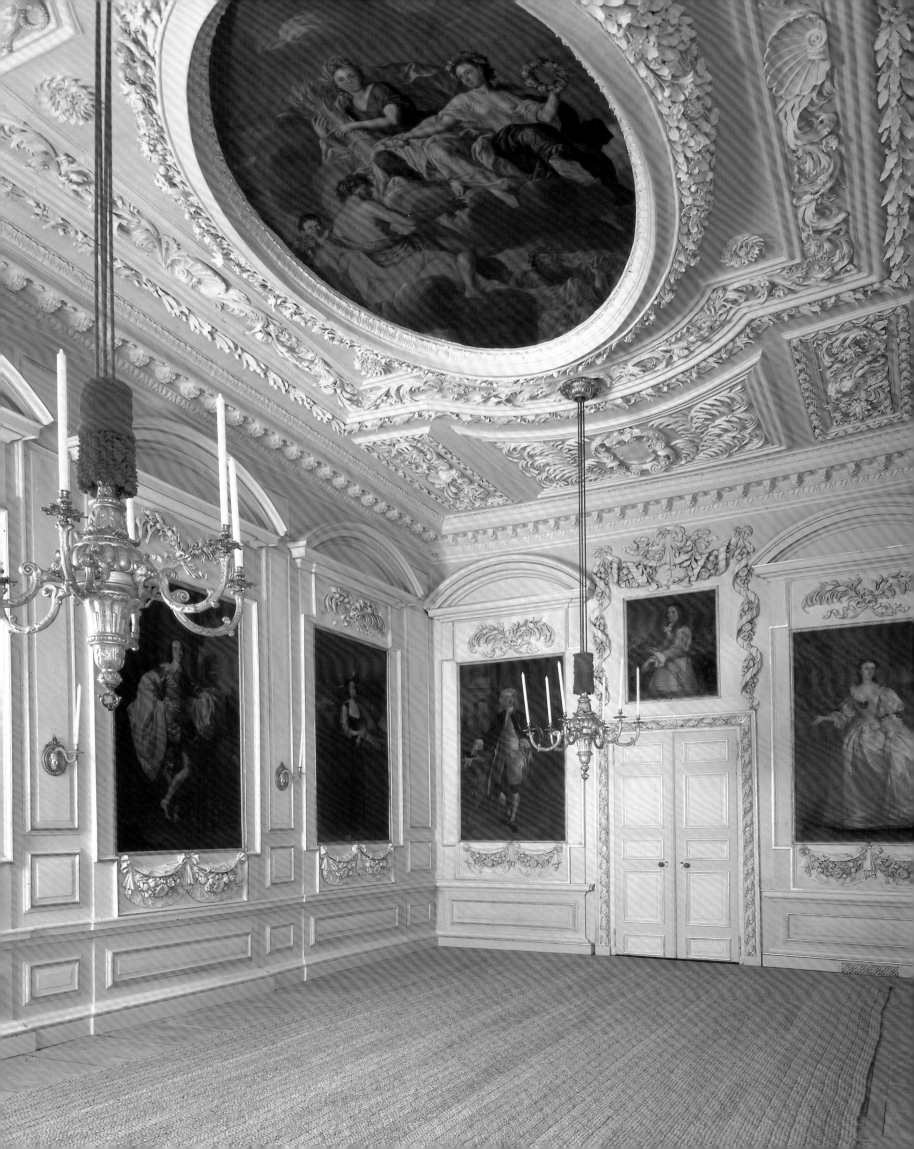

One of the latest rooms to be lit with a gilded wooden chandelier was the saloon at Woburn Abbey, where the unusual one of eighteen lights with arms springing from a deep open oval frame was supplied by William Hollinsworth at a cost of £86 in 1758.[86]

At the end of the seventeenth century, rock crystal chandeliers were occasionally found in royal palaces, as can still be seen in the Privy Chamber at Hampton Court Palace, which has one brilliantly restored after the fire. However, they may have been too expensive for country houses, and the set of five at Penshurst Place are probably a royal perquisite. One of the rare (and not wholly clear) references to such chandeliers is found in George Nix's bill for Ham House in 1730, when he charged £5 for 'new Cleaning & Silverd Wyering, and making up the Christall Shandaleer & mending the Brass work & 12 Nossells fitted into the Socketts'.[87]

Seemingly the earliest reference to a glass chandelier in England is in 1714, when John Gumley, who set up a glass house in Lambeth in 1705, advertised 'Looking Glasses, Coach Glasses and Glass Schandeliers' in the *London Gazette*. One of the earliest surviving examples is one of twelve lights from Thornham Hall, Suffolk, which has been dated about 1732 (now at Winterthur).[88]

References to glass chandeliers in houses in the 1740s and 50s are more rarely found in inventories than might be expected, and it is exceptional to come across a payment for surviving examples like the pair of eighteen lights in the Tribunes at Holkham. They were supplied by Maydwell at a cost of £200 and listed in the inventory of 1760. Maydwell and Windle are recorded in the Strand between 1751 and 1778 and some idea of the range of what they sold can be gathered from their trade card. Sets of glass chandeliers as existed in the Great Drawing-Room at Norfolk House and the gallery at Northumberland House were evidently a great extravagance.[89]

Silver chandeliers must have always been rarities: not only do few survive from this period, but references to them are seldom found. The chandelier at Drumlanrig Castle, Dumfriesshire, which was bought in the nineteenth century, dates from about 1670, the Chatsworth one from 1694 and a pair at Knole from about 1700, one at Williamsburg from 1691–7 and one at Hampton Court Palace was made in 1699 by George Garthorne for Kensington Palace as part of an order originally intended for the King's Drawing-room but never used in that palace. Lord Warrington had a pair for six lights weighing 1,060 ounces made by Peter Archambo in 1734 and these were evidently in the gallery in 1758. (They survive but are no longer in the house.) At Petworth in 1749–50 there was a chandelier with eight branches and a pair of silver sconces in the Tapestry Room.[90]

However, there was more use of silver plating than is realized today, for sconces and chandeliers, as well as objects like the Grantham (Fig. 139) and Cholmondeley cisterns. At Kiveton there were silvered brass sconces in the Vestibule and Great Staircase. At Canons there were two large silvered branches and chain in the saloon valued at £90, and in the drawing-room two pairs of silvered sconces valued at £30. The inventory for Blenheim in 1740 lists silver branches in the Bow Window Room, the Duke's Dressing-Room and Grand Cabinet, where there was 'A silver branch in the middle of the room, all the branches tho they are called Silver are only Gilt to look like Silver'. There was a pair of silvered chandeliers in the Great Room at Marlborough House, and a large silvered chandelier in the drawing-room. Other examples were used at Erddig, where there were silvered sconces in the drawing-room, forming part of a silver scheme that seems to have related to the use of the silver tea plate in the dressing-room, Best Bedchamber and Crimson Damask Bedroom, the second bedroom on the principal floor.[91]

No silvered chandeliers or sconces appear to have survived, but it seems that they also occurred in gilded brass. At Houghton, for instance, the pair of chandeliers in the Saloon and the single one in the Middle Parlour, which would account for three out of the four listed in the 1745 inventory, may be what at the time was called French metal might and have been supplied by William Hubert, who repaired 'French mettle Branches' and supplied 'a fine French lustre neatly repaired composed of French metal and cristal cutt'.

The term 'French Plate Gilt' occurs in connection with candlesticks and 'double branches' in a Temple Newsam inventory of 1758, and James Lomax has suggested that they may have been used on the eight carved and gilt torchères provided for the gallery in the 1740s.[92]

# 5

## *William Kent and Architectural Decoration*

There are two essential elements missing from the aspects of planning and decoration of interiors discussed so far. First, a sense of style to complement the new Palladian houses being built from about 1720 onwards; and second, the creator of that style. Here William Kent fulfils a dual role. Not only was he the creator of a formal style for interiors that was to be dominant until the late 1750s and early 1760s, but he developed a concept of architectural decoration that was new in England. However, his name is so well known, and so often bandied about, that it is not widely understood when and how he came to fulfil those roles in the early and mid-1720s.

Part of the problem lies in gaps in English architectural history, in particular the lack of a full study of Lord Burlington's role as an architect and promoter of architectural ideas. It is very difficult to understand William Kent's contribution without having a precise picture of Lord Burlington's.

Also, because of the recent interest in garden and landscape history, attention has been concentrated on Kent's achievements in those areas. The result is that the different aspects of Kent's career are seen out of focus and to some extent out of order, as appears in the only modern book on him, Michael Wilson's *William Kent: Architect, Designer, Painter, Gardener*, published in 1984. In that description lies part of the problem, because it lists his activities out of chronological order; and 'designer' does not adequately cover his novel role as a decorator of interiors, the word 'decorate' first being used in England in connection with his work.[1]

If they are re-ordered as Painter, Designer and Decorator, Gardener, and Architect, he starts to appear in a different light, because there was a natural progression from one sphere to another. However, in order to understand those early stages, it is necessary to relate his early training as a history painter in Italy to his switch soon after his return to England in 1719 to decorative and ornament painting, to decoration about 1723–4 and the design of complete rooms by 1725. His career as a garden designer began about 1728, and that led him to think in the round, designing garden buildings and temples that brought seventeenth-century Italianate landscape paintings to life. They start about 1730–1, with the Hermitage at Richmond for the Queen; the rather staccato Temple of Venus at Stowe, where in the centre block he combined a screen of columns and an apse that looks forward to his later explorations of space in his interiors; and the temple at Holkham, begun in 1730 and com-

pleted in 1735. He then turned to architecture, becoming involved with Lord Leicester and Lord Burlington's scheme for the house at Holkham, where he made a suggestion for the treatment of the south elevation; and he began to think in a variety of styles. However, it was through his love of ornament that he developed a vocabulary in paint that could be used in other mediums, in wood, plaster or silver, and on different scales, from a great room via a state barge (Fig. 230) to a cup in gold only 11 inches high (Fig. 237). He designed an inkstand for Queen Caroline (Fig. 162) that would have worked equally well as a gothick temple in a garden.[2]

His painterly approach gave his architectural decoration an unusual freedom and boldness and enabled him to draw on ornament of many periods. Never an orthodox Palladian, his sources of inspiration ranged from antique decoration and records made of it in his own time, via Italian mannerist work of the sixteenth century to the late Baroque that was fairly recent or current when he was in Italy, as well as ideas found in Palladio and the buildings and drawings of Inigo Jones, which he learned about through his association

162. *William Kent's design for a silver standish for Queen Caroline for Merlin's Cave at Richmond as engraved by Vardy in 1744. It could have worked equally well as a gothick temple in a garden.*

*163. A Roman Table engraved by Giovanni Giardini in his* Disegni diversi *(1714). A book mainly of metalwork designs that Kent could have brought back to England.*

with Lord Burlington. Above all, Kent's work expresses his exuberance and verve and has a beguiling freshness and exaggeration, even if it is understandable why Lord Oxford, who was a great supporter of Gibbs, wrote after a visit to Raynham in 1732: 'The rooms are fitted up by Mr Kent, and consequently there is a great deal of gilding, very clumsy over-charged chimney-pieces to the great waste of fine marble.'3

Ironically, Kent's least interesting work is as a figurative painter on ceilings and walls. Yet at the same time it was his training as a painter and his study of great cycles of painted and stucco decoration in Italy, such as the gallery of Palazzo Farnese, the later work of Pietro da Cortona combining painting and stucco, particularly in Palazzo Pitti in Florence, and the decoration and furnishing of such Roman palaces as Palazzo Colonna, that dominated his approaches to everything else he did. Today, his work as the first English architectural decorator is generally seen as being less significant than his work as a designer of landscapes or as an architect, because decoration itself is usually discounted. Yet, with the possible exception of William Talman and his son John, Kent seems to have been the first Englishman to design complete rooms in which pictures, furniture and upholstery were integrated with the design of walls and ceilings and related to pattern and colour. A key step was his making 'laid-out' or 'exploded' drawings (Fig. 11) that show all four walls on a single sheet, a type of drawing unknown in England before he started to do them. He was the first English architect to design a quantity of furniture and plate, and to use the gothick style for decorative work in secular buildings (Fig. 233): indeed, his light-hearted approach to gothick ornament influenced virtually all eighteenth-century designers (Fig. 300). Moreover, he was the first Englishman to design garden buildings in the chinoiserie style, for Esher Place, Surrey in the early 1730s.4

Born in Bridlington on the Yorkshire coast in late December 1685, he probably moved to London about 1705. In July 1709, he set off to study painting in Italy with John Talman (1677–1726) and they reached Rome early in 1710. The younger Talman, who had been in Rome in 1699–1702, must have been a stimulating com-

panion for him, because already he had a considerable interest in interiors, decoration and the relationship between objects and their settings. That can be seen from a handful of tantalizing small sketches of a new type in England, probably done about 1702. He was a passionate collector of drawings, including those of architecture – his father owned the drawings of Inigo Jones and John Webb as well as the Palladio drawings acquired by Jones in Italy that Lord Burlington bought in 1721 – and he commissioned an 'abundance of fine drawings to be made in several parts of Italy relating to architecture which I have (finely) coloured as the originals to (show) give a lively Idea of the Italian Gusto in their beautiful manner of ornamenting the insides of buildings'. He also formed an exceptionally large collection of prints. Moreover, like other English visitors to Rome with Catholic sympathies, he responded to the richness and ornamental fantasy of Roman Baroque buildings as well as to those of antiquity and the High Renaissance.5

By then, the most creative period of Baroque art was over, Pietro da Cortona having died in 1669, Bernini in 1680 and Paul Schor, a painter with a talent for talent for decoration, in 1674. As a result of changing attitudes and financial pressures, papal patronage had wound down in the last quarter of the seventeenth century, and the decline in Roman funds provided opportunities for foreigners and particularly the English to buy works of art.6

Kent seems to have studied under Giuseppe Chiari (Fig. 206), the best-known pupil of the greatest living painter in Rome, Carlo Maratta, who died in 1713 at the age of eighty-eight. He had the financial support of several English gentlemen, among them Sir William Wentworth of Bretton in Yorkshire from 1710, and a little later Burrell Massingberd of Ormesby in Lincolnshire and Sir John Chester of Chicheley, who hoped that he, too, would become a great history painter while supplying them with copies of famous pictures and antiquities.

The two most valuable English contacts Kent made in Italy were with Thomas Coke, then in his teens but years later to become 1st Earl of Leicester and builder of Holkham, whom he met in 1714; and in 1719 with the twenty-year-old Lord Burlington. Evidently on the recommendation of Chiari, he made extensive travels with Thomas Coke and helped him to collect books and manuscripts, drawings, paintings and sculpture, and give commissions, including those to Chiari and Procaccini for pictures of *Perseus and Andromeda* and *Tarquin and Lucretia* (Fig. 446). It was Kent who helped Coke acquire his first picture in November 1714. But it may have been Coke, through his own studies and those he evidently made with his architect master, Giacomo Mariari, who aroused Kent's interest in architecture.7

In his letters Kent can be seen preparing himself for his return to England as a painter. In 1717 he wrote to Burrell Massingberd: 'Mr Talman was here this morning and would have me done this ceiling after ye grotesk manner, but I think it will not be well unless the whole was so. I believe you may remember this sort of painting as what ye Ancients used, but I am resolved to do a thought of my own.' Perhaps Talman had in mind the drawings of antique painting done by Francesco Bartoli, of which a group were bought by Kent for Coke. That is Kent's earliest reference to a style of painting that he was to use at Kensington Palace (Fig. 175). In another letter he wrote: 'I am still in resolution to set out next spring & my Ld Lemster has agreed with a very good sculptor (G. B. Guelfi) to come along with me writeings are made to give him so much a year, I hope

164. *Eros and Psyche, the saloon ceiling at Burlington House painted by William Kent in 1720. It was his first major commission on his return to England.*

165. *The saloon at Burlington House, London. The form of the room is probably due to Colen Campbell, who refronted the house about 1718–19. The ceiling was painted by William Kent, and he probably also designed the picture frames. In the course of the current restoration traces of Kent's figurative painting of the cove are being uncovered. The recently regilded Kentian picture frames can be compared with the carved frames at Kensington Palace (Figs. 181, 182) and painted frames at Houghton (Fig. 189).*

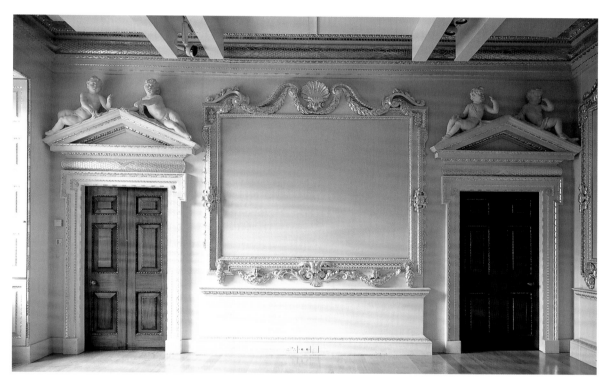

to have him to do ornaments in stucco after ye Italian Gusto. I am making all preparations & continually adrowing ornaments & Architecture & getting things yet I think will be necessary for use in England'; and again: 'I lay what little money I have on prints and stucco figures as heads and feet etc, which will be of great use to me when I cannot see ye Antiques. I now am make a study of ornament that will be proper to adorne about my paintings if (I) can introduce the Italian Gusto into England.'[8]

No list survives of the prints he owned, but it is likely that he had etchings by Stefano della Bella, who was surprisingly popular in the eighteenth century and whose friezes could well have influenced some of his own, and a set of engravings of the Farnese gallery. Among recent prints, he could have acquired a set of *Designi Diversi inventati e delineati da Giovanni Giardini* (Fig. 163), who was primarily a silversmith but included three designs for tables in the set published in Rome in 1714.[9]

However, it is striking that, having been trained in the Maratta

tradition, Kent does not seem to have responded at all to the architecture of Borromini and the *movementé* aspects of post-Borromini design that occur in the work of Carlo Fontana or the plates in Rossi's *Studio d'architettura civile* of 1702. Yet they appealed to James Gibbs, as can be seen in his dedication page of Flamstead's *Historiae caelestis* of 1712, to patrons like John Bourchier, Sir John Chester and the Duke of Beaufort, and other designers including Francis Smith of Warwick and John Channon.[10]

At the end of 1719, Kent finally returned to England from Paris with Lord Burlington, and his first major job was to paint the central panel of the ceiling of the saloon at Burlington House with *Eros and Psyche* (Fig. 165). Precisely when he did that and what else he did in the room is not recorded. On 19 January 1719/20 he wrote to Massingberd of his work there: 'I have made a sketch in Collers for the Great Roome in the front, and all the rest of the ornaments yt are to be al Italiano.' That suggests that Campbell was responsible for the form of the room with its coved ceiling as part of his

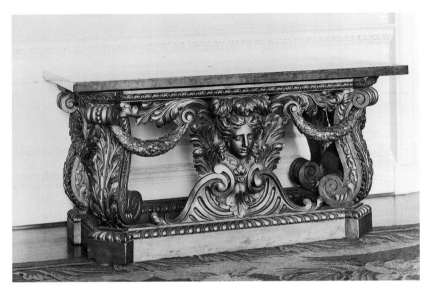

168. *One of a set of Venetian armchairs upholstered in crimson velvet evidently acquired by the Earl of Manchester while ambassador in Venice in 1706–8 and formerly at Kimbolton Castle, Huntingdonshire.*

166. *One of William Kent's etched vignettes in Pope's translation of Homer's Odyssey published in 1725. This side table is one of his earliest representations of furniture based on his memory of Roman tables and realized in a table formerly at Devonshire House (Fig. 167).*

167. *A Kentian table formerly at Devonshire House, London, and now at Chatsworth. Kent began to rebuild the house in 1734.*

refronting of the house in 1718–19 and possibly for the architectural frame and the pedimented pier-glasses between the windows. The figures of boys on the four secondary doorcases (Fig. 165) could have been the contribution of unrecorded Italian stuccadores working for John Hughes, the English plasterer, between September 1719 and January 1721, and so initially at least under Campbell's direction. The other main feature of the room is the four architrave frames for pictures (Fig. 165), which appear to be in Kent's manner. They stand on their own bases, forming complete units rather than floating on the walls.[11]

While Kent cannot be credited with the idea of architrave frames, he was the first designer in England to dress them up with such ornaments as the shell in the pediment, the garlands weaving in and out, and the carved leaves that curl over the sides and bottoms of the frames, ideas seen in sixteenth-century Venetian frames and *trompe-l'œil* versions in cycles of painted decoration as in the gallery at Palazzo Farnese and prints after them. He went on to use enriched architrave frames in many variations and mediums, as can be seen in the King's Gallery at Kensington Palace (Fig. 181) and in

*trompe-l'œil* on the staircase at Houghton (Fig. 189), but these seem to be their first appearance in his work.

The crowding of the room with architectural interest suggests a certain nervousness at the challenge provided by Lord Burlington. On the piers between the windows are pedimented architrave frames – what Richards at Raynham called 'tabernacles' – that were surely intended for looking-glasses. In their handling they could as easily be by Campbell as Kent, as can be seen from Campbell's design for a dining-room for Lord Bute (Fig. 52), and they parallel the glasses in the Great Room at Marble Hill (Fig. 77) and Gibbs's designs for Fairlawne (Fig. 73). There is no record of what the main picture frames were intended to contain; nor of how the room was furnished, but the projecting bases to the picture frames and the frames on the window wall make it difficult to place any furniture against them and argue against pier-tables being part of the original design.[12]

That in turn suggests that Kent had not yet turned his mind to design tables with figurative and naturalistic ornament. His first may have been the set of four large sphinx tables supplied to Kensington Palace by James Moore in 1722–3, which Pyne, who illustrated one in Queen Caroline's dining-room and another in Queen Caroline's Bedroom at Kensington, attributed to him. Next came those in his tail pieces to *The Odyssey* in 1725 (Fig. 166); and those included in his designs for the saloon at Houghton of the same year (Fig. 185). The Kensington tables are close in date to those shown in Gibbs's designs for the Great Room at Fairlawne and the sphinx tables

shown in Thornhill's design for the hall at Moor Park (Fig. 32) about 1724. Are the earliest surviving examples the pair of gilded tables recently reacquired for the gallery at Chiswick, but unrecorded in documents?[13]

Whatever their history, it was really Kent working with Richards who developed the form, as can be seen at Ditchley (Fig. 389), Houghton (Fig. 199) and Raynham (Fig. 225). The origin of these tables (Fig. 167) lies in Italian and particularly Roman palace decoration of the mid- and late seventeenth-century, where they were developed as pieces of sculpture incorporating figures and swirling foliage to complement the architecture and support slabs of marble. Although some were exported, none seem to be recorded in England at that stage. Nor, it seems, were many chairs, and the Venetian chairs in their original crimson velvet formerly at Kimbolton must have always been a great rarity (Fig. 168). The idea must have come through prints and sketches made in Italy by Talman, who sketched Roman-looking tables of swirling foliage in his *Design for an Italianate Interior*, and by Kent and possibly other artists as well.

Presumably the completion of the saloon at Burlington House preceded Kent's first public commission, to paint the ceiling of the newly formed Cupola Room at Kensington Palace (Fig. 171). That was obtained through the machinations of Lord Burlington and the support of Sir Thomas Hewett, who had become Surveyor to the Board of Works in 1719 and had met Kent in Italy. Both of them saw that the winning of a major royal commission was potentially of great importance in establishing the new taste in architecture and architectural decoration and making it synonymous with the new dynasty.[14]

It is usually said that Kent added insult to injury by cribbing Thornhill's design 'For ye Cieling of ye Great Room at Kensington', (Fig. 172) which shows a scheme of coffering, a form of decoration already of considerable interest to him, as can be seen in the chapel at Wimpole and in drawings in the Victoria and Albert Museum, and it was intended to be lavishly gilded. That may have happened, but the situation was more complicated, as is recorded by Vertue, who was not well disposed towards Kent, considering him over-promoted by Lord Burlington. When, in 1718, Thornhill had wanted the post of History Painter to the King, he had been supported by the Surveyors and Officers of the King's Works; 'yet what a clamour. What outbursts of Invasion. what blending of Parties together – against him in all his affairs' when the following year he declared he would practise as an architect, hoping to succeed Benson as the Surveyor of the King's Works. So there was marked hostility to him in official circles when the Kensington Palace job arose after he was appointed Sergeant Painter to the King in 1720. Thomas Coke, the Vice Chamberlain of the Household, was quick off the mark when Thornhill, already recognized as an expensive painter, quoted £800 for the Cupola Room ceiling. He requested a quotation from Kent, who had been tipped off to undercut him with one of £300.[15]

Whatever the background, Kent's treatment is more dramatic and makes more play with the Garter star in the centre of the ceiling. So it is possible that the design was laid down when it was decided to dedicate the room to the Order of the Garter. How that came about is not known, but it seems that the architectural design of the room had been worked out by, or for, Sir Thomas Hewett within a shell constructed during the time of his predecessor,

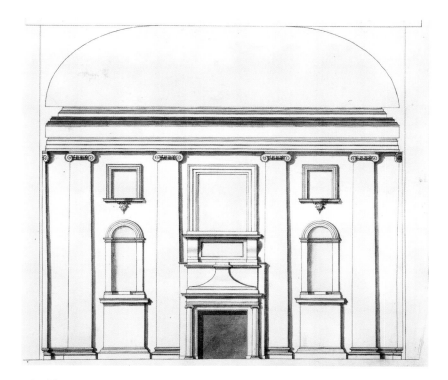

169. *Kensington Palace, design for the Cupola Room attributed to Sir Thomas Hewitt, Surveyor of the King's Works. An unusually Italianate scheme produced about 1720 before the suggestion of a Garter theme or William Kent became involved with the decoration.* Kensington Public Library.

170. *The chimneypiece in the Cupola Room with its relief of a Roman Marriage after the Antique by Rysbrack commissioned in January, 1723–4, and one of the theatrical bright oil gilt statues that fill the niches and one of the busts that fill the upper recesses. It was the first use of a relief in an English overmantel.*

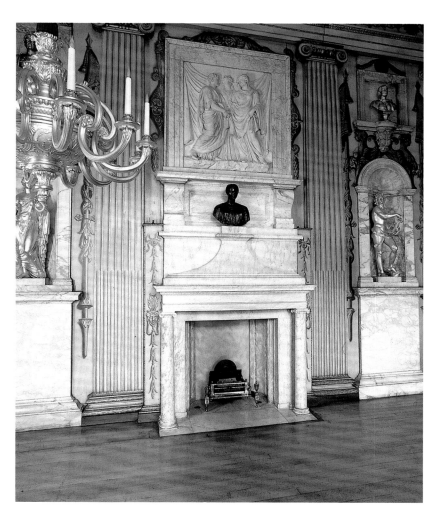

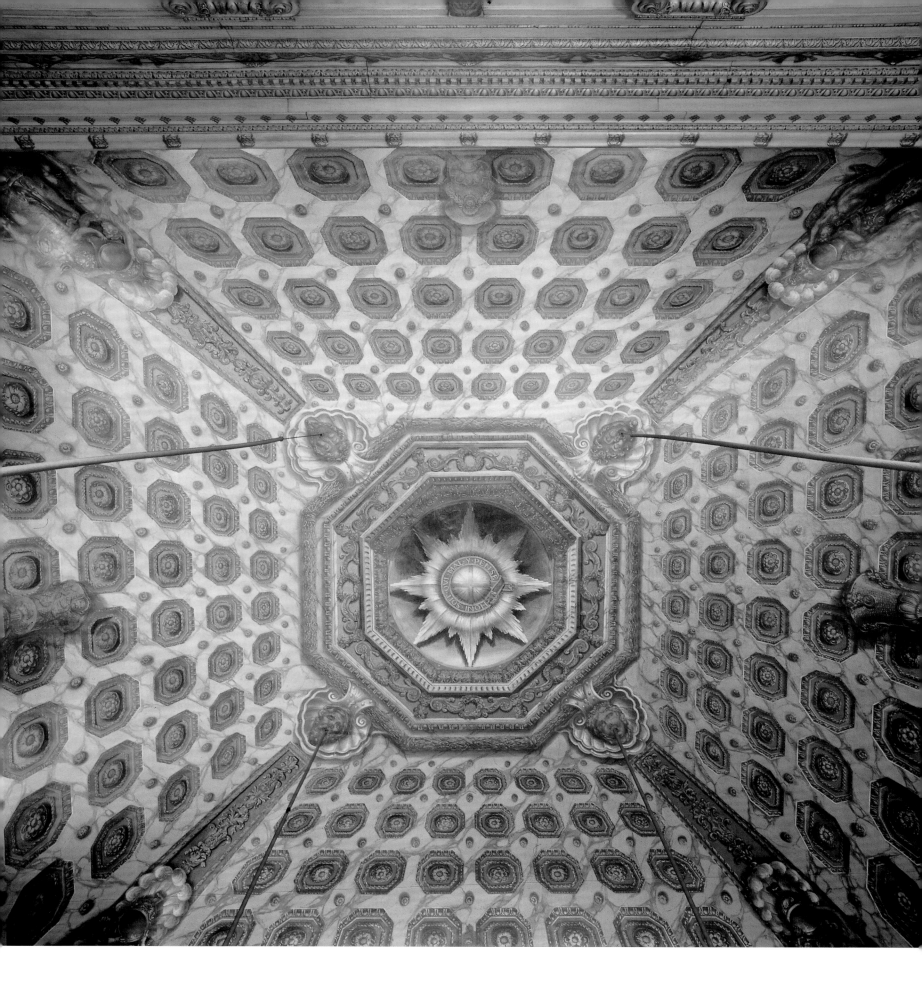

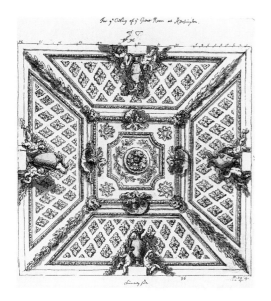

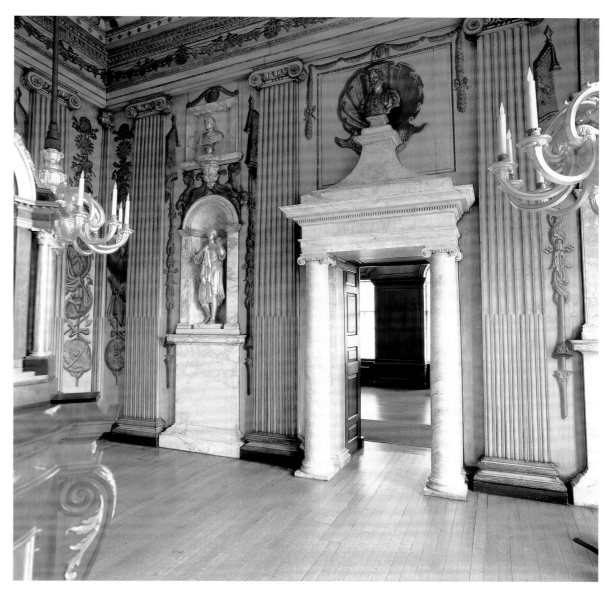

171. *William Kent's ceiling of the Cupola Room with its Garter symbolism, a commission obtained in February, 1722, through the machinations of Lord Burlington and the support of Sir Thomas Hewitt.*

172. *James Thornhill's rejected design for the ceiling of the Great Room, now Cupola Room.* Victoria and Albert Museum.

173. *The Cupola Room. Kent's* trompe-l'œil *painting of the pilasters and grisaille trophies on the walls was a second phase, added about 1725–6.*

William Benson, possibly by Colen Campbell, whom Benson had appointed his deputy. In January 1720, the King ordered work to go ahead on the upper storeys of the new building, to be completed by March 1721. It is possible that the King used the still unfinished room when he was in residence between August and October 1721. It was one of three rooms that had to be fitted into a confined space between Wren's pavilions and King William's gallery range. Surviving drawings (Fig. 169) show it as an unusually Italianate hall with pilasters, niches for statues and marble doorcases, but with no suggestion of wall painting, coffering in the cove or the Garter theme. Thus the dedication to the Garter may have been a change of mind, with the decision to decorate the walls as a second.

Kent gained the commission to paint the ceiling at the end of February, 1721–2, and the work proceeded sufficiently fast for it to be commented on unfavourably in May 1722 and to be completed by August that year. But how long a gap there was between Kent completing the ceiling and being asked to decorate the walls (Fig. 173) is not clear.

Between the two, in 1722–5, he painted five other ceilings at the palace, in the King's Bedchamber, the King's Great Drawing-Room (Fig. 177), the Privy Chamber, the Council Chamber and the Presence Chamber (Fig. 175). Three were in the grotesque style, first the King's Bedroom in 1723 and then the Council Room and Presence Chamber in 1724, but the last is the only survivor. The

room has to be imagined as Kent completed it, and as Pyne shows it, with the existing wainscot framing tapestry (but without the pictures on it) painted white (Fig. 174) and its carved cornice gilded, and the Gibbons overmantel moved into the room. His ceiling is based on drawings by Bartoli after the Antique, with a white ground, which gives an illusion of height in a low room and made better sense when the woodwork was white, and broad cross bands in lively red leading to a central roundel. If the red strikes us as surprisingly strong, it follows Bartoli's rendering of the cinnibar red found in Roman painting and now faded in most surviving examples. Vertue described it as being 'in imitation of the Antient Roman Subterranen Ornaments . . . poor Stuff', but is there more to it than that, bearing in mind that Kent used it in three rooms? Could it be that Kent was using the grotesque style not only as a reminder of Renaissance palace decoration, of which there were reminders in tapestries that had belonged to Henry VIII hanging in the King's Apartments at Hampton Court, but to create an Ancient Roman mood in the palace that was part of a deliberate attempt to create a new style for the new dynasty?[16]

From Kent's own point of view, it was probably a stimulating and liberating commission, because it enabled him to experiment with winged spinxes, shells, urns and vases, all of which were to become part of his vocabulary and be used in other mediums and on other scales.

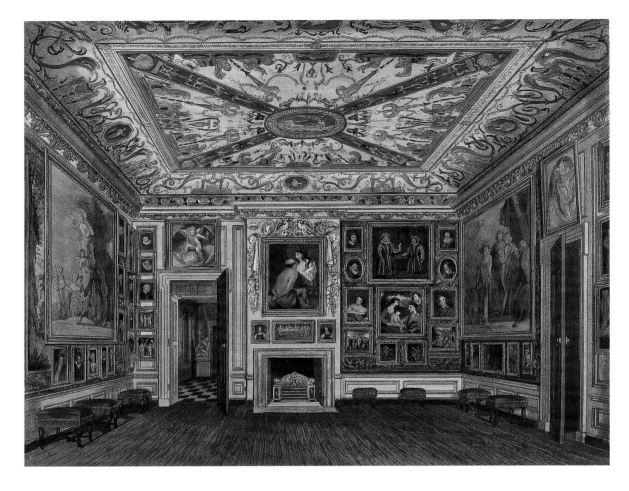

174. *Pyne's view of the Presence Chamber. A panelled and tapestried room of the Wren period redecorated by William Kent, who painted the woodwork white, gilded the cornice, introduced a Grinling Gibbons overmantel from the King's Drawing-Room, and painted the ceiling. The paintings hanging over the tapestries were a post-Kent introduction.*

175. *A memory of William Kent's time in Rome. The ceiling in the grotesque style in the Presence Chamber, 1724. The only survivor of three ceilings he painted in that style at Kensington.*

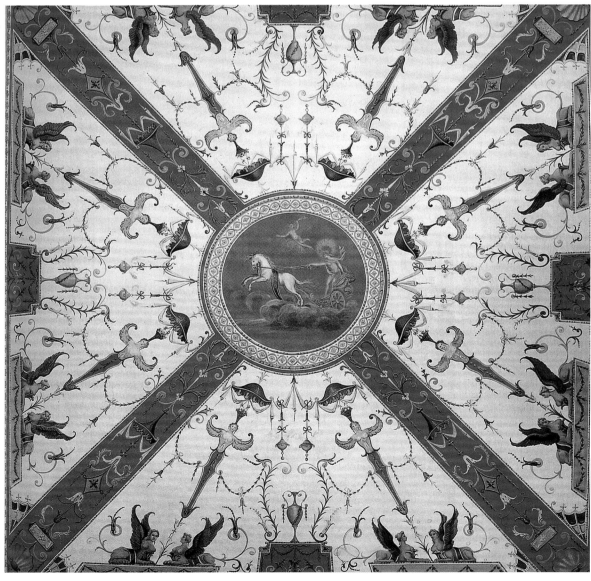

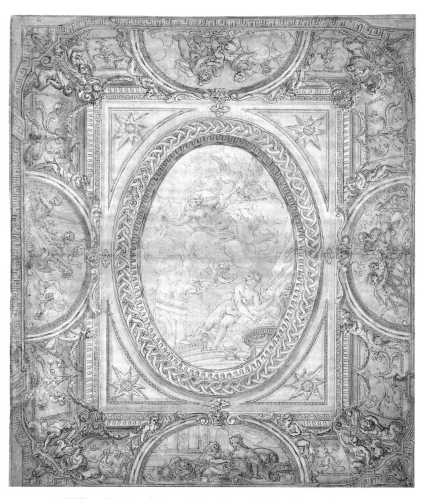

176. *William Kent's preliminary design of 1722 for the ceiling of the King's Drawing Room, probably fitted up by Thomas Hewitt, who is likely to have designed the deep beam pattern. Kent's proposal for the cove is comparable with his first suggestions for the saloon at Houghton (Figs.185, 186).* Private Collection.

177. *William Kent's ceiling in the King's Drawing Room. The central oval is* Jupiter and Semele.

In the Privy Chamber and the King's Drawing-Room, Kent painted what must be Hewett's heavily beamed Jonesian ceilings in what was intended to be a version of the late Roman Baroque style with central oval figurative panels, *trompe-l'œil* mouldings to the beams, and ornament in the coves. The tones of the two ceilings are different, that in the Privy Chamber having a strong orange-ochre cast to it, while that in the Drawing-Room is a stone colour, and in both there is a good deal of grey grisaille ornament in imitation of the newly fashionable Italianate plasterwork. The executed design for the drawing-room ceiling (Fig. 177), with *Jupiter and Semele* in the central oval, is less elaborate than the preliminary drawing (Fig. 176), which is close to the proposed treatment of the ceiling of the saloon at Houghton in 1725 (Fig. 195), and is painted in grey-white grisaille, again to imitate plasterwork, with green bronze roundels on a mosaic ground.

The way Kent used hatching in gold to create sparkle is particularly effective and suggests that he had a good understanding of gilding, having looked closely at interiors in Rome such as the gallery of the Palazzo Colonna.

As well as painting the ceiling in the King's Drawing-Room, Kent produced an overall scheme for the room that is only known through his charge for the designs in 1727: 'For drawing the sides of the Drawing roome, with all the pictures sketch in proper Colours, designing & drawing the mouldings & ornaments for all the picture frames, Glasses etc; For drawing the Gallery with all the pictures Sketch in proper colours, the frames drawn wth their ornaments, at large for the sconces and glasses.'

He also made his first recorded design for an architectural feature, the chimneypiece and overmantel (Fig. 178), which was carved by James Richards in 1724. The rectangular opening has a frieze decorated with a central mask and a pair of garlands and contained by a pair of brackets, and it is framed by a pair of female half-terms looking outwards. Above the cornice is a shallow marble attic (a modern replacement), but the treatment of the upper part of the chimney breast, with a painting of *The Holy Family* by Rubens (still in the Royal Collection) in an earred frame in a broken pediment, can only be judged from the engraving in *The Designs of Inigo Jones* of 1727. The effective use of grey and white marbles and bold relief carving as well as carved mouldings and terms looking outwards is quite different in handling from that of the chimneypieces in the Cupola Room and Privy Chamber. Also, its tones relate to those of the grisaille painting on the ceiling.[17]

In considering Kent's interiors and to get a sense of the difference between his personality as a designer and Gibbs's or Flitcroft's, his drawings need to be looked at as a group; but, unlike those for his landscapes, these have never been illustrated together. Also, except for his later Houses of Parliament drawings in the Soane and Victoria and Albert Museums, there are no sets of drawings relating

178. *William Kent's engraving of his first chimneypiece and overmantel in the King's Drawing Room in his* Designs of Inigo Jones, *1727. The chimneypiece carved by James Richards is still there, but the overmantel has disappeared.*

179. *William Kent's sketch for enriching a mirror frame evidently set out by a draughtsman.* Trustees of the Chatsworth Settlement.

180. *William Kent's design for the Duke of Grafton's dining room with a continued chimney-piece and a pair of full length portraits in architectural frames. A drawing probably prepared for the plate in Ware's* Designs of Inigo Jones, *1731. It influenced Flitcroft's dining-room at Ditchley (Fig. 390).* Private Collection.

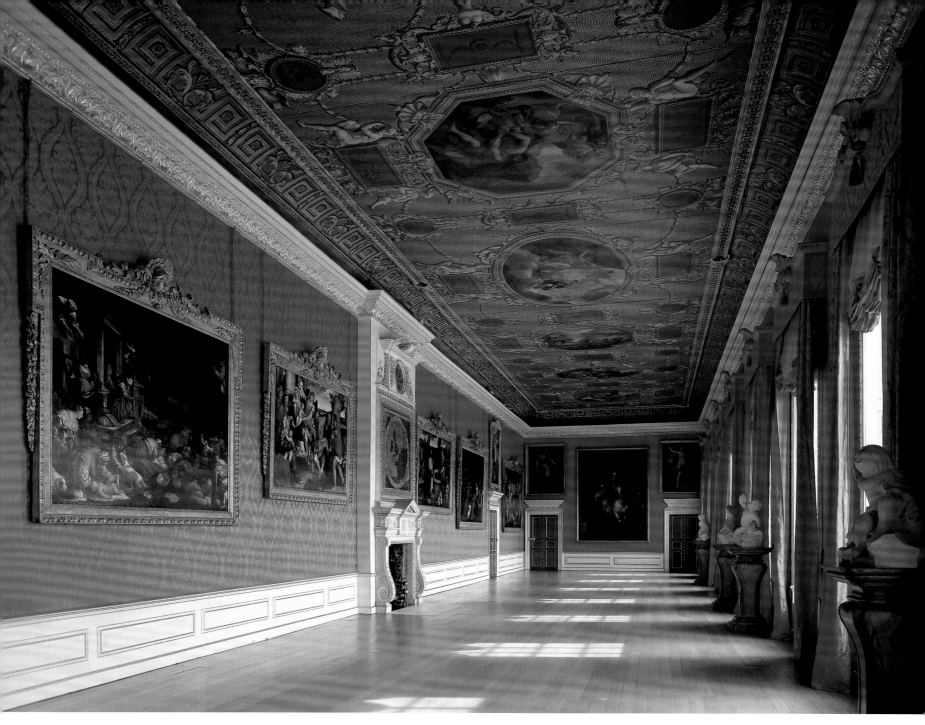

181. *The King's Gallery at Kensington Palace. William Kent painted and gilded the oak panelling of William III's gallery and hung the walls with crimson damask, designed the door architraves, chimneypiece and overmantel, painted the ceiling, and* designed picture frames carved by John Howard in 1727 for the set of great Venetian pictures. The ceiling depicts the story of Ulysses based on Pope's 1725 translation of The Odyssey *which was illustrated by Kent.*

to individual projects, just a scattering of sheets as for Holkham. He never, in fact, became a competent architectural draftsman, but always remained an expressive sketcher who depended on a draughtsman like Henry Flitcroft in the early years and later John Vardy and Stephen Wright to provide an accurately drawn framework that he could develop. That can be seen in his drawing for the North Hall at Stowe (Fig. 11), of which John Harris has written: 'Indeed it probably stands at the watershed between Kent the interior decorator and Kent the architect. The drawing characterises Kent's technique: a draughtsman supplies the outline framework, over which Kent makes loose, freehand sketches in his peculiar bistre-wash technique.' The same process can be seen on the simpler scale of a design for a mirror (Fig. 179) at Chatsworth and Vardy's drawing for the Treasury chimneypiece in the Victoria and Albert Museum, which again Kent drew over. Thus when Lord Burlington asked him about 1724 to prepare an edition of Inigo

Jones's drawings for publication, it was Flitcroft, not he, who redrew the original drawings for the engraver. And a drawing like that for the chimneypiece in the hall at Houghton, now in the Courtauld Institute, is surely not Kent's design but prepared for an engraver?[18]

Vertue regarded him as a poor draftsman, as can be seen from what he wrote in 1731 of Newton's monument in Westminster Abbey: 'a noble and Elegant work of Mr Michael Rysbrack. much to his Reputation. tho the design or drawing of it on paper was poor enough, yet for that only Mr Kent is honoured with his name on it (Pictor et Architect inventor) which if it had been delivered to any other Sculptor besides Rysbrack, he might have been glad to have his name omitted'.[19]

On the other hand, his drawings were probably immediately intelligible to assistants and craftsmen who had to work from them and understood the way he thought; and at the same time they have a beguiling freshness that would have appealed to patrons. There is a

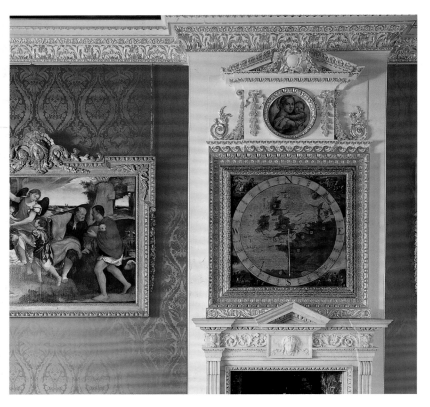

182. *A detail of the chimneypiece and overmantel in the King's Gallery incorporating the earlier wind dial in its frame and part of one of Howard's picture frames.*

strongly imaginative quality about his inventions, such as the etched tail pieces in *The Odyssey* (Fig. 166). More careful but stimulating drawings like the design for the table in the Green Velvet Drawing-Room at Houghton (Fig. 212) dated November 1731 (Victoria and Albert Museum) are now rare but presumably were what he handed over to James Richards for carving. That particular drawing was engraved as plate 41 by Vardy in *Some Designs of Mr Inigo Jones and Mr William Kent*.[20]

Sadly, none of his early coloured designs for rooms at Kensington survive, and they can only be imagined by combining the drawings for the Houghton saloon (Figs. 185, 186), the drawing (private collection) for the engraving of the Duke of Grafton's dining-room (Fig. 180) published in Ware's small *Designs of Inigo Jones* of 1731, the drawing showing his paintings in the hall at Ditchley (Fig. 388) and the later drawing for the library at Holkham (Fig. 439).[21]

At the same time as painting the ceilings at Kensington Palace, he also painted the walls of the Cupola Room (Fig. 173), where in January 1723–4 Rysbrack had been commissioned to do the relief of a Roman marriage after an antique in the Palazzo Sacchetti in Rome. This was the first occasion on which Kent and Rysbrack can be seen working together, and the commission may have come about through Sir Thomas Hewett, who sat to Rysbrack for a portrait bust in 1723.

The co-operation between Kent and Rysbrack was to become important in Kent's interiors because Rysbrack may have encouraged Kent's painterly appreciation of sculpture and sculptural detail and his eye for the figuring of marble, as can be seen in the Marble Parlour at Houghton (Fig. 217) and the chapel at Blenheim, where Kent designed and Rysbrack carved the monument to the Duke of Marlborough in 1732. Certainly the first time Kent's appreciation of marble is apparent is in his combination of *trompe-l'œil marbling* with Rysbrack's real marble in the Cupola Room (Fig. 170).

What makes Kent's decoration of the walls of the Cupola Room so appealing is that he was able to give a solemn scheme a lightness of touch and and a dash of wit through his detail, which neither Thornhill nor Gibbs could ever have done. It is not clear from the original designs (Fig. 169) whether the intention was to line the walls between the pilasters in wood, and it may have been Kent's suggestion to do so, following the way the wainscot is fitted round the screen in the hall at Chicheley (Fig. 375). Between the pilasters painted with *trompe-l'œil* flutes he painted flags and in the corners of the room long trophies that 'hang' from the star and George of the Garter, while the frieze is filled with formalized collars of the Garter. The trophies bring to mind those in stucco that the Italian stuccadores modelled soon afterwards in the hall at Moor Park (Fig. 36) where they were working alongside Thornhill.

Yet a third element in the room is the theatrical gilding of the statues in the niches and the matching busts standing on the swept pediments of the doorcases, which are answered by a black bust above the chimneypiece. While Vertue thought the statues 'guilt with burnish'd gold' makes 'a terrible glaring show. & truly gothic', their recent regilding is dazzling and one is left not quite certain as what is real, surely one of the secrets of great decoration.[22]

The room was originally furnished with sixteen large square walnut stools covered in crimson damask placed in front of the pilasters and two long stools, all of which were made by Richard Roberts. In 1723 Gumley and Moore provided 'Four large Sphynx Stands for Tables' designed by Kent and four chandeliers with twelve arms, which appear in the Pyne view: recently they have been reproduced in carved and oil gilt wood (Fig. 170).

In 1726, although apparently Kent still had no real experience of building, thanks to Lord Burlington's influence he was made Master Carpenter to the Board of Works in succession to Sir Robert Walpole's own architect at Houghton, Thomas Ripley, who was promoted Comptroller of the Works in succession to Sir John Vanbrugh. So he was in a stronger position when in 1725–7 he was decorating the King's Gallery (Fig. 181), a more original creation than is generally recognized today, with its close relationship between the great Venetian pictures on the walls and the painted decoration in the Italian manner on the ceiling. It was rather awkwardly related to the rest of the King's Apartment and lacked an imposing entrance from the rooms of parade, because, when planned by Wren for William III, it had been a private gallery leading off the King's Bedchamber at its east end. So Kent had to contrive a new way into what was the largest of the rooms of parade from the existing King's Staircase, whose walls he also painted. As in the Presence Chamber, he was obliged to retain William III's dado, carved cornice and frieze and also the painted wind dial over the chimneypiece. However, he rose brilliantly to the challenge that faced him, as can be seen from the recent restoration. He introduced a new chimneypiece and overmantel to frame the wind dial (Fig. 182), and new doorcases. The friezes to their overdoors with their central leaves echo those in the main frieze (Fig. 183), while their acanthus carving echoes that of the frieze of the chimneypiece. Also, he painted the wainscot white, then an extravagant idea because of its tendency to go off, and hung the walls with strongly contrasting crimson damask, a dramatic change from the brown wood with green velvet of the original scheme. The recent regilding of the room has been an exercise in solid and parcel gilding: the raised ornament in the seventeenth-century cornice is picked out, as

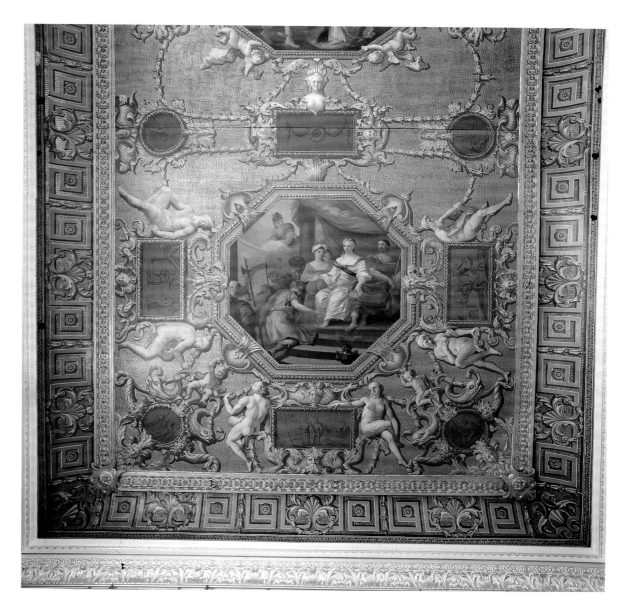

183. *A section of the painted ceiling of the King's Gallery. Kent broke up its flatness and disguised its lack of height by painting a series of framed pictures of different shapes against a golden mosaic ground. In his grisaille figures and ornament he challenged the work of the Italian stuccadores.*

is the frieze of the doorcase; the frame of the painted wind dial is gilded solid like the picture frames, while the architectural mouldings of the door architraves are gilded on their highlights and some of the flat edges are gilded solid for emphasis. Thus there is a subtle interplay that echoes the handling of the ornament on the ceiling.

The concept of crimson damask, white paint and generous gilding now seems a convention of palace decoration. But it sounds as if it was still a new fashion in 1732 when Sarah, Duchess of Marlborough wrote to her favourite granddaughter, Lady Diana Spencer: 'Though several people have larger rooms, what you have is as much as is of real use to any body, and the white painting with so much red damask looks mightily handsome.'[23]

The length of the room and its lack of height presented a major problem, but Kent disguised that by providing an unusually low dado and a shallow cove, and he broke up the flatness of the ceiling by painting it (Fig. 183) with a series of framed pictures of different shapes set against a golden mosaic ground that creates a broken effect. The central oval is flanked by octagons, then rectangular octagons and with octagons at the ends, interspersed with rectangular, square and circular tablets with figures and ornament in grey grisaille like plasterwork. The pattern and ornament is thus more important than the subject-matter of the pictures, which illustrate the story of Ulysses taken from Pope's 1725 translation of *The Odyssey*, which Kent illustrated: together, they lead the eye down the

length of the room, without overwhelming it with large figurative panels or challenging the Venetian pictures on the walls. The painted frames he was soon to adapt for real frames in carved and gilt wood.

According to the accounts, Kent again charged for designs 'with all the Pictures sketcht in proper Colour', which, alas, have disappeared. However, his intended effect has been largely recreated, at least on the long wall, by bringing back the six large Venetian pictures of different sizes that were listed in the room in 1732. Their matching frames were carved by John Howard in 1727 and relate to the outer frame of the wind dial, with the masks in the frames echoing that in the tablet of the chimneypiece and the garlands linking up with garlands in the top storey of the overmantel. The end walls were originally much stronger, because they had two huge Van Dycks (still in the Royal Collection), one of *Charles I with his family*, which was enlarged and turned from a horizontal into a vertical to fit, and a seventeenth-century copy of *Charles I and Monsieur de Sainte Antoine* to recreate the original Baroque illusion of the King riding into the room. The sparseness of the hang, with no supporting small pictures, must have been a striking innovation at the time.

The room lacks the carvings on the piers between the windows that appear indistinctly in Pyne's view. The lower walls on both the chimneypiece and window sides look naked without any supporting furniture, and, although there is no evidence that Kent designed pier-tables for the room, it was furnished, even if not as fully as in

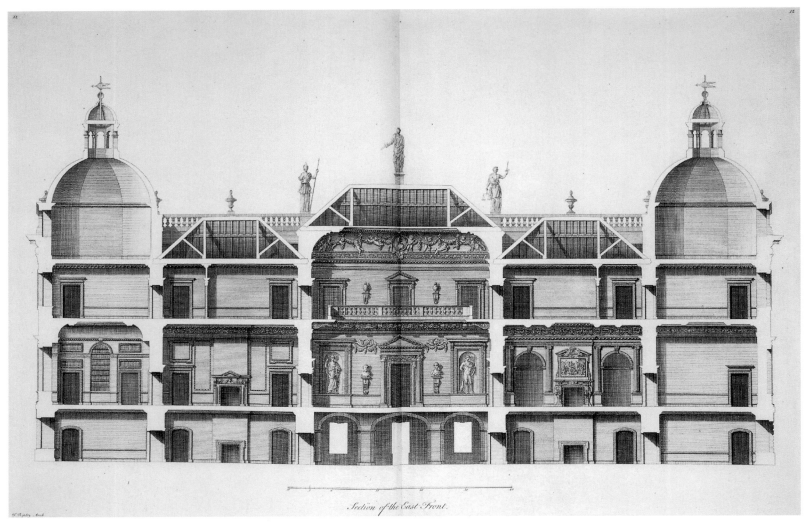

*Section of the East Front.*

184. *Houghton Hall. Section of the house from* Ware's Plans, Elevations and Sections of Houghton in Norfolk, *1735.*

the Pyne view, which shows no tables on the long wall as might be expected. In addition to a pair of elbow chairs and twenty walnut stools, it had a pair of 'very large hanging glasses silvered at £150 each', two 'very large carved gilt frames for marble slabs at £40 each', one of which could be that seen at the end of the gallery in Pyne's view, four stands with marble tops at £18 each, six oval sconces silvered at £8 each, all provided by Gumley and Turing in November 1727. The combination of silvering and gilding in a room is unusual, but perhaps the silvering was intended to echo the grisaille figures on the ceiling.[24]

In spite of all the effort put into the recent restoration of the state rooms at Kensington Palace, they do not pull together to form a strong sequence and so Kent's approach to their design cannot be judged as a whole. Indeed, it can only really be understood if it is compared with the totality of his achievement.

## WILLIAM KENT'S INTERIORS AT HOUGHTON HALL

The first sign of Kent's involvement with Sir Robert Walpole's still incomplete house at Houghton is a pair of tantalizing designs for the saloon that are dated 1725 (Figs. 185, 186). Whether they were actually commissioned by Sir Robert or done by Kent to attract his attention is unclear. Certainly they remained in Kent's possession until his death and were unknown until they first appeared on the London art market in 1983. On the other hand, Kent must have had

access to Sir Robert's picture collection, because in the drawings he included the four *Markets* by Snyders and Jan Wildens acquired by Sir Robert in 1723–4 (Fig. 196).[25]

By 1725, as was explained earlier, Sir Robert had dropped James Gibbs from any role at Houghton and was consulting Colen Campbell about design matters while relying on Thomas Ripley to supervise the new building. At the same time, he would have been well aware of how Lord Burlington was packing the Office of Works with his own men and he would have seen the new integrated decorations at Kensington Palace designed by Kent, demonstrating his feeling for the relationship of pictures to decoration. Given Sir Robert's own undoubted eye, apparent from his picture purchases, it is not surprising that he decided that the principal rooms, whose form was already settled, should be a sequence of picture rooms decorated in Kent's new manner. Contrary to the apparently seamless character of the house and landscape at Houghton, it is now apparent how much the design of both developed over the years, with significant changes of mind that include Kent's involvement with the decoration of the rooms on the main floor.

Kent's 1725 proposal for the saloon shows decorative painting on the cove of the ceiling, with a chimneypiece and overmantel, piertables and a complete arrangement of pictures that already belonged to Sir Robert Walpole and that suggested the themes of the cove painting. They are drawings of a totally new type for an English designer, although they were preceded by some sketches by

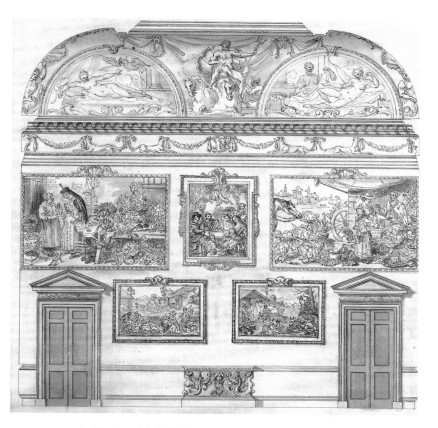
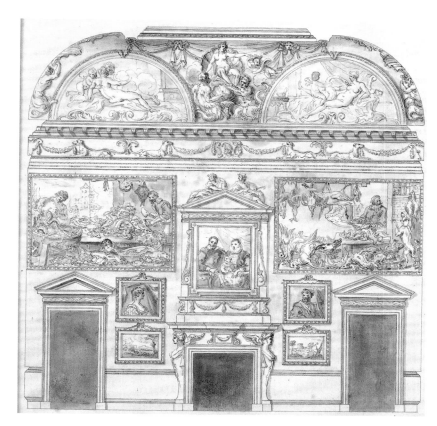

185, 186. *Houghton Hall. William Kent's earliest surviving designs for an interior, showing a proposed arrangement of Sir Robert Walpole's pictures in the saloon in 1725. He also suggested figurative painting of the Elements in the cove that related to the themes of the four big pictures of markets by Snyders and Wynants (Fig. 196)*

*recently purchased by Sir Robert as well as a typically witty frieze of hounds pulling on garlands centring on the saracen's head crest of the Walpoles and one of his first proposals for a side table.* Private collection.

John Talman, and are seemingly comparable with the now-lost drawings for Burlington House and Kensington, and were soon to be followed by the drawing for the hall at Ditchley (Fig. 390).

Kent's next dated design for Houghton was the first one for the Marble Parlour, of 1728 (Fig. 216), and after that there were none until he drew up the design for the pier-table in the Green Drawing-Room dated 1731 (Fig. 212), by which time the fitting-up of the principal rooms was nearing completion. Even if Kent started work at Houghton as early as 1725, he could not have done much by 1726, when Sir Robert was given the Order of the Garter, the first commoner ever to be so honoured by the King, because the Garter insignia is incorporated into the decoration of most of the principal rooms. In June 1727, King George I suddenly died while on a visit to Hanover, and Sir Robert must have wondered whether he would continue to hold office under his successor. It is reasonable to assume that he would not have felt confident enough to go ahead with such a magnificent scheme until he was confirmed in office.

By 1727 Kent had evidently learned how to marshal together all the elements of an interior at Kensington – architecture, decorative painting, sculpture, plasterwork and carving, furniture and upholstery – and bind them into a unity. He also knew a great deal more about Inigo Jones's architecture through having prepared the folio volumes of *The Designs of Inigo Jones* that appeared that year, with some of his own designs included.

But what we may underestimate is his feeling for pictures – their primacy in interiors and so for picture hanging, which do not necessarily go together and, indeed, often conflict. A good deal has been worked out about this in recent years at Kensington Palace, but at Houghton, despite the prints in *The Houghton Gallery*, until very

recently it has been difficult to get a clear idea of the relationship of the pictures to the decoration. Now, however, as a result of *A Capital Collection*, edited by Larissa Dukelskaya and Andrew Moore, which is in effect an illustrated edition of Horace Walpole's *Aedes Walpolianae*, it is possible to see how the pictures paced out the rooms on the *piano nobile* and how the painting of the ceilings of the saloon and the Green Velvet Drawing-Room grew out of the pictures originally on their walls.[26]

Vertue wrote of Sir Robert's purchase of Carlo Marratta's portrait of Clement IX (Fig. 207) in 1739 that 'this is to be plac'd in the picture room at Houghton called the Morrat Room where there is many fine pictures of that celebrated Master' and again of 'the range of the State Rooms', 'every room in a different manner but the great Collection of noble original pictures exceed all others in number and variety'. Thus they were not rooms of parade with pictures, but picture rooms that were rooms of parade.[27]

At Houghton, Kent had a new shell to work within, and, while he could not alter the plan (Fig. 190) or the proportions of the rooms on the *piano nobile*, he was able to devise all the decoration and achieve a logical sequence partly based on current ideas of furnishing but taken much further. However, wheras at Erddig (Figs. 363–8) the build-up was achieved by upholsterers, furniture makers and sellers of looking-glasses, at Houghton direction came from a history and decorative painter. There is a symbolic, iconographic unity to each of the main rooms, with the subjects of the ceilings reflected in their colours and continued into the details of the furniture and sometimes echoed in the pictures that Sir Robert hung on the walls.

That unity is first seen on the Great Staircase (Fig. 187), which

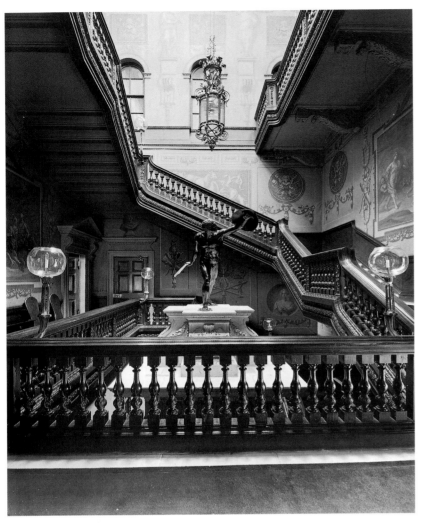

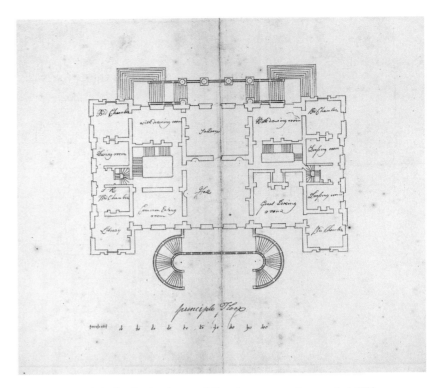

188. *James Gibbs's plan for the* piano nobile, *about 1720–1. It seems that Gibbs rather than Colen Campbell made the first, key plan for the house. The first thought for what became the screen in the Marble Parlour (Fig. 217) is indicated.* British Architectural Library.

190. *Plan of the second floor as illustrated by Ware. This shows its ingenious arrangement with three sizes of bedrooms with closets, service rooms and privacy from the stairs.*

*Houghton Hall*

187. *The principal staircase that rises the full height of the house. The balustrade is of carved mahogany and the walls are lined with canvas painted by William Kent. The bronze copy of a classical gladiator by Le Sueur was given to Sir Robert by the 9th Earl of Pembroke. From the angles of the balustrade can be seen the original gilded wooden arms with glass shades that carried candles.*

189. *One of William Kent's grisaille allegories on the staircase illustrating the story of Meleager and Atlanta in white, gold and ochre frames similar to those of plaster in the saloon at Burlington House (Fig. 165) and carved wood in the King's Gallery at Kensington Palace (Figs. 181, 182).*

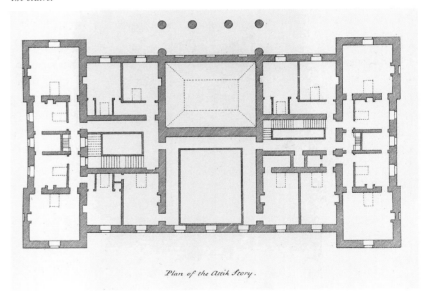

*Plan of the Attik Story.*

191. *The Stone Hall. William Kent's dramatizing of Campbell's design with its stronger vertical emphasis and his use of busts on brackets, the continued chimneypiece by Rysbrack and figurative sculpture on the doorcases. In front of the overmantel relief of* The Sacrifice to Diana *is the bust of Sir Robert Walpole as a new Roman and wearing the Garter star. In the pediment is a fox's mask, a detail comparable with those in Fig. 236.*

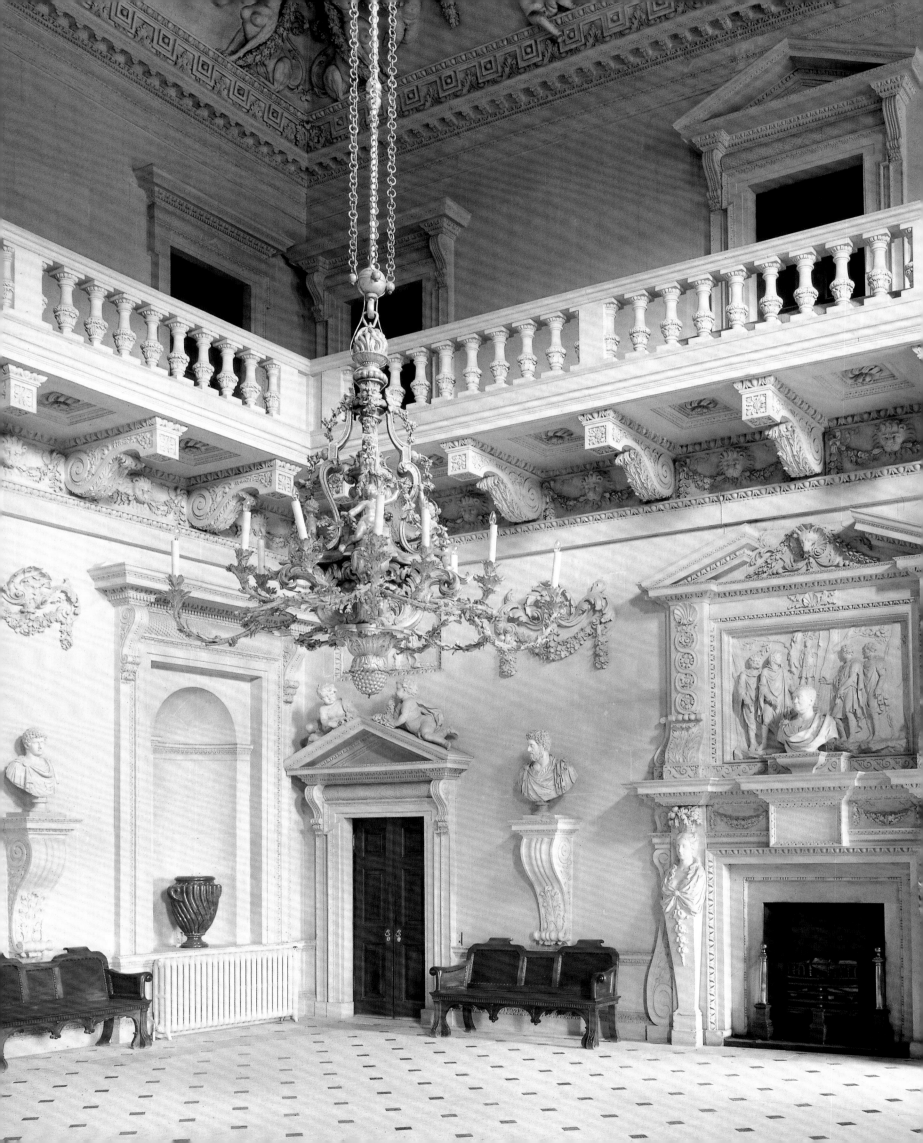

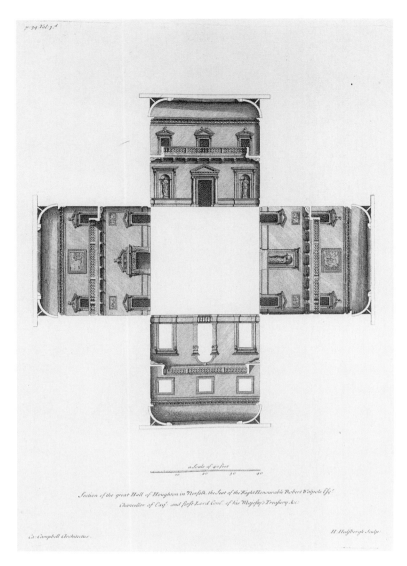

192. *Campbell's design for the double-height hall included in* Vitruvius Britannicus *III. As so often in his designs the proportions have a strongly horizontal character that lacks visual excitement.*

starts in the comparative darkness of the ground floor, where the stair well is largely filled with the four towering columns forming a stone temple base for the huge bronze *Gladiator*. This is a bronze copy of the classical marble in the Borghese Collection made in the seventeenth century by Le Sueur for the 4th Earl of Pembroke for the garden at Wilton, where it was installed before 1645, and given to Sir Robert by the 8th Earl of Pembroke.

The balustrade of the staircase and the dado is all of mahogany, the first sign of its architectural use in the house and often taken as a symbol of Sir Robert Walpole's extravagance. However, recent research has shown that it was a stroke of relative economy on Sir Robert's part and probably made on the recommendation of Ripley. Walpole bought his wood in Jamaica, had it sent back in three ships to London and then brought round by sea to King's Lynn. Thus economy and magnificence went hand in hand, and there was no need for the gilding that Sir Matthew Decker said was intended.[28]

The walls are lined with canvas painted stone-colour to continue the idea of the arcade and to match the stone doorcases. They are decorated with mythological hunting scenes of *Meleager and Atlanta* in grisaille set in white and gold-on-ochre *trompe-l'œil* frames (Fig. 189) of a pattern close to the carved and gilded frames that Kent designed for the King's Gallery at Kensington (Fig. 181). They are

flanked by *trompe-l'œil* trophies suggesting plasterwork and emblematic of hunting, with statues in niches; and at second-floor level busts and terms perhaps inspired by Inigo Jones's designs for Whitehall Palace engraved in Kent's book and panels of ornament on a browner ground. The entablature is parcel-gilt, and all the gilding on the walls is, in fact, ochre paint with freely painted highlights in gold. The last is so skilfully done that few people ever stop to see how the effect is achieved. The canvas has a pronounced twill weave that gives an added sense of life to the painting, which suggests that Kent may have had some experience of theatrical scene-painting.

As the *Gladiator* comes into full view when visitors climb the third flight of stairs to the first-floor landing, he invites them to pause before passing through the pedimented stone doorcase into the Stone Hall and the start of what Lord Hervey called 'the floor of taste, expense, state and parade'. In no other English interior is a piece of sculpture placed so dramatically to fulfill such a theatrical role.[29]

The Stone Hall (Fig. 191) in its present form is a great room by Kent that was completed by July 1728, but it is only right to see it as his revision of a proposal by Campbell shown in *Vitruvius Britannicus* III (1725, Fig. 192) that may itself be a replacement of an unrecorded Gibbs scheme. The hall is a celebration of Walpole's triumph as a new Roman and of the pleasures of the chase and country life. Watched by Rysbrack's figures of *Peace and Plenty* that celebrate Sir Robert's rule over the east door, which are based on sketches by Kent and were originally modelled in terracotta by the sculptor, who kept them until a sale of 1766, Rysbrack's bust of Sir Robert in toga and Garter star presides over the room from the chimneypiece. He is raised slightly above the mostly antique busts of emperors and historical figures on long brackets, so that he appears as their heir. Behind him is Rysbrack's *Sacrifice to Diana* (Fig. 191), and above the doors are the sculptor's smaller reliefs depicting sacrifices. These are derived from engravings of the Arch of Constantine used in the English translation of Montfaucon published by David Humphreys as *Antiquity Explained and represented in Sculpture* (1721–5), where they represented the 'Hunting of the Ancients'.[30]

The pairs of boys on the pediments of the doorcases are sometimes seen as a Campbellian and sometimes as a Gibbsian idea. They were usually executed by the Italian stuccadores, but here they were modelled by Rysbrack.

The two themes continue up to the ceiling (Fig. 193) and its cove with the lively figures of boys swinging from the oak garlands that link the roundels of Sir Robert, his first wife, son and daughter-in-law. Kent took credit for the design in the headpiece in his *Designs of Inigo Jones*, and the ornamental plasterwork was carried out by Artari in either 1726 or 1728, there being payments for wine for the Italians between July and October 1726 and to Artari himself in February to May 1728. The ceiling above has a great display of the Walpole arms, crest and supporters with the Garter, all the ornament set against a pale blue ground that may well be original, like the gilding of the lettering of the Garter and family mottoes. In the outer segments are symbols of hunting that answer the fox's mask in the pediment of the overmantel.

Originally the Stone Hall was lit by what Sir Matthew Decker called a noble lantern with eighteen candles, but the six mahogany seats or benches had not yet arrived when he was there. The lantern was replaced by the 2nd Lord Orford, who bought the carved and gilt twelve-light chandelier, one of the finest of its kind, at a Cholmondeley sale in 1748.[31]

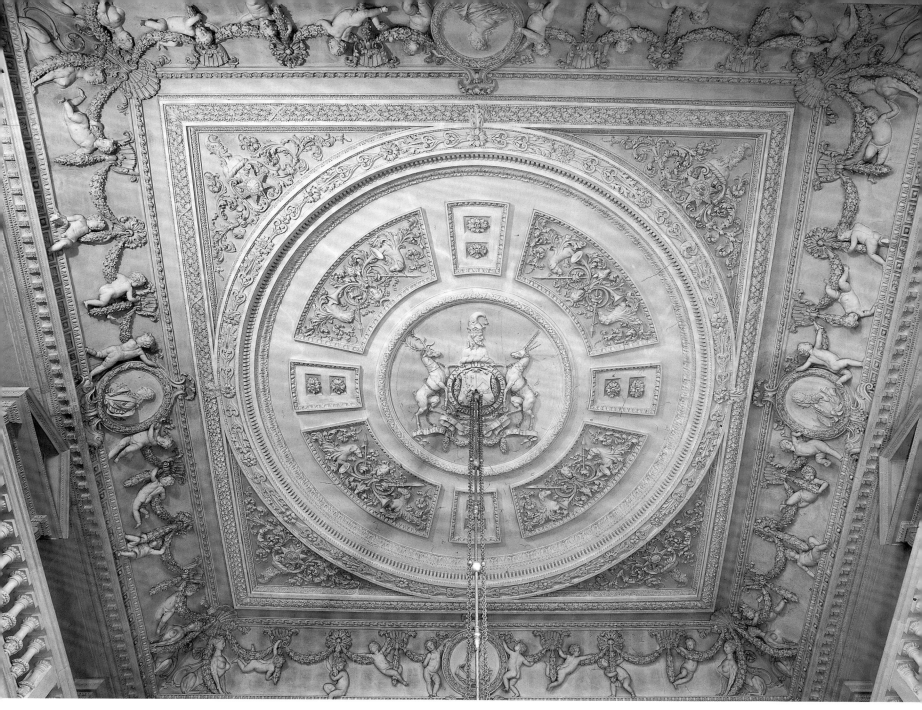

193. *The ceiling and cove of the Stone Hall modelled by Giuseppe Artari. The bed of the central circle and the panels around it have pale blue grounds and the letters of the motto and Garter ribbon are edged in gold that is presumably original.*

Even by Kent's standards, the pair of hall tables are difficult to describe: at each end are carved vase-shaped supports with four scrolls at top and bottom to provide feet and support the top of the frame, and the supports are linked by carved garlands echoing those in the cove and on the walls and meeting in a central mask. They flank the bronze cast of the marble Laocoön, then regarded as one of the most important pieces of antique sculpture, which Sir Robert's eldest son, Robert, acquired for him in Paris, and for which Kent designed the stone base with its emblems of Minerva.

It is a great thrill to open the double doors from the hall into the saloon (Fig. 194) and so pass from cool stone and sculpture into the glow of crimson and gold and pictures, and from the demesne of Diana into that of Apollo and Venus.

Here, the whole room was articulated by the pictures that were hanging here by 1736. Presumably their arrangement was worked out by Sir Robert and Kent, even if the physical task may have been

carried out by Ripley, as at Wolterton, or by John Howard, who not only made frames for Sir Robert and acted as an agent for him in his purchases but was paid for hanging pictures in 1729. Over the chimneypiece was a huge *Baptism of Christ* by Albano, which Sir Robert bought from John Law's collection, presumably after he died in 1729. Facing it on the south wall was an even larger *Stoning of St Stephen*, at that time attributed to Le Sueur. On the east wall, flanking the hall door, were the two pairs of the *Markets*, which were evidently hung rather awkwardly with only a narrow gilt moulding separating the upper and lower pictures, presumably to create a stronger vertical emphasis on the wall. Over the west doors were two Murillos, an *Assumption* and an *Adoration of the Shepherds*, which continued the strikingly Roman Catholic aspect of the display; and over the east doors were Giordano's *Cyclops's Forge*, which Sir Robert had bought in 1722, and Le Brun's *Daedelus Trying On Icarus's Wings*. However, in 1742 Sir Robert rehung the east wall, removing the

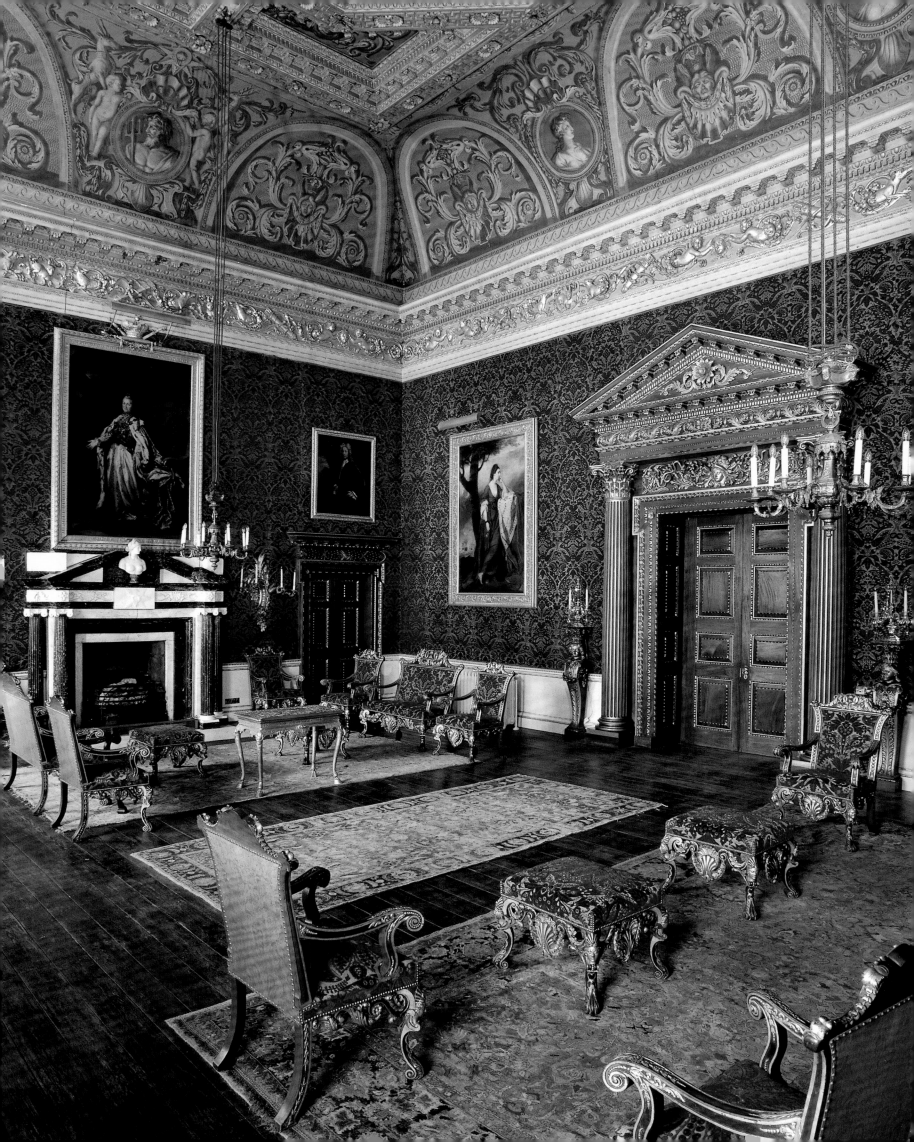

*Markets* and replacing them in the lower register with Van Dyck's *Rest on the Flight* and Rubens's *Christ in the House of Simon the Pharisee*, bought in 1733 and 1732 respectively.[32]

The *Markets* led up to the painted decoration of the cove and ceiling. The central octagon (Fig. 195) depicts *Apollo Driving His Chariot of the Sun*, a favourite subject at the time and one that Kent may have remembered from Giuseppe Chiari's 1693 ceiling in the Palazzo Barberini in Rome. It is painted in grisaille rather than full colour against a mosaic ground, an idea derived from Raphael, but here insisted on by Sir Robert, who did not wish the pictures to be overwhelmed, and enforced by Kent wanting to challenge the reliefs of the Italian stuccadores. On the north and south coves are roundels of Neptune and Cybele for Water and Earth, supported by pairs of boys and the Walpole supporters and Garter star; on the longer east and west coves are roundels representing the four seasons, which, as we have seen, grew out of the symbolism of the *Markets*. The ceiling itself was modelled by Artari, who was paid £131 14s. 5d. for it out of a total account of £560 10s.

The frieze is ornamented with trios of heads of Diana held up by half-putti separated by trophies of bows and arrows from trios of hares and hounds that are completely un-Palladian (Fig. 197). It suggests that Kent may have looked at friezes by the seventeenth-century Florentine etcher Stephano della Bella, a comparison that becomes even clearer when this frieze is compared with Kent's proposal for the frieze in the Marble Parlour that forms part of a recently discovered sheet for the ceiling of that room (Fig. 198).[33]

A bust of Venus stands on the chimneypiece, while Apollo's sunflower appears in the pediment over the east door (Fig. 200). The sunflower may have a double significance because it was also a symbol of constancy to the monarch.

The richness of the imagery may distract the eye from taking in the form of the room, which conceivably went back to Gibbs. That is suggested by the way the upper windows on the west wall are set back behind the vaulted cove, a detail never photographed because of the light, but a favourite idea of Gibbs, derived from vaulting in Roman halls as engraved by Rossi. Kent carried that idea round the cove in what read as recessed arches with stone-coloured grisaille ornament against mosaic grounds, receding behind the main cove that is painted in stone grisaille with green leaves heightened with gold: together, they create a sense of vaulting. It was Kent's painterly eye and his memory of late seventeenth-century Roman interiors that enabled him to conceive of the room as a setting for Sir Robert's pictures in which architectural furniture, pier-glasses and tables, chairs and stands all relate to plasterwork and decorative painting; and may well have continued into the picture frames. That can be seen in his use of shells that appear in paint on the cove and in carved wood at the top of the pier-glasses and the bases of the

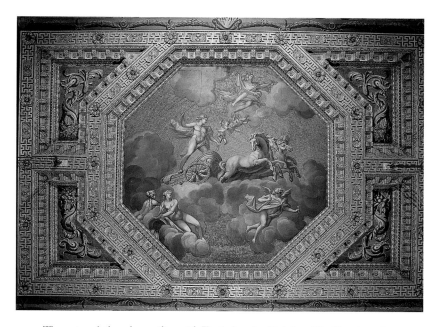

195. *The centre of the saloon ceiling with Kent's* Apollo Driving His Chariot of the Sun *in grisaille on a gold mosaic ground rather than full colour.*

196. *Frans Snyders and Jan Wildens* A Game Market *One of a set of four large* Markets *that Sir Robert probably acquired in 1723 and appear in Kent's design for the saloon in 1725. Interpreted as allegories of the Elements they suggested the original and executed subject matter of Kent's painting in the cove.* The Hermitage Museum, St Petersburg.

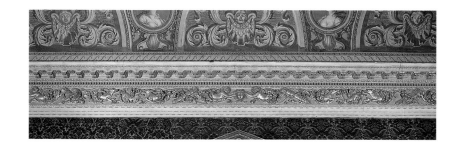

*Houghton Hall.*

194. *The saloon. The room retains all its original decoration, its parcel gilt seat furniture and crimson caffoy hangings, but the intended balance is lost through the absence of the original pictures and frames.*

197. *A detail of the saloon frieze with its masks of Diana with her trophies and gambolling hares.*

198. *A detail from a design at Houghton for the ceiling of the Marble Parlour showing a proposed but unexecuted frieze.*

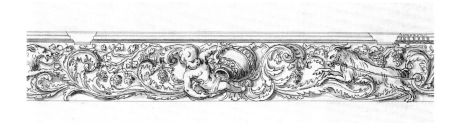

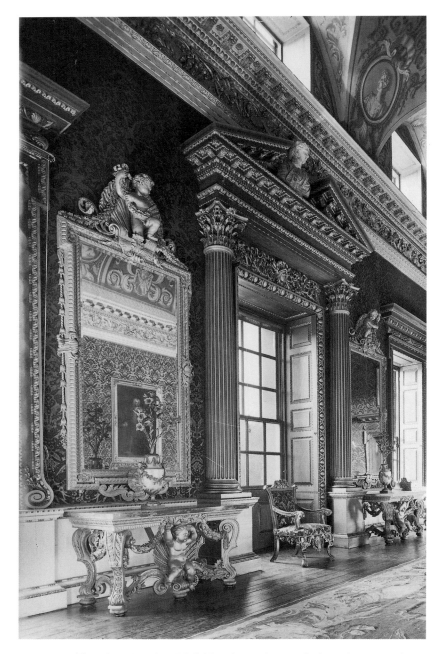

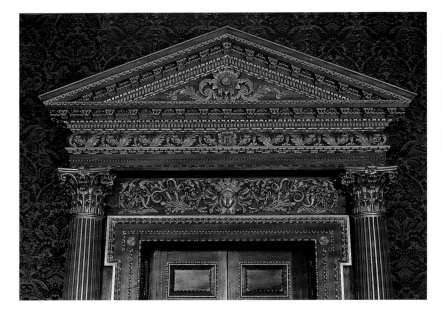

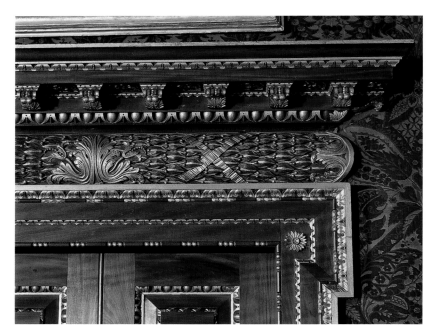

199. *The saloon, Houghton Hall. The gilt pier glasses with plates of exceptional size, presumably imported from France, and their related tables with porto venere slabs on the west wall of the saloon, all presumably designed by William Kent and carved by James Richards. Curtains were never planned, so the mouldings of the insides of the shutters were carved and gilded.*

200. *The head of the east doorcase in the saloon showing the subtle way in which the oil gilding complements the carving.*

201. *A side doorcase in the saloon showing the carving and gilding of the mouldings of the doors and of the architraves. Only the spines and berries of the bay leaves in the frieze are gilded.*

pier-tables on the west wall (Fig. 199), where the motif of the boy and the shell echoes the decoration at the foot of the dedication page of his *Designs of Inigo Jones*, and on the framing of the chairs.[34]

What is also exceptional is that Kent designed not only the pair of pier-tables with the glasses above them that have bevelled plates of very large size, which must have been imported from France, possibly through the good offices of his brother, Horatio, whom he had sent as ambassador to Paris, but an even larger table for the south wall that provides a strong architectural balance to the chimneypiece at the other end of the room. It has the same double scroll legs at the corners with sphinxes standing on scrolls helping to support the top and framing a carved centrepiece on the apron with the Walpole crest encircled by the Garter. The tops are of black and yellow *porto venere* marble, which matches the chimneypiece, where it is combined with light grey and white statuary marble only for the

carved frieze with its central Garter star and for the capitals and bases of the columns.

The oil gilding is also brilliantly planned and it still has a marvellous smouldering quality as well as unexpected sparkle in the frieze. Indeed, it is only in connection with gilding that Kent's name appears in the accounts of Ambrose Paine, with £1 12s. 6d. paid on 4 August 1732, to Mr Cooper for leaf gold for Mr Kent and another small payment on 6 September for leaf gold for the saloon. How far to take parcel gilding is always a problem, but here the connection between carving and gilding is handled with great skill, not only on the hall doorcase (Fig. 200) and the carved mouldings of the doors (the mouldings are uncarved in the stone hall and on the south side of the house), the side doorcases (Fig. 201) and the frame to the centre window (Fig. 199), but on the chairs (Fig. 202). There are remarkably few flat mouldings gilded, and the effect is achieved through

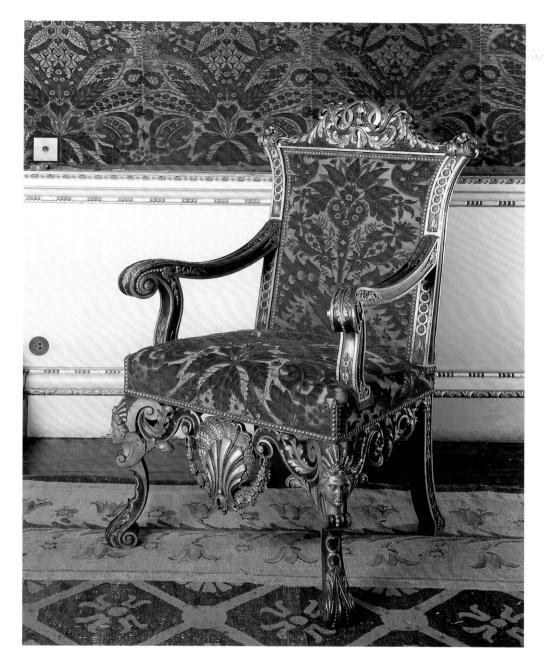

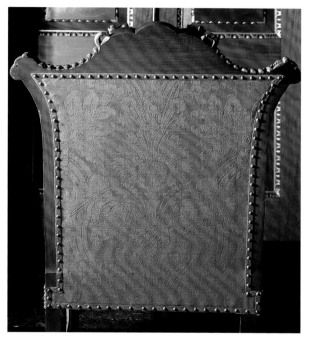

202. *The crimson caffoy used for both walls and chairs was supplied in 1729. The boldly figured, middle-price material was the conventional choice for saloons in the 1720s. The parcel-gilt mahogany chairs were probably carved by James Richards after a design by Kent.*

203. *A Spitalfields dress silk of about 1728. The design is similar to that of the caffoy and shows how dress materials influenced patterns for upholstery. Victoria and Albert Museum.*

204. *The stamped pattern of the woollen material relating to that of the caffoy on the back of one of the saloon chairs. The material is space nailed.*

gilding carved surfaces and knowing how to hold back on special features such as the capitals to the hall doorcase, where alternative rows of leaves, spines and the tips of leaves curling forwards are gilded, with the drums of the columns gilded and the flutes left plain. Similarly, on the friezes to the doorcases on the north and south walls (Fig. 201) only the central and end leaves, the crossed ribbons and the spines and berries of the bay leaves are gilded.

The room was never planned to have curtains, and so not only do the window architraves have carved and gilded friezes and cornices, but the mouldings of the shutters are carved and gilded. Sir Matthew was impressed: 'all the doors, shutters, and lining of the windows thro' the whole houses are of mahogany wood, and so finely worked, with such beautifull brass lockes and ingines that it is surprising, and all goes so easy as if everything went upon springs, not withstanding the substantialness of the work'.

The choice of crimson caffoy for the walls and upholstery was conventional, and the material was supplied by Thomas Roberts at 14s. 6d. a yard in January, 1729, coming to a total of £118 18s. There is no bill for the furniture, but James Richards almost certainly made the frames for the tables and glasses and the set of twelve armchairs, pair of settees and four stools (Fig. 202). Since the figure of the caffoy fits the chairs so well, Kent must have had the material to hand when he designed them. The chairs are backed with a woollen material stamped with a figure (Fig. 204), a unique survivor in England, very close to that of the caffoy and space nailed. Unusually, the gilding is not on a gesso ground and that gives it a lighter quality in keeping with the architectural gilding in the room and suggests that it was done by the same hand.[35]

The seat furniture may be the first grand set made in England in mahogany, as well as being the first in parcel-gilt mahogany; but it

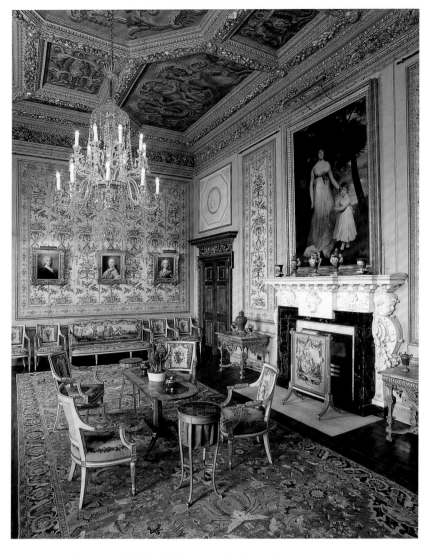

205. *Houghton Hall. The White, originally Green, Drawing-Room, as it was in. Now hung with a late eighteenth-century brocaded white silk instead of plain green velvet close hung with pictures mainly by Carlo Maratta.*

206. *G. B. Chiari* Bacchus and Ariadne. *One of a set of four pictures by Kent's former master in Rome hung in the Green Velvet Drawing Room in 1736 that appear to relate to Kent's treatment of the ceiling.* The Hermitage Museum, St Petersburg.

207. *Carlo Marratta* Pope Clement IX. *It was bought by Sir Robert in 1739 and placed above the chimneypiece in the Green Velvet Drawing-Room. Not only was it the finest of the Marattas in the room but it was a significant* coup de rouge *in the decorative scheme.* The Hermitage Museum, St Petersburg.

was clearly designed by someone who was not experienced as a chairmaker. Presumably Kent produced sketches based on his own imagination, because there do not seem to have been Roman precedents for chairs, as opposed to stools, to go with big tables. Thus he combined a variety of motifs such as the double shells with garlands and the masks with head-dresses that were another favourite Italian and French device with a long history.[36]

An often overlooked detail in the room are the pair of small, probably gilt brass, chandeliers of eight lights that are listed in the room in 1745. A rare survival, they may have supplied by William Hubert, a Huguenot metalworker, whose bill for metalwork repairs in 1730 still survives.

The dado was evidently originally not white, because in 1756 Mrs Lybbe Powys observed: 'the fitting up and furniture very superb; and the cornishes and mouldings of all the apartments being gilt, it makes the whole what I call magnificently glaring, more especially as the rooms are, instead of white, painted dark green olive; but this most likely will be soon altered'. By then, not only was the green stone colour and such lavish gilding of the architecture out of fashion, but the white paint contradicts details such as the bases to the window architraves of the windows in the drawing-room.[37]

The eye is never allowed to rest, and yet it is never tired or bored: the room provides endless pleasure, because it is splendid without

208. *Houghton Hall. Part of the ceiling of the White Drawing-Room. The pantheon on the ceiling with Venus in the centre surrounded by Jupiter, Juno, Apollo and Cybele echoed the subject matter of Sir Robert's pictures, while the colouring reflected the idea of green and gold in the furnishings.*

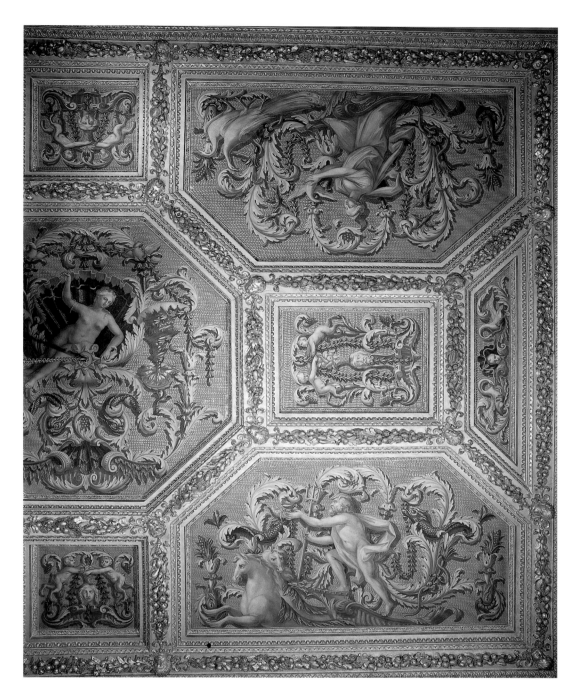

being pompous. Moreover, originally it looked out on an equally elaborate formal garden laid out a few years before the new house was conceived.

The drawing-room (Fig. 205) next door has been substantially altered since Sir Robert's day and so has lost its original sense of being richer than the saloon. Not only have the pictures, the green velvet hangings and the original overmantel to its chimneypiece gone, but the woodwork was not white. Also, the brocaded silk hangings given to the 4th Earl and 1st Marquess of Cholmondeley by the Prince of Wales after his visit in 1797 are the opposite of Kent's intention in scale and tone. However, the original idea can still be visualized through the architectural decoration and furniture and in details such as the more lavish carving of the doorcases and the gilding of the mouldings of the doors, which are of the same pattern as those in the saloon but more fully gilded, and in the higher proportion of carved white marble to *porto venere* for the chimneypiece.

Again, the pictures provided the key to the decoration. The principal picture on the north wall was Maratta's *Judgement of Paris*, which

Sir Robert owned by 1728, and that was balanced on the south wall by its pendant, *Acis and Galatea*, which also came from the Pallavacini collection in Rome and so was presumably bought with it. The top row on the east wall had four pictures by Chiari, Kent's old master, a pair of religious pictures and a pair of mythologies, *Apollo and Daphne* and *Bacchus and Ariadne*. Most of the rest of the pictures were religious. The original hang listed in 1736 was altered later, first in 1739, when Sir Robert bought Marratta's striking portrait of Clement IX (Fig. 207) that became a dramatic overmantel, and again in 1742, by which time it was called the Maratta Room.[38]

Kent saw the room as being in green and gold with white, with iconography and decoration working hand in hand, with the mythological pictures on the walls leading the eye up to the ceiling to complete the pantheon. Venus presides in the centre reclining in her shell (Fig. 208) and round her appear Jupiter, Juno, Apollo and Cybele, representing the Elements, with Apollo's mask on the tablet of the chimneypiece flanked by his sunflower.

Whose idea it was to make the change from crimson caffoy in the saloon to green velvet here – and when – is not recorded, but it fits

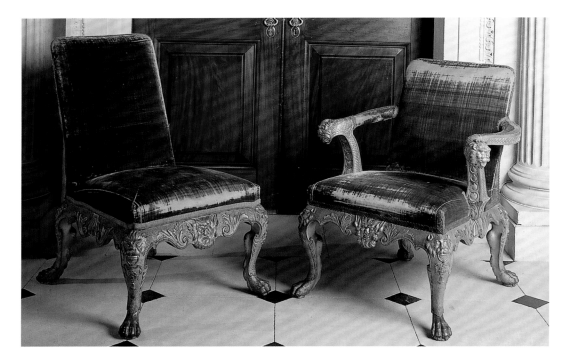

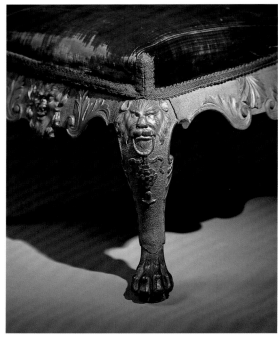

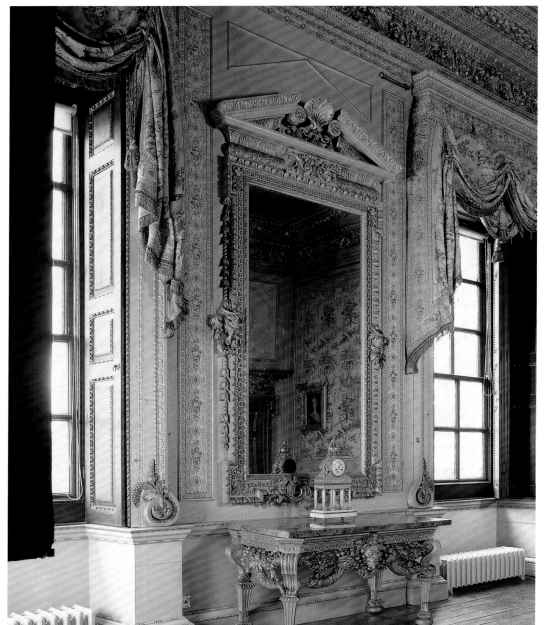

Houghton Hall.

209. One of the carved and gilt arm chairs and one of the side chairs originally in the Green Drawing-Room and Green Velvet Bedchamber. They are covered in the original green velvet and trimmed with gold lace.

210. A detail of a chair leg from the Green Drawing-Room set. When the oil gilding was bright, there was a contrast between the carved highlights and the matt sand-gilt ground, a familiar idea on picture frames but unusual on seat furniture.

211 and 212. The pier-glass and table with lapis lazuli top in the White Drawing-Room and Kent's drawing of it in the Victoria and Albert Museum. One of the few pieces of furniture for which there is a Kent drawing.

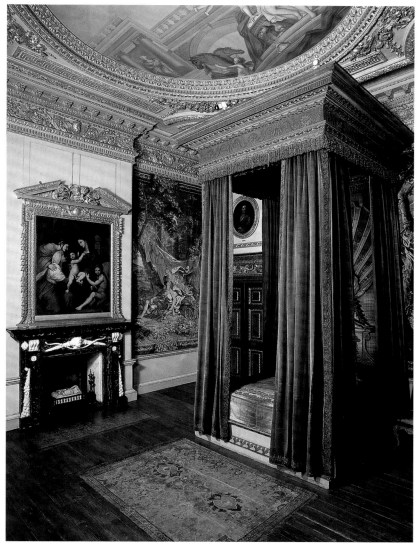

213. *William Kent's bed in the Green Velvet Bedchamber. Green is the colour of* Venus, Goddess of Love and Sleep; *the ceiling depicts* Aurora Rising *and the tapestries* The Love of Venus and Adonis. *The careful measurement of the green velvet for the estimate apparently by Thomas Roberts, Sir Robert's upholsterer, suggests that he may have made the bed in the house.*

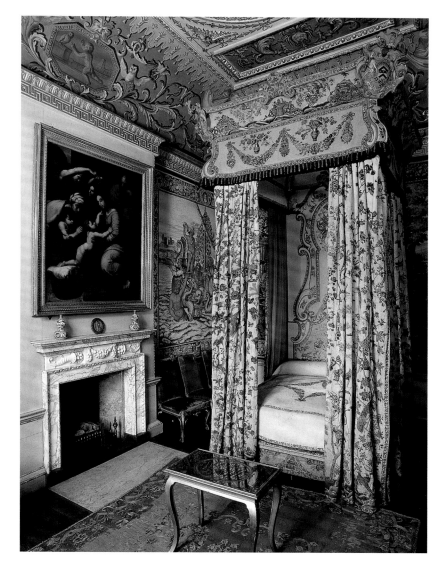

214. *The Needlework Bed with English embroidery. Stylistically it dates from about 1715 and so may have been one of Sir Robert's purchases for the old house but the arms were altered after Sir Robert was given the Order of the Garter in 1726. It was in use as the principal bed before the green velvet bed was completed in 1731.*

with the decision to dedicate both the drawing-room and bedroom to Venus, whose colour was green. That seems more important than the liking of green as a background for pictures. However, it may also be significant that Sir Robert did not use the words 'state rooms' to describe them; and the change of colour may have been seen as deliberate getting away from crimson with its connotations of grandeur and 'state'. 'The furniture is to be green velvet' wrote Lord Hervey to the Prince of Wales on 14 July 1731, and at Houghton there survives an estimate of the material required, worked out in breadths and drops and then converted into yards. It shows that 521¾ yards were needed for all the rooms, 280½ yards for the drawing-room and 187¾ for the bedroom, and that Sir Robert already had 205¾ yards in hand. That probably explains why the material today appears to be in two lots, one being slightly bluer than the other, but it is not known who supplied it or what it cost. However, on the outside of the estimate appears the name of 'Thos Roberts', the upholsterer who evidently carried out all the work on Sir Robert's houses. Presumably he was responsible for its hanging here.[39]

Sir Robert furnished the room with a suite of the same size as that in the saloon, two settees, twelve armchairs and four stools, the

frames being carved and gilded and the covers being of green velvet edged with gold gallon (Fig. 209). It is most unusual to find such a grand set of furniture oil gilded, but that must have been decided on to make it relate to the architectural gilding of the room. Inevitably much of the original contrast has been lost between the matt sand gilding of the ground and the bright carved ornament (Fig. 210). It is not known who made the chairs and there are no helpful parallels to them, but, unlike those in the saloon, they were made by a chairmaker who was a carver as well as a gilder. So it is tempting to suggest James Moore the younger, perhaps working with Benjamin Goodison, as can be seen in the shaping of their legs with their lion's masks on their knees, the lion's head ends to their arms and lion's paw feet. Presumably Richards carved the pier-glass and the frame of the table (Fig. 211), which is the only piece of furniture at Houghton for which Kent's drawing survives (in the Victoria and Albert Museum, Fig. 212): it is dated 1731. It has a top of lapis lazuli – intentionally finer and more valuable than the slabs of *porto venere* marble in the saloon – and they face the chimneypiece, which reverses the balance of marbles in the saloon, with only a *porto venere* architrave and carved white marble terms, cornice and frieze with Apollo's head carved. There were pairs of large silver sconces at

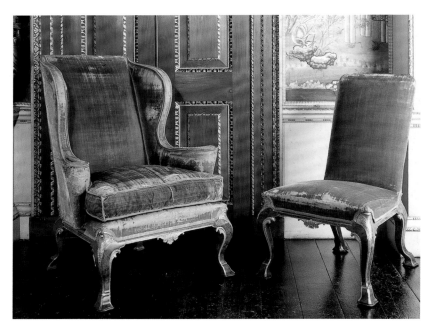

215. *One of the wing chairs and side chairs with walnut and parcel gilt frames and green velvet covers in the Needlework Bedroom and originally in the Cabinet Room at Houghton. Their close resemblance to the frames of seat furniture provided for Chicheley (Fig. 382) suggests that they were ordered for the rooms at Houghton.*

each end of the room that would have looked striking against the green velvet. Curtains and valances were included in the estimate for the velvet, but they were not listed in the 1745 inventory, the shutters again having carved and gilded mouldings.

If the balance has altered in the drawing-room, in the Green Velvet Bedroom (Fig. 213) there has been virtually no change. The room is dedicated to Venus, goddess of love and sleep, and that is expressed in the ceiling, the frieze, the tapestries, the green velvet and the design of the bed.

The ceiling, unlike those in the preceding rooms, is painted by Kent not in grisaille but in colours, albeit soft ones, evidently at Sir Robert's insistence. It shows *Aurora Rising*. The frieze takes up the idea of cupids' heads from the drawing-room, but here they are given wings and are repeated in the frieze of the chimneypiece, where the carved white marble is set against a bold black and yellow frame, creating a quite different balance from that in the drawing-room. The tapestries depict *The Love of Venus and Adonis* after Albano and were woven in Brussels. Walpole used much more tapestry at Houghton than might be expected today, but, although Gobelins tried to persuade him to buy tapestry from them, he made do with existing sets. The apparently gilded borders of the tapestries are echoed in the gilded carving of the doors, which repeat the pattern of those in the drawing-room (and continue round as far as the Cabinet Room, except for the different friezes of the doorcases in the following three rooms).

In Kent's green velvet bed there echoes of High Baroque decoration in Rome, but it is a much more sober design, following the simplification of silhouette that became fashionable in England in the second decade of the century, even if it is unusually architectural in its treatment. It consists of a canopy in the form of an entablature, with a deep gold fringe with bundles and fine gimp picking out the entablature. The frieze is ornamented with Apollo's sunflower, and the base of the bed is treated as architectural mouldings. The pedimented bedhead springs up into a double shell, making it into

Venus's triumphal car. But does its design also reflect the strongly architectural character of the original painting in the overmantel, Jean Le Maire's *Alexander Adorning the Tomb of Achilles*, which is the kind of allusion that a painter–decorator like Kent would have enjoyed?[40]

According to the estimate for the green velvet, 134¼ yards was needed in the bedroom, and the way the parts of the bed are described suggests that it was to be covered on the spot by the upholsterer who did the estimate – apparently Thomas Roberts. The real extravagance was in the trimmings and the way they are used. It is particularly interesting to see how the elements of the mouldings are treated, with the highlights and some faces emphasized, a worked equivalent of a wooden entablature painted green and parcel gilded, confirming the way mouldings are gilded in other rooms. Happily on this occasion Sir Robert failed to destroy the bill from the supplier of trimmings, Walter Turner, Richard Hill and Robert Pitter, who charged no less than £1,219 3s. 11d. in 1732.

With the bed are more of the side chairs of the design used in the drawing-room and with them a wing chair now in the Cabinet Room. The only other piece of furniture listed in the inventory was the oriental lacquer chest with the Walpole arms, one of several in principal bedrooms. Evidently furniture in natural wood was considered unsuitable for such rooms.

Similar principles of decoration follow on in the succeeding rooms of parade, first in what was called the Van Dyck Dressing-Room in the eighteenth century, because of its tapestries after early seventeenth-century full-length royal portraits woven by Francis Poyntz about 1675 and thought to have belonged to Sir Robert's father. It seems that Kent took the carved detail in the friezes of the doorcases from the tapestries.[41]

The needlework bed (Fig. 214) has hangings of English embroidery in an Indian style. The back cloth is a particularly fine design, with the embroidered motifs standing out against the creamy-white quilted ground and the mouldings outlined in light green braid. The curtains are worked with trees of life, flowers and birds and are lined in green silk to echo the colour of the braid. Given the presence of the Garter in the arms on the headcloth and on the cornice, it has been presumed that the bed was ordered after 1726 and that it came quickly, because it was ready for the Duke of Lorraine's visit in 1731. Recently, however, it has been noticed that the arms are an alteration and that stylistically the bed is more likely to date from 1715, so perhaps it was ordered as part of the alterations to the old house that Sir Robert carried out about that time. Why it was displaced is not recorded, but perhaps its oriental aspect was thought not formal enough to suit the scheme for the great rooms developed by Kent.[42]

The seat furniture in this room is the first part of a large set with frames of walnut and water gilt gesso and covered in more of the green velvet (Fig. 215). Their line is particularly good, but there has been some doubt as to their date: it has been suggested that they could have been made about 1715–20 and therefore possibly ordered for the old house and recovered for use here. More recently, Adam Bowett has suggested that the design is more typical of the 1720s, which would mean they were ordered for the new house. That appears to be supported by the very similar Chicheley seat furniture (Fig. 382), which was ordered for the Lady's Drawing-Room, whose fitting up was paid for in 1725.

Originally the room at the north-east corner of the house was to have been another bedroom, but so rapid was the growth of Sir

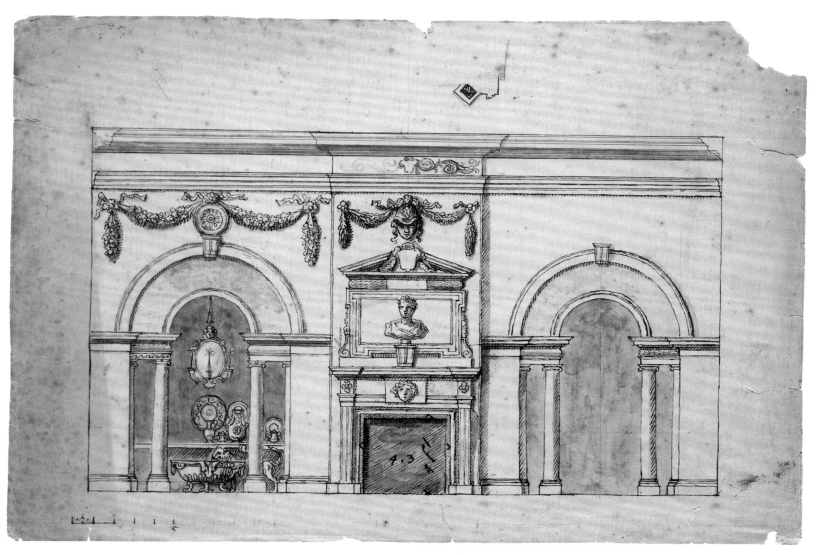

216. *One of William Kent's preliminary designs for the Marble Parlour based on a Venetian window motif with a predecessor to the overmantel relief by Rysbrack delivered in 1731. It also show an arrangement of historic plate and a sconce in the left hand recess. It was engraved without the plate in Ware's* Designs of Inigo Jones, *1731. Private collection.*

Robert's collection that he decided to make it into a major picture room, first as another drawing-room hung with green velvet for large Flemish pictures, two full-length and three half-length portraits by Van Dyck, and then in 1742 into a crowded cabinet for his smaller pictures. Proposed arrangements are shown in an exploded design by Kent in the Ashmolean Museum, which shows Rubens's *Meleager and Atlanta* cartoon filling much of the north hall, and in variant drawings by another and slightly later hand in the house. The overmantel, now filled with a looking-glass, was designed to frame Rubens's portrait of *Hélène Fourment,* there by 1736 when given to Van Dyck, (now in the Gulbenkian Museum, Lisbon). After the pictures were sold in 1779, the green velvet hangings were replaced by the present blue-ground Chinese wallpaper. The room contained more of the parcel-gilt walnut chairs.[43]

The last of the parade rooms is the Marble Parlour (Fig. 217), which is in many ways the most remarkable of all the interiors at Houghton. As has been said before, in the 1720s it was a novel idea to have a dining-room as part of the main run of rooms in a house, and it was Gibbs who first suggested the idea at Houghton, his plan (Fig. 188) showing access for servants from the landing of the north staircase behind the chimney breast. It is conceivable that the use of the order of Ionic pilasters in the room also goes back to him, because they appear in several of his rooms but rarely in Kent's. The latter's 1728 design for the room with arched openings and columns,

included in Ware's *Designs of Inigo Jones* of 1731, shows the recess filled with displays of plate (Fig. 216) that are omitted from the engraving.

If the use of marble in the Marble Parlour was Kent's idea, it is likely that the planning and selection of the materials may have owed a great deal to Rysbrack's expertise. The Ionic order is superbly expressed in different marbles, black for the skirting, black and yellow for the dado, with white for the mouldings and capitals and violet for the shafts of the columns. The west wall is lined with a white with grey veining, with slightly stronger veining on the chimney breast and different shades of white for the chimneypiece and overmantel. The sense of shadow in the recess is exaggerated by the marbles, white with grey veining for the walls, pilasters in violet and the string course in grey with yellow. The tables have more black veining in the legs as well as black feet, and violet with white for the frames. And what is surprising is that the marbles are even used for the two invisible doorcases that face each other behind the chimney breast.

It was at quite a late stage that it was decided to commission another overmantel relief from Rysbrack in a whiter white marble of a *Roman Sacrifice*, very similar to those at Clandon, together with a new chimneypiece. It was installed by Christopher Cass before 24 December 1733 in place of a great achievement of the Walpole arms that is shown in a design for the room.[44]

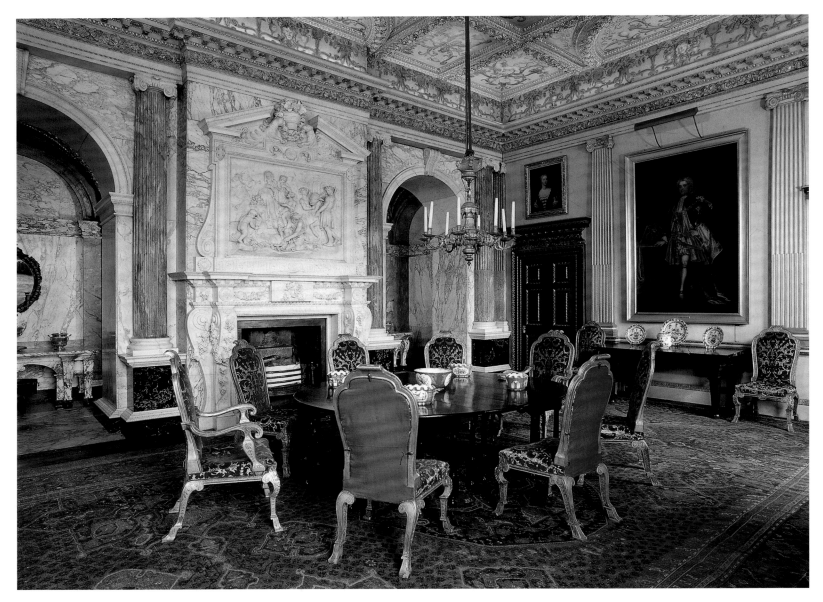

217. *Houghton Hall. The west and north walls of the Marble Parlour. The original concept relating to service in the room can be traced back to Gibbs's design (Fig. 188) but the planning and selection of the marbles for the order surely owed a great deal to* Rysbrack's expertise. Between the pilasters on the north and south walls in 1736 were large pictures by Guido Reni and Salvator Rosa.

Again, the original choice of pictures provided a key to the room. The 1736 list gives as Guido Reni's *Doctors of the Church*, which was regarded as one of the glories of the collection, and Salvator Rosa's *Prodigal Son* as the principal pictures between the pilasters on the north and south walls and sixteenth-century Venetian pictures as overdoors (Fig. 219), which with all the marble must have created a remarkable illusion of a palazzo in Venice in contrast to the Roman pictures in the drawing-room. But again that did not last long, because Sir Robert removed the principal ones about 1742 and replaced them with the two full-length Van Dycks of the Earl of Danby and Sir Thomas Wharton from the north-east corner room.

As might be expected in an eating room, Bacchic motifs occur not only in the painted panels of the ceiling, but in the ribs of the ceiling, the painted frieze above the entablature (Fig. 220) and in the entablature itself, and then below in the doorcases, the chimney-piece and overmantel, and they continue into the gilded pier-glass and table between the windows on the east wall. The painted frieze incorporates pieces of display plate probably inspired by sixteenth-

and seventeenth-century engravings of urns and vases that continued to fascinate collectors, or possibly by Fischer von Erlach's fantastic vases reissued in London in 1730.[45]

The ceiling is painted in stone colours, green, ochre and gold, so that the grapes and leaves read as green and gold; and this colour scheme continues down into the frieze, with the green originally answered in the upholstery of the chairs. On the ceiling beams the grapes are white and their stems and leaves are gilded, while in the frieze the finish is reversed, with the leaves left white but their spines and edges and the grapes gilded. The grapes, too, continue downwards into the chimneypiece, the friezes and the frames. Kent also knew how to economize: the carving below the dado rail, which is of a more elaborate pattern than in the other rooms, might be presumed to be gilded; but in fact it is painted ochre colour.

In 1745 the room was furnished with a marble table and a large pier-glass with sconces, which were part of Kent's contribution, and a settee and twelve armchairs, which are known from the 1792 inventory to be the set of gilded chairs with eagle arms and lion's

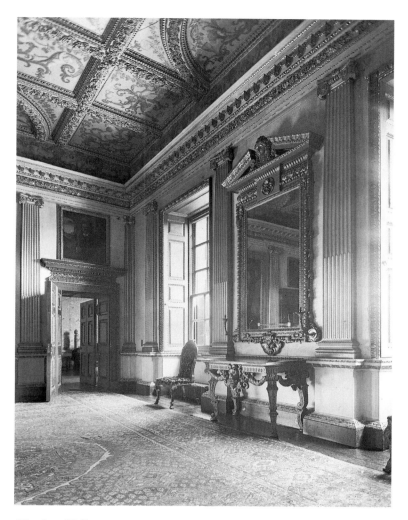

*Houghton Hall*

218. *The pier-glass and table in the Marble Parlour. Their ornament ties up with that in the doorcases, the entablature and on the ceiling.*

219. *Paris Bordone* Venus, Flora, Mars and Cupid. *It was one of four Venetian pictures that formed the original overdoors in the Marble Parlour.* The Hermitage Museum, St Petersburg.

220. *A section of the frieze in the Marble Parlour. Kent painted it with pieces of display plate probably inspired by earlier prints or Fischer von Erlach's fantastic vases.*

paw feet covered in green damask (Fig. 221). They appear to be the only known example of gilded chairs in a dining-room, but the existence of a settee with them suggests that they may have been made for a drawing-room rather than this room and then recovered. They were almost certainly not designed by Kent but produced by a chairmaker. However, it is not known who made them. They seem to be by a different hand from those in the drawing-room, although both sets have sand gilt grounds to throw up the carving.[46]

The room has never had curtains, and so the narrow architraves to the windows are carved and gilded, with the shutters folding back into the thickness of the wall and opening to revealing the mouldings of their panels carved and gilded. No carpet is mentioned in the 1745 inventory, but on the floor is a handsome Ushak that may well have been in use in Sir Robert's time. A French visitor, Jacques Serces, who visited the house in the 1740s, noted 'how richly cover'd are the floors in ye whole house with fine Turkey or Persian Carpets, not leaving room for a foot to step forward'.

There are two surprises in the inventories. There is no mention of

the big table that expands to 16 feet, but if this was ordered for the room, which seems likely, it would be the earliest of its type and scale known. It is not even listed outside the door. Second, there is the absence from the ends of the room of the pair of mahogany tables with black marble tops of a pattern only seen here and at Wolterton.

What is missing from the room is a full display of plate, great sideboard dishes and sets of waiters for glasses, and almost certainly an epergne for the table. Kent's earlier scheme (Fig. 216) shows the marble tables with displays of plate of different dates. Representations of plate at that date are exceedingly rare. The inventory specifies the silver cocks under the marble tables and a marble cistern, which are still there, but there is no evidence of Sir Robert having owned a silver cistern. In fact, very little of Sir Robert's dining plate survives apart from a pair of wine coolers of markedly French form by William Lukin dated 1716 (Fig. 222) in the Metropolitan Museum. There are also a few pieces close in date to the completion of the Marble Parlour, a cake basket by Lamerie of 1731–2, a pair of four-light candelabra by the same maker and of

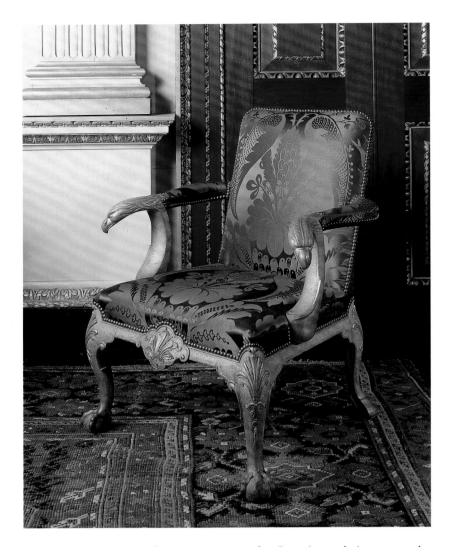

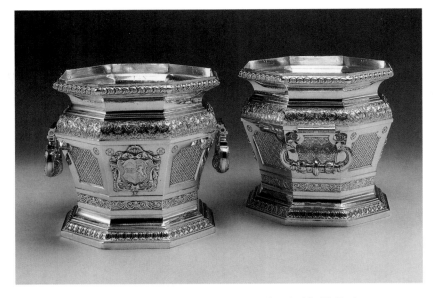

221. *One of the gilt chairs with eagle arms originally used in the Marble Parlour covered in a copy of the original green damask, a design known in wallpaper (Fig. 120). Like the chairs from the Green Drawing-Room, they have sand-gilt grounds.*

222. *One of a pair of French-style silver wine coolers by William Lukin, 1716. One of Sir Robert's early purchases of plate.* Metropolitan Museum of Art, New York.

the same year, and two tureens, one by Crespin made in 1733 and a second made to match it by Wickes in 1738.[47]

Kent also designed the fitting-up of the rooms intended for family occupation at the south end of the house, and of these the most highly wrought are Sir Robert's study or library and his bedroom next door. In the study (Fig. 223), which makes an interesting comparison with the design for the dining-room at Wotton, each wall is treated like a Venetian window, which is how it appears to be lit when seen from outside. Within, however, only the central sections of the windows below the arched heads are glazed, with the side sections treated as bookshelves. On the north wall the centre of the Venetian feature is the overmantel with the full-length portrait of George I in its splendid frame by Kent, and on the west wall it is filled with bookshelves. The framing of each arch projects slightly and contains shelves down to the dado and there is a bracket on top, presumably for a small bronze. On the west and north walls there are pairs of matching doors, one of each being real and the other hiding shelves, and over them are pairs of framed 'overdoors' that consist of a single row of books, and these are repeated above in the area between the secondary and main cornices. The outer east and south walls are panelled between the dado and cornice, with carved mouldings matching the overdoors framing bookshelves, while the plain panelling of the dado hides more shelves. The chimneypiece is of purple marble with a carved white statuary marble frieze.[48]

On a single visit to the house it is hard to take in the subtlety of Sir Robert's considerably lower bedroom (Fig. 224) next door, although it is immediately striking that this appears to be the only bedroom in existence with a complete order as opposed to a screen

of columns. It is only if one is fortunate to sleep in it that the complexity of the Ionic order gradually becomes apparent and gives an uncanny sense of Kent creating a room for a patron who shared his pleasure in the subtleties of classical architecture. On the north wall a screen of Ionic pillars frames the space for the bed, with curved walls incorporating curved doors (with brass locks made on matching curves) leading into the two closets. The order on the east and west walls disguises the changing planes of the walls in the bays, first the matching recessions for the two doors and then a slightly deeper recession on the west wall, with one large panel that drops below where the dado rail would normally be and that faces the chimneybreast that advances to just behind the order. On the south, window wall, there are a pair of shallow pilasters flanking the window, with a suggestion of two more in the corners lying behind the pilasters that relate to the side walls.

Only at Houghton is it possible to see so clearly how planning, use, decoration and furnishing could be so fully worked out in the first half of the eighteenth century, and, although the pictures have gone, the evidence in the *Aedes Walpolianae* and other manuscript picture lists shows what a dominating role the pictures had in the decoration. Today that can only be sensed at Holkham, where the final balance in the parade rooms was worked out in the 1750s, but those rooms date from after William Kent's death and there is an avoidance of decorative painting: they are the rooms created for an architecturally minded collector. At Houghton, on the other hand, a painter–decorator was working closely with a picture collector. Perhaps nowhere else was there quite that situation, and while Houghton is full of lessons for the period, it was probably always unique.

*Houghton Hall*

223. *Sir Robert Walpole's Library at the south-east corner of the house. All four walls are based on a Venetian window motif. In the foreground can be seen the desk adapted from a French design. The portrait of George I was given by him to Sir Robert who placed it in a splendid Kent frame.*

224. *Sir Robert Walpole's bedroom designed with a complete order and panelled in mahogany as it was in 1921. His bed of Chinese taffeta stood in the recess between the Ionic pillars with closets to left and right. The marble bath and panelling were a recent change.*

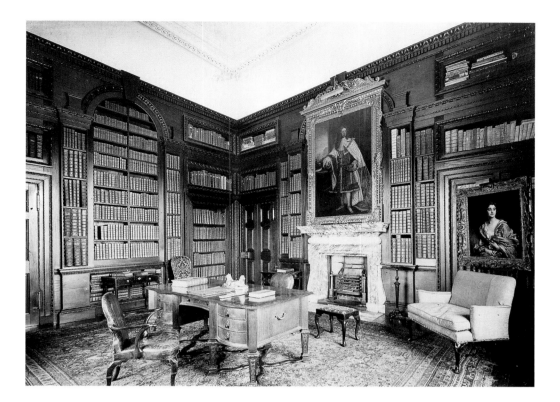

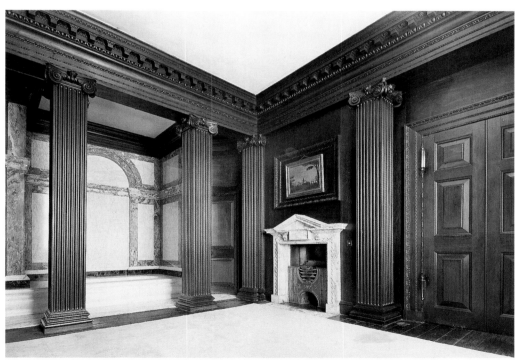

## THE VARIETY OF KENT'S WORK AS A DECORATOR

William Kent's approach to decoration and architecture through painting explains his freedom and variety, but almost always his schemes only survive in part and so the essential unity has been lost. Often rooms have lost their hangings, their pictures or their furniture as well as their original finishes, so only the bones survive — ceilings, chimneypieces and architectural woodwork. That means it is a case of attempting to recreate a complete equation by putting together disparate elements. The often witty doodles that appear so unexpectedly on Kent's drawings suggest that he had a compulsive imagination and could flit naturally from classical ideas to chinoiserie or gothick fantasies to suit his clients and his friends.

It is revealing to compare Kent's work at Houghton with his contemporary architectural decoration at Raynham, a few miles away and the home of Sir Robert's brother-in-law, the 2nd Viscount Townshend. Their owners' intentions seem to have been quite different. It is as if Lord Townsend, who, having split with Sir Robert, decided not to challenge him and quite consciously close to stress his family's deep roots in Norfolk and Raynham's continuity from the age of Charles I and Inigo Jones. As we have seen, Ripley began work in 1724, and by the end of 1726 payments were made in connection with the interior. Mansfield as plasterer appears at the end of that year; Richards as carver at the end of 1727; and Knot as painter in June 1728. Nowhere does Kent's name appear among those paid, and Lord Townshend must have dealt with him directly.

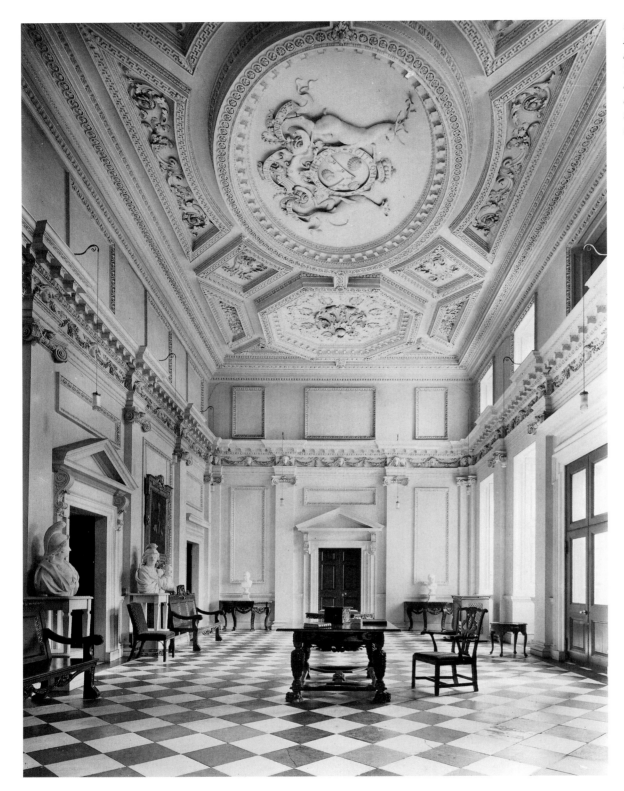

However, for Kent the commission must have had a special resonance because the house was then believed to be entirely by Inigo Jones. When Sir Matthew Decker visited it in 1728, he noted: 'within very much beautifyed, with which they were actually now at work, and for that reason were the whole apartments below stairs unfurnished'. The hall (Fig. 225) was 'finely finished', and so was the Belisarius Room with its picture by Salvator Rosa in its 'most costly gilded frame' by Kent (now at Renishaw Hall, Derbyshire).[49]

The main evidence for the fitting-up of the house comes in the detailed bill for carving amounting to £820 drawn up by Richards in 1730. It gives an unusual insight into the role and costs of overmantels, applied ornaments and architectural furniture, underlining Kent's facility as an ornamentalist. So it is frustrating to have no drawings or sketches by him to show how he relied on the experience of Richards to carry out his ideas. The account starts by listing carved architectural detail and then goes on to list extra ornaments, but does not include painting or gilding or the costs of looking-glass. In the Common Eating Room the tabernacle frame between the windows on the west wall cost £4 13s. 6d., and the pair of sconces on the north wall £8 1s. 0d. In the adjoining drawing-room the four carved ornaments over the doors cost £7 16s. 6d. .[50]

It is unknown what the hall was like before it was refitted by Kent, but presumably he did not alter its proportions. He designed it to appear as a room a storey and a half high, with an order of

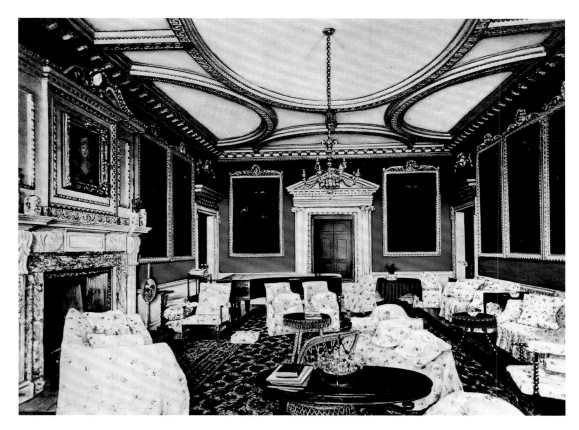

226. *The Red Saloon, Raynham, as it was about 1875–80. William Kent decorated the room round a set of seventeenth-century full-length portraits known as the Vere Captains, whose martial character he echoed in the carved helmets in the frieze that still survive. The pictures were sold in 1921.*

227. *A portrait called Sir Thomas Dutton. One of the early seventeenth-century Vere Captains from the Red Saloon at Raynham.* The National Trust, Lodge Park, Gloucestershire.

Ionic pilasters, a complete entablature and an attic storey above carrying a great beamed ceiling with the Townshend arms in the centre flanked by octagons with central roses that look as if they were intended for lanterns. Mansfield was in charge of the plasterwork and was paid £743 for work between 1726 and 1731, unusually working with Bagutti, who was paid £47 in December 1727, conceivably for the enrichments of this ceiling, including the arms that recall the Walpole arms by Artari in the hall at Houghton (Fig. 193). At each end are pedimented doorcases and a third is aligned on the front door, with unpedimented doorcases flanking it. The walls in both storeys are panelled in plaster, but there is no chimneypiece and overmantel and no sculptural reliefs. Richards charged £22 10s. for the four tables, but there is no mention of the pair of carved settees.

Through the central door lies the single-storey Red Saloon, which was converted out of the seventeenth-century chapel and decorated round a famous set of twelve seventeenth-century full-length portraits known as the Vere Captains, which the Townshends had inherited. Kent presumably devised and Richards made the frames for them with laurel branches and helmets in the frieze above them and, although the pictures and frames have gone, the helmets remain as part of the architectural decoration of the room. An old tinted photograph (Fig. 226) shows the pictures hung very close together and the walls red in tone as if they were damask, but that gives no real sense of how dramatic and colourful the effect must have been. That is brought to life by one of the Vere Captains, the early seventeenth-century portrait called Sir Thomas Dutton (Fig. 227) that now hangs in the Entrance Hall at Lodge Park,

Gloucestershire. To what extent Kent was having to make do with the pictures that Lord Townshend owned or making a definite point is hard to decide, but it seems to be a deliberately British contrast to the European character of the saloon at Houghton (Fig. 194). Kent also designed a new overmantel to sit on the seventeenth-century chimneypiece, treating it as a chimneybreast in three parts with a scrolled and broken pediment on the centre part only, to disguise the lack of height in the room. Richards charged £5 3s. 7d. for that. He also charged £10 5s. for the two small table frames with Bacchus's heads for the window piers, but the related tabernacle glasses have disappeared.[51]

Of the other ground-floor rooms, the most interesting today is the dining-room (Fig. 228), with its triumphal arch that disguised the service entrance to the room while providing a frame for plate arranged on the table against the wall, surely a development of the idea of the Marble Parlour at Houghton and Lord Burlington's rather different use of a triumphal arch in the hall at Northwick Park, Gloucestershire. There is no mention of the screen in Richards's account, but the overmantel frame cost £7 7s. 4d. with 14s. 6d. extra for the festoons; the tabernacle £3 19s. 9d. plus extra and the table originally below it but now to the right of the chimneypiece £9 11s. 6d.; the three ornaments in the panels over the doors behind the screen cost £5 14s. 9d. and the pair in the main part of the room £4 17s.; the table frame behind the screen cost £12 13s. 6d.

Kent also partly redecorated the Great Dining-Room or Belisarius Room on the first floor whose character was already set by its massive seventeenth-century ceiling. He devised a painting scheme

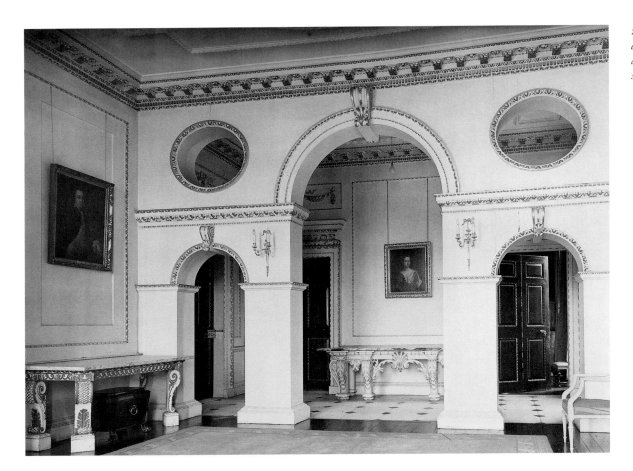

228. *Raynham, the triumphal arch in the dining-room that frames the side table for a display of plate and also hiding the service doors.*

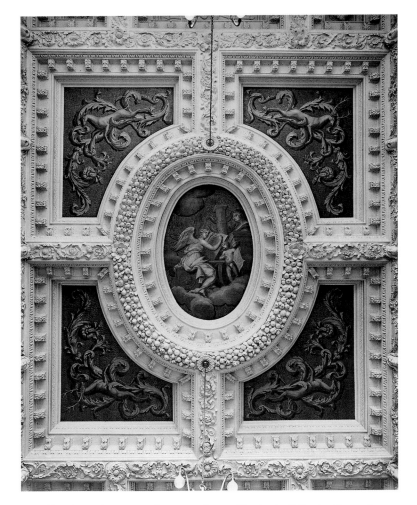

229. *Raynham, the seventeenth-century plaster ceiling in the Belisarius Room, the original Great Dining Room on the first floor, with decorative painting added by William Kent, a central oval dedicated to Inigo Jones, then assumed to be the architect of the house, and the Townshend supporters in the spandrels.*

for it (Fig. 229), with a central roundel with a dedication to Inigo Jones set against a painted mosaic ground, with the Townshend supporters and acanthus foliage set against more mosaic in the four corner sections. He also added a classical frieze. To pull the room together, he designed a particularly bold marble chimneypiece to support a portrait of the wife of the original builder in a special frame. Since the sale of contents in 1921, the walls and ceiling have not pulled together, but Kent almost certainly devised an arrangement of full-length portraits in architrave frames as well as the Salvator Rosa of *Belisarius* that would have created a strong pattern, as can be seen from one round a portrait in the National Portrait Gallery. Perhaps they would have been seen against a bold figured wallpaper like the one in the Privy Council Offices and existing at Christchurch Mansion (Fig. 120) and Clandon (Fig. 121).

In 1732 Kent received a commission to design a barge for Frederick, Prince of Wales. It was a marvellous opportunity to draw on his experience of designing ornament, furniture, interiors and garden buildings over the previous eight to ten years and produce a richly carved and gilded confection with a prow and stern as fanciful as any state coach. It was carved by John Boson.[52]

Kent's drawing for the stern, which can be seen in the engraving by Vardy (Fig. 230) published in 1744, leads on to the two pairs of carved and gilded sconces in the Ballroom at Knole (Fig. 231), which may have come from the 1st Duke of Dorset's London house, on which Kent may have worked round about 1730. Although undocumented, they are so imaginative in their design and their play with heraldry and so ingenious in the way the once bright oil gilt ornament stands out against sand gilt grounds that it is tempting to attribute them to Kent. The back plates hang on a ring from a leopard's head, the Sackville crest, and they centre on

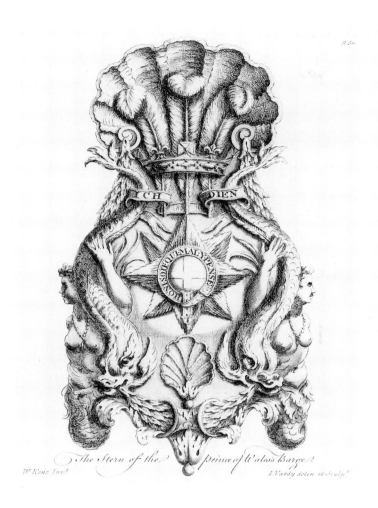

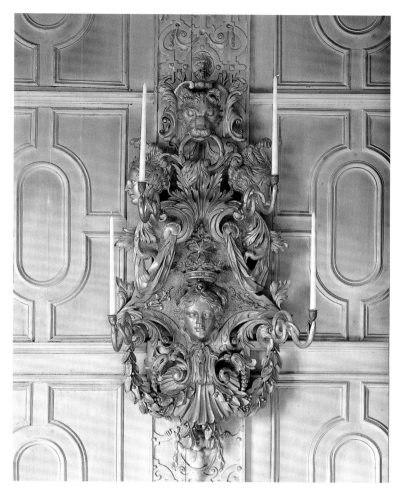

Apollo's head beneath a duke's coronet topped by the Dorset star with carved scrolls leading into four curling metal snakes that carry candles. That they were conceived as pairs can be seen from the way the leaves curl in different directions from the rings.[53]

Those sconces lead on to other Kentian pieces at Knole, in particular the spectacular frame round the painting by John Wootton commemorating the 1st Duke's appointment as Lord Warden of the Cinque Ports in 1727. This has a broken pediment formed by the Sackville leopards and incorporates the Sackville *vain*, stylized heraldic representations of squirrel skins as the border to the inner frame.[54]

Neither Kensington nor Houghton had given Kent opportunities to explore sequences of varied spaces such as Lord Burlington had pursued at Chiswick in the mid-1720s, and the first evidence of his interest in that aspect of planning occurs in the early 1730s. It appears in his additions to Esher Place, where the outlines of the original Tudor towers of the gatehouse were carried through into the planning of the rooms (Fig. 232); his Hermitage for the Queen at Richmond; and in the Temple of Venus at Stowe, where before 1731 he designed the central block with a screen of columns with an apse behind and also curved arcades to flanking pavilions.[55]

At what point Kent became involved with the concept of the house as opposed to the landscape at Holkham is hard to say, but the steps in his own career suggest that it was unlikely to have happened much before 1730–1 and may even be as late as 1733–4. Thus, he may not have played a significant role in the first project or even with the concept of the second with its four flanking wings (Fig. 437). Coke had strong ideas of his own that were akin to those of Lord Burlington. Indeed, the concept of the hall may have been derived from his admiration for the Temple of Venus and Roma as

230. *The stern of Frederick Prince of Wales's barge designed by Kent in 1732 and carved by John Boson, as engraved in John Vardy's* Some Designs of Mr Inigo Jones and Mr William Kent, *1744.*

231. *One from two pairs of carved sconces with a Duke's coronet at Knole. They may have been designed by Kent for the 1st Duke of Dorset's London house, about 1730. The star is a Sackville crest. Originally the bright gilt ornament stood out against the sand gilt ground.* The National Trust, Knole.

232. *The elevation and plan of Esher Place, Surrey. Vardy's engraving shows how Kent added wings on to the Tudor gatehouse and the way its towers suggested rooms of different shapes and with canted bays.*

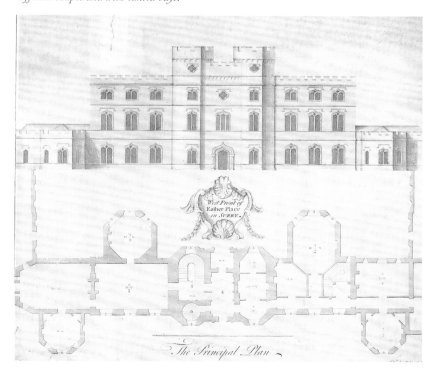

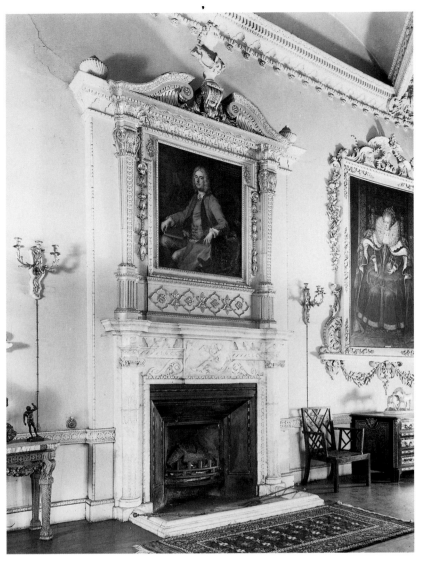

233. *The chimneypiece and overmantel with gothick detail in the library at Rousham, now the drawing-room, with Van Loo's portrait of General Dormer. Like the library at Newhailes, it was a double-height room and the Great Room of the house.*

for Thomas Coke's own use, not surprisingly later generations have made it into the favourite sitting-room of the house. It has five windows, three looking west towards the lake and one south over the park towards the obelisk, with one north on to the Strangers' Wing. The spaces between the west windows are broader than usual, because they take breakfront bookcases that match the pair flanking the chimneypiece; and there are more straight-topped bookcases beyond the doors and flanking the windows on the end walls. The chimneypiece is in white with yellow marble, which tones so well with the bindings, and it has a carved and gilt overmantel now containing a classical mosaic. Whether there was originally so much architectural gilding is hard to say, but it seems that the upholstery was in black leather, because now elsewhere in the house are a settee with particularly good lines and two patterns of armchair that could have come from the room.

The variety of the ceilings in the wing is a constant source of pleasure, and so it is regrettable, if to be expected, that subsequent Lady Leicesters have made a few changes to their own rooms. The second most important room in the wing was Lady Leicester's dressing-room, whose three central windows have a southward view over the park to the obelisk. According to Brettingham's book, 'The Statuary Marble Chimney-Piece, ceiling, Soffas, Chairs, Table Frames and two Pier Glasses, were all executed from designs of Mr Kent'. The room was first hung with green damask in 1740 (since replaced), but the original overmantel with an oval opening for a picture (now in the Strangers' Wing) has been changed for one with the Canaletto view of Venice originally in Lady Leicester's Bedroom. Tantalizingly, none of the furniture can be identified, although among the candidates for the seat furniture are two sets in the house . Lady Leicester's Bedroom was originally hung with Vanderbank tapestry of *The Loves of the Gods* after Albano, the same subject as the tapestries in the Green Velvet Bedroom at Houghton, with two overdoor pieces added by Bradshaw; but these are now in the Strangers' Wing. In her closet was the large Francesco Bartoli drawing of her husband and Dr Hobart in the church of the Gesù in Rome (Fig. 435) that is such surprising evidence of the young man's taste for Baroque architecture, and the walls were crowded with drawings, small pictures and miniatures.[57]

If Queen Caroline's library at St James's Palace had been built according to the design dated 1735 in Sir John Soane's Museum, it would have been the most complex architectural interior designed by Kent and unrivalled in the first half of the century. It was to be divided into three bays by four pairs of free-standing columns that supported cross vaults, an idea surely taken from a Roman bath. On one long side there were to be Venetian windows and they were to be reflected in a matching arrangement set in shallow curved recesses that were presumably to be shelved, as in the study at Houghton (Fig. 223); and there were to be chimneypieces at each end. According to the plate in Pyne's *Royal Residences*, which shows the room before it was demolished in 1825, the Roman vault was given up. Instead, all four walls were treated as arcades, five bays on the long sides and two bays flanking the central chimneypieces on the end walls, with a deep cove to the ceiling and a Jonesian system

illustrated by Palladio, as can be seen in Brettingham's earliest surviving plan of about 1726, which indicates most of the ideas seen in Kent's undated drawing (Fig. 442). That shows it as a square with a Corinthian order on a high basement and horseshoe stairs, which was almost certainly an idea of Coke's taken from the original late seventeenth-century staircase in the Painted Hall at Chatsworth (Fig. 18). Kent would also have known of Lord Burlington's richly columned hall at the York Assembly Rooms. But is there another, intriguing influence here, Sir Edward Lovett Pearce's Houses of Parliament in Dublin that started to rise in 1729?. It is hard to believe that architectural *cognoscenti* in London were not aware of that unique project in Europe. So was Kent – or Coke and Kent – influenced by the now lost Dublin House of Commons, with its octagon of columns on a high base encircling the floor of the house, and by the surviving House of Lords with its echoes of Ancient Rome in its shallow barrel vault and great apse?[56]

Kent was more involved with the design of the main rooms in the Family Wing, especially the ceilings, chimneypieces and overmantels. His design for the library (Fig. 439) shows not only the bookcases but painted decoration in the cove, which was not carried out. It is one of his most successful rooms, and, although conceived

234. *No. 44 Berkeley Square, London, designed for Lady Isabella Finch in the early 1740s. Sir John Soane's lecture illustration of the complete design of the staircase at 44 Berkeley Square from the first flight to the ceiling. Sir John Soane's Museum.*

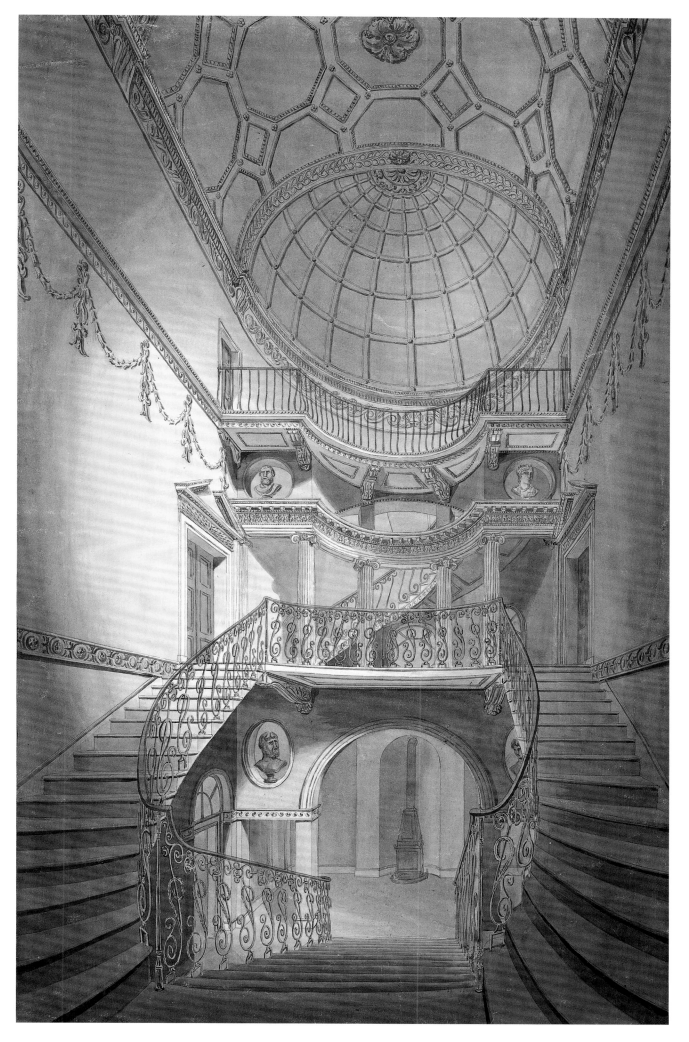

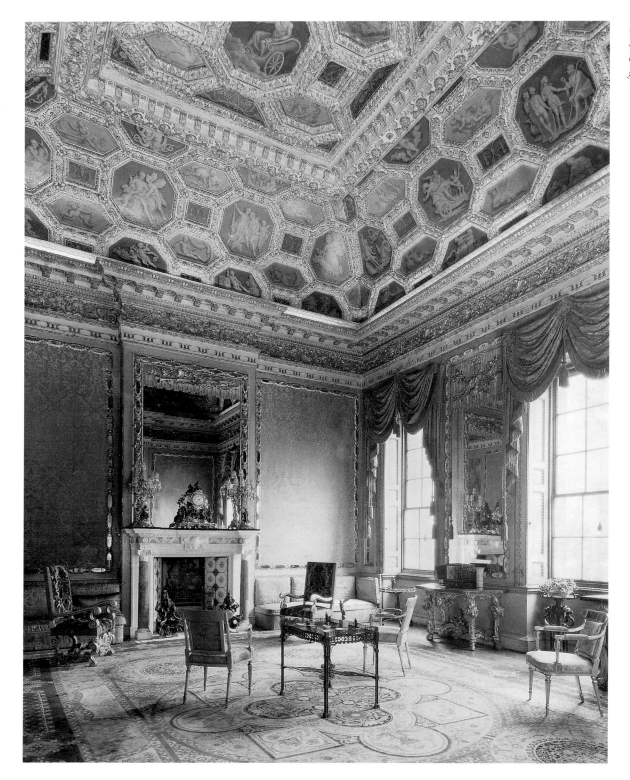

235. *The Great Room at 44 Berkeley Square with its richly gilded and mosaic ceiling painted in grisaille on coloured grounds.*

of beams in the centre. On one long side there were five windows set behind the arches and each of these appears to have been flanked by narrow presses with doors. On the facing wall the bookcases were also closed presses.[58]

In considering Kent's work as a designer of interiors it is tempting to separate his gothick from his classical building and to relate his gothick interiors to the broader history of the gothick revival, but that breaks the flow of his work and disguises how one influenced each other. What may be the first sign of his historical enthusiasm and interest in the Middle Ages are the three paintings with medieval subjects that he painted for Queen Caroline in about 1730–1, *The Battle of Agincourt*, *The Meeting of Henry V with the Queen of France* and *The Marriage of Henry V.*[59]

His first use of the gothick style seems to have been at Hampton Court Palace. According to Horace Walpole, that came about at the suggestion of Sir Robert and occurred when he restored the inner gatehouse of the Clock Court in 1732 as part of his alterations for the young Duke of Cumberland, the favourite son of George II and Queen Caroline. The first-floor room over the gateway is the Duke's dining-room, whose ceiling may be Kent's earliest essay in the free gothic manner and is the precursor of the ceiling in the library at Rousham. The design is puzzling, but makes sense when it is seen as being based on ceilings surviving in Cardinal Wolsey's rooms in the Palace. The structural work was probably finished by 1736, because the furnishing account runs from 1736 to 1737.[60]

That commission overlapped with his restoration and extension

of Esher Place, Surrey, the brick gate tower surviving from the house Bishop Waynflete built about 1480. That had been bought in 1729 by Henry Pelham, the brother of the Duke of Newcastle, who owned Claremont, the neighbouring place on the hill. First Kent proposed a new classical villa on a hill in the manner of a seventeenth-century landscape drawing, perhaps his first sketch for a country house, but then, apparently inspired by working at Hampton Court, he showed how to add on to the gate tower instead (Fig. 232).[61]

After considering more complex additions, he built three-bay wings on each side and gave the gate tower lead cupolas like those on the gatehouse of St James's Palace. On the river front the wings terminated in single-storey pavilions with canted bays reflecting those on the gate tower; and on the east front he gave the wings three-storeyed canted bays. It was as if he, like Vanbrugh, had absorbed the movement of Elizabethan architecture and then combined it with the internal spatial complexity that Lord Burlington had explored at Chiswick. Although the wings have gone and little trace of his decoration survives, the engraved plan shows rooms with complex shapes, rectangles with one or two canted bays and octagons, shapes that seem to grow out of the old building with its towers and at the same time anticipate plans of the 1740s and 50s.

Horace Walpole greatly admired what Kent did at Esher Place. In 1748 he wrote to Horace Mann: 'Esher I have seen again twice and prefer it to all villas . . . Kent is Kentissime there.' On the other hand, in 1754 Gray wrote to Wharton: 'you do not say enough of Esher. It is my other favourite place. it was a Villa of Cardinal Wolsey's, of whch nothing but a part of the Gateway remain'd, Mr Kent supplied the rest, but I think with you, that he had not read the Gothic Classicks with taste or attention. he introduced a mix'd Style, wch now goes by the name of the *Batty Langley* manner'.[62]

Kent's attitude to an old house can now best be seen at Rousham (Fig. 233) in Oxfordshire, where about 1738–40 he altered the Jacobean manor house for General Dormer and added on wings with canted bays. Within, he formed two important rooms, the classical parlour with a painted grotesque ceiling and the library-cum-great-room in the gothick style. The latter has lost its bookcases and its walls are now lined with portraits framed in sumptuous plaster frames done by Thomas Roberts of Oxford about 1765 when the books were sold and the room became a drawing-room. What survives is the form of the room, its chimneypiece and overmantel and the curious ceiling with its cross ribs resting on the gothick cornice and supporting a kind of vaulting. The marble chimneypiece supports a gilded overmantel framing the portrait of the room's creator, General James Dormer, by Van Loo.[63]

Vardy included three other plates of Kent's gothick work in *Some Designs of Mr Inigo Jones and Mr William Kent*: the screen to the courts at Westminster Hall of 1739, the screen at Gloucester Cathedral of 1741 and the pulpit at York. These must have had a considerable influence on Rococo gothic and the two-dimensional character of gothick work for the rest of the century. However, by 1753 the work at Gloucester did not win the approval of Horace Walpole, who was becoming more involved with gothick design through working on his library at Strawberry Hill (Fig. 92): Kent 'knew no more there than he did anywhere else how to enter into the true Gothic taste'.[64]

In the early 1740s Kent designed a miniature palazzo for Lady Isabella Finch on the west side of Berkeley Square that is one of his most brilliant creations. It is also one of his most tantalizing, because no one knows how the commission came about. Lady Isabella was a well-connected but presumably not well endowed spinster who served at court as a lady-in-waiting to two of the unmarried daughters of George II. Evidently she was a close friend of Kent, because he remembered her in his will. The most striking feature of the house is the masterly staircase (Fig. 234) that grew out of the original design for the hall at Holkham (Fig. 442): it starts as a single flight and then divides into two curving arms that climb to the first floor where the curve is answered by a screen of columns with a concave centre. Behind that can be glimpsed a single flight curling up rather steeply to the second floor and to the balcony that projects out over the screen. The curves are answered by the design of the balustrade with its scrolls and overlapping gilded scrolls, a marvellous pattern that was borrowed for use at Milton near Peterborough and at Holkham. No wonder Horace Walpole called the staircase 'as beautiful a piece of scenery, and considering the space, of art, as can be imagined'.[65]

Kent designed two other fine London interiors in the 1740s, the saloons at 44 Berkeley Square (Fig. 235) and 22 Arlington Street, the latter for Henry Pelham, who succeeded Sir Robert Walpole as Prime Minister. The Saloon at No. 44 is a rectangle with only a slight break in one end wall for a shallow chimney breast, and it is made into a thrilling room by its deep cove and ceiling so glowing in gold and dark colours that it takes time to read the complex pattern of octagons, hexagons and rectangles and the cameos with them on the bed of the ceiling and continued into the cove.[66]

The Great Room at 22 Arlington Street dates from a few years later, building having begun in 1747, but it was not completed until 1750, by which time Kent was dead and his assistant Stephen Wright was in charge. The plan of the room is more elaborate than that at No. 44, because it is on a cross, but with an extra projecting bay on its west side and a slight projection in the facing wall for the main doorcase. From the entablature springs an even more complex ceiling that is further elaborated by the pattern of the red, blue and green grounds to the grisaille figurative paintings in the panels.

Nothing as intensely decorated as these two ceilings exists in a country-house interior, and perhaps they should be seen as being in a distinctively metropolitan style.

By the time Henry Pelham died and the inventory of No. 22 was made in 1754, the room had crimson damask hangings and twelve mahogany carved and gilt chairs covered with damask, three stools, a large Persian carpet, a pair of gilt tables with granite slabs and glasses over them, and a glass lustre hung with silk lines and tassels. The complete contents were valued at £865 11s., which was much more than the drawing-room (£291 8s.) and the Dining Parlour (£125 16s. 6d.), the only rooms whose contents were valued at more than £100.

In the mid-1740s, Kent designed Wakefield Lodge as a hunting box for the 2nd Duke of Grafton, who founded the Grafton Hunt about 1750. The Duke, who as Lord Chamberlain to George I and George II had been involved with Kent at Kensington, got him to design the dining-room illustrated in Ware's book in 1731. He also contemplated getting Kent to build a new house at Euston in Suffolk in the early 1740s, as well as remodelling the landscape. That project came to nought, and instead Brettingham remodelled the seventeenth-century house. No records survive for Wakefield Lodge, but it was probably complete by the time Kent died in 1748,

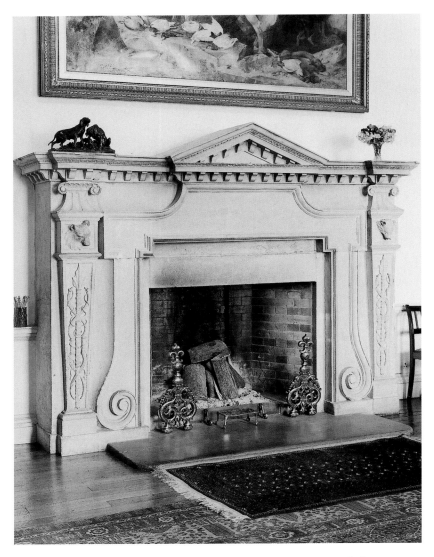

236. *The stone chimneypiece with heads of a fox and a badger in the hall at Wakefield Lodge, Northamptonshire, a hunting box designed by Kent for the 2nd Duke of Grafton in the mid 1740s.*

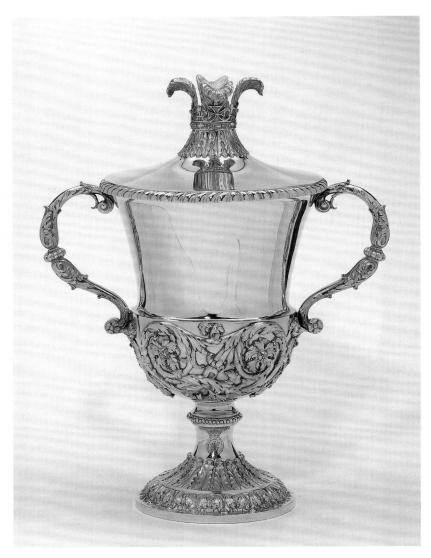

237. *The Pelham cup. Of gold and 11 inches high it was designed by William Kent and made by George Wickes in 1736 for presentation to Frederick Prince of Wales. On loan to the Victoria and Albert Museum.*

because Horace Walpole wrote to George Montagu in 1751 that 'the design is Kent's, but, as was his manner too heavy'.[67]

The main room is a double-height central hall with a gallery at first-floor level that was clearly modelled on that at the Queen's House, with a chimneypiece characteristically enlivened with a fox's head and a badger's head that recall the doodles that often appear in the corners of his serious drawings (Fig. 236).

Plate is usually regarded only as a side line in Kent's work, but it may be more significant than has been recognized. His interest first appears in the decorative tailpieces that he did for the 1725 edition of *The Odyssey* and then in the painted frieze of the Marble Parlour at Houghton (Fig. 220) in the early 1730s. Evidently he was fascinated by the complex forms of mannerist plate that was still collected, and he must have looked carefully at the ornament used by silversmiths; so it is interesting that he envisaged old plate in the recesses in his design for the Marble Parlour (Fig. 216).[68]

Leaving aside his gothic inkstand for Queen Caroline's Hermit's Cave at Richmond (Fig. 162), he does not seem to have started to design plate that was made until 1736, the year he became Deputy Surveyor to the Board of Works and George Wickes became Gold-

smith to the King and Prince of Wales. Then he designed and Wickes made a gold cup 11 inches high at a cost of £301 1s. for Colonel Pelham to give to the Prince of Wales (Fig. 237). About the same time he designed a large silver chandelier for the King, and five were made in 1737 by the Hanoverian goldsmith, Balthasar Friederich Behrens for Herrenhausen 'after a model sent from England'. Most of the elements of which the chandeliers are composed can be identified in Kent's designs in other materials: the sphinx heads appear in tables, the candleholders in the sconces at Houghton, while the putti appear in that house in paint, plaster and carved wood, and the double shells verge on being his hallmark. But, as always, he combined the elements to create an original and striking effect.[69]

In 1741 he designed a candlestick of which four were made in 1741–2 by Crespin: these were evidently bought by the 5th Earl of Carlisle in 1790 and remain at Castle Howard. There is also a silver mug based on an alternative design for Colonel Pelham, an epergne made by Wickes for Frederick, Prince of Wales and a splendid pair of tureens made for Lord Montford. Vardy illustrated all five in his book in 1744.[70]

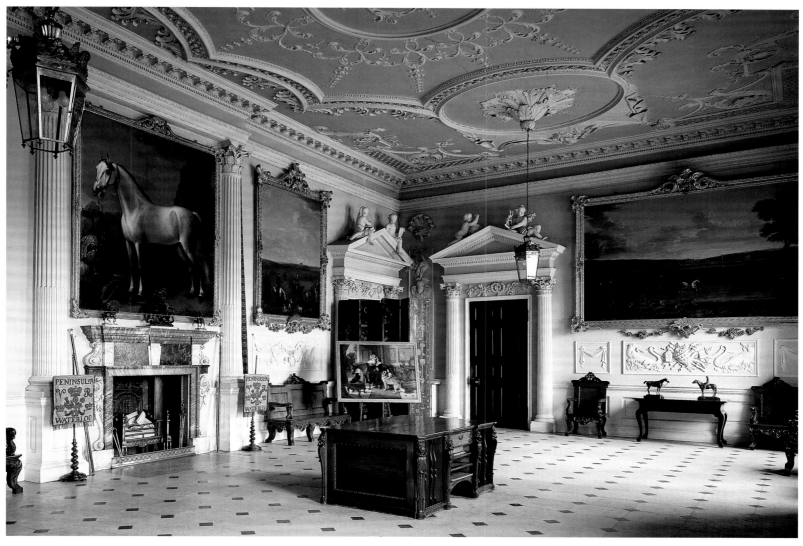

238. *The Hall at Badminton. Long attributed to William Kent, it is now seen as an interior designed for the 3rd Duke of Beaufort by James Gibbs about 1740 and fitted up by Francis Smith. It is the setting for a series of sporting pictures by John Wootton,* *the first of which is dated 1734 and the last 1744. The picture frames are attributed to John Boson. The room was presumably completed shortly before the Duke's death in 1744/5.*

### THE INFLUENCE OF KENT

It is still not always easy to separate the work of Kent from that of his fellow designers, and even on occasion his longer-standing rival James Gibbs. That is to be seen in the interpretation of the entrance hall at Badminton (Fig. 238), long attributed to Kent but now seen as an interior by Gibbs of about 1740. What also contributes to the complexity of the picture is his relationship with favourite artists and craftsmen, most of whom he collaborated with through the Office of Works. Yet another element is his indirect influence through the publication of his designs, first in his *Designs of Inigo Jones* in 1727, then in Ware's book of 1731, in Ware's *Houghton* of 1735 and finally in Vardy's *Some Designs of Mr Inigo Jones and Mr William Kent* in 1744.[71]

Kent's influence also spread through architects who worked with him, in particular Henry Flitcroft (1697–1769), Stephen Wright (first recorded 1746, died 1780) and John Vardy (1718–65). Flitcroft, although overshadowed by him, was a distinctive designer in his own right: by 1720, soon after he had completed his apprenticeship, he became Lord Burlington's assistant and draftsman; and it is easy

to see why a number of patrons went to him rather than to Kent, because his work was less dominating. Flitcroft's pier-tables seem to have been particularly admired, as can be seen with the Ditchley design (Fig. 390), in which Lock seems to have been involved and of which there are several other versions, at Wimpole and formerly at St Giles's House, in both of which Flitcroft was involved in the 1740s, at Shugborough and formerly at St Giles's House.

Stephen Wright only emerges as a definite figure in 1746, when he became Clerk of Works at Hampton Court Palace, but he may have worked for Kent since at least the late 1730s. He was left £50 in Kent's will. He completed 22 Arlington Street for Henry Pelham after Kent's death and worked on Worcester Lodge at the entrance to the park at Badminton, aligned on the centre of the great house three miles away. It seems that about 1746–7 Kent did little more than add the pediment and wooden cupolas to the roof of the big house for the 4th Duke of Beaufort and then began on Worcester Lodge. However, he died before the project had gone very far, and the splendid room on the first floor appears to be entirely by Wright. A storey and a half high, with tall round-headed windows on each side giving great views over the park and towards open country, it is

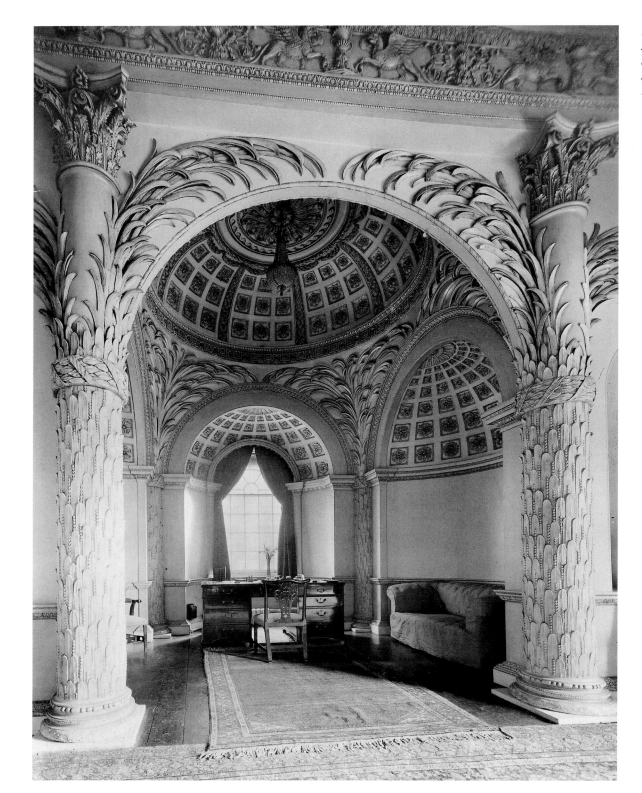

239. *Spencer House, London. The inner section of the Palm Room by John Vardy, before 1758, as it was in 1926. One of the most original and complex interiors of the 1750s.*

divided horizontally, like the hall at Raynham, by a secondary entablature complete with pediment over the projecting chimney breast to define the main floor with a bigger entablature and a deeper frieze half a storey above. From that rises a deeply coved ceiling with a central square, with an inner octagon and a central circle linked by eight radiating beams and the beams forming the square supported by eight brackets linking it to the entablature, a simplification of the ceiling at 22 Arlington Street.[72]

The enduring influence of Kent on Wright can be seen in his design for a chimneypiece at Clumber Park, Nottinghamshire for the 2nd Duke of Newcastle in the late 1760s or 1770s, when, like Kent, he based the frieze on an etching by Stefano della Bella but in

execution altered some of the details to make them Neo-Classical.[73]

John Vardy was the most original of Kent's followers and developed his own style. It is to be regretted that so little of his work survives. He first came into contact with Kent through becoming Clerk of Works at Greenwich in 1736, and then Hampton Court, Whitehall, Westminster and St James's from 1746. It was he who published *Some Designs of Mr Inigo Jones and Mr William Kent* in 1744. After Kent's death, he and William Robinson completed Horse Guards. He was a fluent draughtsman, and, while his vocabulary of ornament was mainly derived from Kent and he continued to uphold the grand classical tradition developed by Kent and understood by Lord Leicester at Holkham, he was also interested in the

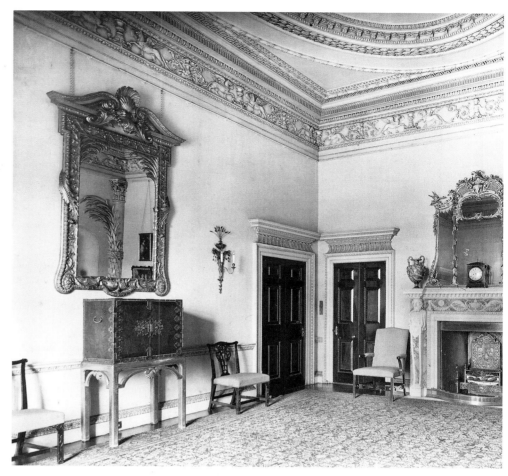

*Spencer House, London*

240 *and* 241. *Vardy's design for the glass for the Palm Room and the glass when still in the room in 1926. The frieze can be compared with that at Holkham (Fig. 446).* RIBA Drawings Collection.

242. *One of the originally white and gold chairs in the French style with palm legs for the Palm Room shown before their current restoration.* Museum of Fine Arts, Boston.

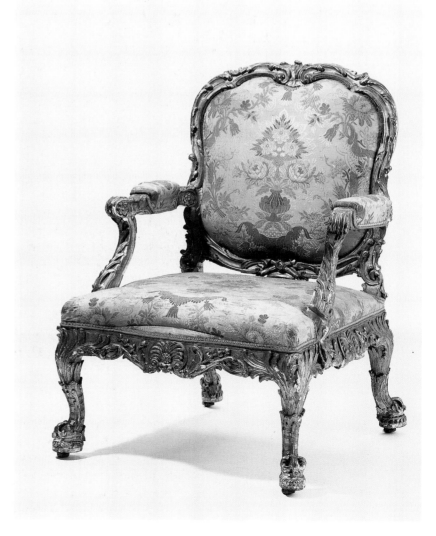

publications of the 1750s on classical architecture, as was Lord Leicester. He moved away from Kent's over-emphatic detail to produce smoother and lighter designs, and it seems more likely that the glass with the Prince of Wales's feathers in the Victoria and Albert Museum usually credited to Kent is by him. He had great feeling for carving, perhaps because his brother, Thomas, was a skilled carver, and they are thought to have worked closely together. There is evidence of his interest in French furniture, as can be seen from his two unusual drawings of a buhl armoire and a bureau plat by van Risenbergh, and it seems likely that he was influenced by the French enthusiasm for naturalism in ornament that started with Meissonier.[74]

As yet, no one has brought together all his designs, and so it is not clear how his work developed in the late 1740s and early 1750s. In the Victoria and Albert Museum there is a design for a royal bed by him dated 1749 that appears to tie up with the splendid bed now at Hardwick, which is hung in the same cut velvet as the state bed at Holkham (Fig. 450). According to the Duchess of Northumberland, who saw the bed 'of a very beautiful 3 colour Velvet' at Chatsworth in 1766, it was made by Cobb and Vile.[75]

His work at Spencer House grew out of a commission originally given to him in 1755 by Lord Montfort, who could have encountered him in 1744 when Vardy included a plate of the tureen

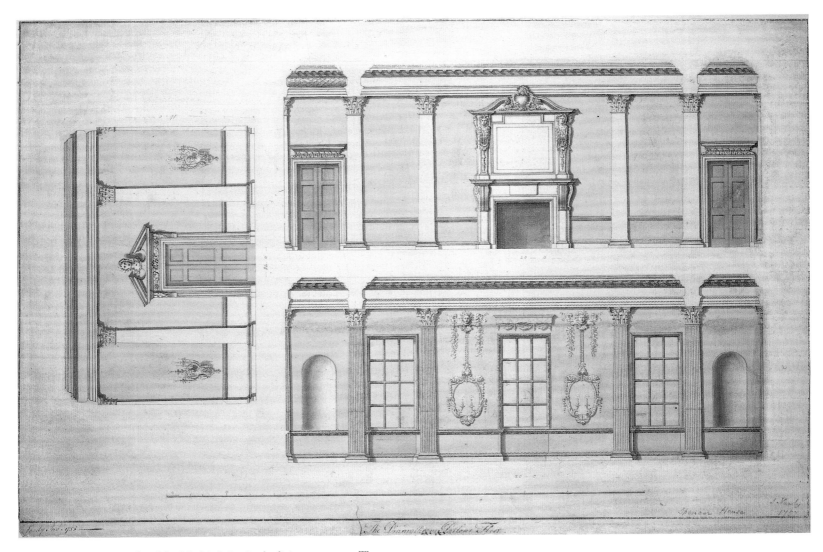

243. *Spencer House, London. John Vardy's design for the dining-room, 1755. The earliest dated example of the use of colour in a drawing for an interior, it shows a continued chimneypiece, pilasters and pier glasses between the windows. The room was later remodelled by Henry Holland.* Greater London Record Office.

designed for him by Kent in his book; but that came to nothing because of Lord Montfort's suicide the same year. The site for the new house was then sold to the future Lord Spencer, who came of age and married that year, and he took on Vardy as his architect. Of Vardy's work for the Spencers, the principal survivor is the Palm Room, one of the most original and complex rooms of the decade (Fig. 239). The main rectangle has a frieze taken from Desgodetz, and the south wall is treated as a screen with half-columns modelled as the trunks of palm trees, which burst into sprays of fronds framing the central arch and side niches, while the columns continue in a conventional classical style up to Corinthian capitals, reflecting the original order in the Temple of Antoninus and Faustina. The idea of the columns and sprays of palm was inspired by John Webb's design for Charles II's bedchamber at Greenwich Palace, which Vardy had engraved in 1744, and the palm became a favourite motif with him, as can be seen in the glass that used to hang in the room (Fig. 240).[76]

The arch opens into a domed space with three coffered apses, the centre one containing the window. According to one of Vardy's drawings for details, the room was painted pale green and white with parcel gilding, and the coffering was picked out in pink, a combination of colours more usually associated with Adam's work in the 1760s. A set

of French-style chairs with palm legs made for the room are an early example of the fashion for white and parcel-gilt frames (Fig. 242).

Vardy's adjoining dining-room was altered by Holland, but a 1755 design survives for an usually complex room with an order of marbled or scagliola pilasters and two screens of columns and a continued chimneypiece (Fig. 243). The drawing is unusual for its use of colour: indeed, Ian Bristow has said it is 'the earliest dated English architectural drawing so far noted which seems clearly to imply the use of one of the more expensive paint colours on a wall surface'.[77]

Vardy also produced two designs for pier-tables and glasses for the dining-room (Figs. 244, 245), one based on a double-bodied sphinx etched by Hollar, and a second with winged griffins, the Spencer crest, central mask and garlands of grapes and wine leaves and a glass to go over it with winged sphinxes. In these he showed himself to be the real creative heir to Kent. Although there is no record of the glasses, the two tables, now at each end of the room, were evidently made by different carvers.[78]

At about that time he may also have been consulted by Lord Leicester over final details at Holkham, such as the overmantel frames in the saloon (Fig. 446) and the detailing of the side table in the apse in the dining-room (Fig. 458).[79]

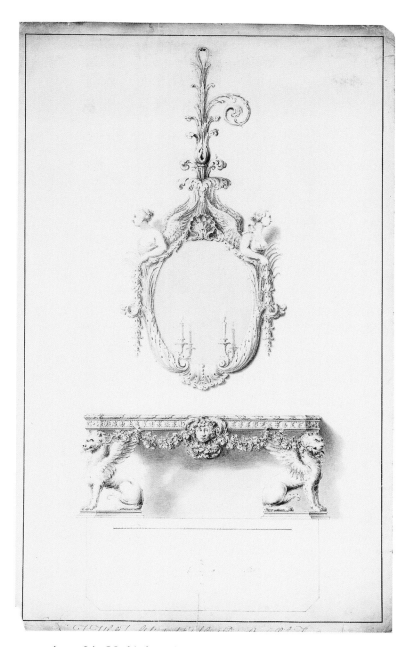

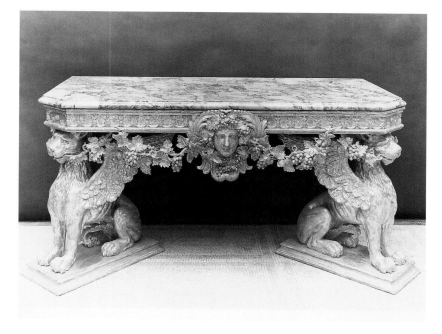

244 *and* 245. *John Vardy's design for one of a pair of side tables and glasses for the dining-room and one of the carved and gilt tables as executed with legs in the form wyverns, the Spencer crest.*

The drawing is in the British Museum and the tables are on loan from Temple Newsam and the Victoria and Albert Museum to Spencer House.

Then in 1761 he began to work for the 5th Duke of Bolton, who succeeded that year but committed suicide in 1765. Within that short period he worked both on the Duke's London house in Grosvenor Square and also at Hackwood in Hampshire, for which the main evidence is a series of pier-glasses and tables now dispersed. For the hall he designed a pair of glasses and tables that are in parcel-gilt walnut to suit its seventeenth-century character, and the tables, which have inset black and gold veined marble tops, have deep friezes unexpectedly copied from a Batty Langley chimneypiece design. They were the prelude to the larger pair of gilt-framed glasses with broken pediments filled with answering eagles and supported on either side by tritons with wings, who hold up the ends of garlands of leaves hanging from a central ring; behind the tritons are sprays of palm (Fig. 246). With them went a pair of marble-topped tables with central masks of Flora and garlands of flowers. Presumably it was for the adjoining room that he designed a less architectural pair of glasses with central cartouches formed of leaves of acanthus arranged in shell shapes: again there are garlands

hanging from a central ring and sprays of palm emphasizing the main panels of looking-glass. Below them went a pair of tables with canted corners.[80]

As well as architects, certain craftsmen, particularly carvers, were important in the dissemination of Kent's style, even if it is difficult to work out precisely how much of the Kentian character of their work is due to his orders and how much to their absorption of his ornament. His favourite carver was James Richards, who is first recorded working for Colen Campbell at the Rolls House and Burlington House and had become Master Sculptor and Carver in Wood to the Office of Works in 1721. Kent first worked with Richards at Chicheley in 1722, then at Kensington Palace in 1724, where he carved the chimneypiece in the King's Drawing-Room (Fig. 178), and after that on many other commissions, including Houghton and Raynham. In 1727 Richards charged £237 6s. for picture frames, tables and six large sconces for Kensington. He also worked for other architects, among them Campbell at Compton Place in the late 1720s, Lord Herbert in the Great Room at Marble

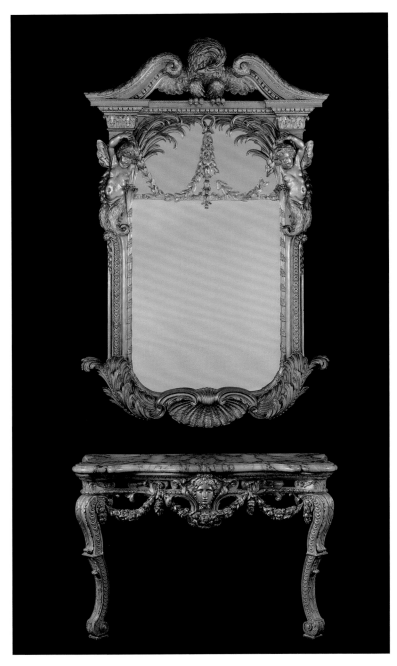

246. *One of a pair of gilt pier-tables and glasses designed by John Vardy for the Duke of Bolton either for Hackwood Park, Hampshire, or the Duke's London house.*

Hill and Flitcroft. He also worked freelance, carving, painting and gilding two table frames for James Moore, who carried out Kent's designs for Sherborne (Fig. 249), as will be explained.[81]

Kent also used John Howard, a joiner, carver, gilder and picture-frame maker who was appointed King's frame maker in 1714 but whose work is mainly recorded in the 1720s. He also acted as a picture dealer and agent, buying for Sir Robert Walpole. Now he is principally known for the set of frames designed by Kent for the King's Gallery at Kensington Palace (Fig. 181).[82]

John Boson was a successful independent carver who never had a post in the Office of Works: Vertue described him as 'a man of great ingenuity. and undertook great works in his way for the prime people of Quality & made his fortune. very well in the world'. He may have trained under a ship's carver and then is recorded at Hawksmoor's St George's Bloomsbury in 1720–3 and in 1725 at 4 St

James's Square. He is first recorded in connection with Kent in 1732, when he worked on the Prince of Wales's barge and at Kew Palace. After that, he carved the library tables and the frames of the pier-glasses to Kent's designs for Lady Burlington's Summer Parlour at Chiswick in 1735 (Fig. 248), which must be the earliest pieces of English furniture identifiable in a drawing or painting (Fig. 247). In 1740 he made a pair of sconces similar to those recently found at Houghton for Lord Charles Noel Somerset, afterwards 4th Duke of Beaufort, which are still at Badminton; and he is also thought to have carved the set of large frames for the Woottons in the hall at Badminton in 1740. In 1742 he was commissioned to make the base in the form of a triumphal arch for the sixteenth-century *pietra dura* cabinet at Stourhead. It is not recorded who designed it, but the detail is not Kentian and it seems to be too imaginative to be by Flitcroft, who was altering the house at the time. About the same time he appears to have been working with Goodison on the state rooms at Leicester House. He died in 1743.[83]

On several occasions Kent worked with the two James Moores, father and son, but the father, who was a cabinet-maker, died in 1726 and the business was carried on by his son, a cabinet-maker and upholsterer, who was dead by 1734. The father seems to have been one of the most important suppliers of furniture in the 1720s, judging by his work for the Duke and Duchess of Marlborough in London and at Blenheim and the particularly grand gilt gesso coffer in the Victoria and Albert Museum supposedly made about 1720 for

247. *A sketch by William Kent of Lady Burlington sitting in her Garden Room at Chiswick House, Middlesex, which he designed about 1735, with part of one of the two pier-glasses and commodes. The earliest portrayal of identifiable pieces of English furniture.* Trustees of the Chatsworth Settlement.

Sir William Bateman, when he married their granddaughter. The Moores provided the 'four large sphinx stands for tables' for the Cupola Room at Kensington Palace in 1723–4, which appear in Pyne's *Royal Residences* and he attributed to Kent.[84]

Later Kent designed and James Moore the younger made a small group of pieces for Sir John Dutton for Sherborne House and Lodge Park, Gloucestershire. In 1728 Kent was paid £31 10s. for 'his trouble making Plans for me at my Lodge & House'. For the dining-room at the Lodge, which was not a conventional dining-room but a large first-floor room used in connection with sporting life, Moore in 1730 supplied a pair of mahogany settees (Fig. 249, now lent back to the room from Temple Newsam) at a cost of £30, four stools for £20, and charged £5 10s. for 'making 2 Table Frames for ye Carver for 2 Marble Tables at ye Lodge'. James Richards was paid £13 10s. for carving the two frames and £5 10s. for painting and gilding them. Presumably the frames were brown and gold rather than a light colour and gold, to go with the mahogany settees.[85]

Three years earlier, George Nix supplied the similar set of benches (Fig. 250) now at Boughton to the 2nd Duke of Montagu, but it is possible that they were designed by Flitcroft, who had made

a survey of Montagu House, Bloomsbury in 1725 and a few years later had designed a new house in Whitehall for the Duke.[86]

Goodison, who described himself as a cabinet-maker but not an upholsterer, is first recorded in September 1719, when the Duchess of Marlborough wished to pay him £500 for 'his master Moore' for furniture for Blenheim. Early the following year he received £6 6s. on Moore's behalf from Lord Burlington for 'sconces and branches', and he succeeded him in royal service in 1726–7. In 1729 he supplied a massive lantern for the Queen's Staircase at Hampton Court Palace, which had been painted by Kent. He appears to have been a major figure in the dissemination of the Kentian style, although, as Geoffery Beard has written, there is no documented connection of his name with Kent until Holkham in 1739, when he made furniture for the Temple. He is particularly associated with furniture of an architectural character. He also reframed pictures by Monnoyer for the 2nd Duke of Montagu for Montagu House, Whitehall.[87]

However, the further one moves from documented Kent jobs and craftsmen who had fairly regular contacts with him, the more the difficult it is pin down his influence, partly because there has

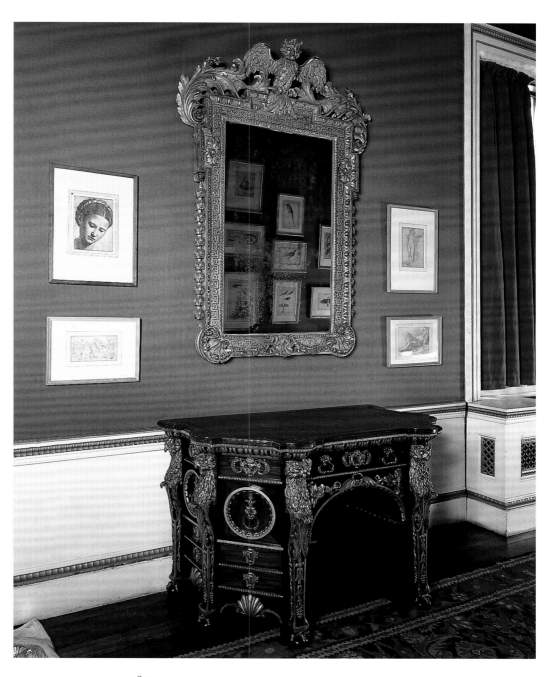

248. *One of the pier-glasses and commodes designed by William Kent and made by John Boson for the Garden Room in 1735. Both incorporate the owl, the crest of the Saviles, Lady Burlington's family, as well as a symbol of Minerva.* Trustees of the Chatsworth Settlement.

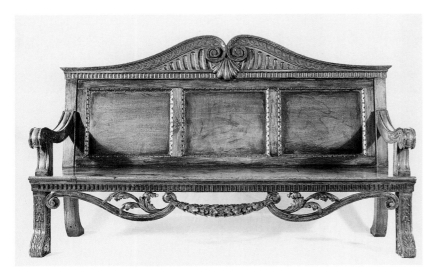

249. *A mahogany bench designed by Kent for the dining-room at the Lodge, Sherborne Park, Gloucestershire, which was carved by James Richards working for James Moore the younger who supplied them in 1730.* Lent from Temple Newsam to the National Trust at Lodge Park.

250. *One of a set of benches made by George Nix for the 2nd Duke of Montagu in 1728 (?), perhaps designed by Flitcroft. Now at Boughton House, Northamptonshire.*

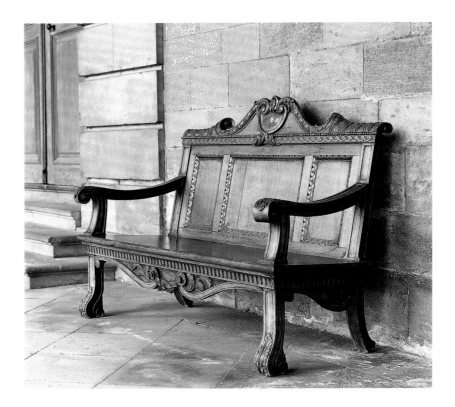

been less research on designers like Daniel Garrett. Garrett was clearly one of the talented architect decorators of the 1740s and 50s, as can be seen in the saloon at Wallington (Fig. 278) and in records of the gallery at Northumberland House (Fig. 84). Even so, it comes as a great surprise to find him proposing a library with an apse and screen at both ends at Kirtlington (see pp. 299–300) that seems to be a direct link between Kent's and Adam's ways of thinking.[88]

251. *One of a set of three carved and gilt eagle console tables probably supplied by Francis Brodie of Edinburgh to Innes House, Morayshire. Brodie included an eagle table on his bill head dated 1739.* Private collection.

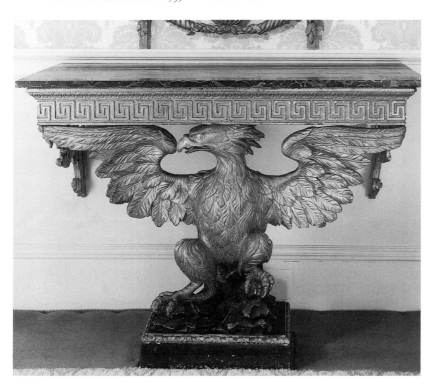

There are also numerous pieces that are more or less in his spirit but cannot be tied to payments in accounts. Among them are the Coleshill and Longford tables, the former presumably originally for the hall at Longford and now in the Victoria and Albert Museum. At Stourhead and Firle are pairs of small pier-tables with hound support that are contemporary with work of the early 1740s in both houses. Could they be associated with John Phillips, a carver who supplied pairs of pier-tables to the 3rd Duke of Beaufort in 1728–33, including sphinx tables in 1731 for £150 (?), dolphin tables and a pair of eagle tables?[89]

Understandably, the eagle table is a form invariably attributed to William Kent, because the genesis of the idea appears as one of his decorations to Pope's *Odessey* (Fig. 166); but in fact there are no documented references or examples in houses where he is known to have worked. At present, the earliest recorded reference to the type is in an account of Thomas Moore with Dudley Ryder in 1734, which mentions 'an Eagle frame & Top Carved and guilded in burnished gold' costing £12; and with it a 'large Carvd & guilt sconce Pedmt frame with a new glass', also costing £12. That may be slightly later than the eagle table at Badminton by Phillips referred to above. Slightly later, in the 1730s, Roger Morris showed a pair of eagle tables with glasses in his design for the window wall of the drawing-room at Adderbury House (Fig. 252) when it belonged to the 2nd Duke of Argyll. He proposed other tables in a Kentian manner for that house, presumably to be produced by carvers who had worked with Kent and Flitcroft. An illustration of an eagle table appears on the bill head of a Scottish cabinet-maker, Francis Brodie of Edinburgh, in 1739, and he probably supplied the one now at Innes House, Morayshire (Fig. 251). Another early one is 'the side board Table Supported by an Eagle' supplied to the Duke of Hamilton and now at Holyrood.[90]

Dolphin tables are rarer, but, unlike the eagle tables, they can be definitely associated with Kent, who seems to have used the idea for the first time for the massive tables shown by Pyne in the Privy

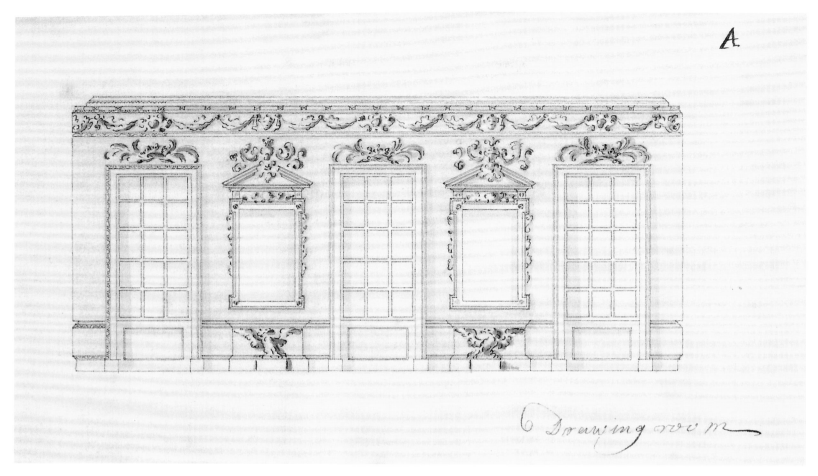

252. *One of a group of designs for Adderbury House, Oxfordshire, attributed to Roger Morris, showing pier-glasses and eagle tables in the drawing room, late 1730s? They are a pointer to his interest in architectural decoration.* Duke of Buccleuch.

Chamber or Queen's Drawing-Room at Kensington Palace and now at Windsor. Smaller and simpler examples survive at Badminton, where they were supplied by John Phillips in 1731. There are two presumably contemporary pairs at Boughton, now attributed to Goodison and presumed to come from Montagu House, but equally plausibly they could have come from Adderbury. As with so many decorative ideas at the time, there appear to be strong links between carving and silver design, where marine motifs became particularly fashionable in the late 1730s and early 1740s, as can be seen on the arm badge by Lukin in the Victoria and Albert Museum and Sprimont's design for a salt cellar (Fig. 26).[91]

While comparatively few of Kent's drawings survive, in his own time and soon after they seem to have been circulated, because in 1752 James Whittle made a large mirror 'by a design of Mr Kent's' for the 4th Duke of Bedford and Thomas Brand; and at Alscot Park, Warwickshire, there is a table made in 1750 by Linnell 'to a design of Kent's'.[92]

On occasion, a design by Kent was reused, as with the pattern of the balustrade at 44 Berkeley Square, which was copied at Milton, where Flitcroft was involved in the early 1750s, and in the hall at Holkham (Fig. 441) after Lord Leicester's death in 1759.

Also, of course, his ideas were spread through prints of his work, first those in his *Designs of Inigo Jones* and then through Isaac Ware's intentionally popularizing *Designs of Inigo Jones and Others* (1731). The latter was used for the chimneypieces at Lydiard Tregoze and in the Gallery at Temple Newsam (Fig. 322) and probably by Carr at Heath

Hall. They were also known through Ware's Houghton book, and were quoted in some of the unexecuted drawings by John Sanderson for the dining-room at Kirtlington Park; and then by Vardy. How familar they must have been is apparent from the profusion of anti-Kentian details in Hogarth's prints such as *A Rake's Progress* (1735) and *Marriage à la Mode* (1745).[93]

What is hard to tell is how often the engraved designs published in 1744 were used by furniture makers who had no direct contract with either Kent or Flitcroft or with the inner circle of carvers used to working with them. Occasionally chairs are encountered that have no provenance and could be based on the engravings, while others with curious proportions look like adaptations of engraved designs rather than the product of direct contact with the master.

Kent's influence, however, was not just on designers and craftsmen of his own generation and the one after. It also extended to younger patrons and designers, because he had created a grand style of classical decoration that was still influential in the 1750s and 60s. That can be seen most clearly in the completion of the principal rooms at Holkham, but also in the 4th Duke of Bedford's remodelling of Woburn in the 1750s and the first stages of Sir Nathaniel Curzon's rebuilding of Kedleston. Stuart, Adam and Chambers all looked back to him, as can be seen, for instance, in Adam's design for the chairs for 22 Arlington Street which were intended to go into a great room of the early 1740s.

His legacy was also fostered by the loyalty of certain families, in particular the Pelhams. Quite apart from their use of their

influence to foster Kent's public career, which probably included his appointment as Master Mason and Deputy Surveyor in 1735 and the acceptance of his scheme for Horse Guards, which was only completed in 1759, eleven years after his death, they employed him on many occasions. However, it is not clear whether that started with Thomas Pelham-Holles, 1st Duke of Newcastle, formerly a major patron of Vanbrugh, who went to him in 1725 over alterations to Newcastle House in Lincoln's Inn Fields, or his brother, Henry Pelham, who involved him in alterations to 32 Old Burlington Street. In 1729 the latter bought Esher Place (Fig. 232) and Kent not only restored and extended the Tudor gatehouse, as we have seen, but was involved with the gardens there and at the Duke's Claremont; and in 1740 Henry Pelham bought 22 Arlington Street, which Kent rebuilt for him.

The connection does not end there, because the 9th Earl of Lincoln, the nephew of the Pelham brothers and later 2nd Duke of Newcastle, involved Kent in the landscape at Oatlands, and at some stage after Kent's death acquired the designs for the saloon at Houghton (Figs. 185, 186). Moreover, both he and the 1st Duke took on Stephen Wright, whom they saw as the preserver of the Kent style. The 1st Duke, as Chancellor of Cambridge, got him the job of refronting the University Library in 1754; and the 2nd Duke commissioned him to design Clumber in Nottinghamshire. Lord Lincoln also admired Kent's plate: not only did he inherit the gold cup designed by Kent (Fig. 237) through his wife, the daughter of Henry Pelham, but he bought a pair of tureens designed by Kent for Lord Montford and in 1773 a pair of candlesticks by Parker and Wakelin 'after Kent'. Thus Kent remained a positive force in English design long after his death.[94]

# 6

*Parade, Comfort and Variety, 1740–60*

While it is tempting to divide the four decades between 1720 and 1760 into the Palladian and Rococo periods, the stylistic differences do not really explain why the second two decades, particularly as far as interiors are concerned, have such a different character from the first two. Thus they are discussed from four interlocking points of view, the development of a great range of English skills, particularly in the applied arts and throughout the country, the importance of the amateur interest in architecture and country-house building, with its particular enthusiasms but also limitations on creativity and imagination.

Closely linked with that was the evidently increasing influence of ladies on the way of life in houses and so how they were decorated and furnished, with a growing desire for comfort and privacy and a corresponding move away from grandeur and formality. This in turn led to a major shift of balance in the way houses were fitted up, with less emphasis on upholstery and more on the role of the cabinet-maker and the range of pieces he was expected to provide. However, there is no single designer who opens the metaphorical door, nor a single house, like Houghton, that seems to encapsulate this changing situation. It is a case of returning to a jigsaw and trying to piece together a picture from often ill-shaped pieces.[1]

The unusually long period of peace from 1713 to 1739, and with France until 1744, had been marked in England and Ireland, but to a lesser extent in Scotland, by a great bout of house-building, not only country houses but also town houses in London and Dublin. In England, that was brought to an end by the outbreak of war with Spain in 1739 followed by the start of the War of Austrian Succession in 1741. Not only did Kent's private practice tail off, partly because he had so much public work, but Gibbs's shrank almost to nothing, and younger architects like Brettingham, Ware and Vardy found it hard to win commissions for new houses.

War, however, could be too simplistic an explanation: probably a high proportion of the major landowning families had invested heavily in building in the first four decades of the century, and also there was a swing away from great houses to houses of more moderate size and increasingly based on the villa form. Moreover, economics could have coincided with an increasingly influential historical sense that encouraged owners of inherited houses and of old houses recently acquired to concentrate on alterations or additions. These provided plans and styles that were up to date as well

as the greater visual and spatial variety that comes with an old house altered, as Roger North had recommended. Perhaps there was also a desire for a contrast in character between an up-to-date London house and a country seat that reflected the passage of time.

Certainly a list of English houses altered in the period 1740–60 is almost as striking as that of new houses begun in the earlier years, including as it does Arbury, Badminton, Burton Constable, Corsham, Croome, Euston, Felbrigg, Hartwell, Longford, Milton, St Giles's House, Ragley, Shugborough, Stourhead, Temple Newsam, Uppark, Wallington, Welbeck, West Wycombe, Wimpole and Woburn. The list is long, and the variety endless.

While the more original complete new houses tended to be villas, patrons continued to decorate; and it is arguable that interiors were more original for their decoration and furnishing than their architectural design. It was as if there was a change of mood among patrons, marked by a swing away from the excitement of architectural pioneering in the second and third decades of the century to a softer, more sophisticated approach concerned with the elegance and comforts of life within doors in the fifth and sixth decades. A number of the new houses were designed by architects of the second rank but with a talent for decoration, among them John Sanderson, while James Paine and Robert Taylor were major architects who were skilled decorators as well as imaginative planners.

Architects' drawings became more elegant and showed more awareness of the relationship of ornament and decoration to architecture, as can be seen in Sanderson's drawings for a Pantheon-like room in The British Architectural Library and for Kirtlington (Fig. 404) and Paine's for Felbrigg (Fig. 426), Gopsall and Nostell. Some of them also show a new awareness of the role of colour and upholstery in decoration, as in Vardy's drawings for the dining-room (Fig. 243) and Palm Room at Spencer House. However, the exploded drawing of the Great Drawing-Room at Blair Castle produced by Steward Mackenzie in 1758 (Fig. 253) is most unusual in showing all the detail and the walls coloured up: either side of the continued chimneypiece are a pair of seventeenth-century full-length portraits and very large landscapes on the two end walls, variant treatments of doorcases and overdoors, three pier-glasses and tables between the four windows, and festoon curtains.[2]

The 1740s and 50s also saw a flowering of English craftsmen, particularly carvers and plasterers, who sprang up and worked in many parts of the country, not just London. It was as if all the

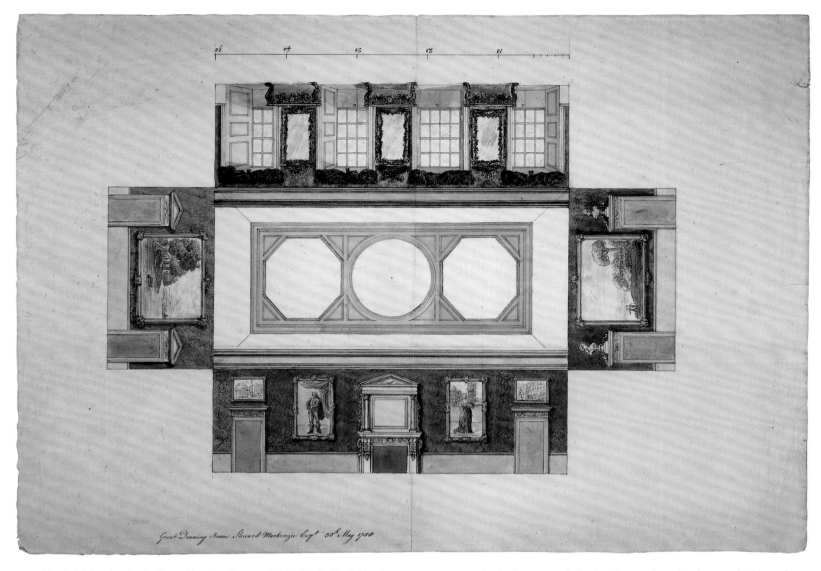

*Great Drawing Room Steward Mackenzie Esq.r 30.th May 1758*

253. *Exploded drawing for the Great Drawing-Room at Blair Castle, Perthshire, by Steward Mackenzie, 1758. A rare coloured drawing of a large room with alternative* *treatments for the doorcases and showing pictures, three pier-glasses and tables and festoons curtains.*

campaigning to improve the status of English artists and craftsmen that had been going on since the end of the second decade of the century began to bear fruit. They no longer had to play second fiddle to foreigners. They were also able to contribute to and benefit from the burst of publications dealing with design, ornament and the promotion of new styles. Moreover, there were technical advances in a range of materials and techniques, especially printing, which affected textiles, wallpaper and tiles, and included papier mâché, casting in plaster, and ceramics. These developments were particularly important because they encouraged the expansion of the middle market and more transitory forms of decoration. Flock wallpapers, for instance, imitated much more expensive cut velvets, while papier mâché made it possible to have at moderate cost elaborate ceilings that would otherwise involve sending for specialist stuccadores, as well as trophies, sconces and looking-glass frames that hitherto had only been available in carved and gilt wood. Makers of porcelain and pottery could imitate the shapes of silver.

Improvements in wallpaper meant that from the mid-1730s it became increasingly used in the principal rooms of houses as well as bedrooms, where it competed with and soon overtook woven hang-

ings. Securely documented examples from that decade, however, are now hard to find, but strong contenders are in the Green Drawing-Room (Fig. 254) and Prince Regent's Bedroom at Clandon (Fig. 121). The Green Drawing-Room paper is printed flat, not in flock, from two small blocks on small sheets, and originally the ground had a slight sheen to it: at the time, it may have been called 'mock flock'. It appears to have been part of the original building of the house, because it continues behind the carved and gilded overmantel of the 1740s, so predating the first hanging of the room in damask. The bedroom paper is a red flock version of Kent's Privy Council paper and the Christchurch Mansion paper (Fig. 120), and it is unusual because it has an extra printing that creates a shadow effect, a detail that was copied for the Temple Newsam paper (Fig. 323).[3]

Perhaps such a paper is what John Drummond had in mind in 1735 for Quarrell in Stirlingshire, a house extended by James Gibbs: 'I shall wainscot or line the drawing room 4 foot high and then put upon the plaister from that to the cornice a plain green or red stuff or the new sort of paper printed like a green damask to hang my pictures on which will have almost all gilded frames.' And by the mid-1740s flock paper was being used in ambitious rooms like the Gallery at Temple Newsam.[4]

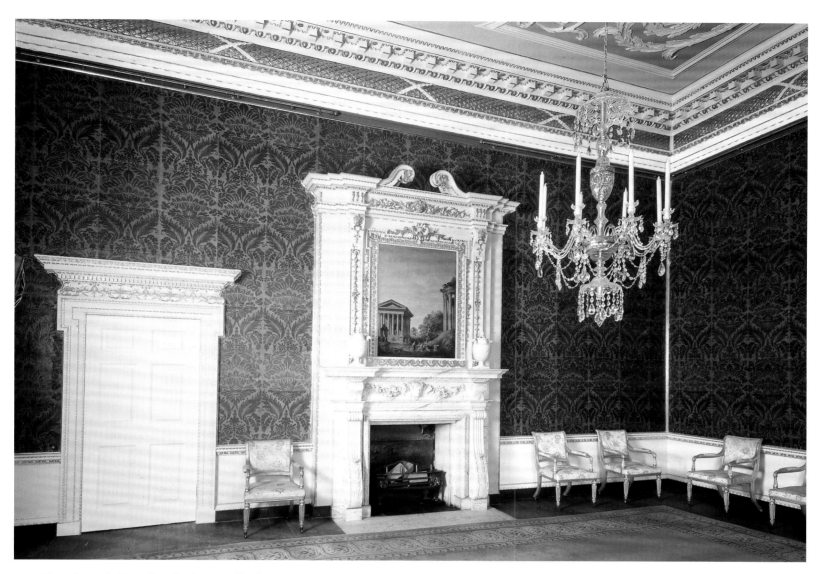

254. *The wallpaper in Green Drawing-Room at Clandon, about 1730. Possibly called at the time 'mock flock', because it was printed flat, it had a glazed ground that was dulled down when it was restored after its discovery in the late 1960s. It predates the overmantel in the style of Flitcroft, which was evidently added in the 1740s when the room was first hung with damask and the entablature was probably gilded (Fig. 151).*

In 1741 Lady Hertford wrote to Lady Pomfret:

Yesterday I was busy in buying paper, to furnish a little closet in that house, where I spend the greatest part of my time when I am within doors; and, what will seem more strange, bespeaking a paper ceiling for a room which my Lord has built in one of the wood. The perfection which the manufacture of that commodity is arrived at, in the last few years, is surprising: the master of the warehouse told me that he is to make some paper at the price of twelve and thirteen shillings a yard, for two different gentlemen. I saw some at four shillings, but contented myself with that of only eleven pence; which I think is enough to have it very pretty; and I have no idea of paper furniture being rich.[5]

Lady Hertford also mentioned a papier mâché ceiling in 1741 or 1742 when she wrote to Mrs Knight that a pavilion at Percy Lodge was 'fitted up within with paper in imitation of stucco; the ceiling is of the same and appears like fretwork'. In 1749 Mrs Delany wrote of going to Joseph Dufour, the Huguenot frame-maker, who was 'the famous man for paper ornaments like stucco, bespoke a rose for the top of Her Grace of Portland's dressing room'. And in 1753 the Duchess had a complete papier mâché ceiling put up at Bulstrode.

Indeed, by the late 1750s papier mâché was so successful that it was seen as a threat by carvers.[6]

Lady Luxborough described in a letter to William Shenstone how Moore, the plasterer who was based in Warwick and had been in London,

talks to me of a sort of stucco-paper which I had never heard of; and says Lord Foley has done his chapel (at Witley) in Worcestershire with it. By his description, the paper is stamped so deep as to project considerably, and is very thick and strong; and the ornaments are all detached, and put on separately . . . the ornaments for the cornices are likewise in separate pieces, and when finished, cannot, I suppose, be known from fretwork.[7]

The range of what could be done in papier mâché is surprising. As well as complete schemes of Rococo decoration, as on the stairs at Cottesbrooke Hall, Northamptonshire and in the saloon at Hartlebury Castle, Worcestershire, which was put up soon after 1759, there is the ceiling in the library at Stratfield Saye in Hampshire, which is taken from one of Wood's prints of Palmyra in Syria. The most elaborate example, however, is the one mentioned by Lady Lux-

255. *Part of a papier mâché ceiling in Prynne's Bedroom at Dunster Castle, Somerset, supplied by Spinnage and Crompton in 1758. One of the few documented examples.*

256. *A section of gilded papier mâché ornament at Doddington Hall about 1760: the putto and sheep are based on an engraving.*

257. *Papier mâché ornament in the Chinese taste on the ceiling of a closet at Duff House, Banffshire, before 1761. The tack holes are clearly visible.*

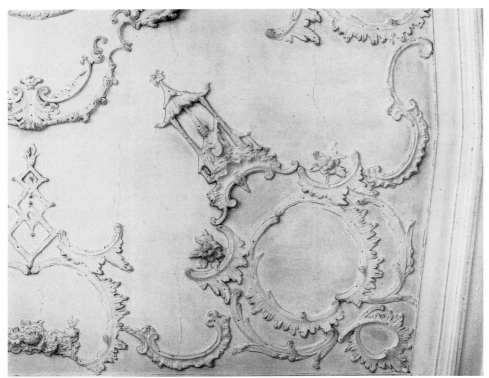

borough at Witley, where Italianate plasterwork of the 1720s in the chapel at Canons was copied to frame painted panels by Bellucci bought at the Canons sale in 1747. Papier mâché could also be used to build up impressive gilded trophies, as can be seen in the King James Drawing-Room at Grimsthorpe, and for the gilded frames of looking-glasses and sconces, as at Doddington Hall, Lincolnshire (Fig. 256).[8]

Although a good deal still survives, examples are rarely documented. Apparently the only Rococo ceiling for which there is a design that can be attributed to a supplier is at Dunster Castle in Somerset (Fig. 255): it was supplied by Crompton and Spinnage in 1758. The gothick ceilings at Strawberry Hill in the Holbein Room (1758–9, Fig. 304) and gallery (1763, Fig. 305) and the elaborate fan vault in the drawing-room at Alscot Park, Warwickshire (1765) were all supplied by Bromwich.[9]

Since papier mâché was easy to pack up and send, it turns up in houses far from London, like Duff House in Banff, where it is found in the dining-room and in one of the upper tower rooms where there is a ceiling in the Chinese taste (Fig. 257). The latter has little paint on it and so the tack holes are clearly visible. It was supplied before 1761. The Premnay letters provide another Scottish example, because they include sketch designs for a ceiling and cove ornaments. Numerous examples are recorded in Ireland and it was also sent to America.[10]

The manufacture of paint also improved. In 1727 Dan Eaton wrote to Lord Cardigan:

> I believe it would be the best way for your Lordship to buy the colours ready ground in London, for I know they grind them there with a mill, and can afford them cheaper than any one can grind them by hand; and if you have different colours they may be easily mixt. Or you may pitch upon a proper colour and have it sent down thick, and some clear oil, and it may be made here fit for the brush without any trouble.

258. *A section of cotton printed from copper plates signed and dated by Robert Jones 1761. Part of a 6-foot design using prints of different dates ranging from 1652 to 1740.* Victoria and Albert Museum.

259. *A panel of Bristol tiles in the drawing-room fireplace at Frampton Court, Gloucestershire, 1730s.*

That sounds like ready-mixed paint as it is understood today. Some years later it was advertised by Joseph Emerton, a 'Colourman' in the Strand, whose printed instructions survive together with a bill dated June 1742 for paint supplied to Sir James Dalrymple for Newhailes. How long the firm had been going is not known, but it seems to have been started by his sister-in-law's first husband, who died in 1741. According to his advertisement, he 'Sells all Sorts of Colours ready prepared (at the lowest Prices) that any Gentlemen, Builders, & may set their Servants or Labourers to Paint their Houses, only by the Help of a printed Direction, which he gives with his Colours'.[11]

The greatest advance in textile printing was made in 1752 by Francis Dixon of Drumcondra, near Dublin, who worked out how to print on cotton from copper plates and so get much finer detail and more subtle effects. On 9 December that year Mrs Delany wrote: 'Just here Bushe made me go with her to Drumcondra, half a mile off, to see a new manufactory that is set up there of printed

linens done by *copper-plates*'. Dixon sold his discovery to an English textile printer, George Amyard, and in 1756 Nixon and Amyard went into business together. They evidently had a rapid success with material for both furnishing and clothes, because already in 1758, when Benjamin Franklin was in London, he told his wife how he had bought fifty-six yards of cotton, 'printed curiously from copper plates, a new invention, to make bed and window curtains; and 7 yards for chair bottoms, printed in the same way, very neat. These were my Fancy; but Mrs Stevenson tells me I did wrong not to buy both of the same colour. Also 7 yards of Printed cotton blue ground to make you a Gown.'[12]

Early examples of printed cotton are hard to date, and there is some uncertainty as to which are English and which French prints, but how far the English had advanced by 1761 can be seen in the splendid design by Robert Jones of Old Ford signed with justifiable pride and dated that year (Fig. 258). The design is 6 feet high and so particularly suitable for bed and window curtains. It involves two

260. *The hall at Farnborough Hall, Warwickshire. It was designed to take Panini's view of St Peter's Rome, and a collection of classical busts acquired in the 1730s by* *William Holbech in the course of his Italian tour. The plasterwork by William Perritt was measured in 1750.*

plates, the design combining elements from prints 100 years apart in date, one being from a Berchem etching of 1652 and another from a print of peacocks and poultry produced by Josephus Sympson in 1740 after a painting by Marmaduke Cradock; but the sources of the ruins and the swans have not been identified.[13]

By 1753 Horace Walpole records that it was possible to have wallpaper matching linen in his Breakfast Room at Strawberry Hill. Three years later, at Holkham, the bedrooms on the top floor of the family wing had bed curtains and chairs in linen of the same pattern as the wallpaper.[14]

Quite apart from the appeal of the designs and the fact that they were readily washable, which was a great advantage for beds, they were cheap. In 1767 Cullen wrote to Lord Hopetoun that a single-colour print cost 2s. 6d. to 5s. a yard, but a good sort cost 3s. 6d. for cotton, with paper costing 5d. or 6d.[15]

Tiles to line fireplaces provided scope for decoration and a very wide variety of individual designs are recorded, but it is rare to come on complete panels like the presumably locally made ones in the Mahogany Parlour at Goldney House and the displays of flowers in urns still *in situ* in a fireplace at Frampton Court (Fig. 259).[16]

In 1756 John Sadler of Liverpool began to produce tin-glazed tiles to line fireplaces, decorated with transfer-printed designs from copper plates with motifs and borders that are akin to those found on cotton and porcelain. Again, they are rarely found *in situ*, and probably the best evidence of their use, although slightly later than the period under review here, is at Croft Castle in Herefordshire.[17]

A practical and decorative invention was floor cloth, a precursor of linoleum now only known from documents. Early references include the hall at Ombersley in 1732 and 'a large floor cloth' in the Dining Room at Dalham Hall (?) in 1736. Three years later, John Carwitham brought out a set of twenty-four copper plates of designs for 'Various Kinds of Floor Decorations represented both in Plano and Perspective. Being Useful Designs for Ornamenting the Floors of Halls, Rooms, Summer Houses etc Whither in Pavements of Stone or Marble, or With Painted Floor Cloths.' Such a floor cloth is recorded in the dining-room at Holkham.[18]

Sculpture, particularly busts, also took on a more decorative role, particularly in libraries. William Kent used statues as well as busts to great effect in the Cupola Room at Kensington Palace (Fig. 170), and busts in the hall at Ditchley (Fig. 385) and the Stone Hall at Houghton (Fig. 191). He also took up the French idea of placing them in the centre of chimneypieces, as can be seen in the Stone

Hall and saloon at Houghton (Fig. 194). They were also placed in pairs at the ends of chimneypieces, as can be seen at Holkham (Fig. 447) and in the hall at Burton Constable. Then in the early 1740s they were used with great effect in the hall at Lydiard Tregoze, where they sit on brackets with winged griffons derived from the Temple of Faustina in the centre of each panel, so pacing out the design of the room. An even more imaginative use occurred a few years later in the hall at Farnborough (Fig. 260), which is decorated round a set of classical busts set in oval niches.[19]

However, antique busts or new busts by Rysbrack and his contemporaries, who raised the genre of the portrait bust to a new height in the 1720s, were expensive, and they were imitated in plaster, notably by John Cheere, the younger brother of Henry, who began to make them in sets in the late 1740s – eight of the set from Kirkleatham Hall are dated 1749. That made them readily available for decorative use, not only in libraries, where there was an ancient tradition of placing busts above bookcases, but in halls and staircases, often as part of schemes of plaster ornament. They were highly effective when placed high, as in the library at Temple Newsam, where they were originally bronzed. In the dining-room at Felbrigg (Fig. 427) they form an essential element in the counterpoint of light and dark notes in the room, as they do on the staircase in the same house, where they were put up in 1752. In Dublin in 1752 Mrs Delany 'called on a famous statuary, who has been here about two years – Vanhost. He served his time with Scheemaker, and seems an ingenious man, and a great artist in his way: takes as strong a likeness as ever I saw taken in marble – his price is forty guineas for the model and the bust.' She hoped that her husband would sit to him, but meanwhile he 'bought four busts, and bespoke two more for his library – Seneca, Aristotle, Galen, and Horace: they are done in plaster of Paris, and varnished so well that they look like polished marble at a proper distance'.[20]

Alongside the taste for busts was one for brackets to support them or lights. The variety of designs is wide-ranging. There were examples in stone and painted or gilded wood for busts by Kent in the Stone Hall at Houghton and the central hall at Chiswick, and for Tottenham Park (now in the Victoria and Albert Museum). He also designed them for small bronzes as well as busts in the parlour at Rousham (Fig. 233). Sometimes they were in plaster as part of a scheme of decoration as in the hall at Honington, formerly in the hall at Weald Hall, and the saloon at Langley (Fig. 316), or gilded like the pair with figures of Apollo and Victory possibly by Cheere that hang in the Cabinet at Felbrigg. Many of carved and gilt wood in the style of Lock and Johnson survive, but often without their history.[21]

As with busts, plaster brackets were inexpensive, as can be gathered from the Premnay letters. A Bacchus's head was priced at £2 15s., while bronzed figures of Flora and Venus Aphrodite cost £2 2s.; and a bracket was £1 5s.[22]

Not only did British talent flourish and develop new fields of activity, but also there were more cross-overs between the different arts and crafts, particularly in central London with its close-knit world of artists and craftsmen. William Hogarth, for instance, was apprenticed to Ellis Gamble, an engraver of plate, and in 1728, some years after he might be presumed to have ceased to work in that vein, he engraved Sir Robert Walpole's salver that was made out of his old seals by Lamerie. The commission is likely to have been suggested by Sir Robert himself, who may not only have admired Hogarth, commissioning him to paint a portrait of the young

261. *A design for a salt cellar and spoon attributed to Nicholas Sprimont, the silversmith and porcelain-maker, among the Lock drawings in the Victoria and Albert Museum.*

Horace, but wanted to muzzle him. Certainly there must have been some connection between Hogarth and Lamerie, because Hogarth engraved his book-plate.[23]

Elaine Barr, writing of George Wickes, pointed out the importance of the outside modeller for Rococo silversmiths; and Michael Snodin has written of Lamerie: 'the designer (and perhaps the modeller) of Lamerie's high style rococo silver was somebody connected with the stucco or carving trades.' and 'It is perhaps no accident that the Lamerie designer's most public exhibition of his skills, the Goldsmiths' Company dish, should also be the piece closest to the form of the stuccador'. How often did Rysbrack help a silversmith, as he did when he modelled the figures for the huge Kaendler cistern?[24]

Similarly the ornament prints of Brunetti (Fig. 35), who worked primarily as a painter of architecture and theatrical sets, suggest that he had close links with the Italian stuccadores. Michael Moser, who was principally a chaser in gold and silver and therefore used to working on a very small scale, also designed the plasterwork in the Rotunda at Ranelagh, opened in 1742. That is particularly tantalizing, because it is not known who executed it; but the building was erected by William Jones, who later in 1751 built the remarkable octagonal saloon at Honington (Fig. 81), which has elaborate but anonymous stucco decoration. Moser also taught at the St Martin's Lane Academy, and so there could be a link between his teaching, Paine's skill as a draughtsman and his designs for decoration at Nostell and Felbrigg (Fig. 426). Could Moser have designed more plasterwork that has not yet been identified? That is possible, because James Shruder, who called himself a chaser in 1733, advertised himself as a modeller and papier mâché manufacturer in the 1760s.[25]

Certainly silversmiths and stuccadores used similar sources of designs, as can be seen with the *Sacrifice* reliefs that occur at Houghton and Ditchley and on a gold box in the Gilbert Collection, while the motif of the relief of Jupiter on the Mountrath dish by Lamerie also occurs on the ceiling of the staircase designed by John Carr at Lytham Hall, Lancashire, probably modelled by Cortese.[26]

A somewhat similar situation arose with Nicholas Sprimont, a

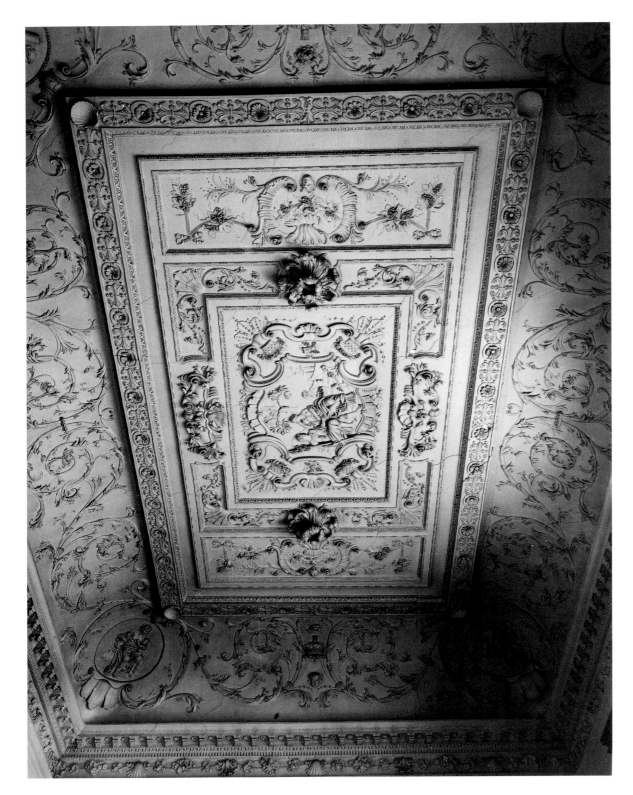

262. *Plasterwork of the 1750s at Chatelherault, Lanarkshire, by Thomas Clayton as it was in 1919. It has been recently restored on the basis of the Country Life photographs.*

Huguenot silversmith from Liège who arrived in about 1742, worked with Crespin and designed a remarkable tureen for Lord Leicester with legs in the form of ostriches, the crest of the Cokes, and an earl's coronet that dates it after 1744. The ostrich legs are reminiscent of a pier-table with ostrich legs at Holkham that may have been carved by Lock for Goodison (Fig. 457). Certainly there appears to be a possible link between Sprimont and Lock, because among the Lock drawings in the Victoria and Albert Museum is one for a salt cellar and spoons formerly attributed to Lock and now to Sprimont (Fig. 261) that appears to link up with an unmarked spoon for a salt cellar made in 1742 by Sprimont for Frederick, Prince of Wales. Not long after that, Sprimont turned to porcelain-making, becoming the moving spirit at Chelsea in 1745. There, he produced

a figure of Hogarth's pug dog, Trump, which had been modelled by Roubiliac. Clearly there are many more such connections to be uncovered.[27]

There were parallel developments in the furniture-making trades, with advances in chair-making, particularly in mahogany, and in the carving of mahogany, and of soft wood for gilding. Indeed, the 1740s and 1750s were decades that saw many famous names emerging, with Matthias Lock (c. 1710–65) starting to publish designs in the 1740s, John (1729–96) as well as William Linnell (about 1703–63), Thomas Chippendale (1718–79), John Cobb (about 1715–78) and William Vile (about 1700/05–1767); but more needs to be discovered about how they learned their crafts and in particular their ability to draw and in Lock's case to etch. Very little has

come to light about Lock's work as a carver as opposed to a publisher of designs, or the Linnells' before 1755, and nothing about Chippendale's before his publication of his *Director* in 1754, and Vile's and Cobb's before they established their partnership in 1751.[28]

In the field of plasterwork, it was the younger generation of English plasterers rather than the Italians who responded to the new naturalistic ornament. Among the Italians still at work after 1740 was Giuseppi Artari, who completed the hall at Ragley in 1759–60; Pietro Lafrancini who worked at Wallington in 1740–1 (Fig. 278) and in the gallery at Northumberland House (Fig. 84); and Paolo and Filippo Lafrancini, who worked at 85 St Stephen's Green, Dublin, Carton (Fig. 56) and Russborough (Fig. 78) in Ireland; Francesco Vassalli, who seems to have settled somewhere in the Midlands and may have worked at Mawley, Shugborough and then in 1758 at Hagley (Fig. 387); and Giuseppe Cortese, who concentrated on commissions in the north of England, as can be seen at Gilling and Lytham. All these masters had their distinctive styles. Thus today they appear to overshadow Thomas Clark, who flourished from 1742 to 1782 and became Master Plasterer in the Office of Works in 1752. Clark worked at Holkham from 1745 to 1760, quite often for Flitcroft, and at Norfolk House. While a master of classical ornament, he does not seem to have had an identifiable style of his own.[29]

In contrast, Thomas Roberts of Oxford (1711–71) had a distinct personal manner that involved a great deal of undercutting. Having started with Charles Stanley at the Radcliffe Camera in Oxford in the late 1730s, he then worked at Kirtlington in the mid-1740s, Rousham and at Nuttall Temple (Fig. 271) as late as 1769. Thomas Stocking of Bristol (1722–1808) was another regional specialist. He did the staircase at The Royal Fort in Bristol and the ceiling of the gallery at Corsham in 1763–6. In the north of England there was Thomas Perritt, who made the gallery ceiling at Temple Newsam (Fig. 322) in the early 1740s and then worked at Nostell Priory for Paine (Fig. 58). Among his apprentices was Joseph Rose senior, whose work is to be seen at Felbrigg (Fig. 427) and who with his nephew and namesake became the favourite plasterer of Robert Adam. The plasterwork of the late 1740s at Farnborough Hall (Fig. 260) is by William Perritt, brother of Thomas. There was also a team of evidently English plasterers at work in Dorset, Somerset and Wiltshire in the 1740s, particularly in houses associated with the Bastards of Blandford and Nathaniel Ireson of Wincanton; but so far their names have not been discovered.[30]

In Scotland between about 1740 and 1760 the leading plasterer was Thomas Clayton, who was probably English: he worked at The Drum about 1740 (Fig. 62) and then at Hamilton Palace and Chatelherault (Fig. 262), Blair Castle and Hopetoun (Fig. 123) in the 1750s. In Ireland, the Italians remained prominent longer, but also there were Patrick and John Wall, who worked on the Provost's House at Trinity College, Dublin (Fig. 82).[31]

It is striking how many of these craftsmen were not London-based but worked in regional centres, some of which do not seem obvious today; and also what a wide field they covered. All the time the list is growing, and in recent years it has extended from the building trades to furniture-making and upholstery, particularly in Yorkshire, as can be seen from the trade cards of Joseph Hall of Hull and Wright and Elwick of Wakefield. In Scotland, among the discoveries have been Francis Brodie of Edinburgh (Fig. 251), Alexander Peter, a cabinet-maker who supplied furniture to Dumfries House, and William Matthie, a carver and gilder who contributed glasses to that and other houses. In Ireland, among the figures now appearing from the shadows are the carvers John Houghton, who was dead by 1761, and John Kelly, who died in 1775, to whom frames from Russborough are attributed (Fig. 318), and the looking-glass seller, Booker of Dublin, who produced a number of distinctive glasses and is first recorded about 1760. The vitality of regional work is one of the delights of the period.[32]

The new forms of naturalistic and asymmetrical ornament now generally described as being Rococo first appeared in England in silver and silks and afterwards spread to carving and plasterwork, and then to printed textiles, wallpaper and ceramics. That was encouraged by the flow of ornament prints and sets of designs of a novel type in England. They could be adapted for a variety of media and encouraged a variety of styles, classical, French, chinoiserie and gothick. The first of these prints were *Sixty Different Sorts of Ornament* (Fig. 35), produced in 1736 by Brunetti, the Italian decorative painter who had worked alongside the Italian stuccadores and Sleter on the hall ceiling at Moor Park (Fig. 33), which may explain the affinity between some of his prints and the work of stuccadores. He described them as 'Very Usefull to Painters, Sculptors, Stone-Carvers, Silversmiths etc'. They include cartouches and trophies, chimneypieces, mirror frames and, for the first time, chairs and tables of impractical elaboration that would appeal to carvers and painters of conversation pictures. Paine copied one of his cartouches on the Mansion House at Doncaster, and William Perritt's plaster ornament at Farnborough Hall could have been inspired by them, while Batty Langley might have adapted one of his chimneypieces and overmantels. Other plates look forward to the flowing designs of Matthias Lock, who certainly used them, and to those of John Linnell.[33]

In 1739 William Jones, a minor architect who designed the Rotunda at Ranelagh Gardens, brought out *The Gentlemen or Builders Companion* in imitation of Ware's *Designs* of 1731 for those working in the building trades. He was the first Englishman to publish designs for furniture, which he copied from a variety of sources (Fig. 265).

He was soon followed by a number of others, among them Edward Hoppus, Batty Langley, whose *The City and Country Builders and Workmens Treasury of Design* came out in 1740, and William Delacour, whose *First Book of Ornament* followed in 1741. Abraham Swan's first book, *The British Architect: or The Builder's Treasury of Staircases*, appeared for the first time in 1745, but that appears to have been more used in the American colonies.

1744 saw not only Vardy's *Some Designs of Mr Inigo Jones and Mr William Kent* but the first sets of designs for carved ornament in the Rococo taste in Lock's *Six Sconces*. That was followed by his *Six tables* in 1746 and then by *A New Book of Ornaments*, published with Copland in 1752. Lock's idea was then taken up by the elusive and even more fanciful carver, Thomas Johnson, who produced *Twelve Girandoles* in 1755, *A Collection of Designs* in 1758 (Fig. 263) and in 1760 and 1761 a *New Book of Ornaments* and *One Hundred and Fifty Designs*. Oddly, no payments to him for carving have yet come to light, nor any connection with an upholsterer or cabinet-maker. So pieces that relate to his designs, like the torchères at Hagley (Fig. 422), a glass at Newburgh Priory, a console table at Corsham, girandoles and a set of four mirrors at Blair Castle, remain problematic. Meanwhile, in 1754 Thomas Chippendale had brought out the first

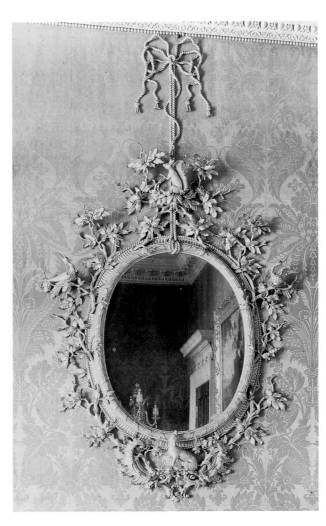

263. *The plate from Johnson's* Collection of Designs, *1758.*

264. *An oval glass at Corsham Court, Wiltshire, apparently based on a design by Thomas Johnson published in 1758.*

265. *A 'Kentian' table from William Jones's* The Gentleman or Builder's Companion, *1739. That was the first book by an English author to contain engraved designs for furniture.*

edition of *Gentleman & Cabinet-Maker's Director*, with a second and revised edition following in 1763.[34]

However, what complicated the field was the way prints were copied and adapted without any acknowledgment, and artists and craftsmen took from them what seemed to be useful, but often after trimming, thus leaving no clue as to their origin. At the simplest level, Kent's and Gibbs's chimneypieces were copied both quickly and widely in books like Hoppus's *Gentlemen's and Builder's Repository* of 1737.

The way that collections of prints of mixed dates and styles were used by craftsmen can be seen in the book (now in the Metropolitan Museum, New York) compiled by Gideon Saint (Fig. 266), who, according to his trade card pasted into the front of the book, was a 'Carver & Gilder at the Golden head in Princes Street near Leicester Fields' who 'makes *all sorts of* Sconces, Girandoles, Chandeliers, Brackets, Tables, Chimne-Pieces, Picture Frames & *in the best and most reasonable manner*'. Apparently he lived from 1729 to 1799, but so far his name has never been found in any accounts.[35]

Saint's book, apparently dating from the early 1760s, combines his own drawings with a mixture of prints ranging from a table from Boulle's *Nouveaux Deseins* published about 1712–15 and two big tables copied by Saint from Le Pautre's *Livre de Tables* published in 1685 to prints cut from several of Lock's publications and Johnson's *Collection of Designs* of 1758. Almost all the names and dates have been cut off the prints, although the majority are etched in that curiously spidery manner of the English Rococo.

A similar mixture can be seen in a group of prints that passed by descent from one of the mid-eighteenth-century Italian plasterers working in Ireland and now in the Irish Architectural Archive in Dublin. They are particularly interesting because recent research has revealed the range of sources available to stuccadores in Ireland. Paolo and Filippo Lafrancini, for instance, used an engraving of Lanfranco's *Council of the Gods* painted in the gallery of Villa Borghese in Rome in 1624–5 and published about 1685 for the ceiling in the saloon at Carton of about 1739 (Fig. 56). Similarly at Kilshannig, in Co. Cork, they took details from the *Assemblee Des Dieux* painted by Coypel in the gallery of the Palais Royale in Paris in 1702 and published in 1717; while a relief of the late 1750s now

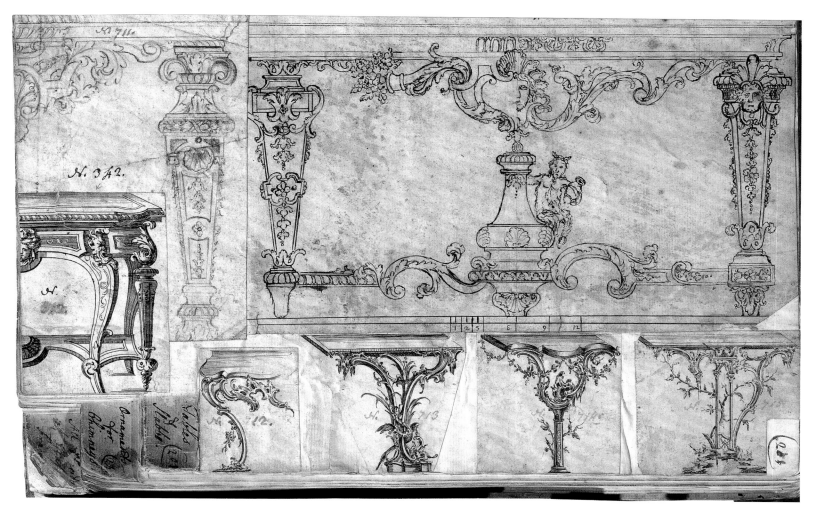

266. *A page from the scrapbook of Gideon Saint, an obscure carver with no documented work, who combined prints of varying dates with his own sketches.* Metropolitan Museum, New York.

267. *A carved, painted and parcel gilt console table, about 1760 attributed to Saint. The combination of colour and gold, discovered when the table was restored about 1990, is a rare survivor.* Private collection, formerly with Jonathan Harris, London.

268. *The largest from a set of painted toiles by Andien de Clermont probably commissioned by the Duke and Duchess of Northumberland for Syon House in the 1750s. As the Duchess records, the birds were copied from Edwards's illustrations. The peacock pheasant on the left is taken from the print of Fig. 269.*

269. The Peacock Pheasant, *a plate from George Edwards's* Natural History of Uncommon Birds *(1743–51).*

attributed to Barthelemij Cramillion surprisingly turns out to be taken from Goltzius's *Venus Wounded by Love* issued in 1596. Another set of Goltzius prints, *Roman Heroes* of 1586, were used on the cabinet made about 1740 and attributed to John Channon that is now in the Bristol Museum.[36]

Perhaps the development of naturalistic ornament was also encouraged by the increasing enthusiasm of both ladies and gentlemen for flowers, gardens and landscapes. There was a rapid growth of increasingly well illustrated books on botany, and these were borrowed for use in decoration. The first book with colour plates of plants, John Martyn's *Historia Plantarum Rariorum*, was published as early as 1728, and in 1730 *Catalogus Plantarum* was issued by the Society of Gardeners. The drawings for both were done by Jacob van Huysum, and many of the prints were made by Elisha Kirkall, an inventive print-maker, who experimented with coloured mezzotint and imitations of chiaroscuro woodcuts as well as wallpaper printing. An early and surprising example of that kind of borrowing is a painted and dyed cotton palampore produced on the Coromandel coast of India about 1730–40, where the bunches of flowers

in the corners are taken from the set of prints of flowers in the style of Van Huysum for all twelve months of the year published by Furber in 1730.[37]

Naturalistic flowers appear in all aspects of decoration, textiles and wallpaper, carving, plasterwork and silver as well as porcelain, as can be seen in the botanical plates made at Chelsea about 1755, some of which were taken from illustrations done by George Ehret for Philip Miller's *Figures of Plants* and other books.

However, so far no link can be found between botanical illustrators and designers of silks. With Joseph Dandridge (1665–1746), who was one of the best silk designers, for instance, there is no evidence of his work as a botanist or friendship with the great naturalists of his day. Similarly, it is still a mystery how Anna Maria Garthwaite (1690–1763), the most fluent of all English designers of silks from the late 1720s, learned how to observe flowers and plants so well. Although she was a contemporary of George Ehret (1708–80), the most distinguished botanical artist at work in England from 1736 until his death, there is no evidence of contact between them, and when her designs suddenly became more naturalistic in 1742–3, no connection can be found with botanical drawings.[38]

Not surprisingly, the fine designs appeared first in silks, but quite quickly they were adapted for floral designs on printed cotton, as can be seen in the collection formed in about 1750 by John Holker, an industrial spy and Jacobite who sold British know-how to the French. They are also to be seen among the designs for textiles by John Baptist Jackson, who, like Kirkall, was an innovative printmaker and producer of wallpaper.[39]

This interest in botanical illustration and gardens seems to have influenced interiors not only through the appearance of floral ornament, but through being part of a broader movement that encouraged a new interplay between gardens and interiors and the move away from the raised *piano nobile*.

Engravings of birds were also widely used in decoration, by painters, porcelain modellers, textile designers and so on. Here, the key book was Edwards's *Book of Birds*, which was published in parts between 1743 and 1751. Kalm, a noted Swedish?, records meeting the author in 1748: 'the great Ornithologist, Mr Edward who had produced a book on birds in the English language, with matchless copper plates, all in life-like colours, so that it looked as if the bird stood living on the paper'. His plates (Fig. 269) were used by Clermont in his set of painted toiles produced in 1750–2 for the Duke and Duchess of Northumberland at Syon (Fig. 268), and they were copied by Samuel Dixon for his embossed bird prints produced in Dublin first in 1750 and then in 1755 and by the Chelsea modellers.[40]

All these threads and developments provide a background to the stylistic changes associated with the Rococo. However, its victory was more limited in England than in France and Germany, where it embraced architecture, decoration, furniture and everything in sight. Here, patrons generally preferred a classical framework with Rococo ornaments, as can be seen with the gallery at Temple Newsam (Fig. 322), which took shape in the late 1730s and mid-1740s, and the Kirtlington dining-room (Fig. 399), also conceived and decorated in the early 1740s. There was surprisingly little interest in the flow of space in plans until Paine and Taylor designed villas in the 1750s.

It was a period a-bubble with ideas and choices that influenced interiors, with different interlocking styles to explore and on occasion combine to create variations in mood in a house as well as the absurdities and pretensions satirized by Hogarth in his *Taste in High Life*, published in 1746. All the time, decoration was becoming lighter and smoother, less emphatic and calmer, with ornaments becoming smaller and contrasts of materials and textures reducing. Dark marbles went out of fashion, and chimneypieces and doorcases became less assertive and their designs more broken up. The grand classical manner inspired by Palladio and Inigo Jones, developed by Kent and carried on by his colleagues and successors, Flitcroft, Ripley, Brettingham and Vardy as well as Gibbs, was still the style for the interiors of great houses, with the principal rooms at Holkham and Woburn as its grandest expressions in the 1750s. However, each of the alternatives had its own message: the half-understood anglicized version of the French style, as seen at Chesterfield House, Petworth (Fig. 64), Norfolk House (Fig. 154), Woodcote Park, Surrey, Stratfield Saye and Woburn; the chinoiserie adapted by carvers, plasterers and designers of textiles; and the gothick, partly based on engravings of medieval features and monuments, which, through giving no sense of the scale of the originals, falsely emphasized their linear and pattern-making quality, giving them a Rococo appearance. All these are discussed separately, but what is striking was the way that they were combined. It was considered appropriate to mix chairs in the French style and chinoiserie detail in glasses in a drawing-room, and Horace Walpole ordered French lacquer commodes and encoignures for his gothick gallery at Strawberry Hill (Fig. 305).[41]

Most of these threads were not fully worked out by 1760, and indeed some of the most extravagant achievements of the Rococo style date from after that, as can be seen in Luke Lightfoot's work at Claydon House, Buckinghamshire in the 1760s and the way designs by Lock, Johnson and others continued to be republished in the late 1760s and were adapted by Ince and Mayhew for the exceptionally large overmantel glass in the Red Drawing-Room at Burghley supplied in 1767–8. Thus the Neo-Classical triumph was neither immediate nor total. On the other hand, the mid-1750s saw the first signs of reaction against the Rococo: there was a new interest in the classical world beyond Rome with the publication of Robert Wood's books on Palmyra and Baalbec in 1753 and 1757, and a younger generation of architects with different interests in classical architecture and decoration inspired by Rome, Athens and Paris were returning to England, led by James Stuart and William Chambers in 1755 and Robert Adam in January 1758.

## THE CONTRIBUTION OF AMATEURS AND LADIES

Building and decorating, like gardening, were regarded as among the pleasures of life – as Lady Louisa Conolly wrote in 1761 about her new dairy at Castletown, 'Its so pleasant I think to have some work going on, that one looks over oneself.' Perhaps that was why many patrons felt happiest with architects and architect–builders of the second rank: they could draw out fluently the ideas they were given and were sound and reliable, with good local connections in the building trades, and were as full of themselves as Robert Adam, doing what they were told after matters had been discussed among friends. That can be seen above all at Holkham with Matthew Brettingham, who trained as a bricklayer in Norwich and became executant architect, and Lord Leicester as dominant patron, well

nigh a professional in matters of architecture, who was consulted over Euston and Harewood and whose influence was recognized by Robert Adam in the mid-1750s. The handful of Lord Leicester's surviving letters to Brettingham written between 1734 and 1741 show how deeply he was involved with every decision at Holkham. It is not surprising that the 'Norfolk Tour', with visits to Holkham, Houghton, Raynham, Narford and Euston, was made by many people thinking of building, among them the 4th Duke of Bedford, who was a friend of Lord Leicester, and Lord Lyttelton before they began work at Woburn and Hagley.[42]

In July 1755 (?), Lord Lyttelton wrote to Sanderson Miller:

My Health, I thank God, is much the better for my Norfolk Tour, and I have much discourse for you upon the fine things I saw there. You must take an opportunity for seeing them too; for to a man of your taste no part of England is so well worth a visit, at least none that I have seen. Lord Leicester's alone would pay you the trouble and expense of your journey.[43]

Another of Lord Leicester's friends was the 2nd Earl of Egremont (1710–63), for whom the elder Brettingham designed Egremont House in Piccadilly in 1756. There are numerous parallels in what they acquired. Marbles bought by the younger Brettingham in Italy are to be found both at Holkham and Petworth. So is the same pattern of cut velvet, similar glasses by Whittle and Norman, as well as furniture and tapestries from Paul Saunders. Such friendships and the fruit they bore are hard to reconstruct after 250 years, but clearly they were important in the making of fashion.

Among amateurs with a particular interest in interiors was Sanderson Miller (1716–80), the Warwickshire gentleman who promoted the gothick style but was also a classicist, as can be seen at Hagley. Lord Lyttelton consulted a confusing number of people, as well as having to listen to his second wife. Among them were John Chute (1701–76) of The Vyne, a proficient draughtsman who was both a talented goth, as can be seen at Strawberry Hill and Donnington Grove, Berkshire (1763), and a classicist, as in the staircase at The Vyne (1770), and Thomas Prowse (1708–67), who designed Hatch Court, Somerset (1755); and through Prowse, Lyttelton called on John Sanderson to produce the final drawings.[44]

Sanderson Miller leads on to Sir Roger Newdigate of Arbury (1719–1806). Having succeeded his brother as 5th baronet in 1734 and made a grand tour in 1738–40, he married Sophia Conyers. He may have studied architecture as a boy and certainly had lessons while in Rome, and by the mid-1740s he was a competent architectural draughtsman when he made record drawings of Old Copt Hall, his brother-in-law's house in Essex, and also designs for a new classical house there. Thus he was well equipped to make working drawings for the alterations at Arbury that he began in 1750 and continued for the next forty-five years, gradually replanning it as well as fitting it out in a developing gothick style. The first major room was the library, which was largely complete in 1754; that was followed in the early 1760s by the parlour and then by the dining-room, whose furnishing dragged on until the late 1780s. Finally came the great fan-vaulted saloon finished in the 1790s, and by then Arbury outshone Strawberry Hill as a work of architecture and decoration, although Horace Walpole never even acknowledged its existence.[45]

Strawberry Hill, however, has always been the more famous and influential place, and, while Horace Walpole cannot be counted as

an amateur architect, he was certainly an amateur of architecture, and the whole way in which Strawberry Hill grew expressed the amateur approach. In its genesis three friends were particularly important, Richard Bentley – 'a treasure of taste and drawing' as Walpole called him, but not by nature a goth; John Chute, who formed the original Committee of Taste from 1751 to 1761 with Walpole; and then from 1762, after Bentley's departure, Thomas Pitt – like Chute, an amateur architect. At the same time, a host of professional architects were involved, starting with William Robinson on the spot from 1748 to 1773 and later including Robert Adam, James Essex and James Wyatt. Robinson's hand is now the least visible, but he evidently adapted designs by Kent and Gibbs for the chimneypiece in the Breakfast Room. Over the years the house grew in stages to accommodate Walpole's expanding collections, and it developed stylistically, starting out in a completely light-hearted manner and gradually becoming more serious in intention and more original through the asymmetry of its plan, but it always remained an amateur's house.[46]

John Freeman (c.1689–1752) of Fawley Court, Henley-on-Thames was another talented amateur. His principal known work is the octagonal saloon at Honington (Fig. 81), which he designed for his friend Joseph Townshend in 1751 and had built by William Jones.[47]

One of the most original amateur architects was Thomas Wright (1711–86), the astronomer and designer of landscapes, whose importance has only been recognized in recent years. He is thought to have been involved in the late 1740s in Thomas Anson's remodelling and extension of Shugborough, with its Great Room and library (Fig. 89). However, his most ambitious new house was Nuthall Temple (Fig. 270) in Nottinghamshire, the last and freest of the eighteenth-century versions of Palladio's Villa Rotunda, which he built in 1754–7. There he created sequences of rooms of complex shapes: the entrance portico in antis led into a shallow vestibule and then into a central octagonal hall, which rose the full height of the building: it had a gallery at first-floor level carried on a ring of columns and elaborate ironwork by Robert Bakewell (Fig. 271). The walls had lavish plasterwork by Thomas Roberts completed in 1769. Beyond the Octagon was the saloon, which had a proto-Adam plan of a central projecting bay on the main axis and screens of columns at either end.[48]

If amateurs helped to mould the character of English design throughout the first half of the eighteenth century, ladies seem to have become increasingly influential during the second quarter. Their letters and journals, which survive from the 1740s onwards, give a new degree of detail about life. Among the most vivid are those of Mrs Delany, who was born in 1700 and became free after the death of her first husband in 1724: although never rich, she was well born, intelligent and observant, artistic in a practical way and someone whose company was eagerly sought by all who had the good fortune to know her, from King George III and Queen Charlotte downwards but particularly by the Duchess of Portland. Mrs Lybbe Powys began her journal in 1756. Lady de Grey, who was born in 1722, wrote many letters from the time of her marriage in 1740. Another invaluable series of letters are those between the daughters of the 2nd Duke of Richmond: Caroline, who married Henry Fox, later Lord Holland; Emily, who married the Earl of Kildare, subsequently Duke of Leinster; Louisa, who married Tom Conolly of Castletown; and Sarah, who married Charles Bunbury

*Nuthall Temple, Nottinghamshire,
designed by Thomas Wright and built
in 1754–7.*

270. The plan of the ground floor from
Vitruvius Britannicus *showing the
sequence of spaces from the portico
through the octagonal hall to the saloon
with a bow and two screens of
columns. Now demolished.*

271. *The central hall. The ironwork
was by Robert Bakewell and the plas-
terwork by Thomas Roberts was added
in 1769.*

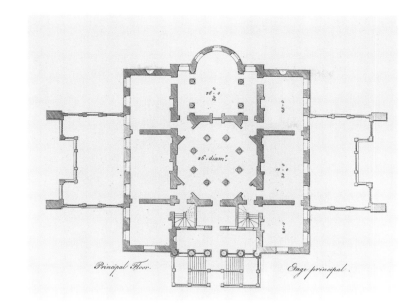

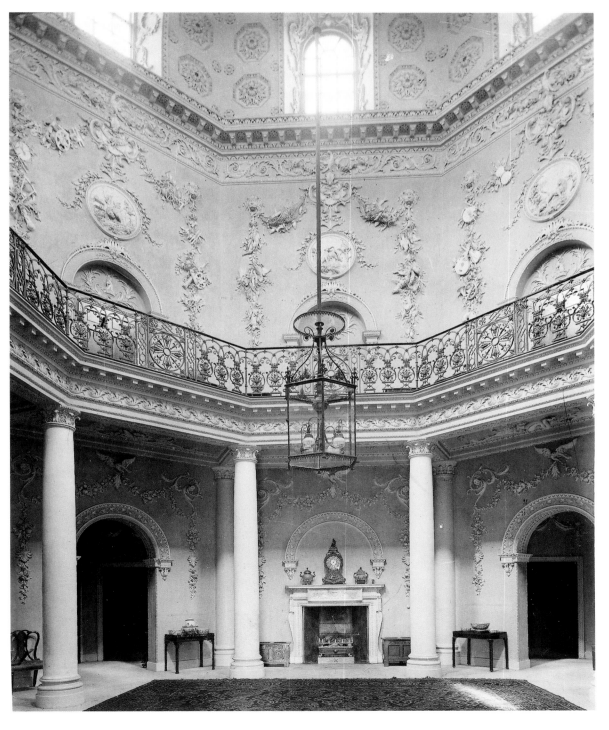

272. *Engraved* Picture frames for Print Rooms *by Francois Vivares, 1754. They were among the prints used in the dining room at Rokeby and by Lady Louisa Conolly for her Print Room at Castletown.* Chippendale Society.

and then George Napier; so linking Holland House in London and Carton and Castletown in Ireland.[49]

Wives did not always agree with husbands, as appears in the correspondence relating to the building of Hagley in the 1750s. The most absurd example could be found at Castle Ward in Co. Down, where in the early 1760s Bernard Ward, later 1st Lord Bangor, and his wife, the former Lady Anne Magill, could not agree on the style for their new house, so one half is classical and the other gothick. Not surprisingly, they parted soon after it was built.[50]

The first time a circle of intelligent, visually minded ladies seems to have come together was in the household of Queen Caroline, a much underestimated figure, who died at the age of fifty-four in 1737. Apart from having the Duchess of Dorset, the wife of the 1st Duke, as Mistress of the Robes, the Queen had six Ladies and six Women of the Bedchamber. Among the Ladies was the Countess of Pomfret, who was pretentious about intellectual matters and seemingly rather a goose: Horace Walpole made fun of her sense of humour and her 'paltry air of significant learning and absurdity'. On the other hand, she saved part of the Arundel Marbles, which she gave to the Ashmolean Museum at Oxford, and built Pomfret Castle in Arlington Street in the gothick style, with interiors of exceptional quality that aroused the jealousy of Horace Walpole, who lived almost opposite her. She was a close friend and correspondent of Lady Hertford, later Duchess of Somerset, who seems to have shared her gothick tastes, and their letters to each other were published as early as 1805.[51]

One of the Women of the Bedchamber was Henrietta Hobart, the daughter of Sir John Hobart of Blickling and first wife of Charles Howard, later Earl of Suffolk, a mistress of George II and a friend of Pope, who is now remembered as the builder of Marble Hill (Fig. 77). She is one of the people in the *Tea Party at Lord Harrington's House* (Fig. 5). A subscriber to *Vitruvius Britannicus* III and Kent's *Designs of Inigo Jones*, she had a real knowledge of architecture. In 1724, two years after work had begun on Marble Hill, Mrs Campbell, whose husband later became 4th Duke of Argyll, wrote to her: 'How does my Good Howard do? Methinks I long to hear from you; but I suppose you are up to the ears in bricks and mortar, and talk of freize and cornice like any little woman.' Even Lord

Chesterfield consulted her when he wanted to add a room to the embassy in The Hague.[52]

Ladies who were significant patrons tended to be heiresses. Among them were Lady Oxford, the daughter of the 1st Duke of Newcastle and wife of the 2nd Earl of Oxford. It was thanks to her generosity and good will, as well as that of her daughter, the Duchess of Portland, that her husband's great collection of manuscripts was sold to the nation for a nominal £10,000 to form the Harleian Collection in the new British Museum. After the sale of Wimpole and her husband's death in 1741, Lady Oxford lived in her own house, Welbeck Abbey, devoting the last fourteen years of her life to its remodelling. Although only part of her work remains, most of her Gothick Hall with its ambitious fan vault (Fig. 300) survives as arguably the earliest major interior of its type, begun soon after 1747 and completed in 1751.[53]

Her even more talented daughter, Margaret, who was born in 1715, married the 2nd Duke of Portland. 'A lovely gifted woman, with an active mind, varied interests and a great deal of energy' and happily married to an unremarkable husband, she was interested in many different forms of natural history, botany, entomology and animals, keeping a menagerie at Bulstrode. Not only is the Portland Vase named after her, but so is a rose and a moth. She was a patron of George Ehret, from whom she commissioned 1,000 botanical drawings, a friend of Pope, Swift and Garrick and knew Rousseau; but she comes across most vividly in the letters of Mrs Delany, who has left a vivid picture of life at Bulstrode. She was a passionate collector of pictures, gems, snuff boxes, shells and curiosities, and after her death their sale in 4,156 lots spread over thirty-six days.[54]

Among other heiresses who left their mark on their houses was Lady Leicester, one of the daughters of the 6th Earl of Thanet and wife of the builder of Holkham. Not only did her inheritance help her husband to start work in the park at Holkham in 1729, but it was due to her management of everything at Holkham in her husband's last years and then to her persistence and expenditure of her own money as well as his after his death that the great enterprise was eventually completed in 1765.

The Duchess of Norfolk, the wife of the 9th Duke, was a coheiress, and, while her fortune may have been modest, its very existence may have given her a degree of self-confidence and independence that made her the dominant figure in their marriage and in the building of both Norfolk House in St James's Square in London and a vast unfinished palace at Worksop in Nottinghamshire. Evidence of her skill as an embroiderer can be seen in the hangings that she made for her bed at Norfolk House.

The Duchess of Beaufort, who married the future 4th Duke in 1740, was born Elizabeth Berkeley of Stoke Gifford, which she eventually inherited in 1770 on the death of her brother, Lord Botetourt. While the Beauforts employed Kent on the exterior of Badminton and to design Worcester Lodge in the park, they also went to William and John Linnell to furnish the Chinese Bedroom (Fig. 340), a contrast in mood that suggests the involvement of the Duchess. Certainly as a widow she was a formidable figure, Horace Walpole calling her the Dowager Duchess of Plantagenet or Broomstick. In the early 1770s, when she was in France, she tried unsuccessfully to persuade her son to buy a set of Gobelin tapestries, and, when in Rome, she bought from James Byres a handsome chimneypiece that is still in the drawing-room at Badminton.

Such well-connected ladies seem to have responded quickly to

novelties in decoration, improved or inexpensive new materials such as wallpaper and papier mâché, and imaginative ideas such as print rooms. The first person to have a print room, for instance, seems to have been Lady Cardigan, the wife of the 4th Earl: in 1742 she bought eighty-eight Indian pictures and employed Benjamin Goodison to paste them all over the walls of a dining-room.[55]

Sometimes ladies made their own print rooms, as Lady Louisa Conolly proposed to do at Castletown: in 1762 she wrote to her sister Caroline to thank her for prints from London, saying that 'I have not had time to do my print room yet'. She asked for more prints in 1768, and by 1773 the room was finished.[56]

For borders she used some of those by Vivares and also some of the game trophies after Huet originally published about 1750 (Fig. 272). Vivares must have specialized in the trade, because the title page to the Huet set described it as 'A new Book of Hunting Trophies properly adapted to the new method of ornamenting rooms and screens with prints'. Vivares borders published on 15 March 1754, are found in the Print Room at Rokeby, which was part of the alterations begun by Sir Thomas Robinson in 1753 and so probably the earliest surviving example. A catalogue of Vivares prints dating from the 1760s concluded: 'To be had all sorts of the best borders, festoons and trophies etc likewise all sorts of prints for hanging rooms'.[57]

An alternative to pasting prints directly on the wall, or glazing and framing them, was to mount them on stretchers and give them printed borders. Inevitably, few have survived in good condition, but one house where they are to be seen is Burton Constable. Mrs Delany described how to deal with them in a letter to her brother in 1751:

> I have received the six dozen borders all safely, and return you, my dear brother, many thanks for them. They are for framing prints. I think them much prettier than any other sort of frame for that purpose and where I have *not* pictures, I *must* have prints; otherwise I think prints best in books. The manner of doing them is to have the straining-frames made as much larger than your print as will allow of the border, the straining-frame covered with coarse cloth, the print pasted on it, and then the borders, leaving half an inch or rather less of margin round the print. Mr Vesey has a room filled with prints made up in that way, and they look very well.[58]

Ladies' work, of course, extended far beyond the sewing and needlework done by Mrs Delany, the Duchess of Norfolk and the Countess of Berkeley. The latter worked the splendid heraldic covers for a long settee, two short settees or armchairs and four side chairs with gilded frames and shaped backs close to the manner of James Moore, father or son, and presumably dating from the mid- to late 1720s that are now at Berkeley Castle (Fig. 273). Lady Berkeley, born Elizabeth Drax, married the 4th Earl in 1744 and on the back of the long settee are displayed the arms of Berkeley impaling Drax three times and once on the side chairs with the arms of Berkeley on the armchairs: one is initialled 'EB' and dated 1749.[59]

As an alternative to needlework, the Duchess of Norfolk used to cut out birds from Chinese wallpaper to thicken up other papers, as Lady Mary Coke described in 1772: 'I called on the Duchess of Norfolk, who was I found sorting butter-flies cut out of india paper for a room She is going to furnish'. Lady Hertford in one of her letters to Lady Pomfret wrote: 'Within doors we amuse ourselves (at

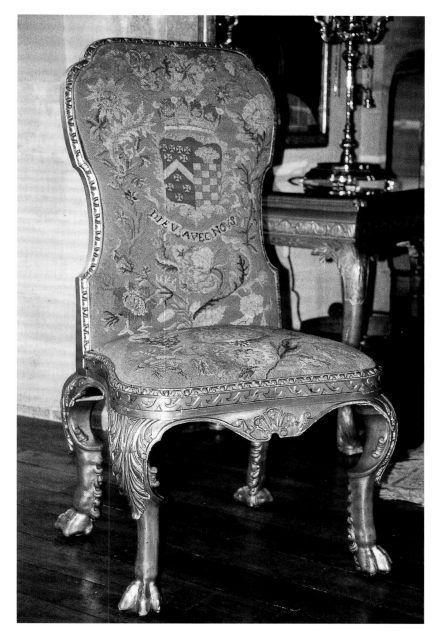

273. *A chair from a set of gilt seat furniture at Berkeley Castle, Gloucestershire. They are close to the manner of James Moore and dating from the 1720s with heraldic covers of the arms of Berkeley impaling Drax worked by Elizabeth Drax, who married the 4th Earl of Berkeley in 1744. One is initialed 'EB' and dated 1749.* Private collection.

the hours we are together) in gilding picture frames, and other small things: – this is so much in fashion with us at present, that I believe, if our patience and pockets hold out, we should gild all the cornices, tables, chairs, and stools about the house.'[60]

A remarkable survivor of this combination of eye and energy is the Countess of Darlington's carpet at Raby Castle, Co. Durham (Fig. 274), which is one of the most ambitious carpets dating from the mid-century. Lady Darlington, born Lady Grace Fitzroy, daughter of the 1st Duke of Cleveland and wife of the 1st Earl, is not apparently recorded by contemporaries as an especially talented needlewoman, and yet her name is attached to a huge carpet measuring 26 feet 6 inches by 17 feet wide (and so big that it is impossible to photograph the whole from a scaffold). It was under way in 1745, because in the steward's account book for that year there are two payments for wool – on 27 April a sum of £2 17s. for '20d. of Worsted at a Sale for the Great Carpet' and on 10 May £4 6s. 6d. to

274. *The Countess of Darlington's carpet at Raby Castle, Co. Durham, made in the mid-1740s and possibly designed by Daniel Garrett using French ornament prints.* Lord Barnard.

'Thos: Hill by a Bill for Worsteads for the Great Carpet'. There is no clue as to who designed it, but he appears to have been familiar with architectural and French ornament and possibly used to designing plasterwork; and at Raby it is tempting to suggest that he could have been Daniel Garrett. If so, that makes it an interesting precursor to the carpets made by Passavant and designed by Robert Adam for Moorfields and Axminster.[61]

The influence of ladies was particularly evident in the way that their dressing-rooms were used and decorated as sitting-rooms, comfortable, informal and intimate – and hopefully warm. Here

again, Mrs Delany is a source of evidence. When she stayed at Bulstrode with the Duchess of Portland in 1738, she recorded how

> by half-an-hour after six we are in the dressing-room, armed with pen and ink, and the fair field prepared to receive the attack. Then comes Lady Elizabeth, Lady Harriott, and the noble Marquis; after half an hour's jumping, they are dismissed, and we soberly say, 'Now we will write our letters.' In comes the Duke, '*the tea stays for the ladies*:' well, we must go, for there's no living at Bulstrode without four meals a day . . .

And later, in 1754, 'After Dinner our Duchess and I hold a tete a tete in the dear dressing-room till five; then all hands to work till between six and seven, then tea, and we return to the dressing room, and I read whilst the rest work. We are now in a course of Beaumont and Fletcher's plays. . .'[62]

The informality and the way that other children joined their mother is well captured in Lady Kildare's letter to her husband in December 1762, from Carton:

> But I have a cheerful and pleasant prospect before my eyes within doors; the dear little brats are, thank God, so well, so merry, so riotous, so hardy, and so full of play from morning till night that it wou'd enliven the dullest of mortals to see them. The two nurses, Milburn and Glexton, are the best play fellows for children I ever saw; they invent some new diversion every night, they play and romp in Lady Kildare's dressing room, and I sit in the Indian paper drawing room (Fig. 347), so I have them or not just as I like; Henry naked is the dearest little being on earth.[63]

The dressing-room was a centre of life, and, because it was used a great deal, was a room that needed frequent attention. It also lent itself to its occupant expressing her fantasy in its decoration and furnishing.[64]

That can be gathered from Mrs Delany's references to the periodic redecoration of the Duchess of Portland's dressing-room, and from what survives of Lady Strafford's at Wentworth Castle. The latter brings to life Arthur Young's description: 'Her Ladyship's reading closet is elegant, hung with a painted sattin, and the ceiling in Mosaics festooned with honeysuckles; the cornice of glass painted with flowers. On the other side of the dressing-room is a bird closet in which are many cages of singing birds.' The Duchess of Northumberland gave more detail of the apartment in 1766: the bedroom

> is square hung with Blue and White Chinese Paper, the Chimneypiece is porphyry with ornaments and Medallions of Statuary Marble. It is lighted by a large Venetian window. The Frize is of Gold with Ornaments of Blue; the Ceiling (which still survives) is Wreaths & Garlands of Blue heighten'd with Gold, with festoons at the Angles. Within is her Closet, which has an arch'd Cieling painted Blue with a Trellis upon it with a Honeysuckle running all over it (Fig. 275) and the Floor is inlaid with a pretty figure. The hangings Straw Colour Sattin painted with sprigs of natural flowers. French chairs embroidered with flowers upon Brown by the famous Mrs Brown.

No interior as fanciful as that survives today in England, and so a complete dimension of decoration has been lost.[65]

275. *The ceiling of the Countess of Strafford's dressing room at Wentworth Castle, Yorkshire, 1750s. A trellis with trailing flowers against a dark blue sky ground. The cornice was decorated with painted looking glass and the walls were hung with straw colour satin painted with sprigs of natural flowers.*

## PLANNING AND THE GROWTH OF COMFORT

'It is an unalterable Decree of the fates that Grandeur and Comfortableness must not dwell together. My wife mourns and says she shall be blown away and starv'd to Death; but She as well as the rest of the world must submit to the laws of the goddess *Taste* who is now the *Great Diana* of England.' So wrote Lord Lyttelton to Sanderson Miller in 1753, when they were considering plans for the new house at Hagley.[66]

The growth of the influence of ladies was paralleled by a growth of interest in comfort, intimacy and privacy, light and informality in houses; and there was a move away from the Baroque concern for parade and progression, while seriously allegorical decorative painting went of fashion. It is impossible to prove the connection through documents, but it is hard not to relate them and see them coming together in the flourishing of the villa form as the basic type of country house after 1740. So, although attention has concentrated on the Palladianizing of English taste following on from the intellectual and political pursuit of Palladianism by Lord Burlington in the 1720s, surely there is another way of looking at the spread of the villa, as an architectural response to changing ways of living?

There are a number of interlocking changes to be considered.

276 and 277. *The plan of the main floor of Wallington before and after its remodelling by Daniel Garrett in the early 1740s. The moving of the entrance to the side of the house meant that the three principal rooms had views over the landscape undisturbed by the arrival or departure of visitors.*

First is the disappearance of the two-storeyed hall from new houses, except on rare occasions in great houses as at Kedleston. Second is the increasing separation of day rooms and bedrooms, so that, except in very large houses, bedrooms retreated from the main floor, and everywhere the great dining-room dropped out of use. At the same time, the common parlour tended to lose its dual use as an eating room and sitting-room, becoming solely a sitting-room, while the great parlour tended to disappear as the dining-room became larger and more formalized. At the same time, the drawing-room tended to increase in size to match the dining-room, while becoming more formal and feminine as the dining-room remained masculine, so that the rooms balanced and complemented each other. Libraries also became larger and more accessible and were often used as informal sitting-rooms. Glazing bars became thinner and panes of glass larger so that windows let in more light. No one

house illustrates all those points, and of course there are exceptions, but a house of the 1750s had a different character as well as a different style from one of the 1720s. It is striking how many houses built at the end of the seventeenth century were turned round in the 1740s and 50s, with new entrances being formed so that arrivals and departures did not disturb the view from the main rooms, and houses gained a large room for company.

That can be seen at Stanford (Fig. 7), and at Wallington (Figs. 276, 277), which was replanned and redecorated about 1740 by Sir Walter Calverley Blackett with the aid of Daniel Garrett. On the east side they made a new entrance front, with the old open way through to the courtyard being closed to become a narrow vestibule. That led into a new corridor running round three sides of the courtyard, but no attempt was made to create a spacious entrance hall. The north side of the court remained virtually untouched as the office range, while the main staircase was removed from the west range and rebuilt on the south side of the court, improving circulation and making a better principal guest apartment on the ground floor of the west range, with an ante-room, bedchamber and dressing-room. To the south of the vestibule there was a parlour for everyday living, while the south range, which had contained the original great hall, was remodelled, with the old hall being reduced in size, made central and double height to form a festive saloon with a coved ceiling (Fig. 278). It is a particularly beautiful room, relying on plaster ornament by Pietro Lafrancini both in the cove and on the walls, where it originally framed four oval looking-glasses, two on the window piers and, unusually, two facing them (now converted into china cabinets). That was flanked to the west by a drawing-room made out of the old parlour (now the library) and to the east by a matching dining-room made out of two rooms and connecting with the parlour. Thus ladies in the drawing-room did not hear the gentlemen in the dining-room. At the same time, all three rooms had an unimpeded view over the rolling landscape.[67]

Another revealing remodelling of the mid-1750s is that at Arniston, where John Adam completed the house that his father, William, had begun to transform in the 1720s and the family left unfinished in the early 1730s. William Adam had designed a spatially complex but well-thought-out house (Fig. 31) for Robert Dundas, with an everyday entrance in the east link, a double-height hall (Fig. 30), as we have seen, an eastern third for daily living with a parlour and family apartment, a new great parlour and evidently a drawing-room and second apartment on the west side; above the latter was to be a great apartment consisting of a double-height great dining-room and drawing-room, leading to a single-storey principal bedroom over part of the great apartment; and finally on the second floor the noble library (Fig. 86) over the double-height hall. However, the western third was left either unbuilt or unfinished for over twenty years, and by then the idea of a raised great apartment was out of fashion. What was required was a dining-room and drawing-room on the main floor. They were provided by John Adam, but the drawing-room was larger, as a room for company. The latter took a long time to complete: unusually, it was hung with a Chinese paper, of which all trace has been lost; but its original gilt pier-glasses and pier-tables, perhaps by William Mathie, survive in the house, as does its very fine English carpet that is similar to examples at Dumfries House and Petworth.[68]

A striking feature of new houses of the 1750s is that they display a greater awareness of spatial variety in their plans and the shapes of

individual rooms. The origins of that can be traced back to the beginning of the century, to Hawksmoor's Orangery at Kensington Palace and the gallery he and Vanbrugh designed at Blenheim; and Vanbrugh became increasingly interested in the relationship of shapes of rooms and complex forms in the years before and after 1720, as can be seen particularly in his designs for Eastbury and Seaton Delavel. Lord Burlington's approach was rather different in that he adapted spatial concepts derived from antiquity, as can be seen in the gallery and Summer Dining-Room at Chiswick; and Kent adopted a more pictorial treatment in the hall (Fig. 441) at Holkham and staircase at 44 Berkeley Square (Fig. 234). However, there seems to have been little interest in the circles and ovals found in French plans or in the graceful sweep of French staircases, and there are few rooms to compare with the tripartite Long Room at 12 North Audley Street or Garrett's proto-Adam proposal for the library at Kirtlington (Fig. 399) with semi-circular ends and screens of columns.[69]

Thomas Wright was one of the first designers to take on Kent's interest in space. As we have seen, not only did he begin to give elevations more complex outlines, as in the double-height bows at Shugborough and Horton, but he devised complex rooms like the library, the Menagerie at Horton (after 1739) and the Root House in the park at Badminton. Isaac Ware used single-storey bows at Wrotham in 1754, but did not design complex rooms. Thus there is nothing to compare with Vardy's Palm Room at Spencer House (Fig. 239).[70]

If William Talman was the first classical architect to build a new house with a central canted bay to contain a room with bowed ends, at Panton Hall, Lincolnshire, about 1719, the year of his death, Vanbrugh was the first designer to make use of bows in new buildings, as can be seen initially at Blenheim (Fig. 355). There, it may have been at the suggestion of the Duchess, or Vanbrugh may have got the idea in France, or from an increasing appreciation of Elizabethan and Jacobean houses and a desire to handle them sympathetically. That was taken up not only by Kent in his bays at Esher Place (Fig. 232) in the early 1730s, but also at Ham, where the seventeenth-century bays on both fronts were rebuilt by the 4th Earl of Dysart with the aid of John James in 1742–4; in Sanderson Miller's bay windows at Radway Grange and at Arbury; at Wimpole, which Flitcroft began to refront for the Earl of Hardwicke in 1742, as soon as he had bought it from the Oxfords; at Milton, where Flitcroft began an extensive remodelling of the old house for the 3rd Earl Fitzwilliam in 1750; and at Hartwell, which was recast by Henry Keene in the late 1750s. The continuity of thinking is also strong at Newburgh Priory in Yorkshire, where the 4th Viscount (and later 1st Earl of) Fauconberg, after working away slowly at the house from the 1720s, had to rebuild the centre of the old house after a fire in 1757. He retained the idea of the twin Jacobean bow windows recorded in a seventeenth-century picture and incorporated it into a double-bowed villa containing a large dining-room with a buffet and a smaller drawing-room.[71]

The real change in thinking was brought about by a younger generation of architects, who introduced a new freedom and sophistication to the planning of houses. James Paine (1717–1789) and Robert Taylor (1714–78) were the key figures, but Paine, although three years younger, got going first, in the north of England. Starting as clerk of works at Nostell Priory in 1737, he took on the decoration of the interior in the late 1730s and early 1740s and had his first public success with the Doncaster Mansion House, which

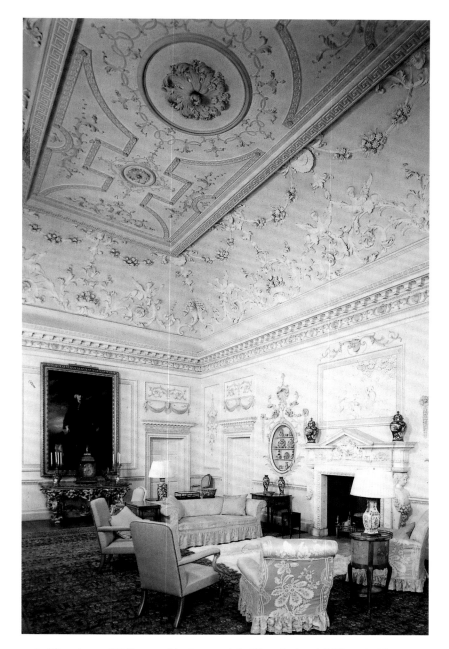

278. *The saloon at Wallington with plasterwork by Pietro Lafrancini. The paler blue ground to the cove is old and the walls were originally painted in a similar way, but, when they had to be repainted in the late 1960s, the colours were reversed because it was felt that new blue walls would overwhelm the cove. The oval 'niches' were originally filled with looking glass so matching those on the window walls.*

he designed in 1745 and had ready for opening in 1749. That year, it seems, the painter Francis Hayman introduced him to William Wyndham of Felbrigg, who commissioned him to alter the old house (Figs. 424, 425), while the Mansion House soon led to a number of commissions completing or altering houses in that neighbourhood. Thus from the mid-1750s he was designing new villas and rather larger villas-with-wings, among them Serlby, Nottinghamshire and Gosforth in 1754; Belford Hall in Northumberland in 1755; Axwell, Co Durham, in 1758; Stockeld, Yorkshire in (1758 and Bywell, also in Northumberland, about 1760). They were the imaginative houses, with a series of exciting staircases invariably centrally placed.[72]

The plan of Serlby was particularly inventive: the five-bay main block had a small hall, 16 by 14 feet, flanked by a drawing-room 20 by 20 feet and a larger dining-room 30 by 20 feet. Behind the hall

was a circular staircase hall with the stairs curling round; and beyond that a big saloon, 36 by 24 feet and 18 feet high, two feet higher than the other main rooms. In the link to the left was a drawing-room, with a family apartment beyond in the wing, and they were balanced on the other side by a library and a study for the owner.[73]

At Gosforth, Paine planned a three-storey house, with the main rooms on the first floor. His published plan shows on the ground floor a vestibule and on the right 'a common sitting room' 35 feet 9 inches by 23 feet 9 inches, and on the left the master's study. On the main floor was an ante-room, dining-room and drawing-room, which led through to the 'best bedchamber' and dressing-room. At Belford a flight of steps led up the hall; to the right was the dining-room, with a breakfast room behind, and on the left the drawing-room with a bedchamber behind.[74]

Paine, having apparently trained at St Martin's Lane Academy, was a fluent draughtsman with a feeling for ornament and decoration, as can be seen in his early interiors at Doncaster Mansion House and in his designs for Felbrigg (Fig. 426) and Gopsall. He had an eye for plasterwork and its relationship to painting, and he was interested in furniture, as can be seen in drawings at Nostell (Fig. 59) and at Felbrigg and what was produced from them (Fig. 434). Thus it is not surprising that he had great success, particularly in the north of England.[75]

For Taylor, having trained as a sculptor under Henry Cheere and then studied in Rome, the start came slightly later, but from the mid-1750s he, too, designed original villas, starting with Harleyford (Fig. 90), Danson Hill, Kent, Asgill House, Richmond and Barlaston Hall, Staffordshire, which is attributed to him. In all these houses, bays and bows add not only variety to their exteriors but interest to interiors, improving their lighting and giving them more varied views out on to landscapes that no longer depended on symmetrical axes. Those views increased the sense of contact between interiors and settings, which was also encouraged by the increasing size of panes of glass, the lightening of glazing bars and their being painted white.[76]

Two other architects who also need to be borne in mind for their interiors in the 1740s and 50s are John Sanderson and John Vardy, who has already been mentioned on page 191. Sanderson's career in fact started in the early 1730s, when he designed the short-lived Stratton Park, Hampshire, illustrated in *Vitruvius Britannicus*, for the 4th Duke of Bedford, who married Lady Diana Spencer, one of the daughters of the Duke of Marlborough, and succeeded in 1732. In the 1740s and 50s his particularly well-drawn designs for interiors, like that for a Pantheon-like interior in the British Architectural Library, show his growing sympathy for the Rococo style; while those for Kirtlington (Fig. 404) show an unusual ability to adapt his schemes to the particular gifts of the artists and craftsmen with whom he hoped to work and a particular interest in incorporating paintings into schemes of decoration. There are pointers to a Sanderson circle involving William Hallett the cabinet-maker, Charles Stanley, the Anglo-Danish sculptor and stuccadore who specialized in reliefs, and his still unidentified ornamentalist. Comparisons of Sanderson's Kirtlington designs and work attributed to him at Langley Park (Fig. 316) raise the possibility that he may have been involved with Stanley in the hall at Honington in the early 1740s, and in the late 1740s with William Perritt, the English plasterer, at Farnborough (Fig. 260), both houses being in the vicinity of Kirtlington. Later, in 1754, he was introduced to the Hagley project as a draughtsman by Thomas Prowse, and it seems that a

good deal of the success of the house may stem from his now-lost drawings for its interior.[77]

Interiors and decoration in the north of England had a vitality of their own that drew on the tradition of craftsmanship that had been strong in York since about 1700. Daniel Garrett had developed a northern practice, and then James Paine, and they were joined by John Carr (1723–1807). Carr's skill in his early years is well demonstrated at Heath Hall, Wakefield, where about 1754 he enlarged a three-bay house into a five-bay block with wings ending in canted bays on both main elevations. The finest room, now called the drawing-room, fills one complete wing. It has rich Rococo stucco decoration, possibly by the elder Joseph Rose or Thomas Perritt, and should perhaps be regarded as a Great Room. The three windows in each of the bows fitted within the canted bays have round-headed windows and are set in arches with pilasters and cornices, and the idea of arches and cornices continues round the room, with the long side walls having shallow arcades which could have been inspired by the early design for the Marble Parlour at Houghton as illustrated by Ware in 1731 (Fig. 216). It is an imaginative conception and richly ornamented in a way that overcame the need for large pictures.[78]

Carr was also a designer of handsome staircases, as can be seen at Lytham Hall, Lancashire, begun in 1757. There, the hall door leads under an Ionic screen into the body of the staircase hall, where a single flight leads up to a Venetian window framed by Corinthian columns, where it divides and returns to the landing with a matching order of columns. The Venetian window motif is repeated on a smaller scale and in the Ionic order framing the entrance to the principal bedroom. The ceiling over the staircase has a deep coffered cove with a central medallion of Jupiter the thunderer framed in an octagon of Rococo ornament, possibly by Cortese.[79]

These architects all combined spatial variety with symmetry in their planning, but the increasing interest in additions and alterations also encouraged a freer approach and that was taken up in a fresh way when Horace Walpole added the gallery, Round Drawing-Room and Tribune to Strawberry Hill in the early 1760s and apparently for the first time developed a deliberately asymmetrical plan (Fig. 303).

## THE CHANGING BALANCE OF THE UPHOLSTERER AND CABINET-MAKER

One of the most significant changes for interiors in the middle of the century was in the relative importance of the upholsterer and cabinet-maker. Indeed, the word 'furniture' gradually changed its meaning: at the beginning of the period it meant what would now be called upholstery, but then gradually took on its modern meaning of frames or carcasses, made of wood and sometimes incorporating upholstery.

One way in which the change can be sensed is in the development of printed designs for furniture that started to be published in England in the late 1730s and 1740s. The first were wild designs for chairs and tables by Brunetti in his *Sixty Different Sorts of Ornament* (Fig. 35) that look like the thoughts of a decorative painter who had worked in the theatre. Then in 1739 William Jones in his *Gentlemen or Builder's Companion* included usable designs for tables and glasses (Fig. 265) that were much closer to the spirit of Gibbs than Kent. The following year, Batty Langley in his *City and Country Builders and Workmans Treasury of Designs* included chests on stands, bookcases and tables copied or adapted from prints by Pineau or taken from

Mariette's *Architecture a la Moderne*. Delacour published designs for chairs with pierced backs in 1741, and in 1744 Vardy produced *Some Designs of Inigo Jones & William Kent* (Fig. 230). The first designs for carved work were Matthew Lock's *Six Sconces* of 1744 followed by his *Six Tables* of 1746. While Vardy's book was in the nature of a tribute to Kent and Lock's etchings it must have been partly an advertisement for his own work as a carver, the very existence of this group of prints points to developments in the furniture market, new demands and new opportunities. They prepared the way for the then still obscure Thomas Chippendale's own much more ambitious and comprehensive piece of self-advertisement in 1754, *The Gentleman & Cabinet-Maker's Director* in which he boldly described himself as 'Cabinet Maker and Upholsterer'. That must have been novel, because even the previous year in *The General Shop Book: or, The Tradesman's Universal Direction* the author wrote that the upholsterer 'makes up most of the furniture of a dwelling house, and puts it up, especially the beds, hangings and curtains, and employs a great many tradesmen, as the cabinet-maker, skreen-maker, chair-carver, glass-grinder, and frame-maker'. Yet the situation was changing before that, because Sir James Dashwood's payments in his account book for Kirtlington distinguish between those to John Gill of Maddox Street, Hanover Square, his upholsterer, and William Hallett, his cabinet-maker, and those to Hallett were invariably larger.

Upholstery was becoming simpler. That can be seen on the grandest scale by comparing the Blenheim inventory of 1740 describing the Duchess of Marlborough's work, partly planned in the second decade of the century, and that of Houghton compiled five years later, describing work of the late 1720s and early 1730s. The gold and silver trimmings in particular would have tarnished and that explains why in 1752, when the Duchess of Northumberland went to Blenheim, she thought 'The furniture of the House in general is both old fashioned & shabby'.[80]

However, the change was not yet complete, because at Houghton all the parade rooms except for the Marble Parlour were hung with either material or tapestry. But with the passing of the great house and of great apartments in the 1740s and 1750s, the practice of hanging suites of rooms with materials and tapestry declined. The main rooms at Holkham are a rare example dating from the 1750s, but there the concept dated back to the late 1720s and 1730s. Woburn is another, but there it seems that the Duke of Bedford was being consciously traditional, not only preserving old features of the house but creating rooms that expressed his high rank in a traditional, almost old-fashioned, way.[81]

Wallpaper provided a cheaper and effective alternative, and so the gallery at Temple Newsam (Fig. 322) was hung with it rather than even a moderate-priced material like the Norwich damask used in the gallery at Houghton. When Uppark was remodelled in the late 1740s, neither of the new drawing-rooms was hung with damask, but wallpaper was chosen instead. At Felbrigg, only the Cabinet was hung, with a mixed damask (Fig. 429). At Hagley (Fig. 412), a new house of the 1750s, only the drawing-room was hung and that was done with second-hand tapestry to create a French effect. By then, damask hangings were coming to be seen as both expensive and over-formal, except in the grandest rooms. That can be gathered from the delays over the hanging of the Great Apartment at Hopetoun (Fig. 123) which was carried out eleven years after it was first measured.

The decline in hanging rooms in material also changed the balance in decoration. Again, that can be seen in the gallery at Temple

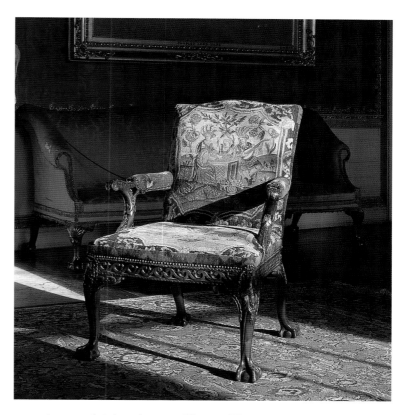

279. *A pattern chair in mahogany at Hopetoun House, possibly supplied from Edinburgh in 1758. Pattern chairs were often provided for houses far from London where there were skilled craftsmen on site.*

Newsam (Fig. 322), where the gilded seat furniture with its tapestry covers and related carved tables, stands and girandoles and the frames to the pictures are more striking than the flock paper.

It was probably more usual than is realized, particularly in houses far from London where carriage was difficult and expensive, for the owner to acquire a pattern chair from a leading London furniture-maker and then have it copied on site or locally. The earliest example at present recorded is at Holkham in 1737, when William Hallett supplied a pattern chair, which could have been intended as a model for the Family Wing. Later, in 1755, when Lord Leicester was completing the main rooms, he obtained from Vile for the high price of £8 'a Pattern chair like ye Duke of Devonshire'. Tantalizingly, neither can be identified with certainty.[82]

There is still a fine pattern chair at Hopetoun (Fig. 279), which may have been supplied by the Edinburgh Upholstery Company in 1758 at a cost of £5. It has alternative treatments of each seat rail, a Vitruvian scroll, a Greek key and diamond-paned fret. It was also was used as the basis of the set of seat furniture made for the Red Drawing-Room by Thomas Welsh, a local carver who had worked at Newhailes and then spent many years at Hopetoun.[83]

When Lord Dumfries was thinking about furnishing Dumfries House in the mid-1750s, his first idea was to get a pattern chair and two settees from London and have the rest of the chairs made in Edinburgh. But in the end he decided to get Chippendale in London to make the complete set of fourteen mahogany chairs, a pair of settees to flank the chimneypiece, a pair of card tables, three carved and gilt pelmet cornices, and a pair of large carved and gilt girandoles. But he went to George Mercer, a London carver and evidently a friend of the Adams, for the pier-tables, and to William Mathie, a Scottish carver and gilder, for the pier-glasses. His reasoning for this division is not recorded, but could it have been the risks

involved in sending fragile glasses so far? It is the size and complexity of such commissions and the amount of carving that help to explain how firms of cabinet-makers like Chippendale's came to take over from upholsterers.[84]

The change-over from the primacy of the upholsterer to that of the cabinet-maker is partly to do with the sophistication of chair-making, but also with the increasing demand for carcass furniture and for carved work for the frames of glasses with and without related tables, brackets, girandoles, pelmet cornices and so on.

Evidence about how a leading upholsterer like Bradshaw organized all the trades involved with his work is still lacking, but chair-making became an increasingly specialized skill as forms became lighter, and certain makers seem to have developed particular reputations. William Hallett, for instance, seems to have been particularly well known for his chairs from the mid-1730s onwards (Fig. 400), as was Paul Saunders in the 1750s, as can be seen at Holkham (Fig. 451), Petworth and Hagley (Fig. 414).

A maker of frames needed a skilled upholsterer to do the stuffing of seats, backs and arms that would provide a firm shape for the final covering. In recent years there has been a considerable interest in this, with old examples carefully studied and copied, so that there are a growing number of restorations that show how upholstery and frames should complement each other. Study has also brought out how much less attention English chairmakers devoted to comfort than the French, with less frequent use made of deep down-filled cushions over a padded frame. The English seem to have preferred a firm base, which probably related to the way of dressing, particularly the corsetting of ladies. There is, for instance, no English equivalent to the chairs in Jean-François de Troy's *The Reading from Molière*, where ladies are free to sink into low chairs, although Horace Walpole did mention them in the Breakfast Room at Strawberry Hill. Instead, the English seem to have relied on float tufting that holds the stuffing in place while creating a subtle rhythm. It seems to have come into use in the 1740s and become fashionable in the 1760s.

Related to chair design is that of settees, which increased in size and comfort as well as the elegance of their shape, in particular the curve of their backs and arms. At present, the earliest documented examples appear to date from about 1750, with a sofa bed at Burghley being supplied by Robert Tymperon of Stamford in 1750 (Fig. 131) and one at Nunwick in Northumberland being made by William Gomm in 1752 to take the needlework cover made by Lady Allgood. They coincide with an order of furniture from William Linnell for Sir Richard Hoare of Barn Elms in 1753 that included ten mahogany French elbow chairs costing 4 guineas each and a large sofa with a curved back and corner sections costing £12, which are now at Stourhead. About the same time, a pair was supplied for the Great Parlour at Felbrigg, probably by William Bladwell, who was paid nearly £1,000 in 1756. Evidently they were then a new form, because Chippendale omitted them from the 1754 edition of *The Director* but included the earliest printed designs in the 1759 edition. John Linnell shows one flanking a continued chimneypiece in a drawing of about 1755. There was also a pair in the Refectory at Strawberry Hill (Fig. 50), supplied the same year. They seem to have become *de rigeur* in fashionable drawing-rooms, as can be seen at Holkham (in a variety of sizes, Fig. 446), the saloon at Woburn and the gallery at Hagley. The fashion must have had a con-

siderable bearing on the way the upholstery and furniture-making trades developed in the mid-century and also on the planning and the scale of drawing-rooms.[85]

Large plates of mirror glass remained expensive and so it was quite usual to build up groups of plates, as in the Music Room at Norfolk House (Fig. 154), or add new plates to old or use old plates in new combinations, as in the drawing-room at Holkham (Fig. 456). Great imagination was shown by designers and carvers in making compositions using plates of different shapes and sizes, as at Hagley (Figs. 416, 418), Hopetoun and Halnaby. From about 1740 there was a fashion for oval glasses (Fig. 88), and designers added ornament create striking vertical compositions, as in the dining-room at St Giles's House (Fig. 57) and the Great Drawing-Room at Hopetoun (Fig. 123).[86]

At the same time, glasses started to spread round rooms, with those on the window piers balanced by others on facing walls and overmantel glasses increasing in size and elaboration. This can be best seen in schemes like the dining-room at Felbrigg (Fig. 427). Overmantel glasses increased in size and elaboration, as with the glass originally in the Chinese Bedroom at Badminton and other designs by John Linnell. In the octagonal saloon at Honington (Fig. 81) there is no space for glasses in the window bay, but unusually on the facing wall there are large glasses in parcel-gilt plaster frames in the recesses, so that there is a sense of reflected light continuing round the room. The most imaginative surviving use of looking-glass can be found in the gallery at Strawberry Hill, where the three recessed bays behind the canopies that face the windows – an idea first proposed by Richard Bentley – were finally lined with looking-glass set behind a white and gold net that framed the portraits. In the centre recess, Walpole used a panel with the Walpole crest engraved from behind, which his father must have ordered for the head of a looking-glass several years before he was given the Order of the Garter and then discarded.

If upholsterers are hard to identify because most of their work has disappeared, with furniture-makers – chair-makers, cabinet-makers, carvers and gilders – a lot has survived but most of it is hard to pin down to makers; and the picture has become confused by shaky attributions. Since Ralph Edwards and Margaret Jourdain wrote their first slim *Georgian Cabinet Makers* in 1944, a vast amount of research has been done, as can be seen from the Furniture History Society's *Dictionary of English Furniture Makers* 1660–1840, edited by Geoffrey Beard and Christopher Gilbert (1986). Even so, a haze surrounds most of the now revered names who began to emerge in the 1730s – Giles Grendey, William Hallett, Benjamin Goodison and Vile and Cobb – let alone people who have only been rediscovered in recent years, like William Gomm. Even Chippendale's career before he published *The Director* in 1754 is a blank. When a pioneering exhibition is held, like that devoted to brass inlaid furniture and the circle of John Channon in 1993, the bringing together of the pieces for the first time leads to considerable revision of thinking as well as the emergence of new pieces.

This is not the place to attempt to sort out the key makers, but the uncertainty has to be taken as evidence of the continuing dominance of upholsterers faced by rival trades as they responded to the increasingly sophisticated requirements of clients for sets of furniture for a wider range of rooms.

# 7

*The Rise of Historical Thinking*

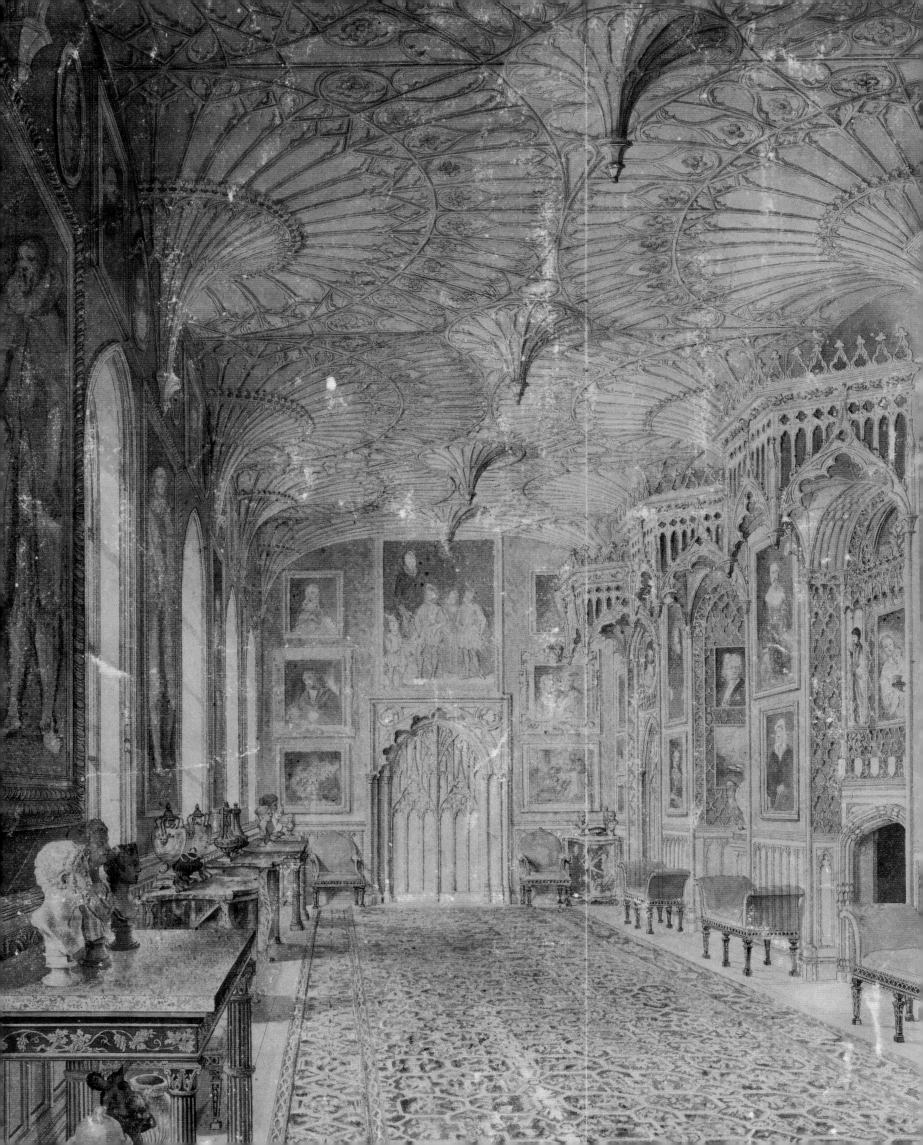

Oh. the dear old place. you would be transported with it . . . The house is excellent; has a vast hall, ditto dining-room, King's chamber, trunk gallery at the top of the house, handsome chapel, and seven or eight distinct apartments, besides closets and conveniencies without end. Then it is covered with portraits, crammmed with old china, furnished richly, and not a rag in it under forty, fifty, or a thousand years old . . . I rummaged it from head to foot, examined every spangled bed, and enamelled bellows, for such there are; in short I do not believe the old mansion was ever better pleased with an inhabitant, since the days of Walter de Drayton, except when it has received its divine old mistress. If one could honour her more than one did before, it would be to see with what religion she keeps up the old dwelling and customs as well as old servants.

So wrote Horace Walpole about Drayton – and its owner, Lady Betty Germain, one of the company in the painting of a tea party at Lord Harrington's house (Fig. 5) – in 1763, just when he was completing his gallery at Strawberry Hill.[1]

His response to the romance of Drayton is a reminder of how wide-ranging the reaction to ancient places and objects had become by the mid-eighteenth century; and how much our perception of that reaction has changed during the past forty years. Until the 1960s, it was reasonable to write about the thread of historical thinking in eighteenth-century houses largely in terms of the Gothick Revival, Horace Walpole and Strawberry Hill. The gothick style used to appear as one aspect of the Rococo, a light-hearted alternative to the French and chinoiserie styles and a foil to formal classicism. However, it is coming to be seen as part of a broader and deeper movement involving historical concerns that ran counter to the view of the classical style as flowing onward through the eighteenth century with an unexpectedly wide influence on the way houses were handled, within and without.

It brings in the awareness of the magical atmosphere of old houses like Drayton, the significance as well as the decorative possibilities of heraldry and genealogy; the collecting of historical records; the significance of the provenance of objects; the way English heroes like King Alfred and King Edward I were venerated for achievements that were seen as offering parallels to contemporary life, while both Mary Queen of Scots and Charles I became cult

figures. At Stowe, Lord Cobham's classical Temple of British Worthies, designed by Kent in 1734–5, displays busts of King Alfred and Edward the Black Prince, the latter being seen as a precursor of Frederick, Prince of Wales, and it looks across the Grecian Valley to the Temple of Ancient Virtue; while Gibbs's Gothic Temple of 1741 was dedicated 'To the liberty of our Ancestors'. Antiquarianism and archaeology were both becoming powerful influences, encouraging the compilation of illustrated books on historic buildings and encouraging the habit of visiting ancient places for pleasure, as can be seen from Vertue's notes made on his tours with Lord Oxford and the letters of Horace Walpole. It was an age of antiquaries, and as early as 1707 Humphrey Wanley, John Talman and John Bagford discussed the formation of a Society of Antiquaries, although nothing happened until two years after Talman came back from Italy in 1715.[2]

All this meant that in country, as opposed to town, houses, family history continued to play an important role. Many owners would have responded to Lady Oxford's emphasis on 'the Seat of my Ancestors' and it inspired them not only to preserve relics of the past, but to restore and recreate them. Occasionally they made careful records, like Sir Roger Newdigate's of Elizabethan features of Old Copt Hall, Essex, made in about 1744 before it was demolished. In 1740 Lady Hertford wrote to Lady Pomfret:

I think your reflexions on the modern rage for pulling down the venerable castles and abbeys which were built by our ancestors, are very just . . . I am perhaps partial to them, from the circumstance of having passed the first years of my life at Long-Leate, which I believe is allowed to be the first shell now remaining of the houses built in the reign of Edward the Sixth. Though I was only 9 years old when my father died, I still remember his lamenting that my grandfather had taken down the Gothic windows on the first floor, in one of the fronts, and put up sashes, in order to have a better view of his garden from a Gallery that occupied almost all that side of the house. As soon as the present Lord Weymouth married, and came to live here, he ordered the sashes to be pulled down, and the old windows to be restored. I flattered myself that this was a good omen of his regard to a seat which for 200 years had been the delight and pride of his ancestors.[3]

That kind of thinking encouraged owners to synthesize the old and the new and enjoy a sense of variety, preferring an old house

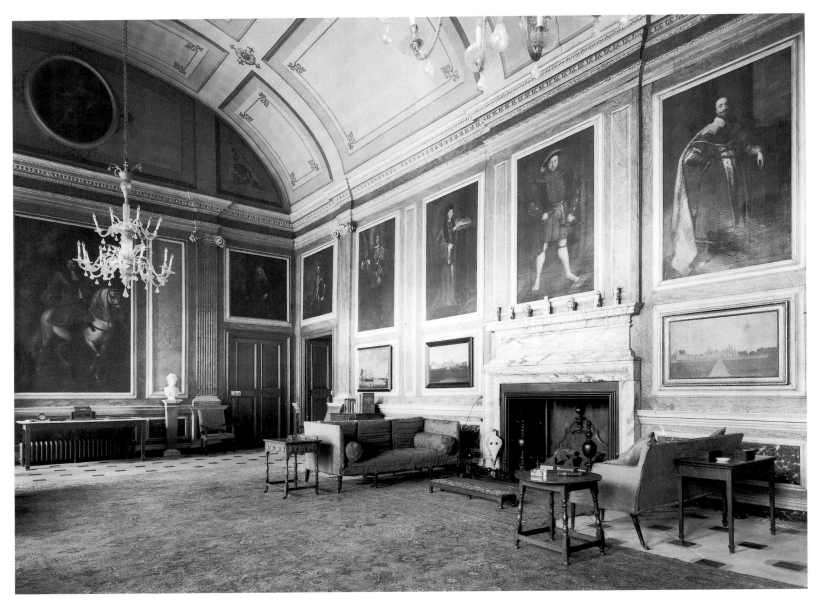

280. *Portraits of kings painted painted for the 2nd Earl of Peterborough in the Great Hall at Drayton House, Northamptonshire.*

brought up to date to a totally new one. As Lady Caroline Fox wrote soon after her husband had taken the lease of Holland House, Kensington in 1746: 'I love these old-fashioned houses.' That appreciation and enthusiasm for the past had a profound influence on the pattern of fashionable taste and so the nature of English country houses, their interiors and attitudes to them.[4]

On the other hand, it is puzzling that most enthusiasts, even Horace Walpole, seem to have had little sense of historical time and period. There does seem to have been a special affinity for the seventeenth century and the court of Charles I, as can be seen in the admiration for Van Dyck by artists and collectors and the cult of Van Dyck dress by sitters for portraits like Lord Guilford, the owner of Wroxton. At The Vyne, John Chute's fascination with his seventeenth-century ancestor, Chaloner Chute, gave rise to the Tomb Chamber adjoining the chapel, with Thomas Carter's recumbent figure based on the full-length portrait in an enriched Rococo frame now in the library. The virtuosity of late seventeenth-century craftsmanship was also admired, particularly the carving of Grinling Gibbons and the enriched plasterwork of Charles II's reign. That can be seen in the way trophies of Gibbons carvings inspired Rococo plasterwork in the saloon at Hagley (Fig. 410). At Felbrigg,

the late seventeenth-century plasterwork was preserved in the Great Parlour and embellished in the Cabinet Room when they were remodelled by Paine in about 1750 (Fig. 419). Similarly at Farnborough a seventeenth-century plaster garland on the staircase ceiling was combined with a new dome and Rococo ornament.[5]

There was a strong interest in medieval castles, and indeed, the castle-style for new building can be traced back to the revival of chivalry in the late sixteenth and early seventeenth centuries, to castle-style houses such as Bolsover in Derbyshire, Lulworth in Dorset, and Ruperra in Glamorgan. However, from the second half of the seventeenth century the connection seems to have had more to do with concepts of ancient nobility and lineage than with military architecture. Certainly that is so with the redoubtable Lady Anne Clifford, Countess of Pembroke (1590–1676), who restored her string of northern castles.[6]

Among other places with a historicist thread is Hoghton Tower, near Preston in Lancashire, where Sir Charles Hoghton's alterations between 1692 and 1702 included a new formal approach and symmetrical entrance front with battlements. The 2nd Earl of Peterborough (1623–97), of Drayton, who was deeply interested in family history and published his *Succinct Genealogies* in a limited edi-

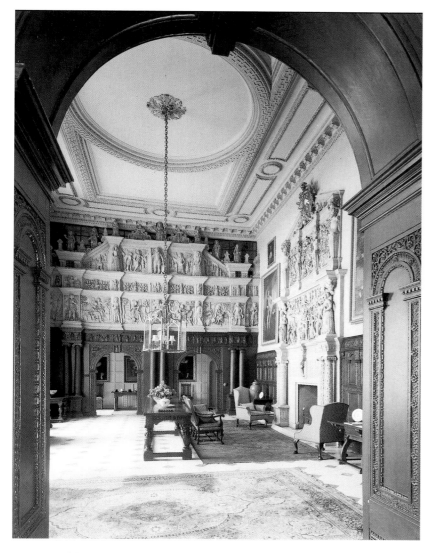

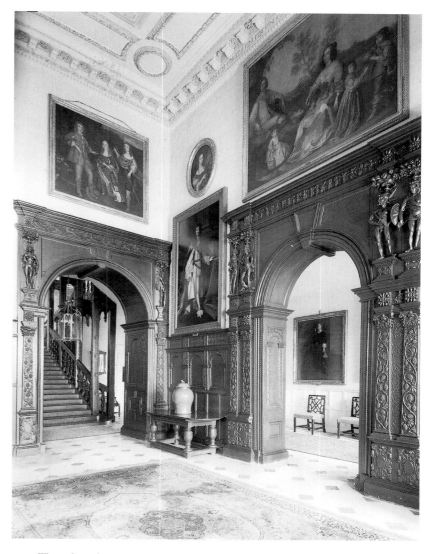

281. *The Jacobean Great Hall at Burton Agnes, Yorkshire. The view back from the east arch towards the original screen and fireplace with the overmantel added from another family house in the 1760s.*

282. *The arch on the east wall of the Great Hall at Burton Agnes was opened up about 1712 as part of the replanning of the house. At the same time the hall was enriched with Jacobean carved woodwork from elsewhere in the house and probably painted a stone white to relate to the screen.*

tion in 1688, gave the entrance front of his house a castellated screen wall that any casual visitor would take to be medieval. Inside, he had historical portraits of kings painted for the Great Hall (Fig. 280) and a set of family portraits extended for the King's Dining-Room, while in the Norfolk Room he had painted overdoors of knights in armour copied from medieval illuminated manuscripts that he had adapted for plates in his *Genealogies*. However, he was no library knight. He fought for Charles I, was wounded twice and twice went into exile, and when he tried to follow James II abroad, he ended up in the Tower of London.[7]

What Lord Peterborough did at Drayton can be compared with Lord Coningsby's remodelling of Hampton Court in Herefordshire. Before 1699, possibly as the last phase of work on the house, he restored the main front with its medieval tower and chapel, developing it in a symmetrical way with the high gate tower as the counterpart of the centrepiece of a five-part classical composition. However, his thinking was not just architectural: it was part of a passionate concern for medieval things and the way that he and his contemporaries looked to medieval history for parallels to the events of their own time. All his life he was a supporter of constitutional government, of William III and then George I. That in turn

explains his interest in King Henry IV, whom he saw as a king chosen by Parliament: he not only had what he believed to be a contemporary portrait of that king, but he got Kneller to paint a huge equestrian picture of him as Duke of Hereford. He had his own imprisonment in the Tower commemorated in a group portrait of his two daughters and himself in which he holds a charter granted by Henry III confirming King John's Magna Carta. Thus his restoration of Hampton Court was not just a visual matter. Sadly, all his interiors were altered later, although his chimneypiece survives in the Great Hall.[8]

A similar approach can still be seen on a more modest scale at Canons Ashby in Northamptonshire, which was inherited in 1708 by Edward Dryden, a nephew of the poet. Soon after that, he furnished his hall in a pseudo-medieval manner, with arms, armour, spears and swords, and hung a panel from the Board of Green Cloth with the arms of William III, which he must have obtained from his brother-in-law, who had been Master of the Board. What Edward Dryden did at Canons Ashby anticipated Horace Walpole's display of armour on the stairs at Strawberry Hill by forty years.[9]

Vanbrugh's response to old buildings can be seen not only in his plea for the preservation of Old Woodstock Manor in the park at

Blenheim, which the Duchess of Marlborough was determined to sweep away, but in his designs for Blenheim and Grimsthorpe, with their suggestion of castle towers, and his treatment of Kimbolton and Lumley Castles. Concerning Kimbolton, Vanbrugh wrote to his patron, Lord Manchester in 1707: 'As to the Outside, I thought 't was absolutely best, to give it something of the Castle Air, tho' at the Same time to make it regular.'[10]

His outworks at Castle Howard relate to the 3rd Earl of Carlisle's interest in family history and desire to emphasize the dignity of his own line, although his earldom only dated from 1661. Lord Carlisle abandoned his ancestral seat at Naworth Castle in Cumberland, and settled at Henderskelfe in Yorkshire, which he proceeded to rename Castle Howard. Thus, as Charles Saumarez-Smith has written, 'Castle Howard was a way of articulating three-dimensionally his family ancestry and lineage'.[11]

That kind of thinking, as well as Vanbrugh's handling of the spaces at Castle Howard, seems to have appealed to Sir Griffith Boynton, the 3rd Baronet, of Burton Agnes, some thirty miles to the east. When he married in 1712, he remodelled the Jacobean house, both modernizing it and playing up its historical character. He opened up the plan by cutting a new archway in the east wall of the Great Hall (Figs. 281, 282) that linked it to the vestibule and new garden hall behind, the arches recalling their use at Castle Howard, Beningbrough and Aldby; and he formed a lower apartment for daily living with a new Great Parlour or dining-room and a remarkable lacquer drawing-room (Fig. 327, see page 254). Upstairs, he formed a new Great Apartment, with a Great Dining-Room that appears to have been an extension of the old Great Chamber, and a new drawing-room leading to the dressing-room, which was next to the old principal bedroom. He lined the new drawing-room, now called the King's State Bedroom, with Jacobean woodwork to create an antiquarian room in tone with the bedroom now called the Queen's State Bedroom. At the same time, he reused exceptional Jacobean carving, apparently from the Great Chamber, to frame the arches in the Great Hall to balance the original alabaster and stucco screen, probably painting all the woodwork a stone colour to resemble up-to-date stucco work.[12]

Sir Griffith's changes can be compared with what Sir Clobery Holte, who died at the age of forty-seven in 1729, is presumed to have done at Aston Hall, Birmingham. Again, his changes are undocumented, and they are confused by what his son, Sir Lister, did a generation later. Perhaps he rebuilt the five centre bays of the house to provide a central entrance instead of the original side entrance into a screens passage, as at Chastleton and Burton Agnes, and he remodelled the hall itself. He removed the screen from the north end, but reused the idea of its arches for the wooden aedicules that frame the paintings flanking the new door in the centre of the west wall, and either reused or copied the strapwork from the top of the screen for the decoration of the doorcases. The whole room would look more convincing if the woodwork and walls were painted a stone white, as they probably were in the early eighteenth century and as they appear in old *Country Life* photographs, not stripped as they are today. The only clue for the date of the room is that the landscapes in the arches and the golden statues in grisaille, hatched in gold over brown, were in existence by 1721. How the room was furnished is not known, but the scheme evidently also

included the full-length neo-Jacobean portrait of Sir Thomas Holte with the house in the background rising behind the usual late seventeenth- or early eighteenth-century arrangement of the forecourt as a parterre with statues, a picture that still hangs on the south wall.[13]

There is a similar reuse of old panelling at The Vyne, which was gradually remodelled by Anthony Chute, who died in 1754, and his brother John, who died in 1776, in a way that modernized the plan while preserving much of the ancient appearance of the rooms. Until the early 1770s, the old Great Hall survived just off-centre on the north front, the former entrance with John Webb's portico, but then, when the house was turned round, it became the saloon. However, it retained old panelling painted blue and decorated with gilt lead rosettes. To the east of it lay what had evidently always been the Common Parlour, but it seems to have been enlarged by Anthony Chute, who lined it with reused linenfold panelling that he had painted blue. For the window pier he acquired the unusual Rococo circular glass with an Apollo's head and rays in the centre that looks so good against the panelling.[14]

The Great Hall at Grimsthorpe must have been conceived about 1715, when Vanbrugh started to work for the 1st Duke of Ancaster, and was probably completed by Hawksmoor after Vanbrugh's death in 1726. The arcading of the entrance front and great court, which could be seen as a classical version of Norman work, is continued into the hall. In its upper arcade Thornhill painted grisaille statues of the monarchs whom the Bertie and Willoughby families had served and been honoured by, William I, Edward III, Henry V, Henry VII, Henry VIII and William III. The series ends above the massive stone fireplace with George I, who created the dukedom. The fireplace bears the Duke's monogram topped by his coronet flanked by the medieval-looking crowned saracen's head crests of the Willoughby family.[15]

The hall at Palace House, Beaulieu, which is recorded in an early nineteenth-century watercolour (Fig. 283), was formed about 1715 by the young 2nd Duke of Montagu out of the vaulted entrance in the gatehouse to Beaulieu Abbey, which he transformed into a castle-style house. He was mad about castles: not only did they tie up with his passion for family history and genealogy and his enthusiasm for the military life, which was fired by his admiration for his father-in-law, the Duke of Marlborough, but they lead on to his own later work in the 1740s as Master of the Ordnance, when he equipped the British Army and Navy for war. With him, past and present fused together in a remarkable way.[16]

It seems it was his father who commissioned the set of six full-length portraits of ancestors in black and gold frames attributed to Jeremiah van der Eyden for Montagu House and that were hanging in the Great Hall at Boughton by 1718. However, they fit better with the interests of the 2nd Duke, who gave a heraldic cast to several rooms at Boughton. The first-floor room that is now the library he lined with small-scale panelling that looks far older than the eighteenth century, and in it he set up an overmantel (Fig. 284) that traces his descent on his father's and mother's side from Edward I and ends with the triumph of his own marriage to Lady Mary Churchill. Inset in the frieze of the room are circles painted with the arms of the original Knights of the Garter, to which he was so proud to be appointed in 1718.[17]

On the ground floor he formed a new long gallery, the Audit Gallery (Fig. 285), which he fitted with a sixteenth-century chimneypiece and heraldic overmantel and lined with vertical panelling that

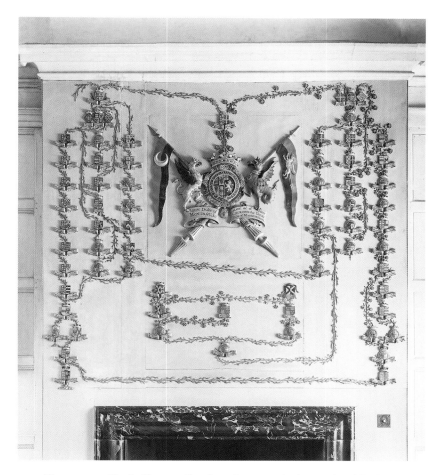

284. *The overmantel in the library at Boughton that traces the descent of 2nd Duke of Montagu from Edward I and ends with his marriage to a daughter of the 1st Duke of Marlbrough.*

is intended to look contemporary with it. To its frieze he applied a double row of roundels painted with coats of arms that trace the descent of the Montagus from Edward I down to his son-in-law and also the arms of former Knights of the Garter with whom he could claim a connection.

Where the chimneypiece came from is not recorded, but in 1729 Booth, the agent, wrote to the Duke 'The parler of Mrs Creeds house is Square Panneld Wainscot & there is two chimneypieces with ye genealogy of part of the Family over them in stone, if your Grace please to have them taken down with what else they may be of antiquity they may be carried to Boughton this Season.'[18]

On the Chinese stairs, which may have been designed by Flitcroft and probably date from the early 1740s, the Duke fixed shields with the Montagu arms in carved wood to the end of each tread. That led Horace Walpole to make his quip in 1763: 'there was nothing but pedigrees all round me and under my feet, for there is literally a coat of arms at end of each step of the stairs – did the Duke mean to pun, and intend this for the *descent* of the Montagus?'[19]

The Duke's interest in castles, which is reflected in albums of plans and elevations at Boughton, can be compared with the early eighteenth-century history of St Michael's Mount in Cornwall. Today it appears as a semi-fortified abbey, the English answer to Mont St Michel; but its eighteenth-century character as a fortress has been overlaid by its nineteenth-century Rhineland restoration. In fact, it was the subject of at least two phases of eighteenth-century restoration, by Sir John St Aubyn, the 3rd Baronet, who lived from 1700 to 1744, and his son and namesake, the 4th Baronet, who lived from 1726 to 1772. When the 3rd Baronet came of age, he

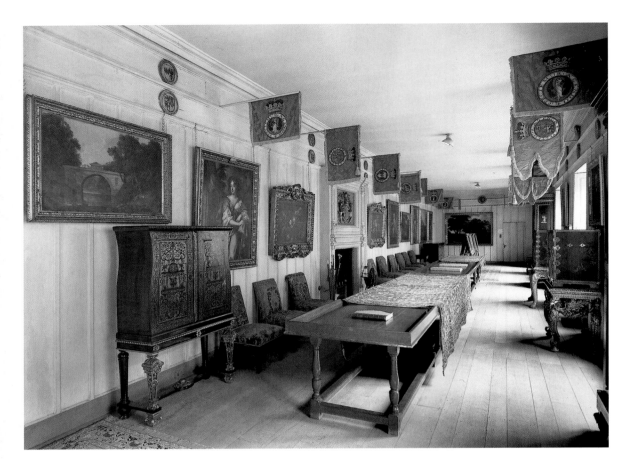

285. *The 2nd Duke of Montagu's Audit Gallery at Boughton. Constructed and fitted out in the 1720s in the style of an earlier Long Gallery with vertical panelling and a resited sixteenth-century chimneypiece with the Montagu arms. In the frieze are roundels of coats of arms tracing the descent of the Montagus from Edward I and the original Knights of the Garter with whom the Duke could claim a connection.*

286. *The White Parlour at Longford Castle. Jacob Bouverie preserved the old panelling but painted it white and gold in 1737. On the right can be seen a curved table in a Kentian manner which is related to the hall table now in the Victoria and Albert Museum.*

287. *The Blue Drawing-Room at St Michael's Mount, Cornwall. By 1736 Sir John St Aubyn, 3rd bart, had sufficiently restored the Mount to occupy it for part of the year, and it was probably his son and namesake who formed this room in part of the former Lady Chapel before 1755.*

the chimneypiece is copied from Batty Langley's *Ancient Architecture Restored* of 1742. The large drawing-room was probably fitted out in the early 1750s.

The Mount has a good collection of gothick furniture that includes examples of the different types of chairs regarded in modern parlance as 'antiques' and also new furniture with gothick detail of the 1750s or 60s (see pages 234–5).

As in France, towers had special connotations for early Georgians, and even the corner pavilions of a classical house seem to have suggested continuity and were favoured by patrons partly for that reason. That is apparent from an anonymous visitor to Houghton describing it as built 'castle wise'. Sir Robert was probably aware of that, because he is supposed to have got the idea from seeing the towers of old Osterley.

Towers can also be seen at Longford Castle, an Elizabethan fantasy in the shape of a triangle with round towers at each corner, representing the Trinity. In 1717 it was bought by Jacob Bouverie, later 1st Viscount Folkestone, a member of a successful Huguenot family long established in England who did not wish to appear *nouveau riche*. He rebuilt the centre of the entrance front as an antiquarian exercise and remodelled much of the interior in an up-to-date classical manner, filling it with fine furniture and pictures (Fig. 63); but at the same time he was careful to retain the historic character of the house where he thought it appropriate. Thus in the circular White Parlour (Fig. 286) he kept the old panelling and overmantel, but painted it white and gold, writing to a friend in 1737: 'I have added a good deal more guilding than we talked of & in my opinion not a bit too much.' And in the library a pre-Salvin photograph shows that he set a bust of King Alfred above the chimneypiece.[21]

To what extent he saw the place as conferring antiquity on the family is hard to say, but that possibility is suggested by the histories of Clevedon Court in Somerset and Markenfield Hall in

found the Mount more or less abandoned and in ruins, the family living much more comfortably at Clowance, a house a few miles inland. While at Oxford, he got to know William Borlase (1695–1772), who became a well-known Cornish antiquary and lived most of his life in sight of the Mount. It would be impossible not to be moved by that view, and it may have been Borlase who first encouraged Sir John to repair the buildings. Certainly by 1736 the St Aubyns were spending some of the year at the Mount, evidently using it as an eighteenth-century holiday house.[20]

Perhaps it was the 4th Baronet who decided to convert the ruined Lady Chapel beside the church into two drawing-rooms (Fig. 287) that demonstrate in a neat way the development of the gothick style. In the smaller, inner drawing-room the ceiling is still classical, but

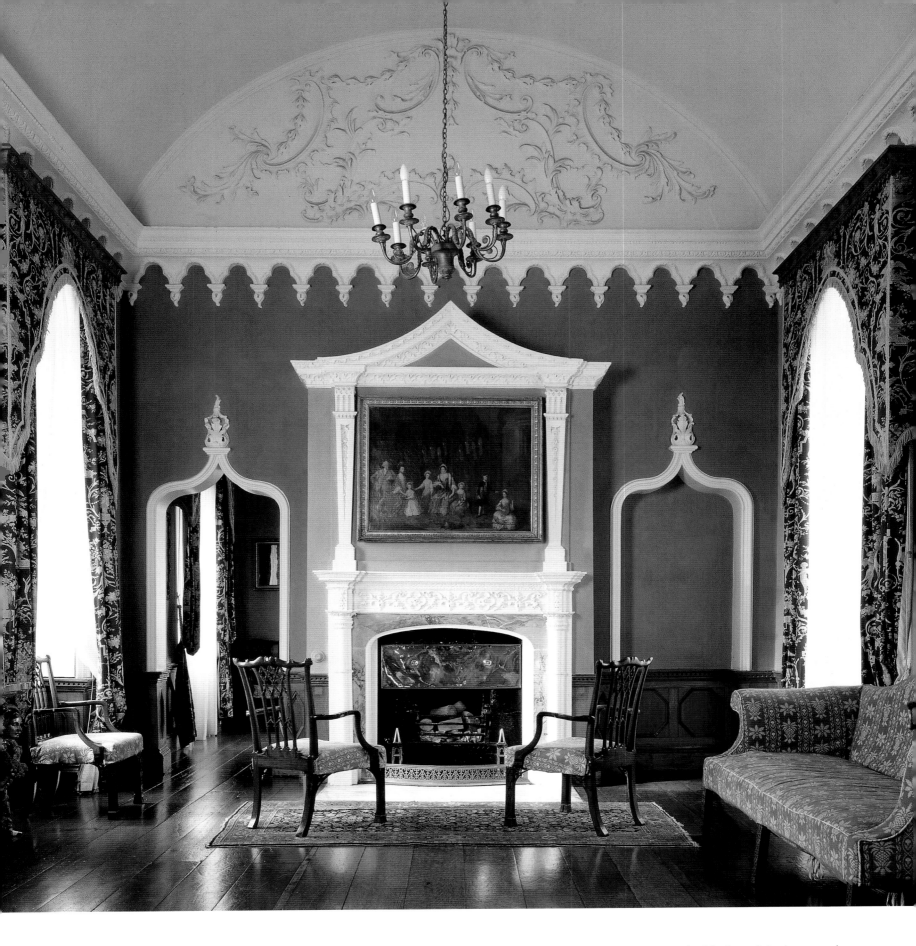

Yorkshire. In the case of Clevedon, the property was bought for its mineral rights in 1709 by the future Sir Abraham Elton, a highly successful Bristol merchant, but seemingly in the late 1720s his son and namesake was drawn to the medieval and Elizabethan house, which he modernized. There he set up his own arms and crest, borrowed from an apparently unrelated family of Elton in Herefordshire. In 1761 the medieval manor house of Markenfield, which had declined into being a working farm, was bought by

Fletcher Norton, who was connected with the original owners but had really hoped to acquire Norton Conyers in the neighbourhood, and he repaired the hall block but never lived in it. When he was made a peer, he took the title of Grantley of Markenfield, doubtless to give it an ancient ring.[22]

In the mid-1750s Lord Dacre wrote to Sanderson Miller about Capability Brown's appointment to Burghley House, saying he 'tells me that he has the alteration of Burleigh, and that not only of the

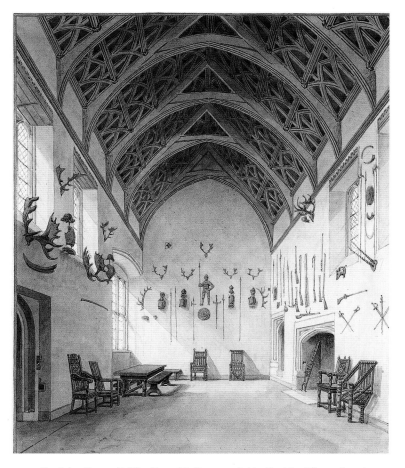

288. *Cotehele, Cornwall. The Great Hall as recorded by Buckler. The ancient character of the Great Hall was preserved and enhanced by mid-eighteenth-century members of the Edgcumbe family, who used to visit it from Mount Edgcumbe.*

Park but of the House which wherever it is Gothick he intends to preserve in that stile: and whatever new ornaments he adds are to be so'. His patron was the 9th Earl of Exeter, who had inherited in 1754 and, like many of his contemporaries, chose to be painted in Van Dyck dress. It was he who finally completed the remodelling of the interior begun at the end of the seventeenth century by the 5th Earl. He was at pains to continue the idea of the brown wainscot but took all the detail from plates in Robert Wood's books on Baalbec and Palmyra. In the 1760s he commissioned furniture from Ince and Mayhew that respected the late seventeenth-century character of the rooms. In 1767 they reused seventeenth-century marquetry for commodes and encoignures, remounting the old work on new light-coloured grounds. They cleaned the blue and silver tapestries in the room that Lord Exeter took for himself and provided a bed with 'A large Antique headboard' to suit the character of the room. However, at the same time Lord Exeter, who had gone abroad for three years after the end of the Seven Years War in 1763, was also a patron of Piranesi, acquiring a chimneypiece by him for Burghley. In 1778 Brown wrote to Lord Harcourt from Burghley: 'This is a great place, where I have had twenty-five years pleasure in restoring the monument to a great minister of a great Queen.'[23]

How the combination of historical thinking and visiting historical places influenced owners is unclear, but earlier houses as far apart as Hardwick and Cotehele were in part treated as historical experiences to be enjoyed by the family and by visitors.

Hardwick was carefully maintained in the middle and later decades of the eighteenth century, by both the 4th and 5th Dukes of Devonshire. Indeed, Hardwick and Chatsworth were seen as com-

plementary places, with Hardwick telling the earlier story of the Cavendish family by concentrating the earlier portraits there. It continued to be associated with Mary, Queen of Scots, although she had been imprisoned at Chatsworth and was executed some years before the new house was even begun. Yet Bishop Kennet wrote in his *Memoirs of the Family of Cavendish* (1708), 'her Chamber and rooms of State, with her arms and other ensigns, are still remaining at Hardwick'. Thomas Gray, who went there in 1762, wrote: 'one would think Mary, Queen of Scots, was but just walk'd down into the Park with her guard for half an hour. her Gallery, her room of audience, her antichamber, with the very canopies, chair of state, footstool, Lit-de repos, Oratory, carpets & hangings, just as she left them. a little tatter'd indeed, but the more venerable; & all preserved with religious care, & paper'd up in winter.'[24]

Later restorations have overlaid whatever the 4th Duke may have done before he died in 1764, but there are tantalizing pointers to mid-eighteenth-century thinking. In the first section of the Long Gallery, for instance, the pictures were hung and framed to tell the story of the two queens, Mary, Queen of Scots at full length and a supposed Queen Elizabeth at half length, both in black and gold frames in a pattern of about 1700. Round them were arranged the other participants in the story, their frames expressing their importance in degrees of elaboration and simplification. Visitors then saw the bedroom associated with Mary, Queen of Scots. In essence it has not changed since 1785, when it was first drawn by Grimm, who showed the remarkable carved panel over the door with Mary's arms as Queen of Scotland, which appears to be sixteenth-century Scottish work and so possibly a genuine relic of the Queen. Grimm showed a bed with hangings somewhat akin to those on a bed at Cothele, but both the present black velvet bed and the bed in the Blue Room were restored by the 6th Duke in the mid-nineteenth century. Even so, the shape of the black velvet bed, the pattern of its crimson damask head cloth and the shape of the chairs in the Blue Room with their damask covers ornamented with sixteenth-century embroidery, raise the possibility that the 6th Duke was restoring beds that had last been touched eighty to one hundred years earlier.

Cotehele in Cornwall has a similar eighteenth-century history to Hardwick. The Edgcumbes, who had owned the medieval manor house since the mid-fourteenth century, developed it as a historical place to visit on expeditions from their main house at Mount Edgcumbe. To what extent it is a survival and to what extent a creation is problematic. It is not clear how early the latter process started, but it was probably in the time of Sir Richard (1680–1758), who was created a peer on Sir Robert Walpole's fall, and continued by his son, the 2nd Baron (1716–61), who had several friends in the circle of Horace Walpole. The rooms appear to have been arranged to create an old English feeling, and the Edgcumbes seem to have had a particular nose for old tapestry and textiles, which they combined with furniture that they believed to be old or had made up, together with delft and old glass.[25]

The Great Hall (Fig. 288) still has very much the feeling conjured up by the writer in *Common Sense* in 1739: 'There was something respectable in those old hospitable Gothic halls, hung round with helmets, breast-plates and swords of ancestors: I entered them with a constitutional sort of reverence, and looked up on those arms with gratitude as the terror of former ministers and the check of kings.' In the Old Dining-Room the tapestry was cut about as if it

289 and 290. *An early nineteenth-century lithograph by Condy of the Red Bedroom and the room as it is today. A principal bedroom made up according to eighteenth-century conventions with seventeenth-century* passementerie *on the bed to be shown to visitors rather than slept in by guests.*

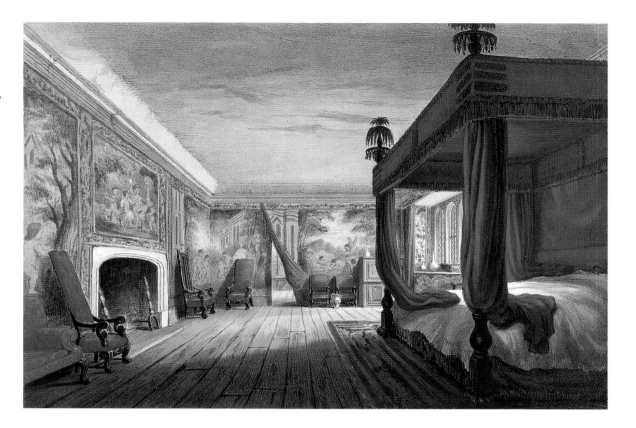

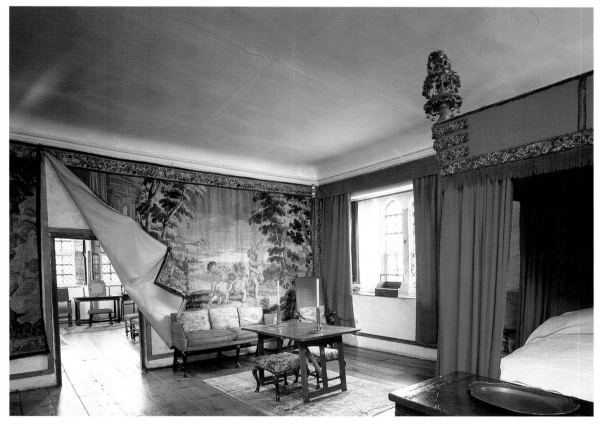

was eighteenth-century pictorial tapestry, as at Belhus, and an eighteenth-century 'overmantel', the equivalent of one in carved wood or plaster, is dominated by an equestrian figure cut from *The History of Circe* tapestry.[26]

The Red Bedroom (Figs. 289, 290) is surely an eighteenth-century creation of a principal bedroom – note the colour – with its seventeenth-century bed finials and *passementerie* on the valances reused and all the chairs covered in red damask to create a uniform effect.

In the adjoining South Room the bed has deep valances worked in red wool on a white ground, but the colour is so faded that the hangings are reminiscent of those drawn by Grimm in Mary, Queen of Scots's room at Hardwick. In Queen Anne's Room (Fig. 291) is a bed of early eighteenth-century proportions and materials but incorporating sixteenth-century carved and painted posts and seventeenth-century carving for a headboard. Like the Great North Room at Strawberry Hill (Fig. 306), these rooms were arranged to be looked

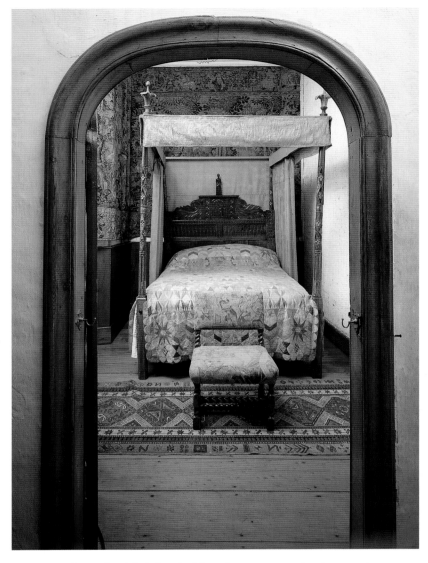

291. *Queen Anne's bed of early eighteenth-century proportions incorporating sixteenth-century carved and painted posts and seventeenth-century carving.*

three plates from Langley's *Gothic Architecture Improved* of 1741–2 (Figs. 293–5). That is the centrepiece of a scheme combining reused Jacobean panelling and new gothick plasterwork.[28]

Horace Walpole, John Chute and Sanderson Miller all had copies of Batty Langley's *Ancient Architecture Restored* (1742), even if later they were not keen to admit they had used it. That can be gathered from Walpole, who had just become serious about stylistic matters at Strawberry Hill, writing to Bentley in 1755 about Latimers, near Chesham: 'the house has undergone Batty Langley-discipline: half the ornaments are of his bastard Gothic, and half of Hallet's mongrel Chinese. I want to write over the doors of most modern edifices, *Repaired and beautified, Langley and Hallet churchwardens.* The great dining-room is hung with the paper of my staircase, but not shaded properly like mine.' He also overlooked his own recent use of Hallett to make the chairs for his Refectory (Fig. 50).[29]

Sir Lister Holte of Aston Hall owned Langley's *Builders's Compleat Assistant* and *Builder's Jewel*, both 1741, *Ancient Architecture Restored*, 1742, and *The City and Country Builders and Workman's Treasury of Designs*, 1745, and how he used them can be seen in the Green Drawing-Room, the principal withdrawing room of the Jacobean house adjoining the Great Dining-Room on the first floor. He retained the original ceiling but otherwise remodelled the room, supposedly about 1750. He moved the Jacobean chimneypiece and installed a new cornice and doorcases taken from Batty Langley. These are painted green to tone with the flock wallpaper, of which traces were found in the early 1980s and copied at that time. It is a Rococo 'S' pattern of leaves and flowers, with a diaper ground in grey and white, the pattern printed in a sharp green and then over printed in a darker green flock; and the green was continued into the damask curtains.[30]

To what extent it is correct to distinguish between the gothick and Jacobean revivals is not clear, but at Wroxton Lord Guilford combined both in his restoration of the Jacobean house. In the former dining-room, for instance, he put up a new Jacobean-style ceiling, which could be papier mâché, and a new fireplace based on a Batty Langley design; and in the Gold Room there is a particularly fine chimneypiece that looks suspiciously like a mid-eighteenth-century version of a Jacobean one.[31]

## THE ENTHUSIASM FOR PORTRAITS, STAINED GLASS AND TAPESTRY

Today, visitors to country houses are usually more interested in painters of portraits than sitters, and it requires a special kind of mind to respond to the likenesses of a 2nd Duke or 4th Earl and spot their wives; and for most people old *Peerages* are as impenetrable as modern railway timetables. Yet part of the pleasure of visiting houses for the generations of the 2nd Lord Oxford, Vertue and Horace Walpole was seeing the portraits they contained and recalling the lives and ancestry of those depicted in them as well as checking likenesses against memories of others seen elsewhere.

For eighteenth-century owners, their portraits were the visual counterparts of their often decorative family trees, and in many houses they were set out to tell family histories. Sometimes that was still done in long galleries, as at Hardwick and Bulstrode, where the Duke of Portland arranged about thirty full-length portraits of the Southampton family brought from Titchfield. Queen Caroline hung portraits of early monarchs in her dining-room at Kensington

at rather than used, because they had no closets or dressing-rooms that would have been *de rigueur* at that time.

It was natural that what was essentially a private field of activity should soon be taken up publicly by designers, particularly those interested in the new world of design and ornament prints. The most interesting figure was Batty Langley. Although an admirer of Hawksmoor's gothick work at Westminster Abbey, he was essentially a popularizer of decorative ornament in architecture. His publications were obviously well timed, because as early as 1743 Thomas Adey used the gothick style for his new house at Stout's Hill, Uley in Gloucestershire, which was possibly designed by William Halfpenny, the probable architect of the gothick garden house at Frampton Court, a few miles away.[27]

How his plates could be used is well illustrated in the hall at Tissington Hall in Derbyshire (Fig. 292), which was remodelled by William Fitzherbert III about 1757, the year that Joseph Hall of Derby supplied the stone continued chimneypiece that is based on

292. *The hall at Tissington Hall, Derbyshire. A remod-elling of 1757 with a new stone chimneypiece based on three engravings by Batty Langley, reused Jacobean panelling and new plasterwork.*

293–5. *Plates from Batty Langley's* Gothic Architecture Improved *(1741–52) used to design the chimneypiece and frieze in the hall at Tissington.*

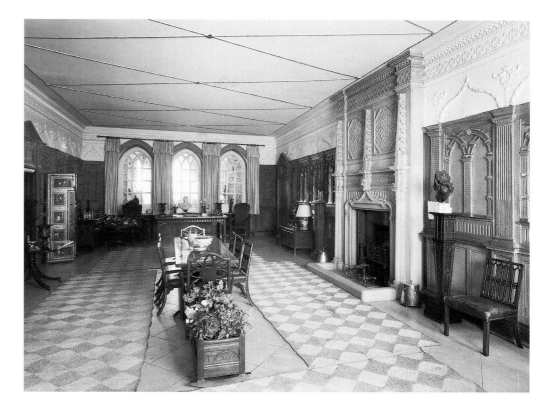

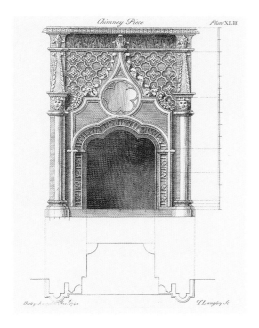

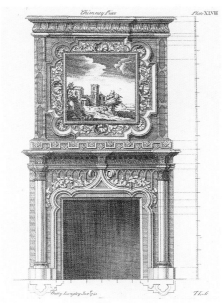

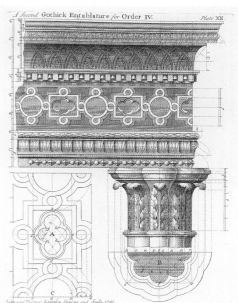

Palace, as Pyne shows. At Woburn, portraits were hung by the 4th Duke of Bedford as an introduction to the history of the family in his new gallery, between the two staircases, that leads to the saloon and the rooms of parade, with the overmantels to the chimneypieces in the two end sections having panels of the Bedford arms designed by the Duchess. At Blair Castle, the Duke of Atholl arranged a long series of portraits on the main staircase (Fig. 296) leading up to the principal rooms and even acquired missing figures who were part of the family story. Occasionally an owner commissioned a set of por-traits of his friends, like the twenty-five full lengths painted by Aikman to go with Jervas's portrait of George II in the gallery at Blickling that now line the walls of the staircase hall, or the set of portraits of members of the Kit Kat Club that were commissioned by Henry Tonson for the dining-room at Barn Elms.[32]

Sometimes the play made with portraits appears to have arisen from a shortage of other pictures, as with the dedication of the saloon at Raynham to the Vere Captains (Fig. 226) and the gallery at Hagley to the seventeenth-century Brouncker portraits (Fig. 420).[33]

On occasion, portraits were placed to make special points. At Dalkeith, for instance, the Duchess of Buccleuch hung the huge French equestrian portrait of her attainted husband, the Duke of Monmouth (now over the chimneypiece in the Great Hall at Boughton) at the head of the great stairs at the entrance to the Great-Dining Room, while over the door to the Ante-Room on the ground floor she hung a picture of St John the Baptist that was a likeness of the Duke of Monmouth.[34]

A few rooms were devoted to telling a very ancient story, as recorded in old photographs of the Great Hall at Lyme Park. Probably in the early 1730s Peter Legh II classicized the Great Hall and installed a new chimneypiece alluding to his ancestor's service under Edward III and the Black Prince and hung their portraits at each end of the room.[35]

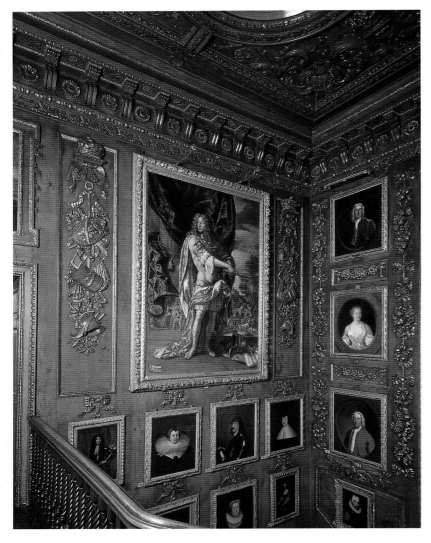

296. *Portraits illustrating the history of the Murrays, Dukes of Atholl, arranged as part of the design of the new staircase leading to the great rooms at Blair Castle, late 1740s.*

Others dealt with more recent history, as can be seen in the dining-room at Ditchley (Fig. 390) and the room at Sudbury (Fig. 161) now called the saloon, but the Parlour in George Vernon's day and refitted as a dining-room about 1750 by the 1st Lord Vernon. Taking the existing elaborate seventeenth-century ceiling and complex panelling as the key, he commissioned extra full-length portraits of his sister in Van Dyck dress by Seeman, painted in 1741, and his second wife by Hudson (?) to add to earlier ones by Kneller, Dahl and Vanderbank of himself and his first wife, painted in 1737, his brother-in-law, Sir William Yonge, with Michael Wright's half-length portrait of the builder and Riley's of his wife above the doors. His pictures must have been considerably larger than any that George Vernon hung there, and that changed the balance of the room, giving it a mid-eighteenth-century cast. He also altered the room more than has been realized, because in 1750 there were still three windows on the west wall. So it may have been he who installed the pedimented aedicules that frame the full-lengths so boldly alongside the old woodwork and possibly painted the whole room white, or at least a light colour, for the first time soon after 1750.[36]

On the other hand, there are a few country houses where family portraits always played a minor role. At Houghton, only the Supping Parlour was a family portrait room, and at Holkham Lord Leicester commissioned Casali to paint a set of imaginary portraits of ancestors for the Ante-Room to the Strangers' Wing.

The enthusiasm for old portraits was stimulated partly by the increasing publication of engravings of historical portraits, like the set of heads set in inventive Rococo borders made to illustrate Nicholas Tindal's *Continuation of the Mr Rapin Thoyras's History of England*, announced in 1736 and published in various ways after that in the 1740s and 50s, and also by the growing taste for country-house tours. This can be seen in the notes made by George Vertue, often while travelling with Lord Oxford, who was a collector of portraits as well as other kinds of historical evidence. Among their contemporaries were the 2nd Duke of Montagu, William Stukeley and James West. A fascinating purchase is the dramatic portrait by William Scrots of the Earl of Surrey (now at Arundel Castle), which was bought by Sir Robert Walpole and given by him to the Duke of Norfolk. But how early the interest influenced owners of new houses to acquire old portraits to create a special atmosphere is harder to say. Obviously Horace Walpole is significant in that respect: he began to buy historical portraits as soon as he got back from Italy, several years before Strawberry Hill was even an idea. For instance, he bought the Eworth portrait of the Duchess of Suffolk and Adrian Stokes at Lord Oxford's sale in 1742/3. However, once he began to enlarge Strawberry Hill in the 1750s, it became clear that collecting and building went in hand, with portraits playing a significant role, as in the concept of the Holbein Room (Fig. 304), where he evoked the early Tudor court with Vertue's copies of Holbein's drawings. He was happy to combine what he believed to be originals with what he knew to be copies, because, while he was buying partly for decorative effect in the gallery, portraits recalled past lives and times as well as his own connections and friendships.[37]

There was a similar interest in old stained glass, particularly armorial and small pictorial panels often imported from Flanders. Again, it was a combination of an interest in historical evidence and an awareness of decorative value, particularly their colour when seen against the light. How early this developed is hard to tell, but, as with the gothick style, Horace Walpole was not quite the pioneer that he would have us believe. As soon as he began to gothicize Strawberry Hill, he began to use panels of stained glass in the top lights of windows, setting them off with plain-coloured glass orders that were an integral part of the design: indeed, they were among the strongest historical notes in his early decorative schemes (Figs. 297, 298). In 1750 he sent a man to Flanders to buy old glass, and he returned with 450 pieces, mainly pictorial and heraldic panels. That year, when he wrote to Horace Mann in Florence about the castle idea, he said: 'If you can pick me up any fragments of old painted glass, arms or anything, I shall be excessively obliged to you.' In 1753 he could write: 'I have amassed such quantities of painted-glass, that every window in my castle will be illuminated with it: the adjusting and disposing of it is vast amusement.' He devoted a great deal of thought to its arrangement and to the colour of the plain glass in which he had it mounted, as can be seen in the bay window of the Breakfast Room on the first floor, where the blue of the mounting glass related not only to the view but to the colour of the walls in the room.[38]

Among earlier collectors were the 4th Earl of Radnor, who lived at Radnor House, Twickenham and who in the mid-1730s and early

297 and 298. *Stained glass in the Blue Bedchamber at Strawberry Hill. An engraving of Horace Walpole seated beside the window in the library that shows the relationship of clear glass below with the view to the river and stained glass in the upper lights.*

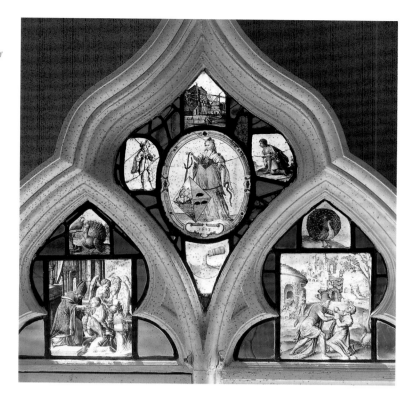
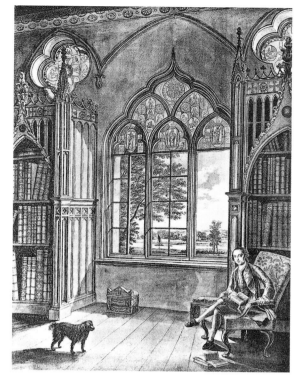

1740s had windows with gothick heads containing in their upper lights panels by William Price the younger mixed with old Flemish glass. That was a few years before Thomas Barrett's purchases for Belhus that included armorial panels from Hurstmonceaux Castle. Another early collector was Lord Guilford, who in 1747 had seventeenth-century glass by Van Linge reset by William Price in the east window of his new chapel at Wroxton. He also brought glass from Kirtling in Cambridgeshire, which he inherited in 1734 and reduced in size in 1744. He was closely followed by Lord Brooke, who set old glass given to him by Lord Exeter in his new chapel at Warwick Castle in 1748. Sir Lister Holte took nine panels from the hall range of Brereton Hall, Cheshire when he demolished it, and installed them in the hall at Aston Hall.[39]

How early people began to acquire tapestry as a historical relic or to create a mood of antiquity is unclear, but in the early 1750s Thomas Barrett Lennard formed a Tapestry Room at Belhus, where old photographs show the effect of his cutting on the chimneybreast (Fig. 299). At the end of that decade, Thomas Gray tried in vain to help his friend find old tapestry for his house. In 1759 he wrote:

> I am sorry to tell you that I try in vain to execute your commission about tapestry. what is so bad, as wry-mouthed histories? and yet for this they ask me double the price you talk of. I have seen nothing neither, that would please me at any price. I allow tapestry . . . to be a very proper furniture for your sort of house; but doubt, if any bargain of that kind is to be met with, except at some old mansion-sale in the country, where People will disdain tapestry, because they hear, that Paper is all the fashion.[40]

That can be compared with what happened at about the same time at Doddington, an Elizabethan house that was being restored and where a contrast was made between fashionable papier mâché (Fig. 256) and Rococo wallpaper (Fig. 150) and old tapestry hung in two bedrooms. Indeed, there appears to have been a continuity of tone between the flock paper in the drawing-room and the old tapestry put up by the local tailor in the Holly Room.[41]

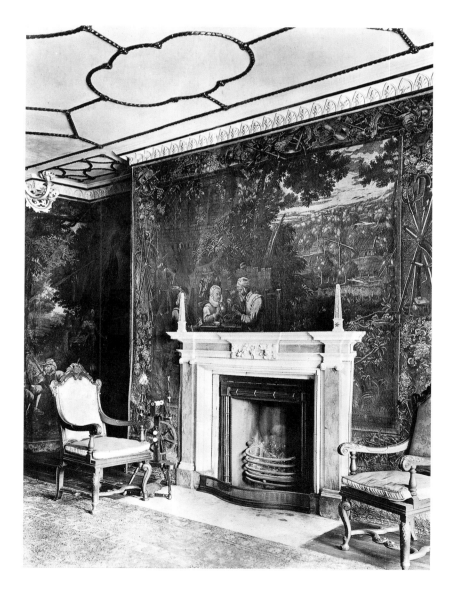

299. *The chimneybreast in the Tapestry Room at Belhus. The tapestry was cut in a typically eighteenth-century way to frame the new classical chimneypiece.*

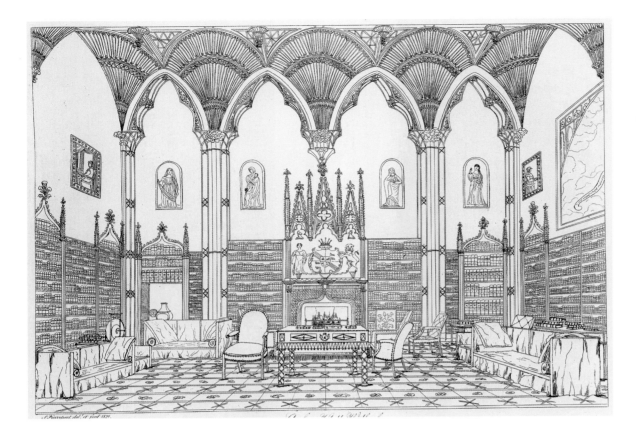

300. *The Great Hall or dining-room at Welbeck Abbey, Nottinghamshire, as recorded by Lady Sophia Cecil in an etching in 1821. Begun by the newly widowed Countess of Oxford in the early 1740s, evidently with the help of John James, it was probably the earliest ambitious gothick revival interior.*

## NEW INTERIORS IN THE GOTHICK STYLE

Until the early 1730s, the gothick style was mainly used for ecclesiastical and educational buildings, and so appealed to Wren and Hawksmoor for emotional and intellectual as well as visual reasons. In 1713, when Wren was considering the completion of Westminster Abbey, he wrote: 'I have made a Design, which will not be very expensive but light, and still in the Gothick Form, and of a Style with the rest of the Structure, which I would strictly adhere to, throughout the whole Intention: to deviate from the old Form, which would be to run into a disagreeable Mixture, which no Person of a good taste could relish.'

It was with that thinking in mind that Hawksmoor began the western towers of the Abbey in the gothick style in 1735 and the same year John James began a similar recasing of the neighbouring church of St Margaret's Westminster. The completion of the Abbey seems to have fascinated contemporaries, and there are a number of paintings that show alternative solutions, including a cupola or a tower and spire over the central crossing.[42]

The choice of the gothick style for a country-house chapel was therefore not just a fashionable decorative idea but a statement about the continuity of the Catholic Church in England. So it is not surprising to find it used from the late 1740s. The chapel at Wroxton in Oxfordshire, where Sanderson Miller was involved, seems to have been finished in about 1747; the one at Warwick Castle was described by Philip Yorke as being fitted up in 1748, but with no name attached; and that at Hartlebury Castle, the seat of the Bishop of Worcester, was designed by Henry Keene in 1750. Horace Walpole, who visited Wroxton in 1753, wrote: 'The chapel is new, but in a pretty Gothic taste, with a very long window of painted glass, very tolerable. The frieze is pendent, just in the manner I propose for the eating-room at Strawberry Hill.'[43]

Another early example is the Ante Chapel at The Vyne, which was one of John Chute's first alterations after inheriting in 1754 and followed on from Horace Walpole's recommendations in 1755. He panelled the walls and gave the room a new ceiling (whose design Horace Walpole reused in the Great North Bedchamber at Strawberry Hill). However, his most dramatic alteration followed fourteen years later, when he devised and Spiridione Roma painted large *trompe-l'œil* panels to fit above the panelling in the body of the chapel that give an impression of fan-vaulted side aisles with windows beyond. The elaborate perspective is reminiscent of John Chute's playing with the classical orders in his new staircase constructed at the same time, and he must have devised it to complement the early sixteenth-century stained glass already installed in the east window, an allusion to the relationship of the vault and glass in the chapel of King's College, Cambridge. Roma's painting, taken down in the early 1840s, has been recently restored and put back in position.[44]

The earliest large Gothick Revival room to survive in part is the fan-vaulted dining-room (Fig. 300) at Welbeck Abbey that Lady Oxford built after she went to live there as a widow in 1742. It now appears that it was probably designed by John James, who was employed there as surveyor between 1742 and his death in 1746, and is his only gothic room. In 1744 Lady Oxford wrote of the dining-room: 'ye ceiling is to be painted with ye arms of my family, and ye marriages into it in proper colours to be hung with full length pictures in cedar frames those you saw in the dining room here with more, a Gothick chimneypiece designed partly from a fine one at Bolsover'.[45]

Lady Oxford's reference to cedar frames as being suitable for early portraits brings to mind not only the simple black-painted frames that seem to have been favoured for old portraits in the 1730s and onwards but the elaborately carved but ungilded frames added to the set of Lely period portraits in the gallery at Hagley in the late 1750s (Fig. 420).

When Horace Walpole went to Welbeck in 1756, he was in his element and wrote to Richard Bentley:

Oh, portraits – I went to Welbeck. It is impossible to describe the bales of Cavendishes, Harleys, Holleses, Veres and Ogles: every chamber is tapestried with them; nay, and with 100 other fat morsels; all their institutions inscribed, all their arms, crests, devices sculpted on chimneypieces of various English marbles in ancient forms – most ugly. Then such a Gothic hall, with pendent fretwork in imitation of the old and with a chimney-piece like mine in the library . . . so much of every thing I like that my party thought they would never get me away again.[46]

Sanderson Miller of Radway in Warwickshire was another pioneer of the gothick style. Coming of age in 1737, and in fairly easy circumstances, he devoted his life to literature, gardening, architecture and helping his friends. In 1745, about the same time as he added two-storeyed canted bays in a Jacobean style to his own house at Radway, he became involved with the remodelling of Belhus in Essex for the young Thomas Barrett, later the 17th Lord Dacre, who had inherited at the age of nine in 1725. They turned the house round in a similar way to Wallington, but using the gothick style. A new west-facing entrance front with low corner towers was built, and within was a new central entrance hall panelled in the gothick style and decorated with armour (Fig. 301); behind, a new staircase in a Jacobean Revival style with newels topped with Barrett's coroneted crest. Then, as a second stage in the 1750s, he put a floor into the old south-facing Great Hall, so that he had a large drawing-room above a new dining-room. He was an early collector of heraldic glass, inheriting fifteenth- and sixteenth-century panels from Hurstmonceaux, which had been removed when the castle was sold in 1708 and came through his mother, Anne, Baroness Dacre, and he combined them with old panels displaying the arms of his own family. He also bought Flemish Renaissance carving that he reused in his hall. He also added to the collection of family portraits that he concentrated in the dining-room. The drawing-room he lined with canvas, and pasted on to it a cut-out gothick design in paper (Fig. 302). Horace Walpole, who went to see the house in 1754 with John Chute, wrote enthusiastically to Richard Bentley: 'I never saw a place for which one did not wish, so totally void of faults. What he has done is in Gothic, and very true, though not up to the perfection of the committee.'[47]

Sir Roger Newdigate began on his long drawn out and complicated transformation of Arbury in Warwickshire in 1748, initially with Miller's help. The seventh and youngest son of the 3rd Baronet, he succeeded at the age of fifteen in 1734, but it was only in 1748 that he contacted Sanderson Miller and in about 1750 he got Hiorn of Warwick to copy one of the Radway gothick bay windows for the library. Four years later, he built the matching bay for the parlour at the other end of the south front and began the fitting-up of the library. The parlour followed on in 1761–3, with the aid of Henry Keene, the remarkable Surveyor of Westminster Abbey, who paid his first visit to Arbury in 1761. Keene had long admired Henry VII's Chapel at Westminster, as can be seen in his chapel of about 1750 at Hartlebury Castle, and the now-lost fan vault of the octagonal church at Hartwell in Buckinghamshire. All those buildings were preparation for what he was to do at Arbury, and the parlour was a much more serious interior than the library, with Perpendicular panelling of the walls incorporating family portraits enlarged to fit and a shallow vaulted ceiling with coats of arms. It was for that room that a remarkable set of gothick chairs and settees with needlework

301. *Belhus, Essex, now demolished. The new gothick hall built by Thomas Barrett, later Lord Dacre, with the help of Sanderson Miller, as it was in 1920. They used imported Flemish carving and decorated the hall with armour.*

302. Trompe-l'œil *gothick decoration in the drawing-room at Belhus consisting of a cut-out design in paper pasted on to lined canvas.*

by Sir Roger's mother, who died in 1765, were supplied, and the room ended up as the drawing-room.[48]

After that, Sir Roger decided to remodel the centre of the house that contained the old hall as a fan-vaulted hall or dining-room. However, it was only in 1773 that it was brought into use as an eating room, finally being completed in 1778. Only then did he embark on the saloon, with an even richer and more complex fan vault: that was finished in 1795.

But to return to the 1750s and Sanderson Miller. In 1754 John Ivory Talbot of Lacock Abbey in Wiltshire, who had recently carried out some minor alterations in the gothick style, asked him to help form a new hall there to fit in with the ancient character of the house and its earlier history as a nunnery. Clearly they looked at Batty Langley, and the room has a slightly tentative quality to it, with rather thin detail. The most original feature is the set of terracotta figures in the niches and on brackets by an otherwise unknown Austrian sculptor, Victor Alexander Sederbach, which John Ivory

*Strawberry Hill*
303. *Plan of the first floor in 1784 showing how the house was enlarged to accommodate the ever growing collection and display it to visitors while giving the impression that it was an old house that had grown with time.*

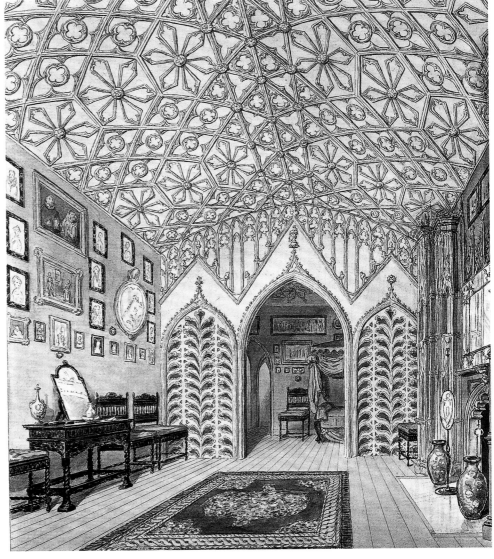

304. *The Holbein Room. Richard Bentley's last contribution to the house, it was added on in 1758 after Horace Walpole acquired Vertue's collection. He placed there a carved ebony table and chairs, presumably seventeenth-century examples from Goa, and had a new bed of purple cloth made in an old style.* Lewis Walpole Library, Farmington.

Talbot commissioned in 1756. On the ceiling the shields in the quatrefoils are painted with the arms of Talbot's friends. In the fireplace are a pair of handsome seventeenth-century andirons given to Talbot by Lady Dacre as 'antiques', presumably a handsome housewarming present.[49]

The most convincing early gothick interiors after the hall at Welbeck were to be found in Lady Pomfret's remarkable castle-style house built in Arlington Street in the late 1750s, apparently the only one of its kind in London and, alas, demolished in the late 1930s. Horace Walpole said that Sanderson Miller was responsible for it, but recently it has been suggested that it was built by Stiff Leadbetter with the aid of Richard Biggs. Biggs was Clerk of Works at Windsor Castle from 1745 and 1776 and so had an intimate knowledge of St George's Chapel, which explains the unexpected accuracy of the Perpendicular detail in Lady Pomfret's rooms. Building began in 1758; by October Lady Pomfret was able to walk through the rooms, and the house must have finished by the time she died in 1761.[50]

The gothick style also worked well in libraries that were scholars' retreats. Which is the earliest one is not certain, but it could be the delightful room at Malmesbury House, Salisbury that was fitted up for James Harris, a philosopher, most probably between 1745 and 1749. Another possibility is the library at Felbrigg fitted up for William Wyndham by Paine in the early 1750s.[51]

Strawberry Hill has deliberately been left to last, because after the first phase of light-hearted alteration and decoration, from 1748 to 1753, Horace Walpole began to make major, more serious, additions to the house, and it became a more significant and ultimately more original house (Fig. 303). From posterity's point of view, it is unusually well recorded because Walpole was the first person to commission perspectives of its interiors. The almost miniature scale of the house as first remodelled was matched by light-hearted and insubstantial trimmings very much in the manner of Batty Langley. Apart from the stained glass in the upper lights of the windows, the most interesting detail is the chimneypiece in the Breakfast Room, which appears to have been designed by Robinson out of a combination of Gibbs and Kent designs, the centrepiece being from the former and the columns from the engraving of Kent's chimneypiece in the library at Rousham, the kind of borrowing that Walpole would soon choose to forget.[52]

In 1754 he built on to the north side of the house an addition on

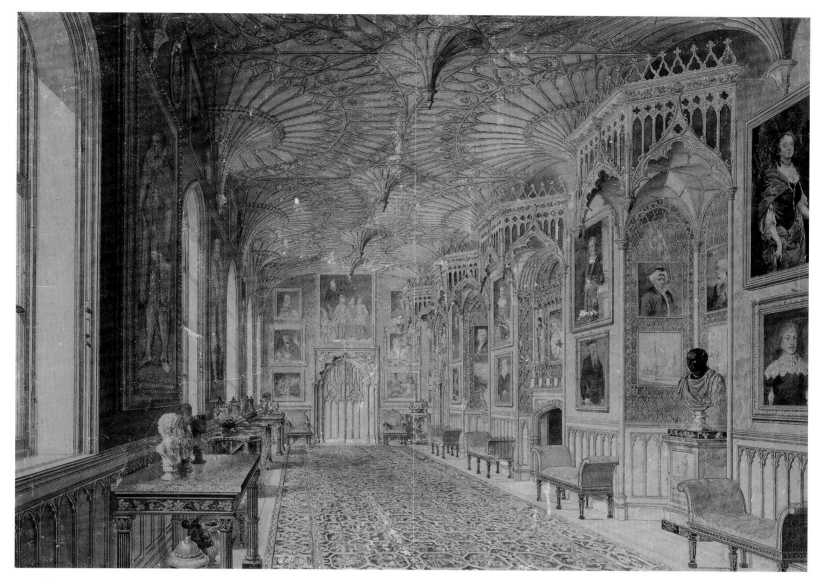

305. *The gallery, first mentioned as an idea in 1758, with Bentley's initial designs of 1759–60 substantially revised by John Chute in 1760–1 and amended by Thomas Pitt in 1762–3. The fan vault is in papier mâché by Bromwich and the walls were hung in crimson Norwich damask to suggest that the room was part of a Great Apartment. The furniture was in black and gold, part gothick and part fashionable lacquer in the French taste by Langlois.* Victoria and Albert Museum.

306. *The Great North Bedroom. Added on as the last show room in 1770. Again it was hung with crimson Norwich damask and the festoon curtains probably of lustring were pulled up into the dead light above the windows with the gilded cornices placed above them. The furniture was in a deliberate mixture of styles with carved black ebony as well as painted chairs in the French taste.*

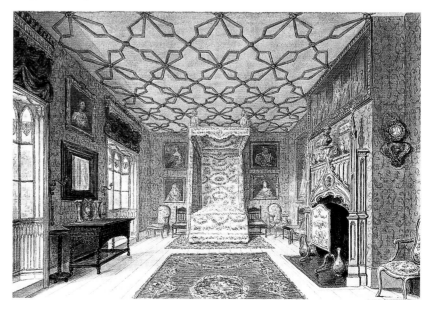

a considerably larger scale, to provide two new rooms, the great parlour or Refectory, as he liked to call it, on the ground floor, which was really a conventional dining-room, with a correspondingly generous library over it. At that stage, both rooms were intended for his own use and pleasure. What is remarkable in both is the delight of the detail that came about through John Chute bringing order to Richard Bentley's highly original flights of fancy as a designer of ornament.

Four years later, Walpole built on the Holbein Chamber (Fig. 304), apparently to house the collection he had acquired from George Vertue: it gave him the building bug and also the idea of developing Strawberry Hill as a show-place, separating his own private rooms from those that he planned to show.

Even though he had to wait until he had accumulated enough money, Walpole envisaged a gallery as a gothic idea of a fashionable great room (Fig. 305), a round tower and a cabinet, or Tribune as it was finally called, which were finally completed in 1763–6. They were followed by the Great North Bedchamber in 1770 (Fig. 306), after it had been decided in 1768–9 to complete the round tower as a drawing-room rather than a bedroom. Thus Walpole created a great apartment of a traditional kind with the climax in what he

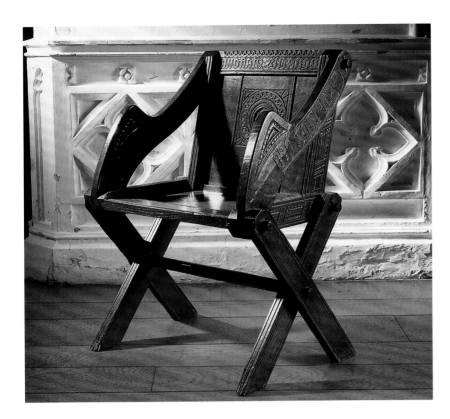

described to Horace Mann in 1772 as 'the sumptuous state bed chamber'. Yet it was on a novel asymmetrical plan, as if contrived in an old shell, and it exploited changes of direction, scale and light levels. He decorated it in a way that observed the conventions of his father's generation, with a white and gold colour scheme and crimson Norwich damask in the gallery, drawing-room and bed-room, which must have seemed consciously archaic by the 1760s. There was also a traditional build-up in the furniture, but done in an up-to-date way. In the gallery were black and gold table frames, chairs and stools by Vile, and black lacquer encoignures by Langlois; and these were followed by green and gold frames and Aubusson covers on the chairs in the drawing-room; and white and gold frames by Vile with Aubusson covers and 'Wolsey' ebony chairs (Fig. 306) in the bedroom, with a bed hung with Aubusson floral tapestry and lined with crimson silk. All this was an exercise in historical imagination to provide a setting for objects rich in their own historical associations. At the same time, it was a project whose combination of seriousness and joking not only gave pleas-ure and satisfaction to Walpole and his friends but to all those who came on carefully organized visits.

### THE ANTIQUARIAN TASTE FOR FURNITURE

Just as the Gothick Revival used to be regarded as revolving around Strawberry Hill, its furniture was seen as the key to new furniture in the gothick style. However, the situation is more complicated, because while new gothick furniture made by fashionable cabinet-makers began to be ordered in the early 1750s, there are two other groups to be considered: one is of furniture recognized at that time as being old, but seldom as old as was thought; and a second is of fine beds of a bygone era that were carefully preserved and often thought to be older than they really were in the late seventeenth or early eighteenth century.

At St Michael's Mount there is an unusually good mixture of the first and second categories. It has examples of the three kinds of

chair that were regarded in modern parlance as 'antiques'. The oldest was thought to be the so-called Glastonbury chair (Fig. 307), a form copied from what was believed to be the original from Glastonbury Abbey and now in the Bishop's Palace at Wells. Horace Walpole con-sidered it to be medieval, but it is probably sixteenth century.[53]

The second type of chair, of which there is one at the Mount, is probably seventeenth century, but Horace Walpole thought it to be Welsh and much older (Fig. 308). He first described the chairs in a letter to George Montagu in 1761 in the house of Richard Bateman at Old Windsor: 'Dicky Bateman has picked up a whole cloister-full of old chairs in Herefordshire – he bought them one and one, here and there in farm houses, for three and sixpence and a crown apiece. They are of wood, the seats triangular, the backs, arms and legs loaded with turnery.' Walpole was delighted to be able to buy them at Bateman's sale in 1775 for the cloisters at Strawberry Hill. Three other examples are to be seen at Cotehele.[54]

The third chair was what Horace Walpole called a Wolsey chair, which is usually a seventeenth century Indo-Portuguese chair in ebony (Fig. 309). Wolsey chairs seem to have been mentioned for the first time in 1752 by Thomas Gray at Esher Place, and so were presumably acquired some twenty years earlier when it was restored by Kent. By 1759 Horace Walpole had acquired some for the Holbein Chamber (Fig. 304) at Strawberry Hill and he bought more at Lady Conyers's sale in 1763. Presumably they were liked because of their high gloss and the association of black with age, as can be seen in the taste for black frames for old portraits. A surprising number of them are to be found in English houses and, while many were bought as antiques in the early nineteenth century, a number must have been acquired in the early years of the gothick revival.[55]

Alongside those chairs regarded as ancient relics is a quantity of new gothick furniture at the Mount. There is a particularly good set of hall chairs with the arms of the 4th Baronet and his wife, whom he married in 1756; they are a development of the Windsor chair idea. The drawing-rooms are furnished with three closely related sets of upholstered furniture close to the manner of Bradburne and

Three kinds of chairs at St Michael's Mount sought after as 'antique' in the second quarter of the eighteenth century.

307. A 'Glastonbury' chair, copied from one in the Bishop's Palace at Wells that was then believed to be medieval and come from Glastonbury Abbey.

308. A seventeenth-century turned chair then thought to be 'Welsh' and be much older. Horace Walpole had a collection of them in the cloister at Strawberry Hill.

309. A seventeenth-century ebony chair from Goa then associated with Cardinal Wolsey. They seem to have been first used at Esher Place; Horace Walpole used them in the Holbein Room at Strawberry Hill (Fig. 304).

roundels of gothick tracery on the doors and cluster columns at the corners of each of the four piers formed by the openings.[59]

It is not clear when people began to value beds of the Baroque period and preserve them as historical relics, but a possible first was at Blair Castle, where a new state bedroom was created for the 2nd Duke of Atholl during restoration after the 1745 sack: it was formed round the Baroque state bed brought from Holyroodhouse in about 1709. Other early examples, even if not exactly datable, are at Cotehele (Fig. 291) and Hardwick. And when Walpole was working on the Holbein Chamber, his first hope was to get an old bed from Burghley, though in the end he had to have one made by Vile.[60]

Old needlework was always valued, as can be seen at Hardwick in the time of the 4th Duke of Devonshire and at Blair, where the Duke of Atholl had seventeenth-century embroidery worked by Lady Derby remounted to create an up-to-date effect on a new bed. In 1758 he was sent a letter about it: 'I am extremely glad the Sowed bed answers so well; it could have been a great pity not to preserve so venerable piece of Furniture as that Sowing.'[61]

310. A gothick chair with the arms of the 2nd Duke of Montagu (d. 1749) made for the hall at Palace House, Beaulieu. The earliest known new gothick chairs and based on the Windsor chair form.

France in the 1760s; and in the Large Drawing-Room there is an amazing gothick confection of a console table.

In the early 1750s gothick furniture was becoming a standard part of a cabinet-maker's business. In the gallery at The Vyne there is a set of stools with gothick details to the legs and covers of black leather made by Vile at a cost of £3 12s. each in 1753 (his earliest recorded commission). Chippendale included designs for gothick chairs in the 1754 edition of The Director (but he did not add library bookcases and a bed in the gothick style until the third edition in 1763). Also at The Vyne, but probably a little later, there is a gothick pier-table and glass decorated in black and gold to match the earlier cornice that was refinished in that way. Perhaps the idea came from the pair of glasses incorporating portraits from either side of the window in the Refectory at Strawberry Hill, now at Wolterton.[56]

The earliest known new gothick chairs are those made for the hall at Beaulieu that are derived from Windsor chairs and bear the arms of the 2nd Duke of Montagu, who died in 1749 (Fig. 310). They are one-offs, the result of thinking by an amateur who could not buy what he needed. Another early reference to gothick chairs came in 1749, when Lord Lyttelton wrote to Sanderson Miller: 'I forget how many chairs are wanting for the castle (at Hagley); but how can I bespeake them without the model you drew for them? You know they are not to be common chairs but of a "gothick form".'[57]

When Walpole was thinking about furnishing the Great Parlour in 1754, he wanted to keep to the traditional idea of a parlour chair, but make it gothick. So he and Bentley together designed chairs based on medieval window tracery, and they were made by William Hallett. His choice of a black finish for them, which had been quite usual for the seats of parlour chairs in the early years of the century, was to be significant for the house, because he, like others, seems to have used it to suggest antiquity.[58]

Chippendale illustrated a gothick library table in 1754. The earliest documented gothick library table is that at Felbrigg, made in 1753 at a cost of £21. There was a more elaborate but slightly later one at Pomfret Castle (now at Temple Newsam): it has four openings with

311. *Gothick wallpaper found on the stairs at Amen Court, near St Paul's Cathedral in London, about 1760. It has been copied for a room at Temple Newsam.* Temple Newsam.

It would appear that the preservation of beds and bedrooms started within a few years of great apartments going out of fashion, as people turned against using beds hung with what was thought to be gloomy damask. Then they began to be regarded as evidence of family dignity, along with sets of portraits and old silver.

Sometimes a principal bed was moved: at Erddig (Fig. 369) in the early 1770s it went upstairs to a new principal bedroom on the first floor to free its old space for a new dining-room; at Clandon (Fig. 104), it appears to have been brought downstairs so that it could be seen and its original room could still be the principal bedroom for guests. Together with its armchair, six side chairs and pelmet cornices, the Clandon bed was probably ordered by Sir Richard Onslow, the Speaker of the House of Commons and later 1st Lord Onslow, who died in 1717, and so must have been made for the previous house. It is now placed in the room next to the saloon, where it was described in the 1778 inventory. However, that does not make sense, and, since there is no mention of hangings in the inventory, that also suggests that it was not its original location in the Leoni house: as the house had a Great Dining-Room on the first floor, it would be logical for the principal bedroom to open off it.

How much making-up of furniture went on is hard to tell, but occasionally pieces are encountered in country houses. Among them is Queen Anne's bed at Cotehele (Fig. 291) and the Green Dale Oak cabinet with a gothick framework and carved panels that was made for Lady Oxford at Welbeck out of an oak tree of exceptional size in the park that had been killed by the steward cutting an arch through it for his master and mistress to drive through; it was commented on by Horace Walpole on his visit in 1756. The sale catalogue of Belhus in 1923 illustrates a cabinet incorporating carved Flemish Renaissance panels that must have been made for Thomas Dacre.[62]

It was the success of gothick interiors that encouraged the production of gothick wallpapers. One of the first may have been at Belhus in Essex. An old *Country Life* photograph shows the draw-ing-room (Fig. 302) formed in the early 1750s out of the upper part of the Great Hall brought up to date with what Tipping described as a 'cut-out paper design of the most 'compleat Gothick'. The house has been demolished and the paper lost.[63]

By 1753 Horace Walpole had a 'gothic paper in stone colour in mosaic' with a chimneypiece based on a tomb in Westminster Abbey and coats of arms in stained glass in the bow window of the Little Parlour or Supper Parlour, which later was furnished with a table and eight ebony chairs bought at Lady Conyers's sale. But when he decided to paper the hall and staircase at Strawberry Hill, he had to have the paper specially printed in perspective to represent gothick fretwork, with the design taken from a print of Prince Arthur's tomb at Worcester as engraved in Francis Sandford's *A Genealogical History of the Kings of England*, published in 1677. When he actually saw the tomb, he was very surprised to find that it was on a scale smaller than his paper 'and is not of brass but of stone, and that wretchedly whitewashed'.[64] In 1761 when Thomas Wharton wanted gothick papers for his house, Old Park near Durham, he consulted Thomas Gray, who in 1761 wrote:

> I will look out for papers in the shops. I own I never yet saw any Gothic papers to my fancy. there is one fault, that is in the nature of the thing, & cannot be avoided. the great beauty of all Gothick designs is the variety of perspectives they occasion. this a Painter may represent on the walls of a room in some measure; but not a Designer of Papers, where, what is represented on one breadth, must be exactly repeated on another, both in the light & shade, and in the dimensions. This we cannot help; but they do not even do what they might: they neglect Hollar, to copy Mr Halfpenny's architecture, so that all they do is more like a goosepie than a cathedral. You seem to suppose, that they do Gothic papers in colours, but I never saw any but such as were to look like Stucco: nor indeed do I conceive that they would have any effect or meaning. lastly, I never saw any thing of gilding, such as you mention, on paper, but we shall see.[65]

A few weeks later, he wrote again: 'On rummaging Mr Bromwich's & several other shops I am forced to tell you, that there are absolutely no papers at all, that deserve the name of Gothick, or that you would bear the sight of. They are all what they call *fancy*, & indeed resemble nothing but ever was in use in any age or country.' He went on to suggest that Wharton should copy a detail from Durham Cathedral or Dart's *Canturbury* or Dugdale's *Warwickshire*: 'send the design hither. They will execute it here, & make a new stamp on purpose, provided you will take 20 pieces of it, & it will come to ½ or a penny a yard the more (according to the work, that is in it). This I really think worth your while . . . you can proportion the whole better to the dimensions of your room.'

'Fancy' may describe the fragments of paper that survive in the Ancient High House in Stafford and in a house in Amen Court (Fig. 311) near St Paul's Cathedral in London, which has been copied for a room at Temple Newsam. They may be compared with Chippendale supplying thirty pieces of 'Cathedral Gothic' paper for the back staircase of Sir William Robinson's house in Soho Square in 1760. Printed in grisaille, they are remarkably effective imitations of Rococo plasterwork in low relief, and they appear to relate to a group of classical arcade or pillar and arch papers; but Gray would not have recommended them to Wharton.[66]

# 8

## The Role of Pictures in Decoration

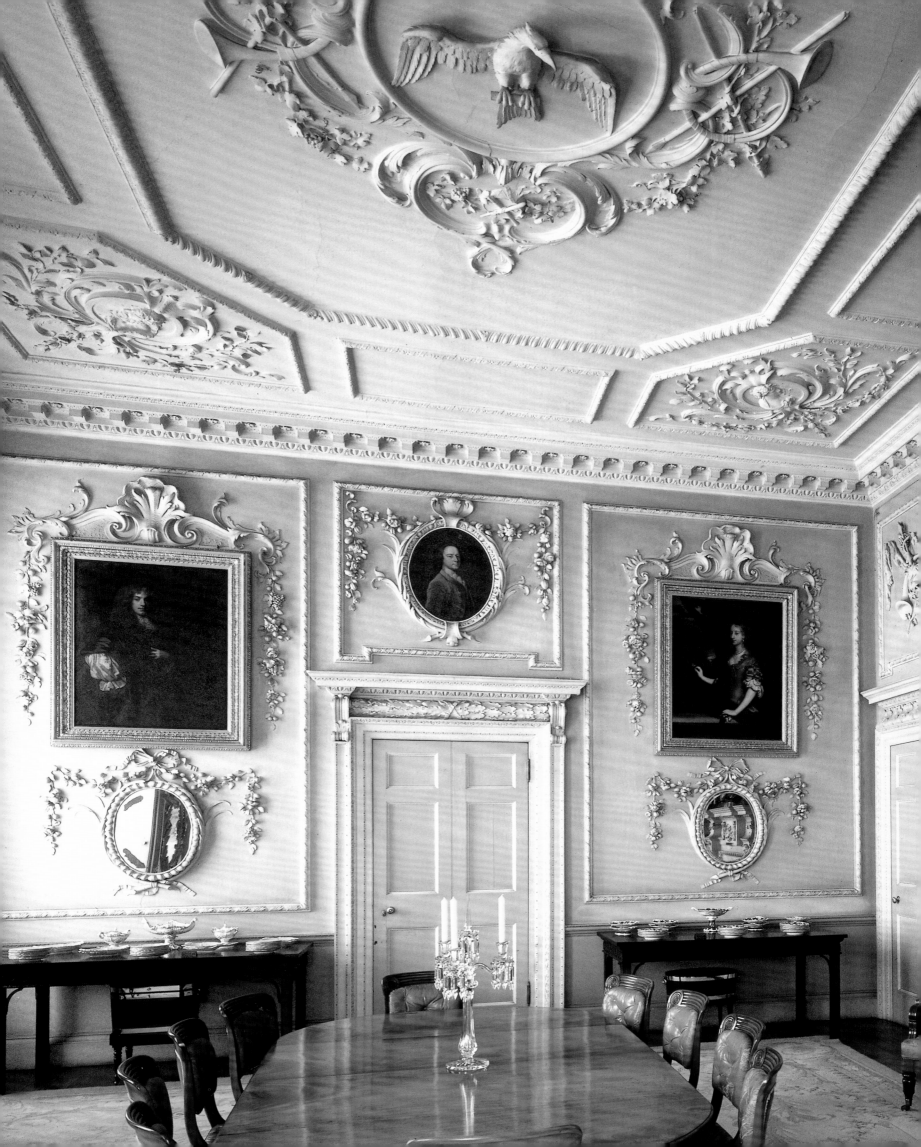

When Gustav Waagen, the German art historian, visited the British Isles on several occasions in the mid-nineteenth century to survey private as well as public collections of works of art, he was struck by how English collectors in the past had been influenced in what they acquired by concepts of decoration, what suited houses and rooms, and how pictures related to each other. He also showed, as Frank Herrmann has pointed out, 'that the English were almost unique in their love of surrounding themselves with objects of beauty from many previous ages in the rooms in which they and their families passed their lives. Elsewhere in Europe up to that time such pieces were more usually confined to special cabinets and galleries.'[1]

Waagen's was an acute observation, particularly for eighteenth-century interiors, because it is difficult to appreciate the pace of sequences and the balance within individual rooms without being able to envisage what pictures they contained, how they were framed, how they were placed, and, indeed, how they dictated the decoration, as has now become possible to understand at Houghton. That is what makes complete, or more or less complete, survivals like the Cabinet at Felbrigg (Fig. 419) or the Landscape Room at Holkham (Fig. 448) so precious and so instructive. They also underline how difficult it is to bring about a convincing recreation of an eighteenth-century room that has lost its original pictures. It is not just a matter of sizes and proportions, but also subject-matter, tonal interrelationships and, of course, quality; as well as frames and the relationship of their gilding to other gilding in a room.

The rise of picture collecting in the early eighteenth century had a range of effects on English interiors and decoration. First, it probably helped to kill the taste for painted ceilings, because they may have been found to be distracting from pictures and created problems of colour balance, not least because they drew the eye too high. At Houghton, for instance, it seems that Sir Robert Walpole insisted that Kent's ceilings should be painted in half rather than full colour. And at Holkham there was no decorative painting at all. It is known that Lord Leicester considered a ceiling painting by Kent, possibly for the hall, and also decorative painting in the library (Fig. 439); but neither idea came to anything. Nor did he pursue the idea in the 1750s. Thus the last of the Palladian galleries to have a painted cove and ceiling was at Mereworth, by Amiconi and Sleter in 1732 (Fig. 83); and there the pictures were not very strong.[2]

The taste for pictures also killed the use of panelling, and that became one of the major differences between French and English rooms. The French stayed loyal to boiserie with large glasses, but the latter were not available in England. In England, on the other hand, people found even big panels set in moulded frames an awkward background for pictures other than portraits and often they tried to ignore them by hanging pictures across them. A modest example of that can be seen in *The Bateson Family* of Belfast, apparently painted in 1762 and attributed to Strickland Lowry, now in the Ulster Museum, that seems to be a convincing rendering of a room.[3]

The growth in the number of pictures in turn encouraged the taste for walls hung with material, particularly boldly figured damasks, which existed in many qualities in the eighteenth century, with mixed rather than silk damasks often chosen for a gallery or a drawing-room. Picture hanging may have also helped to kill the fashion for velvet as a furnishing material, because it is so easily bruised. Conversely, it encouraged the use of wallpaper, particularly figured flock, when the standards of production improved in the 1730s. That can be seen in John Drummond of Quarrell's remark in 1735, quoted on page 192. Similarly in 1742 Mrs Delany was certainly not alone when she resisted friends' pressure to hang a room with mohair instead of paper when she was going to put up a lot of pictures.[4]

The increase in the size and quality of collections also led to the development of the saloon as a picture room. Probably one of the first was that of John Sheffield, Duke of Buckingham, at Buckingham House in London, which had a very different character from that at Castle Howard, as can be seen from the description on page 58. How many others there were in the first twenty years of the century is hard to judge, but the idea had matured by the time the decoration of the saloon at Houghton was being discussed in 1725 and Kent produced his first designs for the room (Figs. 185, 186). Indeed, Houghton is one key house for understanding the role of pictures in decoration, as we have seen.

Holkham, as is seen later, is the other key house. There, in the mid-1740s and 1750s, Lord Leicester was encouraging the younger Brettingham to develop the collection to suit the great rooms that were planned and to acquire particular pictures to fill gaps in the planned display. Earlier, in 1738, when completing the rooms in the family wing, he wrote to the elder Brettingham: 'send me also a drawing of the upright sides of the dressing room, wth the dimensions & drawings of the pictures upon them, draw lines as we sploins [?], wch we put up to represent the hanging of the pictures, & we have fix't, care sd be taken to place things to hang the pictures agst as to the other rooms we shall consider'. And by the end of his

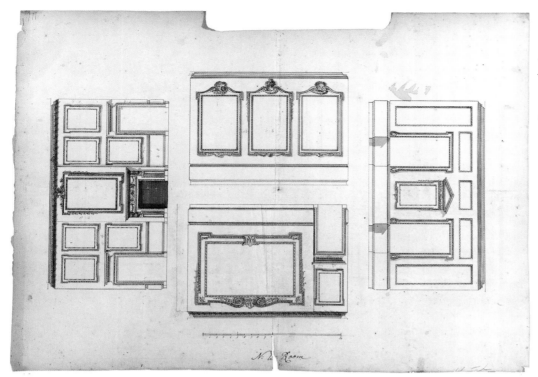

312. *Thomas Ripley's drawing of the dining-room at Wolterton Hall, Norfolk, showing the arrangement of the portraits, about 1739. Over the chimneypiece he placed the full length of Queen Caroline, with four half-lengths of the royal children to flank it, three full lengths of George I, Charles I and Charles II on the west wall, and a huge group of his own family by Soldi facing it.*

313. *The dining-room at Wolterton as it was in 1957.*

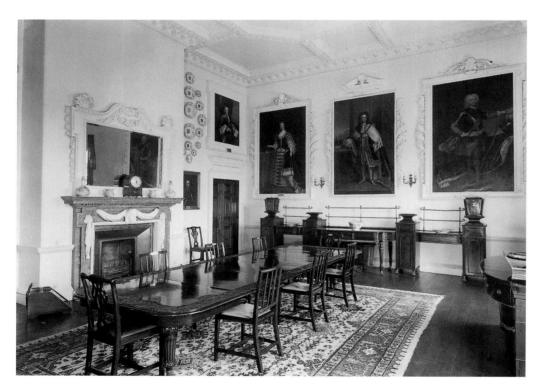

life he had decided where all the pictures were to go, even if the rooms were not quite ready for them to be hung.[5]

At Wolterton in 1739, Lord Walpole seems to have turned to Ripley to help with the hanging of the portraits in the dining-room (Fig. 312). Over the chimneypiece he placed the full-length of Queen Caroline, which, together with that of the King, had been presented by the sitters. The Queen's picture was flanked by four half-lengths of the royal children. On the west wall were full-lengths of George I, Charles I and Charles II, and facing them was a huge group of Walpole's family by Amiconi. Unusually, Ripley's elevational drawing for all four walls survives, as well as a letter in which he wrote:

> I took all the pictures and frames out of the cases and see the frames all put together and the picktures safe put into them.

They are hung up in their proper places. Now your family piece is up in a right height, it looks extreamly well. The Queen's picture does mighty well over the Chimne in the Dineing Room, amongest her Children. The French King did not do well at the East End between the late and present King. I have therefor put the late King in the middle, King Charles the first on one side and the present King on the other side of him. The frames being all of a size and make that End of the Room look mightily well.[6]

The increasing feeling for a precise relationship between pictures and decoration can be seen in the development of plaster frames for pictures as part of fixed schemes of decoration in the 1740s and 1750s; but it may also have been the result of a reaction against the greater costs of carving and gilding wood as opposed to modelling

314. *The dining-room at Farnborough Hall as it was in 1975 when furnished as a drawing-room. The decoration of the room was devised round a set of pictures of Rome and Venice by Panini and Canaletto set in plasterwork, possibly planned by John Sanderson, executed by William Perritt and measured in 1750. At the end of the room is a buffet niche.*

315. *The stucco frame by William Perritt to one of the Canalettos in the dining-room at Farnborough.*

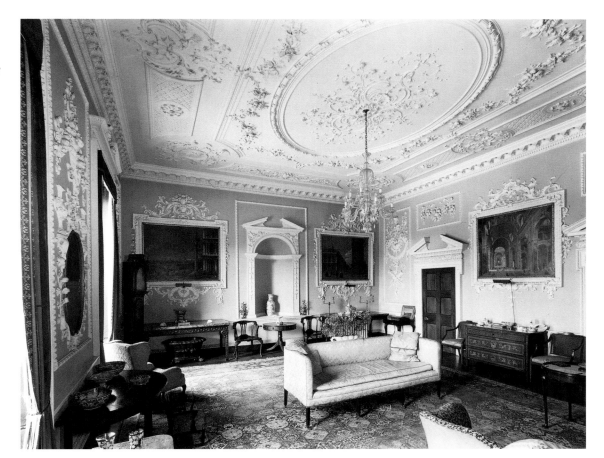

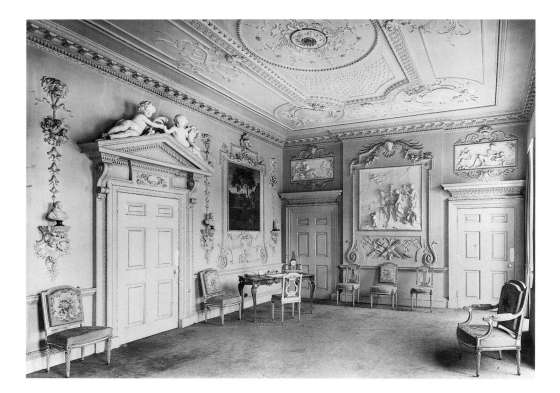

316. *The saloon at Langley Park, Norfolk, decorated before 1746, as it was in 1927. An early example of the linking of pictures and reliefs and plasterwork in the decoration of a room. The plasterwork long attributed to Charles Stanley has similarities with designs for Kirtlington included in chapter 10.*

317. *The Great Room at Rolls Park, Essex, called the Music Room in 1918. The undocumented room has since been demolished, but presumably dated from about 1750. The photograph show the large picture of the Harvey family flanked by two tall ornamental panels incorporating brackets for lights. Facing them was a group of mainly oval pictures that are unusually closely linked by stucco ornament.*

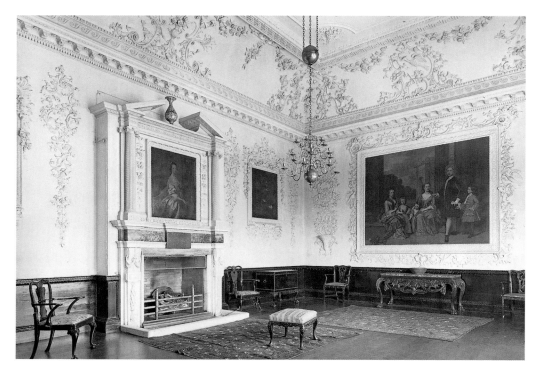

and painting plaster frames. There are earlier examples, such as the frames in the saloon at Burlington House (Fig. 165), where there is no record of the paintings intended for the room, and the saloon at Bower House, Havering, an early house by Flitcroft, where a series of Baynes family portraits were placed high on the walls, with narrow panels between their bottoms and the dado rail.[7]

One of the most significant examples of pictures as part of a scheme of decoration is in the Court Room of the Foundling Hospital, London, that was carried out in the years 1745–8 through the support of the leading artists in London who gave their work. The room is hung with four large paintings of biblical subjects representing the rescue of children, a scheme worked out by Hogarth – Highmore's *Hagar and Ishmael*, Hayman's *The Finding of Moses*, Wills's *Little Children Brought to Christ* and Hogarth's *Moses before Pharoah's*

*Daughter*. These four pictures are supported by eight roundels of London hospitals set in elaborate Rococo frames of oak garlands, including contributions from Gainsborough and Wilson. There is no record of who designed the room, but it seems possible that it was Sanderson who worked out the scheme, because he built part of the hospital and also gave a remarkable console table for the room.[8]

While the history painters must have been disappointed by the lack of response among private patrons, the idea of the fixed arrangement caught on and there were a number of examples of pictures and plasterwork being combined effectively. One of the first was in the dining-room at Farnborough Hall (Fig. 314), which was decorated round a series of views of Venice and Rome by Panini mostly acquired by William Holbech when he was in Florence, Rome and Venice in 1732–4. It is not known who designed the

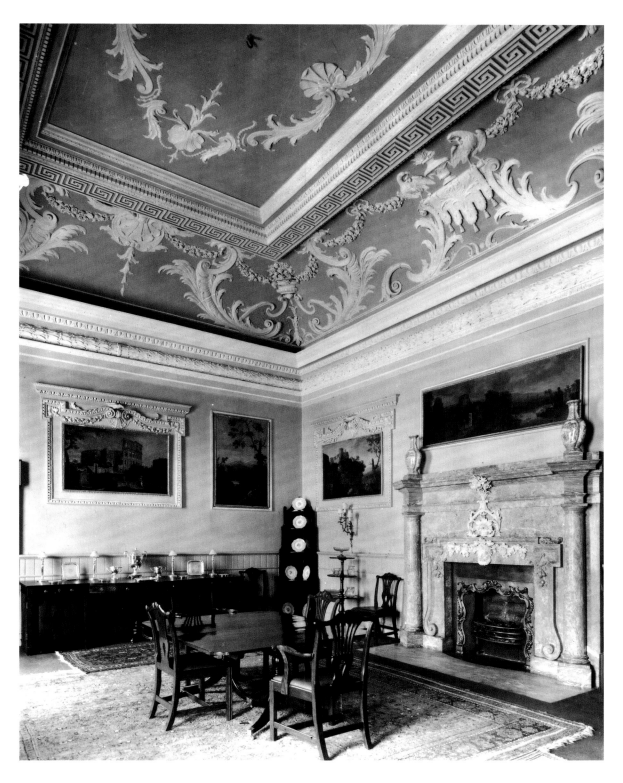

*318. The dining-room at Russborough in 1937. This shows the framed paintings by George Barrett that formed part of its original decoration, soon after 1750. The pictures and frames are no longer there.*

unusually sensitive remodelling of the seventeenth-century house for him, but the presence in the saloon of six panelled doors in what appears to be a distinctive Sanderson proportion raises the possibility that he produced the designs, as he did at Kirtlington. Nor is the date of the start of work recorded, but it seems that, while one pair of Canalettos can be dated to the mid-1730s, when Holbech was in Italy, the other is later, and that would fit with the family tradition that they were painted when Canaletto was in England between 1746 and 1755. So it appears that the set was extended to fit the scheme for the room, where the stucco decoration by William Perritt was measured in 1750. It is interesting to see how high on the walls the pictures are placed, and how much lighter, as well as cheaper, Perritt's scheme is than a set of carved and gilded picture and mirror frames.[9]

The undated saloon at Langley (Fig. 316) was decorated by John Sanderson with an elaborate scheme of plasterwork framing classical landscapes and plaster reliefs by Charles Stanley.[10]

At Russborough, the walls of the dining-room (Fig. 318) were decorated round a set of classical landscapes by George Barret, three of which were enlargements of small pictures by Busiri that Joseph Leeson is thought to have bought about 1750 on his second Italian visit – neither the pictures nor the frames are now in the room – while the drawing-room was given extravagant plaster frames in a quite different spirit by the now so-called St Peter Stuccadore to take the set of four oval *Times of the Day* by Vernet, which were ordered in 1749 by Robert Wood for delivery in the middle of 1751. They were sold from the house in 1922, and by one of those amazing turns of history Sir Alfred Beit was able to buy them back for the room in the 1970s.[11]

There was a similar fashion for arranging earlier portraits in a decorative pattern, as can be seen in Paine's dining-room at Felbrigg (Fig. 427, detail p. 238) and in his design for the dining-room at Gopsall. At Rolls Park, Essex (Fig. 317), there was evidently a problem of clothing the walls of the Great Room and balancing a big mid-eighteenth-century family group with a set of seventeenth-century oval portraits, but they were all set in fixed plaster frames, even if the overall arrangement was less elegant than in the Paine design.[12]

What is unclear is how far back that kind of thinking can be traced in England. It is regrettable that nothing seems to be known about the plans of the 5th Earl of Exeter, who was a passionate collector of mainly Italian pictures in the late seventeenth century and began a remodelling of the interior of Burghley House. His collection is exceptional in including so many pictures by living artists, but sadly he died before the rooms were complete; and they were to remain so for fifty to sixty years.[13]

There was an ancient tradition of portraits of philosophers and writers, either painted or as busts, in libraries, and there was a steady demand for them. One of the best examples was in the library at Chesterfield House, where Vertue noted in 1748:

> Lord Chesterfield haveing a fine room in his new builded house he intends to call (it) the Poets room therein he design to have the portraits of many most memorable Poets heads of this nation. Chaucer, Shakespeare. Johnson. Milton. Cowley. Dryden are amongst he has some original from the life he bought at several times from Ld Oxford Lord Hallifaxes Collections etc. ... many others are copied to the size he wants.[14]

Pictures to go over chimneypieces as opposed to being placed in overmantels seem to have caused special difficulties, particularly in drawing-rooms, where large overmantel glasses were seldom used before the 1760s. And in the late 1740s and 1750s there seems to have been a fashion for decorative pictures in elaborate Rococo frames. What appears to be such a frame survives from Russborough, now without a painting in it (Fig. 80), and there do not appear to be any *in situ*. However, at Wallington there is a landscape with ruins by Pierre Antoine the younger in a carved Rococo frame that looks as if it was intended as the drawing-room overmantel.[15]

What makes it so hard to understand the relationship between pictures and decoration is that not a single house has survived intact, without either major losses or major accretions, particularly of portraits from other families into which they have married. Indeed, the houses that have survived have usually done so through inheritances of property and thus of portraits; and that has tended to swamp historic hangs.

Quite a number of leading families kept their good pictures in London as long as they retained a large London house. For instance, in the eighteenth century there were very few works of art at Chatsworth, and these were mainly family portraits, which were divided with Hardwick; the pictures, drawings, medals and other collections of works of art were concentrated at Devonshire House. Similarly, collections like those of the Duke of Buccleuch and the Duke of Northumberland were kept in their London houses.

Yet another reason why the relationship between pictures and decoration is so difficult to trace is that when in the nineteenth century some families tended to live in what had been rooms of parade, they preferred family pictures and landscapes to Grand Tour history pictures. Later, they kept the family portraits and also pictures of their horses and dogs, but *Cleopatra* tended to find her way to Christies. So certain houses are full of portraits and little else. Antony in Cornwall, for instance, is now crowded with portraits, containing as it does not only its own Carew portraits but Pole portraits from Shute in Devon. They are a fascinating collection historically and artistically, but they give the house a very different character from the one it must have had in the mid-eighteenth century.[16]

Today, an even spread of pictures is expected throughout an old country house, rather like the same amount of strawberry jam on every slice of bread, with the strawberries spread evenly. But an eighteenth-century owner would not have done that. He would have tended to concentrate his Italian history pictures, classical landscapes and Dutch cabinet pictures in a saloon or drawing-room, whose walls would have been hung with damask or some other material; and he would have grouped portraits, sporting pictures or still lifes in a dining-room, which would definitely not have been hung with material and might have been panelled until about 1740 and then plastered. Tapestry would have been chosen for warmth in bedrooms and dressing-rooms. That can still be seen at Holkham, where the larger pictures were always concentrated in four main rooms.

The aim in this chapter is to show how collecting European pictures affected certain houses, to consider what was thought suitable for which rooms; and then examine some of the difficulties owners faced in the arrangement of their pictures and how they had to resort to the use of copies of history pictures or decorative canvases.

It would be interesting to know what was the earliest gallery of pictures in a private house in London or the country, as opposed to a long gallery with portraits as at Hardwick; which was the first gallery to be hung with material as opposed to tapestry or panelling; and what is the earliest picture room for which there is some kind of visual record as opposed to a picture list. Two early drawings that come to mind are for the arrangement of the Kit Cat portraits at Barn Elms in about 1733 and a crude diagram of the pictures in the Gallery at Houghton in the early 1740s, which is in a copy of the second edition of Horace Walpole's picture catalogue printed in 1775, now in the Fitzwilliam Museum.[17]

At Blenheim there was the programme of tapestry in the principal rooms and the Duke of Marlborough devoted both the Gallery and the Cabinet Room to pictures.

Of early eighteenth-century galleries, there is documentary evidence about those at Hamilton Palace in Scotland, and Knowsley in Lancashire, while the essentially unaltered gallery at Wentworth Castle, which was completed by James Gibbs in 1724, still exists but without its pictures. That is a very un-English room, running the length of the great fifteen-bay range designed in 1709 by Jean Bodt, an architect at the Prussian court to which Lord Strafford had been ambassador; but the screens of columns were set up in 1720.[18]

The gallery at Longford as it exists today is in many of its details a restoration by Salvin in the 1870s, but, happily a photograph of it in its pre-Salvin state (Fig. 319) shows how little it has changed in essentials. It was formed in 1740 out of the old Matted Gallery by Jacob Bouverie, 1st Viscount Folkestone, soon after he bought the place. He does not seem to have altered its proportions and so it is

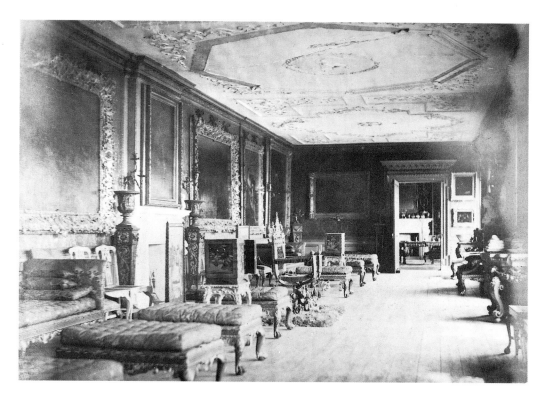

319. *The gallery at Longford Castle. It replaced an earlier gallery and was refitted in the 1740s to take Jacob Bouverie's collection of pictures mostly bought in the 1740s and 50s and it is shown here before it was restored by Salvin in the 1860s. It was hung with green damask and contains a sumptuous set of mahogany and parcel gilt seat furniture attributed to Benjamin Goodison.*

only high enough to take a single row of large pictures. He spent £170 on the damask for the walls and no less than £266 15s. on the chimneypiece by Rysbrack. And he bought sumptuous carved and parcel-gilt mahogany stools and long stools, which seem to have been considered the correct furniture for a gallery, apparently from Goodison. Vertue noted in 1740: 'The Gallery adorned with busts of Marble. Vases – fine marble Tables two large pictures landskips cost 55 painted by Claud Lorrain – he is furnishing a room purposely for pictures.'[19]

Over the years Bouverie built up a group of very distinguished pictures for the room. At Dr Mead's sale in 1754 he bought the pair of Claudes that still hang at either end of the room and also Holbein's portrait of Erasmus. The gallery used to contain a pair of splendid Poussins, *The Worship of the Golden Calf*, now in the National Gallery, and *The Crossing of the Red Sea*, now in Melbourne.

What might have been the finest gallery of all if it had been completed was that in Sir Thomas Robinson's wing at Castle Howard, begun in 1753 but still unfinished on the 4th Earl of Carlisle's death in 1759.[20]

The problem for English collectors was finding large pictures with suitable subjects by acknowledged masters at prices they were willing to pay, and the even greater difficulty of finding them in pairs. Thus Sir Matthew Fetherstonhaugh must have been particularly delighted when he was able to acquire a set of six large canvases by Giordano of *The Story of the Prodigal Son*, and these now form the basis of the hanging schemes in the saloon and the two drawing-rooms at Uppark.[21]

Some owners never solved the problem, as happened with the dining-room at Kirtlington and the saloon at Wallington, where Sir Walter Calverley Blackett obtained a plaster relief after Schiavone's *Apollo and Marsyas* as an inexpensive overmantel and four oval glasses in plaster frames, also an inexpensive choice, but never acquired pictures for the big panels at the ends of the room. Only towards the end of his life did he hang his full-length portrait by Reynolds, which has never looked at ease in the room because it conflicts with the design of the panelling.[22]

Subject-matter was of importance, as Richardson said of copies: 'Our walls like the trees of Dodoma's Grove speak to us, and teach us History, Morality, Divinity; excite in us Joy, Love, Pity, Devotion etc. If Pictures have not this good Effect, 'tis our Own Fault in not Chusing well, or not applying our Selves to make a Right Use of them.' That can also be seen in Pope's letter of 1736 to Ralph Allen about pictures for Prior Park, his great house overlooking Bath: 'A Man not only shews his taste but his Virtue, in the Choice of Such Ornaments And whatever Example most strikes us, we might reasonably imagine may have an influence upon others, so that that History (if well chosen) upon a Rich-Man's walls, is very often a better lesson than any he could teach by his Conversation.' His first suggestions for subjects were 'The Discovery of Joseph by his Brethren' and 'The Continence of Scipio'. The latter was chosen by Lord Leicester for the saloon at Holkham, and at Houghton there was a Poussin of the same subject.[23]

One of the most interesting reflections of Richardson's writing existed in the 2nd Duke of Richmond's dining-room at Goodwood, which he hung with ten of the *Monuments to the Remembrance of a Set of British Worthies*, 'joyn close together all round the room', as Vertue noted in 1738, that came from the set of twenty-four commissioned by Owen McSwiney as a speculation.[24]

That approach can be compared with Gavin Hamilton's suggestion in 1755 to the 4th Marquess of Tweedale for the completion of the saloon at Yester, near Edinburgh:

> as your lordship semd desirous of having something in the historical way, I have taken the liberty to introduce a history picture in the other side representing some great & heroic subject so as to fix the attention of the spectator & employ his mind after his eye is satisfied with the proportion of the room & propriety of its ornaments, I am entirely of the Italian way of thinking viz: that there can be no true magnificence without the assistance of either painting or sculpture[25]

The difficulty of getting the right pictures could be seen in James Stuart's Great Room at Spencer House (Fig. 320), where it took ten

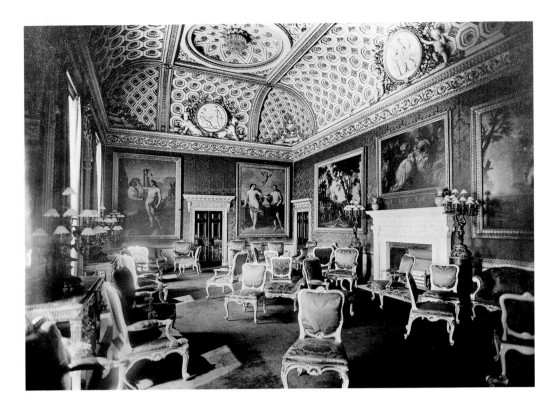

320. *The Great Room at Spencer House designed by James Stuart as it was in 1895. John Spencer bought Sacchi's* Apollo Rewarding Merit and Punishing Arrogance *(on the left) and Reni's* Liberality and Modesty *(on the right) in 1758, the pair of large Salvator Rosas in Italy in 1764 (one seen on the right) and the pair of Guercinos for the other end wall in 1768.*

321. *The hall at Aldby Hall, Yorkshire. It was designed round the life-size picture of the Darly Arabian, which belonged to the father-in-law of John Brewster, the builder of the house in the 1720s, who may have been an amateur architect.*

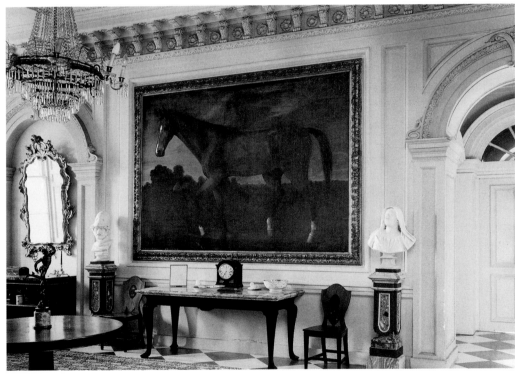

years to clothe the walls. First, in 1758 John Spencer bought Reni's *Liberality and Modesty* and Sacchi's *Apollo Rewarding Merit and Punishing Arrogance* (now in the Metropolitan Museum) that were eventually hung either side of the door at one end of the room; then in Italy in 1764 he bought the pair of large Salvator Rosas that were placed on the long wall flanking the chimneypiece; and only in 1768 did he acquire the pair of Guercinos for the other end of the room to balance the Reni and Sacchi.[26]

If originals could not be obtained, copies had their place and certainly they were not despised as they are today. Jonathan Richardson observed in *The Art of Criticism* (1725): 'A Copy of a very Good Picture is preferable to an Indifferent Original; for There the Invention is seen almost Intire, and a great deal of the Expression,

and Disposition, and many times good Hints of the Colouring, Drawing and other Qualities.'[27]

Thus sets of copies were organized for great rooms and saloons, as happened at Stourhead in the mid-1740s, as Sir Richard Colt Hoare explained some years later: 'Except in one instance, the pictures are all copies, but selected with great taste as to their subjects, and executed by the best artists who resided in England and at Rome.' On one side of the door was *Wisdom as the Companion of Hercules* after Veronese and on the other *The Daughter of Herodias, with the Head of St John* after a picture in Rome by Reni, copied by Batoni. The other pictures were *The Death of Dido* after Guercino and *The Rape of Helen* after Reni, both in the Spada Gallery; *The Family of Charles I* by old Wyck after Van Dyck; *Perseus and Andromeda*

after Reni in the Palazzo Rospigliosi; and the only original, *The Judgement of Midas* by Bourdon.[28]

The most ambitious example was the gallery at Northumberland House (Fig. 84), which was added on to the house by the Earl of Northumberland as soon as he and his wife inherited on the 6th Duke of Somerset's death in 1752. Designed by Daniel Garrett as a great reception room with elaborate plasterwork by the Lafrancini and with Benjamin Carter's two great continued chimneypieces, whose overmantels contained life-size portraits of Lord and Lady Northumberland by Reynolds, it was too large for even the Northumberlands to line with major Old Masters. So instead, through the good offices of Horace Mann and Cardinal Albani, it was arranged that Mengs should copy Raphael's *School of Athens*; Batoni, *The Council of the Gods* and *The Wedding of Cupid and Psyche*; Constanzi, Annibale Carracci's *Bacchus and Ariadne*; and Masuccio Guido, Reni's *Aurora*. It was the most ambitious project of its kind in an English house and was finished by 1757.[29]

Another solution was to clothe the walls with a set of canvases of Roman ruins. One early example of classical ruins as a theme for decoration on a large scale may be found on the staircase at 20 Cavendish Square, which is attributed to John Devoto and dated about 1730. If that date is correct, it would coincide with the rising taste for Panini's ruin pieces in the 1730s, with the earliest commission for a group being from Lady Suffolk, whose set of five in the Great Room at Marble Hill is dated 1738 (Fig. 77).[30]

The taste for ruins was to spread to the decoration of porcelain, printed cotton, wallpaper and plate, but it appeared rather earlier in gardens, as can still be seen at Shugborough, where they seem to have been designed for Thomas Anson by Thomas Wright sometime before 1749, and, as we have seen, Anson formed in his north wing a Great Room decorated with ruin pieces of classical architecture.[31]

A similar solution can be seen in the saloon at Yester (Fig. 322), where in 1761 Lord Tweedale, having rejected Gavin Hamilton's advice about history painting, obtained from William Delacour seven large decorative canvases depicting classical ruins. Delacour, who had come to England before 1740 and worked as a scene painter as well as producing one of the first sets of Rococo ornament prints in England, became the first director of the School of Design in Edinburgh.[32]

Most eighteenth-century halls were designed as architectural spaces not intended for pictures, but exceptions were occasionally made for sporting pictures or portraits of horses that reflected the increasing interest in fox hunting, racing and breeding horses. One is at Aldby Hall, Yorkshire, where in the mid-1720s John Brewster designed the hall round the life-size picture of his father-in-law's horse, the Darly Arabian (Fig. 321). The idea goes back to the Palazzo del Te in Mantua, and that was probably the origin of the set of pictures of great horses painted for the Duke of Newcastle for Welbeck. In 1727 Vertue saw them there: 'In the Hall several great Horses painted large pictures as big as the life. Manage horses.' The Duke's daughter and heiress, Lady Oxford, who was a hunting enthusiast herself and was painted on horseback by Wootton in 1715 soon after her marriage, removed them to Wimpole; but by 1740 Vertue saw them at Bulstrode, which belonged to her son-in-law, the Duke of Portland, 'the five large hunting pieces painted by that famous Master de Vos these pictures lately removed from Wimpole'.[33]

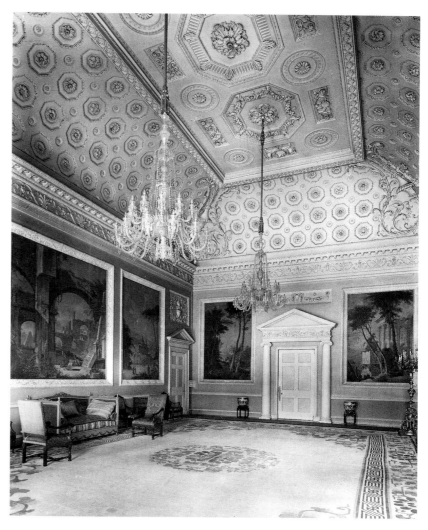

322. *William Delacour's ruin pictures painted in 1761 for the saloon at Yester, Midlothian, designed by John Adam, as it was in 1932 (?). Lord Tweedale rejected Gavin Hamilton's suggestion of a series of history paintings and turned instead to Delacour, the first head of the School of Design in Edinburgh. Also he rejected the idea of any gilding in the room.*

The two best surviving examples are at Althorp, and Badminton (Fig. 238). At Althorp, the hall was remodelled by the 5th Earl of Sunderland between 1729, when he inherited, and 1734, when he handed over to his brother, John, on inheriting the Marlborough dukedom. He was also the builder of the stables. The huge paintings dated 1733 by John Wootton (but still in his studio in 1734) echo the frieze that is ornamented with fox's masks, hounds, heads of Diana and symbols of the chase in the spirit of the frieze in the saloon at Houghton.[34]

Wootton was also responsible for the set of canvases painted for the 3rd Duke of Beaufort for the hall at Badminton, which used to be attributed to Kent but is now recognized as being by James Gibbs with its order of Corinthian half-columns on high bases framing the chimneypiece and doorcase and its trophies of Italianate plasterwork in the corners of the room. There are five large pictures in fine frames usually regarded as Kentian, but subtly different in handling and possibly by John Boson. Over the chimneypiece is a portrait of *Poppet* and the other four are hunting scenes, starting with *Henry, 3rd Duke of Beaufort Stag Hunting at Badminton*, which was painted in 1734. The *Hawking piece with a view of Netheravon House* and *Henry, 3rd Duke of Beaufort and his neighbours and friends* was added in 1744.[35]

The balance of portraits and subject pictures in particular rooms

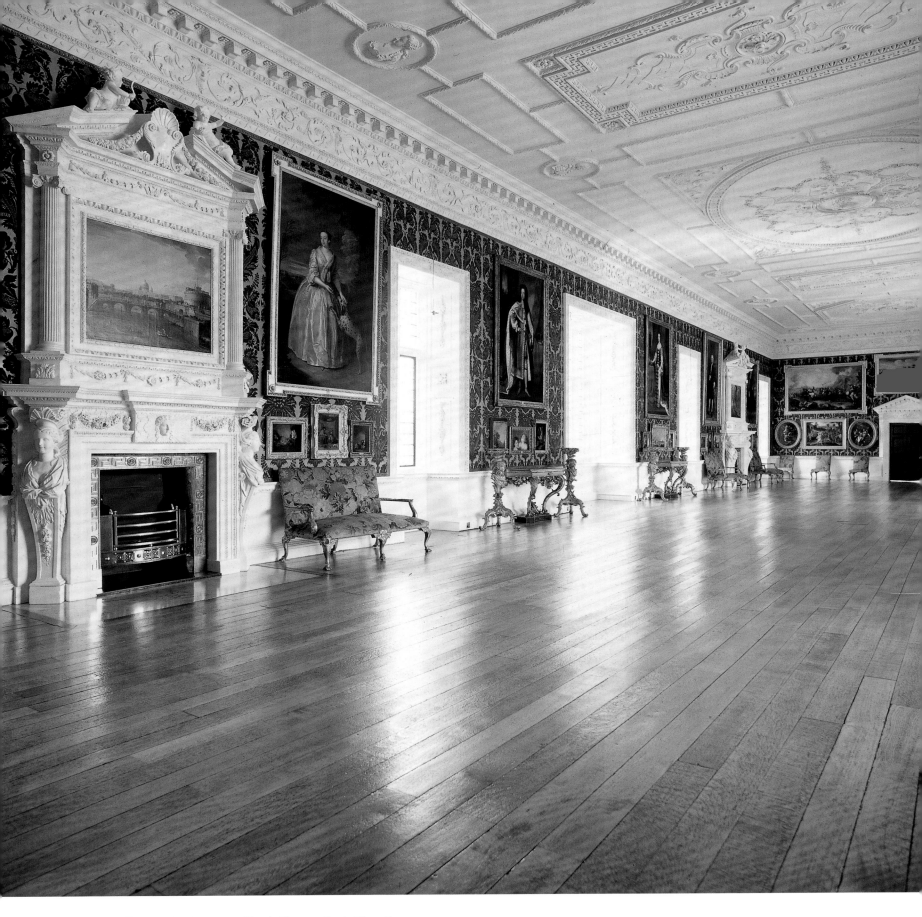

323. *The gallery-cum-drawing-room at Temple Newsam, Leeds. The gallery was probably designed by Daniel Garrett for the 7th Viscount Irwin and completed in 1745. A recent restoration of the original arrangement of pictures set against a copy of the original flock paper. The 7th Viscount combined inherited and commissioned family and royal portraits with pictures collected in Italy by his eldest brother, the 4th Viscount. The twin chimneypieces, unusually of stucco, with wooden overmantels framing pictures by Antonio Joli, were copied from an engraving of a Kent design in Ware's* Designs of Inigo Jones, 1731.

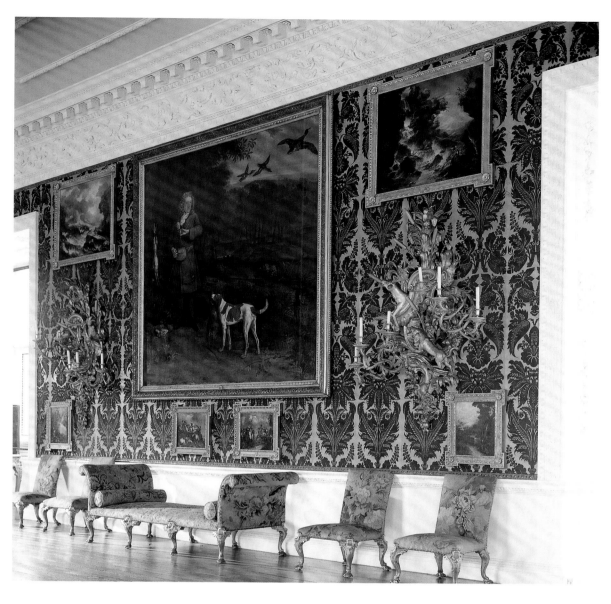

324. *The gallery, Temple Newsam. The centre of the south wall with Knyff's portrait of the 3rd Viscount Irwin, the father of the 4th and 7th, dressed in an early version of a frock coat for shooting. It is flanked by the pair of huge carved and gilded sconces with complementary hunting detail by James Pascall. Beneath can be seen part of the extensive set of water gilt seat furniture, tables, sconces and stands supplied by Pascall, who was principally a picture frame maker.*

has to be related to what new pictures could be afforded. That can be seen in the recent recreation of the historic hang in the gallery at Temple Newsam (Fig. 323). The house had been inherited in 1736 by the 7th Viscount Irwin, who was then forty-five. He could not afford and nor did he wish to replace the hollow 'E'-shaped Jacobean house, but he had difficulty modernizing the plan. The hall, for instance, was in the south wing, while the inconvenient gallery, which was then the principal drawing-room, was in the north wing. It has been suggested that at least the basic design of the gallery and its ceiling is by Daniel Garrett. In the double portrait of Lord Irwin and his wife painted by Mercier in about 1741, Lord Irwin holds the design for the ceiling, but there is no evidence to suggest that he was an amateur architect.[36]

The ceiling was carried out by Thomas Perritt and Joseph Rose senior, as is known from Perritt's detailed bill, but what is unusual is that traces of a terracotta colour have been found in the old paint on the entablature and ceiling, and the interpretation of that has given a warm cast to both and contrasts with the white of the dado. The two chimneypieces, unusually of stucco, and their overmantels of marbled wood were carved by Robert Doe, a London craftsman, copying Kent designs in Ware's *Designs of Inigo Jones*. And as evidence of the recent improvement in wallpaper production, the walls were hung with a flock paper in green in the so-called Amberley pattern.

The gallery was completed in about 1745, and the earliest picture list was compiled in 1750. It shows that the room contained eighty-three pictures. Of these, forty remain in the room. The 7th Viscount had inherited portraits and a group of Italian pictures collected by his eldest brother, the 4th Viscount, who had died in 1714. He himself could not afford to buy subject pictures, and so he had to make an effective display out of what he had inherited, with a few additions of his own. On the long north wall, where there were five windows and the two chimneypieces, he hung mainly royal portraits with William III and Queen Mary, who are still there, and James II, Queen Anne and the Prince of Denmark, who were answered by the portrait reliefs of their Hanoverian successors on the ceiling. On the south wall, in the central position, he hung Knyff's portrait of his father, the 3rd Viscount, as a sportsman (Fig. 324), and he flanked it with the pair of huge carved and gilt sconces; and in the end bays he hung Richardson's double portrait of his brother, the 5th Viscount, with his wife, and the Mercier of himself with his wife. On the end walls there were big landscape-shaped pictures with ovals below them and there were ovals over the doors. These must have created a pattern similar to that in the dining-room at Felbrigg (Fig. 427, detail p. 238) and perhaps it can be seen as a Rococo idea. A sense of unity was also strengthened by the use of different sizes of earred architrave frames.

The arrangement of the pictures was set off by the particularly fine set of water gilt furniture that is fully Rococo in feeling and

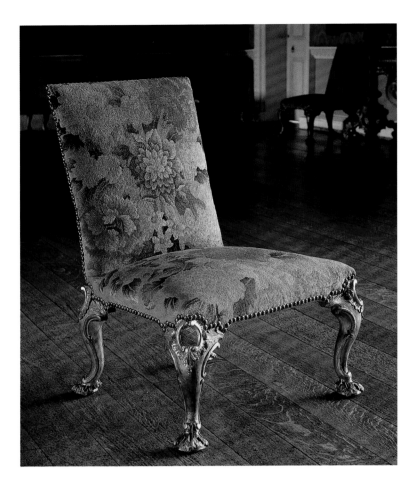

325 and 326. *A side chair in the gallery at Temple Newsam showing how the yellow needlework with bright gilt nails complemented the originally bright gilding of the frames with their contrasts between the burnished carving and the matt grounds. Below, a cushion from one of the long stools rolled back to show the intensity of the unfaded colours.*

quite different in mood from the restrained classical conception of the room. It was supplied by James Pascall, an otherwise almost unknown carver of Huguenot descent recorded between 1733 and 1754, who seems to have been primarily a picture-frame-maker. He was no doubt chosen for his modest charges, which he explained: 'I am ye Maker my Self and does Everything at ye first hand.' The suite is a huge one, consisting of twenty chairs, which cost two and a half guineas each, a day bed costing £8 10s., four settees, which cost £28 13s. 6d. a pair, a pair of small pier-tables with enriched gesso tops that are late for their date, a pair of larger pier-tables with marble tops (now at Floors Castle), eight candle stands, four of which remain in the room, and the pair of large sconces. The total bill came to £364 16s. 7d. Most of the furniture is still in the room (Fig. 325), the seat furniture covered in its original needlework in a bold design of scrolling leaves echoing the leaves in the wallpaper with bright flowers on a golden yellow ground. Inevitably the yellow has faded (Fig. 326) and the gilding has gone down, but the original brightness of the yellow, which can still be seen on the undersides of the balusters, was reflected in the water gilding, with its contrasts of matt areas and highly burnished carving; and both were confirmed by the gilt heads of the big nails and by the plain yellow wool on the backs of the chairs.

The most spectacular elements are the two sconces, and recently, since the rehanging of the pictures, it has become clear that their hunting detail relates to the Knyff portrait, which occupied the place of honour in the centre of the south wall. Again, their gilding has gone down, so there is little burnishing left, but originally there were contrasts between the burnished and matt areas and the special working of details such as the stags' horns and the heads of the bull-rushes.

The recent copy by Allyson McDermott of the original green flock wallpaper is instructive for a number of reasons. First, it was done on a special handmade English linen paper that has a body and life to it that influences the ground. The ground is actually a varnish pigmented with malachite and so has a sheen to it that imitates the satin ground of a damask and catches the light. After that, a secondary blue-green was stencilled on, and that gives the look of a shadow in the infill of the leaves of the design (copied from the paper in the Prince Regent's Bedroom at Clandon). Only after that was the wool flock applied. In this particular printing, the three blocks were placed a little further apart than usual, and that gives an added importance to the ground, so that, while the figure is in flock, the largest and brightest area of colour is that of the ground, which sings out and seems to reflect a sunny green landscape outside.

Evidently the hanging of the paper and the placing of the pictures were carefully related, with the original small cabinet pictures in the bottom row seeming to line up with the figure of the paper and with the chairs placed beneath them. The present pictures are a little larger than the originals, and so it is impossible for everything to line up in that way.

# 9

*The Influence of the Orient on Decoration*

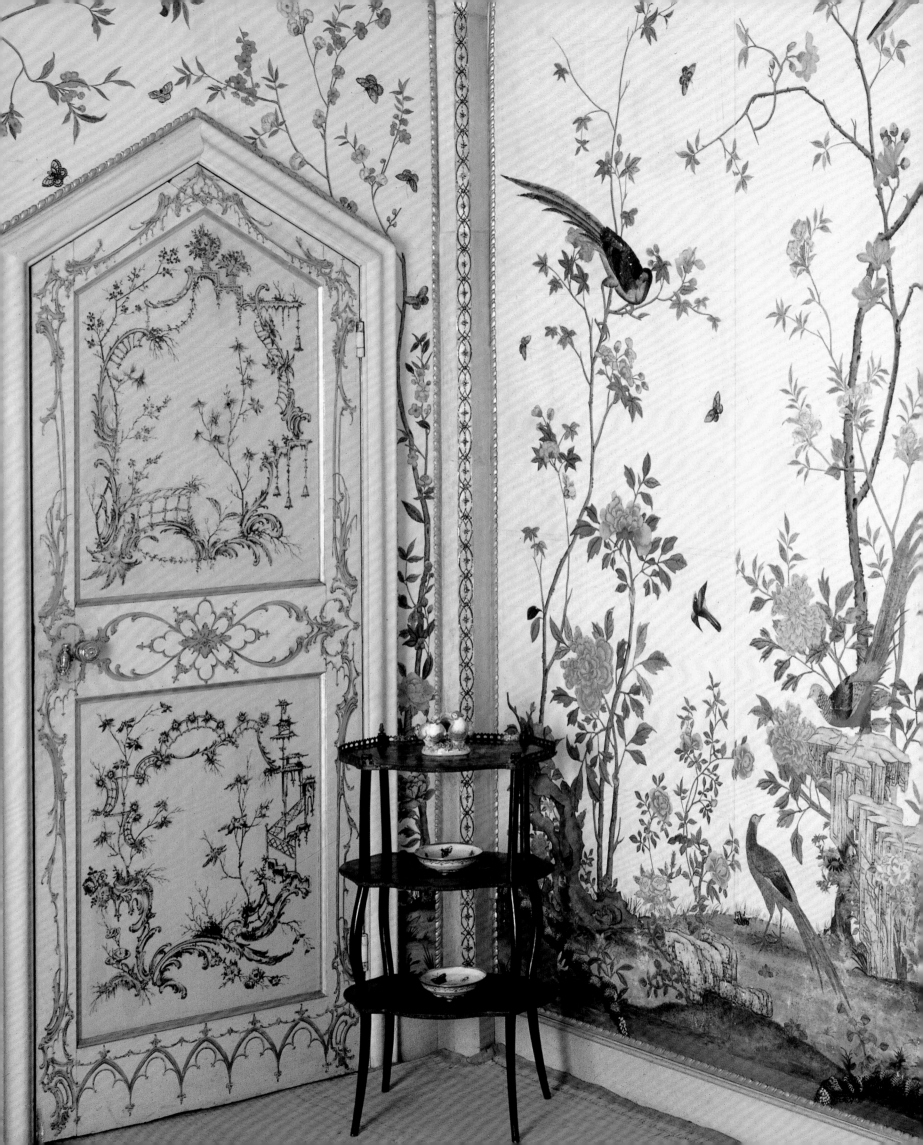

## CHINOISERIE IN DRESSING-ROOMS, BEDROOMS AND DRAWING-ROOMS

Chinoiserie has contributed to the delight of English rooms since the seventeenth century, even if at the time there was little awareness of what was Chinese, Indian and Japanese, and where different kinds of porcelain, silk and cotton, lacquer and wallpaper came from. Moreover, it had a more radical, far-reaching and long-lasting influence on English taste and decoration. It contributed to the lightening of the look of rooms as well as clothes. It encouraged the broadening of the range of colours used in decoration and also the move towards informality through the development of japanned furniture.

It is revealing that chinoiserie objects and European imitations of them were often to be found in bedrooms and dressing-rooms and then in drawing-rooms, in rooms particularly associated with the private lives of ladies and their organization of tea drinking. The growing influence of ladies, particularly from about 1725, was crucial, because as bedrooms and dressing-rooms became more private, they also became more comfortable and informal as well as being places where their occupants were prepared to try out new ideas in decoration and experiment with schemes that were not too expensive or long-lasting. Thus in 1751 Mrs Delany wrote of her friend Mrs Vesey having 'a whim to have Indian figures and flowers cut out and oiled, to be transparent, and pasted on her dressing room window in imitation of painting on glass, and it has a very good effect'. Oriental objects not only fitted in with this trend but encouraged it.[1]

From the 1670s on, there had been a growing enthusiasm for oriental things that can be seen not only in imported objects and European adaptations, but also in prints such as those illustrating Johan Nieuhoff's *An Embassy from the East India Company of the United Provinces to the Grand Tartar Cham, Emperor of China*, first published in Amsterdam in 1658 and translated into English in 1669, and in Stalker and Parker's *A Treatise on Japanning and Varnishing* (1688) and C. de Moelder's *Proper Ornaments to be Engraved on Plate* (1694). Today the cumulative impression that chinoiserie objects made in late seventeenth- and early eighteenth-century country houses can only be judged from inventories of the period. The quantity of porcelain, lacquer and japanned furniture, and oriental textiles in houses like Drayton and Petworth, was amazing, and it is striking what a crucial role the collecting of porcelain, mostly by

ladies, had on the wider enthusiasm. Queen Mary was a passionate collector, and as Defoe wrote: 'The Queen brought in the Custom or Humour, as I may call it, of furnishing houses with China-ware, which increased to a strange degree afterwards piling their China upon the Tops of Cabinets, Scrutoires, and every Chymney-Piece to the Tops of the Ceilings, and even setting up Shelves for their China-Ware, where they wanted such places.' She used it as major element in the decoration of nine rooms at Kensington Palace.[2]

Some idea of that can be seen in Marot's prints (Fig. 330), and the reality can still be experienced at Burghley, where there is a large collection of oriental porcelain dating from the late seventeenth and early eighteenth centuries, including pieces inherited by Lady Exeter, the wife of the 5th Earl, from her mother, Lady Devonshire, who died in 1690. These include the earliest documented pieces of Japanese export porcelain in the western world. At Drayton, it can be related to the taste of Lord Peterborough's daughter and heiress, the Duchess of Norfolk, subsequently the wife of Sir John Germain. Both call to mind Wycherley writing in *The Plain Dealer* in 1674 of porcelain as 'the most innocent and pretty furniture for a lady's chamber'.[3]

Not surprisingly, porcelain shapes influenced silver forms, particularly those for tea and coffee pots, while its decoration influenced that of silver, where from about 1670 there was a fashion for flat chased designs in a chinoiserie style, possibly created by one specialist engraver. They can be seen on the toilet service from Sizergh Castle, Cumbria, made in about 1680 and supposedly given by King Charles II to the Strickland family (now in the Victoria and Albert Museum).[4]

The association of chinoiserie decoration seems to have been established with dressing-rooms and bedrooms before drawing-rooms, and in the case of dressing-rooms in great apartments it provided a way of creating a completely different mood after the build-up of formality to a climax in the bedroom, and one that was not an anticlimax. Here, the lacquer closet must have been strikingly effective. Such rooms were created at both Chatsworth and Burghley, the former by Gerrit Jensen, who charged £141 for working the lacquer, carving the cornice, veneering the floor in walnut and cedar and making glass pilasters to frame the mirrors, making the door, glazing the sashes and making two carved squabs. When Celia Fiennes visited Chatsworth in 1697, she noted: 'The Duchess's Closet is wanscoated with the hollow burnt japan and at each corner are peers of Looking -glass, over the Chimney is Looking glass an

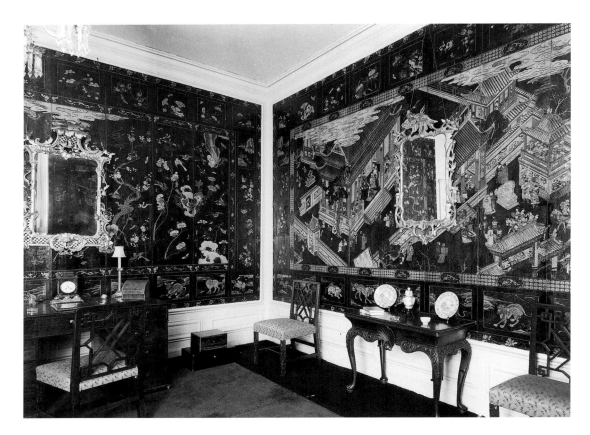

327 and 328. *The only surviving lacquer drawing-room, originally called the Japan Room, at Burton Agnes, lined with panels of dismembered screens. The scheme incorporates oval portraits of Queen Anne and George I, which suggests it was fitted up about 1715. There is no evidence about how the framing woodwork was decorated but perhaps it was painted to imitate lacquer or painted in a chinoiserie style as at Carshalton (Fig. 142).*

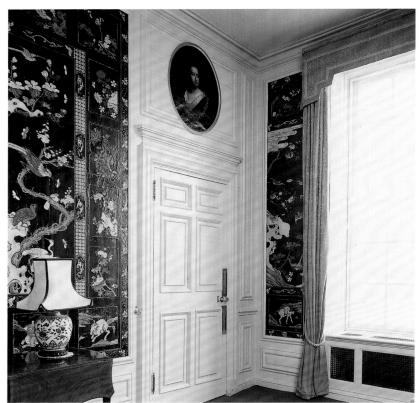

oval, and at the 4 corners, after this figure, and hollow carving all round the glass.' The room only lasted a few years because it was dismantled when the west front was rebuilt in 1700; but it is thought that some pieces of the lacquer were made up into a chest-on-gilt stand that gives an idea of how colourful the little room must have been. At Burghley, Celia Fiennes recorded: 'My Ladyes Closet is very fine the wanscoate of the best Jappan the cushons very rich work; there is a great deal of fine worke under glasses and a Glass-case full of all sorts of Curiosityes.' Another was described at Badminton in 1694 by Edmund Spoure: 'There is one room the

finest that I ever saw, and it is a large proportionable room; the walls are all wainscotted, as I may term it, with true East India japan in figures of birds, beasts, fruits, trees, and flowers, in their proper colours.'[5]

Panels of cut coromandel lacquer can still be seen in the closet to the state bedroom at Drayton, where it seems that they were introduced in about 1702–5 by William Talman as the background for part of the porcelain collection of the Duchess of Norfolk. According to the inventory of 1710, there were ten Indian panels of wainscott round the room, and the furniture was either lacquer or jappaned, with the window curtains, portières, valances and cushions all of white silk.[6]

Lacquer rooms bigger than a closet or dressing-room must have always been rare, and few are described. There was one at Buckingham House in London, which was begun in 1705, again possibly to the design of Talman, and so the room itself was presumably fitted up in about 1708–10. It sounds as if it was a drawing-room, being on the first floor in the centre of the west front, behind the saloon in the centre of the east front. The inventory of 1743 described it as 'Lined with India Japan Boards, all the Japan finisht with carving and gilding, all the glass and picture frames the same. Eight carved and gilt flowers fixt in the lower panels.'[7]

Now the only surviving lacquer drawing-room is at Burton Agnes. Formerly called the Japan Room (Fig. 327), its walls are lined from skirting to cornice with cut lacquer panels from a coromandel screen sawn through so that both the front and the back could be used, with narrower panels filling the spaces between the windows and doors. Over the doors are oval portraits of Queen Anne and George I, so presumably the room was fitted up about 1715 by Sir Griffith Boynton, the 3rd Baronet, a few years after he married in 1711, as part of his alterations. There is no evidence of how the framing was painted or how the room was furnished, but the room gives a sense of the taste for brilliant colour and highly polished surfaces.[8]

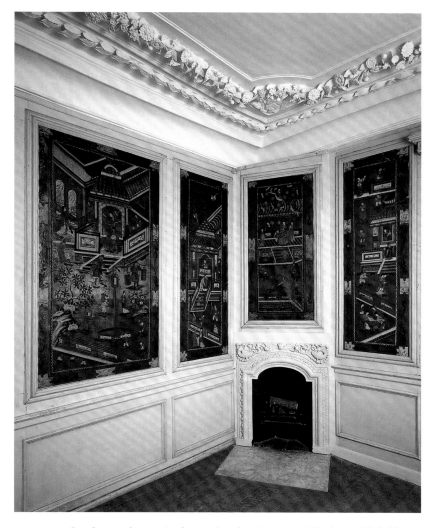

329. *Leather panels imitating lacquer in a dressing room at Honington Hall. The panels are of three different sizes and must have been made for the purpose. Recently it has been suggested that they date from 1725.*

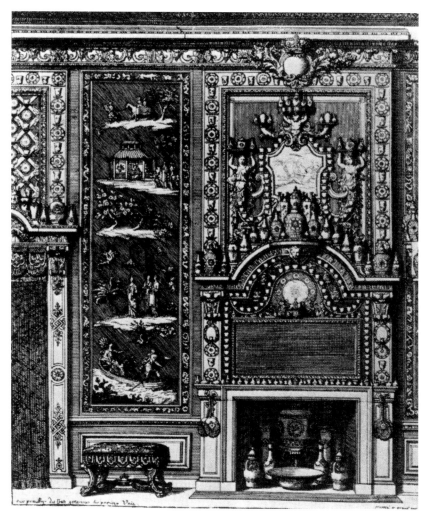

330. *An etching of part of a closet by Marot, about 1700. The panel of chinoiserie decoration to the left of the chimneypiece could be tapestry or lacquer and suggests that he may have been involved with the origin of the design for the chinoiserie tapestries first woven by Vanderbank for Queen Mary at Kensington Palace.*

It was possible to create a similar effect more cheaply by using leather panels decorated in an oriental style, as in the closet at Honington Hall (Fig. 329), where they are of three different sizes with borders and must have been ordered to fit the existing panelling, probably after 1715. Leather panels of a similar character were also made for chairs covers, as can be seen on a set of chairs of about 1705–10 formerly at Parham Park, Sussex and now in the Lady Lever Art Gallery.[9]

Chinoiserie decoration also occasionally appears on the stiles and rails of panelled rooms, as if to suggest that the main panels were framed in lacquer. Among the surviving examples are those in a first-floor room at Hill Court, Herefordshire, where they frame panels of figured marbles set in marbled mouldings; at Great Hundridge Manor, Buckinghamshire, where the panels imitate walnut; at Swangrove, on the Badminton estate; in Lady St John's Parlour at Old Battersea House, London; and in the Painted Parlour at Carshalton House, Surrey.[10]

The last (Fig. 142) is one of the most remarkable painted rooms of the early eighteenth century and appears to date from about 1710, but certainly before 1713, when Edward Carleton, a tobacco merchant and the builder of the house, went bankrupt. The late Edward Croft Murray attributed the whole room to Robert Robinson on the basis of the parallels he saw with the panels signed and dated 1696 by Robinson (d. 1706) in Sir John Cass's Institute in

London and a set of panels acquired by the Victoria and Albert Museum in 1954. However, the main landscapes in an Italianate Dutch manner are quite unlike Robinson's work, and it seems unlikely that he would have painted the remarkably free stiles and rails, even if he was still alive when the room was done.[11]

Whether all the panels in the Carshalton room were painted on site or ordered from a London painter and then fitted into the room is not clear, but the original effect must have been of a red japanned room with the stiles and rails painted to resemble lacquer and green-black painted mouldings with some gilding, while the moulded cornice is painted in *trompe-l'œil* to resemble carving. There are also landscapes in the dado panels, on the doors and the backs of the shutters.

The taste for lacquer or leather led to the idea of adapting tapestry as John Vanderbank did for Queen Mary's Drawing-Room at Kensington Palace in 1690. Whether Marot was in some way involved in the project is not known, but it is quite possible, because one of his prints for the corner of a room on the scale of a dressing-room issued about 1700 shows panels that look suspiciously like tapestry (Fig. 330).[12]

The Queen's tapestries do not survive, and the only early set still in its original position is the pair in the Blue Drawing-Room at Belton House (Fig. 331), which Sir John Brownlow ordered from Vanderbank in 1691, 'the said hangings to be of Indian figures

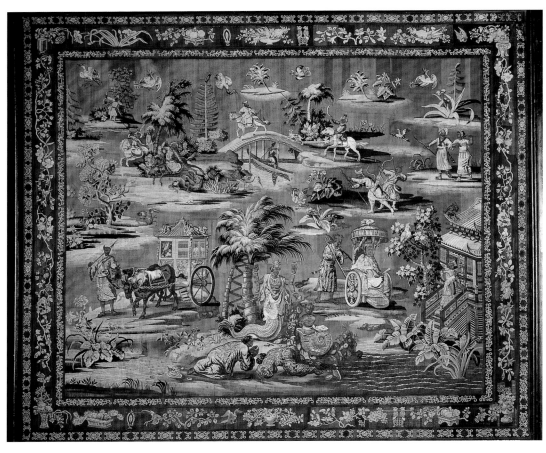

331. *One of the Vanderbank tapestries woven for the Blue Drawing Room at Belton House in 1691. The earliest examples still in situ of designs woven for Queen Mary that became a fashionable form of decoration imitated and adapted by other weavers. It is not known whether Marot was involved with the original weaving but the print of Fig. 330 raises the possibility.*

332. *One of the set of three similar tapestries supplied by Leonard Chabaneix in 1700 for the state bedroom at Melville House, two of which are now at Russborough.*

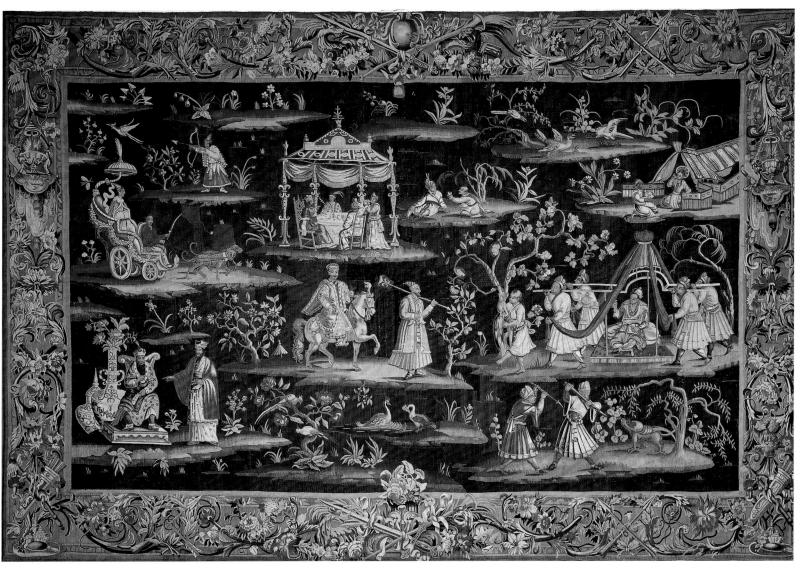

333. *The State Bedroom at Kimbolton as it was in 1911. The early eighteenth-century bed was made partly out of the Earl of Manchester's canopy of state with crimson velvet, doubtless bought in Venice, and strips of Chinese embroidery. The walls were hung with more of the velvet bordered with strips of the embroidery.*

according to the pattern of the Queens which are at Kensington and to be finished as well in every kind'. The room was panelled to take them and they contributed to it being one of the most expensively furnished in the house, according to the 1698 inventory, which valued its contents at £300. Recently it has been discovered that the marbling now faded to a green colour is almost certainly original and was a brilliant blue flecked with gold to tone with the blue borders of the tapestries: that would fit with it being called the Blue Drawing-Room in Lord Tyrconnel's time.[13]

Vanderbank's tapestries proved to be a lasting success, with many versions woven over the years and imitations made by other weavers. For instance, the set of three panels acquired to go with the great Lapierre bed at Melville House in Scotland (Fig. 101), of which two are now at Russborough in Co. Wicklow (Fig. 332), was supplied in 1700 by Leonard Chabaneix. One of them is a mirror image of a Vanderbank panel in the Victoria and Albert Museum. At almost the same moment another pair was supplied to Hopetoun by John Hibbert, a London upholsterer, so it appears that plagiarism started early on. Part of the reason for their choice must have been the contrast in scale between a towering bed and their small motifs, making it a pleasure to lie in bed and enjoy complete scenes rather than just a hero's legs or a horse's head. At Melville House there was an additional link between the tapestries and the bed through the scale of the floral pattern of the white Chinese damask lining the curtains. Lord Carlisle also chose a set of Vanderbank tapestries for his bedroom at Castle Howard that still survives in the house.[14]

Queen Mary's taste for oriental porcelain and choinoiserie tapestry extended to her japanned bed at Kensington in 1690, which was supplied by Thomas Roberts, while at Windsor she had one of Indian embroidery on white satin, which was presented to her by the East India Company. It is possible to trace a series of beds associated with ladies that have or had oriental hangings and clearly contrasted with their husbands' rooms. At Wanstead in 1724 Lady Castlemaine's apartment 'consists of a Parlour, finely adorned with *China* paper, the Figures of Men, Women, Birds, Flowers, the Liveliest I ever saw come from that Country. The Anti-Chamber is furnish'd with *China* silk, stained in Colours, incomparably fine; the Bed-Chamber, Dressing-room, and Closet, all also of *China* Silk'.[15]

One of the most surprising uses of chinoiserie motifs on a bed was in the state bedroom at Kimbolton (Fig. 333), where early twentieth-century photographs show the bed partly made out of the Earl of Manchester's canopy that he presumably had when he was ambassador to Venice, velvet presumably bought by him in Venice similar to that on the chairs of 1706–8 (Fig. 168) and strips of Chinese embroidery. These were also used to border the panels of velvet wall hangings in a fashion similar to that surviving at Ham House and described in the Blenheim inventory.[16]

Complete sets of Chinese embroideries were also chosen for best beds, as can be seen at Erddig (Fig. 369), where the bed is so described in the 1726 inventory, and may give an idea of what Lady Castlemaine's furnishings were like. The Erddig bed was made in about 1720 by John Hutt, a cabinet-maker in St Paul's Churchyard, London, but possibly he was collaborating with John Belchier, a neighbouring craftsman, who incorporated very similar gilt gesso detail a few years later on the frame of a glass (Fig. 366) he provided for the room. The embroideries are cut and worked with great imagination and skill to relate to that frame. With the bed are a set of green japanned chairs (Fig. 371) that are still *en suite*. However, when the bed was taken upstairs soon after 1770, the Soho tapestries (Fig. 368) with figures in oriental dress, which had been adapted to fit the room, were replaced by a more fashionable green-ground chinoiserie wallpaper.[17]

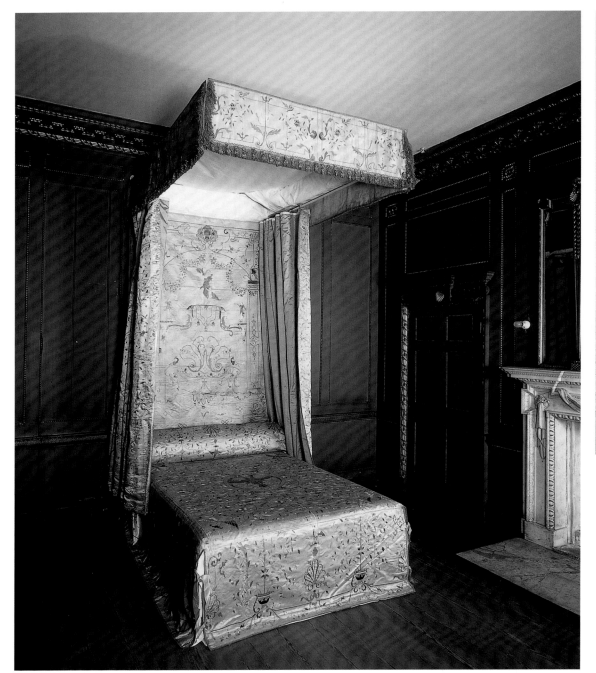

334 a and b. *A recently rediscovered set of Chinese embroidered bed hangings at Newhailes, about 1740, and a panel of chinese wallpaper surviving in the dressing room, part of a scheme of Chinese wallpaper hung in all the rooms of the Great Apartment in the late 1730s.*

The other bed with a complete set of Chinese embroidered hangings is that discovered in the early 1980s at Calke Abbey, where it had lain unpacked for at least 150 years. Its history and even its precise date is unclear, but it most likely dates from the early 1730s and was probably made for the marriage of the Princess Royal to the Prince of Orange in 1734 and was a perquisite of Lady Caroline Manners, who married Sir Henry Harpur the same year. The silhouette of the bed is strictly architectural, like Kent's green velvet bed at Houghton, and its effect depends on the contrast of the dark blue ground of the outer hangings and the white of the interior.[18]

Recently, another set of Chinese embroidered bed hangings was rediscovered at Newhailes (Fig. 334). Almost certainly they are the hangings of the best bed acquired as part of the improvements carried out by Sir James Dalrymple about 1740 and described in the late eighteenth-century inventory, where they are listed as 'An Indian embroider'd bed lined with blue silk', 'a Coverlet the same lin'd with

white silk', 'a Piece of hanging the same'. They appear to be a ready-made set exported to Europe, as can be seen from the head cloth, which is based on a print by Berain, rather than a special order. Since the walls of the drawing-room and dressing-room had Chinese paper, that raises the possibility that the treatment of the apartment grew out of the acquisition of the bed hangings.[19]

Painted Chinese taffeta was also used, and although Sir Robert's own bed at Houghton has disappeared, there is still a fine bed on the second floor that is listed in the 1745 inventory (Fig. 335). The bed curtains were renewed in the 1930s when the bed was relined and the posts fitted, but the cornice, valances and trimmings are part of the original angel bed. The walls are also lined with painted Chinese taffeta showing sprays of flowers, birds and butterflies, and although the material appears to have been taken down and remounted, it presumably more or less follows the original arrangement. In fact, three closely related designs with stencilled outlines are used, but two are in two different colour ways, and they appear

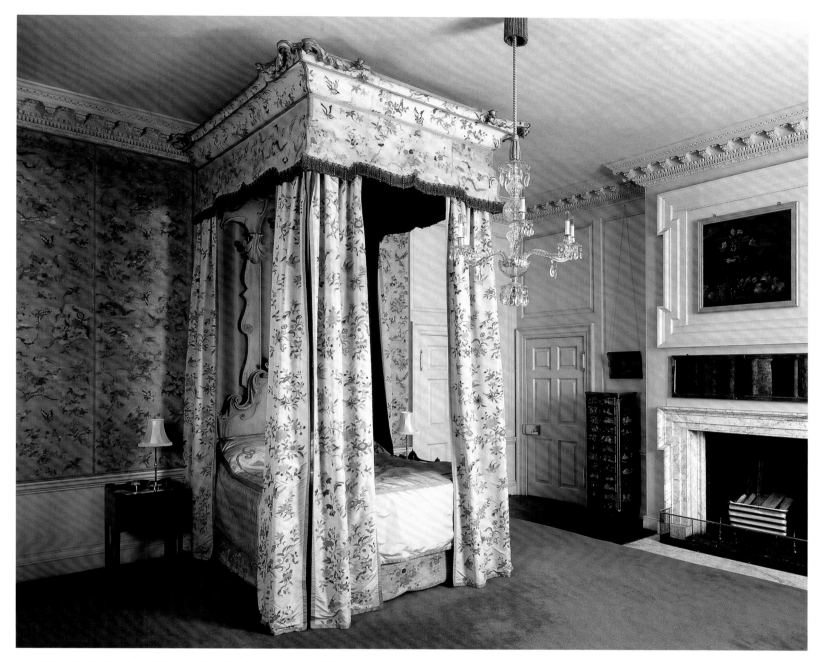

335. *The painted taffeta bed at Houghton listed in the 1745 inventory. The cornices and valances are original as are the wallpanels; the bed curtains are a restoration.*

to be on the half-drop, with two complete repeats in each drop, so that it reads as a completely free pattern.

On the same floor at Houghton there were also beds of Indian 'white work', of which part remain (Fig. 336): they are of lightly quilted cotton on the same principal as the embroidered bed below and decorated with thin bands of Indian embroidery.

Evidently there was a fashion for such 'white work' beds and quilting, because, according to the 1740 inventory of Blenheim, one of the first-floor rooms had a bed of Indian quilting bordered with very fine Indian calico. There are references to quilting in the Purefoy letters: in 1735 Baxter the upholsterer was asked to send down patterns of quilting with the lowest prices of each pattern, which was for 'one of the new-fashioned low-beds without a cornice'. But then he was told Mrs Purefoy would not pay more than 10*s*. 6*d*. a yard for the material.[20]

The most influential period for chinoiserie got under way in the 1740s. In 1746, when Mrs Delany stayed at Cornbury in Oxford-shire, she was very taken with her rooms. The apartment allotted to her and the Dean was

> so neat and so elegant that I never saw anything equal to it. It consists of two large rooms and a bedchamber: the first room is hung with flowered paper of a grotesque pattern, the colour-ing lively and the pattern bold and handsome. (that is the Dean's dressing-room); the next room is hung with the finest Indian paper of flowers and *all sorts of birds*, (that is my dressing room); the ceilings are all ornamented in the Indian taste, the frames of the glass and all the finishing are well-suited; the bedchamber is also hung with Indian paper on a gold ground, and the bed is *Indian work* of silks and gold on white satin.[21]

By then, as with the gothick style, the taste for chinoiserie was as much to do with gardening as decorating, bringing the two closer together. It seems to have been Kent who first proposed Chinese buildings for the garden at Esher Place in the early 1730s, but the

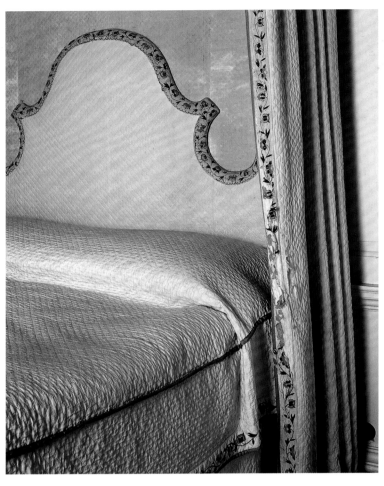

336. *A detail of one of the quilted calico or 'white work' bed edged with Indian embroidery at Houghton. A simple version of the Needlework Bed (Fig. 214).*

337. *A design for a bed from Edwards and Darly's* A New book of Chinese Designs *published in 1754, about the time the Badminton bed was being made.*

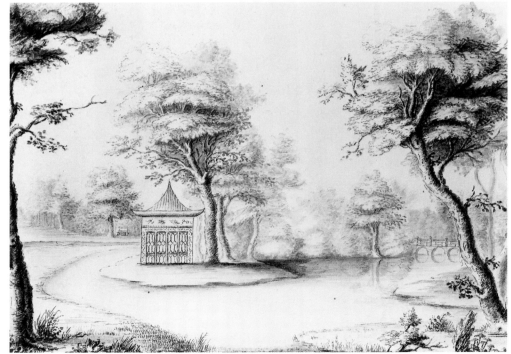

339. *The chinese house at Wroxton Abbey, Oxfordshire, drawn by Mrs Delany. Constructed before 1748, such a concept could have influenced the form of the Badminton bed (Fig. 340).*

338. *Designs for garden seats and chairs from William Halfpenny's* New Designs of Chinese Temples, *1750.*

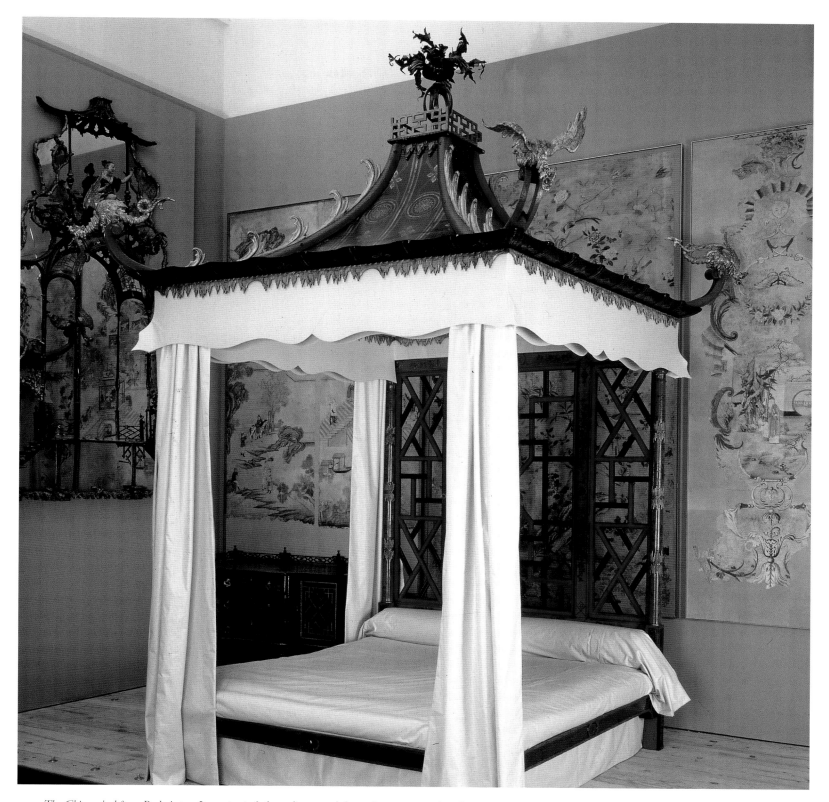

340. *The Chinese bed from Badminton. It was part of the earliest recorded complete set of matching bedroom furniture and was provided by William Linnell, evidently to the design of his son, John, about 1754. The bed was originally hung with a chintz, but* *since there is no record of its design or colouring, the bed has been hung with a partial set of 'ghost' hangings to show how the hangings might have looked. Some of the water gilding of the dragons has now been revealed.* Victoria and Albert Museum.

earliest surviving Chinese garden building is that put up at Stowe in 1738 (now brought back to the grounds, if not to its original site).[22]

There are numerous references to such buildings in the following years, among them the House of Confucius at Kew designed by Goupy and/or Chambers immediately after he returned from the East in 1749; one at Wroxton mentioned by Philip Yorke in 1748 and drawn by Mrs Delany (Fig. 339); one made by William Linnell for Woburn in 1749; and, in a class of its own, the dismountable

Chinese Tent from Montagu House, Whitehall, which was made by Samuel Smith for the terrace there in 1745 and is now at Boughton.[23]

The finest survivor is the Chinese House at Shugborough, which was also first described by Philip Yorke in 1748. It was built to contain some of the Chinese objects that Admiral Anson brought back for his brother from his visit to Canton in 1743. These included a pair of painted glasses in hardwood and parcel-gilt frames (Fig. 352)

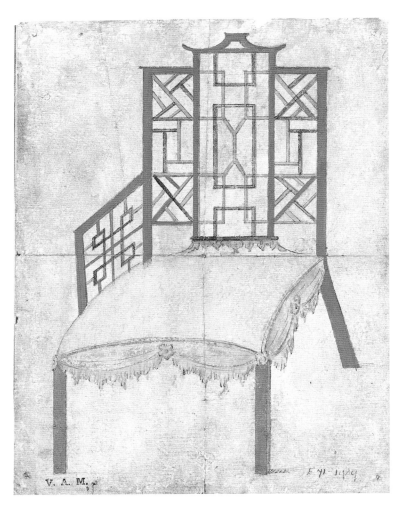

341. *A detail of the high quality japanning on the Badminton bed.*

342. *John Linnell's design for the Badminton armchairs. There are minor differences in the details between the design and the finished chairs, but the drawing shows the original scarlet japanned finish. Whether the elaborate upholstery was ever done as shown in the design is unknown.* Victoria and Albert Museum.

343. *Chinoiserie decoration in the Birdcage Room at Grimsthorpe Castle, Lincolnshire, a medieval vaulted space painted in green, white and gold and originally furnished to match, according to Arthur Young in 1760.*

and also an armorial dinner service. In 1750 Lady Anson, the admiral's wife, mentions in a letter to Lady de Grey her dressing-room at Shugborough hung with 'the prettiest Indian papers I ever saw of the Landskip kind with Figures', part of which was given to Thomas Anson by Captain Dennis, a colleague of her husband. In 1763 Philip Yorke thought: 'The apartment within (a bedchamber and 2 dressing rooms) is furnished with Chinese taffeta and paper, and adorned with the prettiest Chinese paintings I know of in England.'[24]

Not surprisingly, the taste was soon taken up by the new English print and engraved ornament market. In 1750 William Halfpenny broughtout *Twenty Designs for Lattice* and at some point between during 1750 and 1752 he also published *New Designs for Chinese Temples*. He included two chairs, plates 46 and 47 (Fig. 338). In 1751 Matthew Darly, who was a designer and engraver, as well as a manufacturer of paper hangings, including some in the Chinese taste, brought out *A New Book of Chinese, Gothic and Modern Designs* (Fig. 337) and in 1754 *A New Book of Chinese Designs*, which was partly reprinted by Sayer in *The Ladies Amusement* in 1766. Pillement's *A New Book of Chinese Ornaments* came out in 1755, with William Chambers's *Designs of Chinese Buildings, furniture, dresses etc* following in 1757 and Decker's *Chinese Architecture, Civil and Ornamental* in 1759. The fashion was also fostered by new books on furniture designs, among them Chippendale's *Director* of 1754 and Ince and Mayhew's *Universal System* in 1762.[25]

The influence of such prints can be seen in the furniture formerly in the Chinese Bedroom at Badminton (Fig. 340), which was fitted up for the 4th Duke of Beaufort and his Duchess by William and John Linnell by 1754, when it was seen by Dr Richard Pococke. The design of the bed, now in the Victoria and Albert Museum, is highly imaginative and the decoration subtle, yet it is also tentative, as if John Linnell, who was probably the designer, was casting around for ideas and had looked for inspiration at garden houses, like those at Wroxton, Wallington and Shugborough, as well as plates in Halfpenny's *New Designs for Chinese Temples* of 1750 and Edwards and Darly's *A New Book of Chinese Designs* of 1754 if it was out in time. The main framework of the bed head is in red, with delicate chinoiserie decoration imitating lacquer in different colours of gold powder as if it was alluding to the traditional idea of crimson for grand beds. The diagonal struts to the side sections and the struts of the central rectangle are in dark blue, the cross struts in all three sections being in black; and the lining-out and the gilded decoration are done in different colours of gold, with the lines shadowed. The bed posts are decorated like the framework, in red with delicate chinoiserie decoration, but it is possible that the raised ornaments that are now gilded were originally black. The canopy of the bed is in black and different colours of gold. The carved dragons crowning the canopy were originally water gilt but only a few areas of the original treatment show how sparkling they once were. There is no record of how the bed was dressed, in particular the form of the valances, or the original chintz for the hangings, but it must have been a fine one in balance with the chinoiserie decoration; and presumably it had a white ground to relate to that of the original wallpaper. Even so, it seems likely that the hangings were secondary to the frame, as if demonstrating the change-over from the dominance of the upholsterer to that of the cabinet-maker.[26]

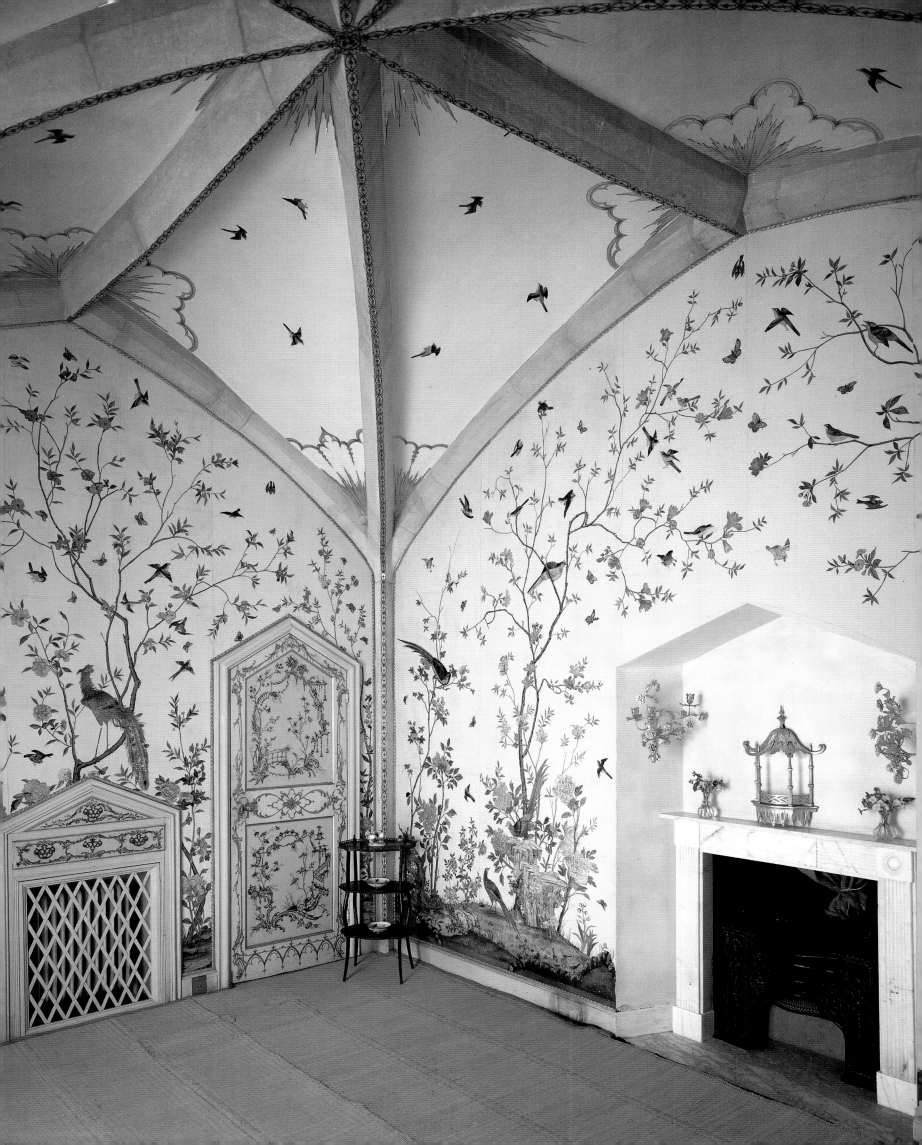

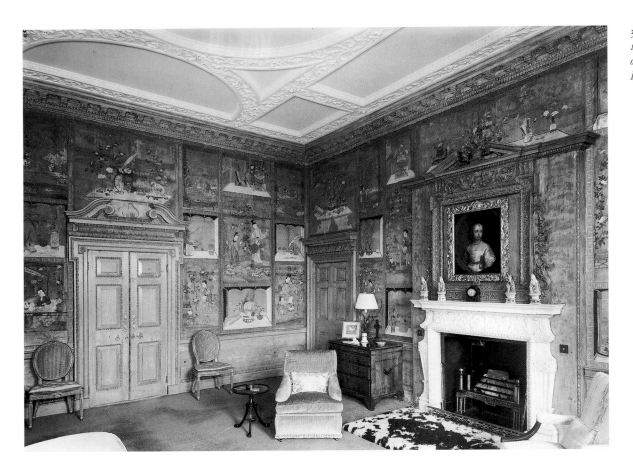

344. *Chinese wallpaper evidently dated 1748 in Chinese characters in a bedroom or dressing-room at Milton redecorated by Flitcroft in 1750–1.*

With the bed the Linnells supplied a set of eight armchairs (Fig. 342), a commode, which may have been in the dressing-room, because it was always in black and gold, and two pairs of standing shelves. Apparently there was also an overmantel glass, which was akin to the second dated drawing by John Linnell, and a pier-glass, both of which were partly gilded and painted.

What seems to have been overlooked is that they are elements of the earliest surviving bedroom suite, and as such they are a milestone in the history of furnishing, leading on to the fashion for painted furniture for bedrooms in the 1760s.

The association of chinoiserie with ladies can be followed through in the 1750s. In 1756, when Mrs Delany went to Lady Lincoln's assembly 'that was *to outshine* the Duchess of Norfolk', she noted that the great apartment was done in crimson damask with very fine tapestry and Lady Lincoln's private apartment of an antechamber, dressing-room and bed-room was 'furnished with beautiful Indian painted taffeta'. Lady Lincoln was the daughter of Henry Pelham, Sir Robert Walpole's successor as Prime Minister, and her husband later became 2nd Duke of Newcastle.[27]

Similarly, the unpublished 1756 Stowe guidebook that covers the interior of the house describes Lady Temple having a chinoiserie apartment. In her dressing-room the hangings, chairs and window curtains were of fine printed cotton and the room contained a fine old Japan cabinet, ornamented with china jars, and over the chimneypiece was a fine view of Peking by Joli. The same idea was continued in her bedchamber and Chinese Closet, where Lady Temple kept her valuable china. Again, that was in contrast to the state apartment with Borra's new state bed.[28]

Perhaps the prettiest surviving chinoiserie room is the Birdcage Room (Fig. 343) at Grimsthorpe Castle, which was presumably decorated not long before it was first mentioned by Arthur Young in

1769. Not the least remarkable thing about it is that it is really a medieval vaulted room that is entirely disguised by its painting in green, white and gold in the Chinese style. Unfortunately there is no record of the painter. Originally there was furniture painted in green, white and gold to go with it, but that has disappeared.[29]

### WALLPAPER, MATERIALS AND FURNITURE

Although there are a number of references to Chinese wallpaper in the early eighteenth century and the Blew Paper Warehouse advertised the '*True Sorts* of *Japan* and *Indian Figured Hangings,* in Pieces of Twelve Yards long, and Half Ell Broad, at 2*s.* 6*d.* by the Piece', there appear to be no complete early examples and even very few documented and dated fragments. That gives a particular importance to the paper in the dressing-room at Newhailes (Fig. 108), which, as has been explained, was part of a scheme of decoration running through the drawing-room, bedroom and dressing-room carried out about 1740. The paper in the drawing-room is shown in a nineteenth-century watercolour.[30]

It is only from the 1740s onwards that it becomes possible to get a sense of how designs and colours developed, but there has been a tendency to date papers too early, particularly those with strongly coloured grounds. Mid-eighteenth-century papers like that at Felbrigg, hung in 1751, not only have a white ground but the design is more angular and less flowing. That agrees with what James Mackay wrote in the Premnay letters: 'The India paper that is most in use here, has a white ground and full of flowers, birds and trees etc. The Sheets Some are 9 feet long by 3 feet wide; at 10 shillings each, others 4 feet 6inches long by 22 or 23 inches wide at 3 shillings each'.[31]

Early English imitations are also hard to find *in situ*, but one was

345. *The Chinese wallpaper in the drawing room at Dalemain, Cumberland, about 1760. The earliest known example surviving in a drawing room. The room also retains a carved wooden Rococo chimneypiece.*

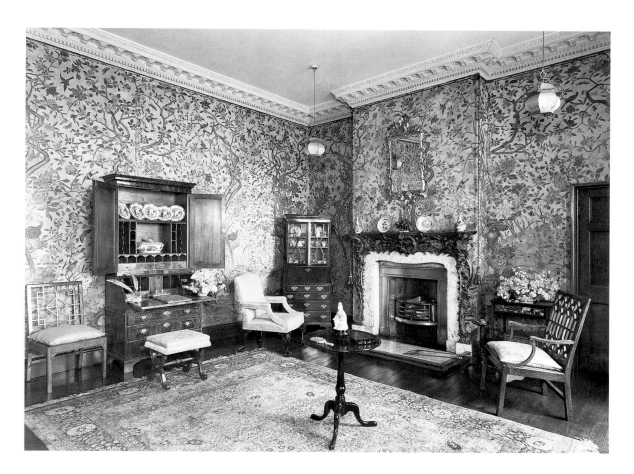

found underneath leather hangings dated 1723 at Longnor Hall, Shropshire in 1952. A fragment was given at that time to the Victoria and Albert Museum, which dated it at about 1740, but it may be part of Sir Uvedale Corbett's completion of the house in the 1690s. According to the 1701 inventory, there was no bedroom on the ground floor, but the room is at the end of the house and has two closets, an arrangement that suggests that it might have been intended for that purpose. The main panel is a very spare design, with an unusual proportion of comparatively little subject-matter against a great deal of background, which suggests a certain lack of confidence on the part of the painter that could point to an earlier date than 1740.[32]

A surviving paper close in date to Mackay's description is at Milton, in Northamptonshire (Fig. 344), in a room that must have always been a bedroom or dressing-room. It is apparently dated 1748 in Chinese characters and was presumably hung in the course of the alterations made by Flitcroft for the 3rd Earl Fitzwilliam in 1750–1.[33]

At Longford Castle, where there were two principal bedrooms in the mid-eighteenth century, one was hung with Teniers tapestry and the other with India paper. For the latter, Bromwich was paid £50 in 1750. The paper appears to be reproduced in *Country Life* in 1931, but there is no trace of it today, possibly because it was rehung by Salvin in one of his new tower rooms that no longer exist.[34]

At Felbrigg there is a paper in a dressing-room that evidently formed part of the scheme for the adjoining White Bedroom, as it was called in 1771. That had a white silk damask bed, white calico curtains to protect it, white lustring window curtains and a white and gold glass, probably the Rococo one bought from Bladwell in 1752. If that sounds early for an all-white bedroom, the glass provides a pointer to it; and certainly white and gold glasses were fashionable in bedrooms in the 1750s. The white idea continued in the

dressing-room, which still retains its white ground Chinese wallpaper that was supplied by Paine. There were sixteen rolls 4 feet wide, but hanging it could not be entrusted to a local, so William Wyndham reluctantly had to accept that he would have to employ a specialist charging 3s. 6d. a day while at Felbrigg and 6d. a mile for travelling. The curtains were of green lustring and the room contained the six Chinese fret chairs, almost certainly also by Bladwell.[35]

Another surviving example of a Chinese paper in a dressing-room is at Woburn Abbey, where it was hung in 1753 as part of the great apartment, a few years before the 4th Duke of Bedford remodelled the main rooms in the south front in a formal classical style. Again, the paper provides a deliberate change in mood.[36]

Perhaps the earliest Chinese paper surviving in a drawing-room is that at Dalemain in Cumberland (Fig. 345), a squire's house in a remote part of the country. It was hung in about 1760 and also has a fanciful carved Rococo chimneypiece. That seems to be an unusual choice, but, as at Newhailes, was possibly influenced by a shortage of suitable pictures for a drawing-room. Another example was at Stretton Hall, where in 1759 Lady Louisa Conolly told her sister, Lady Kildare, that on the ground floor was 'a pretty, india-paper drawing-room that looks to the garden'. Rather surprisingly, one is noted by the Duchess of Beaufort in the library at Sudbury in 1751 – 'Hung with India Paper the Book Cases in it are partly guilt & ye ionic order very pretty'. In 1755, when Lady Suffolk formed a new dining-room at Marble Hill, she had the room hung with '62 Sheets of India Paper' and '135 yards of Border' on sized linen by William Hallett Jnr.[37]

Arguably the most sophisticated Chinese paper recorded is that from Hampden House, Buckinghamshire (Fig. 346), that appears to have been hung about 1756 as part of the alterations to the house carried out by Trevor Hampden between 1752 and 1760. Trevor Hampden was an amateur architect who also consulted Richard

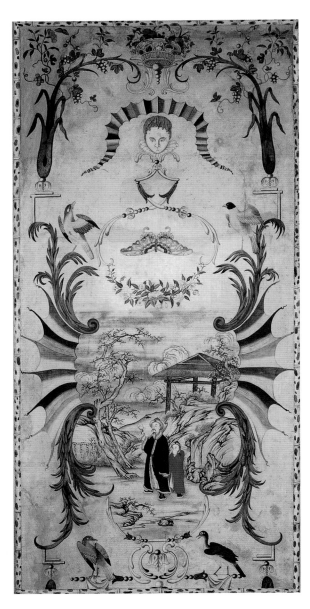

346. *Two panels of Chinese wallpaper formerly at Hampden House, Buckinghamshire, evidently hung about 1756. The design is taken from engravings by Huquier after Watteau, but the scenes have been altered to Chinese landscapes.* With Harris Lindsay, London.

Bentley, the associate of Horace Walpole, who designed a butterfly frame in the Chinese taste for him. The design of the paper is taken from a set of engravings by Huquier after Watteau originally issued about 1730, but whereas they show scenes of *L'innocent badinage* in the centres, these scenes are Chinese. It is conceivable that Thomas Bromwich was involved with the order, because in 1756 an identical set of panels was acquired for the Landgrave of Hesse by Freiherr von Furstenberg, who is known to have visited Bromwich when he was in London that year and described the paper to his patron. A damaged and incomplete panel survives in the Victoria and Albert Museum and two panels in good condition were on the London art market in 1999.[38]

The idea of print rooms first appears in connection with the taste for chinoiserie. In 1742 Lady Cardigan, the wife of the 4th Earl, bought eighty-eight 'Indian pictures' and called in Benjamin Goodison 'to paste them all over the walls of a dining room'.[39]

Bromwich and Legh advertised on their trade cards in the 1760s that they fitted up rooms with 'Indian Pictures or prints', and in 1764 they supplied a set of five panels, which have contemporary white and gold frames, to the 5th Lord Leigh for Stoneleigh Abbey.

One of the subjects is also to be seen over a chimneypiece in a former bedroom at Saltram, so perhaps they sent another set of panels there but did not put it up. The repetition of one panel eight times and another six, and some odd shapes, suggest that the hanging may have not been done by a specialist like the man used at Felbrigg.[40]

A variant of the idea can be seen at Carton in Co. Kildare, where about 1759 Lady Kildare decorated what she called the India Paper Drawing-Room (Fig. 347) in what turns out to have been an ingeniously botched Georgian way. Not only does the paper and the elaborately carved and gilded continued chimneypiece survive, but there is a related carver's design for the latter. In 1759 Lady Kildare told her husband that she wanted India paper for four rooms but only had enough for three; and yet 'I have set my heart upon that which opens to the garden being done, for tis certainly now our best and only good living room'. The paper consists of some large panels as at Stoneleigh and Saltram, with smaller panels cut into fanciful shapes and all mounted on a plain blue paper ground, which she appears to have brought from Kildare House in Dublin and reused. She also mentioned using 'fine chintz furniture lined with blue silk that I have taken out of the old beds'.[41]

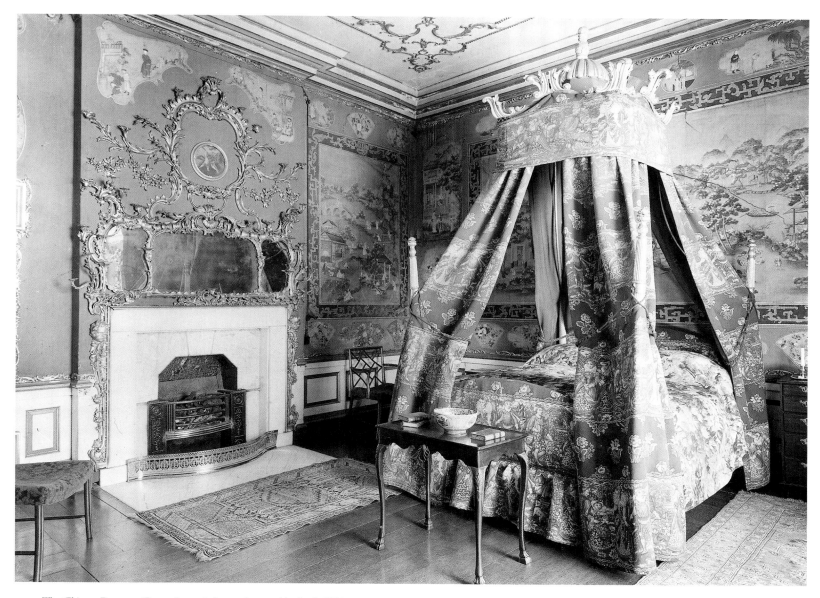

347. *The Chinese Room at Carton in 1936. It was decorated by Lady Kildare as a drawing-room about 1759, reusing a plain blue paper from Kildare House, Dublin, and cut-out panels of Chinese wallpaper. The carved and gilded chimneypiece and overmantel is part of the original scheme, but it has now lost a painting or panel of paper from the top frame.*

The simple marble surround is framed in elaborate gilded Rococo wood carving that continues into a complex overmantel incorporating panels of looking-glass and originally a painting as well as brackets for china. The drawing, apparently by an Irish carver, provides two suggestions for the confection with china in position. It ties up with Lady Kildare's sisters writing of the relationship between the colours of china and decoration in their dressing-rooms, and Lady Holland sending her sister, Lady Kildare, 'four Indian pictures on glass particularly as you are fitting up everything with Indian paper and taffeta etc'.

The use of Chinese wallpapers in the eighteenth and early nineteenth centuries is still familiar, because there are so many post-1760 examples, but not surprisingly silks and cottons have survived much less well. However, great quantities were imported. Postlethwayt, for instance, in records: 'one ship from India, namely, the Tavistock, brought in one article of wrought silk 9000 pieces of damask (besides a great many of several other sorts) each of which was worth at market, one with another 9l or more: so that the said damask only amounted to 89,000'.

The King of Spain's Bed at Petworth was of Indian green and white satin edged with broad and narrow silver lace and thirty-four silver tassels. In the adjoining drawing-room the hangings were of India damask bound with gold lace, the settee was of Indian brocade and the twelve chairs matched the hangings.[42]

At Warwick Castle there is a state bed that belonged to Queen Anne, which was given to the 1st Earl of Warwick by George III. It has hangings of crimson velvet paned with sea-green figured velvet, which, according to Peter Thornton, appears to be Chinese. The bed has a strong architectural cornice like the Dyrham bed and the valances and curtains are trimmed with a tufted pink and green fringe; and with the bed are still the original armchairs and stools.[43]

Probably the earliest example *in situ* is the set of bed hangings at Raby Castle, in Co. Durham (Fig. 348). Nothing is known of its history, but it must have been made in about 1730 for a small bed like the crimson damask bed surviving at Hampton Court Palace and the embroidered bed in the Cabinet Room at Houghton. The head-cloth appears to be after a French ornament print, possibly by Berain or someone close to him, a Chinese equivalent of certain Indian cottons.[44]

In 1759 Lord and Lady Kildare made several references to India

267

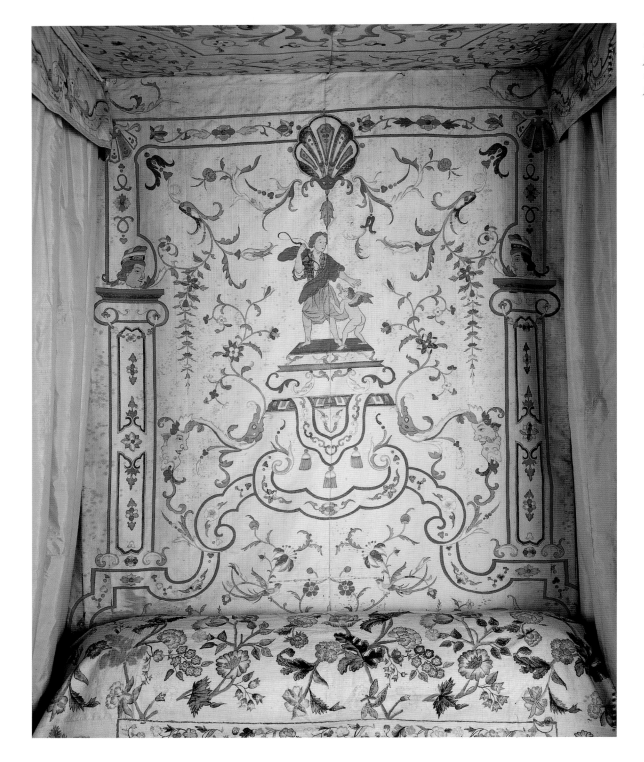

348. *A set of painted silk Chinese hangings on a small bed at Raby Castle, probably about 1730. The headcloth appears to be after a French ornament print.* Lord Barnard.

taffeta that was evidently painted. They first mentioned 150 yards, and Lord Kildare then wrote to say that he had bought ten pieces for sixty-five guineas. Lady Kildare replied that she had no idea that it would come to so much, 'having seen beds at Woburn, Petworth and other places (not in the best apartments) of this sort . . . The quantity was what Spring told me was necessary for our two beds, a pair of window curtains, and four chairs'. Notoriously extravagant, she continued: 'In short, it is as cheap silk-furniture as one can have. I know you will smile at this, but 'tis really true.'⁴⁵

Early examples of printed cotton in bedrooms are very rare, and palampores are rarely encountered in country houses. One of the few bed cornices covered with cotton (Fig. 349) is at Milton, in a bedroom close to the one with Chinese paper. That gives added

importance to the Chintz Bedroom of the early 1740s in the Nostell Doll's House (Fig. 14). At Ashburnham Place, Sussex, there used to be a set of late seventeenth- or early eighteenth-century painted and dyed hangings and a related set of embroidered hangings that are now in the Victoria and Albert Museum.⁴⁶

In the Purefoy letters there are references to chintz for window curtains for a drawing-room in 1738. They wanted eighteen yards of chintz 'or something that would suit workt chairs, workt in shades on white', and there is a 'PS I suppose you will warrant its standing ye colour when it is washed'. But there were problems, because the chintz came in pieces three yards long and the window needed three and a quarter yards as well as material for valances. Since they could not get that, they decided to have white Indian Damask which is

349 a and b. *Imported printed cotton on a bed at Milton. The hangings have been altered but the covered cornice appears to be original. Probably close in date to the wallpaper of Fig. 344.* Private collection.

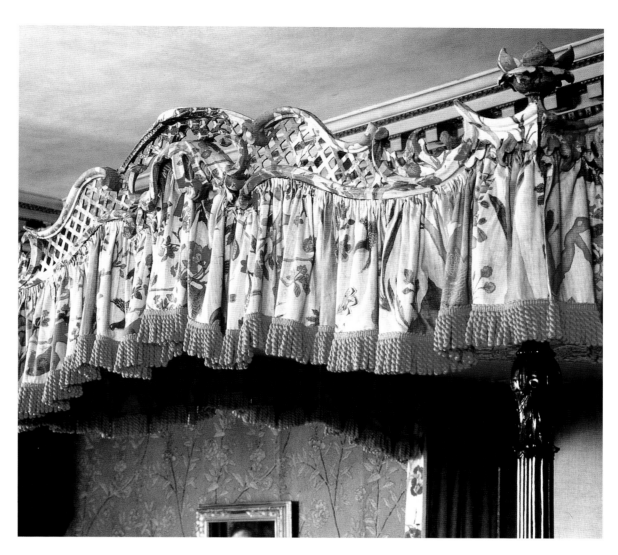

'above three quarters of a yard wide & wee used to buy for about seven shillings a yard'. In the end, they bought 50 yards of white damask at 5 s. 6 d.[47]

The connection between chinoiserie furniture and chinoiserie decoration is harder to pin down, but in 1751 Madame du Bocage breakfasted with Mrs Montagu at her house in Hill Street 'in a closet lined with painted paper of Pekin, and adorned with the prettiest Chinese furniture'. Probably that was newly done, because the previous year Mrs Montagu wrote: 'Thus has it happened in furniture; Sick of Grecian elegance and symmetry, or Gothic grandeur and magnificence we must all seek the barbarous gaudy *gout* of the Chinese.' It is likely that Mrs Montagu's furniture was made by William Linnell, whom she mentioned in letters to Gilbert West in 1751: 'If Mr Linnell designed to gild the bird he sent me the drawing of, it will look like the sign of the eagle at a laceman's door. If Japanned in proper colours, it will resemble a bird only in colour, for in shape it is like a horse. I wish these men of art could sometimes deviate into the natural.'[48]

The publication of ornament prints with a chinoiserie character encouraged the inclusion of chinoiserie details in Rococo designs for carved glasses and tables, as in Lock and Copland's *A New Book of Ornaments* of 1752. They seem to have been considered particularly suitable in glasses for drawing-rooms, like the splendid example from Halnaby Hall, Yorkshire, now in the Victoria and Albert Museum.[49]

From the late seventeenth century, oriental porcelain had been used for the ornamenting of rooms, because the singing quality of

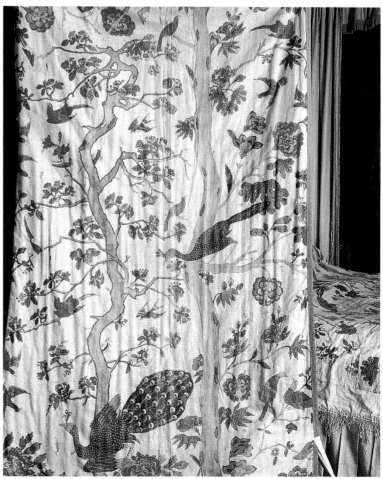

350. *An early-eighteenth-century beech chair japanned in gold and green on a red ground with a curved back based on an oriental design.* Victoria and Albert Museum.

351. *Dark red lacquer furniture almost certainly made for Sir Francis Child the younger, a director of the East India Company in 1718–19, and now at Osterley Park, Middlesex.*

blue and white and the clarity of *blanc de chine* works so well in rooms with a lot of woodwork, providing highlights that were particularly important when artificial light was so soft. It even provided a theme for rooms, particularly in princely circles on the continent. But to what extent its arrangement on chimneypieces, cabinets and door-cases influenced the decoration of rooms in England is hard to say. However, the collecting of china in the mid-eighteenth century led to the development of special china cabinets, as can be seen from the plates in Chippendale's *Director.*

In 1747 Mrs Boscawen wrote to her husband about the decoration of their London house: 'upon the whole, my house is much nearer completed than you expect, I believe. I have tried at china ornament for my chimneypieces, which demand them in great quantities, but I have not been able to raise myself to the price of anything good and I don't care for a parcel of trumpery-like some chimney-pieces we know of.'[50]

Soon after that, there occur a few references to the colouring of china being taken into account in the decoration of rooms, but in those cases they were not necessarily oriental.

Many black lacquer and japanned cabinets, chests and screens survive in country houses and a remarkable number are listed in

inventories. Clearly they fulfilled an important role in enlivening rooms with their combination of gleaming black and gold decoration, gilt metal mounts and lockplates, even in the principal apartment at Blenheim, where French or Italian cabinets might have been expected. But were the notes of black appreciated as a foil to richly coloured materials and gilt gesso, like the gleaming lacquer tops of the gesso tables in the drawing-room at Lyme? Just as rooms need *coups de rouge*, do they need notes of black? There do not appear to be any contemporary comments on this, but Horace Walpole, who used black to strike historical notes, also had black lacquer both in the gallery (Fig. 305) and the Round Drawing-Room. It may also have been considered as an effective alternative to brown furniture, which was clearly considered unsuitable for important bedrooms, as can be seen in the Houghton inventory.[51]

On the other hand, it is frustratingly difficult to document pieces of coloured japanned furniture and get a feeling of where they were placed in a house and how they related to colour schemes. This is described at Kiveton on page 77, but it is now very unusual to find a piece like the red japanned secretaire at Erdigg (Fig. 372), which was in the Blue Mohair Bedroom, the principal bedroom on the upper floor, or the green japanned chairs (Fig. 371) that always went with

the best bed. At Canons there were several japanned secretaires in dressing-rooms, ranging in value from £7 for that in Lord Carnavon's dressing-room to a large one with glass doors worth £25 in the Duke of Chandos's dressing-room and a red japanned scriptoire with glass doors worth £12 in the Duchess's closet.[52]

Striking reds, greens, blues and whites were achieved not only on secretaires and cabinets but on the frames of glasses and on chairs and tea tables, indeed whole sets of furniture like that made by Giles Grendey and exported to Spain or Portugal. Examples of red, green and blue are encountered, as well as white, as can be seen at Boughton, but, with the exception of the last, none have a good provenance, and it is impossible to relate them to schemes of decoration.[53]

There was also an understandable late seventeenth-century fashion for japanned frames for glasses, especially when they were *en suite* with tables and stands, because they must have been much easier to produce than carved or veneered sets. Indeed, it would be interesting to collect evidence about their relative costs. However, early in the eighteenth century they seem to have dropped out of fashion in the face of competition from carved and gilt frames that bring looking-glasses alive more effectively.

A remarkable number of lacquer cabinets were imported, particularly from Japan, and they have continued to be admired, adapted and imitated. Other examples of oriental furniture include . . .

How often chairs were brought over in the late seventeenth and early eighteenth centuries is hard to assess, but certainly illustrations were known and inspired English imitations. The Victoria and Albert Museum, for instance, shows a beech chair japanned in gold and green on red ground that is not only oriental in its style of decorations but in form, with its curved back (Fig. 350). It was thought to have been made about 1700, but that may be too early in view of Adam Bowett's analysis of the Canons Ashby chair (Fig. 130).

There were also pieces of lacquer furniture with coats of arms on them, screens, coffers, chairs and tables. The assumption is that the chairs, with their flat backs and hard seats of lacquer possibly made in Canton and mounted on English frames, were for use in halls, but they would not have stood up to much wear and so that is probably incorrect. Among them are the group in dark red lacquer (Fig. 351) now at Osterley Park and bearing the Child arms on the backs and seats. They were almost certainly made for Sir Francis Child the younger, who was a director of the East India Company in 1718–19 and 1721–35, and are thought to have been ordered for his house in Lincoln's Inn Fields. A related set of black lacquer chairs with gilt chinoiserie decoration on the backs but without Sir Robert Walpole's arms were in the Picture Gallery at Houghton in 1745.[54]

Chinese mirror-glass painting has had a somewhat similar history to coloured japanned pieces of furniture in appealing to twentieth-century collectors, and these pieces are also exceedingly hard to document. At Shugborough there are a pair of outstanding Rococo carved and gilt frames for glass paintings, but only one retains its original plate (Fig. 352), and they are supposed to have been in the Chinese House. At Saltram there is a good group of them that tie up with the decoration of the bedrooms and dressing-rooms, but cannot be documented for lack of an inventory.[55]

Lacquer furniture had a long-term influence on English furniture, for from the end of the seventeenth century painted furniture and particularly chairs were described as japanned, even when they were painted plain black. Later, it must have been the influence of

352. *A Chinese mirror painting at Shugborough, 1740s*. The National Trust, Shugborough.

coloured japanning that led to the fashion in the 1750s for finishing chairs and stools in a colour with parcel gilding, as with the stools in the Music Room at Norfolk House, and a little later to the painting of chair frames and mirror frames in a colour. In the late 1750s Robert Dossie wrote in *The Handmaid of the Arts* of the japanning of furniture: 'This is not at present practised so frequently on chairs, tables, and other furniture of houses, except tea waiters as formerly.' However, in the 1760s Chippendale began to paint bedroom furni-

ture to relate to the colours of printed cotton and wallpaper; and by 1768 the fashion for painted chairs had even reached the drawing-room at Lansdowne House.[56]

Painted furniture helped to create a light, fresh look that also had the advantage of being inexpensive. On the other hand, it was not long-lasting. It is rare to come across early examples in good condition; and since the nineteenth century a great deal of it has been refinished in gold.

# 10

*Planning and Sequences of Decoration, 1700–60*

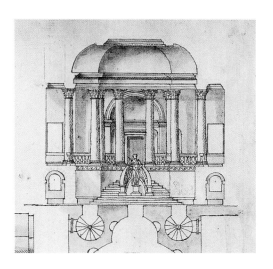

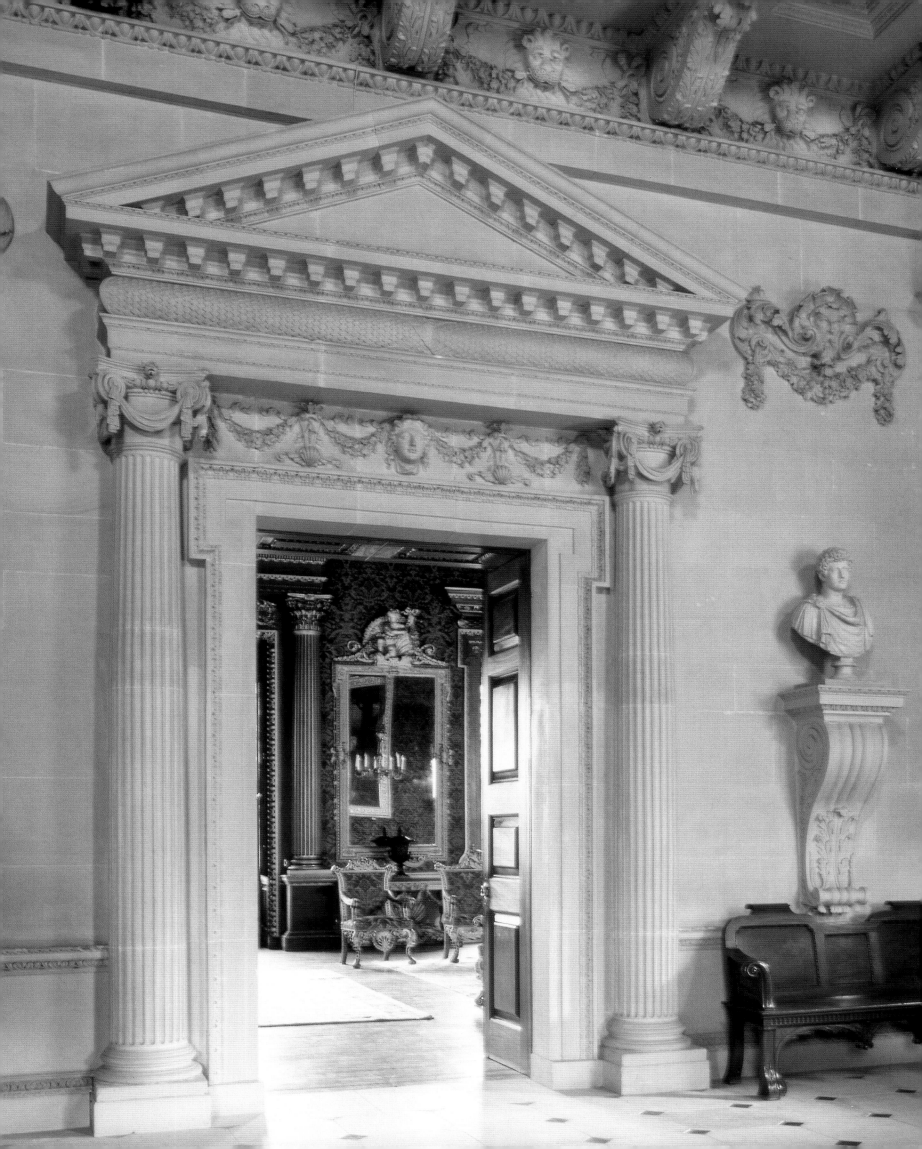

In concentrating on elevations and plans of country houses but seldom including sections, early eighteenth-century English architectural books emphasize the symmetry and geometry of the houses but seldom explain how they worked, often omitting the names of rooms. So it is difficult to tell which were the everyday, family rooms and which for parade. Since most larger houses divided in that way, it is essential to understanding the way they were fitted up, decorated and furnished. Houghton (pp. 150–69) and Holkham (pp. 313–24), on the grand scale, and the Nostell Priory Doll's House (Fig. 15), on the miniature, provide keys, because they show how important sequences of rooms were, how and when colours were continued, how materials changed and how they related to the fitting-up of rooms. How these points worked in other houses can be sensed when it is possible to relate their surviving interiors or contents to inventories and other documents. Therefore, having considered individual rooms by type in chapter 2 and other aspects of decoration and furnishing in subsequent chapters, this final chapter considers how rooms in eight houses fitted together in terms of architectural finish, including colours and gilding, upholstery and pattern, furniture and its finishes, as well as the choice of pictures. They show not only how unity and variety were balanced and how a sense of pace was achieved, but how economics and practical thinking dictated the way everyday rooms were treated and how they contrasted with costly parade rooms.

It is disappointing not to be able to do justice to certain patrons and designers, either because of alterations to their houses or the dispersal of the original contents. Lord Burlington, Vanbrugh and Hawksmoor, Gibbs, Flitcroft and Vardy, Paine and Taylor all suffer in this respect. On the other hand, it is possible to reconstruct pictures of Blenheim, Chicheley, Erddig and Ditchley for the first half of the period and of Kirtlington, Felbrigg, Hagley and Holkham for the second. These suggest some of the conventions and how they developed over the period; and also how the mood of houses changed, becoming less grand and formal towards the middle of the century, with more emphasis on alteration and redecoration as opposed to new building, and a switch from great houses to villas.

*The view from the Stone Hall into the Saloon, Houghton Hall*

## BLENHEIM

Blenheim, where the foundation stone was laid in 1705, is particularly revealing, because it was conceived both as a national monument and a house for a family. The Duke and Duchess of Marlborough had very strong ideas about what they wanted – and their views were different. The Duke had a clear understanding of the heroic concept and the role that pictures and tapestry could play in realizing that, seeing Blenheim as a British rival to European princely palaces. The Duchess, on the other hand, disliked show and resented its cost. Thus there was surprisingly little architectural carving in the parade rooms, with moulded rather than carved cornices and architraves to doors and windows, except in the ante-room to the south-east apartment, now the Green Writing Room, and also probably little architectural gilding. On the other hand, the Duchess clearly enjoyed the processes of working out all the details of upholstery with James Moore on the spot, carefully noting every yard of trimming she paid for herself. As she wrote to Robert Jennens on 2 September 1715, 'I am employed every Morning at least Four Hours in cutting out, and ordering Furniture for *Woodstock*. My next Bed will bee for the Room you choose', and on another occasion: 'What I value myself upon is the furniture which I have done at home and have made it very little use of upholsterers, which has made it cost less by a vast sum and is ten times more agreable and handsome than if it had been done by them.' The Duke and the Duchess pulled in different directions, yet they worked within what proved to be some of the upholstery and furnishing conventions of their time, and these gave Blenheim a sense of build-up that is now hard to trace after the 4th Duke's alterations in the eighteenth century and the 9th Duke's late in the nineteenth century.[1]

Vanbrugh's plan was an advance on his earlier scheme for Castle Howard in that the family rooms formed a complete apartment in the east range of the palace (Fig. 354), with the Duke's rooms linking on to the twin great apartments planned on royal lines in the south range, and the Grand Cabinet on the south-east corner, available for his own use or with the south-east apartment. However, Vanbrugh did not attempt to create much sense of variety in the proportions of the rooms of the great apartments, although he ingeniously provided dressing-rooms and closets behind them in the ends of what could otherwise have been a cross corridor. Instead, he left variety and pace to the upholsterer and to the Duke's growing enthusiasm for pictures and tapestry.[2]

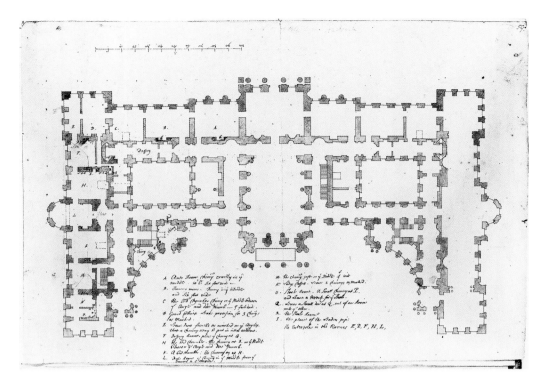

353. *Blenheim Palace, Oxfordshire. Proposed plan for the Palace, about 1705. It shows an early, unexecuted arrangement at the east end of the house (on the left), particularly in the east corridor, the oval vestibule into the Bow Window Room, and the Grand Cabinet at the north-east corner not yet formed. It also shows a dining room with a screen of columns overlooking the northern internal court.* Sir John Soane's Museum.

354. *The executed plan of Blenheim from* Vitruvius Britannicus I, *showing the improved relationship of the rooms of parade to the family rooms, with the Grand Cabinet at the north-east corner. The screen has disappeared from the dining-room.*

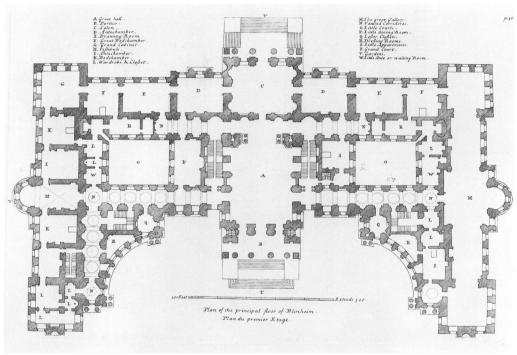

Unfortunately, it is impossible to tell how closely Vanbrugh was involved with the original furnishing plan or how early James Moore came on the scene as upholsterer–decorator. The latter was clearly working for the Duchess at Marlborough House by 1709. Very careful planning and measuring based on the plans of Blenheim must have preceded the Duchess's first request to Lord Manchester, the ambassador in Venice, for help in getting materials in 1708, because the quantities were huge and the costs enormous: 1,300 yards of green damask, 600 of yellow and 600 of crimson, 200 of scarlet velvet and 200 of blue velvet, 100 of scarlet damask, 200 of scarlet satin and 200 of blue velvet to match the velvets, a total of 3,300 yards, costing £2,136 19s. Could Moore have already been involved at that stage? When remarks in the correspondence with Lord Manchester are related to descriptions in the 1740 inventory, it would appear that many of the materials used in the family apart-

ment completed in 1719 and in the south-east apartment completed by 1725 follow the initial order in 1708, which suggests that even at that stage there was a strong sense of how to create a sense of pace in the house through upholstery and the amount of gilding. So even though the original materials have vanished, comparisons with other houses, including Kimbolton, where some of Lord Manchester's own materials survived into the early days of country-house photography (Fig. 333), make it possible to visualize their character and understand how much of the pace was achieved through sequences of colours and materials.[3]

The first room of the private apartment was the Bow Window Room in the centre of the east range (Fig. 355). That formed a central vestibule for the Duke's and Duchess's rooms and was entered at the junction of two monumental vaulted stone corridors, one from the family entrance in the colonnade on the east side of the

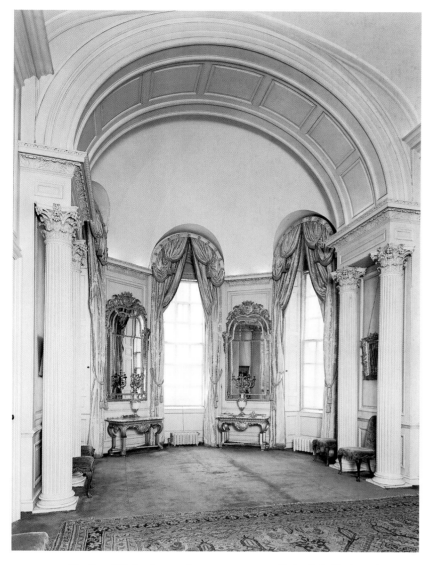

355. *The Bow Window Room, the centre room or vestibule of the Duke and Duchess's apartments on the east side. It was originally hung with tapestries from* The History of Alexander *set and the frames of the pier-glasses and tables supplied by James Moore were described as brown and gold, not gilded solid.*

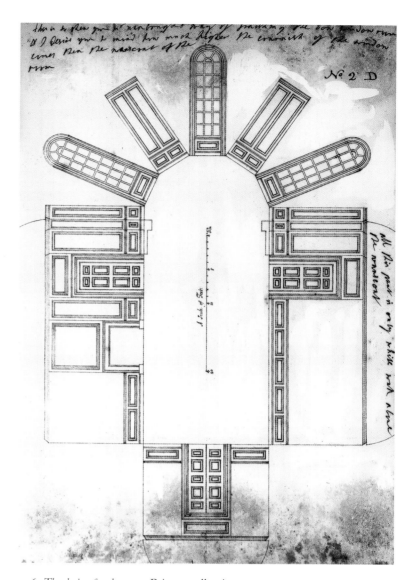

356. *The design for the room.* Private collection.

Great Court and the other from the Great Hall that formed part of the only complete cross corridor through the palace, linking the Bow Window Room to the centre of the gallery with its matching bow for which the statue of Queen Anne was originally intended. According to the 1740 inventory, the room had a pair of *Alexander's Battles* tapestries, now called *The History of Alexander*, that provided a classical parallel to the Duke's own battles, a pair of pier-glasses and tables with white marble slabs and what were described as brown and gilt frames, which could mean brown paint or in that situation parcel-gilt walnut, and fourteen chairs covered in 'Dutch mackett a thing called caffoy with a white ground and coloured flowers'. While the tapestries established a heroic note, the parcel-gilded tables and glasses were one down from those completely gilded, and the caffoy would have been coarser and cheaper than a cut velvet; and, although we do not know where it would have been woven, it would not have been one of the Italian materials. Presumably it had some crimson in it, because the curtains were of crimson lustring, the colour indicating the room as a principal one and preparing the way for crimson and scarlet in the Duke's own rooms. The room's importance was also underlined by its silver chandelier, which, perhaps thanks to the Duchess's frugality, was

actually made of silvered brass. The marble of the chimneypiece was white, an expensive choice, and that matched the tops of the tables and stands.[4]

To the south of the Bow Window Room lay the Duke's dressing-room and bedroom, which had more of the *Alexander* tapestries and were again red rooms, with crimson damask hangings and upholstery and crimson lustring curtains in the dressing-room and then scarlet velvet in the bedroom. Again, there was a silvered chandelier in the dressing-room. In the bedroom, not only was the bed hung in velvet and the eight chairs covered in velvet trimmed with gold lace, but the window curtains were in velvet, too. The choice of the lighter and brighter scarlet rather than the conventional crimson was evidently the Duchess's. In 1708 she wrote to Lord Manchester 'Your Lordship says scarlet is the more difficult colour, and seems to think they do not dye that so well as we do, for I think you sent me the most beautiful colour I ever saw, and I like it better for a bed than crimson, being less common as well as much handsomer.'

Beyond the Duke's bedroom on the corner of the house was the Grand Cabinet, which as early as 1706 the Duke had decided to form and hang with the finest pictures he could buy. It was all done in crimson damask, including the window curtains, and the settee,

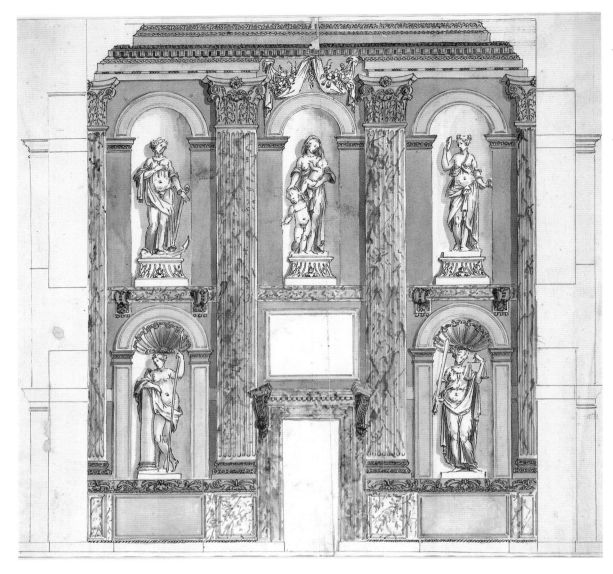

357. *A design for the saloon by Nicholas Hawksmoor and Grinling Gibbons with a giant order of pilasters and life-size statues by Italian sculptors, about 1707.* Bodleian Library.

358. *The first room of the southern apartment, hung with the Blenheim and Lille panels from* The Victories *series as it was in 1890. This shows the room with a Chambers chimneypiece but before the decoration was embellished by the 9th Duke of Marlborough.*

six chairs and twelve stools had gilt frames, as did the pair of pier-tables; also, there was another silvered chandelier.

The point of the distinction between crimson lustring, damask and scarlet velvet curtains is brought out by the contrast in the Duchess's bedroom to the north of the Bow Window Room, which was hung with 'beautiful Tapestry: The subjects from Classical Allegory'. There, the bed was a less stately blue damask lined with 'Indian' embroidery, with an outer valance of 'a very Rich Embroidery which was made by the Duchess of Marlborough's Clothes'.[5]

Early eighteenth-century tourists entered the south-east apartment from the Cabinet and so saw its three rooms in reverse: architecturally, they were intended to be considered as a sequence starting in the saloon. That was finally decorated much more simply than Vanbrugh and Hawksmoor had originally intended (Fig. 357). In place of a giant order of marble pilasters and two rows of Italian marble statues, including Baratta's *Fame* (now in the Fitzwilliam Museum) and bronze casts by Soldani of famous statues in niches shown in a drawing of about 1707, which shows a much grander version of the Cupola Room at Kensington Palace, it was more simply – and cheaply – painted by Laguerre with the *Four Continents* on the walls and *The Triumph of the Duke of Marlborough* on the ceiling in succession to Thornhill's *Triumph of the Duke of Marlborough* on the hall ceiling. The furnishing was as in the Bow Window Room,

with parcel-gilt tables and stands and twenty chairs covered in Dutch moquette.[6]

From there, the colours and materials built up. In the three-bay ante-room called 'the Room next the Salon' in 1740 and now the Green Writing Room, the hangings were green damask, as was the upholstery, with curtains of green lustring; the frames of the pier-tables and stands were again brown and gold rather than fully gilded.

The adjoining drawing-room, now called the Red Drawing-Room, probably had crimson damask upholstery, although that is not recorded in 1740, the Duchess only noting that the silver embroidery on the chairs belonged to her. The tables and frames had gilded frames. The build-up would also have been expressed in the presence of tapestries from the Duke's *Victories* set.

More of the *Victories*, or possibly panels from *The Art of War* set, hung in the bedroom which served as the state bedroom in the Duchess's time. The bed and upholstery was all in crimson damask and finished in gold galloon, while the six chairs and four stools had gilded frames, as did the pair of tables and matching stands.

The several designs of pier-glass and table that survive were evidently supplied by James Moore before and after 1719 and they must be among the earliest coordinated pieces. However, all are now gilded, so it is not certain which set belongs in which room. Similarly, it is not clear how the *Art of War* and *Victories* tapestries were intended to be arranged, or, indeed, how much tapestry was

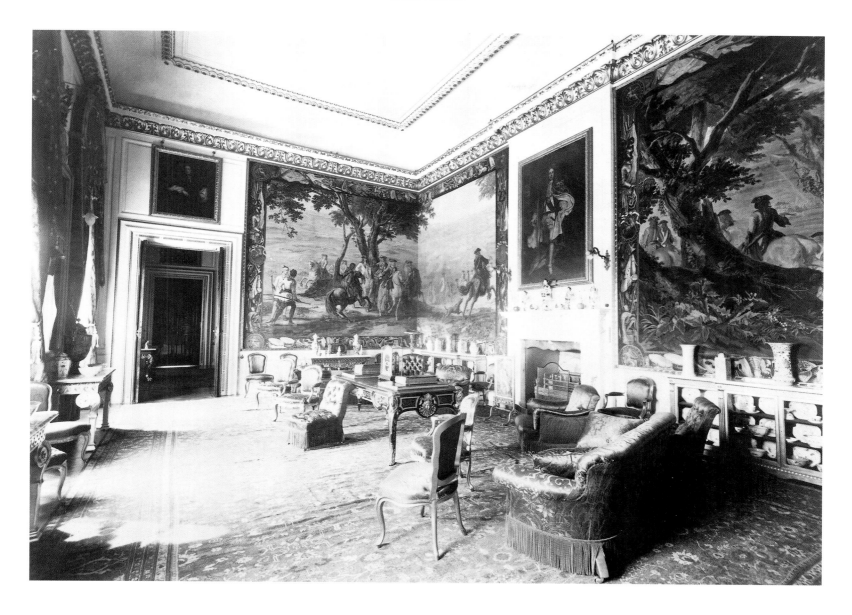

planned when the upholstery materials were ordered in 1708. By December 1704, the Duke had acquired some tapestry, and by the end of 1706 he was writing to the Duchess about tapestries already woven for them in Brussels, possibly the five panels of *The Art of War* set, which may have been presented to the Duke when he made his triumphal entry into Brussels that year. The following spring he asked for measurements for the hangings he was about to order for their own apartments, presumably *The History of Alexander*. Perhaps that was one of two sets made in Brussels according to measurements provided by Vanbrugh that he mentioned in 1709.

After that came *The Victories* (Fig. 358), which must have been inspired not only by the battle tapestries woven for Louis XIV and by earlier sets of decoration like the paintings commemorating Condé's victories that were placed in the gallery at Chantilly. They were woven by Judocus de Vos in Brussels, but it is not known when they were commissioned. It is possible that they were extended after the victory at Bouchain in 1711, which is commemorated by no less than three panels, two of which are 25 feet wide. Alan Wace has suggested that weaving only began in 1712 and continued until about 1716. That would mean the Duke continued with them at a time when building at Blenheim was at a standstill and it looked as if it might never be resumed.[7]

Nor is it clear how the *Victories* were intended to be incorporated into the decoration of Blenheim, and some changes may have been made when the south-east apartment was completed first. The earliest description of them *in situ* appears to be Thomas Martyn's in *The English Connoisseur* (1766), shortly before the changes carried out by Sir William Chambers for the 4th Duke. He describes *The Battles of Blenheim* (1704), *Malplaquet* (1709) and *The Surrender of Lille* (1708) hanging in the first two rooms of the south-west apartment that was originally intended as the state apartment.

One other point concerns the bed in the crimson damask bedroom. The Duke seems to have wanted a state bed made out of his canopies on the lines of that at Raynham (Fig. 95) and formerly at Kimbolton (Fig. 333); and evidently one was made, because it was listed in an upstairs bedroom rather than in the unfinished state bedroom adjoining the gallery. That was in the Duke's mind as early as 1709, because when he ordered a canopy for what proved to be the unsuccessful treaty signing that year, he wrote: 'Pray take to have in mind so that it may serve for part of a bed when I have done with it here.'[8]

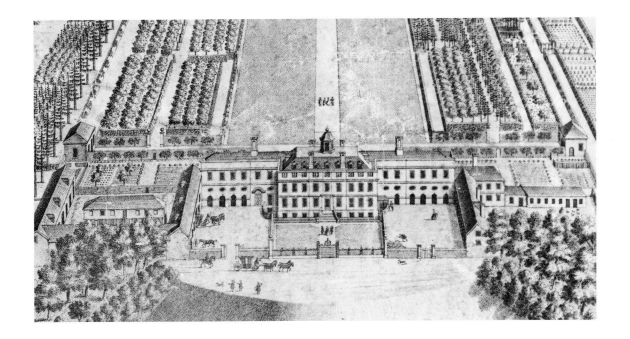

*Erddig, Clwyd*

359. *A detail of Badeslade's 1740 view showing the west front of the original late seventeenth-century nine-bay house and its forecourt and the wings and side courts added in the 1720s. The door in the north wing was the everyday entrance to the house.*

360, 361. *Plans of the main and second floors as they were in the mid 1720s. The layout of the main rooms on the east front has been altered.*

362. *A modern model showing the original layout of the principal rooms. The Red Damask Bedroom, the saloon, drawing-room, principal bedroom and dressing-room.*

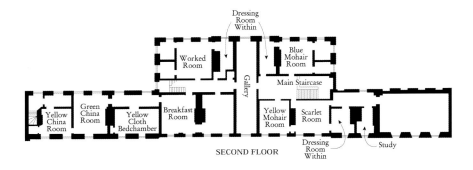

SECOND FLOOR

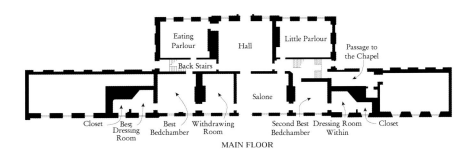

MAIN FLOOR

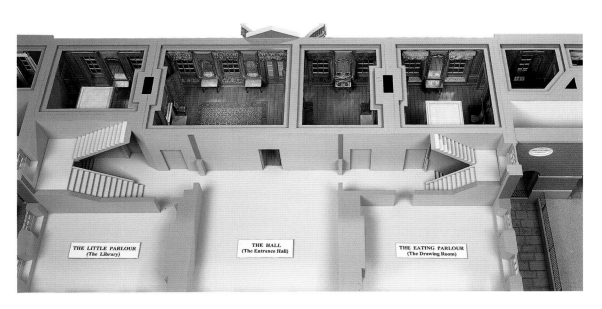

363. *One of the original pair of large glasses in gilt gesso frames with glass branches supplied for the saloon by John Pardoe at £12 the pair in 1720. They were above walnut tables.*

364. *One of the original unrestored matching pelmet cornices with gesso mouldings and valances cut as false festoons for the saloon as seen in the gallery in 1978. The materials are worked in a similar way to the case covers on the chairs.*

365. *The walnut chairs with their original case covers or 'false cases' of red and yellow caffoy and yellow satin supplied for the saloon as restored in 1977.*

## ERDDIG

Even in its incomplete state at the Duchess's death in 1744, Blenheim was the most grandly conceived interior in Britain in terms of themes and materials, but the role of upholstery in the build-up of the interior can be compared not only with Houghton but on a more modest scale with Erddig, near Wrexham in North Wales.

Surprisingly, that house was remodelled, extended and refurnished by a bachelor in his late fifties, John Meller, who had been a successful barrister in London and bought the place in 1714. Architecturally, what he did is unremarkable and the layout of the parade rooms that he formed was altered later, but if his surviving furnishings are related to the accounts and the inventory compiled in 1726 and to a reconstruction of the plan in his time (Figs. 360,

361), it is possible to get a clear idea of the processional approach to planning and furnishing in the years when the Duchess of Marlborough was completing Blenheim. After nearly 300 years it is impossible to recognize all the nuances of taste, but Meller's may have had an element of the Londoner showing off. Certainly the impressionable John Loveday, who went to Erddig in 1732 thought 'Ye Apartments handsome, & furnish't in ye grandest manner & after ye newest fashion'. But how clear an overall idea Meller had when he embarked on his saloon, drawing-room and Best Bedroom is not clear (Fig. 362). Indeed, payments suggest a step-by-step approach, because in the drawing-room, for instance, the pier-glass and table were not bought as a pair, as might be expected, but the table arrived three years after the glass.[9]

367. *The same pattern of cut velvet on the State Bed at Powis Castle.* The National Trust, Powis Castle.

366. *The silver gesso pier glass supplied for the drawing-room in 1723 at a cost of £21 and the silver gesso table with a looking glass top with the Meller arms supplied in 1726 at a cost of £14, both by John Belchier.*

The use of the word 'saloon' for the largest room, which was three bays long and of a single storey, might have been thought pretentious in sophisticated circles. With its simple wainscot and avoidance of hangings, it was closer to a great parlour. Its set of eight chairs and settee was of uncarved walnut upholstered in watered worsted, but for formal occasions they had flamboyant false cases of boldly figured caffoy with bands of yellow silk and red fringe, which still survive (Fig. 365); and also case covers of yellow stuff. At the windows were pelmet cornices with valances cut as false festoons (Fig. 364) reminiscent of Marot's print and made to match the false cases (two of which survive in store), and three 'sutes of crimson and yellow window curtains' and two caffoy window seats. On the piers between the windows were a pair of looking-glasses (Fig. 363) in gilt frames with two pairs of glass arms each, which were supplied by John Pardoe in 1720 at a cost of £12 the pair; but the pier-tables were walnut with marble slabs.

As usual, the panelled drawing-room was smaller, with two windows, and so it had a single pier-glass in a silver gesso frame (Fig. 366) with two pairs of glass arms and below it a silver gesso table with a sparkling looking-glass top displaying the Meller arms engraved on the back of the glass. The glass was supplied by John Belchier in 1723 at a cost of £21 and the table was purchased three years later for £14. The eight chairs and settee also have silver gesso frames (Fig. 368) and their original covers of silk cut velvet in a dramatic pattern that is best appreciated in the bed hangings at Powis Castle (Fig. 367). John Loveday was quite taken in by the gesso: 'In one room are Chairs, ye frames of wch are plated with Silver.' However, gesso was about to go out of fashion, presumably because of its tendency to chip and its susceptibility to damp. There were two 'sutes' of crimson velvet curtains with window seats to match, an overmantel glass with a silvered frame and a pair of silvered sconces; and even the hearth was of steel to match rather than brass. [10]

*Erddig, Clwyd*

368. *Some of the Soho tapestries of oriental subjects enlarged for use in the original principal bedroom and the silver gesso chairs and settee with their crimson cut velvet upholstery originally in the drawing-room.*

369. *The bed covered with oriental embroidery on a white satin ground and gilt gesso carved ornament supplied by John Belchier and John Hutt in as restored about 1970.*

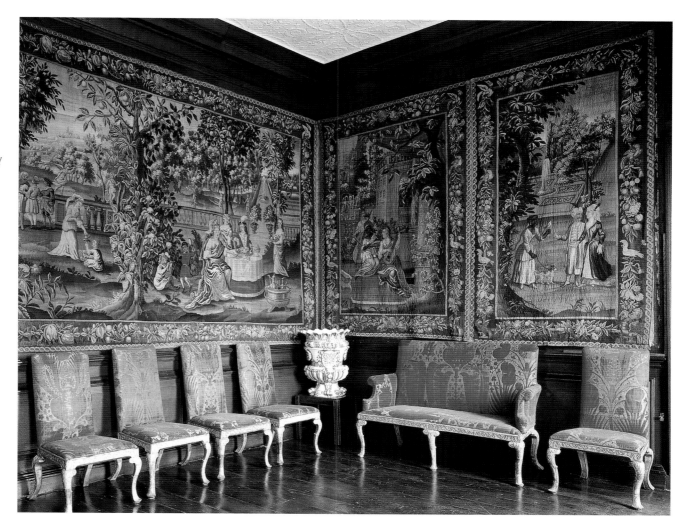

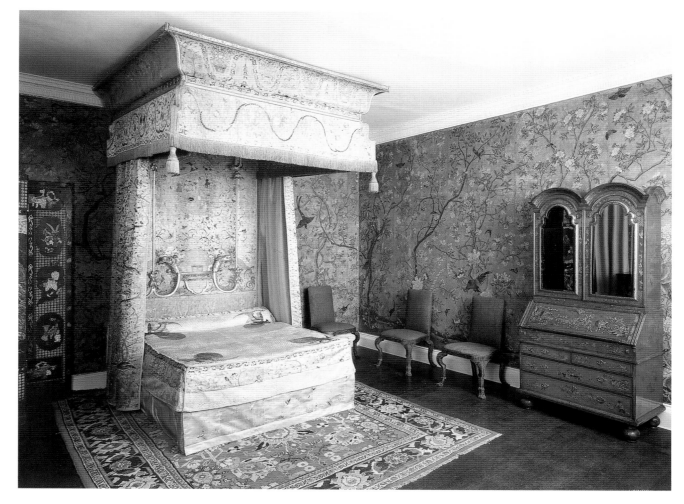

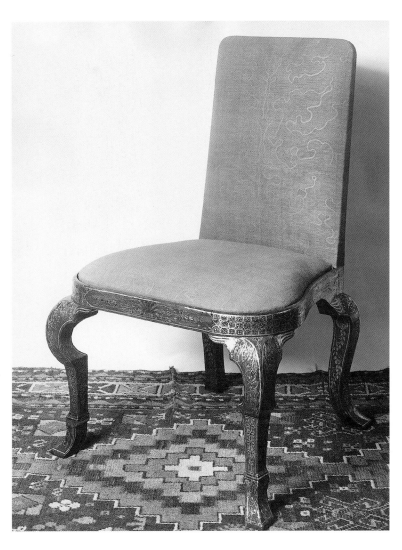

370. *The pier glass with detail relating to the bed supplied for the bedroom by Belchier at a cost of £50 in 1726 and the Louis XIV dressing-table originally placed beneath it.*

371. *One of the six chairs japanned in green and gold and with their original fixed upholstery of green watered woollen material. Originally the chairs had case covers or 'false cases' of 'gold stuff' that have not survived.*

The climax to the apartment was provided by the Best Bedchamber, which was enlarged by Meller. The walls were hung with three panels of Soho tapestry incorporating figures in oriental dress, which is now partly in the Tapestry Room (Fig. 368). That was intended to set off the spectacular bed (Fig. 369) provided by John Belchier and Hutt and hung with oriental embroidery on a white satin ground, with the framing of the head cloth shaped to accommodate the design of the embroidery and finished in gilt gesso. The bed is lined with white silk. Originally there were embroidered white satin window curtains with valances and window seats to match. Between the windows was a French buhl bureau dressing-table, rather oddly recorded by John Loveday as having belonged to Henry VIII, but of greater interest as an early example of a piece of Louis XIV furniture in use in England. Above it was the finest of the pier-glasses in a frame whose bold outline reflects the headboard of the bed (Fig. 370): That, too, was supplied by John Belchier, for £50. The six chairs (Fig. 371) and two stools with green japanned frames originally had false cases of gold stuff, a rare example of coloured japanning that can be related to its original context; and they still retain their original fixed upholstery of green watered worsted.

Beyond was a dressing-room hung in blue damask with matching curtains. That had two dressing chairs, two stools and a couch with a walnut frame all covered in blue damask, with white cloth case covers, and a pair of silvered branches for candles.

The Second Best Bedchamber to the north of the saloon was done in crimson damask and had an angel bed (now recovered and

upstairs), six walnut chairs, a large pier-glass and gilt table (with a leather cover) and a pair of silvered sconces. Its dressing-room was hung and furnished in red mohair and had white curtains trimmed in red.

What is striking is the contrast between the lavish use of looking-glass and gesso furniture and the absence of case furniture and mahogany. Apart from the buhl dressing-table, the only notable piece is the red lacquer bureau (Fig. 372), which was in the Blue Mohair Bedroom on the upper floor.

372. *A scarlet japan bureau originally in the Blue Mohair Bedroom on the upper floor. One of the few pieces of coloured japanned furniture that can be identified in early inventories.*

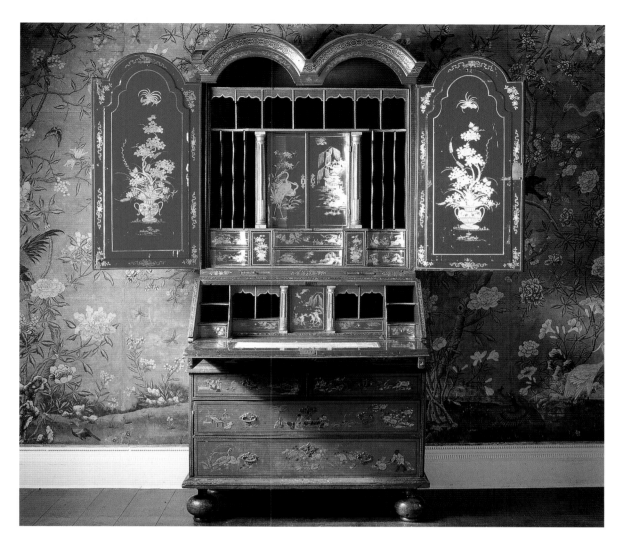

CHICHELEY HALL

The possible brashness of Meller's taste is suggested by the contrast with the furnishing and fitting-up of Chicheley in Buckinghamshire, a new house built in the early 1720s and seemingly more or less completely furnished by the time its builder, Sir John Chester, died in 1726. The original plan survives, as does the fitting-up of the rooms, and although most of the original furniture has left the house, the inventory taken in 1755 on the death of the thirty-one-year-old Sir Charles Chester, the builder's grandson, appears to describe Sir John's furnishing virtually unaltered.[11]

Like Belton and Houghton, Chicheley divides into thirds both vertically and horizontally (Fig. 373). That to the left of the hall was intended for everyday family life, the hall and principal staircase occupying the centre, and the principal rooms the third to the right. The everyday entrance was always on the west side, as it remains today, and the common parlour (now the dining-room) was at the south-west corner of the house, originally looking out on to the west court, so keeping an eye on all the comings and goings. Beside it is the west staircase that reaches the full height of the house, and on each floor there was a door making a break between the west end and the main part of the house that survives in its original position on the first and second floors.

When the plan was first agreed in 1719 with Francis Smith, the builder, it is conceivable that the hall was to be of a single storey, but intended to have the unusual Italianate arcade linking it to the staircase behind (Fig. 374). The arcade and its handling must have been

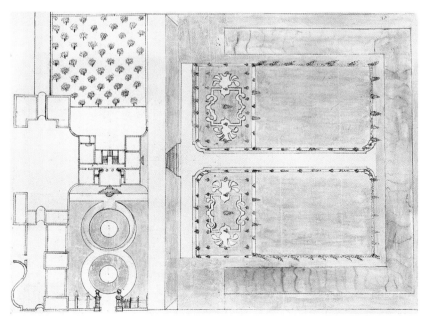

373. *Chicheley Hall, Buckinghamshire. One of the original plans for the layout before the kitchen wing was drawn in, showing the relationship of the new house to the recently created formal garden and canal to the east and the forecourt on the west side.*

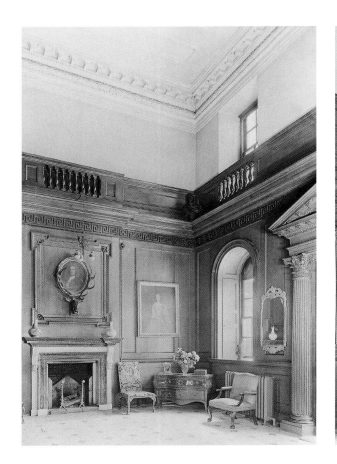

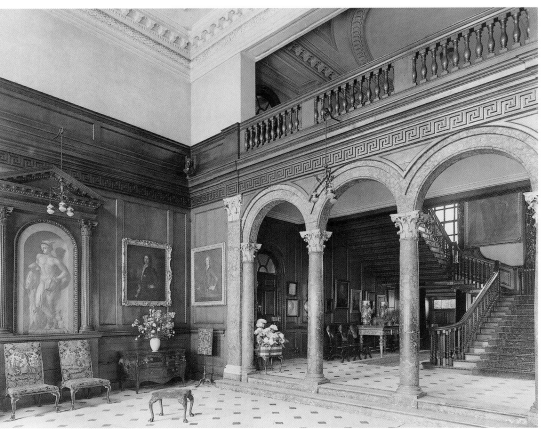

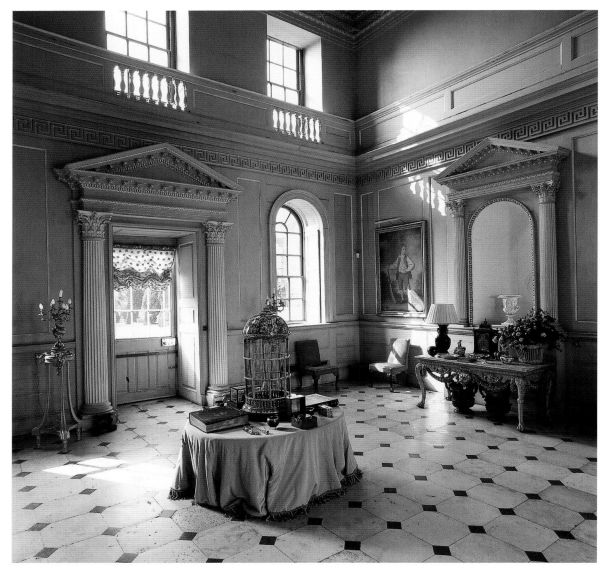

*Chicheley Hall, Buckinghamshire*

374. *The hall as it was in 1936 showing how the tonal contrast of the panelling to the plaster walls above created the illusion of a gallery running round the hall. On the right can be seen one column of the Kentian doorcase so different in style from the Rossi-inspired doorcase and window architraves outside.*

375. *William Kent's grisaille figure of Mercury in the niche carved by James Richards on the west wall and the screen on the north wall with the staircase beyond. The classical frame to the niche matches that framing the front door. It seems that originally the hall was to be single-storey with the unusual scagliola and alabaster screen and then the ceiling was raised and the lower walls panelled. The panelling had to be fitted round the existing capitals of the scagliola pilasters.*

376. *The south and west walls of the hall.*

377. *The original Great Parlour, now the Drawing-Room, as in 1975. The combined white marble chimneypiece and landscape glass is flanked by wooden pilasters and above the marble frame is a marquetry panel incorporating the monogram of Sir John Chester, the builder of the house, and his second wife.*

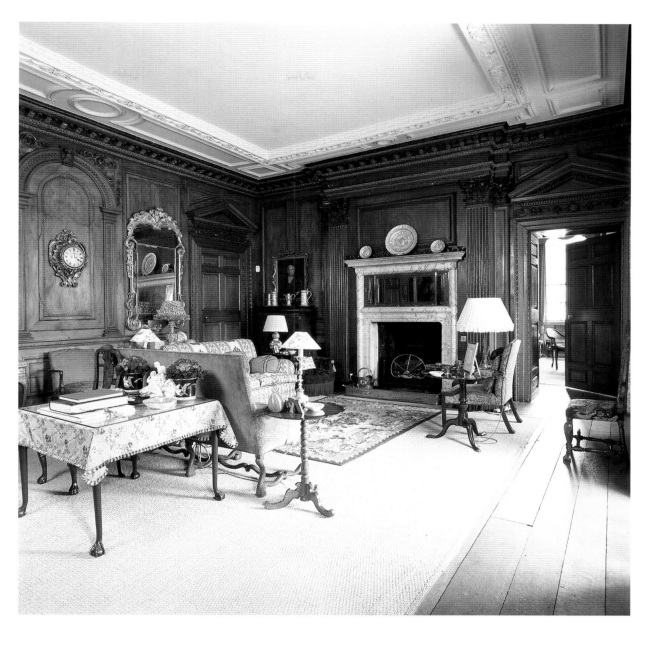

an idea of Sir John and his friend Burrell Massingberd, a Lincolnshire squire and amateur of architecture with whom he had been to Italy in 1711–12. The choice of marbles and scagliolia is unusually complicated, while the capitals are of alabaster, presumably obtained in Derbyshire or Nottinghamshire. When they decided to enrich the exterior with architraves to some of the windows and doors copied from Rossi's *Studio d'Architettura Civile* of 1702, they also made the hall double height. Over its completion they consulted William Kent, whom they had supported in Italy from 1713, and the young Henry Flitcroft as draughtsman. It was then that the lower walls were panelled, so that the woodwork (painted by Felix Harbord for the late Earl Beatty, who believed the graining was nineteenth century and left the evidence of stone colour in a grained lobby off the Lady's Drawing-Room, doubtless wanting it to look like the hall at Ditchley) had to fit round the arcade. It was completed with a balustrade that created the illusion of a gallery running round the hall, as in the Queen's House at Greenwich. At the same time, a marble chimneypiece was placed facing an architrave frame on the west wall, which was carved by James Richards, who was to become one of Kent's favourite craftsmen; and that was used to contain a statue of Mercury painted in grisaille by Kent. The frame relates to the front doorcase, which is in

a Burlingtonian style quite different from the Rossi-inspired details outside, and both relate to the main cornice. In the centre of the ceiling is the unconvincing painting by Kent that Sir John commissioned from him while he was in Italy, which had been intended for the staircase of the old house.

Behind the screen, a short corridor gives dignity to the approach to the door to the Great Parlour (Fig. 377), now the drawing-room, while also providing convenient access both to Sir John's dressing-room, now the library, and through it to the Gentleman's Drawing-Room and, via a lobby, the Lady's Drawing-Room (Fig. 378), the two rooms that flank and open out of the Great Parlour. The naming of those rooms is most unusual and the explanation may lie in the house being built by Sir John and his second wife, whom he married in 1714.

All three rooms were fitted up by Thomas Eborall, one of Smith's favourite joiners, from Warwick, who was paid £182 15s. for them in September 1725. As usual, the Great Parlour is completely panelled, in a rather masculine style with boldly pedimented doorcases (Fig. 380) and carved architraves. The standard of finish is unusually high, with even the fields of the dado panels edged with a band of burr elm and the dado rail having a band of veneer. That continues into the arched feature in the centre of the west wall,

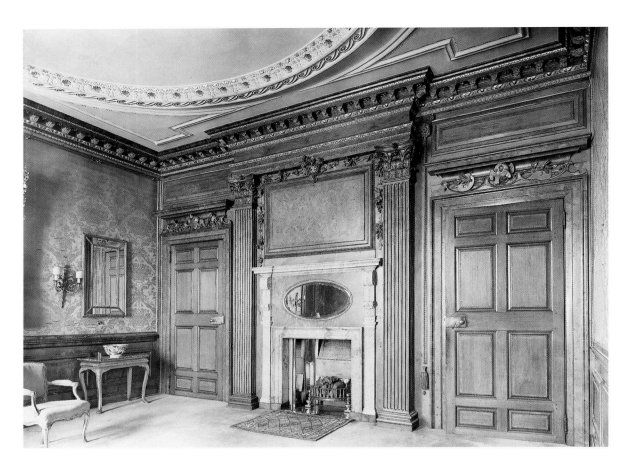

*Chicheley Hall, Buckinghamshire*

378. *The chimneypiece in the Lady's Drawing-Room, now the Morning Room.*

379. *The original Great Dining Room, over the Great Parlour, when it was the Picture Bedroom in 1936 and still hung with its late-17th-century portraits in their carved frames hung high. The panelling, which was probably originally wood colour, was designed round the pictures, with their frames suggesting carved mouldings to the panelling. The overmantel, a copy of Veronese's, could be one of the pictures arranged by William Kent in Rome.*

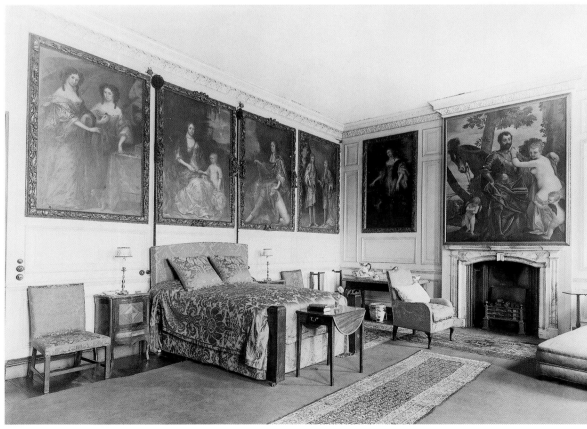

which is inlaid with two bands of herringbone pattern in padouk and oak, which would have originally read as a reddish colour and buff. Smaller versions of that feature also appear on the piers between the windows that seem to argue against the idea of pier-glasses and pier-tables being planned to go there. The chimney-breast is framed by Corinthian pilasters in Smith's favourite manner, with a Talmanesque white marble chimneypiece incorporating an overmantel glass in its frame. Over that is a panel with a monogram in marquetry of the initials of Sir John and Lady Chester that recalls details in other Smith houses such as Davenport and Mawley. In 1755 the room was furnished with twelve walnut chairs with green damask seats and green damask draw-up curtains and gilt cornices. There was also a table with a gilt frame and a marble top inlaid with magpies and snakes, which perhaps went in the centre of the west

381, 381. *The heads of the doorcases in the Great Parlour and the original Lady's Drawing-Room, now the Morning Room. They show the developing sequence in the architectural language from masculine to feminine, with carved architraves in the former and veneered walnut in the latter. The Gibbonsesque carving in limewood, evidently partly stained dark, in the drawing-room is emblematic of the Chesters' interests.*.

382. *The back of a side chair from the parcel-gilt walnut set with needlework covers originally supplied for the Lady's Drawing Room. The covers made them the most valuable pieces of furniture in the house.* Now on loan to the National Trust at Montacute, Somerset.

wall and was still in the house in 1936. There was no dining-table or settee, and apparently no pier-glasses or pier-tables. The total value of the contents was put down at £35 4s. 6d. in the 1755 inventory.[12]

The same order of pilasters and cornice is used in the two flanking rooms, but the smaller Lady's Drawing Room at the south-east corner of the house is much more elaborately fitted up. Indeed, it is now unique in two respects. It is exceptional among Smith's houses and Eborall's work in that the wainscot is extensively veneered in elm over-grained to look like walnut. Inevitably the over-graining has worn away and faded over the years and the overall effect is lighter than it was originally, but it can be seen on the entablature over the chimneypiece. Second, it appears to be the only known room where such a relationship appears between the fitting-up and the seat furniture.

The concept of the room follows the convention of the time for a drawing-room in that the main panels were hung with material, the probable colour being suggested by the curtains and case covers, perhaps a mixed or wool damask rather than a silk that would have been too lustrous with the covers of the chairs. As in the Great Parlour, the dado rail and the edges of the panels of the walls and doors are veneered with burr elm, but instead of the door architraves being carved they are moulded and elaborately veneered, with the friezes having emblematic carving in the style of Gibbons by Smith's favourite carver, Edward Poynton from Nottingham, relating to the interests of Sir John and Lady Chester. It appears to be in

two colours, with some elements stained a darker colour. The plaster cornice is grained to match the veneering on the door heads and parcel-gilt, the graining remaining richer in colour than the now faded elm veneer; and there is some picking-out of the ceiling ornament in gold, a detail not found in the other rooms.

The cornice is closer to the tone of the original ten walnut and parcel-gilt chairs and settee, which are very similar to the large set at Houghton (Fig. 382); they are now mostly on loan to Montacute. Their frames and covers in *gros-* and *petit-point* needlework, together with the related four-fold screen, brought the value of the contents of the room to £103 4s. in 1755, much the highest in the house. The fact that they are parcel rather solid gilt seems typical of Sir John's nice sense of his own status and that of his house. Unfortunately, there is no identifiable payment for them in his accounts, and since Eborall was only paid for his work in September 1725, it is conceivable that they had not arrived when Sir John died early in 1726. In 1755 they had case covers of green serge trimmed with fringe, and the curtains were of green lustring with carved but apparently not gilded cornices.

The Gentleman's Drawing-Room was more simply treated, with less carving and a chimneypiece of grey marble but carved architraves to the doors. Some of the wainscot mouldings and the dado rail are veneered, while above the dado rail on the west and north walls the woodwork is only grained, which suggests that room was originally hung with tapestry or material; but being regarded as a fixture in 1755, that was not listed. There were twelve walnut chairs with blue damask covers, a settee and four stools, and a sconce in a gilt frame; but, since everything was valued at only £12 17s. 6d., the damask was probably wool, not silk. Perhaps the grained woodwork was put in after 1755, when the room may have become the dining-room.

What is immediately striking is the absence of any red from these three rooms, which seems to support the idea of it as a grand colour: perhaps Sir John regarded it as a pretentious choice for his house, while being suitable for a great nobleman like the Duke of Marlborough.

The sequence did not end with these three rooms, because the justification for the spacious and handsome staircase leading only to the first floor was that it led to the Great Dining-Room (Fig. 379) over the Great Parlour. In the 1936 photograph, showing it as the Picture Bedroom, the panelling appears to be painted a light colour and the main feature is the set of seventeenth-century portraits in

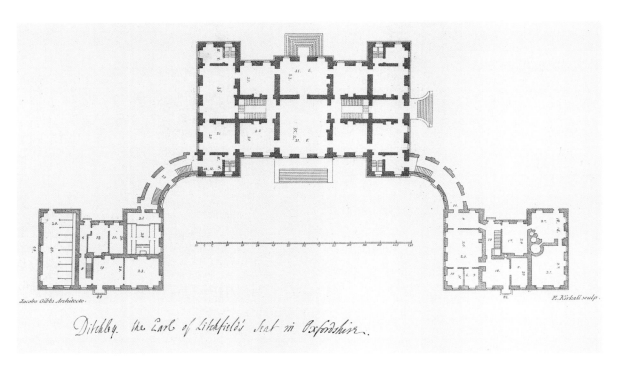

Ditchley. the Earl of Litchfield's Seat in Oxfordshire.

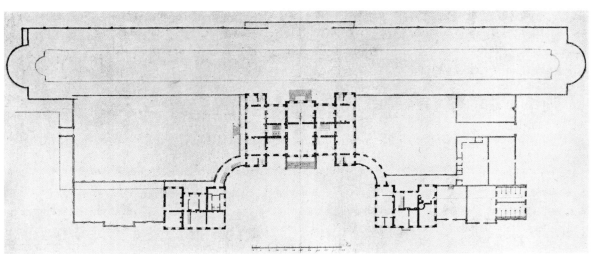

*Ditchley Park, Oxfordshire*

383. *The plan of the house as originally laid out. This show the everyday rooms to the right of the hall fitted up in the 1720s and the parade rooms to the left completed in the late 1730s.*

384. *A now-lost drawing showing how the plan was to be altered in the late 1740s to convert Flitcroft's dining-room into a large drawing-room and form a new dining-room in the east part of the house.*

385. *The hall. Apparently designed by Henry Flitcroft, to whom a payment was made in 1724, with Kent as decorative painter and probably commenting on the ornament and furnishing.*

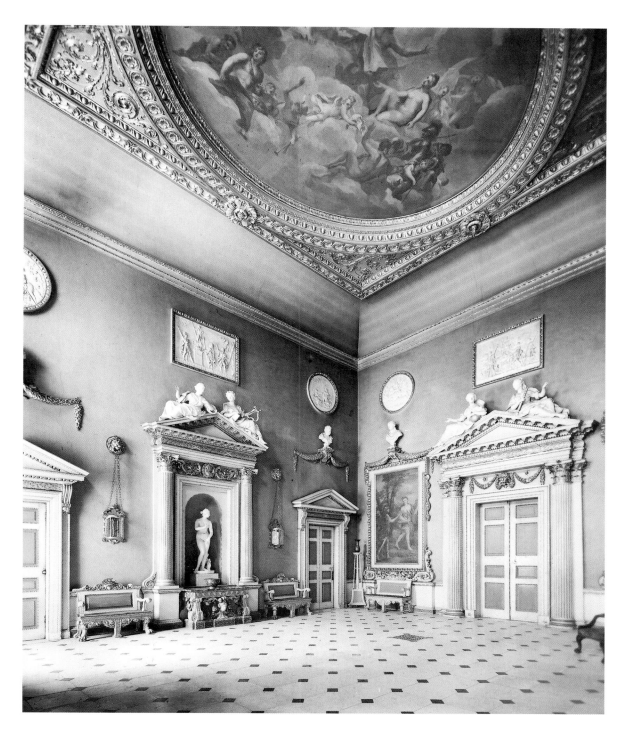

carved frames hung close together and placed rather high. Presumably the panelling was originally oak or painted a wood colour, and the portraits would have read as being incorporated in the panelling with carved mouldings. Either way, it was the only room in the house planned around pictures and the copy after Veronese could have been one the pictures obtained through Kent in Italy. However, that has gone as have the portraits, and the room has been repanelled. In 1755 the room was furnished with twelve walnut chairs with worked seats, which would never have been used for regular dining, and a settee covered with silver stuff paned with velvet and embroidered, which sounds old-fashioned and was banished from use, but no dining-table. There were two marble tables with gilt frames and one of the pairs of fine glasses still in the house. The total value put on the contents of the room in 1755 was £54 16s.[13]

Next to it was the principal bedroom, which had a bed of blue and yellow damask; its contents were valued at £66 13s. 6d.

## DITCHLEY PARK

The sense of grading running through both Erddig and Chicheley in terms of qualities and costs can also be seen at Ditchley in Oxfordshire, where work began about the same time but carried on considerably longer. Ditchley also shows how changes in ways of living soon led to alterations in the plan and uses of rooms. The house was begun by the 2nd Earl of Lichfield in 1720 and, like Chicheley, it was built by Francis Smith but 'according to a Draught given by Gibbs'. Quite how much was due to Gibbs is uncertain, but certainly the plan (Fig. 383) seems to look forward to that for Houghton (Fig. 188).[14]

As at Chicheley and Houghton, the main floor is divided into three main sections, with the hall (Fig. 385) 31 by 35 feet and behind it another room, 31 by 23 feet, and a nearly symmetrical layout of two sets of flanking rooms. The eastern part evidently worked as a house-within-a-house for family living, with an entrance from the

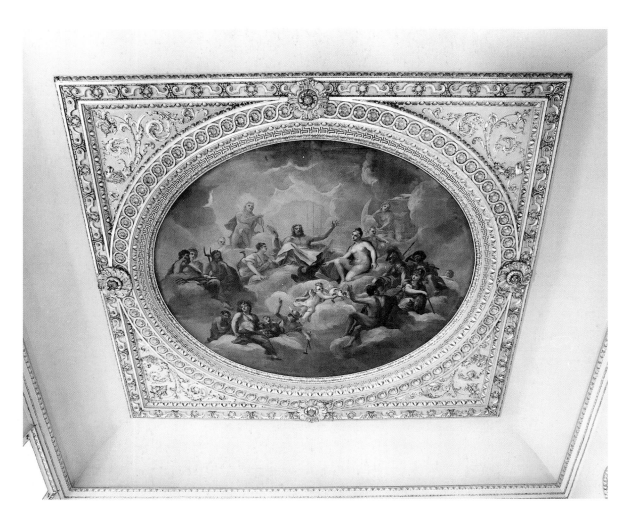

386. *Kent's* Assembly of the Gods *inset in the hall ceiling.*

387. *The saloon, planned by Gibbs as a dining room, as is suggested by the niche on the west wall, but called the saloon by 1743. Soon after that it was considered too small for that purpose. Francesco Vassalli, Francesco Serena and Giuseppe Artari all worked on the stucco decoration in the house in 1725–7.*

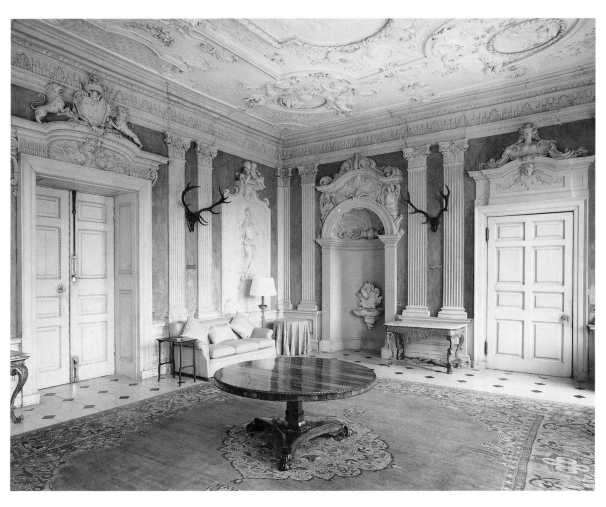

sunk Lions Court with its imposing gate piers topped by earlier lions
with shields bearing the Lee and Royal arms. The outer steps to the
door shown in Gibbs's published plan do not appear to have been
built, and a lower door must have been used.

In the centre of the east elevation on the main floor was a small
room, which could have been originally intended as a hall but
became the Breakfast Room. That was simply furnished with six
walnut smoking chairs with leather seats: its complete contents were
valued at only £10 16s. in the 1743 inventory compiled on Lord
Lichfield's death. It was flanked to the south by the everyday draw-
ing-room, which had three pieces of gilt leather hangings supplied
by Joseph Fletcher in 1722–4, nine walnut banister back chairs with
pincushion squabs, a settee covered in green mohair and an elbow
chair covered in needlework, all given unity by their green shalloon
covers, a large slab on a walnut frame, a harpsichord and two pairs
of green mohair curtains, all valued at £37 10s. On the north side of
the Breakfast Room was the Crimson Damask Bedroom, where the
material was silk. Here there were six walnut back stool chairs and an
easy chair, and four pieces of *Playing Boys* tapestry: evidently it was
the temporary principal bedroom because its contents were valued
as high as £137 5s. To the west of it was a drawing-room, again
tapestry-hung and done in crimson silk damask. It had eight back
stool chairs and a half settee with gilt frames, all with shalloon cov-
ers, probably supplied by Bradshaw, the total value coming to £143
13s. Thus the two rooms formed an apartment opening off the
saloon.

On the south front between the hall and the east drawing-room
was the everyday dining-room. In 1743 it was furnished with twelve
walnut banister-back chairs with leather seats, two marble slabs
on walnut frames, two crimson stuff damask curtains and a round
black stand for a cistern, everything totalling £44 14s. 6d. There were
no tables listed in the room, but in the closet were a large mahogany
table, with a leaf to add, three oval dining-tables and a wainscot
breakfast table, all valued at £6 10s.

By 1724–5 attention had moved on to the centre of the house,
to the hall (Fig. 385) and the room behind that Gibbs called the
dining-room in his book. By 1743 it had become the saloon (Fig.
387). Horace Walpole, writing in 1760, said the latter was 'a wretched
saloon'. Indeed, its long and rather narrow proportions, stone floor
and stucco decoration by Vassalli, Serena and Artari with a buffet
niche facing the chimneypiece suggest that it was designed as a din-
ing-room. The placing of the pairs of pilasters and the reliefs would
have made it difficult to place pier- or side tables and suggests that
the room was designed shortly before it was usual to intergrate the
design of a room with furniture. Even though it had changed its
name by 1743, it still only had simple parlour furniture, walnut
banister-back chairs with black leather seats valued at only £10,
hardly saloon furniture.[15]

Lord Lichfield was evidently coming to realize that the Baroque
ornament of the Italian stuccoists was not in keeping with the new
Palladian style of Lord Burlington, whom he could have encoun-
tered hunting with the Charlton in Sussex or in London, because in
July 1724 there was a payment of fifteen guineas to H. Flitcroft. That
year, the hall chimneypiece with its Portland stone architrave and
terms of statuary marble was supplied by Christopher Horsenaile at
a cost of £62. The following year, William Kent was paid £150 in two
instalments for his ceiling painting of *The Gods in Council Deliberating
on the Fall of Troy* (Fig. 386). Perhaps it was at the same time that he

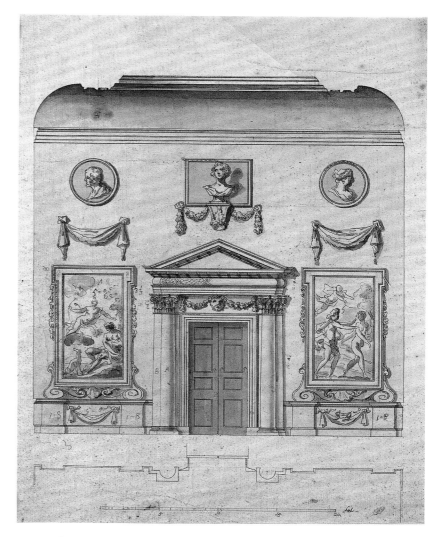

388. *A drawing for the north wall by William Kent showing his proposals for his two
paintings* Venus leading Aeneas Through the Wood *and* The Bringing of
Aeneas's Armour *paid for in 1731.* Ashmolean Museum.

389. *The table below the niche in the hall evidently carved by James Richards in 1726.*

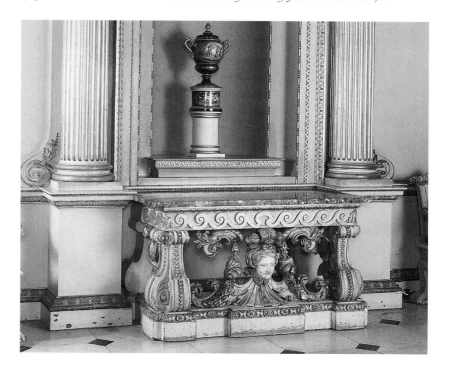

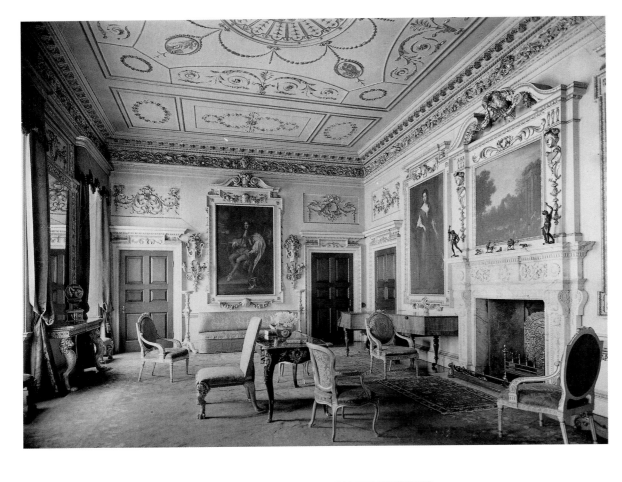

390. *The original dining-room fitted up to Flitcroft's design in 1736–9 and converted into a drawing-room about 1750, as it was in 1934. Here the design is closely based on William Kent's design for a dining-room for the Duke of Grafton (Fig. 180), who was Lord Lichfield's cousin, and the portraits proclaim Lord Lichfield's descent from Charles II. The design was included in Ware's* Designs of Inigo Jones, 1731.

391. *The original drawing-room fitted up by Henry Flitcroft in the late 1730s. Cheere supplied the chimneypiece in 1740.*

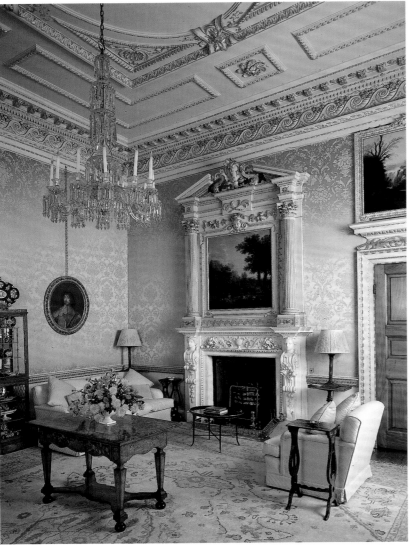

worked up the drawing in the Ashmolean Museum that shows his thoughts for the pictures on the north wall (Fig. 388), and if so it is close in date to his first Houghton designs (Figs. 185, 186). In 1726 a payment was made to James Richards for a carved table frame (Fig. 389), which it is tempting to associate with the painted table in the style of William Kent in the hall. There is no record of payment for the Rysbrack reliefs that are circular versions of those in the Stone Hall at Houghton (Fig. 191). It is unusual to find the first round of gilding carried out, with more being added in 1738. In 1731, William Kent was paid for the two paintings on the north wall of *Venus Leading Aeneas through the Wood* and *The Bringing of Aeneas's Armour*. The hall is so different from the saloon that it seems that Kent and Flitcroft worked on its design, rather as they had at Chicheley.

When John Loveday visited the house in 1734, he noted 'one half the house below Stairs is not yet fitted up'. In 1736 Flitcroft returned to complete it, designing the dining-room or Great Room (Fig. 390) as it was called in 1743, the drawing-room (Fig. 391) and the other rooms on the west side. His drawings for those rooms, together with some for tables and glasses, were charged for over the next five years. Charges for designs for two sets of table frames appeared in the accounts in March 1740, and for drawing three tables and glass frames in March 1741.[16]

Presumably Flitcroft showed these to Bradshaw, who was the upholsterer finishing the house, and it seems that he went to Matthias Lock, who did the drawing now in the Victoria and Albert Museum and carved the pair of tables from the dining-room now at Temple Newsam.[17]

Flitcroft's design for the dining-room was strongly influenced by Kent's design for the dining-room for the 2nd Duke of Grafton, a cousin of Lord Lichfield (Fig. 180). It was panelled round four full-length portraits in parcel-gilt frames to bring out Lord Lichfield's

392. *One of the mahogany dining chairs formerly at Ditchley. Apparently one of the earliest examples of their type and probably supplied by William Bradshaw.*

393. *Two of the chairs in the French taste from the carved walnut set with tapestry covers apparently supplied for the drawing-room by William Bradshaw about 1740.* Private collection.

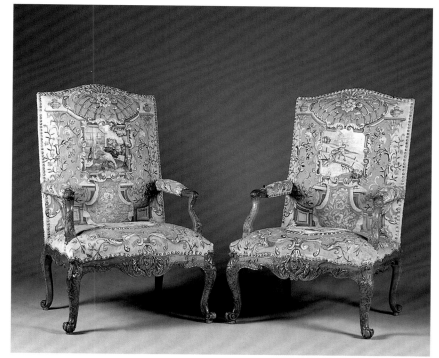

royal connection: at the ends of the room were Charles II and his mistress, the Duchess of Cleveland, both by Lely, and on the chimneypiece wall their daughter, Lady Charlotte Fitzroy, who married the 1st Earl of Lichfield (who as a result was given the earldom), and her brother, the 1st Duke of Grafton. The 2nd Earl had Catholic, Tory and possibly Jacobite sympathies and they may be referred to in the chimneypiece by Henry Cheere, supplied in 1739 at a cost of £105 10s. 6d., because the sunflower motif may be a subtle allusion to his loyalty to the Stuarts.

By 1743 the room was handsomely furnished with a large Turkey carpet, the two tables now at Temple Newsam and two glasses, two large gilt stands and ten carved mahogany chairs with red morocco seats and four elbow chairs. The chairs, presumably represented by one formerly in the house, are among the earliest known mahogany dining chairs (Fig. 392).[18]

The drawing-room (Fig. 394) between the dining-room and the saloon must have always been a difficult room to arrange and uncomfortable to use, because of its small size and the placing of Cheere's marble chimneypiece, supplied in 1743, close to the dining-room door on the south wall. The seat furniture consisted of a set of six walnut chairs (Fig. 393) and a pair of settees covered in tapestry (now in a private collection) that appear to have been supplied by William Bradshaw. They appear to be one of the earliest examples of English furniture in the French taste and so the earliest example of an English drawing-room having a *soi-disant* French character. Since no hangings are mentioned in 1743, it is possible that the room was still not quite finished. By 1766 it had been hung with green damask. The overmantel painting is by John Wootton, possibly added by the 3rd Earl.

The principal bedroom was also evidently unfinished in 1743. Presumably the remarkable Genoa cut velvet with its design of the Indian god Shiva, which had been bought in 1738, had not yet been made up, because another of Cheere's chimneypieces, this time with a Panini overmantel, only arrived in 1743. There is no mention of a bed; and the contents were only valued at £10.

Bradshaw was paid about £340 for furniture between 1740 and 1742 and then compiled the inventory in 1743. His total valuation came to £1,489, with the plate at a further £1,488 7s. 6d.

Evidently the 3rd Earl soon found his father's house did not work well for him, and in 1749 he broke down the division between the family and parade sides of the house by turning Flitcroft's principal dining-room on the west front into a drawing-room and making a new dining-room at the east end of the house out of the Breakfast Room and south-east drawing-room. So both the dining-room and drawing-room became large rooms of equal size, which had become the fashion. That is shown on a plan that relates to a now-missing elevational drawing with the silhouette of the house made more dramatic with a central pediment and cupolas on the end bays, like those added by Kent at Badminton in 1746–7. The connection between the Lichfields and the Beauforts seems to have been close. Is it possible that the 3rd Earl consulted Kent again before he died in 1748, or Stephen Wright, who inherited Kent's mantle at Badminton and built Worcester Lodge? That also raises the possibility that about the time the Linnells furnished the Chinese Bedroom at Badminton (Fig. 340) they provided the exceptional gilded and painted carvings that used to be in the Tapestry Room (Fig. 394) on the south front and also the carved and gilt ornaments for the revised drawing-room.[19]

Despite these changes, by 1781 the house seemed old-fashioned to the daughter-in-law of the 11th Viscount Dillon, who had inherited in 1776, because she wrote to her husband: 'I never saw so many Rooms, so thrown away, for full half a dozen of Them are no other use but to walk thro.'

The changes to the plan in 1749 and the daughter-in-law's comments become much more intelligible when Ditchley is compared with a new house of the early 1740s such as Kirtlington and one of the early 1750s, like Hagley. Both have fewer but larger rooms, and, instead of being conceived in terms of apartments with bedrooms providing the climaxes, they have a new balance between drawing-rooms and dining-rooms, with libraries as rooms for daily living. Also, the upholsterer's contribution was becoming less important in establishing the pace of rooms through sequences of materials.

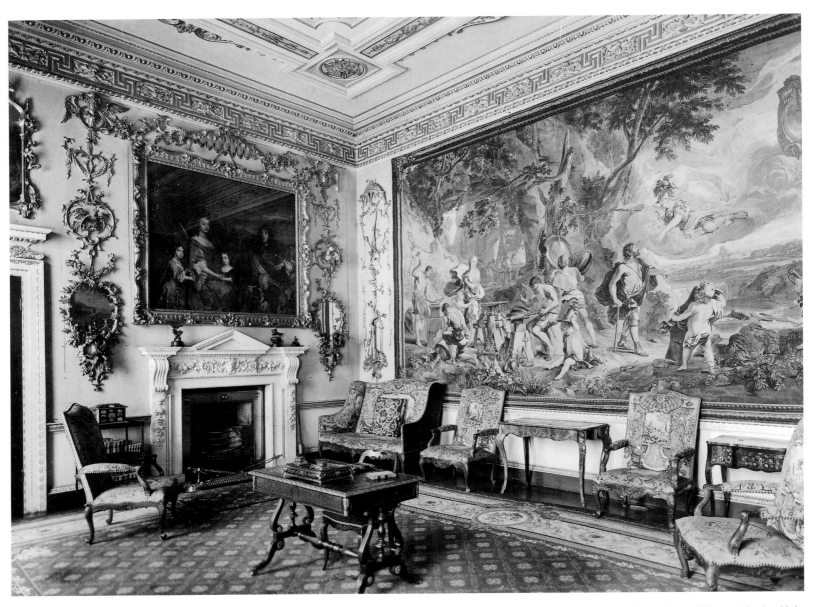

394. *The Tapestry Drawing-Room at Ditchley, as it was in 1932, with one of the two large Brussels tapestries in the room in 1743, the tapestry-covered furniture originally in* the drawing-room (Fig. 393) and the carved, gilded and painted drops evidently added by the 4th Earl of Lichfield.

## KIRTLINGTON PARK

The comparison of Ditchley and Kirtlington is particularly telling because they are only a few miles apart, and Ditchley must have been one of the houses that the young Sir James Dashwood thought about when he returned from his continental travels in 1736 and was considering what sort of house to build at Kirtlington. Although the final drawings were done by John Sanderson, they were developed out of earlier schemes by James Gibbs and Daniel Garrett, as well as Francis Smith. Sir James wanted a house on an unusually large scale for its time, and the basic idea was of a main block with two wings like Ditchley, but with the main floor raised above a complete ground storey and an everyday entrance through the steps leading up to the front door. As can be seen from the plan in *Vitruvius Britannicus* IV (Fig. 395), on the main floor there was a large hall with a saloon behind, but the saloon was considerably larger than that at Ditchley, being 40 by 30 feet, with a coved ceiling. That was flanked by a great dining-room (now in the Metropolitan Museum) and great drawing-room 36 by 24 feet, and together they filled the whole east front, with three rooms as opposed to five at

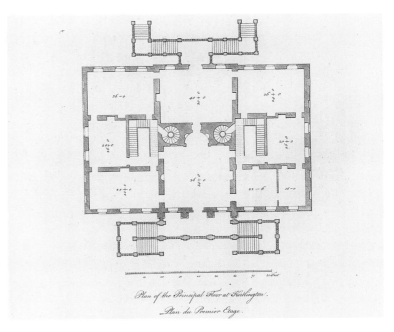

395. *Kirtlington Park, Oxfordshire. The plan of the main floor from* Vitruvius Britannicus IV *(with modern key).*

*Kirtlington Park, Oxfordshire*

396. *Characteristic singerie and arabesque painting on the ceiling and cove in the Small Drawing-Room by Andien de Clermont, who was paid in 1745.*

397. *Sanderson's first design for the dining-room with an oval painting in the centre of the ceiling inspired by the saloon ceiling at Houghton and large paintings in the manner of Amiconi and Sleter in the end panels, one framed in a version of the original saloon overmantel at Houghton.* Metropolitan Museum, New York.

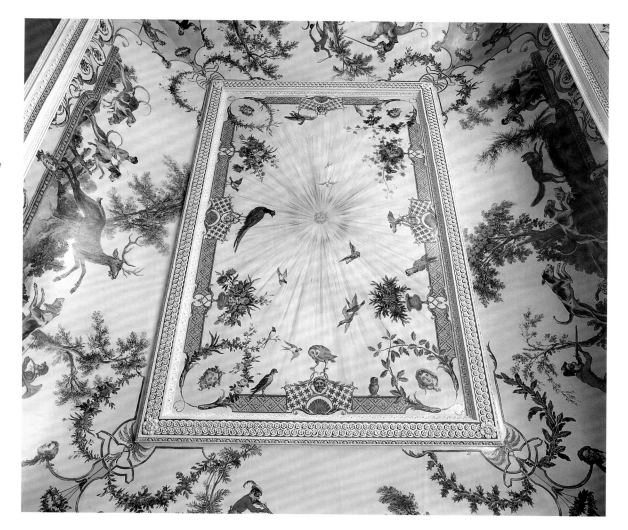

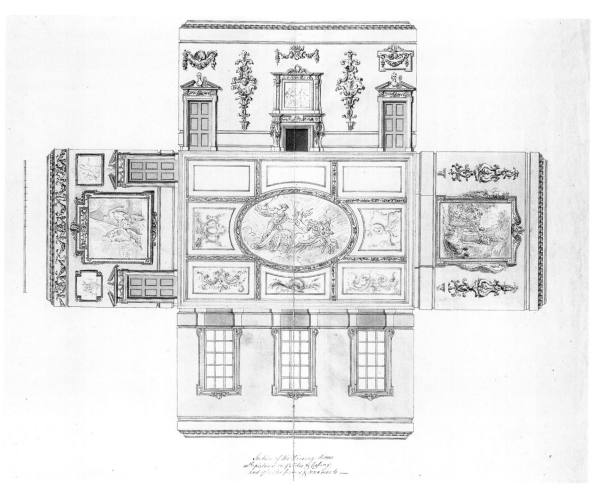

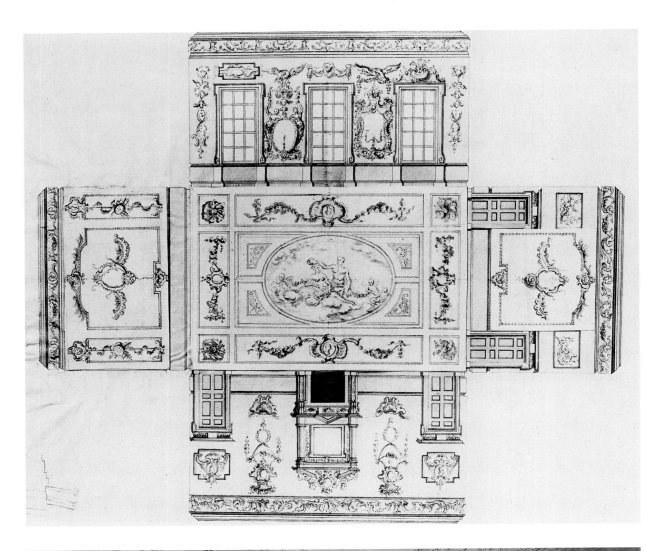

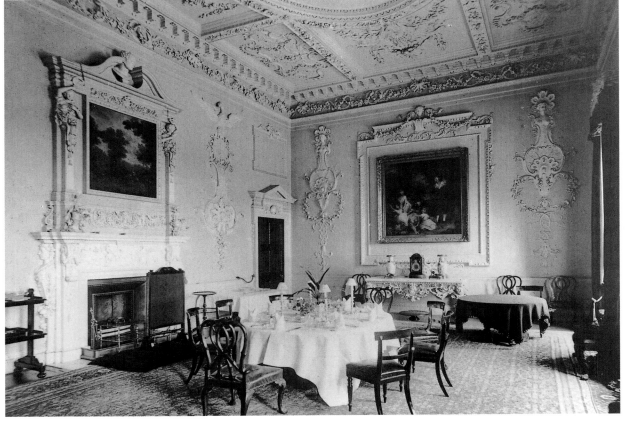

*Kirtlington Park, Oxfordshire*

398. *Sanderson's second design for the dining-room with alternative stucco treatments for the panels (with flaps) at the end of the room and for alternative pier glasses on the window wall, one with a single candlestick on a bracket and the other with a two-light candleabra.* Metropolitan Museum, New York.

399. *A photograph of the dining-room in situ in 1909 when it still retained the carved side table now in the Royal Ontario Museum, Canada, and the original mahogany chairs with interlacing splat backs attributed to William Hallett (Fig. 400).* Oxfordshire County Council.

400. *One of the mahogany armchairs from the dining room attributed to Hallett.* Mallett and Son, London.

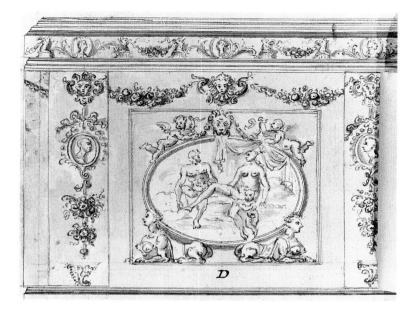

Ditchley. To the left of the hall was the library, and behind it a small drawing-room, but there was no parlour. To the right of the hall was a bedroom apartment. However, Sir James only completed the fitting-up of the hall, library, small drawing-room and great dining-room, and in these rooms upholstery appears to have been less important than it would have been a generation earlier. Indeed, it is striking that the payments to William Hallett as cabinet-maker exceeded those to John Gill of Maddox Street, the London upholsterer. On the other hand, Sanderson had an appreciation of decoration, in particular the roles of plasterwork and painting, and the particular strengths of the craftsmen who would be working on the house, as can be seen in the series of designs for the dining-room and library and the final forms of the rooms.[20]

For the dining-room there are two sheets of designs showing all four walls, and what appears to be the earlier one (Fig. 397) shows a combination of stucco with decorative painting in the manner of Amiconi and Sleter in the frames on the end walls and *The Fall of Phaethon* on the ceiling, the same subject as that chosen for the saloon ceiling at Houghton (Fig. 195); but that was a form of decoration that was going out of fashion in the early 1740s, particularly after Amiconi left England in 1739.

The second scheme (Fig. 398) was to be all stucco: for that, there is a drawing for the ceiling signed by Sanderson and a separate unsigned drawing for a large relief of *Mars, Venus and Cupid* (Fig. 402) for one of the end walls that ties up with what is shown on one side under flaps on Sanderson's design (Fig. 401) and repeats one of the subjects of the large paintings. It is tempting to attribute the drawing for the relief to Charles Stanley, although no drawings by him are known in England: it is clearly by a sculptor and there is a long tradition of his collaboration with Sanderson at Langley Park (Fig. 316). A drawing on another of the flaps (Fig. 402) shows a frame very like those surrounding the reliefs in the hall at Honington that have long between attributed to Stanley. In the early 1740s, Stanley was working close to Kirtlington on the decoration of the Radcliffe Library in Oxford, but he left England for Denmark in 1746 and perhaps for some time before that he was not available for stucco commissions because he undertook those for funerary monuments. When he dropped out, Sanderson had to revise his designs to suit the different talents and style of the young Thomas Roberts of Oxford, who had been working with Stanley, in particular his love of naturalistic ornament and his avoidance of reliefs.

Roberts was paid for work between November 1744 and January 1745, and then £119 in full on 8 January 1747/8.

The unusually elaborate chimneypiece (Fig. 399) is supposed to have been carved by Henry Cheere for the Sultan of Turkey and that may partly explain the main payment to Cheere of £186 in June

401. *One of drawings by Sanderson on a hidden flap in Fig. 398, with a relief labelled D, based on the drawing in Fig. 402.* Metropolitan Museum, New York.

402. *The drawing here attributed to Charles Stanley for the stucco relief of* Mars, Venus and Cupid *labelled 'Specimen of one End of Dining Room marked D'.* Metropolitan Museum, New York.

403. *Another of the drawings by Sanderson on a hidden flap. The treatment of the frame to the panel is close to those in the hall at Honington and the saloon at Langley Park (Fig. 316) attributed to Charles Stanley.* Metropolitan Museum, New York.

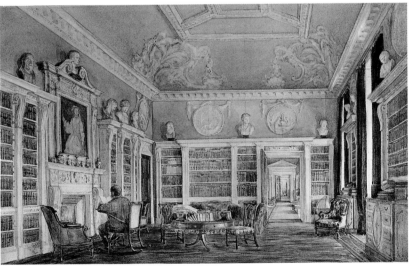

*Kirtlington Park, Oxfordshire*

404. *John Sanderson's third design for the library with alternative proposals for a pier glass in a stucco frame and a bookcase with detached slip showing the commode attributed to Hallett.* Christopher Buxton.

405. *The library as recorded by Alice Dashwood in 1886. On the right can be seen the pair of early commodes now in the Gerstenfeld Collection attributed to William Hallett.* Private collection.

## HAGLEY HALL

The clarity of the Kirtlington plan (Fig. 406) is very striking and it seems to lead on to the conception of Hagley about ten years later. Horace Walpole, who never saw the latter finished, was both unjust and misleading in seeing it as the poor relation of Houghton. Philip Yorke, who went there is 1763, thought it

> a most excellent house of which Mr Miller of Warwickshire was architect. The hall, salon, eating-room, gallery and drawing room on the 1st floor are remarkably well-proportioned and pleasant rooms. There are 2 complete apartments for strangers besides; the attic floor is the best I ever saw; and the rooms in the 4 towers are very good. Lord Lyttelton told me he could make 12 or 14 *lits de maitres*.

His view is confirmed by Arthur Young, who wrote: 'The house is an excellent living one, a well designed mean house between the vast piles raised for magnificence, and those smaller ones in which convenience is alone considered.'[22]

Again, the central third of the main floor is devoted to the hall and saloon, both being of a single storey and with the former measuring 30 feet square and the latter 36 by 30 feet. To the east of hall is the dining-room and that is balanced on the north side by the drawing-room, both being 34 by 22 feet, but separated by one of the twin staircases, a repetition of the Houghton arrangement. The whole east end of the house is devoted to a gallery comparable but longer than that provided in Brown's plan for Croome, measuring 78 by 19 feet and divided into three sections by two screens of columns. Since Lord Lyttelton was not a collector and had not inherited a collection of works of art, it was a room with a social purpose and a descendant of the long rooms found in certain Vanbrugh houses. To the west of the hall is the library (Fig. 407), measuring 33 by 25 feet, which seems always to have been the everyday living-room in the house.

Who contributed what to the final plan when it was under discussion in 1751–3 is not clear, because as well as Miller, several other amateurs of architecture were consulted, among them Thomas Barrett of Belhus, John Chute of The Vyne and Thomas Prowse. Lord Lyttelton also had to take on board the views of his difficult second wife, who left before the house was finished. John Sanderson drew out the final plans, as he had done at Kirtlington. Thus Hagley is a typical result of a circle of amateurs' approach to the pleasures and snags of house-building in the mid-eighteenth century. The final plan is handsome but not inventive, with no pursuit

1746. That was followed by a payment of £52 10s. in 1749 to John Wootton for the overmantel painting.

Sir James made large payments to William Hallett and it is thought that they include the mahogany chairs (Fig. 400) that appear in the room in Fig. 399.

The final form of the library (Fig. 405) can be followed in a similar way through a series of drawings. One (Fig. 404) shows alternative suggestions for completing the piers of the window wall with a commode roughly drawn on a slip that corresponds with a pair from the house also attributed to William Hallett that are among the earliest examples of English commodes and most unusual in having been made for a library.[21]

*Hagley Hall, Worcestershire*

406. *The plan of the principal floor from* Vitruvius Britannicus *(with key).*

407. *The library. It was evidently always the living-room of the house.*

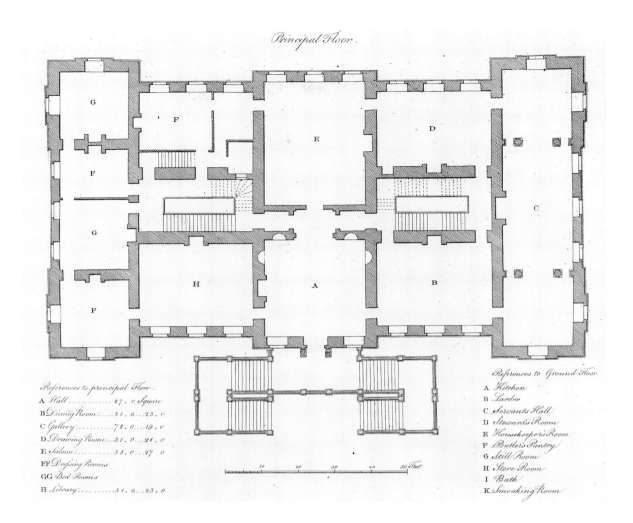

Principal Floor.

References to principal Floor.
A  Hall...............27. 0 Square
B Dining Room......31. 0...23. 0
C Gallery...........78. 0...19. 0
D Drawing Room....31. 0...21. 0
E Saloon............35. 0...27 0
FF Dressing Rooms
GG Bed Rooms
H Library.........31. 0...23. 0

References to Ground Floor.
A Kitchen
B Larder
C Servants Hall
D Stewards Room
E Housekeeper's Room
F Butler's Pantry
G Still Room
H Store Room
I Bath
K Smoaking Room

10    20    30    40    50 Feet

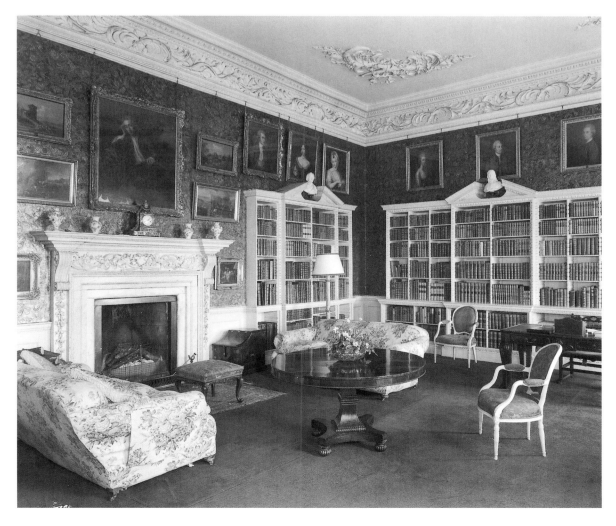

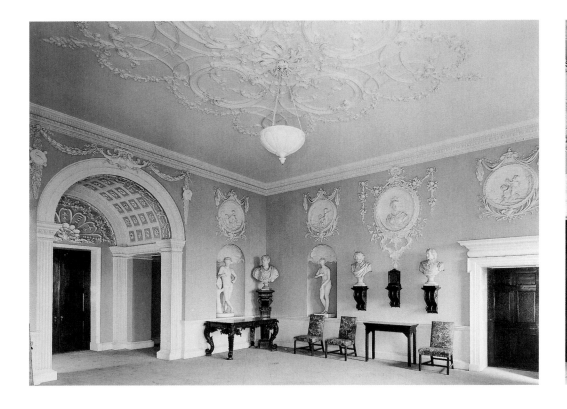

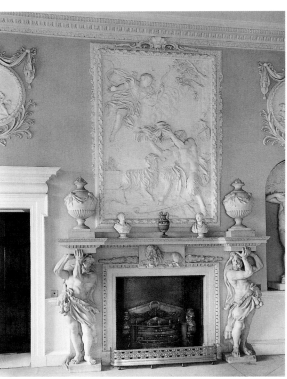

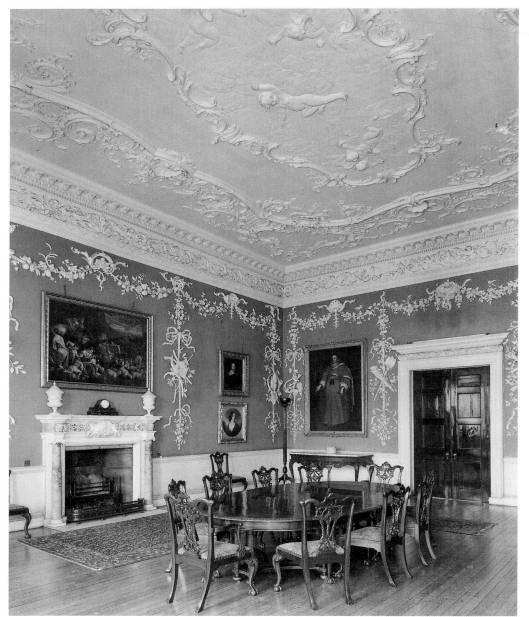

*Hagley Hall, Worcestershire*

408. *The entrance hall. The final drawings for the house were done by John Sanderson and it is possible that the design of the decoration here may owe a good deal to him but working closely with the stuccadore, Francesco Vassalli.*

409. *The stone chimneypiece with its giant figures of Hercules by James Lovell supporting urns and its overmantel relief of* Pan Winning the Love of Diana *after an engraving of a painting by Maratta signed by Vassalli.*

410. *The saloon as it was in 1957. The plasterwork garlands thought to represent Lord Lyttelton's interests also recall carved garlands by Grinling Gibbons that would have suited the pictures of the period of Charles I and Van Dyck that Lord Lyttleton assembled here. The portrait to the left of the door is part of the original scheme.*

411. *A detail of the plasterwork in the saloon.*

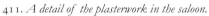

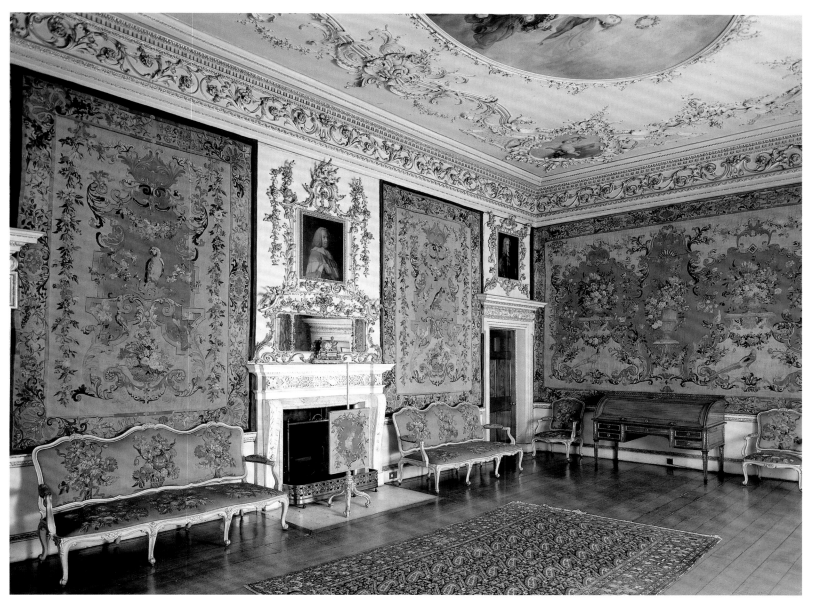

412. *The Tapestry Drawing-Room at Hagley. Its decoration was developed round a set of tapestries originally bought second hand by Lord Lyttleton in 1752 for a bedroom and was intended to create the air of a French drawing-room, providing the idea for the Adam tapestry drawing rooms at Croome Court, Newby and Osterley.*

of spatial complexity or variety, which were about to come into fashion. The final costs came to far more than Lord Lyttelton had hoped.

The entrance hall (Fig. 408) is devoted to sculpture. On the west wall is a tremendous stone chimneypiece by James Lovell (Fig. 409), a sculptor who may have attracted Lord Lyttelton's attention through having worked at Stowe in the early 1750s. It has figures of 'persians' full of movement as they struggle to support the cornice of the chimneypiece with its half-frieze and vases at each end. The overmantel consists of a great plaster relief of *Pan Winning the Love of Diana* after an engraving of a painting by Maratta, signed by Vassalli, who had settled in the Midlands and kept the tradition of plaster reliefs alive into the 1760s, as can be seen at Shugborough and Stoneleigh. Cut into the walls are niches for casts of classical figures, while above them are circular reliefs and facing the chimneypiece on brackets are busts of Rubens and Van Dyck by Rysbrack.

Within the deep coffered arch that frames the saloon door are doors leading to the flanking staircases. The saloon (Fig. 410) is a festive room with plaster garlands dancing round it below the entablature with great trophies framing the pictures, which are surely intended to recall carvings by Grinling Gibbons framing portraits. That seventeenth-century idea fits in with Lord Lyttelton's intention of evoking the age of Charles I and Van Dyck in his choice of pictures and his interest in seventeenth-century history, about which David Hume wrote his *History of Great Britain under the Stuarts*, published in 1754–6. To flank the hall door, he made up a pair out of a Van Dyck of the Earl of Carlisle and the Countess of Portland; over the chimneypiece he hung a version of *The Children of Charles I* and over two doors smaller portraits of Charles I and Henrietta Maria.

It is not clear how the room was originally furnished, but it is thought that the fine carved mahogany side chairs with upholstered seats and backs were always there – even though no settees seem to be recorded – as were a pair of carved side tables. If that is correct, it is interesting to find no gilding on the furniture either here or in the gallery on the other side of the Tapestry Room.[23]

The adjoining Tapestry Drawing-Room (Fig. 412) was decorated round the four tapestries thought to have been woven by Joshua

413. *One of the panels of Joshua Morris tapestry.*

414. *One of the white and gold settees with tapestry covers woven to relate to the hangings, both by Paul Saunders, who was paid between 1758 and 1760.*

415. *The entablature of the chimneypiece and overmantel in the Tapestry Drawing-Room. The yellow and white marbles relate to the colour scheme of the room. The gilded carving while echoing motifs in the tapestries has a strong individuality of its own that suggests it may be by an unidentified local specialist.*

Morris in the 1720s (Fig. 413) that Lord Lyttelton bought second-hand in 1752, 'exceeding cheap'. At first he thought of them for bed-rooms, but then he decided to use them in the drawing-room to make a room in the French taste that took the Ditchley idea a stage further. Who organized all the elements in the room is not clear, but there is a strong sense of control and feeling for decoration that could be due to Sanderson and or Paul Saunders, who evidently supplied the white and gold seat furniture in the French taste and wove its covers (Fig. 414). He was paid three instalments of £50 between 15 December 1758 and 6 August 1760. However, the pier-tables and the pier-glasses (Fig. 416, 418) may be by two other hands, the glasses having a crowded, out-of-town quality comparable with Miller's as opposed to Whittle's glasses at Holkham. They bring to mind the designs for glasses in T. F. Pritchard's record book that notes the work done for him by the carvers Van der Hagen, Nelson and Swift, who turned up in Shrewsbury in the 1760s. Could they, or people like them, have been to Hagley on the way? The yellow ground to the tapestries may have suggested the choice of yellow marble for the tops of the tables and for the chimneypiece (Fig. 415), whose colours are in turn subtly answered by the white and gold of the chairs, tables and glasses. Similarly, the carver of the picture frames, who may also have done the glasses, looked hard at the detail in the tapestries when designing them.[24]

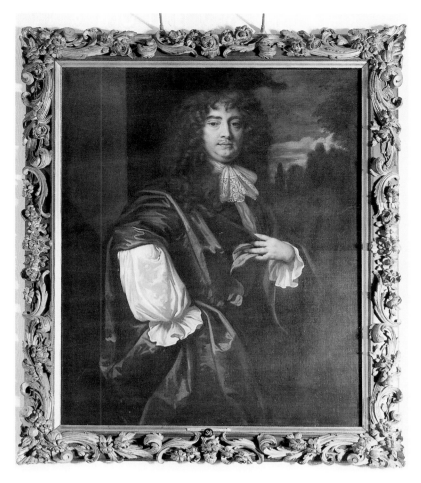

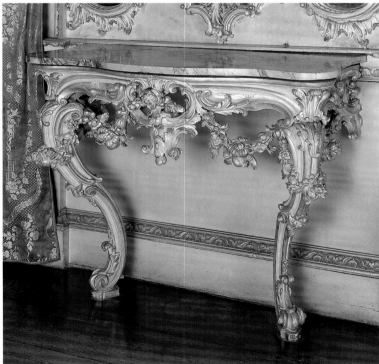

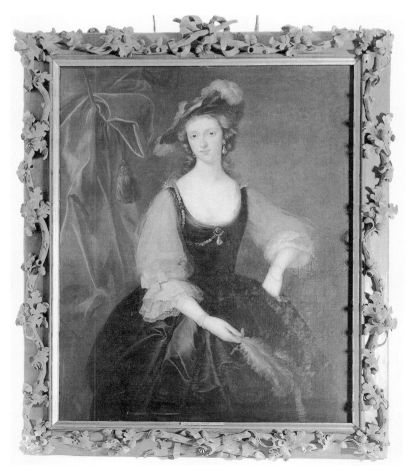

416 *and* 418. *One of the white and gold pier-glasses and the pier tables in the Tapestry Drawing-Room. They appear to be by different hands with the tables possibly by Paul Saunders and the frames of the glasses by a local specialist.*

417 *and* 419. *One of the inherited seventeenth-century Brouncker portraits in the gallery and one of the mid-eighteenth-century portraits in Van Dyck dress added to the set in two variant designs of party coloured but ungilded frames in a manner inspired by Grinling Gibbons that were to suggest the past but also saved on the costs of gilding.*

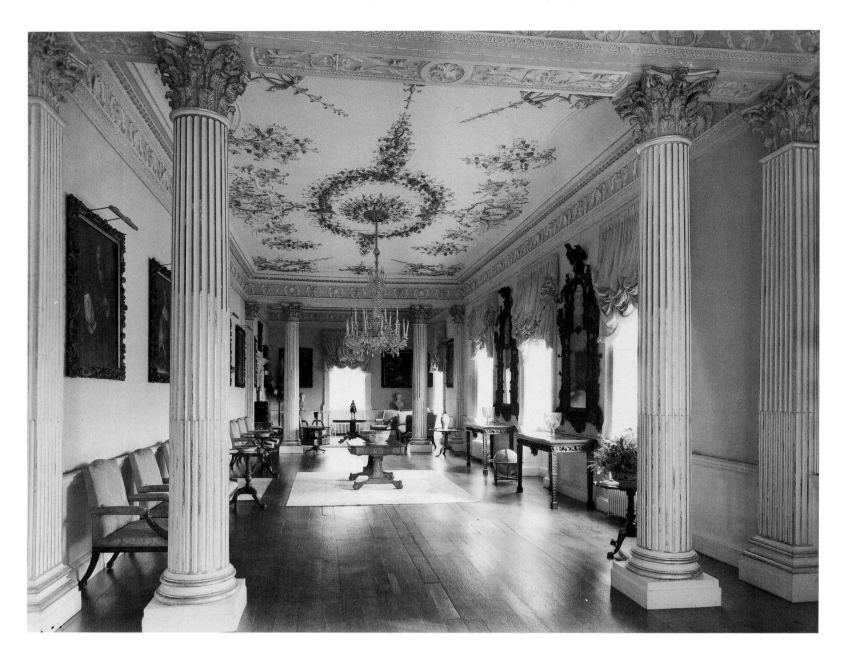

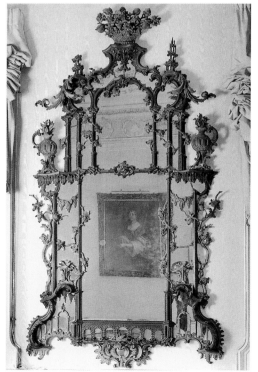

In the gallery (Fig. 420) there is a stronger classical spirit, with its screens of Corinthian columns at each end, and it is remarkable that gilding plays no part in the decoration. The reliance on brown wood seems to derive from the set of seventeenth-century Brouncker portraits that Lord Lyttelton extended, and echoes the seventeenth-century note in the saloon. He had them all reframed in remarkable Rococo versions of Gibbons frames in oak and lime (Figs. 417, 419), and they provided the theme for all the furniture in the room, the pier-glasses and tables (Fig. 421), the chairs (Fig. 423) and formerly the torchères (Fig. 422) and girandoles and even the chimneypiece, which is in carved wood, not marble. Again, it appears that more than one firm or craftsman was involved, with the big mahogany chairs with boxwood enrichments being supplied by a London maker like Saunders, the girandoles possibly by a scarcely known Edward Griffith of Dean Street, a former assistant of Goodison, and the glasses, tables and frames possibly by someone working locally. One pair of the girandoles is based on a design by Thomas Johnson published in 1758 and the other takes motifs from his designs, but the torchères may be by a different maker, because, although they appear to match the chairs, they are, in fact, in pine stained to look like mahogany with painting in stone colour. Unfortunately there is no clue as to the original upholstery or curtains.

The library (Fig. 407) lies to the left of the hall on the family side of the house, and that seems always to have been the natural living-room of the house, taking the place of a common parlour, which was not provided. It is completely lined with breakfront bookcases with busts of Shakespeare, Spencer and Dryden and portraits of Lord Lyttelton's literary friends, including one of Pope, which was left to him by the sitter.

When Mrs Montagu stayed at Hagley in 1771 at the same time as David Garrick, by then a friend of Lord Lyttelton of thirty years' standing, she wrote:

> Mr Garrick is in the highest spirits, and he has the greatest share of vivacity I ever met with in any one, and having a good deal of wit, that makes the most pleasing companion imaginable. As we breakfast in the library we have opportunities of putting books into Mr Garrick's hands, and without too much appearance of design, get him to read aloud some distinguished pieces of poetry.[25]

*Hagley Hall, Worcestershire*

420. *The gallery with its two screens of columns.*

421. *One of the related pier-glasses in the gallery.*

422. *One of the torcheres formerly in the gallery. It appears to be based on plates published by Thomas Johnson in 1758. It is of pine stained to look like mahogany and painted stone colour.*

423. *One of the arm chairs in the gallery. An effect akin to parcel gilding is achieved by the enrichments of carved boxwood that stand out light against the dark mahogany.*

## FELBRIGG HALL

Kirtlington and Hagley are unusual in being new houses, and it is regrettable that there are no villas of the 1750s by James Paine or Robert Taylor, where sufficient is known about the relationship in the planning, decoration and furnishing to provide comparisons. However, Sanderson's approach at Kirtlington can be compared with Paine's at Felbrigg in Norfolk, where he carried out skilful alterations of the Jacobean and Charles II house for William Windham in the early 1750s. Like Sanderson, Paine was a talented draughtsman who had evidently studied ornament, and he produced dazzling drawings for rooms that persuaded patrons and stimulated craftsmen. At Felbrigg, he had an unusual patron in William Windham, an early friend of Garrick, who had gone abroad in 1738 when he was twenty-one and stayed away for almost five years, during which time he had studied glaciers as well as collected the pictures that play such an important role in the house. But he had to wait until his father died in 1749 to begin work on the house. Paine redecorated and partly rearranged the five principal spaces on the ground floor (Figs. 424, 425), starting with a gothicizing of the old great hall (Fig. 426) that was one of the earliest examples of its type but was unfortunately swept away in the nineteenth century. However, his rooms beyond it all survive: first comes his dining-room (Fig. 427), which replaced the Charles II staircase; and behind it he provided a smaller one; beyond that was what was called the Great Parlour (Fig. 428), which replaced the Charles II dining-room and is now the drawing-room; and at the end of the wing is the smaller Cabinet (Fig. 429), a smaller picture room that was Windham's drawing-room.[26]

The dining-room is a particularly sensitive room, being both up-to-date Rococo and yet paying tribute to the history of the house and the family. Round the walls are portraits of Windham's parents and grandparents by Lely, while the chimneypiece is derived from an Inigo Jones design and the ceiling is divided into panels that echo the Charles II ceiling in the Great Parlour.

While Windham may have wished that he had some full-lengths, the five half-lengths meant that he could introduce a set of oval glasses under them and run them round the room. These must have increased the amount of reflected light when dining there on summer afternoons; but, contrary to what might be imagined, candles were not necessarily placed in front of them, because there is no mention of pier-tables being made for the room and none are listed in the inventory; nor are there plaster brackets shown on the design.

What is particularly satisfactory is the counterpoint of shapes and tones round the room. The rectangular portraits with gilt frames, set off by plasterwork and placed much higher than they would be today, are echoed in the doors, which surely originally were dark in tone and not matching the walls, as they have done for many years. The pair of oval portraits over the doors, which are not shown on Paine's design, answer the eight oval glasses. The idea of the oval glasses may have been Windhams's, because in London in 1751 he was delighted to find that an oval glass above a chimneypiece was high fashion.

In 1771 the room contained two large mahogany sideboards, nineteen walnut chairs with leather seats, which perhaps came from the earlier dining-room, a mahogany claw table and a painted floor cloth. No curtains are listed, nor a dining-table.

How often the room was used is hard to tell, because as late as 1734 meals continued to be served in the great hall and Windham

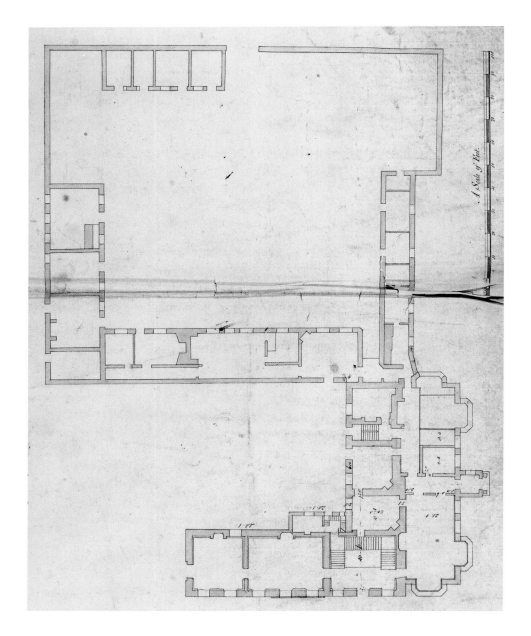

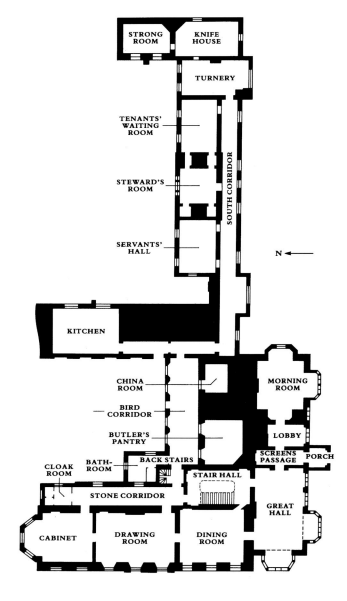

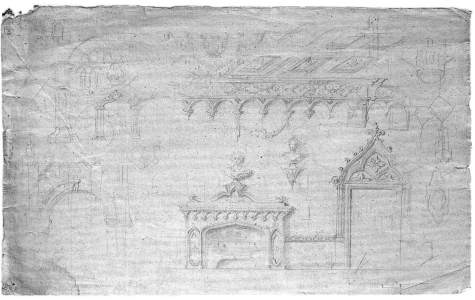

*Felbrigg Hall, Norfolk*

424 *and* 425. *Plans of the house before and after James Paine's alterations.*

426. *James Paine's sketch design for gothicizing the Great Hall. His decorations were swept away in 1840.*

427 (facing page, top). *The north and east walls of the dining-room. This brings out the counterpoint of shapes and also of dark and light tones so effectively created by the portraits of William Windham's parents and grandparents and the bronzed busts on brackets. It seems likely that the doors were also originally dark rather than light. The plaster work was executed by Joseph Rose whom Paine called from Yorkshire in 1752.*

428 (facing page, bottom). *The Great Parlour, now the Drawing-Room. William Windham retained the 1675 ceiling and Paine designed the over doors to the new doorcases to complement the seventeenth-century decoration. He hung the room with a red flowered wallpaper and furnished it as a sitting room with mahogany chairs and settees with splat backs and seats covered in crimson worsted damask. The present damask hangings and gilt seat furniture was introduced in 1824 when it was became the drawing-room. Either side of the end door can be seen the pair of large pictures of London Bridge and the Tower of London by Samuel Scott that William Windham bought in 1753.*

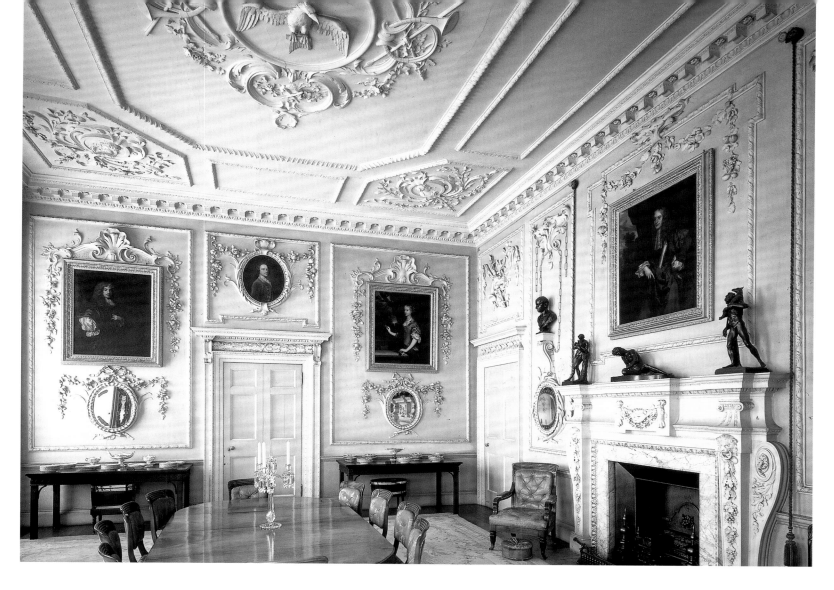

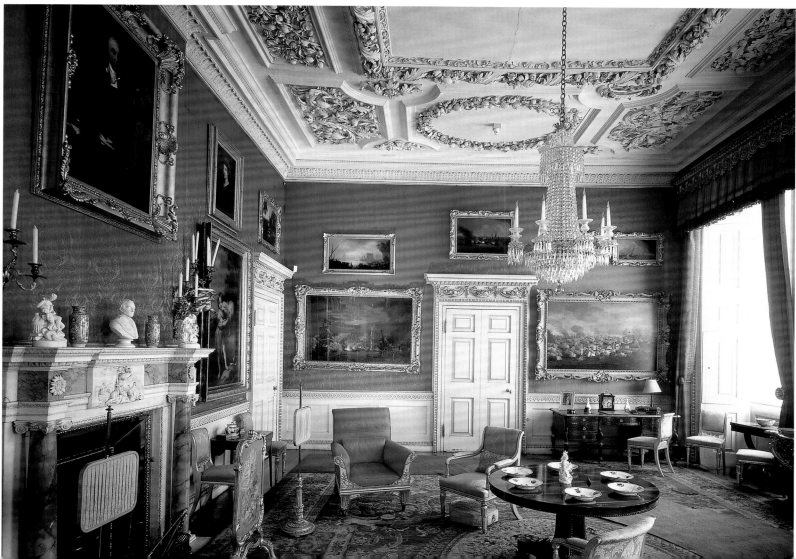

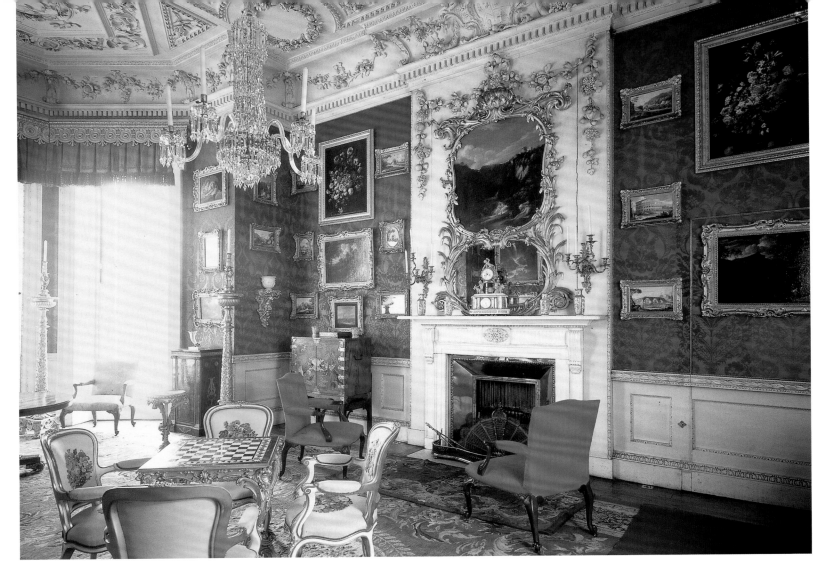

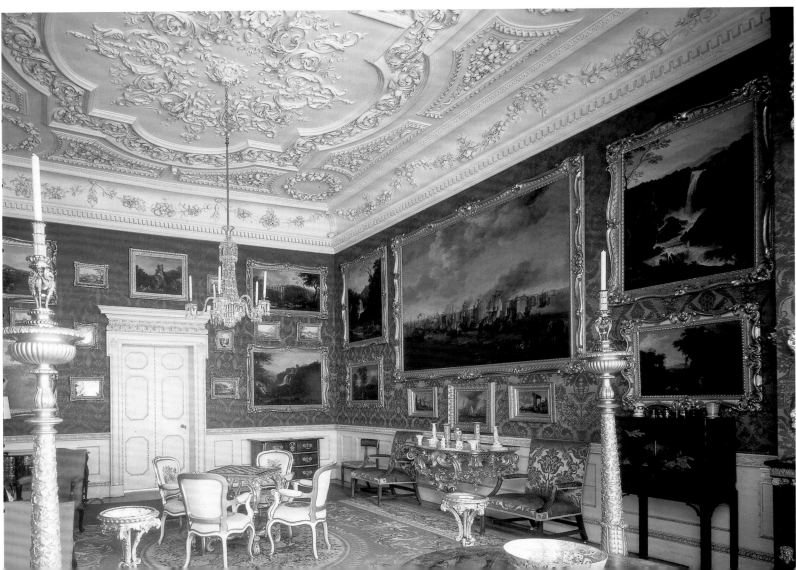

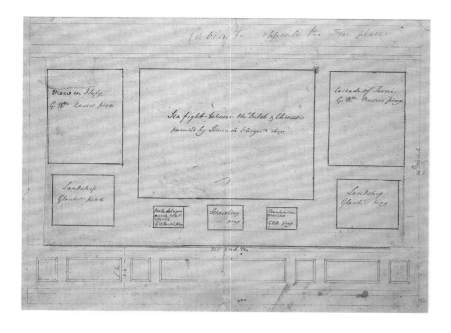

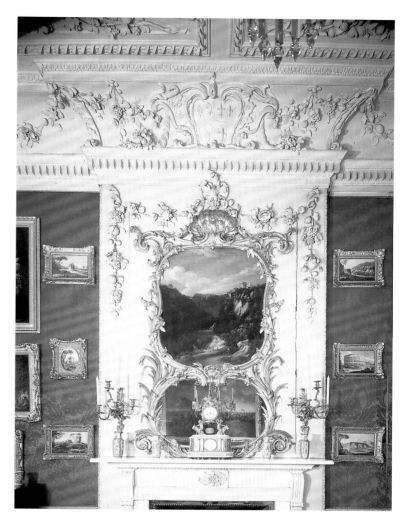

429 (facing page, top). *The Cabinet. The 1675 drawing room enlarged by a bay with Rococo ornament added to the centre of the ceiling and in the bay. The original chimneypiece was replaced in 1822, but the overmantel was designed by Paine. The walls are hung with the original wool damask in a nine foot repeat and sent to the house already cut to the correct lengths; and the hangings are edged with a simple gilded cord.*

430 (facing page, bottom). *The east and south walls of the Cabinet. The pictures still hang according to William Windham's original scheme.*

431 (above). *One of William Windham's sketches for the arrangement of the pictures on the east wall of the Cabinet.*

432 (above right). *The overmantel with its carved and gilded frame enclosing a glass and a landscape in the Cabinet topped by a plaster garland that continues the Rococo plaster work with William Windham's coat-of-arms in the cove immediately above it, echoing the seventeenth-century ornament in the rest of the cove.*

433 (below right). *A detail of the east wall showing how the height of the repeat of the mixed damask fills almost the complete wall between cornice and dado.*

434 (below). *The table on the facing wall designed by Paine that reflects the rhythms of the carved and plaster ornament on the overmantel.*

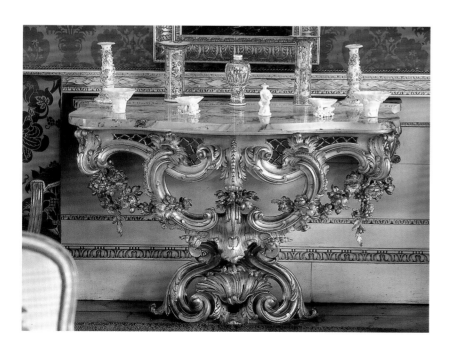

also formed a Common Eating Parlour, a small room furnished with two armed chairs covered in black callimanco and two more walnut chairs with leather seats, two mahogany dining-tables and a marble side table with a marble slab, a dumb waiter, and thirty-nine prints on the wall. Perhaps when the Windhams were on their own, they used this room.

The room next to the dining-room Windham called the Great Parlour (Fig. 428), not the drawing-room, a change of name dating from 1824 when the room was made richer with damask hangings and gilded seat furniture. Windham kept the Charles II ceiling and Paine designed the overdoors to the new doorcases to echo its detail; and he chose a red flowered wallpaper, a Turkey carpet, fourteen simple mahogany chairs with splat backs and a pair of settees, presumably the ones in the hall, covered in worsted damask, which was also used for the curtains. Presumably it was of similar quality to that used in the Cabinet. There were also a pair of gilded side tables, a pair of pier-glasses and tables with gilded frames and white marble slabs and a 'glass lustre for the middle of the room'.

It was the arrangement of the pictures that was Windham's principal concern; and they have a markedly different character from Sir Robert Walpole's at Houghton and what Lord Leicester was buying for Holkham, because he avoided both religious and history pictures. Instead, being very interested in ships and the sea, he collected marine pictures as well as landscapes. At the south end of the Great Parlour he hung the two large Van de Veldes of the Battle of Texel in 1673 and he may have commissioned the pair of Samuel Scott views of London Bridge and the Tower of London in 1753 to face them.

The pictures also provide the key to the Cabinet (Fig. 429), which is one of the most remarkable survivors from the mid-eighteenth century, only rivalled by the Landscape Room at Holkham. It is also a remarkable fusion of Rococo and Charles II elements, with the main plaster ornament dating from the 1670s but with additional ornament in the centre of the ceiling and the cove added by Paine. The overmantel (Fig. 432) and the gilt table (Fig. 434) on the facing wall appear to have been designed by Paine, with the carved garlands on the overmantel echoing those in the plaster, and the outline of the cartouche framing the Windham arms being echoed in the design of the table. They all tie up in a Paine design for a Rococo chimneypiece and glass for another room and with the glass now in the Red Bedroom. The chimneypiece designed by Paine and carved by Carter in 1752 was removed in the 1820s.[27]

The walls are hung with a crimson worsted damask in a huge version of the pattern associated with William Kent and evidently the most popular one for picture rooms in the mid-eighteenth century. Here, the pattern is about 9 feet high, so that it fits almost the whole space between the dado and the cornice (Fig. 433). It is both the longest and the earliest firmly dated example of damask hangings *in situ*, and its choice was probably a matter of preference, cost and local pride. Because of the worsted, it has less sheen than a silk damask, which can be uncomfortably glossy for pictures, and also it would have been cheaper and more long-lasting, as well as possibly woven in Norwich, which was then famous for worsted damasks. Norwich damask, for instance, was used in the Picture Gallery at Houghton in the early 1740s and by Horace Walpole in his gallery at Strawberry Hill in the early 1760s.

In this case, it seems that Paine did the measuring, always a testing job because of calculating the repeats; and also, most unusually,

the material was sent to Felbrigg already cut into the correct lengths. Even so, the upholsterers first hung it incorrectly, putting it on the chimney breast, and then said there was not enough material. Windham wrote to his agent that Paine said 'he wrote to you an exact account of the breadths he ordered he shewed us the scheme by which he gave the order which was very exact'.[28]

As in the Great Parlour, what really excited Windham in the Cabinet was the arrangement of the pictures, which he carefully worked out with squares of cardboard cut to the right dimensions. The arrangement today is almost exactly as he had it. In January 1752, even before the damask was hung, Windham was asking

> at Mr Hull's leisure I would have him make me elevations of the four sides of the cabinet & great parlour each on separate pieces of paper by a scale of one inch to a foot marking the whole height of the dado & all . . . He must mark the cornice, doors everything in general not ye parts and then on pieces of past board . . . I would have the sizes of the best of the picture cut out by the same sacle the outside of the frames and inside marked by a line & what the picture is wrote on it or that last part may be left till I come in this manner.

With that information and details that Windham had with him in London, he wrote: 'I can scheme for hanging the pictures by myself.'

The surviving drawings (Fig. 431) are not the ones that arose as a result of that letter, but are a little later, and they show some changes of mind. The hang was quite dense, and on the east and south walls the main pictures line up at the top so that their carved frames create a gentle flowing rhythm. It is striking that William Windham considered not only the subjects of pictures but how their compositions would work out. Thus below the pair of vertical flower pictures on the north wall, whose subjects tie up with the carving on the overmantel, were a pair of classical landscapes making a contrast with the pair of small Van de Veldes of storms that hang below them.

The room was furnished with a pair of large mahogany settees with bolsters covered in crimson damask, ten large mahogany armchairs and three stools. The chairs were the only ones to be carved and were in the new French style. On the floor was a Wilton carpet planned to the floor.

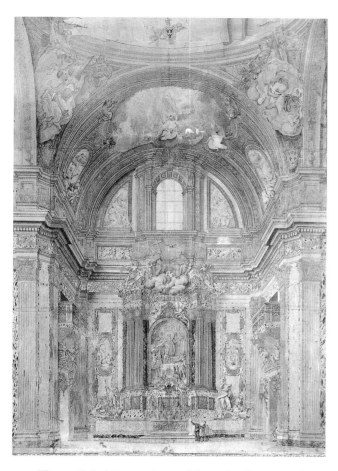

435. *Thomas Coke (1697–1759), created Baron Lovel in 1728 and Earl of Leicester in 1744, and his tutor, Dr Thomas Hobart, admiring the Baroque spendours of the chapel of St Ignazio in the church of the Gesù in Rome, by Francesco Bartoli.*

436. *Thomas Coke by Trevisani.*

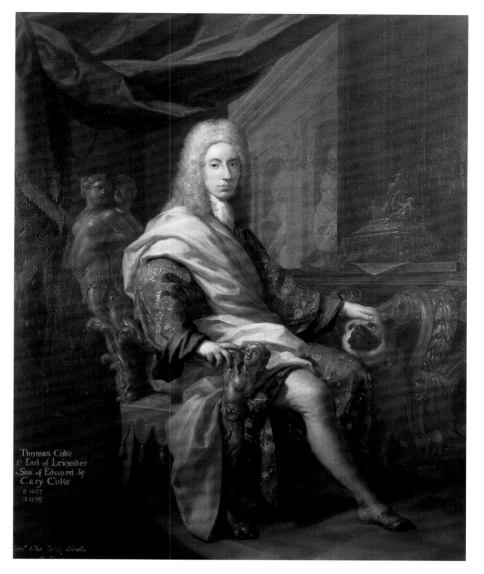

## HOLKHAM

The last house to be included here is Holkham, because it not only demonstrates so many of the ideas about works of art, decoration and furnishing in this period, but it remains a complete work of art with a strong intellectual purpose and most of its pictures and sculpture as well as its decoration and furniture intact. At the same time, it provides a warning about trying to be too precise about dating fashions because it is possible to sense Thomas Coke's enthusiasms changing over the decades. The idea of a new house on the site was probably in his mind when he was in Italy from the age of fifteen to twenty-one in the years 1712–18; he was then collecting books and manuscripts, drawings, paintings and sculpture and studying architecture under Giacomo Mainari, who produced designs for Burrell Massingberd. His taste at that time can be seen not only in the commissions he gave, but in the portrait of him by Trevisani painted in Florence (Fig. 436) and the drawing of him and Dr Hobart unexpectedly admiring the High Baroque splendours of the chapel of St Ignazio in the Gesù in Rome (Fig. 435).[29]

His early purchases of classical sculpture are particularly remarkable for someone of his age, and it would be fascinating if the strongly thematic approach with its historical and literary allusions that Elizabeth Angelicoussis has identified in his final arrangement of statues and busts in marble and plaster, worked out in the 1750s after the younger Brettingham's Italian tour, dated back to his early days as a collector of works of art in late Baroque Rome.[30]

Any early hopes of building soon after his marriage in 1718 were dashed by his losses in the South Sea Bubble of 1720. But he was soon converted to Palladianism and even the earliest known scheme for Holkham, as a house without wings, which is thought to have been drawn out as early as 1726 by Matthew Brettingham on the basis of instructions from Coke and Lord Burlington, was remarkable in that it was conceived as a temple of the arts. It was to have a pillared hall and a tripartite gallery as at Chiswick, a place in which to display his collections in a highly organized way akin to that of a museum. That thinking led him a few years later to revise the plan to the existing form of a central building and four flanking wings, for the family, strangers, the chapel and the kitchen (Fig. 437). Who worked up the idea of the hall at that time, which seems too advanced for Brettingham and Lord Burlington and too early for Kent? Does it owe more than we recognize today to Thomas Coke, who certainly knew the horseshoe stairs at Chatsworth as well as the Temple of Venus and Roma in Rome and Palladio's Redentore in Venice?

Coke was only able to begin constructing the Family Wing in 1734, with William Kent assisting with the architectural decoration, designing the library (Fig. 439) and all the ceilings and the chimney-

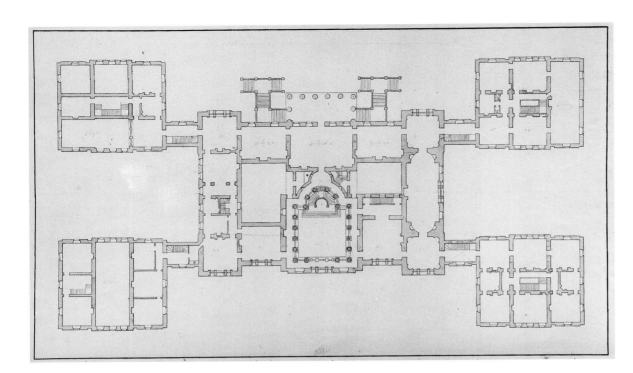

Holkham Hall, Norfolk

437. *Plan of the main floor of Holkham as intended in the late 1720s. That shows the original form of the hall with its horseshoe stairs, a recessed service area in the dining-room, and a screen of columns in the principal bedroom.*

438. *A section through the south front from Brettingham's* Plans, Elevations and Sections of Holkham *first issued in 1761.*

439. *William Kent's design for the library in the family wing that included painted decoration in the cove that was not carried out, late 1730s.*

440 (facing page). *The Library as completed in 1741.*

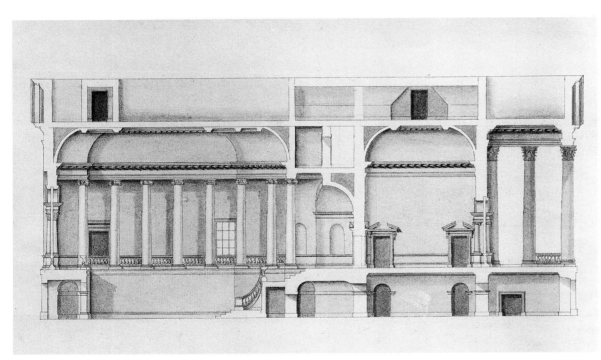

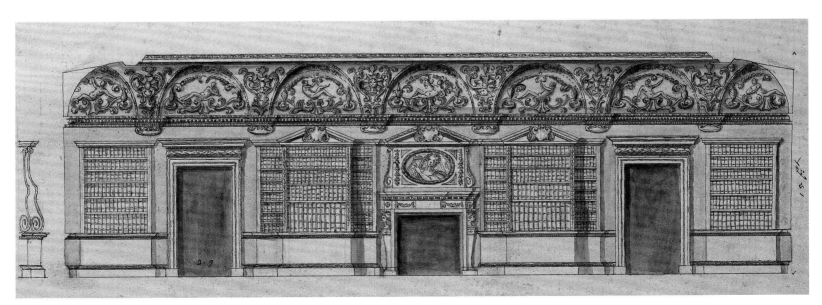

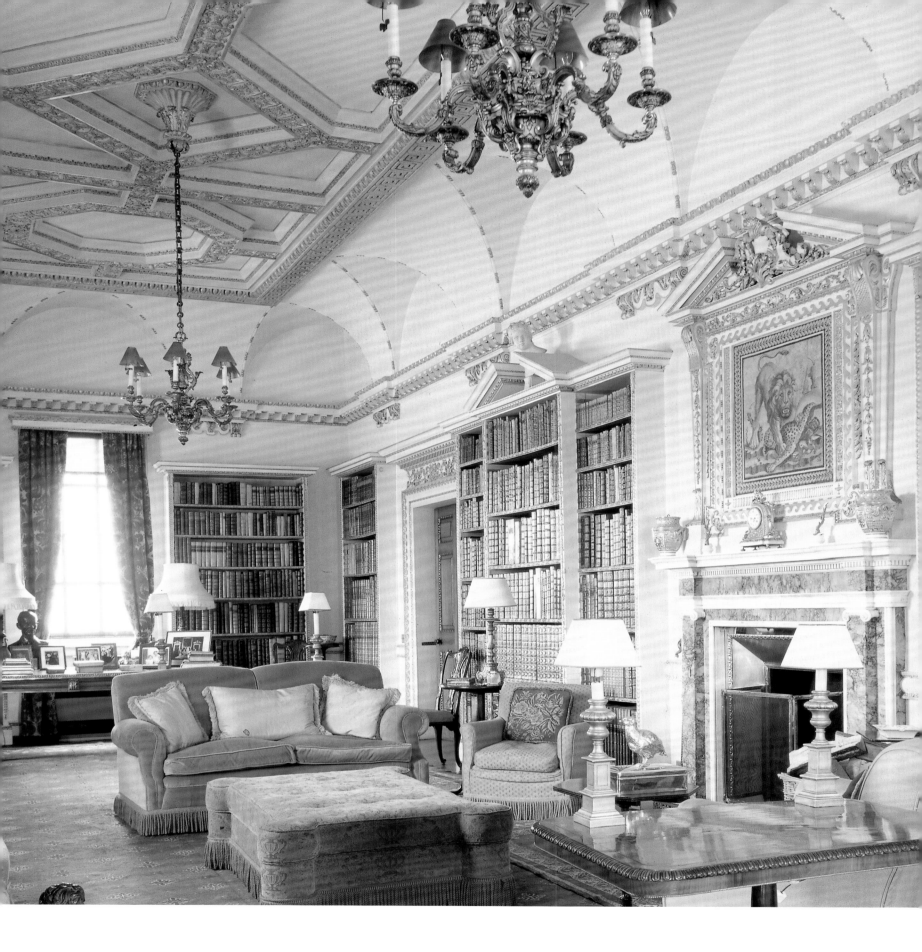

pieces and overmantels on the main floor, as was discussed in chapter five. That was completed in 1741. However, his design for the hall (Fig. 442), one of the most dramatic eighteenth-century interiors in England, must date from before that, even if it seems hard to believe that he was sufficiently experienced to have drawn it out as early as 1726: his handling of such complex ideas seems to fit better with his thinking in the early 1730s.

In 1744 Thomas Coke advanced from being Lord Lovell to become Earl of Leicester. A start was made on the main block after Kent's death in 1748, and the southern half was built by 1753, when he increased expenditure in order to finish the house. Thus the north half of the main block was almost complete by the time he died in 1759, and it was left to Lady Leicester to complete its furnishing and the three other wings.

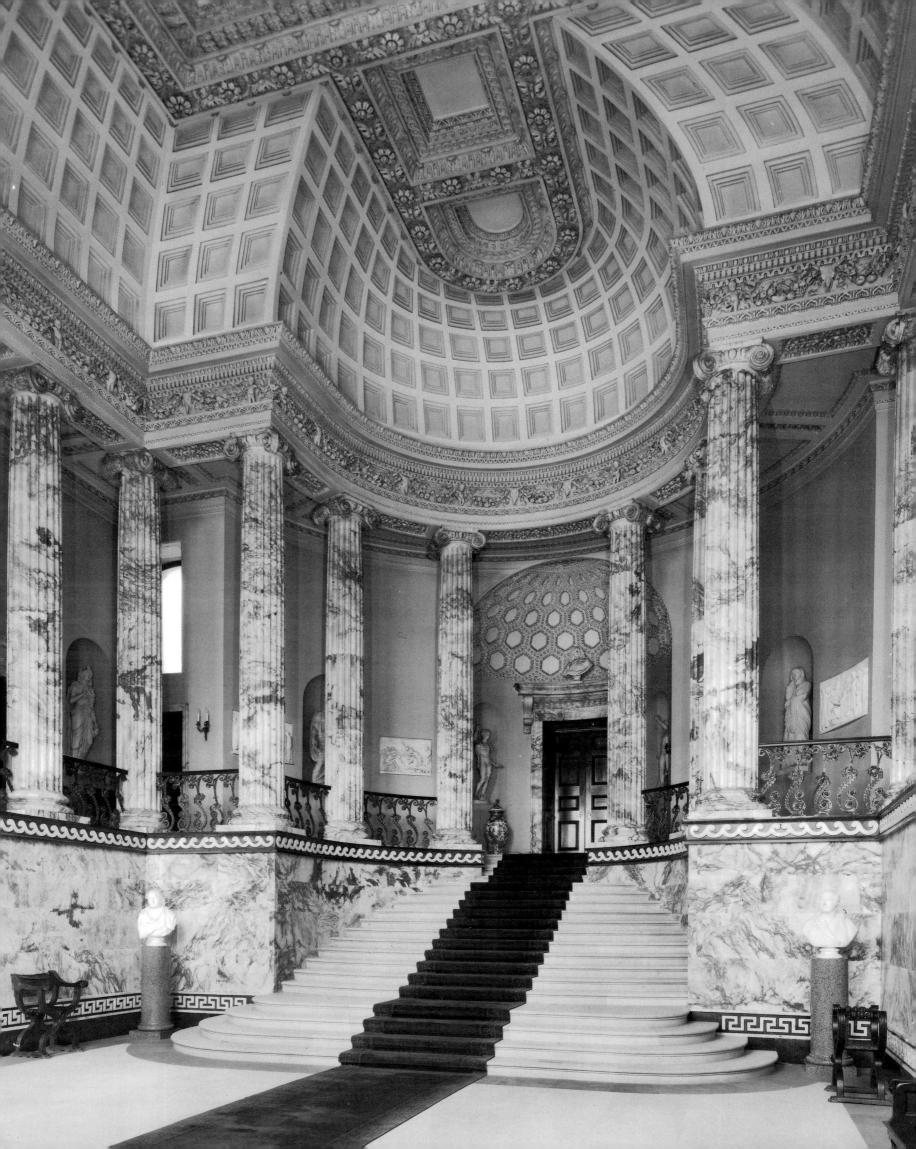

441 (facing page). *The Marble Hall as finally completed in 1759.*

442. *William Kent's design for the Marble Hall. This shows the original scheme with horseshoe stairs and columns of the Corinthian order that were both altered when half built in 1757.*

443. *The pattern of the caffoy used in the saloon (Fig. 446).*

444. *The pattern of the original cut velvet used in the Ante-Room (Fig. 447).*

445. *The pattern of the multicoloured cut velvet used in the State Bedroom (Figs. 450, 451). The same pattern is found on a bed now at Hardwick and on a bed at Petworth.*

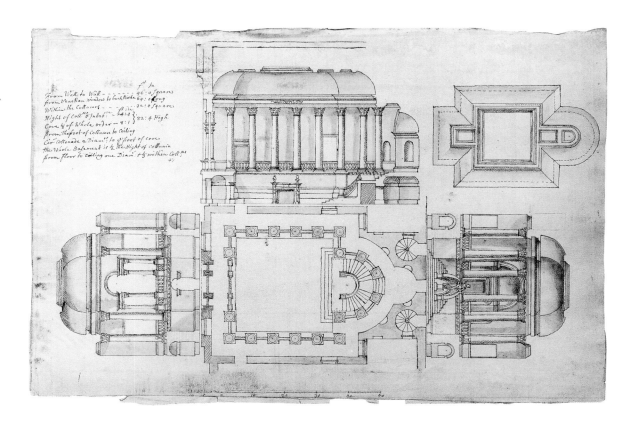

Right up to the end, Coke was absorbing new ideas about architecture and ornament, as can be seen in the remarkable tureen designed for him by Sprimont, which must date from after the granting of the earldom in 1744, his purchase of Robert Wood's *Ruins of Palmyra* as soon as it came out in 1753, his desire to see the unnamed and so untraceable book of French ornaments that Matthew Brettingham the younger acquired in 1755, and possibly at the end consulting Vardy about the design of the overmantels in the saloon. The layout of the steps in the hall, with the removal of the horseshoe steps and the statue of Jupiter placed between them, the choice of the Ionic order and the design of its ceiling were all revised in 1757; at the same time, the niches were cut in the side walls to take a carefully considered arrangement of casts obtained by the younger Brettingham in Rome that would have been clearly intelligible to educated contemporaries. The reduction in the scale of the ornaments in the frieze of the drawing-room and the weight of Carter's (Fig. 446) as opposed to Pickford's chimneypieces (Fig. 447) were again late alterations, bringing them into line with current fashions. Thus the rooms doubtless have a rather different character from the one they would have had if completed in William Kent's lifetime, which must have been Coke's original hope. And by 1759 the days of the Palladian great house were almost over.[31]

With Kent's painterly approach to design and decoration not available to him – he left only early designs for the hall and the ceil-

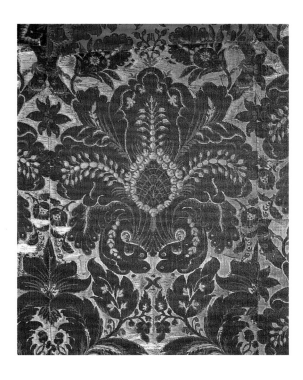

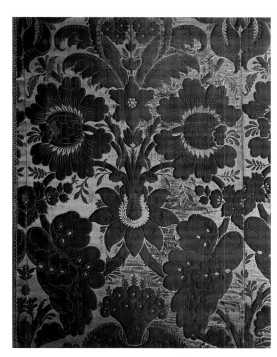

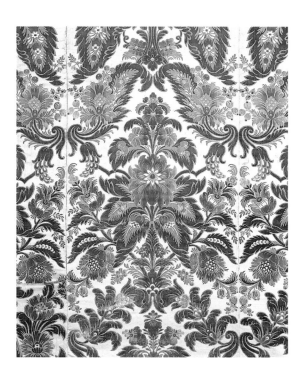

446. *The saloon, Holkham, with its original overmantels, Procaccini's* Tarquin and Lucretia *and Chiari's* Perseus and Andromeda, *commissioned by the young Thomas Coke in Rome. The chimneypiece by Benjamin Carter was installed in 1754.*

*The bold figure of the original caffoy hangings, apparently bought with all the principal materials in 1755, can also be seen.*

ings in the state bedroom and dressing-room – the language of the main rooms is less inventive and drier, being based on careful quotations from precedents set out in Desgodetz's *Les edifices antiques de Rome* (1682) and the works of Palladio and Inigo Jones. They are explained in Brettingham's book on Holkham, first published in 1761 and revised in 1773, an approach to design that Coke shared with Lord Burlington, with whom he had discussed all aspects of the great project, and that is so clear at Chiswick.

Similarly, the idea of hanging the principal picture rooms and bedroom with a sequence of rich materials was an idea that went back to the beginning of the century and can be still seen at Houghton in the late 1720s and early 1730s. Yet Thomas Coke was carrying it out in the mid-1750s, probably buying most of the principal materials in 1755, when he spent the huge sum of £3,166 13s. He acquired 224 yards of caffoy for £195 (Fig. 443); 349 yards of crimson cut velvet for £668 6s. (Fig. 444); 257 yards of multi-

coloured velvet for the bedroom for £899 (Fig. 445); and 434 yards of lustring, for curtains, for £190 6s. Those prices can be compared with the £200 paid for the Albani Claudes in 1755 and the £175 for the *Venus* by Titian bought through Hamilton and formerly one of the principal pictures on the north wall of the drawing-room. The caffoy was for the saloon, where it remains, and the finer cut velvet for the two flanking rooms, where it survives in the drawing-room. Damask was used in the Landscape Room and the cut velvet in the state bedroom. The sequence of three crimson materials but in different textures and patterns was an immensely grand idea and seems to have no parallel in that decade. The idea of a continuity of colour was still the convention, as could be seen at Woburn (though there it was in a less striking blue damask) and as is apparent from William Farington's sense of shock at the variety of colours and materials in the main rooms at Norfolk House when it opened in 1756.

447. *The Ante-Room or West Drawing-Room, Holkham. One of the two matching rooms flanking the saloon with the original arrangement of the pictures on the north wall. The heavy form of the marble chimneypiece by Pickford should be compared with the lighter forms used a little later in the saloon and other rooms (Fig. 446). Over the chimneypiece hangs Pietro Pietris's* Conception of the Virgin *after Maratta commissioned in Rome in 1744 for this position. The cut velvet hangings are an Edwardian reweaving of the original cut velvet that survives in the balancing room.*

The 1750s was almost the last decade for upholstery in splendid cut velvets, and, while the pattern of the crimson cut velvet at Holkham is not recorded elsewhere, the multicoloured velvet is found on the Vardy bed now at Hardwick, which was apparently made by Vile and Cobb, and on one of two beds at Petworth planned by the 2nd Earl of Egremont, a close friend of Thomas Coke, before he died in 1763. Lord Egremont ordered the velvet from Vansommer, Triquet and Vansommer at a cost of 2 guineas a yard in 1763.[32]

In Coke's case, the choice of materials was logical, because he had been buying pictures for the house since he was in Italy nearly forty years before. In 1744 he had supported the younger Brettingham's journey to Italy, partly to buy more pictures, sculpture and casts to fill certain known gaps, like the overmantel in the ante-room for which Pietro Pietris painted *The Conception of the Virgin* after Maratta. Like William Windham, Thomas Coke must have devoted

endless thought to how his pictures would be arranged, and indeed it was only in the early to mid-1750s that he had accumulated enough to make possible the idea of the Landscape Room. In 1755, for instance, he wrote to the younger Brettingham: 'I am glad that we have got those landscapes of Lucatelli as they will be wanted over my doors where they'll do very well.' That suggests his thinking was far advanced. Indeed, it is tempting to think that he may have been encouraged by William Windham's schemes at Felbrigg. In 1756 many pictures were standing waiting to be put up, while certain key pictures, like Hamilton's *Jupiter and Juno* for the overmantel in the state bedroom, only arrived in 1759.

His understanding of the role of pictures in the design of rooms and of the importance of balance in displaying pictures was highly developed, and it is possible to appreciate that more fully now, thanks to changes made by the present Lord Leicester. For instance, he has put back the original Italian pictures that Thomas Coke may

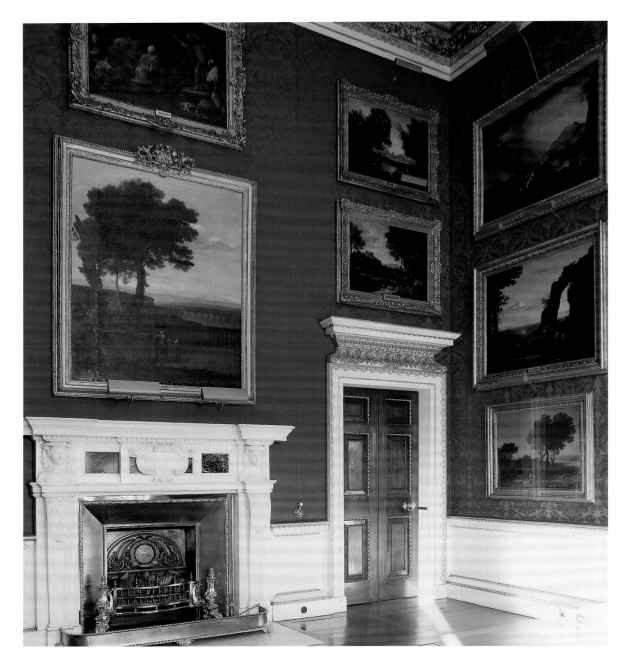

*Holkham Hall, Norfolk*

448. *The Landscape Room, north, chim-
neypiece, wall. The Claude over the chim-
neypiece was bought in 1755, apparently to
complete the hang and the Giordano above
it is the only non-landscape in the room,
its frame relating to that over the door on
the west wall.*

have commissioned when he was only seventeen in Rome in the overmantels in the saloon, in place of full-length English portraits. They are *Tarquin and Lucretia* by Procaccini and *Perseus and Andromeda* by Chiari, former pupils of Maratta. That has transformed the room by bringing back subject pictures and pictures that are much higher in tone; and it has meant that the heavy gilt fillets added to the frames to fit the portraits have been removed, and that has restored the balance of the frames. Originally they were balanced by Chiari's *Continence of Scipio* and Pietro da Cortona's *Coriolanus*.

Contemporary or near-contemporary history pictures in the central room were flanked by two rooms of earlier masters and in the Ante-Room (Fig. 447) the original arrangement of four large pictures on the north wall has remained untouched since the builder's day. In the centre is the Pietro de Pietris *Conception of the Virgin* in its splendid frame, with landscapes by Poussin and Claude in the lower row. On the end walls were Van Dyck's equestrian portrait of *The Duke d'Arenburg*, which Coke bought in Paris on his way back to London, and Rubens's *Flight into Egypt*, which he bought later, presumably as a pendant to it. Both are now in the saloon.

Both the subject-matter and the scale of pictures is reduced in the Landscape Room (Fig. 448), where Lord Leicester has restored as nearly as possible the builder's hang, and it shows how carefully he considered composition, tone and framing. Nowhere else in England is it possible to sense that in an eighteenth-century arrangement. On the west wall the pictures are all lower in tone than those on the east wall. Only one picture is not a landscape and that is the Giordano over the Claude above the chimneypiece, and that has a distinctive frame that matches the one above the west door.

Thomas Coke also remained loyal to the idea of tapestry in principal bedrooms. He had used Vanderbank's version of *The Loves of Venus and Adonis* after Albano, the same subject as was chosen for the Green Velvet Bedroom at Houghton, in Lady Leicester's bedroom. Then in 1758, to complete the set of *The Continents* bought in France for the state bedroom, he commissioned Paul Saunders to devise for two panels representing *Asia* (Fig. 451), a new type of pictorial tapestry based on designs painted by Zuccarelli using plates in Wood's *Ruins of Palmyra*. Subsequently Saunders made sets for Northumberland House (1758), Egremont House (1760) and

449. *An old photograph of the State Bedroom, which shows the original sofa bed (like one at Burghley, Fig. 131) that stood beneath the canopy and the original overmantel of* Jupiter and Juno *by Hamilton, which has been recently put back.*

450. *The State Bed.*

451. *The tapestries on the east wall representing* Asia *designed by Zuccarelli after plates in Robert Wood's* Ruins of Palmyra *and woven by Paul Saunders to complete the French panels of* The Continents *on the south and west walls.*

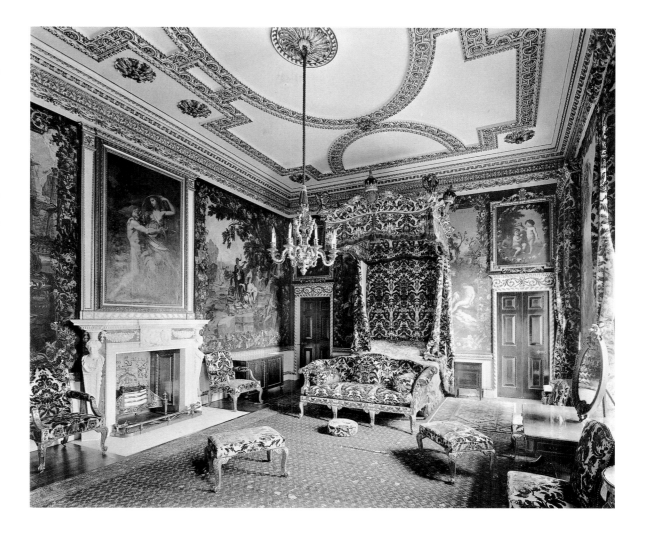

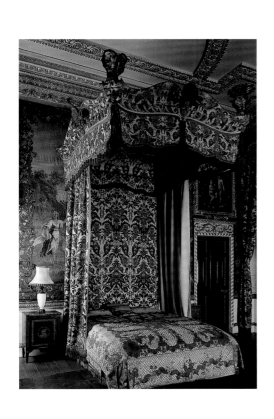

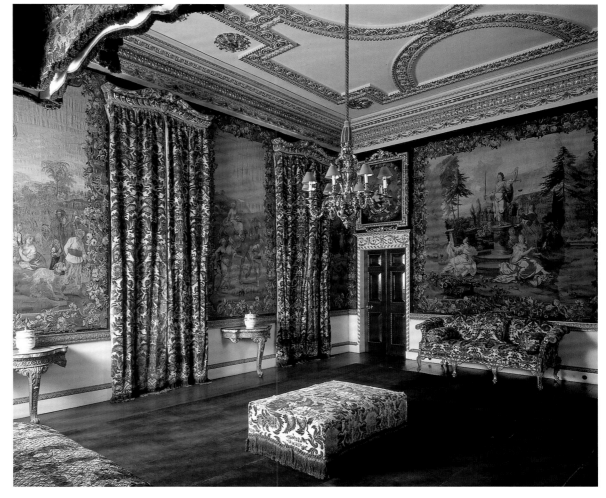

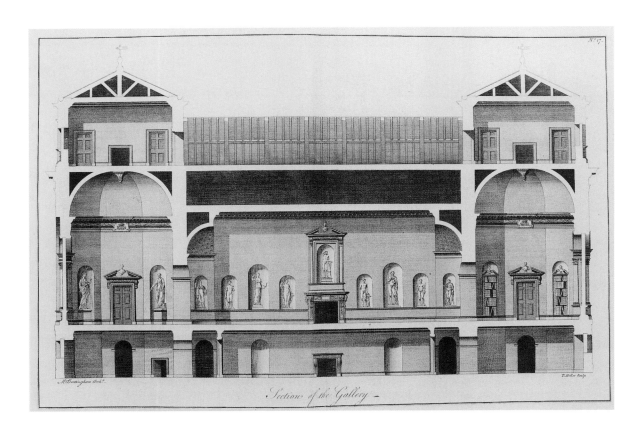

Holkham Hall, Norfolk

452. *The section of the Sculpture Gallery and its tribunes from Brettingham's* Plans of Holkham.

453. *The Sculpture Gallery. The parcel-gilt mahogany seat furniture by Paul Saunders has recently been recovered in blue leather as it was originally.*

454. *One of the parcel-gilt mahogany chairs supplied by Paul Saunders and originally covered in red leather for the dining-room.*

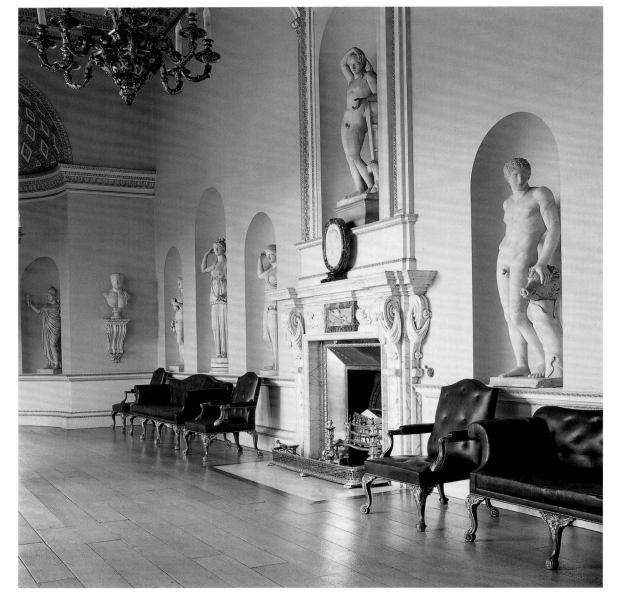

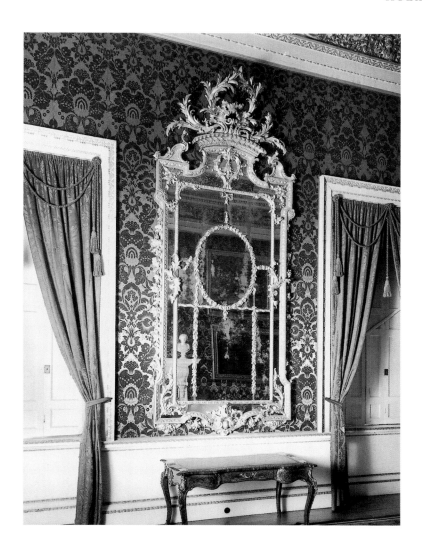

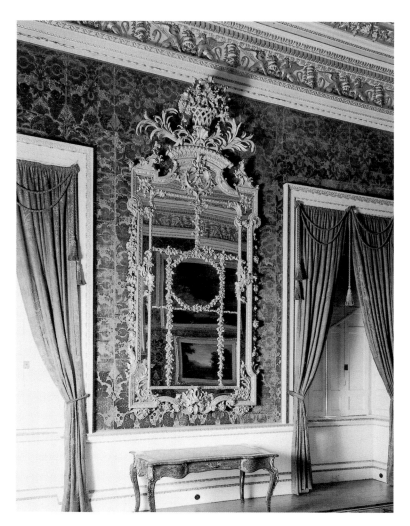

455 *and* 456. *The pier-glasses in the Ante-Room and the Drawing Room. Of similar design but the first was probably carved by James Whittle, the London carver, and the second by James Miller, the house carver, having to make use of old looking-glass provided by Lady Leicester.*

457. *One of the side tables with ostrich legs, the Coke supporters, in the saloon. The mosaic tops came from Hadrian's villa at Tivoli and the frames supplied by Goodison were possibly carved by Mathias Lock.*

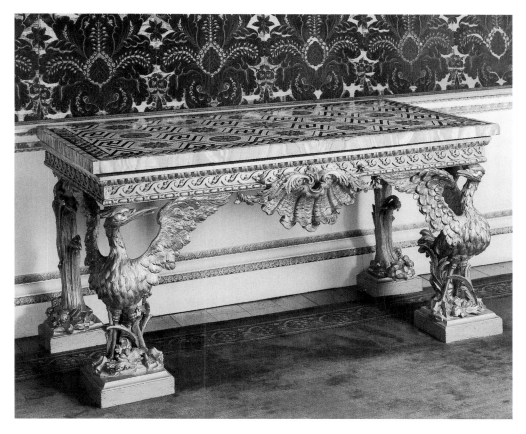

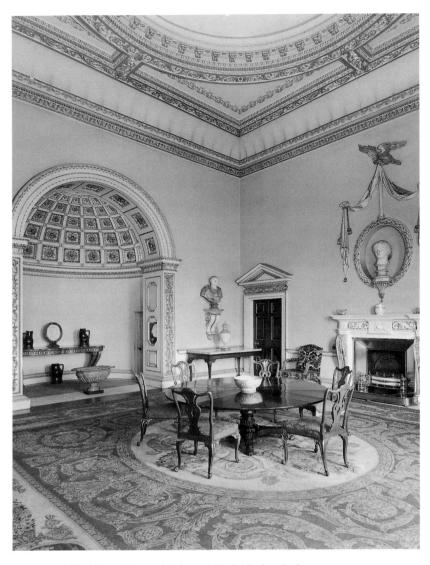

458. *The Dining-Room with the apse for the display of plate.*

Caversham Lodge, Reading. And in the second state bedroom, now called the Brown State Bedroom, he hung Brussels tapestries of *The Seasons*, now in the adjoining room. In the Strangers' Wing, Lady Leicester hung a set after Watteau related to the Bradshaw tapestries at Ham.

If the pictures suggested the use of crimson and gilded seat furniture in four rooms, for the Sculpture Gallery (Fig. 453) and dining-room Thomas Coke made a change to two sets of parcel-gilt mahogany supplied by Paul Saunders, both with leather upholstery

– blue in the gallery, recently restored, and red in the dining-room (Fig. 454).

Again, as in the hall, the final design of the room grew out of the purchases made by Brettingham in Rome and they in turn enabled Lord Leicester to develop his complex programme, worked out by Elizabeth Angelicoussis, linking past and present, interior and landscape. To later generations less well versed in classical history and literature, it seems over-involved, but it fits in with Lord Leicester's intellectual and museological approach to his conception and realization of Holkham. However, it is difficult for us to sense how far his ideas would have been shared by his contemporaries and whether it was a way of thinking more characteristic of the 1720s than the 1750s. It seems to belong with the taste for painted ceilings that died in the 1740s.

The furniture for the main rooms was a combination of what was bought from London craftsmen and what made on the spot. As well as using Paul Saunders as a weaver and chair-maker, Coke employed Goodison for carved work, with Lock possibly working under him carving the ostrich-leg frame for the saloon side tables (Fig. 457) and Whittle carving the frame of the pier-glass in the Ante-Room (Fig. 455). However, the settees and armchairs for the crimson rooms and state bedroom seem to have been made on the spot, and James Miller, the local carver, made the frame for the pendant pier-glass in the drawing-room (Fig. 456), where the composition is confused by Lady Leicester's insistence on reusing old glass.

By the time Lord Leicester died in 1759, the day of the great house was almost over, and, although Robert Adam was to pursue it in a series of brilliant interiors, he never actually won a commission to design, build from scratch and complete a great house. Syon and Osterley, for instance, were remodelling jobs, and at Kedleston he took on a house started by Matthew Brettingham but, having pushed out Paine, never fully realized his intentions.

So it is perhaps apt that Lady Leicester saw Holkham as her husband's monument, and she devoted the next five years to completing it as he would have wished, eschewing any reference to her own valuable role in keeping the project rolling over so many years, watching the accounts and paying some of the bills herself. That monumental aspect of Holkham as it was completed is proclaimed in the inscription she put up over the entrance door: 'This seat, on an open barren Estate, was planned, planted, built, decorated and inhabited the middle of the XVIIIth Century by Thomas Coke, Earl of Leicester.' It is also apparent in the two editions of Brettingham's book, with all their emphasis on state, and the way that Lady Leicester continued to show the house. As Lady Spencer wrote in 1766: 'Tuesday is the day when they show the house, Thursday is her publick day, and it is her delight to show the House . . .'

# Notes

## Preface

1. For plans and sections, see John Harris, *The Palladian Revival, Lord Burlington, His Villa and Garden at Chiswick*, New Haven and London, 1994. It is not known how Lord and Lady Burlington used the house. The inventory taken after Lady Burlington's death in 1770 suggests her rather uncomfortable arrangements as a widow; see T. S. Rosoman, 'The interior decoration and use of the state apartments of Chiswick House 1727–1770', *Burlington Magazine*, October 1985 and 'The Chiswick House Inventory', *Furniture History*, vol. XXII, 1986. The mood of the house is now best expressed in William Kent's two sketches of Lady Burlington in her Garden Room (Fig. 247).

## Chapter 1 Aspects of Early Georgian Fashion and Taste

1. Giles Worsley, *Classical Architecture in Britain*, 1995, p. 197.
2. The drawing in the National Galleries of Scotland is reproduced in Alistair Laing, 'The Eighteenth Century English Chimneypiece', in *The Fashioning and Functioning of the British Country House*, papers presented at a seminar at the National Gallery of Art, Washington, 1989, Fig. 3, p. 243. Francesca Scoones, 'Dr William Stukeley's House at Grantham', *The Georgian Group Journal*, vol. IX, 1999, p. 158. Michael Hall, 'Needlework that fools the eye', *Country Life*, 24 September 1998, p. 106.
3. Richard Martin, *Our New Clothes: Acquisitions of the 1990s, Metropolitan Museum, New York*, 1999, pp. 10, 11.
4. The Lady de Grey letters, largely unpublished, are to be found among the Wrest papers in the Bedford Record Office.
5. For 'Lord Clapham', see Michael Snodin and John Styles, *Design and The Decorative Arts Britain 1500–1900*, 2001, pp. 114–15. For the Devis portrait, see *Treasure Houses of Britain* catalogue (ed. Gervase Jackson-Stops) of the exhibition in the National Gallery, Washington, 1985–6, no. 329, p. 398. Sir Roger's suit can be compared with one of plain purple wool trimmed with broad gold lace in the Metropolitan Museum. See Richard Martin, *Our New Clothes*, p. 43 (1996–117a–c).
6. Aileen Ribeiro, *Dress in Eighteenth Century Europe 1715–1789*, 1984, p. 18.
7. It can also be seen in the portrait of Sir Robert Walpole in his green and gold-braided uniform as Ranger of Richmond Park, painted by John Wootton and Jonathan Richardson about 1725, at Houghton Hall. At Felbrigg survives an apparently unique suit of breeches and two jackets of fine brown corduroy made about 1735–40, presumably for the young William Windham II before he left on his Grand Tour. The heavier jacket has a pair of poacher pockets, suggesting that it was worn for shooting.
8. Baron de Pollnitz, *Memoir . . . being the observations in his travels*, 3rd edition, 1745, vol. III, p. 267.
9. For how people sat, see Gravelot's *Le Lecteur*, now at Marble Hill House, Twickenham. Lady Hertford's letter in *Correspondence between the Countess of Hertford and Countess of Pomfret 1738–1741*, 1805, vol. III, p. 293.
10. The portrait of Lord Burlington painted by Jonathan Richardson about 1717–18 is in the National Portrait Gallery and reproduced in Harris, *The Palladian Revival*, 1994, p. 59. For the Newhailes dressing-gown, see Cornforth, 'Newhailes II', *Country Life*, 28 November 1996, p. 42. For Garthwaite design, see Natalie Rothstein, *Silk Designs of the Eighteenth Century in the Collection of the Victoria and Albert Museum*,1990, p. 179.
11. Stella Tillyard, *Aristocrats: Caroline, Emily, Louisa and Sarah Lennox, 1740–1832*, 1994, p. 62.
12. See the frames mainly designed by Gravelot for the portrait heads of historical figures engraved by Houbraken and announced in 1737, first published in Nicholas Tindal, *. . . History of England*, 1742. Paul Petit frame reproduced in *Treasure Houses of Britain* catalogue, No. 434, p. 497.
13. The trade card of James Wheeley is reproduced in Ambrose Heal, *London Tradesmen's Cards of the XVIIIth Century*, 1925, plate LXIX. The shop of Phillips Garden, a silversmith who supplied the silver to Sir Nathaniel Curzon for Kedleston in the late 1750s, appears in the contemporary trade card illustrated in Philippa Glanville (ed.), *Silver*, Victoria and Albert Museum publication, 1996.
14. H. M. Colvin and John Newman (eds), *Roger North Treatise on Building*, 1981, p. 197.
15. For Ombersley overmantels, see Arthur Oswald, *Country Life*, 2 January 1953, p. 34. For Buxted overmantels, see Christopher Hussey, *Country Life*, 21 April 1934, p. 401. For Drayton tapestries, see Cornforth, *Country Life*, 3 June 1965, p. 1346. For Chatsworth looking-glasses, see Geoffrey Wills, *English Looking-glasses*, 1965, Fig. 20. For Bowhill looking-glasses, see Cornforth, *Country Life*, 12 June 1975, p. 1558. For Drumlanrig *verre églomisé*, see Mark Girouard, *Country Life*, 1 September 1960, p. 434. For Penshurst *verre églomisé*, see Ralph Edwards, *Shorter Dictionary of English Furniture*, 1964, p. 357. For Ditchley Scagliola table tops, see M. J.(Margaret Jourdain), *Country Life*, 29 May 1933, p. 515. For Aston Hall carpet, see Christopher Gilbert, James Lomax, Anthony Wells-Cole, *Country House Floors 1660–1850*, catalogue of exhibition at Temple Newsam, 1987, p. 47.
16. Vanbrugh quoted in Geoffrey Webb (ed.), *The Complete Works of Vanbrugh*, vol. IV, 1928, p. 25. Summerson's figures are given in John Summerson, 'The Classical Country House in 18th century England', reprinted in *The Unromantic Castle*, 1990, p. 82.
17. Arthur Oswald, *Country Life*, 4 December 1858, p. 1284; 11 December 1858, p. 1410; 18 December 1858, p. 1472.

## Chapter 2 Uses of Rooms and Changing Social Practice, 1685–1760

1. *Roger North*, pp. 32, 129, 131, 132. Duchess of Marlborough quoted in David Green, *Sarah Duchess of Marlborough*, 1967, p. 296 n.
2. Mrs Delany quoted in Lady Llanover (ed.), *Autobiography and Correspondence of Mrs Delany*, 6 vols, 1861–1862 Series II, vol. III, p. 108. Pritchard at Powis quoted in James Lawson and Merlin Waterson, *Pritchard as Architect and Antiquary at Powis, The National Trust Year Book*, 1975–6, p. 8. For Strawberry Hill, see pp. 229–34. For Cotehele, see pp. 224–6.
3. For King William's Room, Castle Ashby, see Gervase Jackson-Stops, *Country Life*, 30 January 1986, p. 248. For Aston Hall, see Oliver Fairclough, *The Grand Old Mansion*, 1984, p. 77.
4. For Chatsworth, see Francis Thompson, *A History of Chatsworth*, 1949. Also see James Lees-Milne, *Country Life*, 11 April 1968, p. 890; 18 April 1968, p. 958; 25 April 1968, p. 1040; Cornforth, *Country Life*, 29 August 1968, p. 496; 20 April 2000, p. 94.
5. For Dalkeith, see John Dunbar and John Cornforth, *Country Life*, 19 April 1984, p. 1092; 16 April 1984, p. 1158; 3 May 1984, p. 1120.
6. See photographic copy of Canons Inventory in the Department of Furniture and Woodwork at the Victoria and Albert Museum.
7. Isaac Ware, *The Plans, Elevations and Sections of Houghton in Norfolk*, 1735, and Matthew Brettingham, *The Plans, Elevations and Sections of Holkham, in Norfolk, the Seat of the late Earl of Leicester*, 1761 and 2nd edition, 1773.
8. An unpublished text bound into a copy of the 1756 garden guidebook in the Bodleian Library, Oxford.
9. *Apollo*, June, 1973. *The Triumph of Ceres, of Bacchus, of Neptune, of Mars, of Diana* are illustrated in the Stowe sale catalogue, 1922, Lots 372–6. One of the *Art of War* tapestries with the Cobham arms was sold from Upton House, Christies, 14–15 October 199?, lot 133.

10. Gladys Scott Thomson, *Family Background*, 1949, p. 74.

11. For the visit to Petworth, see James Dallaway, *A History of the Western Division of the County of Sussex*, 1819, vol. 2, Part I, p. 294. For Charles II's visit to Raynham in 1671, see the plan in an album in the RIBA Drawings Collection. This shows that the King was placed in the room on the first floor at the south-east corner of the house; the Duke of York at the north-east corner; the Duke of Monmouth at the south-west corner. Christopher Hussey, *Country Life*, 21 November 1925, Fig. 13, p. 788.

12. Mrs Delany, *Correspondence*, Series II, vol. 1, p. 455.

13. For The Drum, see pp. 35–7. For the Archerfield plan, see Ian Gow, 'William Adam: A Planner of Genius', *Journal of the Architectural Heritage Society of Scotland I*, 1990, plate 7, p. 71. Also see Blair James Macaulay, *The Classical Country House in Scotland 1660–1800*, 1987, p. 113. A. A. Tait, 'William Adam and Sir John Clerk: Arniston and "The Country Seat"', *Burlington Magazine*, March 1969, p. 132.

14. For Chatsworth's Chapel, Private Dining-Room and Duke's Room, see *Country Life*, 18 April 1968, p. 958; 29 August 1968, p. 496; 5 September 1968, p. 552; and for its Centre Bedroom, see Thompson, *A History of Chatsworth*, p. 193, plate 86. For Langleys, see Christopher Hussey, *Country Life*, 23 January 1942, p. 160. For Barnsley, see Christopher Hussey *Country Life*, 9 September 1954, p. 806. For Ombersley, see Arthur Oswald *Country Life*, 2 January 1953, p. 34. For Castletown, see Maurice Craig and the Knight of Glin, *Country Life*, 27 March 1969, p. 722. For Arniston, see Christopher Hussey, *Country Life*, 15 August 1925, p. 251. For Wentworth Castle, see H. Avray Tipping, *Country Life*, 18 October 1924, p. 588. For Clandon (half columns), see H. Avray Tipping, *Country Life*, 10 September 1927, p. 366. For Stoneleigh, see Cornforth, *Country Life*, 14 March 2002, p. 70. For Lyme, see Cornforth, *Country Life*, 26 December 1974, p. 1998.

Another example is the dining-room panelled in mahogany at Goldney House, Bristol: see Arthur Oswald, *Country Life*, 6 April 1948, p. 278.

Irish examples include the hall and drawing-room at Seafield, Co. Dublin; the Cedar Room (now destroyed) at Powerscourt, Co. Wicklow, illustrated in The Knight of Glin, David J. Griffin and Nicholas K. Robinson, *Vanishing Country Houses of Ireland*, 1988, p. 156; the dining-room at Platten Hall, Co. Meath (now demolished), photographs in the Irish Architectural Archive in Dublin; and evidence for them in the Green Damask Drawing Room, the centre room on the west front and so perhaps originally a Great Parlour, at Castletown, Co. Kildare, seen when the hangings were taken down in 1986 (photographs in the Irish Architectural Archive).

15. Cornforth, *Country Life*, 28 November 1985, p. 1692.

16. Belton: John Harris, *The Artist and the Country House*, 1979, plate 416. Tyrconnel picture reproduced in National Trust guidebook to Belton House, 1992, p. 85.

17. John Harris also illustrated Longleat as Figs. 66a and b; Cheveley as Fig. 67; and Denham Place as Fig. 121 and plate xiv, in *The Artist and the Country House*.

18. Celia Fiennes, *The Journeys of Celia Fiennes*, ed. Christopher Morris, 1949, p. 90.

19. H. M. Colvin and John Newman, *Roger North*, p. 127.

20. *Country Life*, 14 November 1925, p. 742; 21 November 1925, p. 782. James M. Rosenheim, *The Townshends of Raynham*, 1989.

21. John Harris *Country Life*, 2 March 1989, p. 92; Cornforth, *Country Life*, 30 April 1987, p. 124, 7

May 1987, p. 104. Andrew Moore (ed.), *Houghton Hall, The Prime Minister, the Empress and the Heritage*, catalogue of the exhibition at the Castle Museum, Norwich and Kenwood, 1996. The decision to build the new house appears to have been taken after Badeslade was paid for his survey of Sir Robert's Norfolk estates in April 1720, when he was also paid for a perspective of the house, and before the middle of 1721, when Ripley was in Yorkshire to arrange about stone for Whitby for the new house.

22. Gordon Nares, *Country Life*, 18 July 1957, p. 116; 25 July 1957, p. 166. Agneta Yorke quoted in an unpublished journal belonging to John Yorke. Philip Yorke quoted in Joyce Godber, 'The Marchioness Grey of Wrest Park', Bedfordshire Historical Record Society, vol. XLVII, 1968, p. 142.

23. Marcus Binney, *Country Life*, 13 February 1975, p. 378; 20 February 1975, p. 434; 27 February 1975, p. 498. Cornforth, *Country Life*.

24. Cornforth, *Country Life*, 9 June 1988, p. 252. The east end of the house has been altered on at least two occasions, once when a large Victorian wing was added, and then when the wing was removed.

25. Gervase Jackson-Stops, *Country Life*, 6 April 1978, p. 906; 13 April 1978, p. 970; 20 April, p. 1070. Badeslade's engraving illustrated in the National Trust guidebook, 1995.

26. Christopher Hussey, *Country Life*, 13 October 1960, p. 800; 20 October 1960, p. 858.

27. Harris, *The Artist and the Country House*. For Ledston Hall, see Fig 196a; Carton, Fig. 166; Calke, Fig. 144 and plate IX. For Kiveton, see *Vitruvius Britannicus*, vol. IV, Blom reprint, 1967, plates 11–12, 15–16. For Wentworth Castle, see *Vitruvius Britannicus* vol. IV, 1972, reprint, plates 57–8. For the Wentworth painting, see Harris, *The Artist and the Country House*, Fig. 359.

28. *Country Life*, 21 November 1996, p. 46; 28 November 1996, p. 42.

29. For Kingston Lacy, see Cornforth, *Country Life*, 17 April 1986, p. 1016; 24 April 1986, p. 1122; 5 June 1986, p. 1576; Antony Cleminson, *Architectural History*, vol. 31, 1988, p. 120. For Ragley, see Peter Leach, 'Ragley Hall Reconsidered', *Archaeological Journal*, 1979, p. 265, which points out that there was a precedent for the hall in Palladio's plan for the Villa Valmarana. The hall was finally completed by Gibbs, who designed the setting for the Rococo plasterwork.

30. For Chatsworth, see *Country Life*, 11 April 1968, p. 890; 18 April 1968, p. 958; 25 April 1968, p. 1040; 20 April 2000, p. 94; lecture by Peter Day at Chatsworth, 2000. Talman's skill as a planner and feeling for space can be seen in his unexecuted plan for Kiveton: see John Harris, *William Talman: Maverick Architect*, 1982, plate 14.

31. *Country Life*, 25 September 1909, p. 420.

32. Edward Croft Murray, *Decorative Painting in England* vol. 1, 1962, p. 216b. Bayly wrote to Thomas Foley in March, 1704: 'You like the greenish pattern for your great hall I think it will be best to advise with Mr Thornhill in that point for I may not only putt you to more charge but doe damage to Mr Thornhills worke for to paint very beautifull coullers will take the eye of from his painting is principall.' He gives prices for his work: 'cedar couller & walnutree neatly done 12d/ Black marble 18 p yd/ white in nuttoyl 18/ Green stone 2 shillings/ Rockstone 3 shills 6d lapus Lasure 5 shills'.

It is tempting to relate that letter to a painted room on the first floor at Hill Court, also in Herefordshire, where building was begun in 1698 by Richard Clarke, who died in 1702, and then completed by his brother Joseph. The room, which was decorated in 1704 by unknown painters, has its main panels painted to look like rock stone with

trompe-l'œil fields, with ruin pieces in grisaille in the panels over the chimneypiece and doors, marbled mouldings, and stiles and rails imitation lacquer. Cornforth, *Country Life*, 3 February 1966, p. 228.

33. H. Avray Tipping, *Country Life*, 27 August 1927, p. 296. Kerry Downes, *Hawksmoor*, 1959, plate 7 shows the hall before it was altered.

34. For Blenheim, see James Lees-Milne, *English Country Houses Baroque*, 1970, p. 166. For Seaton Delaval, see Christopher Hussey, *Country Life*, 8 December 1923, p. 800. For Grimsthorpe, see Christopher Hussey, *Country Life* 19 April 1924, p. 614. For Thornhill, see A drawing for Act I, Scene 3 of *Arsinoe*, an opera by Thomas Clayton, reproduced in Edgar de N. Mayhew, *Sketches by Thornhill in the Victoria and Albert Museum*, 1967, Fig. 3.

35. *John Loveday of Caversham. Diary of a Tour in 1732*, ed. J. E. T. Loveday, Roxburghe Club, 1890, p. 187.

36. For Bramham, see Arthur Oswald, *Country Life*, 27 February 1958, p. 400. For Duncombe, see Giles Worsley, *Country Life*, 24 May 1990, p. 116. For Gilling, see Kerry Downes, *English Baroque Architecture*, 1966, Fig. 324. At Beningbrough, there was originally a bridge across the end of the hall, linking the two ends of the house, as at Castle Howard, and that existed in 1906, albeit in a nineteenth-century form. See James Lees-Milne, *English Country Houses Baroque*, 1970, Fig 438; Marcus Binney, *Country Life*, 3 December 1981, p. 1950; 10 December 1981, p. 2098; 17 December 1981, p. 2170.

37. Christopher Hussey, *Country Life*, 3 December 1959, p. 1014; 10 December 1959, p. 1148.

38. Arthur Bolton, *Country Life*, 19 October 1918, p. 352.

39. The display of the Duke's arms and those on the overmantel mirror recall those on the pair of *verre églomisé* glasses at Drumlanrig, *Country Life*, 1 September 1960, Fig. 4, p. 435 and the gilt-framed glasses at Bowhill, *Country Life*, 12 July 1975, Fig. 10, p. 1562. The Duke's silver cistern is now at Bowhill: *Country Life*, 12 June 1975, Fig. 4, p. 1559.

40. Terry Friedman, *James Gibbs*, 1984, Fig. 141. Gibbs liked the form of the double-height hall and suggested it both for the hall and saloon at Kelmarsh, Northamptonshire, a house he designed about 1728 for William Hanbury. He published a different design for the house in *A Complete Book of Architecture*, 1728, plate XXXVIII. See also Arthur Oswald, *Country Life*, 25 February 1933, p. 198.

41. Although there are no documents, John Harris has suggested that the presence of Thornhill's bust alongside Palladio's in the hall at Barnsley Park raises the possibility that he may have been the architect. *Country Life*, 2 September 1954, p. 720; 9 September 1954, p. 806. For Hall Place, Maidenhead, see Arthur Oswald, *Country Life*, 5 March 1938, p. 246; 12 March 1938, p. 272.

42. *Country Life* 2 January 1953, p. 34; 9 January 1953, p. 94; 16 January 1953, p. 152.

43. For Wricklemarsh, see John Brushe, 'Wricklemarsh and the Collections of Sir Gregory P.', *Apollo*, November 1985, p. 364. As at Houghton, the hall was lit with a lantern of 'distinguished magnificence'.

44. For the Hopetoun design, see *Vitruvius Scoticus*, 1812, reprinted 1980, plate 13. For Arniston, see *Country Life*, 15 August 1925, p. 250; 22 August 1925, p. 284. Alistair Rowan has suggested that the hall is inspired by a plate in Paul Decker's *Architecture Civilis* of 1711, showing a section through the Royal Chapel in Turin, in *William Adam's Library Journal of the Architectural Heritage Society of Scotland I*, vol. 20. For the Yester plasterwork by Enzer, see Alistair Rowan, *Country Life*, 16 August 1973, p. 430.

45. For Castletown, see *Country Life*, 27 March 1969, p. 722. For Molesworth, ibid., p. 723. For the

Berkeley–Percival correspondence, see Benjamin Rand, *The Correspondence of George Berkeley afterwards Bishop of Cloyne and Sir John Percival afterwards Earl of Egmont*, 1914, pp. 194, 197.

The idea of a double-storey hall was taken up by Richard Castle at Leinster House, Dublin; and also at Beaulieu, Co. Louth, where the seventeenth-century house was remodelled in the 1720s; at Seafield, Co. Dublin, probably in the same decade; and at Gloster, Co. Offaly. Another was at Platten Hall, demolished in 1953 (photographs in the Irish Architectural Archive).

46. For Moor Park, see Cornforth, *Country Life*, 10 March 1988, p. 138. Are these scenes perhaps satirized in Hogarth's *The Rake's Progress*, plate 2, *Surrounded by Artists and Professors*, 1735? For Thornhill, see Edgar de N. Mayhew, *Sketches by Thornhill*, Fig. 37 and Charles Saumarez Smith, *Eighteenth-Century Decoration Design and The Domestic Interior in England*, 1993, Fig. 72. Another design by Thornhill is in the Courtauld Institute: see *Country Life*, 16 May 1974, p. 1196. A design for the ceiling in the collection of the late Sir Brinsley Ford is illustrated by Alastair Laing in 'Foreign Decorators', in Charles Hind, *The Rococo in England*, 1984, p. 39, Fig. 7.

47. *Vertue*, vol. III, *Walpole Society*, vol. XXII, 1933–4, p. 35.

48. For Gibbs's Gubbins drawing, see Alistair Laing, 'Foreign Decorators . . .', in Charles Hind, *The Rococo in England*, pp. 33–4. Sir Edward Gascoigne quoted by Alastair Laing from Elizabeth Done, *Sir Edward Gascoigne, Grand Tourist, Leeds Art Calendar*, No. 77, 1975, who transcribed Gascoigne's travel dairy in Leeds City Archives.

49. *Vertue* vol. III, *Walpole Society*, vol. XXII, 1933–4, p. 63. Sleter or Amiconi painted pairs of *trompe-l'œil* canvases in *trompe-l'œil* frames on the staircase, bearing the date 1732, and also the figurative elements in the saloon decorations.

50. Edward Croft-Murray, *Decorative Painting in England*, vol. II, 1970, p. 176. Brunetti also painted the decorative framing to the main pictures and the over-door in the saloon, both of which are very similar in spirit to his ornament prints, and show how close his ornament was to that of the Italian stuccadores. *Sixty Different Sorts of Ornaments invented by Gaetano Brunetti Italian Painter very useful to Painters, Sculptors, Stone-Carvers, Wood-Carvers, Silver-Smiths, etc.*, gives a good idea of their applications, even if it omits stuccadores.

51. For Clandon, see H. Avray Tipping, *Country Life*, 10 September 1927, p. 366; 17 September 1927, p. 398; 24 September 1927, p. 434. Cornforth, *Country Life*, 4 December 1969, p. 1456; 11 December 1969, p. 1582. On the prints, see a group of largely unpublished prints in the Irish Architectural Archive in Dublin. For the ceiling at Radnor House, see M. J. (Margaret Jourdain), *Country Life*, 3 July 1937, p. 12. And for the ceiling at 8 Clifford Street, *Survey of London* vol. XXXII, plates 95–7.

52. Lady Onslow died in 1731 and the only date on the building is 1733, on two rainwater hoppers. Lord Onslow died in 1740, and this was clearly before the house was finished, because Vertue, who went there in 1747, said that it was 'finish't by the present Lord'. Whatever the 3rd Lord Onslow did, his decoration was more modest and delicate than his father's, only appearing in details like the Flitcroftish overmantel in the Green Drawing-Room and the plasterwork on the window pier and reveals in the library. See *Vertue* vol. V, *Walpole Society*, vol. XXVI, 1937–8, p. 153.

53. M. I. Webb, *Michael Rysbrack: Sculptor*, 1954, p. 130.

54. Among other double-height halls are (or were) Althorp, Northamptonshire; Buxted Park, Sussex; Castle Hill, Devon; Langleys, Essex; Lydiard Tregoze, Wiltshire; Oulton Hall, Cheshire; Rushbrooke Hall, Suffolk; Standlynch, Wiltshire; Stratfield Saye, Hampshire; Stratton Park, Hampshire; Towneley Hall, Lancashire; Wakefield Hall, Northamptonshire; Whitley Beaumont, Yorkshire; Wimbledon House, Surrey; Wingerworth Hall, Derbyshire; and Leinster House, Dublin.

55. Antony, *Country Life*, 9 June 1988, p. 252. The saloon is so described in the 1771 inventory of the house in the archives at Antony, which suggests that little had been done since the death of the builder in 1744.

56. *Country Life*, 18 October 1924, p. 588, 11 March 1993, p. 58. The painted panels were added to the ceiling later, the centre one by Amiconi in 1735 and the eight others by Clermont.

57. For Sutton Scarsdale, see Margaret Jourdain, *Country Life*, 15 February 1919, p. 166. Another old but not necessarily original example of picking out baroque plasterwork can be seen in an old photograph of the overmantel in the Yellow Dressing-Room at Wentworth Woodhouse, *Country Life*, 20 September 1924, Fig. 17, p. 443. See also Gomme, *The Genesis of Sutton Scarsdale Architectural History*, vol. 24, 1981, p. 34.

58. For Davenport, see Arthur Oswald, *Country Life*, 27 June 1952, p. 1946; 4 July 1952, p. 40; 11 July 1952, p. 114. For Mawley, see *Country Life*, 2 July 1910, p. 18.

59. Ian Gow, *Country Life*, 15 August 1991, p. 64.

60. For the Petworth chairs, see *Treasure Houses* catalogue, Nos. 59 and 60, p. 135. For the Ham chairs, Peter Thornton and Maurice Tomlin, *The Furnishing and Decoration of Ham House, Furniture History*, vol. XVI, 1980, Fig. 152. The original bill is in the Furniture Department at the Victoria and Albert Museum.

61. Pearl Finch, *History of Burley-on-the-Hill*, 1901, p. 231.

62. For the hall benches, see Christopher Gilbert, *Furniture at Temple Newsam House and Lotherton Hall*, vol. II, 1978, pp. 267–9. These are now on loan from Temple Newsam to Lodge Park. For the Montagu House benches, see Tessa Murdoch (ed.), *Boughton House*, 1992, Fig. 132, p. 134. And for those at Badminton, see Gervase Jackson-Stops, *Country Life*, 9 April 1987, p. 130. At Ragley there is a particularly elegant set with pierced backs that follow the lines of settees of the 1750s, which is contemporary with the plasterwork, H. Avray Tipping, *Country Life*, 22 March 1924, p. 438. There are also good examples at Dunham Massey. See John Hardy and Gervase Jackson Stops, 'The Second Earl of Warrington and The Age of Walnut', *Apollo*, July 1978, p. 12.

63. For the hall tables from Longford and Coleshill, see Christopher Wilk (ed.), *Western Furniture 1350 to the Present Day in the Victoria and Albert Museum*, 1996, pp. 92–3. For the Longford table, see Christopher Hussey, *Country Life*, 12 December 1931, p. 679.

64. Hanbury: Gervase Jackson Stops, *Apollo*, May 1994, p. 10. James Lees-Milne, *Country Life*, 4 January 1988, p. 18; 18 January 1988, p. 66.

65. Ombersley inventory in possession of Lord Sandys.

66. For niches, see *John Loveday of Caversham*, p. 188. Among other halls with niches are Godmersham, Kent: see Christopher Hussey, *Country Life*, 23 Febrary 1945, p. 332; and Castle Hill, Devon: see Christopher Hussey, *Country Life*, 17 March 1934, p. 272; 24 March 1934, p. 300.

67. Isaac Ware, *A Complete Body of Architecture*, 1768 edition, p. 335. For Kirtlington, see *Country Life*, 26 April 2001, p. 103.

68. For Mrs Delany at Dangan in 1733, see *Correspondence*, Series I, vol. I, pp. 345 and 405; for Mount Usher, see Series I, vol. III, p. 122. For other descriptions of Irish country-house life, see Tillyard, *Aristocrats*, p. 60; and Valerie Pakenham in *The Big House in Ireland*, 2000, p. 46 for Sir Jonah Barrington's description of Cullenaghmore, Co. Sligo. See also Lady Kildare to her husband, quoting Lady Caroline Duncannon: 'everybody in Ireland spend all they have in eating and drinking and have no notice of any other sorts of comfort in life; they don't care whether their houses or anything in them is fit to receive. Provided they can stuff them, that's enough.'

69. Colvin and Newman, *Roger North*, p. 137.

70. Ibid., p. 68.

71. Mary Frampton, *The Journal of Mary Frampton* (ed. Harriot Georgiana Munday), 1885, p. 5. For Moreton, see RCHM *Dorset*, vol. II, South East Part I, 1970, with exterior and plan p. 175.

72. Purefoy, *Purefoy Letters 1735–1753* (ed. G. Eland), 1931, vol. I, p. 31; vol. II, pp. 270, 382. I am grateful to Dr Edward McParland for the reference to Trinity College, Dublin. The thinking was the same even if the words were different when Lord Guilford wrote to Sanderson Miller on 27 September 1757, saying he proposed to be 'at Your house, by twelve o'clock, or sooner; if Mrs Miller & you are quite disengaged, & will give is absolutely your own dinner without ceremony'. See Lilian Dickens and Mary Stanton, *An Eighteenth Century Correspondence*, 1910, p. 373.

73. The alternative plans for Herriard Park, Hampshire, begun in 1703 by Thomas Jervoise to the design of John James, show an owner considering the relationship of rooms. See Sally Jeffery, 'John James and George London at Herriard', *Architectural History*, vol. 28, 1985, p. 40; also Christopher Hussey, *Country Life*, 1 July 1965, p. 18.

74. Lady Elizabeth Cust, *Records of the Cust Family*, 1898.

75. Francesca Scoones, *Georgian Group Journal*, vol. 9, 1999, p. 158.

76. Coke to Brettingham, see Christine Hiskey, *The Building of Holkham Hall, Architectural History*, vol. 40, 1997, p. 144.

77. For Paine's plans, see his *Noblemen and Gentlemen's Houses*, 1767. At Uppark, the original name of the Little Parlour survives, but when Sir Matthew Fetherstonhaugh remodelled the house in the late 1740s he may have changed its use when he put Chinese paper into the main fields of the original panels, an idea that lasted until about 1770. However, its character as an eating room survives in the mask of Bacchus and bunches of grapes on its mid-eighteenth-century chimneypiece.

78. For Stoneleigh, see Cornforth, *Country Life*, 14 March 2003, p. 70. For Chicheley, see pp. 285–91. For Mawley, see Hussey, *English Country Houses, Early Georgian*, p. 109.

79. Canons Ashby III: J. A. Gotch, *Country Life*, 21 March 1921, p. 306. Adam Bowett, 'The India-backed chair, 1715–40', *Apollo*, January 2003, p. 3.

80. For Compton Place, see Christopher Hussey, *Country Life*, 13 March 1953, p. 734; 20 March 1953, p. 818. See also G. L. M. Goodfellow, 'Colen Campbell's Last Years', *Burlington Magazine*, April, 1969, p. 185.

81. *Country Life*, 16 April 1987, p. 136.

82. Dunham Massey undated inventory, almost certainly taken on the death of the 2nd Earl of Warrington, 1758, now in the John Rylands Library, Manchester.

83. For Strawberry Hill, see Paget Toynbee, *Strawberry Hill Accounts*, 1927. William Windham continued to use the term Great Parlour at Felbrigg in the 1750s, but by then the room had become the everyday sitting-room next to the dining-room with papered walls and mahogany chairs.

84. Mrs Delany, *Correspondence*, Series I, vol. III, p. 385.

85. For Ham House, see Peter Thornton and Maurice

Tomlin, 'The Furnishing and Decoration of Ham House', *Furniture History*, 1980, p. 42. For Burghley, see Oliver Impey, *Four Centuries of Decorative Art from Burghley House*, 1988, pp. 36, 37. Belton inventories are in the Lincolnshire County Record Office.

86. *Country Life*, 29 August 1968, p. 496.

87. Kiveton inventory in the library of the Victoria and Albert Museum. Plans of the house in Elizabeth Hagglund, 'Cassandra Willoughby's Visits to Country Houses', *Georgian Group Journal*, vol. XI, 2001, p. 185.

88. Blenheim plan in David Green, *Blenheim Palace*, 1951, Fig. 20.

89. *Country Life*, 3 May 1984, p. 1230.

90. Eastbury Worcester College: Kerry Downes, *Vanbrugh*, 1977, plate 134.

91. For Bute's house in Great Marlborough Street, see John Harris, *Catalogue of the Drawings Collection of the Drawings Collection of the Royal Institute of British Architects, Colen Campbell*, 1973, p. 11, Fig. 49.

There is a problematic dining-room or parlour at Clandon, where it is difficult to work out how the house was originally intended to be used. At the north-west corner of the house is the Speakers Parlour, which had been the principal dining-room since the mid-1740s when Vertue described it as a "fine dineing roome". 'Vertue V', *Walpole Society*, vol. XXVI, 1937–8, p. 153. It is too large and richly decorated to be a usual common parlour, but there appears to be no other candidate for that role. Was the Palladio Room a great parlour?

Photographs taken of the room under repair in 1968 show the arrangement of the central door on the long wall, the two chimneypieces on the end walls flanked by pairs of doorcase but no sign of the columns, so could there have been screens of columns in the room? *Country Life*, 4 December 1969, p. 1456; 11 December 1969, p. 1582.

92. Reinier Baarsen, Gervase Jackson-Stops, Phillip M. Johnston and Elaine Evans Dee, *Courts and Colonies The William and Mary Style in Holland, England and America*, published in 1988 in connection with the exhibition at the Cooper Hewitt Museum, New York, and the Carnegie Museum, Pittsburgh, plate 35.

93. For White Lodge, Richmond, see *Vitruvius Britannicus*, vol. IV, plate 4. Gibbs only proposed one in his design for Saccombe Park in the Ashmolean Museum, where he showed them in two rooms. For The Drum, see Arthur Bolton, *Country Life*, 9 October 1915, p. 488. And for the plan, see *Vitruvius Scoticus*, plate 37.

94. *Vertue* vol. III, *Walpole Society*, vol. XXII, 1933–4, p. 104.

95. Joseph Friedman, *Spencer House*, 1993, p. 106.

Another example of a dining-room with two screens of columns is at Firle Park, Sussex, which was extensively remodelled by the 1st Viscount Gage, who succeeded in 1744 and died in 1754. It is not known who carried out the work, although it may have been John Morris of Lewes. Not only was the exterior refaced in an undemonstrative style, but the Great Hall, the staircase and adjoining dining-room, which fills five bays on the south front, were remodelled. Its length, comparatively low ceiling height and the presence of two, rather than the more usual single, screens of columns suggest that it was formed out of at least two earlier rooms. At the end of the room is an unusually proportioned rectangular portrait of Lord Gage in an eared and broken pedimented frame with his arms in the cartouche in the centre that must have been commissioned for the room. It seems unlikely that the room was intended to take a series of full-lengths, as were introduced later. In the room and contemporary with it are a pair of unusual pier tables with a fox holding a garland in his mouth,

which are similar to a pair in the hall at Stourhead, but neither appear to be in their original positions. For Morris, see H. M. Colvin, *Dictionary of British Architects*, 3rd edition, 1995, p. 664, and for Firle see Arthur Oswald, *Country Life*, 17 February 1955, p. 480; 24 February 1955, p. 564; 3 March 1955, p. 620.

96. Paul Duncan, *Country Life*, 29 January 1987, p. 86; *Country Life*, 28 November 1996, p. 42.

97. Some of the wall decoration was added in the nineteenth century to suit its use as a saloon. For Carton, see Brian FitzGerald, *Country Life*, 7 November 1936, p. 488; 14 November 1936, p. 514.

98. For St Giles's, see Christopher Hussey, *Country Life*, 10 September 1943, p. 464; 17 September 1943, p. 508; 24 September 1943, p. 552. Christies, 26 June 1980; 8 July 1999;6 July 2000. For other examples of dining-rooms with full-length portraits, see Ditchley (Fig. 390) and Sudbury (Fig. 161).

99. For Nostell, see Christopher Hussey, *Country Life*, 23 May 1952, p. 1572. The original table and chairs do not survive.

Paine's design for the Best Dining-Room at Gopsall shows a group of oval and rectangular portraits placed in pairs of ovals over the three doors and one end wall. These were to line up at the top with upright rectangular portraits, and tied to busts on brackets below them with busts similarly tied to oval glasses on the window wall. Saumarez-Smith, *Eighteenth-Century Decoration*, plate 116.

That drawing can in turn be compared with the exploded design for the same room, produced by William and David Hiorne, who succeeded to the business of William Smith when he died in 1747. It was to be a handsome room of five bays, with the fifth screened off by a pair of columns that framed the view of the side table framed in an arch. However, the decoration looks provincial in its handling. The screen was reflected in pilasters that ran round the room except on the window wall, and in the centre of the long wall was, surprisingly, a continued chimneypiece of carved wood in the Rococo style made popular by Lock's prints. That faced a pier glass. All the other panels were to be filled with plaster ornament. See Saumarez-Smith, plate 129.

100. For print rooms, see Chloe Archer, 'Festoons of Flowers . . . for fitting up print rooms', *Apollo*, December 1989, p. 386. For Rokeby, see Worsley, *Country Life*, 26 March 1987, p. 176. For Cassiobury and Russell Farm, see Victoria Percy and Gervase Jackson-Stops, *Country Life*, 7 February 1974, p. 252.

101. For Antony memorandum, *Country Life*, 9 June 1988, p. 252.

102. Mrs Delany, *Correspondence*, Series I, vol. III, p. 158.

103. Christopher Gilbert, *The Connoisseur*, December 1964, p. 224.

104. For St Giles's House dining chairs, Christies, 8 July 1999. In 1997 and 1990 Malletts had two very similar sets of dining chairs, but it appears that it was the first set, illustrated in their publication for 1997, that came from Kirtlington, because the feet of the chairs are the same as those in early twentieth-century photographs of the room. I am grateful to Jeremy Garfield-Davies for his help with identification. With these are a number of others like the chairs formerly at Hinton St George attributed to Grendey without a definite date. In the state dining-room at Woburn there is a fine undocumented set dated about 1740 but still made of walnut. See Ralph Edwards, 'Patrons and Sensibility. English Furniture of the Eighteenth Century', *Apollo*, December 1965, p. 449 and Fig. 12, p. 459.

105. For Dudmaston, see Cornforth, *Country Life*, 15 March 1979, p. 714. For Bulstrode, see Mrs Delany, *Correspondence*, Series I, vol. II, p. 443. For Euston, see Norman Scarfe (ed.), *A Frenchman's Year in Suffolk 1784*, 1988, p. 21.

106. For Wimbledon House, see *Country Life*, 2 August 1962, p. 248.

107. The finest early service to survive is that made for the Duke of Leinster. See Elaine Barr, *George Wickes*, 1980, p. 197.

108. For Bodt's design for Wentworth Castle, see Saumarez-Smith, *Eighteenth-Century Decoration*, plate 25. For Talman's design and drawing, see *Walpole Society*, vol. LIX, 1997, plate 25. Kent's design for a dining-room at Wotton House, Surrey, in the Ashmolean Museum, Oxford, shows the end wall as a buffet matching the facing Venetian window, a design related to Sir Robert Walpole's library at Houghton.

109. For Ledston, see Arthur Oswald, *Country Life*, 3 December 1938, p. 556. For a description of the buffet at Drayton, see the copy of the 1710 inventory in the archives of the Woodwork Department of the Victoria and Albert Museum.

110. For Canons, see plans for the second floor in Baker, *Duke of Chandos*, p. 129 and ground floor, p. 144. See also Macky, *A Journey Through England*, 1724, vol. II, p. 8.

111. James Lomax, 'Silver at Castle Howard Three Hundred Years of Investment and Fashion', *NACF Magazine*, Spring 1992.

112. Baron de Pollnitz, *Memoirs*, 1745 edition, vol. III, p. 290.

113. *Journeys of Celia Fiennes*, p. 345. Her description brings to mind the miniature buffet, painted blue and gold, in a white painted parlour in the Uppark doll's house, which is thought to date from about 1735–40. Christopher Hussey, *Country Life*, 6 March 1942.

114. Grisell Baillie, *The Household Book of Lady Grisell Baillie*, Scottish History Society, 1911.

115. For Pollok, see Lawrence Weaver, *Country Life*, 25 January 1913, p. 132. For Glendoick, see David Walker, *Country Life*, 30 March 1967, p. 707. At Newhailes, in the room that was the original Common Parlour, there appear to be built-in bookcases in the piers between the windows on the east and west walls. Their frames, which date from the late 1730s, are really for buffets and in the 1790s there still stood in front of them brass-bound mahogany cisterns. Cornforth, *Country Life*, 22 August 2002, p. 66, Fig. 102.

116. Arthur Oswald, *Country Life*, 11 November 1949, p. 1434.

117. Leslie Harris, *Robert Adam at Kedleston: The Making of a Masterpiece*, catalogue of exhibition in America, 1987, plate 12, p. 27; plates 15, 16, pp. 30, 31. Cornforth, *Country Life*, 13 June 1996, p. 128.

118. James Lomax, 'Lord Warrington's Silver Lighting Equipment', *Apollo*, April 1993, p. 244.

119. Justinian Isham's journal quoted in Joan Wake, *The Brudenells of Deene*, 1953, p. 226.

120. Mrs Delany, *Correspondence*, Series I, vol. III, p. 436, 438, 442.

121. Horace Walpole to Lady Ailesbury, 23 August 1760, *The Yale Edition of Horace Walpole's Correspondence*, ed. W. S. Lewis, 1937–84, vol. 38, p. 72. For Alnwick, see Duchess of Northumberland's notes at Alnwick Castle.

122. In the time of the 4th Duke of Bedford, the plate was generally kept at Woburn and borrowed when needed in London. See *Apollo*, June 1989, p. 415.

123. Macky, *A Journey Through England*, vol. II, p. 42. John Bold, *Wilton House and English Palladianism. Some Wiltshire Houses*, 1988, p. 125.

124. For Drayton, see *Country Life*, 20 May 1965, p. 1218. For Doddington, see Cornforth, *Country Life*, 3 February 1994, p. 46; inventories in the Bodleian Library. For Ham, see Peter Thornton and Maurice Tomlin, *Furniture History*, vol. XVI, 1980, p. 118.

125. See 1727 Kiveton inventory in library of Victoria and Albert Museum.

126. H. Avray Tipping, *Country Life*, 3 December 1927,

p. 820; 3 December 1981, p. 1950; 10 December 1981, p. 2098; 17 December 1981, p. 2170.

127. Webb, *Rysbrack*, p. 130. The wallpaper is of the same pattern as that found in the Privy Council Offices. See Charles Oman and Jean Hamilton, *Wallpapers: A History and Illustrated Catalogue of the Collection in the Victoria and Albert Museum*, 1982, p. 104, No. 60, and p. 109, Fig. 60.

128. Mark Girouard, *Life in the French Country House*, 2000, p. 92. For Melville, see *Country Life*, 30 December 1911, p. 1006. For Dalkeith, see *Country Life*, 31 May 1984 p. 1230. For The Drum, see *Country Life*, 9 October 1915, p. 488. Money seems to have run out after the Great Dining-Room was completed, because the plasterwork was not continued.

129. *Country Life*, 20 November 1986, p. 1620.

130. *Country Life*, 11 November 1949, p. 1434.

131. Grimsthorpe. One of the rare examples is the King James Drawing-Room at Grimsthorpe, but it is not known when the room was formed or when it was given its present name. The room does not appear in the plan in *Vitruvius Britannicus*, vol. III, plate 11. In 1770 Arthur Young described it as a tea room. See *A Tour Through the North of England*, vol. I, pp. 86–8.

132. For Ditchley, see Henrietta Phipps, first wife of the son of the 11th Viscount Dillon, 1781, quoted in *Country Life*, 24 November 1988, p. 83.

133. For the plan of Archerfield, see Ian Gow, *William Adam Journal of the Architectural Heritage Society of Scotland* vol. I, 1990, p. 71, Fig. 7. For Dumfries House, see *Vitruvius Scoticus*, plate 19. For Blair Castle, see Macaulay, *The Classical Country House in Scotland*, p. 113.

134. For Antony, see *Country Life*, 9 June 1988, p. 252.

135. For Mawley, see *Country Life*, 2 July 1910, p. 18. Mrs Powys, *Passages from the Diaries of Mrs Philip Lybbe Powys 1756–1808*, ed. Emily J. Climenson, 1899, pp. 139–141. For Mawley and the Powderham bookcase, see Sarah Medlam, 'The Inlaid Room at Mawley Hall' in Christopher Gilbert and Tessa Murdoch, *John Channon and Brass Inlaid Furniture 1730–1760*, published in connection with the exhibition at Temple Newsam and the Victoria and Albert Museum, 1993, p. 144. Recently, Adam Bowett has suggested that the design of the library chimneypiece at Powderham is taken from plate 37 of Isaac Ware's *Designs of Inigo Jones and others*, 1733, and the overmantel is based on the frontispiece to Palladio's *I Quattro Libri dell' Architettura*, republished by Ware, 1738, while the top of the bookcases is also taken from the overmantel in plate 37. *Furniture History Newsletter*, No. 148, November 2002.

136. *Country Life*, 19 December 1931, p. 696.

137. For the Portland silver tables, see E. Alfred Jones, *Catalogue of Plate Belonging to the Duke of Portland at Welbeck Abbey*, 1935, p. 124, plate XVII. For the Chatsworth silver table, see *Treasures from Chatsworth The Devonshire Inheritance*, catalogue of exhibition in America 1979–80. For Canons, see copy of inventory in the Furniture Department of the Victoria and Albert Museum. For Dunham, see *Treasure Houses* catalogue p. 190, No 122. See also Elaine Barr, *George Wickes*, p. 118.

138. For Crowley's inventory, see Guildhall MSS 8763, 8764. Information from Martin Myrone and Sarah Medlam. That connection also comes to mind with the elegant early eighteenth-century silver gesso pier-glass that formerly hung in the drawing-room at Streatlam Castle, Co. Durham, and is now on loan to the Bowes Museum, and the silver kettle on stand that also belonged to the Bowes family and is now in the Metropolitan Museum. See Margaret Wills and Howard Coutts, 'The Bowes Family of Streatlam Castle and Gibside and Its Collections', *Metropolitan Museum Journal*, 33, 1998, p. 231.

139. Cornforth, *Country Life*, 6 January 2000, p. 52.

140. At Wolterton, the principal bedroom, later the Green Drawing-Room, Lord Orford's Bedroom and the Venetian Room were all tapestry-hung, most unusual for a house of about 1740. *Country Life*, 18 July 1957, p. 116; 25 July 1957, p. 166.

141. For the White and Gold Room at Petworth, see Gervase Jackson-Stops, 'The Building of Petworth', *Apollo*, May 1977, p. 324. Lord Leicester quoted in Cornforth, *Country Life*, 7 February 1980, p. 362.

142. Christopher Gilbert *Furniture at Temple Newsam*, vol. I, 1978, p. 61.

143. The other example is a set of French tapestry covers traceable back to Lord Montfort, the patron of Kent and Vardy, who went to Paris in 1750. They were put on to French frames by Mr Frick and are still in the Frick Collection, New York, but some of the original English gilt frames close Lock drawings still exist. Could the chairs have come from the room called a tea room by Arthur Young (see n. 131 above)?
   At Newhailes, the drawing-room fitted up in the late 1730s appears to have been furnished with an unusually large set of sixteen chairs, two settees and four stools whose covers look as if they were French tapestry and the frames to have been simple English or Scottish-made. They were sold in 1928 and are untraced. There are probably other chairs now spurned by French furniture historians because the frames seemed 'wrong' and equally unrecognized by their English counterparts.

144. For Danthon at Uppark, see *Treasure Houses* catalogue, No. 180, p. 260.

145. The set is signed 'Bradshaw'.

146. For Norfolk House, see Arthur Oswald, *Country Life*, 25 December 1937, p. 634. In the nineteenth century the room was partly redecorated as a ballroom. The tapestries are now at Arundel Castle. One of the doorcases is in the Victoria and Albert Museum; another is in the Metropolitan Museum, New York. In 1999 the marble chimneypiece was with Carlton Hobbs. See also *Survey of London The Parish of St James, Westminster Part One South of Piccadilly*, 1960, vols XXIX and XXX. Notes on the inventory are in the library of the Furniture Department at the Victoria and Albert Museum. And see Desmond Fitz-Gerald, Knight of Glin, *The Norfolk House Music Room*, Victoria and Albert Museum, 1973.

147. Gilbert, *The Life and Work of Thomas Chippendale*, 1978, vol. I, pp. 131–3.

148. Cornforth, *Country Life*, 4 June 1992, p. 74.

149. For Nunwick, see Gordon Nares, *Country Life*, 12 July 1956, p. 80; 19 July 1956, p. 132. See also Margaret Swain, *Country Life*, 21 March 1991, p. 124.

150. Pascall compare with the huge set of seventy-two pieces of scarlet japanned furniture made by Giles Grendey for export to the Duke of Infantado in Spain about 1735–40. No comparable order for an English client is recorded. Christopher Gilbert, *Furniture by Giles Grendey for the Spanish Trade, Antiques*, April 1971, p. 544.

151. For the saloon at Castle Hill, see *Country Life*, 17 March 1934, p. 272, 24 March 1934, p. 300. For Stoneleigh, see *Country Life*, 14 March 2002, p. 70.

152. For 85 St Stephen's Green, see Cornforth, *Country Life*, 20 October 1994, p. 62.

153. Duke of Buckingham to Duke of Shrewsbury, *The Duke of Buckingham's Works*, 1753, vol. II, p. 310, quoted in H. Clifford Smith, *Buckingham Palace*, 1930, p. 27. The ceiling painting he alludes to was originally painted for the hall at the Queen's House at Greenwich and is now at Marlborough House.

154. Ware, *Complete Body of Architecture*, p. 33.

155. Lady Hertford, *Correspondence*, vol. III, p. 103. Mrs

Montagu to the Duchess of Portland, 19 November 1745, *The Letters of Mrs Elizabeth Montagu*, published by Matthew Montagu, Part the Second, vol. III, 1813, p. 37. Madame du Bocage, *Letters concerning England, Holland and Italy*, vol. II, 1770, letter II, p. 7.

156. For Wallington, see Cornforth, *Country Life*, 16 April 1970, p. 855; 23 April 1970, p. 922; 30 April 1970, p. 987. For Stourhead, see John Fowler and Cornforth, *English Decoration in the 18th Century*, 1974, p. 237, Figs. 204 and 205.

157. Thompson, *Chatsworth*, pp. 187, 189.

158. For Eastbury, see Laurence Whistler, *The Imagination of Vanbrugh*, plate 63. For Duncombe, see *Vitruvius Britannicus*, vol. III, plate 85. The plans of Seaton Delaval and Duncombe are also in the same volume. See also Ian G. Lindsay and Mary Cosh, *Inveraray and the Dukes of Argyll*, 1973, Vanbrugh's design, Fig. 17; Roger Morris's plan in *Vitruvius Scoticus*, Fig. 37. The idea was also taken up when old houses were remodelled, as can be seen in the gallery at Wimpole with its twin screens of columns, created out of a series of rooms by Flitcroft in the early 1740s, and the more imaginative gallery at Gilling Castle, Yorkshire with its screens of columns and arches at each end, which was fitted up by Matthew Ward in 1747–8 and had a ceiling by Cortese. Sarah Medlam, *Matthew Ward at Gilling Castle, Furniture History*, 1997, p. 109.

159. Baker, *Duke of Chandos*, pp. 83 and 163.

160. Christopher Hussey, *Country Life*, 6 December 1946, p. 1062. The Powerscourt saloon predates Lord Burlington's design for the Assembly Rooms at York and probably also Kent's first scheme for the hall at Holkham. David Griffin, 'Richard Castle's Egyptian Hall at Powerscourt, Co. Wicklow', *Georgian Group Journal*, 1995, p. 119.

161. *Country Life*, 20 November 1986, p. 1620.

162. Paint analysis has recently established that the colour scheme revealed at Clandon in 1969 dates from 1870 rather than 1730. For Barnsley, see *Country Life*, 2 September 1954, p. 720. For Hall Place, see *Country Life*, 5 March 1938, p. 246; 12 March 1938, p. 272.

163. For Fairlawne, see Christopher Hussey, *Country Life*, 30 October 1958, p. 998. The letter from Derek Sherborn illustrating Gibbs's four elevations for the room is in the Ashmolean Museum. *Country Life*, 27 November 1958, p. 1247. See also Terry Friedman, *Gibbs's Designs for Domestic Furniture, Leeds Art Calendar*, 1972, No. 71, p. 20.

164. For *Wanstead Assembly*, see Richard Dorment, *British Painting in the Philadelphia Museum*, 1986, p. 157.

165. Marie Draper, *Marble Hill House and Its Owners*, 1970. Julius Bryant, *Mrs Howard: A Woman of Reason*, published in connection with the exhibition held at Marble Hill, 1988. The Great Room table is illustrated on p. 45.

166. Fowler and Cornforth, *English Decoration in the 18th Century*, Figs. 204 and 205.

167. Christopher Hussey, *Country Life*, 4 March 1954, p. 591. Alastair Laing, 'The Ruin Paintings in the Dining Room at Shugborough', *Apollo*, April, 1993, p. 227.
   At Chesterfield House there was a somewhat similar arrangement: on the garden front, the main block of the house was flanked by two wings, one containing the library and the other the Great Room, which was hung with Lord Chesterfield's capital pictures. The latter's chimneypiece without its overmantel is now in the Metropolitan Museum. *Country Life*, 25 February 1922, p. 235; 4 March 1922, p. 308.

168. Brian Fitzgerald, *Country Life*, 23 January 1937 p. 94; 30 January 1937, p. 120. Cornforth, *Country Life*, 5 December 1963, p. 1464; 12 December 1963, p. 1623; 19 December 1963, p. 1686.

169. For the Milltown catalogue, see Sergio Benedetti *The Milltowns: a Family Reunion*, published in connection with an exhibition at the National Gallery of Ireland, 1997. There are many other paintings from the collection in the National Gallery, while most of the silver is in the National Museum. It is hard to believe that the Milltowns were sufficiently well off in the second half of the nineteenth century to have undertaken such a rehanging of material or that the taste of that time was so restrained that they would have used the same pattern in all three rooms. One of Joseph Leeson's first big purchases in 1742 was a silver dinner service from George Wickes. Its epergne is now at Colonial Williamsburg.

170. Cornforth, *Country Life*, 21 September 1978, p. 791; 28 September p. 890; 12 October p. 1082. Another possible great room of the 1750s is the drawing-room by Carr of York filling one wing added on to Heath Hall, Wakefield. It is decorated with festive stucco in a design reminiscent of Kent's Marble Parlour design (Fig. 217) and that suggests a room for entertaining. See Arthur Oswald, *Country Life*, 3 October 1968, p. 816.

171. 'Woburn and the 4th Duke of Bedford', *Apollo*, June, 1988. Giles Worsley, *Country Life*, 22 April 1993, p. 50.

172. Yester, *Country Life*, 23 August 1973, p. 490.

173. *Country Life*, 14 October 1976, p. 1034; 21 October 1976, p. 1106.

174. Green, *Blenheim Palace* p. 160.

175. Other galleries are or were those at Heythrop, Oxfordshire (burned down); Dunham Massey, Cheshire, whose contents are listed in the 1758 inventory; and Gilling Castle, Yorkshire, recast in a tripartite form in the 1750s. Sarah Medlam, 'Matthew Ward at Gilling Castle', *Furniture History*, 1997.

   The picture gallery at Houghton was a change of mind on the part of Sir Robert Walpole. When the house was planned, the north-west wing was designed as an orangery, but when Sir Robert fell from power he decided to send many pictures from his London houses to Houghton and that involved converting the orangery into a picture gallery and revising the hang in the main house. How the gallery appeared can be gathered from a comparison of the list of pictures in Horace Walpole's *Aedes Walpolianae* (1747) with a sketch of the hang in the back of a copy of the *Aedes* in the Fitzwilliam Museum, as well as various proposals for the hang preserved at Houghton. See Dukelskaya and Moore, *A Capital Collection: Houghton Hall and The Hermitage*.

176. For Campbell, see Christopher Hussey, *Country Life*, 20 March 1953, p. 818. It is possible at the mid-eighteenth-century alterations at Stratfield Saye may have been designed by John Chute, a neighbour at The Vyne. Christopher Hussey, *Country Life*, 19 November 1948, p. 1050; 26 November 1948, p. 1106; 3 December 1948, p. 1162; 10 December 1948, p. 1218.

177. *Country Life*, 3 April 1969, p. 798. Brian Fitzgerald, *Correspondence of Emily, Duchess of Leinster*, vol. 3, p. 169.

178. For the Woburn gallery, see Christopher Hussey, *Country Life*, 31 March 1955, p. 858. For Strawberry Hill, see pp. 230–31.

179. For Stowe, see Desmond FitzGerald, 'A History of the Interior of Stowe', *Apollo*, June, 1973. For Thomas Wyndham at Hammersmith, see *Vitruvius Britannicus*, vol. IV, plates 28–9. For Stratton Park, see *Vitruvius Britannicus*, vol. IV, plate 52.

180. Ian Dunlop *Country Life*, 30 July 1953, p. 346.

181. Repton, *Fragments on the Theory and Practice of Landscape Gardening*, 1816. For a general account of libraries, see Simon Jervis, 'The English Country House Library: An Architectural History' in *Library*

182. *Georgian Group Report and Journal*, 1987.

183. Gervase Jackson Stops, *Country Life*, 4 June 1981, p. 1562; 11 June p. 1664; 2 July p. 18; 9 July p. 106. I am grateful to James Rothwell for his help.

184. For Arniston, see *Country Life*, 15 August 1925, p. 250; 22 August p. 284. Other examples of near-contemporary upper libraries in Scotland appear in William Adam's plans for the House of Dun, Newliston and Haddo House, *Vitruvius Scoticus*, plates 69, 34 and 55.

185. Sir Matthew Decker wrote of the Wimpole library in 1728: 'The great Library besides the bookes is adorned with many anticq bustoes of great value, and other curiositys of images, and other things more fitt to be admired by virtuos than by us.' David Adshead, '"A Noble Museum of Books": A View of the Interior of the Harleian Library at Wimpole Hall', *Library History*, vol. 18, November 2002, p. 191.

186. Kelmarsh Gibbs's drawings are in the RIBA Drawings Collection.

187. *Vitruvius Britannicus*, vol. IV, plates 59–64. John Brushe, *Apollo*, November 1985.

188. For Queen Caroline's library, see Charles Saumarez-Smith, *Eighteenth-Century Decoration*, p. 83, plate 62.

189. Ian Gow, 'The Most Learned Drawing-Room in Europe? Newhailes and the Classical Scottish Library', *Visions of Scotland's Past. Essays in Honour of John R. Hume*, 2000, p. 81. *Country Life*, 21 November 1996, p. 46. It is also possible that Gibbs was involved about 1719–20 with the library at Newhailes. Dr Mead Mary Webster, *Country Life*, 29 January 1970, p. 249; 24 September 1970, p. 765.

   One of the most splendid designs for a library was that produced by Sir Edward Lovett Pearce for the 2nd Viscount Allen, who inherited Stillorgan in 1727. Pearce proposed to build on two wings, one of which was to contain the library, which was to be 2½ stories high with a double order of columns and a gallery. See Maurice Craig, *Architectural Drawings in the Library of Elton Hall*, Roxburghe Club, 1964. The drawings are now in the Victoria and Albert Museum.

   By the 1730s, even in squires' houses libraries were starting to be architectural rooms and so it is unfortunate that the library at Lamport Hall added by Francis Smith in 1732–5 for Sir Justinian Isham has been altered.

190. For Powderham, see Mark Girouard, *Country Life*, 4 July 1963, p. 18. For Channon, see Christopher Gilbert and Tessa Murdoch, *John Channon and Brass-Inlaid Furniture 1730–1760*, 1993.

191. Joyce Godber, *The Marchioness Grey*, p. 134.

192. The appearance of the room suggests that it was fairly new when Mary Conyers painted it, about 1740, and so it must have been fitted up soon after Sir Roger came of age (he was born in 1719 and inherited in 1734). That in turn suggests that he may have made some classical changes to the old house that were in keeping with his classical designs for Copt Hall in the mid-1740s and the epergne (now in the Victoria and Albert Museum) that was given to him as a wedding present, but that his conversion to the gothick style only developed in the late 1740s, after the deaths of both Francis and William Smith and after some contact with William Hiorne, who made a plan for him in 1748. Reproduced in *Country Life*, 24 September 1988, p. 106.

193. Temple Newsam watercolour, Cornforth, *English Interiors 1790–1848: The Quest for Comfort*, 1978, plate 151.

194. For Kirtlington, see Cornforth, *Country Life*, 26 April 2001, p. 102. For Lydiard Tregroze, see *Country Life*, 14 March 1948, p. 578; 26 March 1948, p. 626.

195. *Country Life*, 25 February 1954, p. 510; 4 March 1954, p. 590; 11 March 1954, p. 670. Eileen Harris, 'Thomas Wright', *Country Life*, 26 August 1971, p. 492; 2 September 1971, p. 546; 9 September 1971, p. 612. The plasterwork may be by Vassalli, who is mentioned as working at Shugborough in a letter from Philip Yorke to his father quoted in Geoffrey Beard, *Decorative Plasterwork in Great Britain*, 1975, p. 249.

196. *Country Life*, 4 June 1910, p. 810. Marcus Binney, *Sir Robert Taylor: from Rococo to Neo Classicism*, 1984, plan, Fig. 27.

197. For Felbrigg, see *Country Life*, 22 December 1934, p. 666. For Arbury, see Michael Hall, *Country Life*, 7 January 1999, p. 30; January 14 1999, p. 40. For Malmesbury House, see Cornforth, *Country Life*, 26 October 1961, p. 1003.

   Another early gothick library is at Sherborne Castle, which was formed in 1757–8 by the 6th Lord Digby, possibly to the design of a surveyor, William Ride, an elegant design of a gothick arcade with ogee heads and circular recesses with bronzed busts and a Jacobean Revival ceiling by Francis Cartwright. Ann Smith and Michael Hall, *Country Life*, 10 August 2000, p. 38. RCHM *Dorset*, vol. I West, 1952, plate 95.

   In addition, there is a design for a gothick library at Corsham by an unknown architect, thought to date from 1759. See Frederick J. Ladd, *Architects at Corsham Court*, 1978, plates 44, 45. See also Christopher Hussey, *Country Life*, 27 November 1937, p. 548.

198. For the Houghton library table, see Edwards, *Shorter Dictionary of Furniture*, p. 556.

   Another exceptional pair of about 1750–5 is attributed to John Channon and possibly from Fonthill Splendens, one of which is in the Victoria and Albert Museum. Murdoch, *John Channon*, p. 91.

199. Lady de Grey, unpublished letters in the Bedford Record Office. Holland House: Brian Fitzgerald, *Correspondence of Emily Duchess of Leinster* (1949) vol. I, p. 18.

## Chapter 3 *The Primacy of Upholstery*

1. For Marot, see Reinier Baarsen et al., *Courts and Colonies*, plates 21, 22, 24. Howard Coutts, *Country Life*, 13 October 1988, p. 232. For the Siena drawing, see Robert C. Smith, *Five Furniture Drawings in Siena, Furniture History*, vol. III, 1967, plate 5.

2. 1727 Kiveton inventory in the library of the Victoria and Albert Museum. Contract plans of the house in 1698 now in the Yorkshire Archaeological Society, reproduced in *The Georgian Group Journal*, vol. XI, 2001, p. 185.

3. Campbell, *London Tradesman*, 1747, reprinted 1969, p. 169.

4. Lady Cust, *Records of The Cust Family*, 1909, p. 251. In recent years there has been a growth of interest in these materials and good versions are now made by specialist weavers.

5. Campbell, *London Tradesman*, pages 331–40.

6. Ibid., p. 261. Lord Manchester, RCHM, Eighth Report 1881, Appendix II, Duke of Manchester, p. 100.

7. Campbell, *London Tradesman*, p. 261.

8. Copy of Canons inventory in the Furniture Department at the Victoria and Albert Museum.

9. For James Moore, see Tessa Murdoch, 'The King's cabinet-maker: the giltwood furniture of James Moore the Elder', *Burlington Magazine*, June 2003, p. 408. I am grateful to her for sharing her thoughts on Blenheim. See also Geoffrey Beard and Christopher Gilbert, *Dictionary of English Furniture Makers 1660–1840*, 1986, p. 618.

10. The Blenheim chairs are illustrated *in situ* in Percy Macquoid, *The Age of Walnut*, 1905, Fig. 30. For

Stoneleigh, see *Country Life*, 14 March 2002, p. 70. For the Harcourt chairs, see Christies, 6 July 2000, lot 20. For the Berkeley Castle chairs, see J. (Margaret Jourdain?), 'Furniture at Berkeley Castle', *Country Life*, 4 February 1933, p. 125.

11. For Bradshaw, see Beard and Gilbert, *Dictionary of English Furniture Makers*, p. 99.

12. For Goodison, see Geoffrey Beard, 'William Kent and the Cabinet-Makers', *Burlington Magazine*, December 1975, p. 867. Beard and Gilbert, *Dictionary of English Furniture Makers*, p. 351.

13. Beard and Gilbert, *Dictionary of English Furniture Makers*, p. 551. Christopher Gilbert, *Furniture at Temple Newsam*, vol. II, No. 446.

14. *Rococo Art and Design in Hogarth's England*, catalogue of the exhibition at the Victoria and Albert Museum, 1984, ed. Michael Snodin, L10–14, pp. 165, 166. A possible later work are the ostrich legs on the side tables in the saloon at Holkham, which Lock may have carved for Goodison.

15. Saunders also wove tapestry for Northumberland House and Egremont House. Geoffrey Beard and Christopher Gilbert, *Dictionary of English Furniture Makers*, p. 782.

16. For the glasses at Hampton Court, see 'The King's Apartments at Hampton Court Palace', reprinted in *Apollo*, August 1994. For the Gumley glasses at Chatsworth, see Edwards and Jourdain, *Georgian Cabinet Makers*, 1944, Figs. 13, 14.

17. See 1717 Kiveton inventory in the Victoria and Albert Museum.

18. For *verre églomisé*, see Cornforth, *Country Life Art and Antiques 2000*, p. 84.

19. For Thomas Stretch, see Eric Till, introduction to *The Travelling Earl 1648–1700*, exhibition at Burghley House, 1988. For the Burley-on-the-Hill groom of the chambers, see Pearl Finch, *History of Burley-on-the Hill*, vol. I, p. 230. For Canons, see Baker, *Duke of Chandos*, p. 196.

20. Copy of Canons inventory in the Furniture Department at the Victoria and Albert Museum.

21. For Knole, see Geoffrey Beard, *Upholsterers and Interior Furnishing in England 1530–1840*, 1986, p. 92, plates 66–9. Edward Impey, *Kensington Palace*, 2003, p. 18, plate 13, illustrates the Burley bed now at Het Loo and shows the repeat and colour balance of the cut velvet. For the chairs, see Christies, 6 July 1989, lots 148–52. For Queen Anne's velvet bed, see Geoffrey Beard, *Upholsterers*, p. 144, plates 132–6.

22. Cornforth, *Country Life*, 6 February 2003, p. 56. It is possible that the Boughton bed was a perquisite from the Great Wardrobe granted when Ralph Montagu was forming his Great Apartment. The ceiling of the bedroom is dated 1689; the panelling was put up by Roger Davis between 1691 and 1694; William II was received at Boughton in 1695; and the bed was first listed in the inventory compiled in 1697.

23. The same pattern found on the Hampton Court beds is also to be seen on canopies at Hampton Court Palace. See Annabel Westman, 'Splendours of State' in the issue of *Apollo* devoted to the King's Apartments at Hampton Court Palace, August 1994. For the damasks at Leeds Castle, see Karen Walton, *The Golden Age of English Furniture Upholstery*, catalogue of the exhibition at Temple Newsam, 1973.

24. For the Drayton bed, see Beard, *Upholsterers*, pp. 135–8, plates 115–20.

    Recently Rosemary Baird has drawn attention to the set of bed hangings worked by the Duchess of Norfolk for the state bedroom at Norfolk House and now at Ugbrooke Park, Devon. She suggests that the Duchess began them soon after her marriage in 1727 and also makes a comparison with Clermont's ceiling at Wilton of 1727. Clearly they must have been designed by a professional artist

and the Syon panels (see p. 202) raise the possibility that he could have been Clermont. See Rosemary Baird, 'The Duchess and her Menagerie in Stitches', *Country Life*, 26 June 2003, p. 108.

25. Lord Rivers to Duchess of Marlborough, RCHM, Eighth Report 1881, Appendix II, Duke of Manchester, p. 100. For the Milton bed, see Cornforth, *Country Life*, 7 December 1989, p. 144. For the Hatfield bed, Cornforth, *Country Life*, 22 December 1983, p. 1850.

26. For 'pillar and arch' designs, see E. A. Entwisle, *A Literary History of Wallpaper*, 1960, plate 20. See also E. A. Entwisle, *The Book of Wallpaper*, 1954, revised 1970, plate 17. Beard, *Upholsterers*, p. 121, plate 73. Oman and Hamilton, *Wallpapers* pp. 92–3. A version of the pattern in green flock wallpaper found at Kilmainham Hospital, Dublin is illustrated by David Skinner in 'Irish Period Wallpapers', *Irish Arts Review*, vol. 13, 1997, p. 53.

27. Houghton document in the archives at Houghton. A later estimate survives for the damask required for Hopetoun, see p. 96.

28. For the Hinton bed, see Christopher Gilbert *Furniture at Temple Newsam House*, vol. III, No. 665, p. 664 and Fig. 1. When the bed was restored about 1930, the velvet and damask were reversed and the decayed damask replaced with antique material.

    LIST OF BEDS
    Aston Hall, ex Wroxton
    Belton House
    Belvoir Castle
    Blair Castle
    Boughton
    Burghley House, Queen Elizabeth's bed
    Burley-on-the-Hill, now Het Loo, Holland
    Calke
    Chatsworth
    Clandon
    Dalemain
    Drayton
    Dunham Massey, fragments
    Erddig
    Glemham, resold at Sothebys
    Hatfield
    Hampton Court, Herefordshire, blue damask bed now Metropolitan Museum, New York, and red damask bed now Het Loo, Holland
    Hampton Court Palace, King's bed, Prince of Wales's bed
    Hardwick Hall, part of Lapierre bed from Chatsworth, green velvet bed from Londesborough Hall, cut velvet bed designed by Vardy
    Hinton St George, now Temple Newsam
    Holkham
    Holme Lacy, now Beningbrough Hall
    Holyroodhouse
    Houghton, green velvet bed, needlework bed
    Kensington Palace, the cut velvet bed in which James II was born, but cut down and altered since it was illustrated by Pyne
    Knole, King's Bed, Venetian Ambassador's Bed, Spangle Bed
    Melville House, now Victoria and Albert Museum
    Newhailes
    Powis Castle
    Raynham, also ex-Raynham Hall, now Hampton Court Palace
    Sewerby, now Burton Agnes
    Warwick Castle
    Wentworth Woodhouse, now Milton
    Wingfield Castle, now Beningbrough Hall

29. Beard, *Upholsterers*, plate 125.

30. Quoted in *Wimpole Hall*, National Trust guidebook, 1979, p. 54.

31. For Wanstead, see John Macky, *A Journey Through England*, vol. I, p. 21: 'the Parlour *China* Paper, the Figures of Men, Women, Birds, Flowers, the Liveliest I ever saw from that Country. The Anti-

Chamber is furnish'd with *China* silk . . . the Bed-Chamber, Dressing-room, and Closet, all also of *China* Silk.'

32. Thomas Chippendale, *The Gentleman and Cabinet Maker's Director*, 1762 edition, plates XLI, XLII, XLIII, XLIV. For the Petworth bed, see Gervase Jackson-Stops, *Country Life*, 14 June 1984, p. 1698.

33. Narford inventory in library of Victoria and Albert Museum.

34. Paul Saunders to Lady Carlisle, *Country Life*, 1 October 1992, p. 80.

35. The present bed comes from Belhus and has been rehung in a two-colour version of the pattern but in different colours to the original wallpaper in the room. Arthur Oswald, *Country Life*, 19 August 1954, p. 572.

36. See copy of Chandos inventory in the Furniture Department of the Victoria and Albert Museum.

37. Duchess of Marlborough to Mrs Clayton, *Letters from Madresfield Court*, 1875, p. 165. For Sir Matthew Decker, see MS at Wilton.

    The record picture of the beds on the second floor at Houghton as conveyed by the 1745 inventory also needs to be related to the tapestries still listed in them in 1892. For instance, the North-West Bedroom had five panels of scripture subjects; The Yellow Damask Bedroom at the south-east corner had four panels of Teniers tapestries; there were two panels of tapestry in the bedroom on the east front to the north of the hall; and the corresponding bedroom on the west front at the south end at the top of the main staircase had 4 panels of floral tapestry. These were sold at Christies on 27 June 1902, lots 132–7. The family bedroom at the south-west corner on the main floor was also tapestry-hung. For Lady Louisa Conolly, see Brian FitzGerald, *Correspondence of Emily Duchess of Leinster*, vol. III, 1957, p. 2.

38. See Compton Place inventory at Chatsworth.

39. See 1726 Erddig inventory, Flintshire Record Office, a copy is in the V&A.

40. See Ditchley inventory, Oxfordshire Record Office.

41. For the Hanbury bed, see Cornforth, *Country Life*, 11 June 1992, p. 122. For Doddington, see *Country Life* 10 February 1994, p. 46. For Weston, see Francis Bamford, *Country Life*, 22 January 1976, p. 174.

42. Mrs Delany, *Correspondence*, Series I, vol. II, p. 562.

43. Sarah Medlam, *Furniture History*, vol. XXVI, 1990, p. 142.

44. Colvin and Newman, *Roger North*, p. 136.

45. Verelst picture on loan to the Victoria and Albert Museum.

46. For Dumfries House, see Christopher Gilbert, 'Thomas Chippendale at Dumfries House', *Burlington Magazine*, November 1969, p. 663. For St Giles's House, see Christies, 26 June 1980, lots 26, 27. Gomm drawings in Saumarez Smith, *Eighteenth-Century Decoration*, plate 234.

47. Executors' accounts at Boughton.

48. Christopher Gilbert, 'Temple Newsam Furniture Bills', *Furniture History*, 1967, p. 23.

49. Belton inventory in the Lincolnshire Country Record Office. Kiveton inventory in the Victoria and Albert Museum. Erddig 1726 inventory in the Flintshire Record Office.

50. See Norfolk House inventory at Arundel Castle. Partial transcription in the Furniture Department of the Victoria and Albert Museum. 1758 Dunham Massey inventory in the John Rylands Library, Manchester.

51. Duke of Cumberland, *Hampton Court Furnishing Bills 1736–37*, PRO LC 9/289. I am grateful to Juliet Allen for this reference.

52. Cornforth, *Country Life*, 11 April 1985, Fig. 8, p. 950.

53. Lady Anson drawing on a letter in the Shugborough papers in the Staffordshire County

Record Office. For 85 St Stephen's Green, see Cornforth, *Country Life*, 10 November 1994, p. 79.

54. Gervase Jackson Stops, *Country Life*, 14 June 1984, p. 1698. The Petworth pattern can be compared with the wool and silk version recently woven for Kedleston, Fig. 122.

55. For the Privy Council wallpaper, see Charles Oman and Jean Hamilton, *Wallpapers*, No. 60, pp. 104 and 109.

56. For Arthur Young at Wallington, see *Tour Through the North of England*, 1770, vol. III, p. 101. For Gibside, see Sarah Medlam, *Furniture History*, vol. XXVI, 1990, p. 142. Eighteenth-century fragments of the pattern were found on the dome of the Petworth bed and on the state bed at Shugborough, where there is also nineteenth-century material. For reasons of cost when the Petworth bed was restored, it was decided to use Warner's Besant design, which is a shortened version of the original pattern but the correct width.

57. Lord Manchester to Duchess of Marlborough, RCHM, Eighth Report, 1881, Appendix II, Duke of Manchester, p. 100. For Kimbolton, see *Country Life*, 11 September 1911, p. 474.

58. Anthony Coleridge, 'James Cullen, cabinet-maker at Hopetoun, II', *Connoisseur*, December 1966, p. 232.

59. The Ditchley inventories are in the Oxfordshire Record Office. For Stoneleigh, see 1738 inventory in Stratford Record Office. For Duke of Cumberland, see *Hampton Court Furnishing Bills*. For Leicester House, see *Survey of London*, vol. XXXIV, *Parish of St Anne Soho*, 1966, p. 449. Mrs Delany, *Correspondence*, Series I, vol. II, p. 308.

60. For Wolterton, see *Country Life*, 25 July 1957, p. 166. For Chevening, see H. Avray Tipping, *Country Life*, 24 May 1920, p. 548.

61. For Stansted, see Clive Aslet, *Country Life*, 11 February 1982, p. 346. For Stowe, see Michael Bevington, *Stowe House*, guidebook, 2002, p. 60. John Hardy tells me that *La Fachinade* with Lord Cobham's arms was sold at Sotheby's on 25 October 1963.

62. For Castle Howard, see Cornforth, *Country Life* 4 June 1992, p. 74. The tapestries from Naworth Castle were sold at Sothebys. At Ham, Bradshaw was paid for putting up the hangings on 5 May 1744. See photocopy of the account from 1742 in the Furniture Department of the Victoria and Albert Museum. The Norfolk House tapestries were soon removed to Worksop, for which they were extended. They are now at Arundel Castle. For Dumfries House, see Christopher Gilbert, *Thomas Chippendale*, vol. I, p. 133. For Stowe, see Dr Richard Pococke, *The Travels Through England*, vol. II, Camden Society, NS vol. 44, 1889, p. 241. For West Wycombe, see Cornforth, *Country Life Annual*, 1972. For Compton Place, see Hussey, *English Country Houses, Early Georgian*, Fig. 135, p. 95.

63. For needlework hangings at Aston Hall, see Oliver Fairclough, *The Grand Old Mansion*, p. 77, Fig. 62.

64. For the Wallington hangings, see Cornforth, *Country Life*, 12 April 1970, p. 922. George Wingfield Digby, 'Lady Julia Calverley Embroideress', *Connoisseur*, March 1960, p. 82, April, p. 169.

65. For the Syon hangings, see *Country Life*, 7 December 1929, p. civ. Sold at Sothebys, 14–16 May 1997, lots 17–23.

66. Alexander Brand, *The Book of the Old Edinburgh Club*, 1935. In September 1681, Sir Alexander Brand petitioned for a monopoly for the manufacture of Spanish leather. For Dalkeith, see *Country Life*, 3 May 1984, p. 1230. In 1701 Anne, Duchess of Buccleuch asked Lord Melville 'to order some Guilt Leather Hangers for the dining room and some such plain chairs as is used for eating rooms I mean Kane or some sort that has no stuff on

them.' Melville House photographed for *Country Life* in 1910–11 but not included in the article of 30 December 1911, p. 1006. Reproduced by Ian Gow in *Scottish Houses and Gardens from the Archives of Country Life*, 1997, p. 78. For Burghley, see Impey, *Four Centuries of Decorative Arts from Burghley House*, p. 37. The Gilt Leather Dining Room was hung with gilt and blue 'Spanish Leather' and had eighteen new gilt and blue leather chairs. For Blenheim, see 1744 inventory.

67. For gilt leather, see Eloi Koldeweij, *Gilt Leather Hangings in Chinoiserie and other styles: an English Speciality Furniture History* vol. XXXVI, 2000, p. 61. For Loreto Abbey, see Cornforth, *Country Life*, 26 November 1987, p. 62. For Compton Place, see Hussey, *English Country Houses Early Georgian*, Fig. 127, p. 90.

68. Lord Harington picture, Mellon Collection at Yale Center for British Art, in Charles Saumarez-Smith, *Eighteenth-Century Decoration*, Fig. 73. For Lady Hilsborough, see Mrs Delany, *Correspondence*, Series I, vol. III, p. 409. 14 February 1756. Lady Hilsborough 'has a very good house, furnished all with yellow damask, with a open border of burnished silver that edges all the hangings'. For Hopetoun, see Fowler and Cornforth, *English Decoration in the 18th Century*, p. 125, Fig. 110. For Longford, see Fowler and Cornforth, *English Decoration in the 18th Century*, p. 125, Fig. 109. For Corsham, see *Country Life*, 12 March 1938, p. lxiv.

69. See copy of the Canons inventory in the Furniture Department at the Victoria and Albert Museum.

70. For Drumlanrig chairs, see Beard, *Upholsterers*, plates 126–7. For Lyme, see Fowler and Cornforth, *English Decoration in the 18th Century*, Fig. 144, p. 153. For Rushbrooke, see Percy Macquoid and Ralph Edwards, *Dictionary of Furniture*, 1st edition, 1924, vol. I, plate XIII facing p. 220. For Hampton Court, see Edwards *Shorter Dictionary of Furniture*, 1964, p. 131, Fig. 58.

71. For the Burley chairs, see Christies, 6 July 1989, lots 148–52. For the Hampton Court settee, see Edwards, *Shorter Dictionary of English Furniture* p. 445. The set of the settee and side chairs from Burley on the Hill and now at Dudmaston, Shropshire have needlework covers inspired by a contemporary textile design but they are no longer thought to be original. Cornforth, *Country Life*, 15 March 1979, p. 714. For Temple Newsam day bed, see Gilbert, *Furniture at Temple Newsam*, vol. II, p. 264.

72. Beard *Upholsterers*, plate 141. Adam Bowett, 'The India-backed chair, 1715–40', *Apollo*, January 2003, p. 3.

73. For Boughton chair, see Beard, *Upholsterers*, plate 79. For Castle Howard chair, see ibid., plate 105. For the Hatfield chair, see Adam Bowett, *English Furniture 1660–1714. From Charles II to Queen Anne*, 2002, reproduced on p. 255.

74. Houghton inventory of 1745.

75. On nailing Vardy's plates, see Fowler and Cornforth, *English Decoration in the 18th Century*, Fig. 150, p. 157. For Castle Howard, see Fowler and Cornforth, *op. cit.*, Fig. 151, p. 157. For Rousham, see Margaret Jourdain, *Country Life*, 20 August 1948, p. 384. In nineteenth-century watercolours of the Long Gallery at Hardwick, the Devonshire House chairs are upholstered in a red material, possibly a velvet, that is likely to have been their original colour. For Lyme, see Cornforth, *Country Life*, 22 February 2001, p. 74. For Corsham, see *Country Life*, 12 March 1938, p. lxiv; Fowler and Cornforth, *op. cit.*, Fig. 149, p. 156. For Hopetoun, see Francis Bamford, *Furniture History*, vol. XIX, 1983, p. 125, plates 32 and 33. For Cusworth, see Fowler and Cornforth, Fig. 152, p. 158.

76. Thomas Roberts's account is partly at Houghton and partly in the Cholmondeley papers in the

University Library at Cambridge.

77. For Stoneleigh chairs, see *Treasure Houses* catalogue, No. 133, p. 202.

78. For Sir William Stanhope, see Simon Jervis, 'Leather Hangings', *Furniture History Society Newsletter* (1989), p. 9. Similarly, the seat furniture in the Great Drawing Room at Norfolk House had carved and gilt frames with crimson velvet covers. See inventory at Arundel Castle, n. 48 above.

79. *Country Life*, 22 February 2001, p. 74.

80. For the Sutton Scarsdale chair, see Gilbert, *Furniture at Temple Newsam*, vol. III, No. 696, p. 581 and plate 6. The name of Thomas How, upholsterer, appeared on the now-missing lead plate recording the names of the principal figures involved in the building of the house. Apart from the pair of chairs at Temple Newsam, other parts of the suite are in the Metropolitan Museum, Frick Collection and the Cooper-Hewitt collection, all New York. Lord Scarsdale's extravagant tastes can also be seen in the 1726 silver cistern by Lamerie now in the Hermitage Museum, St Petersburg and represented by a cast in the Victoria and Albert Museum.

81. Adam Bowett, 'The Commercial Introduction of Mahogany and Naval Stores Act of 1721', *Furniture History*, vol. XXX, 1994, p. 43.

82. Arthur Oswald, *Country Life*, 6 August 1948, p. 278.

83. For Hallett's bill, see Christopher Gilbert, *Connoisseur*, December 1964, p. 224.

84. Dudley Ryder information from Lucy Wood from the Harrowby Papers.

85. For the Holkham chair, see Anthony Coleridge, *Chippendale Furniture*, plate 67. For the Treasury chairs, see *Dictionary of Furniture*, vol. I, p. 231.

86. Sarah Medlam, *Furniture History*, vol. XXVI, 1990, p. 142.

87. Mrs Delany, *Correspondence*, Series I, vol. II, p. 393.

88. *A Journal of a Tour in the Year 1745*, notes from an unpublished manuscript made many years ago, but the location is now missing. The quotation continues 'Soon after two o'clock when the bell had rung, the doors were thrown open, and Admission given to a great crowd with our selves'.

89. For Chicheley, see inventory of 1755. I am grateful to Rachel Watson for the Milton reference. For John Crowley, see Guildhall Ms 8763, 8764. Henry Shelley inventory, PRO PROB 3/35/ 27 (30 March, 1736). I am grateful to Sarah Medlam for these last two references, discovered by Martin Myrone while working on the Henrietta Street room at the Victoria and Albert Museum for the British Galleries project. For Ham, see photocopy of account book from 1742 in the Furniture Department of the Victoria and Albert Museum.

90. For Gibside, see Sarah Medlam, *Furniture History*, 1990, vol. XXVI, p. 142.

91. See also *A Study of Loose Textile Covers for Seat Furniture in England Between 1670 and 1731* by Derek Balfour and Nicola Gentle in the catalogue of the exhibition *Ijdel Stof Interieurtextiel in Western 6 Europe Van 1600 for 1900*, Antwerp, 2001–2. I am grateful to Sarah Medlam for giving me a copy of this catalogue. There are now nine armchairs of three different designs upholstered in old crimson velvet in the drawing-room and five chairs in crimson damask with a gold ground presumably chosen to relate to the brocade of the bed. For the Dyrham covers, see Karin M. Walton, 'An Inventory of 1710 for Dyrham Park', *Furniture History*, XXII, 1986, p. 36.

92. I am most grateful to Claire Brown for arranging for the photography of this unique object, which has not yet been put on display. This has involved making a special chair to take it, a testing task carried out by Albertine Cogram. It can now be shown when a suitable opportunity presents itself.

93. For Cotehele, see Cornforth, *Country Life*, 1 February 1990, p. 52.

94. Three case covers attributed to Mrs Delany sold at Christies, South Kensington, 16 February 1988, lot 82. For the Vyne, see Anthony Coleridge, *Chippendale Furniture*, plate 27. Was the white linen case cover embroidered in silk from Boughton and now in the Victoria and Albert Museum T-83-1973 for use in the summer? Karen Walton, *The Golden Age of English Furniture Upholstery*, No. 44.

## Chapter 4 Aspects of Display

1. For Collis on Goodwood, see Earl of March, *A Duke and His Friends. The Life and Letters of the Second Duke of Richmond*, 1911, vol. I, p. 304.

2. Prince Eugene quoted in Christopher Simon Sykes, *Private Palaces. Life in the Great London Houses* 1985, p. 94. The future Duke took the former St Alban's House in St James Square by 1710 and built a range behind with a great room that must have been one of the first ceilings to combine stuccowork by the Italians and decorative painting in the manner of Pellegrini. Remarkably, it survived behind what became Norfolk House until the latter was demolished in 1938. *Survey of London*, vol. XXIX, pp. 190, 200 and vol. XXX, plate 163.

3. For the scale and range of a great ducal collection, see E. Alfred Jones, *Catalogue of Plate Belonging to the Duke of Portland at Welbeck Abbey*, 1935. For Burghley, see Impey, *Burghley House*, p. 215, plate 110 A and B. See also Penzer on cisterns, *Apollo*, September, October, December 1956; August, September 1957. For the Warrington silver, see J. F. Hayward, 'The Earl of Warrington's Plate', *Apollo*, July 1978, p. 32. See the forthcoming catalogue of the collection by James Lomax and James Rothwell. The cistern and fountain marked by David Willaume I in 1707–8 made for the 5th Earl of Meath has been recently acquired by the Boston Museum of Fine Arts.

4. See copy of the Chandos inventory in the Department of Furniture at Victoria and Albert Museum.

5. The Grantham cistern was on the London art market 2001–2. For Cholmondeley, see Christies, 3 July 1997, lot 15.

The Victoria and Albert Museum has a dish cover of silvered brass or 'close' or 'French' plate with the arms of the 3rd Earl of Carlisle made about 1732. The appearance of these cisterns has led me to look for more examples and for references in bills and inventories. It is evident that considerable use was made of silvered and gilded brass in the first half of the eighteenth century, for chandeliers and light fittings (see pp. 129–34) and for objects used in connection with tea and dinner. The latter include a dish cover ordered by the 3rd Earl of Carlisle now in the Victoria and Albert Museum. Cornforth, *Country Life*, 2003.

6. Among later cisterns are the one with the Royal arms made by Benjamin Pyne in 1724–5 and presented to Sir Spencer Compton, possibly when he gave up being Speaker of the House of Commons on George II's accession in 1727 – he was the owner of Compton Place – and the smaller cistern acquired by Lord Warrington to complete his set in 1729. The last of all is that made for Speaker Cust in 1770 by Thomas Hemming and now at Belton. *Connoisseur*, vol. 51, May 1918, p. 58, sold at Sothebys in 1918 from Northwick Park. For the National Museum of Wales epergne, see Mark Evans and Oliver Fairclough, *National Museums and Galleries of Wales A Companion Guide to the National Art Gallery of Wales*, 1997, p. 23, plate 19. For the Kirkleatham epergne, see James Lomax, *British Silver at Temple Newsam and Lotherton Hall*, 1992, p. 87.

Lady Grisell Baillie's Instructions to the Butler include as No. 19 'The Plate must always be clean and bright, which a little wiping every day will do, when once it is made perfectly clean, which must not be by whitening but a little soap suds to wash it, or spirit of wine if it has got any spots, and wiping and rubing with a bush and then a piece of Shambo leather'. At Erddig there was a modest one bought in 1740 and described in the inventory as 'A Leparne with 6 sconces' weighting 124 ounces 2 penny weights and at 8*s*. 7*d*. an ounce valued at £53 5*s*.

7. Lady Grisell Baillie, p. 274. See copy of Canons inventory in the Furniture Department at the Victoria and Albert Museum.

George Treby ordered a surtout from de Lamerie in 1720; and Lord Fitzwalter ordered a ring from the same maker in 1728. See Christopher Hartop, *The Huguenot Legacy*, p. 31.

8. Elaine Barr, *George Wickes*, pp. 197, 85.

9. See Dunham Massey 1758 inventory. For silver kettle on stand, see *Treasure Houses* catalogue, No 123, p. 191. For silver waiters with wooden tables, see *Treasure Houses* catalogue, No. 122, p. 190.

10. See copy of Canons inventory in the Furniture Department at the Victoria and Albert Museum.

11. The Victoria and Albert Museum has two late-seventeenth-century services, from Sizergh Castle and the Calverley service, both illustrated in Charles Oman, *Caroline Silver*, 1970, plates 86 and 88. George Treby's, bought on his marriage in 1727, by Paul de Lamerie is in the Ashmolean Museum; the Warrington service, by Edward Feline, 1754, is illustrated in *Apollo*, July 1978, p. 39.

12. For Thomas Coke, see D. P. Mortlock, *Thomas Coke and the Family Silver, Silver Society Journal*, 1997. For the Portland plate, see E. Alfred Jones, *Catalogue of Plate Belonging to the Duke of Portland at Welbeck Abbey*.

13. Pearl Finch, *Burley-on-the-Hill*, vol. I, p. 209.

14. For the Wickes candelabra for Leinster, see Christopher Hartop, *The Hugenot Legacy*, p. 126.

15. For Walpole, see Andrew Moore, *Houghton Hall*, p. 143. For the Newdigate epergne, see *Paul de Lamerie*, catalogue of exhibition at Goldsmiths' Hall, 1990, No. 81, p. 126.

16. For Strafford, see Christopher Hartop, *The Huguenot Legacy*, Nos. 2 and 3, pp. 74–82. For the ewer and basin, see *Silver*, ed. Philippa Glanville, Victoria and Albert Museum, 1996, pp. 108, 109. For the Legh silver, see Sothebys, 23 November 1999, lot 241; 1 June 1999, lot 157. See copy of the Chandos inventory in the Furniture Department of the Victoria and Albert Museum.

17. James Lomax, *Apollo*, April 1993, p. 244.

18. For Lichfield, see inventory on his death, Oxfordshire County Record Office. Gold objects were much more expensive and very rare. The Pelham cup, for instance, which was designed by Kent and made by Wickes in 1736 stands 11 inches high and cost £218 19*s*. for the 58 ounces of gold at £3 15*s*. an ounce and £80 for the making. For Carlisle, see James Lomax, 'Silver at Castle Howard. Three Hundred Years of Investment and Fashion', *NACF Magazine*, Spring 1992.

19. For Gibbons, see David Esterly, *Grinling Gibbons and the Art of Carving*, catalogue of exhibition at the Victoria and Albert Museum, 1998. For Chatsworth, see Cornforth, *Country Life*, 20 April 2000, p. 94. Yannick Chestang, *Paintings in Wood French Marquetry Furniture*, in connection with the exhibition at the Wallace Collection, 2001. See Ian Bristow, *Interior House-Painting Colours and Technology 1615–1840*, 1996, pp. 129–30.

20. For Stoneleigh, see *Country Life*, 14 March 2002, p. 420.

21. Ian Bristow, 'The Balcony Room at Dyrham Park', *National Trust Studies*, 1980, p. 141; also *Architectural

*Colour in British Interiors 1615–1840*, 1996, p. 29.

22. Croft-Murray, *Decorative Painting*, vol. II, p. 218.

23. For Stoke Edith, see *Country Life*, 25 September 1909, p. 420. For Erddig, see *Country Life*, 6 April 1978, p. 907.

24. For Great Hundridge, see Christopher Hussey, *Country Life*, 15 February 1941, p. 145; 22 February 1941, p. 166. For Swangrove, see Christopher Hussey, *Country Life*, 16 December 1939, p. 627. For Parsonage at Stanton Harcourt, see Christopher Hussey, *Country Life*, 26 July 1941, p. 160. For White House, Suckley see Cornforth, *Country Life*, 4 February 1993, p. 54. For Hill Court, see Cornforth, *Country Life*, 3 February 1966, p. 288. For Carshalton House, see Cornforth, *Country Life*, 7 September 2000, p. 174.

25. Croft-Murray, *Decorative Painting*, vol. I, p. 216b.

26. *Country Life*, 28 June 1984, p. 1856.

27. Campbell, *The London Tradesman*, p. 103.

28. For the stone-colour Boughton panels, see Tessa Murdoch, *Boughton House*, p. 61 and plate 20. For Wanstead, see Mrs Powys, *Passages from the Diaries*, p. 205. For Eastbury, see Mrs Powys, p. 63. Mrs Delany, *Correspondance*, Series I, vol. II, p. 330.

29. Salmon list in Ian Bristow *Architectural Colours*, p. 67. The bill of James Carpenter, the painter at Aldby Hall, Yorkshire in about 1733–4, records him graining the doors in the hall in mahogany and painting the Common Dining-Room olive, while the more elaborate Doric Room was painted pear. The Damask Room and closet were painted pearl colour. Giles Worsley, *Country Life*, 13 February 1986, p. 377.

30. For Scone bed, see Cornforth, *Country Life*, 11 August 1988, p. 92. For the Blickling bed, see John Maddison, *Country Life*, 24 March 1988, p. 136. For Boughton, see inventory in the Boughton archives. Cornforth, *Country Life*, 6 February 2003, p. 56.

31. For Stoneleigh: see inventory of 1738 in the Leigh papers in the Shakespeare Centre at Stratford-on-Avon. For the needlework chairs, see *Treasure Houses* catalogue, p. 202, No. 133. Cornforth, *Country Life*, 14 March 2002, p. 70.

32. See Kiveton inventory in the Victoria and Albert Museum. Houghton and Compton Place inventories at Chatsworth. For Drayton bed, see Beard, *Upholsterers*, p. 135.

33. Another example of the use of blue round about 1740 occurred at Newhailes, where the curtains in the drawing-room, which was hung with Chinese wallpaper, were blue damask, and so were they in the adjoining principal bedroom and dressing-room.

34. Ian Bristow, *Interior House-Painting Colours and Technology 1615–1840*, p. 20.

35. For Woburn, see Geoffrey Beard, 'Interior Designs and Furnishings at Woburn Abbey', *Apollo*, June 1998, p. 395. For Dumfries House, see Gilbert, *Chippendale* vol. I, p. 133. Mrs Delany, *Correspondence*, Series I, vol. III, p. 385.

36. For Burton Constable, see Cornforth, *Country Life*, 2 August 2001, p. 44. For Carton, see FitzGerald, *Correspondence of Emily Duchess of Leinster*, vol. I, p. 80, and in particular Lady Kildare to Lord Kildare, 10 May (1759). For Doddington Hall, see Anthony Wells-Cole, *Historic Paper* catalogue of exhibition at Temple Newsam, 1983, p. 34 and reproduced on the back cover. For Grimsthorpe, see Young, *A Six Months Tour Through the North of England*, vol. I, p. 86–8.

37. On plain papers at Strawberry Hill, see Horace Walpole to Horace Mann, 1753 Paget Toynbee, *Strawberry Hill Accounts*, p. 61. See also Mrs Delany, *Correspondence*, Series I, vol. III, p. 477.

38. Mrs Delany, *Correspondence*, Series I, vol. I, p. 289. For the Leeds Castle bed, see Percy Macquoid and Edwards, *Dictionary of English Furniture*, vol. I, p. 33, Fig. 22. This was later at Wateringbury Place, Kent,

39. See Ian Gow, 'An Aberdonian Rococo Drawing Room', a forthcoming article of which a draft is in the National Monuments Record of Scotland.
40. Mrs Delany, *Correspondence*, Series I, vol. III, p. 409.
41. Ware, *A Complete Body of Architecture*, p. 558.
42. For Gopsall, see Saumarez-Smith, *Eighteenth-Century Decoration*, plate 116, p. 139.
43. Chambers, *A Treatise on the Decorative Part of Civil Architecture*, 1791, p. 134.
44. Bristow, *Architectural Colour*, p. 93. Lady Luxborough, *Letters written by the late Right Honourable Lady Luxborough to William Shenstone*, 1775, p. 300. Shenstone to Lady Luxborough, in Marjorie Williams, *The Letters of William Shenstone*, 1939, p. 339. Cuenot's bill for Norfolk House is at Arundel Castle. Photocopy in the Furniture Department of the Victoria and Albert Museum. For the Duchess's bedroom, see Arthur Oswald, *Country Life*, 25 December 1937, p. 654.
45. For Orleans House, see Cornforth, *Country Life*, 15 February 1996, p. 40.
46. Letter, *Country Life*, 16 January 1997, p. 114.
47. Lord Chesterfield to Marquise de Monconseil, 1748. *The Letters of Philip Dormer Stanhope, Earl of Chesterfield*, ed. John Bradshaw, vol. II, 1926, p. 883. For Heythrop, see *Noblemens Seat and Parks*, an unpublished anonymous MS tour of the late 1750s belonging to John Harris. For Hagley, see Young, *Tour through the North of England*, vol. III, p. 347.
48. Pococke quoted in Jane Roberts, *Royal Landscape. The Gardens and Parks of Windsor*, 1997, p. 449.
49. Pippa Mason and Michael Gregory, *Of Gilding*, essay published in connection with the exhibition at Wiggins, 1989. Robert Dossie, *The Handmaid of the Arts*, 1758, vol. I, Part III, chapter 1, p. 367. Lord Lyttelton in Lilian Dickins and M. Stanton, *An Eighteenth-Century Correspondence*, p. 291.
50. Fowler and Cornforth, *English Decoration in the 18th Century*, plate XXIX, facing p. 216.
51. Bristow, *Architectural Colour*, Fig. 36, p. 29.
52. Lord Oxford at Raynham, HMC Portland, vol. VI, 1900, p. 160.
53. Bristow, *Architectural Colour*, p. 77.
54. See MS at Wilton House.
55. Campbell, *The London Tradesman*, p. 108. Mrs Powys at Houghton, *Passages from the Diaries of Mrs Philip Lybbe Powys*, p. 6.
56. Some of the gilding in the saloon at Honington was lost in the course of eliminating dry rot in the 1960s and, although what was saved was cleaned, no attempt was made to replace what was missing. *Country Life*, 21 September 1978, p. 791; 28 September 1978, p. 890; 12 October 1978, p. 1082.
57. Bristow, *Architectural Colour*, plate 50.
58. *Country Life*, 15 August 1991, p. 64.
59. For Orleans House, see *Country Life*, 15 February 1996, p. 40. For Sir John Clerk, see John Fleming, *Robert Adam and His Circle*, 1962, p. 24.
60. See copy of the Canons inventory in the Furniture Department in the Victoria and Albert Museum. The ceiling paintings and stained glass are now in the church at Witley, Worcestershire. The costs bring to mind the gilding shown in a stone-coloured room in Nollekens's *Family in an Interior* reproduced in Charles Saumarez-Smith, *Eighteenth-Century Decoration*, Fig. 132.
61. For Blair glass, see Coleridge, *Chippendale*, plate 100.
62. Robert Dossie, *Handmaid of the Arts*, vol. I, 1758, p. 368. Cuenot bill at Arundel Castle, photocopy in the Furniture Department of the Victoria and Albert Museum. For Farington, see Desmond FitzGerald, *The Norfolk House Music Room*, Appendix A, p. 48. And for general information about Norfolk House, see Arthur Oswald, *Country Life*, 25 December 1937, p. 654, and the *Survey of London*, vol. XXIX, *The Parish of St James Westminster, South of Piccadilly*, Part One, p. 192, with plates in vol. XXX.
63. It has been suggested by Joseph Macdonnell that Cramillion may have done the trophies on the ceiling. See his *Eighteenth-Century Irish Stuccowork*, p. 13.
64. Cuenot's bill at Arundel Castle. Photocopy in Furniture Department of Victoria and Albert Museum.
65. For Farington, see FitzGerald, *Norfolk House Music Room*, Appendix A.
66. Gilbert, *Thomas Chippendale*, vol. I, p. 157.
67. At Uppark, until the fire, one of the first-floor bedrooms retained not only its original flock paper but also a white and gold wooden chimneypiece and a pier-glass in the manner of John Linnell: see Christopher Hussey, *Country Life*, 28 June 1941, p. 563. For Croome Court saloon, see Helena Hayward, 'Splendour at Croome Court. New Light on Vile and Cobb', *Apollo*, May 1974, p. 350. One of the original white and gold chairs in the Palm Room at Spencer House, now gilded, is in the Boston Museum of Fine Arts (see Joseph Friedman, *Spencer House*, Fig. 87, p. 118) and copies in white and gold have been made for the room. At Temple Newsam there is an early eighteenth century glass from Boynton Hall decorated with white and gold papier mâché ornaments. Christopher Gilbert, *Furniture at Temple Newsam*, vol. I, No. 270, p. 215.
68. See Norfolk House inventory and Cuenot's bill, n. 64 above. For the Round-Drawing Room, Strawberry Hill see J. Mordaunt Crook, *Country Life*, 7 June 1973, p. 1598. The Gideon Saint table was formerly on the London art market.
   Another early example was at Grimsthorpe, in what Arthur Young described as the breakfasting closet, which was essentially a medieval room with a vaulted ceiling and decorated with Chinese wallpaper, which still survives. He also said that the shutters, doors and the front of the drawers (let into the wall) were all painted in scrolls and festoons of flowers in green, white and gold, 'the sofa, chairs and stool frames of the same'. Young, *Tour Through the North of England*, pp. 86–8.
69. For Charlecote, see Alice Fairfax-Lucy, *Charlecote and The Lucys*, 1958, p. 229. For Lady Hilsborough's drawing-room, see Mrs Delany, *Correspondence*, Series I, vol. III, p. 409.
70. For Leicester House, see *Survey of London*, vol. XXXIV, p. 450.
71. In 'Reflections of Golden Mirrors, Restoration of Wyatt-Chippendale Glasses at Burton Constable', *Country Life*, 2 August 2001, p. 44, I illustrated the different reactions of water and oil gilding.
72. Houghton, HMC 15th Report, Appendix, Part VI, 1897, p. 85. When the picture gallery at Houghton was opened for Sir Robert Walpole's birthday in August 1743, it was lit by sixty-four candles.
73. For Northumberland House, see Count Kielmansegge *Diary of a Journal to England in 1761–2*, 1902, p. 144. When George III visited the Duchess of Portland at Bulstrode in 1779, 'Her Grace had the house lighted up in a most magnificent manner; the chandelier in the great hall had not been lighted for twenty years'. Mrs Delany, *Correspondence*, Second Series, vol. II, p. 496.
74. Baker, *Duke of Chandos*, p. 184, though this does not cover all the detail.
75. Ware, *Complete Body of Architecture*, p. 469. Hardwickes quoted in *Wimpole Hall*, National Trust guidebook, 1979, p. 52.
76. Mrs Delany, *Correspondence*, Series I, vol. III, p. 176.
77. For lanterns at Frampton, see Christopher Hussey *Country Life*, 15 October 1927, Fig. 12, p. 542.
78. For glass arms, see Murdoch, *Boughton House*, Fig. 63, p. 65. For Temple Newsam, see Gilbert, *Furniture at Temple Newsam*, vol. III, No. 810. For Knole, see *Treasure Houses* catalogue, No. 147, p. 225.
79. For the brackets at St Giles's House, Christies, 26 June 1980, lot 24. Coleridge, *Chippendale*, plate 314, p. 204.
80. For the sconces at Castle Howard, see John Tracy Atkins MS in Yale Center for British Art and quoted in Saumarez-Smith, *The Building of Castle Howard*, 1990, p. 93.
81. James Lomax, *Apollo*, April 1993, p. 244.
82. For Wanstead family, see Saumarez-Smith, *Eighteenth-Century Decoration*, plate 74. Wollaston family, plate 76. For Kiveton, see inventory in the library of the Victoria and Albert Museum. For Hubert, see Gilbert and Murdoch, *John Channon*, p. 18.
83. Martin Mortimer, *The English Glass Chandelier*, 2000, p. 58, plate 16.
84. Cornforth, *Country Life*, 10 June 1971, p. 1428. The history of the room needs further investigation because it is clear that the present arrangement of full-length portraits set in aedicules with segmental pediments must post-date the Duchess of Beaufort's 1750 description of the room, where she mentions three windows on the west wall that correspond to the external glazing. John Harris, 'The Duchess of Beaufort's Observations of Places', *The Georgian Group Journal*, vol. X, 2000, p. 38.
85. The chandelier from St Giles's House was sold at Christies, 26 June 1980, lot 89.
86. *Apollo*, June 1988, Fig. 4, p. 395.
87. For Penshurst chandeliers, see Mortimer, *The English Glass Chandelier*, plates 2 and 3, pp. 43 and 45. Nix's original bill for Ham House is in the Furniture Department of the Victoria and Albert Museum.
88. For Gumley, see E. M. Elville, *The Collector's Dictionary of Glass*, 1961, p. 43. For Thornham, see Mortimer, *The English Glass Chandelier*, colour plate 1, p. 10.
89. For Holkham, see Mortimer, *The English Glass Chandelier*, plate 27, p. 75. Maydwell and Windle's trade card is illustrated *op. cit.*, plate 32, p. 81.
90. For Drumlanrig, see Oman, *Caroline Silver*, plate 66. For Chatsworth, see Thompson, *A History of Chatsworth*, Fig. 69. For Williamsburg, see John D. Davis, *English Silver at Williamsburg*, 1976, p. 13. The chandelier was made by David Garnier for William III between 1691 and 1697. For Hampton Court, see Matthew Winterbottom, '"Such massy pices of plate": Silver Furnishings in the English Royal Palaces 1660–1702', *Apollo*, August 2002. For Petworth, see the inventory taken on the death of the Duke of Somerset, March 1749/50, p. 5, Petworth House archives. Photocopy in the Furniture Department at the Victoria and Albert Museum.
91. For Cholmondeley cistern, Christies, 3 July 1997, lot 15. For Kiveton, see the 1727 inventory in the library of the Victoria and Albert Museum. For Canons, see copy of inventory in the Department of Furniture of the Victoria and Albert Museum. The Blenheim inventory is in the British Library. Tessa Murdoch, *Burlington Magazine*, June 2003, p. 414.

## Chapter 5 William Kent and Architectural Decoration

1. Margaret Jourdain, *The Work of William Kent*, 1948. John Dixon Hunt, *William Kent, Landscape Designer. An Assessment and Catalogue of His Designs*, 1987. On

'decorate', see Margaret Jourdain, *The Work of William Kent*, pp. 48, 61.

Lord Oxford wrote of the dining-room at the Angel Inn at Bury St Edmunds in 1732 'much decorated (as Mr Kent's phrase is, and those that follow him)', quoted in Wilson, *William Kent*, p. 46.

2. For the Hermitage at Richmond, see John Vardy, *Some Designs of Mr Inigo Jones and Mr William Kent*, 1744. For Holkham Temple, see W. O. Hassall, *Country Life*, 16 May 1968, p. 1310.

3. Lord Oxford, HMC, Portland MSS, vol. VI, p. 171.

4. For Palazzo Colonna, see Stephanie Walker and Frederick Hammond, *Life and the Arts in the Baroque Palaces of Rome*, published in connection with the exhibition at the Bard Graduate Center for Studies in the Decorative Arts, New York, 1999. No. 134, p. 162, illustrates watercolours of the gallery in 1732 by Salvatore Colonelli Sciarra that show the arrangement of the pictures. On chinoiserie, see John Harris, 'William Kent and Esher Place' in *The Fashioning and Functioning of the British Country House*, p. 13.

5. Susan and David Neave, 'The Early Life of William Kent', *Georgian Group Journal* vol. VI, 1996, p. 4. For the Talman drawings, see John Harris, *William Talman*, 1982, plate 3, Peter Ward-Jackson, *English Furniture Designs of the Eighteenth Century*, plate 2. Talman to Topham, 1710, in Graham Parry, *John Talman. The Letter Book*, *Walpole Society*, vol. LIX, 1997, p. 110.

6. Stefanie Walker and Frederick Hammond, *Life and the Arts in the Baroque Palaces of Rome*.

7. His only ceiling painting in Rome in the church of S. Giuliano dei Fiamminghi, is reproduced in David Watkin, Anthony Ratclif, Nicholas Thompson, and John Mills, *A House in Town: 22 Arlington Street*, colour plate facing p. 33.

8. Kent to Massingberd, letters in the Lincolnshire Record Office. See a forthcoming volume of the *Walpole Society*.

9. For Stefano della Bella, see Susan Lambert, *Pattern and Design*, published in connection with an exhibition at the Victoria and Albert Museum, 1983. Pp. 43–8, illustrates uses of Stefano della Bella etchings, including a design for a chimneypiece attributed to Stephen Wright for Clumber Park. For Giardini, see Stefanie Walker and Frederick Hammond, *Baroque Palaces of Rome*, No. 53, p. 185.

10. Gibbs frontispiece in Friedman, *James Gibbs*, Fig. 74.

11. Kent to Massingberd, see n. 8. It has been suggested that Guelfi may have modelled the figures on the doorcases soon after he arrived from Rome in 1721, because Kent wrote to Massingberd: 'I hope to have him do ornaments in stucco after ye Italian manner.' The room is now in course of restoration, with the painting and gilding of all below the cornice complete. That points to Campbell being responsible for the architectural framework, with Kent adding the four architrave frames that look forward to the *trompe-l'œil* frames on the staircase at Houghton (Fig. 189). Work is proceeding on the cove, where unexpected traces of Kent's original figurative decoration have been found that bear out his letter to Massingberd. As yet, it is impossible to read the design, but there appear to be parallels with his first proposal for the ceiling of the King's Drawing-Room at Kensington Palace (Fig. 176).

12. James Richards's account for carving at Raynham Hall.

13. Where do the problematic pair of tables recently bought back for the gallery at Chiswick House fit in? They have been dated about 1730, their design attributed to Kent and their making to John Boson and G. B. Guelfi, but their detail recalls not only the pier-tables in the saloon at Houghton but the decoration of the cove of the Stone Hall. John Harris has suggested that they may have been made for the old house at Chiswick, and so represent Kent's early thoughts, perhaps in about 1723–4. Certainly it is curious that that they were placed facing the windows with great glasses above them: so does that support the idea that were they originally designed for another location and reused in that position?

Kent also took over the form of side table with a richly carved front that had been developed in France and brought to England by the Huguenot carvers like the Pelletiers Tessa Murdoch, 'Jean, Rene and Thomas Pelletier – a Huguenot family of carvers and gilders in England 1682–1726', *Burlington Magazine*, November 1997, p. 732; June 1998, p. 363.

14. *History of the King's Works*, vol. V, H. M. Colvin and John Newman, *The Royal Palaces 1660–1782*, 1976, p. 198. Edward Impey, *Kensington Palace*, 2003. Kent's appointment was also supported by Thomas Coke (1674–1727), the Vice Chamberlain of the Household. He was the son of Lt.-Col. John Coke of Derbyshire and not directly related (if at all) to the builder of Holkham. D. P. Mortlock, *Holkham Notes and Annals*, privately printed, 2002, p. 83.

15. For Thornhill, see Edgar Mayhew, *Sketches by Thornhill . . .*, 1967, plate 38. For the Cupola Room, see Cornforth, *Country Life*, 5 January 1995, p. 32. *Vertue*, vol. III, *Walpole Society*, vol. XXII, 1933–4, p. 55.

16. Vertue, vol. III, *Walpole Society*, vol. XXII, 1933–4, p. 19. It was a less original idea in decoration than is usually assumed at Kensington, because it was also fashionable in Italy and France both for the decoration of walls and ceilings,as can be seen in Jean Le Moyne (1638–1713), *Plus desseins de plafond dedies a Monsieur frere du Roy* and Marot's *Second livre*. Also, it was used in England by Vanderbank for tapestry, as can be seen at Burghley House.

17. PRO XC 159 33 Work 6/15. Kent's design for the Drawing-Room chimneypiece is in the RIBA Drawings Collection.

18. For the North Hall at Stowe, see John Harris, *The Design of the English Country House*, plate 30, p. 135; plate 30a, p. 134. John Harris: 'William Kent's Drawings at Yale and Some Imperfect Ideas upon the subject of His Drawing Style', p. 137 of *Essays in Honour of Paul Mellon, Collector and Benefactor* ed. John Wilmerding, 1986.

19. *Vertue*, vol. III, *Walpole Society*, vol. XXII, 1933–4, p. 50.

20. Drawing-Room table drawing in Victoria and Albert Museum reproduced in Peter Ward Jackson, *English Furniture Designs of the 18th century*, 1958, plate 18.

21. The Grafton drawing is in a private collection.

22. *Vertue*, vol. III, *Walpole Society*, vol. XXII, 1933–4, p. 19.

23. Duchess Sarah to Lady Diana Spencer, quoted in Gladys Scott Thomson, *Letters of a Grandmother 1732–1735*, 1943, p. 76.

24. The most recent account of Kensington Palace is to be found in Impey, 2003.

25. Kent drawings, William Kent sale, 1749; H.R.; Dukes of Newcastle until 1938; Sothebys, 7 July 1983, lot 100; Sothebys, 19 November 1992, lot 31. For the *Markets*, see Larissa Dukelskaya and Andrew Moore (eds), *A Capital Collection. Houghton Hall and the Hermitage*, published in connection with the exhibition of Houghton pictures from the Hermitage at Somerset House, London, 2002, p. 236. New drawings in Paris sold by Drouot-Richelieu, 13 June 2001, lots 43, 49. Also other drawings by Kent and his circle.

26. For the Houghton Gallery, see John and Josiah Boydell, *A set of prints engraved after the most capital paintings in the collection of Her Imperial Majesty, the Empress of Russia. Lately in the possession of the Earl of Orford at Houghton in Norfolk*. For the *Markets*, see Dukelskaya and Moore (eds), *A Capital Collection*, Nos. 133–6, p. 236.

27. For Carlo Maratti, see Dukelskaya and Moore, *A Capital Collection*, No. 41, p. 134. Vertue, vol. V, *Walpole Society*, vol. XXVI, 1937–8, pp. 14, 121.

28. Adam Bowett, 'The Commercial Introduction of Mahogany and Naval Stores Act of 1721', *Furniture History*, vol. XXX, 1994, p. 43.

29. Lord Hervey letter to Frederick, Prince of Wales, in *Memoirs of the Reign of George II*, vol. II, 1848, also Earl of Ilchester, *Lord Hervey and His Friends*, 1950, p. 71. At Houghton there is an unpublished design for a two-storey hall that may relate to a Gibbs scheme.

30. For the Arch of Constantine, see P. P. Bober & R. O. Rubinstein, *Renaissance Artists and Antique Sculpture*, 1986, plates 182 d and e. For the busts, see Dukelskaya and Moore, *A Capital Collection*, pp. 328–30, 339.

31. The original chandelier was sold to the 4th Earl of Chesterfield between 1747/8 and 1752 and it remained at Chesterfield House, London until the sale of 1932, since when it has disappeared. It appears in *Country Life* photographs of the staircase hall at Chesterfield House. The fact that it was gilt metal raises the possibility that it was supplied by William Hubert, the possible maker of the other metal chandeliers at Houghton (see pp. 132 and Fig. 160). Dukelskaya and Moore (eds), *A Capital Collection*, p. 349.

32. For Wolterton, see p. 23. For the pictures in the saloon, see Dujelskaya and Moore (eds), *A Capital Collection*.

33. For Chiari's ceiling, see Ellis Waterhouse, *Roman Baroque Painting*, 1962, plate 21. For Stephen Wright's use of a Stephano della Bella etching in a chimneypiece design, see Susan Lambert, *Pattern and Design. Designs for the Decorative Arts 1480–1980*, 1983, published in connection with the exhibition at the Victoria and Albert Museum, plates 2.1.a, 2.1.c.

34. Only a few of the pictures in The Hermitage retain their Walpole frames and the only visual evidence is in the sections in Ware's plates of the house.

35. Roberts's bill is at Houghton. Otherwise he is unrecorded. There is no known connection between this Thomas Roberts and Thomas (1685–1714) and Richard Roberts (1714–21), who were joiners, chair-makers and carvers and are particularly known for their work for the Royal Household. James Richards's man, Ralph Kite, was at Houghton in 1728–9. See Geoffrey Beard, 'Kentian furniture by James Richards and others', *Apollo*, January 2003, p. 37.

36. Walker and Hammond, *Baroque Palaces in Rome*, No. 58, p. 190–1.

37. Mrs Powys, *Passages from the Diaries*, p. 6. The use of stone and olive colours is discussed on p. 114; and the white paint may have been first introduced when the 3rd Lord Orford rehung the room after the sale of the pictures in 1779.

38. Dukelskaya and Moore (eds), *A Capital Collection*.

39. Presumably the 3rd Lord Orford found the velvet hangings badly bruised by the picture frames when he sold the pictures in 1770. By 1792 they were replaced by striped hangings. The estimate is at Houghton.

40. For the picture in the Green Bedchamber, see Dukelskaya and Moore (eds), *A Capital Collection*, No. 174, p. 271.

41. Moore, *Houghton Hall*, p. 128, Fig. 59.

42. I am grateful to Lucy Wood for this observation about the needlework bed. Another possible contemporary purchase by Sir Robert is the head of the glass engraved with the Walpole saracen's head crest that Horace Walpole reused in the overmantel in the gallery at Strawberry Hill. For the Calke bed, see *Treasure Houses* catalogue, No. 375, p. 442. I am

grateful to Lynda Hillyer for pointing out to me that the embroidery is English rather than Indian, as had been thought.

43. For the Ashmolean drawing for Cabinet Drawing-Room, see Charles Saumarez-Smith, *Eighteenth-Century Decoration*, plate 47, p. 65. An anonymous post-1742 drawing in the house is illustrated in Andrew Moore, *Houghton Hall*, No. 56, p. 138. For the overmantel, see ibid., Fig. 61, p. 134.

44. Rysbrack's cartoon for the relief in the Marble Parlour is in the British Museum. Reproduced in Moore, *Houghton Hall*, No. 57, p. 140. For the Clandon overmantels, see *Country Life*, 10 September 1927, p. 366.

45. For Fischer von Erlach, see Michael Snodin, 'Paul de Lamerie's Rococo', p. 20 in *Paul de Lamerie*, catalogue of exhibition at Goldsmiths Hall, 1990.

46. While there is no evidence, it is, of course, possible that when Sir Robert sent down pictures from London in 1742 he sent furniture as well.

47. The Walpole silver is illustrated in Moore, *Houghton*, Fig. 60, p. 142; Figs. 61 and 62, p. 143. He also mentions designs by Lamerie for silver chandeliers for Sir Robert. Christopher Hartop, *The Huguenot Legacy*, No. 31, pp. 178–81. The Wickes tureen is illustrated in Barr, *George Wickes*, plate 70 was acquired by Norwich Castle Museum in 2003.

48. It is interesting to compare the design of the room and its use of Venetian window motifs with Kent's design for the dining-room at Wotton House, Surrey, in the Ashmolean Museum, Oxford.

49. There are no payments to Kent in the Raynham papers, but there are references to his working there by Sir Thomas Robinson in 1731 and Lord Oxford in 1732. The most recent account of Raynham in the early eighteenth century is by James M. Rosenheim, in *The Townshends of Raynham*, 1989.

50. James Richards's account for carving at Raynham Hall.

51. For the Vere Captains, see Andrew Moore, *Family and Friends: A Regional Survey of British Portraits*, a catalogue of exhibition at the Castle Museum, Norwich, 1992, plate 28. The portrait of Captain Sir Thomas Dutton in its frame is illustrated in the National Trust guidebook to Lodge Park (2001), pp. 16 and 17. Three more of the Captains are at Courteenhall, Northamptonshire, with two of them appearing in Hussey's *English Country Houses Mid-Georgian*, Fig. 475, p. 231.

52. Geoffrey Beard, 'William Kent and the Royal Barge', *Burlington Magazine*, August 1970, p. 488.

53. *Treasure Houses* catalogue, No. 147, reproduced on p. 225.

54. Robert Sackville-West, *Knole*, National Trust guidebook, 1998, illustrated on p. 13.

55. John Harris, 'William Kent and Esher Place', *The Fashioning and Functioning of the British Country House*, p. 13.

56. Edward McParland, 'Edward Lovett Pearce and the Parliament House in Dublin', *Burlington Magazine*, February 1989, p. 91.

57. Brettingham, *The Plan Elevations and Section of Holkham in Norfolk, the Seat of the late Earl of Leicester*.

58. *The History of the Kings Works*, vol. v, p. 242. Plate 30 shows a drawing of the interior in Westminster City Library and an alternative design by William Kent in Sir John Soane's Museum.

One major missing commission from the Kent story is Devonshire House, Piccadilly, which was a rebuilding after a fire of a late-seventeenth-century house, possibly by Talman, carried out for the 3rd Duke between 1734 and about 1740. Unfortunately it is poorly documented, because there appear to be no designs, accounts or early inventory; and the best evidence is in late nineteenth- and early twentieth-century photographs which show the interiors

heavily overlaid by the 6th Duke. However, the quality of the work can still be judged from overmantels at Chatsworth and in the Manchester City Art Gallery. See Cornforth, *Country Life*, 13 November 1980, p. 1750; 20 November p. 1894. What is not clear is how far the house was, in fact, a rebuilding of a late-seventeenth-century house in the manner of Talman and the extent to which Kent was bound by an existing plan.

At Chatsworth there is the largest concentration of Kentian furniture but with few exceptions it is tantalizingly unclear what originally came from Devonshire House, Chiswick and Compton Place, what the 6th Duke of Devonshire bought at the Wanstead sale, and what he had made by a carver called Cribb. It appears that the 3rd Duke may have done some refurnishing at Chatsworth before he died in 1764.

59. For Kent's paintings, see Oliver Millar, *Tudor, Stuart and Early Georgian Pictures in the Royal Collection*, 1963, Nos. 505–7, p. 171.

60. Juliet Allan, 'New Light on Kent at Hampton Court Palace', *Architectural History*, vol. 27, 1984, p. 50. Simon Thurley suggests that Kent copied one of Wolsey's ceilings in the palace.

61. John Harris, *Esher Place, Fashioning and Functioning of the British Country House*, p. 13.

62. Walpole to Mann, *Yale Edition of Horace Walpole's Correspondence*, vol. 9, p. 71. Gray to Wharton, Paget Toynbee and Leonard Whibley (eds), *Correspondence of Thomas Gray*, vol. 1, 1734–55, 1935, p. 404.

63. Christopher Hussey, *Country Life*, 17 May 1946, p. 900; 24 May 1946, p. 946.

64. Horace Walpole to Richard Bentley, September 1753, *Yale Edition of Horace Walpole's Correspondence*, vol. 35, p. 154.

65. For 44 Berkeley Square, see Mark Girouard, *Country Life*, 27 December 1962, p. 1648. The building accounts in Sir John Soane's Museum show the house was built in 1742–4. A drawing for the saloon ceiling that is a key to the subjects of the cameos appeared in 2002 on the London art market, where it was attributed to Kent. It came from a batch of drawings sold in Paris in 2001 that included several indisputably by Kent and thought to have descended via Stephen Wright, to whom some have been attributed.

66. Peter Campbell (ed.), *A House in Town: 22 Arlington Street and Its Owners*, 1984.

67. For Wakefield Lodge, see *Country Life*, 2 August 1973, p. 298. Walpole to Montagu, *Yale Edition of Horace Walpole's Correspondence*, vol. 9, p. 122.

68. John Hayward, 'William Kent and Plate', *Connoisseur*, March 1969; July 1969; June 1970. Charles Oman, 'Silver Designed by William Kent', *Apollo*, January 1972, p. 72.

69. Barr, *George Wickes*, p. 94. Two of the chandeliers are at Anglesey Abbey, a third is in the Boston Museum and a fourth was sold at Christies.

What other plate he designed or what influence he had on silver is problematic, but in the Victoria and Albert Museum is a silver arm badge made for the oarsmen of the Admiralty barge in 1736–7 by William Lukin, very close to Kent's design for the Royal barge.

70. Montford tureens sold at Sothebys, 10 November 1994.

71. For the hall at Badminton, see *Country Life*, 9 April 1987, p. 128.

72. For Stephen Wright's drawings, see *British Master Drawings* catalogue of collection at Lowell Libson, London, 2002. For Worcester Lodge, see *Country Life* 1939. One of the designs for the interior, attributed to Kent, is illustrated by Howard Colvin, *Country Life*, 4 April 1988, p. 800.

73. Susan Lambert (ed.), *Pattern and Design*, pp. 44–5.

74. For the bureau plat, see Peter Ward Jackson, *English Furniture Designs*, Fig. 45. For Victoria and Albert

Museum glass, see Edwards, *Shorter Dictionary of Furniture*, p. 364.

75. For the Vardy bed, see Peter Ward Jackson, *English Furniture Designs*, Fig. 44. For the Hardwick bed, described by the Duchess of Northumberland see *Country Life*, 7 February 1974, p. 250.

76. Friedman, *Spencer House*, p. 111.

77. Bristow, *Architectural Colour*, p. 71.

78. One of the Vardy tables now belongs to the Victoria and Albert Museum and the other to Temple Newsam, and both are on loan to Spencer House.

79. Vardy drawing at Holkham.

80. The Hackwood design dated 1761 is in the RIBA Drawings Collection and another was at Christies, 8 July 1999. The 5th Duke's taste can also be seen in the extravagant Rococo epergne marked by John Parker and Edward Wakelin and hall marked 1760 is now in the Boston Museum of Fine Arts and discussed in Ellenor M Alcorn, *English Silver in the Boston Museum of Fine Arts*, vol. II, 2000, p. 188.

81. For Richards, see Beard and Gilbert, *Dictionary of English Furniture Makers*, p. 742.

82. For Howard, see Beard and Gilbert, *Dictionary of English Furniture Makers*, p. 454. Dukelskaya and Moore, *A Capital Collection*, p. 435.

83. For Boson, see Beard and Gilbert, *Dictionary of English Furniture Makers*, p. 88. *Vertue*, vol. III, *Walpole Society*, vol. XXII, 1933–4, p. 116. For Badminton, see *Country Life*, 9 April 1987, Fig. 5, p. 130.

84. For Moore, see Beard and Gilbert, *Dictionary of English Furniture Makers*, p. 618.

85. For Lodge Park, see Christopher Gilbert, 'James Moore the younger and William Kent at Sherborne House', *Burlington Magazine*, March 1969, p. 148. Christopher Gilbert, *Furniture at Temple Newsam*, vol. II, p. 268. I am grateful to Jeffrey Haworth for sending me the late Nick Moore's notes, prepared for the National Trust.

86. Murdoch, *Boughton House*, Fig. 133.

87. For Goodison, see Beard and Gilbert, *Dictionary of English Furniture Makers*, p. 351. For the Boughton frames, see plate 45.

88. *Country Life*, 26 April 2001, p. 102. Tessa Murdoch, *Burlington Magazine*, June 2003, p. 420.

89. For the Longford table, see Percy Macquoid and Ralph Edwards, *Dictionary of English Furniture*, 1st edition, vol. III, p. 261, Fig. 26. For the Firle tables, see Arthur Oswald, *Country Life*, 24 February 1955, p. 564. For Badminton, see *Country Life*, 9 April 1987, p. 133, Fig. 7. That the form had an Italian origin can be seen from seventeenth-century examples in the Palazzo Spada in Rome.

90. I am grateful to Lucy Wood for the reference to Dudley Ryder. For Roger Morris, see Richard Hewlings, *Adderbury House*, published in the proceedings of a conference on the Early Eighteenth-Century Great House held in January 1996, ed. Malcolm Airs, and published by the Department of Continuing Education, University of Oxford. For the Brodie trade card and eagle table, see Bamford, *Furniture History*, vol. XIX, 1983, plate 24a and b. For the Innes House table, see Francis Bamford, *Furniture History*, vol. XIX, 1983, plate 24b. See also Sebastian Pryke, 'Francis Brodie: A Palladian Furniture Maker in Scotland', in *Aspect of Scottish Classicism. The House and Its Formal Setting*, St Andrews Studies in the History of Scottish Architecture and Design, 1988.

91. For Boughton tables, see Murdoch, *Boughton House*, p. 135, Fig. 136.

92. For Whittle and Alscot, see Helena Hayward and Pat Kirkham, *William and John Linnell*, vol. 1, 1980, p. 73.

93. For Lydiard Tregoze, see *Country Life*, 26 March 1948, p. 626. For Heath Hall, see *Country Life*, 3 October 1968, p. 816.

94. On collecting Kent plate, see Barr, *George Wickes*, p. 101.

## Chapter 6 Parade, Comfort and Variety, 1740–60

1. Worsley, *Classical Architecture in Britain*, p. 223.
2. Sanderson drawing, *Architectural Drawings from the Collection of the Royal Institute of British Architects*, 1961, plate 13.
3. *Country Life*, 11 December 1969, p. 1582, Fig. 7.
4. Macaulay, *The Classical Country House in Scotland*, p. 93.
5. Lady Hertford, *Correspondence*, vol. II, p. 253.
6. Ibid., vol. III, p. 6. Mrs Delany, *Correspondence*, Series I, vol. II, p. 532. And on Bulstrode, see Mrs Delany, *Correspondence*, Series I, vol. III, p. 260. See also Robert Dossie, *Handmaid of the Arts*, vol. II, Part V, p. 361.
7. Lady Luxborough, *Letters written by the late Right Honourable Lady Luxborough to William Shenstone*, 1775, p. 236.
8. For Cottesbrooke, see Arthur Oswald, *Country Life*, 22 February 1936, p. 194; Gordon Nares, 24 March 1955, p. 506. For Hartlebury, see James Lees-Milne, *Country Life*, 23 September 1971, p. 741. For Stratfield Saye, see *Country Life*, 10 December 1948, p. 1219. For Witley, see Cornforth, *Country Life*, 9 April 1992, p. 54. For Grimsthorpe, see Gervase Jackson Stops, *Country Life*, 3 December 1987, p. 140. For Doddington, see *Country Life*, 3 February 1994, p. 46.
9. For Dunster, see Cornforth, *Country Life*, 9 April 1992, p. 56. For Alscot, see Mark Girouard, *Country Life*, 22 May 1958, p. 1124.
10. I am grateful to Ian Gow for the information on Duff House. See Ian Gow and Timothy Clifford, *Duff House*, guidebook, 1995, p. 50. For Ian Gow, 'An Aberdonian Rococo Drawing Room', see chapter 4, n. 39, above. For Ireland, see David Griffin, 'Eighteenth-Century Papier Mâché Ceiling Decoration in Ireland', *Irish Arts Review*, 1995.
11. Dan Eaton, *The Letters of Daniel Eaton to the Third Earl of Cardigan 1725–1732*, ed. Joan Wake and Deborah Champion Webster, Northamptonshire Record Society, 1971, vol. XXIV, p. 121. For Joseph Emerton, see Bristow, *Architectural Colour*, pp. xv and 67. For Newhailes, see *Country Life*, 28 November 1996, p. 42.
12. For Irish cotton, see Ada Longfield, *Country Life*, 7 December 1972, p. 578. Mrs Delany, *Correspondence* Series I, vol. III, p. 180. Leonard Labaree (ed.), *The Papers of Benjamin Franklin*, 1963, vol. 7, p. 382. These references can be compared with the samples of dress cottons in *Barbara Johnson's Album of Fashions and Fabrics*, ed. Natalie Rothstein, 1987.
13. For Robert Jones, see *Nancy Graves Cabot. In Memoriam, Sources of Design for Textiles and Decorative Arts, Museum of Fine Arts, Boston*, published in connection with an exhibition in 1973, pp. 38–9. It is possible that the swans are taken from extracts of prints by Francis Barlow. See Helena Hayward, *Furniture History*, vol. 11, 1975, plate 106.
14. Walpole to Mann, 12 June 1753, *Yale Edition of Horace Walpole's Correspondence*, vol. 20, p. 382. The wallpaper in the principal bedroom at Christchurch Mansion (Fig. 120) could well have matched the hangings of the bed and so be possibly the earliest surviving.
15. Anthony Coleridge, 'James Cullen, cabinet-maker at Hopetoun House', *Connoisseur*, November 1966, p. 154; December 1966, p. 231.
16. Michael Archer, *Delftware: The Tin-Glazed Earthenware of the British Isles. A catalogue of the collection at the Victoria and Albert Museum*, 1997. For Goldney House, see *Country Life*, 6 August 1948, p. 278. For Frampton Court, see Christopher Hussey, *Country Life*, 15 October 1927, p. 538.
17. See Michael Archer, *Delftware* for examples in the Victoria and Albert Museum, p. 421.
18. John Carwitham floor cloth designs reproduced in Christopher Gilbert, James Lomax and Anthony Wells-Cole, *Country House Floors*, Temple Newsam, 1987, pp. 13–17.
19. For Burton Constable, see Ivan Hall, *Country Life*, 6 May 1982, p. 1278. For Lydiard Tregoze, see Christopher Hussey, *Country Life*, 18 March 1948, p. 578. For Farnborough, see Cornforth, *Country Life*, 11 July 1996, p. 52.
20. For Cheere busts, see *The Man at Hyde Park Corner: Sculpture by John Cheere, 1709–1787*, catalogue of exhibition, Temple Newsam, 1974. Mrs Delany, *Correspondence*, Series I, vol. III, p. 96. Another example of the use of plaster busts is Carr's choice of Shakespeare and Milton for the staircase at Fairfax House, York, in 1762. Cornforth, *Country Life*, 7 March 1985, p. 571, Fig. 4.

    Matthew Brettingham the younger also hoped to profit from the market for casts of busts and classical sculpture and by the time he returned from Italy he was able to offer plaster casts of sixty busts. However, it did not prove to be as profitable a trade as he had hoped. John Kenworthy-Browne, 'Matthew Brettingham's Rome Account Book 1747–1754', *Walpole Society*, vol. XLIX, 1983, pp. 42–3.

21. For Honington brackets see Cornforth, *Country Life*, 28 September 1978, p. 890. For Weald Hall, see *Country Life*, 13 October 1914, p. 454. For Felbrigg, see *Rococo* catalogue, p. 309, S 55.
22. For the Premnay letters: Gow, 'An Aberdonian Rococo Drawing Room', see chapter 4, n. 39, above.
23. For the Walpole salver, see Glanville, *Silver in England*, 1987, Fig. 82, p. 217. For Lamerie, see Michael Snodin, 'Paul de Lamerie's Rococo' in *Paul de Lamerie: The Work of England's Master Silversmith 1688–1751*, published in connection with the exhibition at Goldsmiths' Hall, London, 1990, p. 23. Hogarth did a book plate for Lamerie: see Snodin, *Lamerie*, p. 12.
24. Barr, *Wickes*, pp. 79, 80.
25. For Moser, see Richard Edgcumbe, *The Art of the Gold Chaser in Eighteenth-Century London*, 2000. The plasterwork of the Rotunda at Ranelagh was designed by G. M. Moser and, according to Vertue, vol. III, p. 150, 'executed by French and Italians', *Rococo Art and Design in Hogarth's England Walpole Society*, vol. 22, p. 73, but clearer illustrations in Richard Edgcumbe, *The Art of the Gold Chaser*, plate 87a. For Shruder and papier mâché, see Snodin, *Lamerie*, pp. 24–5.
26. For the Gilbert box, see Richard Edgcumbe, *The Art of the Gold Chaser*, 2000, Figs. 12a, b, c. The box, about 1720, and the related etching by François Chauveau. For Mountrath dish, see Snodin, *Paul de Lamerie*, No. 92, p. 142. For Lytham staircase, see Mark Girouard, *Country Life*, 21 July 1960, p. 130.
27. Arthur Grimwade attributed them to Lock when he illustrated them for the first time in *Rococo Silver 1727–1765*, plate 96, p. 16, but since then they have been attributed to Sprimont, see *Rococo* catalogue, p. 113.
28. Beard and Gilbert, *Dictionary of English Furniture Makers*. Lisa White, *Pictorial Dictionary of British 18th century Furniture Design*, 1990.
29. On plasterwork, see Geoffrey Beard, *Decorative Plasterwork in Great Britain*, 1975. For Ragley, see Arthur Oswald, *Country Life*, 1 May 1958, p. 939; 8 May 1958, p. 1007. For 85 St Stephens Green, see Cornforth, *Country Life*, 20 October 1994, p. 62. For Mawley, see *Country Life* 2 July 1910, p. 19. For Shugborough, see *Country Life*, 4 March 1954, p. 590. For Gilling, see *Country Life*, 26 September 1908, p. 416. For Lytham, see *Country Life*, 21 July 1960, p. 130.
30. For Roberts, see Beard, *Decorative Plasterwork in Great Britain*, p. 235. For Stocking, see idem, p. 247. The Dorset, Somerset and Wiltshire plasterers' work can be seen in various houses, including Crichel, Little Durnford and Malmesbury House in Salisbury.
31. For Scottish plasterers, see Beard, *Decorative Plasterwork in Great Britain*. For Hamilton Palace, see H. Avray Tipping, *Country Life*, 14 June 1919, p. 716.
32. For Joseph Hall of Hull trade card, see Cornforth, *Country Life*, 3 October 1974, p. 932. For Wright and Elwick, see Beard and Gilbert, *Dictionary of English Furniture Makers*, p. 1006. In the Wentworth Woodhouse sale at Christies on 8 July 1998, there were a group of pieces associated with the firm.

    In Shropshire there were the carvers John van der Hagen, who appeared working with T. F. Pritchard in the 1760s when he was probably in his thirties, together with John Nelson and another carver called Swift. They are mainly recorded doing architectural carving but presumably they were capable of carving the frames recorded by Pritchard in his book. It is possible that they might have travelled north via Hagley. See Julia Ionides, *Thomas Farnolls Pritchard of Shrewsbury, Architect and 'Inventor of Cast Iron Bridges'*, 1999.

    For Scottish furniture-makers, see Francis Bamford, *Dictionary of Edinburgh Wrights and Furniture Makers 1600–1840, Furniture History*, vol. XIX, 1983. For Irish furniture-makers, see The Knight of Glin, *Irish Furniture*, 1978. For Booker, see The Knight of Glin, *Country Life*, 28 January 1971.

33. For Brunetti, see Lisa White, *Pictorial Dictionary of British 18th Century Furniture Design*, p. 34, 99, 262, 322, 398. For Paine at Doncaster, see Peter Leach, *Country Life*, 6 July 1978, p. 18.
34. For the Newburgh glass in the White Drawing-Room, see *Country Life*, 11 November 1905, p. 624. Helena Hayward, *Thomas Johnson and English Rococo*, 1964, p. 17, plate 13. For Blair girandoles and Corsham glasses after Johnson, see Coleridge, *Chippendale*, plates 104, 105; Hagley girandoles: Coleridge, *Chippendale*, plates 107, 108.
35. Morrison Heckscher, 'Gideon Saint', *Metropolitan Museum of Art Bulletin*, February 1969.
36. Joseph McDonnell, *Irish Eighteenth Century Stuccowork*, introduction.
37. Wilfrid Blunt, *The Art of Botanical Illustration*, 1950. John Irwin and Katherine Brett, *The Origins of Chintz*, 1970, p. 99 and plate 76.
38. Natalie Rothstein, *Silk Designs of the 18th Century*, 1990, pp. 29, 33.
39. Florence Montgomery, 'John Holker's Mid-Eighteenth-Century Livre d' Echantillons', ed. Veronika Gervins, *Studies in Textile History*, 1977, p. 214.
40. For Northumberland toiles, see Cornforth, *Country Life*, 12 June 1969, p. 1536. The Syon panels were sold by Sothebys at Syon on 14, 15, 16 May 1997, with the largest panel, measuring 10'11" by 16'4" as lot 17. That and several other panels are illustrated in the catalogue. It also quotes three payments to Clermont between 9 July 1750 (£30) and 22 December 1752 (in full, £75), with £12 for painting a glass still in one of the closets off the gallery at Syon. For Dixon, see Ada K. Longfield, 'Samuel Dixon's Embossed Pictures of Flowers and Birds', *Irish Georgian Society Bulletin*, October– December 1975.
41. For Chesterfield House, see H. Avray Tipping, *Country Life*, 4 March 1922, p. 309. For Petworth, see Christopher Hussey, *Country Life*, 19 December 1925, p. 967. For Norfolk House, see *Country Life*, 25 December 1937, p. 634. For Woodcote Park, see John Harris, *The Connoisseur*, May 1961. For

Stratfield Saye, see *Country Life*, 3 December 1948, p. 1162. For Woburn, see Giles Worsley, *Country Life*, 22 April 1993, p. 51; *Rococo* catalogue, p. 204.

42. Louisa Conolly, unpublished letter of 16 July 1761 belonging to the Hon. Desmond Guinness, quoted in Fowler and Cornforth, *English Decoration in the 18th century*, p. 25. For the Leicester letters, see Christine Hiskey, *Architectural History*, vol. 40, 1997, p. 144.

43. Lord Lyttelton, in Lilian Dickins and Mary Stanton, *An Eighteenth-Century Correspondence*, p. 235.

44. For Sanderson Miller, see H. M. Colvin, *Dictionary of British Architects*, 3rd edition, p. 653. See also Dickins and Stanton, *An Eighteenth-Century Correspondence*.

45. Colvin, *Dictionary of British Architects*, p. 699. Michael McCarthy, 'Sir Roger Newdigate: Drawings for Copt Hall, Essex and Arbury Hall', *Warwickshire Architectural History*, 1973, p. 26. For Arbury library, see Gordon Nares, *Country Life*, 15 October 1953, p. 1210. See also John Newman, 'Copt Hall, Essex' in H. M. Colvin and John Harris, *The Country Seat*, p. 18. Michael Hall, *Country Life*, 7 January 1999, p. 30; 14 January 1999, p. 40. Michael McCarthy, *The Origins of the Gothic Revival*, 1987, chapter V.

46. The literature on Strawberry Hill is enormous, but probably the most useful introduction to the interior and its contents is the chapter devoted to it by Clive Wainwright in *The Romantic Interior*, 1989, p. 71. See also J. Mordaunt Crook, *Country Life*, 7 June 1973, p. 1598; 14 June 1973, p. 1726; 21 June 1973, p. 1794.

47. For John Freeman, see Colvin, *Dictionary of British Architects*, p. 381. William Jones had also taken over the building of Edgecote, near Honington, after the death of William Smith, which may explain why he was employed at Honington.

48. For Thomas Wright, see Eileen Harris, *Country Life*, 26 August 1971, p. 492; 2 September 1971, p. 546; 9 September 1971, p. 612. Colvin, *Dictionary of British Architects*, 3rd edition, p. 1100. For Nuthall Temple, see Christopher Hussey, *Country Life*, 28 April 1923, p. 570; 5 May 1923, p. 606.

49. Mrs Delany, *Correspondence*, 6 vols. Ruth Hayden, *Mrs Delany: Her Life and Flowers*, 1980. For Lybbe Powys, see Emily J. Climenson (ed.), *Passages from the Diaries of Mrs Philip Powys*. For Lady de Grey, see Joyce Godber, *The Marchioness Grey*. For the Lennox sisters, see Brian Fitzgerald (ed.), *Correspondence of Emily Duchess of Leinster*, vol. I, 1949; vol. II, 1953; vol. III, 1957. Stella Tillyard, *Aristocrats*.

50. Mark Girouard, *Country Life*, 23 November 1961, p. 1280; 30 November 1961, p. 1321.

51. Horace Walpole to Horace Mann, 23 November 1741, *Yale Edition of Horace Walpole's Correspondence*, vol. 17, p. 210. Cornforth, *Country Life Annual*, 1970, p. 138.

52. Mrs Howard (Henrietta Hobart), see Julius Bryant, *Mrs Howard: A Woman of Reason*, 1988. For Mrs Campbell, see British Library Add MSS 22627, folio 93, quoted in Julius Bryant, *Mrs Howard*, p. 9.

53. For Lady Oxford, see *Georgian Group Journal*, 2001, p. 133.

54. The Duchess of Portland was a great friend of Mrs Delany and one of the principal characters in the latter's *Correspondence*. Sally Festing, *Country Life*, 12 June 1986, p. 1684; 19 June 1986, p. 1772.

55. For Lady Cardigan, see Margaret Jourdain and R. Soame Jenyns, *Chinese Export Art in the 18th century*, 1950, p. 31.

56. For Lady Louisa Conolly see *Country Life*, 10 April 1969, pp. 882–5.

57. For Rokeby, see Giles Worsley, *Country Life*, 26 March 1987, p. 176. For the print-room, see Chloe Archer, 'Festoons of Flowers . . . for fitting up print rooms', *Apollo*, December, 1989, p. 386. Terry Friedman, *A Convenient and Pleasant Habitation*,

Leeds Art Calendar, No. 89, 1981. For Horace Walpole's use of prints, see Paget Toynbee, *Strawberry Hill Accounts*, p. 61.

58. Mrs Delany, *Correspondence*, Series I, vol. III, p. 34.

59. J (Margaret Jourdain), *Country Life*, 4 February 1933, p. 126.

60. Lady Mary Coke on the Duchess of Norfolk, *The Letters and Journals of Lady Mary Coke*, vol. IV, 1772–4, reprinted 1970, p. 101. Lady Hertford, *Correspondence*, vol. III, p. 219.

61. Cornforth, *Country Life*, 31 May 1990, p. 149.

62. Mrs Delany, *Correspondence*, Series I, vol. II, p. 21, vol. III, p. 308.

63. Lady Kildare, *Correspondence of Emily Duchess of Leinster*, vol. I, p. 151.

64. Cornforth, *Country Life*, 16 April 1992, p. 112.

65. Young, *Northern Tour*, p. 143. Duchess of Northumberland quoted in *Country Life*, 7 February 1974, p. 250.

66. Lord Lyttelton quoted in *Country Life*, 27 April 1989, p. 137.

67. For Wallington, see *Country Life*, 16 April 1970, p. 854; 23 April 1970, p. 922.

68. For Arniston, see Christopher Hussey, *Country Life*, 15 August 1925, p. 250; 22 August 1925, p. 284.

69. For Hawksmoor's orangery, see Kerry Downes, *Hawksmoor*, 1959, pp. 81–2, Fig. 21a; Kerry Downes, *English Baroque Architecture*, 1966, Fig. 85. For Seaton Delaval, see plan in *Vitruvius Britannicus* III. For Chiswick, see Harris, *The Palladian Revival*. For 12 North Audley Street, see Christopher Hussey, *Country Life*, 15 November 1962, p. 1212. For the Garrett design, see *Country Life*, 26 April 2001, p. 102.

70. For Thomas Wright, see *Country Life*, 26 August 1971, p. 492; 2 September 1971, p. 546; 9 September 1971, p. 612.

71. For Panton Hall, see John Harris, *William Talman*, pp. 40–2. Payments to John James for work at Ham in the 4th Earl of Dysart's account book. Photocopy in the Furniture Department of the Victoria and Albert Museum. For Milton, see Christopher Hussey, *Country Life*, 25 May 1961, p. 1210. For Hartwell, see *Country Life*, 22 November 1990, p. 68. For Newburgh Priory, see Cornforth, *Country Life*, 28 February 1974, p. 426; 7 March 1974, p. 482; 14 March p. 574.

72. James Paine, *Noblemens and Gentlemens Houses*, 1767. For Taylor, see Marcus Binney, *Sir Robert Taylor. From Rococo to Neo-Classicism*.

73. Serlby, vol. I, plates 37–9. It was built for Lord Galway, who was a connection of Richard Arundell, the Surveyor General of the Kings Works from 1726 to 1737, and Arundell may have played a helpful role in getting Paine started in the mid-1740s.

74. For Gosforth, see Paine, vol. I, plates 15–25. For Belford, see Paine, vol. I, plates 33–4. See also Peter Leach, *James Paine*, 1988.

75. For Doncaster, see Peter Leach, *Country Life*, 6 July 1978, p. 18. For Gopsall, see Charles Saumarez-Smith, *Eighteenth-Century Decoration*, plate 116, p. 139.

76. Marcus Binney, *Sir Robert Taylor, from Rococo to Neoclassicism*, 1984.

77. For Sanderson, see Colvin, *Dictionary of British Architects*, 3rd edition, p. 845. See also *Catalogue of the Drawings Collection of the Royal Institute of British Architects*. S. Fig. 10. For Langley Park, see *Country Life*, 2 July 1927, p. 16. For Honington, see *Country Life*, 28 September 1978, p. 890. For Farnborough, see *Country Life*, 11 July 1996, p. 52. For Kirtlington, see Cornforth, *Country Life*, 19 April 2001, p. 100; 26 April 2001, p. 102. For Vardy, see Colvin, *Dictionary of British Architects*, 3rd edition, p. 1009. Roger White, 'John Vardy 1718–1765 Palladian into Rococo', in *Architectural Outsiders*, ed. Roderick Brown, 1985.

78. For Carr, see Colvin, *Dictionary of British Architects*, 3rd edition, p. 217. Brian Wragg, ed. Giles Worsley, *The Life and Work of John Carr*, 2000. For Heath Hall, see Arthur Oswald, *Country Life*, 3 October 1968, p. 816.

79. Mark Girouard, *Country Life*, 21 July 1960, p. 130.

80. See *Diaries of a Duchess. Extracts from the Diaries of the First Duchess of Northumberland (1716–1776)*, ed. James Greig, 1926, p. 4.

81. For Woburn, see Giles [Worsley], *Country Life*, 22 April 1993, p. 50.

82. For Hallett pattern chairs, see Coleridge, *Chippendale*, plate 67.

83. The Hopetoun chair appears in the 1768 inventory as 'one model elbow chair mahogany tufted with crimson morine and check cover'. Sebastian Pryke, *Pattern Furniture and Estate Wrights in Eighteenth Century Scotland, Furniture History*, vol. XXX, 1994, p. 100.

The Victoria and Albert Museum has an elaborate example of a pattern chair of about 1760, but no history. Its legs have a Kentian feeling, with alternative treatments of the two halves of the chair, front and back legs, arms and back.

84. For Lord Dumfries, see Gilbert, *Thomas Chippendale*, vol. I, p. 130. Francis Bamford, 'Two Scottish Wrights at Dumfries House', *Furniture History*, vol. IX, 1973, p. 80.

85. For Burghley settees, see Eric Till, 'Georgian Cabinet Makers at Burghley', *Country Life*, 29 August 1974, p. 562, 'Wall Sofia bed . . . 8:8:0–2 large pillows for do: 0:17:6'. For Nunwick, see Margaret Swain, *Country Life*, 14 March 1991, p. 124. For Barn Elms, see Helena Hayward and Pat Kirkham, *William and John Linnell*, 1980, vol. 1, p. 21; vol. 2, p. 118, Fig. 228. Apparently the pair at Felbrigg are those now in the hall there. For Linnell, see Helena Hayward, 'The Drawings of John Linnell', *Furniture History*, 1969, Fig. 160; *Rococo* catalogue, colour plate XVI. For Strawberry Hill, see pp. 230–4. For Holkham, see p. 313–25. For Hagley, see pp. 300–7.

86. Hopetoun: Sebastian Pryke, *Country Life*, 10 August 1995, p. 44. For Halnaby, see Geoffrey Wills, *English Looking-Glasses*, Fig. 99. For St Giles's glasses, see Christies, 16 June 1980, lot 54.

*Chapter 7 The Rise of Historical Thinking*

1. Cornforth, 'The Backward Look' in *Treasure Houses* catalogue, p. 60. For Drayton, see *Country Life*, 13 May 1965, p. 1146; 20 May 1965, p. 1216; 27 May 1965, p. 1286; 3 June 1965, p. 1346. For Walpole on Drayton, see Walpole to Montagu, 23 July 1763, *Yale Edition of Horace Walpole's Correspondence*, vol. 10, p. 89.

2. Joan Evans, *History of the Society of Antiquaries*, 1956.

3. Michael McCarthy, *Sir Roger Newdigate: Drawings for Copt Hall, Essex, and Arbury Hall, Warwickshire, Architectural History*, vol. 16, 1973, p. 16. Lady Hertford, *Correspondence*, vol. II, p. 35.

4. Lady Caroline Fox quoted in Tillyard, *Aristocrats*, p. 147.

5. For the cult of Van Dyck dress, see Sarah Stevenson and Helen Bennett, *Van Dyck in Check Trousers- Fancy Dress in Art and Life 1700–1900*, published in connection with the exhibition at the Scottish National Portrait Gallery, 1978. For Wroxton, see Cornforth, *Country Life*, 10 September 1981, p. 854. For Farnborough, see Cornforth, *Country Life*, 11 July 1996, p. 52.

6. Richard T. Spencer, *Lady Anne Clifford*, 1997.

7. For Hoghton Tower, see John Martin Robinson, *Country Life*, 23 July 1992, p. 82; 31 July, 1992, p. 50. For Drayton, see *Country Life* as above, n. 1.

8. Hampton Court: Cornforth, *Country Life*, 22 February 1973, p. 450; 1 March 1973, p. 518; 8

March 1973, p. 582. Knyff's painting of Hampton Court from the north (Yale Center for British Art) is dated 1699. John Harris, *The Artist and The Country House*, plates. 115a and b, pp. 118, 119, colour plates XV, XVI a and b.

9. Canons Ashby: *Country Life*, 9 April 1981, p. 930; 16 April 1981, p. 1026; 28 June 1984, p. 1856; 5 July 1984, p. 20. In the Jacobean overmantel of the former Great Chamber he also inserted panels of coats of arms with the motto 'Ancient as The Druids'.

10. Vanbrugh on Kimbolton, Laurence Whistler, *The Imagination of Vanbrugh*, 1954, p. 132.

11. Saumarez-Smith, *The Building of Castle Howard*, pp. 11–12.

12. Cornforth, *Country Life*, 3 December 1998, p. 101; 10 December 1998, p. 38. There are other examples of eighteenth-century painting of earlier woodwork, as could be seen in the Great Hall at Audley End (see Lord Braybrooke, *History of Audley End*, 1836), the Great Hall at Crewe Hall (see *Correspondence of Charlotte Grenville, Lady Williams Wynn*, ed. Rachel Leighton, 1920, p. 326). Similarly the panelling of the dining-room at Temple Newsam, which appears to be the parlour of the Jacobean house, was painted white in 1717 and was stripped in 1889 to make it appear more historical.

13. *Country Life*, 2 September 1905, p. 306; Arthur Oswald, *Country Life*, 20 August 1953, p. 552; 27 August 1953, p. 620. Oliver Fairclough, *The Grand Old Mansion*, p. 73.

14. Cornforth, *Country Life*, 10 April 2003, p. 76; 17 April 2003, p. 66.

15. *Country Life*, 26 November 1987, p. 72; 3 December 1987, p. 140.

16. Cornforth, *Country Life*, 8 October 1992, p. 58.

17. *Country Life*, 25 February 1971, p. 420. Tessa Murdoch, *Boughton House*, Fig. 12, p. 192.

18. Booth's letter quoted in Murdoch, *Boughton House*, p. 23, n. 27.

19. *Yale Edition of Horace Walpole's Correspondence*, vol. 10, p. 89.

20. Cornforth, *Country Life*, 3 June 1993, p. 84; 9 September 1993, p. 78.

21. Cornforth, *Country Life Annual*, 1968.

22. Clevedon information from Julia Elton.

23. Lord Dacre quoted in Dorothy Stroud, *Capability Brown*, 1975, p. 75. Lilian Dickins and Mary Stanton, *An Eighteenth-Century Correspondence*, p. 334. Eric Till, 'Capability Brown at Burghley House', *Country Life*, 16 October 1975, p. 982. For Ince and Mayhew, see Helena Hayward and Eric Till, 'A Furniture Discovery at Burghley', *Country Life*, 7 June 1973, p. 1604. Brown to Harcourt quoted in Stroud, *Capability Brown*, p. 79.

24. Cornforth, *Country Life*, 24 August 1995, p. 36. Hardwick Gray to Wharton, *The Letters of Thomas Gray*, ed. Duncan Tovey, vol. II, 1904, p. 267.

25. *Country Life*, 6 February 1990, p. 52; 8 February 1990, p. 68.

26. E. F. Carritt, *A Calendar of British Taste 1600–1800*, p. 219.

27. For Batty Langley, see Colvin, *A Biographical Dictionary of British Architects*, 3rd edition, 1995, p. 597. Eileen Harris, *British Architectural Books and Writers 1556–1785*, 1990, p. 262. For Stouts Hill, see James Lees-Milne, *Country Life*, 5 July 1973, p. 506. For Frampton Court, see Christopher Hussey, *Country Life*, 8 October 1927, p. 506.

28. For Tissington see Gervase Jackson-Stops, *Country Life*, 15 July 1976, p. 158; 22 July 1976, p. 214. See also the frieze of the pair of tables designed for the hall at Hackwood by Vardy tables, for which the design is the RIBA Drawings Collection. Sold at Christies, 5 December 1991, lot 248.

29. Latimers near Chesham, Buckinghamshire belonged to the Cavendish family and from

1749–50 was leased from Elizabeth Cavendish by Conway. Walpole to Bentley, 5 July 1755, *Yale Edition of Horace Walpole's Correspondence*, vol. 35, p. 233.

30. Fairclough, *The Grand Old Mansion*, p. 77.

31. For Wroxton, see Cornforth, *Country Life*, 10 September 1981, p. 854; 24 September 1981, p. 1010. At Temple Newsam there is a parcel-gilt mahogany settee whose interlaced back has a semi-gothick character. It comes from Wroxton Abbey, and although dated about 1735–40 it may be a little later and have been ordered for one of Lord Guilford's historicist rooms. See Gilbert, *Furniture at Temple Newsam*, vol. II, p. 270.

32. For Bulstrode, see Vertue, vol. v, *Walpole Society*, vol. XXVI, 1937–8, p. 70. For the Woburn gallery, see *Country Life*, 8 September 1955, p. 490. The walls of the gallery at Woburn, like those at Temple Newsam, were hung with wallpaper – 'fine Pompadour in grain embossed on fine elephant paper'. Gladys Scott Thomson, *Family Background*, 1949, p. 60. For Blickling, see Alistair Laing and John Maddison, 'Lord Hobart's Gallery' in Andrew Moore with Charlotte Crawley, *Family and Friends*, 1992, pp. 39, 225.

33. For the Raynham Vere Captains, see Andrew Moore, *Family and Friends*, plate 28, p. 35.

34. For Dalkeith, see *Country Life*, 2 April 1984, p. 1158. For Monmouth portrait at Boughton, see Murdoch, *Boughton House*, plate 1 facing p. 24.

35. *Country Life*, 19 December 1974, p. 1930.

36. For Sudbury, see Christopher Hussey, *Country Life*, 29 June 1935, p. 682. See chapter 4, n. 83.

37. For Eworth portrait of Duchess of Suffolk and Stokes, see Roy Strong, *The English Icon: Elizabethan and Jacobean Portraiture*, 1969, pp. 72 and 91. Walpole put the Eworth in a Kent frame.

38. For the Strawberry Hill stained glass, see Anna Evis and Michael Peover, 'Horace Walpole's Painted glass at Strawberry Hill' *Journal of Stained Glass*, vol. XIX, No. 3, 1994–5. Michael Peover, *Country Life*, 26 October 1995, p. 54. *Yale Edition of Horace Walpole's Correspondence*, vol. 20, Walpole to Mann, 10 January 1750, p. 111; Walpole to Mann, 27 April 1753, p. 371.

39. For Radnor stained glass, see M. J. (Margaret Jourdain), *Country Life*, 3 July 1937. One window was dated 1735 by William Price. For Belhus, see H. Avray Tipping, *Country Life*, 15 May 1920, p. 656; 22 May 1920, p. 690. For Wroxton, see *Country Life*, 10 September 1981, p. 854. For Aston Hall, see Fairclough, *The Grand Old Mansion*, p. 73.

40. For Tapestry Room at Belhus, see *Country Life*, 15 May 1920, p. 656. Gray, *The Letters of Thomas Gray* (ed. Duncan Tovey), vol. II, p. 100.

41. *Country Life*, 3 February 1994, p. 46; 10 February 1994, p. 46.

42. Christopher Wren, *Parentalia*, 1750, p. 302. The particular association of the gothick style with the Church of England can be seen in the silver gilt altar candlesticks made in that style in 1738 by Paul de Lamerie for Queen's College, Oxford.

43. For Wroxton, see *Country Life*, 10 September 1981, p. 854. For Hartlebury, see *Country Life*, 23 September 1971, p. 740. Walpole at Wroxton, *Yale Edition of Horace Walpole's Correspondence*, vol. 35, p. 73. Walpole to Chute, 4 August 1753.

44. *Country Life*, 28 May 1921, p. 647; 10 April 2003, p. 76; 17 April 2003, p. 66.

45. A. S. Turberville, *A History of Welbeck Abbey and Its Owners 1539–1879*, vol. 1, 1938–9, p. 395. Peter Smith, *Georgian Group Journal*, vol. XI, 2001, p. 133. While John James is not usually associated with gothic architecture, it should be remembered that he had experience of it through his long association with Westminster Abbey, where he became Surveyor to the Dean and Chapter in January 1724/5 and Surveyor of the Fabric in 1736, completing the west towers between that year and 1745.

46. Horace Walpole at Welbeck to Richard Bentley, August 1756, *Yale Edition of Horace Walpole's Correspondence*, vol. 35, p. 270.

47. For Belhus, see *Country Life*, 15 May 1920, p. 656; 22 May 1920, p. 690.

48. *Country Life*, 7 January 1999, p. 30; 14 January 1999, p. 14.

49. H. Avray Tipping, *Country Life*, 17 March 1923, p. 322.

50. Cornforth, *Country Life Annual*, 1970, p. 138. John Harris, 'Lady Pomfret's House: The Case For Richard Biggs', *Georgian Group Journal*, 1991, p. 45.

51. For Malmesbury House, see Cornforth, *Country Life*, 19 October 1961, p. 882; 26 October 1961, p. 1002.

52. For Strawberry Hill, see chapter 6, n. 43.

53. For the St Michaels Mount Glastonbury chair, see Cornforth, 'Chairs Ancient and Gothick', *Country Life*, 9 September 1993, p. 78. Horace Walpole quoted in Clive Wainwright, *The Romantic Interior*, 1989, p. 97.

54. For the Welsh chair, see Toynbee, *Strawberry Hill Accounts*, p. 162. Walpole to George Montagu, 20 August 1761, *Yale Edition of Horace Walpole's Correspondence*, vol. 9, p. 384.

55. For the Wolsey chair, see Toynbee, *Strawberry Hill Accounts*, p. 121. Amin Jaffer, *Furniture from British India and Ceylon, catalogue of the collections in the Victoria and Albert Museum and Peabody Essex Museum*, 2001.

56. For The Vyne, see H. Avray Tipping, *Country Life*, 28 May 1921, p. 649. Anthony Coleridge, *Country Life*, 25 July 1963.

57. Cornforth, *Country Life*, 5 August 1993, p. 50.

58. Toynbee, *Strawberry Hill Accounts*, p. 83.

59. Chippendale, *The Gentleman and Cabinet Maker's Directory*, 3rd edition, 1762, plates LXXVIII–LXXXV. Gilbert, *Furniture at Temple Newsam*, vol. II, No. 426. Lady Pomfret also left the special frame made for the portrait of herself and her husband to Oxford University and it is now at the Ashmolean Museum. *Country Life Annual*, 1970, p. 138.

60. For Blair state bed, see *Country Life*, 18 November 1949, p. 1506. For Strawberry Hill bed, see Paget Toynbee, *Strawberry Hill Accounts*, p. 8.

61. For Lady Derby's bed at Blair, see John, 7th Duke of Atholl, *Chronicles of the Atholl and Tullibardine Family*, privately printed, Edinburgh, 1908, p. 435.

62. For the Welbeck cabinet, see Cornforth, *English Interiors 1790–1848. The Quest for Comfort*, 1978, Fig. 172. Grimm's drawing of the Rectory at Kirby in Ashfield, Notts, which shows the cabinet, is reproduced in Cornforth, *English Interiors 1790–1848*, plate 172.

63. *Country Life*, 15 May 1920, p. 656; 22 May 1920, p. 690.

64. Horace Walpole to Richard Bentley, September 1753, *Yale Edition of Horace Walpole's Correspondence*, vol. 35, p. 150.

65. Gray to Wharton, *Letters*, vol. II, p. 749 and 761.

66. For the Stafford papers, see Anthony Wells-Cole, *Historic Paper Hangings from Temple Newsam and Other English Houses*, Temple Newsam Studies 1, 1993, published in connection with exhibition at Temple Newsam, Nos. 39 and 40, pp. 31–2.

### Chapter 8 The Role of Pictures in Decoration

1. Frank Hermann, *The English as Collectors*, 1999, p. 3.

2. For Houghton, see pp. 150–69.

3. Anne Crookshank and The Knight of Glin, *Ireland's Painters 1600–1940*, 2002, plate 218, p. 170. In their earlier book they attributed it to Philip Hussey.

4. Mrs Delany, *Correspondence*, Series I, vol. II, p. 204.

5. For Coke letters, see Christine Hiskey, *Architectural History*, vol. 40, 1997, p. 144.

6. Moore, *Family and Friends*, plate 30, pp. 35–8. The drawing for the dining-room is one of an interesting set preserved at Wolterton that shows Ripley developing as an architectural decorator as a result of his experiences at Houghton and Raynham, but it seems that most of the rooms were simplified.

7. For Bower House, see Christopher Hussey, *Country Life*, 24 March 1944, p. 508.

8. R. H. Nichols and F. A Wray, *The History of the Foundling Hospital*, 1935. *Country Life* 23 October 1920, p. 535.

9. For Farnborough, see *Country Life*, 11 July 1996, p. 52; 18 July 1996, p. 50.

10. *Country Life*, 2 July 1927, p. 16. Another example was Weald Hall, Essex, where the hall and saloon both had large pictures in plaster frames that are recorded in *Country Life*, 1 October 1914, p. 454. The house appears to be undocumented, but the detail of the plasterwork is not unlike Sanderson's work.

11. For Russborough, see Brian FitzGerald, *Country Life*, 30 January 1937, p. 120. For the St Peters stuccadore, see McDonnell, *Irish Eighteenth-Century Stuccowork*, pp. 11, 24. They can be seen *in situ* in Desmond Guinness and William Ryan, *Irish Houses and Castles*, 1971, p. 338. Unfortunately, as a result of raids on the house, these pictures, along with most of the rest of the Beit pictures, have had to be removed to the National Gallery of Ireland in Dublin.

12. For Gopsall, see Saumarez-Smith, *Eighteenth-Century Decoration*, plate 116, p. 139. For Rolls Park, see Philip Mainwaring, *Country Life*, 31 August 1918, p. 172.

13. References to the 5th Earl of Exeter's collecting can be traced through Oliver Impey, *Burghley House* and the references to exhibitions in the bibliography, in particular *The Travelling Earl*.

14. For Chesterfield House, see H. Avary Tipping, *Country Life*, 25 February 1922, p. 235; 4 March, p. 308. Vertue, vol. v, *Walpole Society*, vol. xxvi, 1937–38, p. 70.

15. For Wallington, see Raleigh Trevelyan, *Wallington*, National Trust guidebook, 1994, p. 44.

16. *Country Life*, 9 June 1988, p. 252; 16 June 1988, p. 162.

17. For Barn Elms, see unpublished drawing in the National Portrait Gallery archives. The panelling in the gallery at Althorp was covered up by Holland and only revealed again in 1904. Holland's scheme can be seen in a Bedford Lemere photograph of 1892 reproduced in Nicholas Cooper's *Opulent Eye*, 1976. The Houghton Gallery drawing in the Fitzwilliam Museum is reproduced in Dukelskaya and Moore, *A Capital Collection*, pp. 421–3.

18. For Knowsley, see Francis Russell, *The Derby Collection (1721–1735)*, Walpole Society, vol. liii, 1987, p. 143. For Wentworth Castle, see H. Avray Tipping, *Country Life*, 25 October 1924, p. 634.

19. Christopher Hussey, *Country Life*, 19 December 1931, p. 696. With them go a pair of pedestals that still support contemporary copies of the Medici vases bought at Lord Halifax's sale in 1740 for £52 10*s.*, and on the chimneypiece there are still bronzes of the Nile and the Tiber bought at the same sale for £35 10*s.*, where *The Rape of the Centaur* was also acquired for £26 5*s.* (now sold). Vertue, vol. v, *Walpole Society*, vol. xxvi, 1937–8, p. 128. There is a fuller account of the gallery by the Duchess of Beaufort in 1750, see John Harris, *The Georgian Group Journal*, vol. x, 200, p. 40.

20. Giles Worsley, *Country Life*, 30 January 1986, p. 274.

21. St John Gore, *Country Life*, 2 December 1965, p. 1474.

22. *Country Life*, 23 April 1970, p. 922.

23. For Richardson on copies, see *On the Science of a Connoisseur*, p. 43. Pope to Ralph Allen, in George Sherburn, *The Correspondence of Alexander Pope*, vol. iv, 1736–44, 1956, p. 13.

24. Vertue, vol. iv, *Walpole Society*, vol. xx, 1935–6, p. 149, and vol. v, 1937–8, pp. 149–50.

25. Hamilton to Tweedale on Yester, *Country Life*, August 1973.

26. Joseph Friedman, *Spencer House*, Fig. 121, p. 143.

27. Richardson, *The Art of Criticism*, 1725, p. 179.

28. Sir Richard Colt Hoare, *The Modern History of South Wiltshire*, vol. I, 1822, p. 82. Fowler and Cornforth, *English Decoration*, Figs. 204 and 205, p. 237.

29. Ian Dunlop, *Country Life*, 30 July 1953, p. 346. John Kenworthy-Browne, 'Matthew Brettingham's Rome Account Book 1747–1754', *The Walpole Society*, vol. xlix, 1983, p. 44.

30. For 20 Cavendish Square, see Edward Croft Murray, *Decorative Painting* II, p. 201a, plate 112. For Marble Hill, see Bryant, *Mrs Howard*, 1988.

31. Alastair Laing, 'The Ruins in the Dining Room at Shugborough', *Apollo*, April 1993, p. 227.

32. For Yester, see *Country Life*, 23 August 1973, p. 490.

33. For Aldby, see Giles Worsley, *Country Life*, 13 February 1986, p. 376. Vertue, vol. v, *Walpole Society*, vol. xxvi, 1937–8, p. 140.

34. For Althorp, see Christopher Hussey, *Country Life*, 19 May 1960, p. 1122.

35. For Badminton, see *Country Life*, 6 April 1987, pp. 128, 227. For John Wootton, see Arline Meyer, *John Wootton Landscapes and Sporting Art in early Georgian England*, catalogue of exhibition at Kenwood, 1984.

36. For Temple Newsam, see Cornforth, *Country Life*, 16 July 1992, p. 66; 2 January 1997, p. 28. Christopher Gilbert, 'A Nobleman and the Grand Tour: Lord Irwin and Marco Ricci', *Leeds Art Calendar*, No. 69, 1969, p. 3.

## Chapter 9 The Influence of the Orient on Decoration

1. Mrs Delany, *Correspondence*, Series I, vol. III, p. 40.

2. Stalker and Parker, *A Treatise of Japanning and Varnishing*, 1688, reprinted 1960. For Queen Mary, see Mark Hinton and Oliver Impey, *Kensington Palace and the Porcelain of Queen Mary II*, 1998. Defoe, *A Tour Through the Whole Island of Great Britain*, ed. G. D. H. Cole, 1927, vol. 1, p. 164.

3. For Burghley, see Impey, *Four Centuries of Decorative Arts from Burghley House* Appendix I. For Drayton, see copy of the inventory in Woodwork Department of the Victoria and Albert Museum.

4. For the Sizergh dressing service, see Charles Oman, *Caroline Silver*, 1970, plate 86. For an example of the influence of a porcelain shape on silver, see a silver tea pot of 1695 at Burghley. Impey, *Decorative Arts from Burghley House*, No. 107, p. 212.

5. For Gerrit Jensen at Chatsworth, see Thompson, *A History of Chatsworth*, p. 157. For the Chatsworth chest, see ibid., plate 70. *Journeys of Celia Fiennes*, on Chatsworth p. 100; on Burghley, p. 69. I am grateful to John Harris for the reference from Edward Spoure's *Journey from to Cornwall to Oxford* of 1694, belonging to Lord Rennell of Rodd. Another japan closet was at Oulton Park, Chesthire, mentioned in but not illustrated in *Country Life*, 30 May 1908, p. 780, and burned in 1926. The house was built between 1698 and 1716, possibly to the design of William Talman. See Peter Brigham, *Society of Architectural Historians Newsletter*, no. 78, Winter 2002/3, p. 6.

6. Gervase Jackson Stops, *Drayton House*, 1978 guidebook. Alan and Ann Gore, *The History of English Interiors*, 1991, Fig. 52, p. 49.

7. Buckingham House 1743 inventory in the Sheffield papers in the Lincolnshire Record Office, quoted in John Harris et al, *Buckingham Palace*, p. 99, n. 26. The room as redone for Queen Charlotte by William Vile in 1763 is illustrated in Pyne's *Royal Residences*.

8. *Country Life*, 10 December 1998, p. 38.

9. For Honington, see *Country Life*, 21 September 1978, p. 791. Eloi Koldeweig dates them to 1725–75 in 'Leather Hangings in Chinoiserie and other Styles: An English Speciality', *Furniture History*, vol. xxxvi, 2000, p. 61. A parallel to the Honington panels is one inscribed 'COVENTRY LONDON' in the Kassel Wallpaper Museum, *Country Life*, 20 April 1989, p. 168. The Lady Lever Art Gallery guidebook, p. 45.

10. The room at Hill Court may have been decorated by Isaac Bayly, because two painters were working there in 1704. For Bayly, see Stoke Edith, *Country Life*, 3 February 1966, p. 288. For Great Hundridge, see *Country Life*, 15 February 1941, p. 145; 22 February p. 166. For Swangrove, see *Country Life*, 16 December 1939, p. 627. For Old Battersea House, see A. M. W. Stirling, *Country Life*, 7 May 1932, p. 514.

11. Carshalton: A. E. Jones, *The Story of Carshalton House now St Philomena's*, 1980. Cornforth, *Country Life*, 7 September 2000, p. 174. Edward Croft-Murray, *Decorative Painting in England*, vol. I, Isaac Bayly, p. 216b; Robert Robinson, p. 223b. I am grateful to Andrew Skelton for his help.

12. For Vanderbank, see Edith Standen, 'English Tapestries "After the Indian Manner"', *Metropolitan Museum Journal*, 15, 1981, p. 119. Marot print reproduced *Courts and Colonies*, Fig. 171, p. 203.

13. For Belton, see Cornforth, *Country Life*, 10 September 1964.

14. For Melville bed, see *Country Life*, 28 October 1999, p. 60. Margaret Swain, 'Chinoiserie Tapestries in Scotland', *CIETA Bulletin* 69, 1991. For Castle Howard, see Saumarez-Smith, *Castle Howard* p. 90.

   Another imitation of the Vanderbank originals is to be seen in a cut-up state at The Vyne, Hampshire, where they are attributed to Vanderbank. They are listed in one of the principal bedrooms in the 1754 inventory.

   The idea was also taken up by Joshua Morris whose name appeared on a tapestry on the London art market in 1999 and illustrated by Edith A. Standen in 'English Tapestries "After the Indian Manner,"' *Metropolitan Museum Journal*, vol. 15, 1981.

15. For Wanstead, see John Macky, *A Journey Through England*, vol. I, p. 21.

16. *Country Life*, 11 September 1911, p. 474.

17. *Country Life*, 13 April 1978, p. 970.

18. *Treasure Houses* catalogue, No. 375, p. 442.

19. Gow, *Country Life*, April 2004.

20. G. Eland (ed.), *Purefoy Letters*, vol. I, p. 99.

21. Mrs Delany, *Correspondence*, Series I, vol. II, p. 441.

22. Harris, *William Kent and Esher Place, The Fashioning and Functioning of the British Country House*, 1989, p. 13.

23. 'The House of Confucius' from William Chambers, *Plans, Elevations, Sections and Perspective Views of The Garden Buildings at Kew*, 1763, reproduced in John Harris and Michael Snodin, *Sir William Chambers, Architect to George III*, 1996, plate 80, p. 57. For Wroxton, see Philip Yorke quoted in Godber, *The Marchioness Grey*, p. 139. The Duchess of Beaufort, who visited Wroxton in 1750, wrote 'Here is a Chinese House painted without side blue & white & hung with printed cotton within it has a window in two sides of a particular shape, its front is to the water & its door is of Glass, the whole not very pretty.' John Harris, *The Georgian Group Journal*, vol. x, 2000, p. 36. *Country Life*, 10 September 1981, p. 854. For Boughton tent, see Tessa Murdoch, *Boughton House*, Fig. 34, pp. 37–8.

24. Thomas Anson also built a Chinese pagoda which was rising in 1752. For Shugborough, see Christopher Hussey, *Country Life*, 15 April 1954, p. 1126 (before the Chinese House was restored). Philip Yorke quoted in Joyce Godber, *The Marchioness Gray*, pp. 138, 161. Lady Anson's letter

among the Wrest papers in the Bedford Record Office.

25. Lisa White, *Pictorial Dictionary of British 18th Century Furniture Design. The Printed Sources*, 1990.

26. Helena Hayward, 'Chinoiserie at Badminton. The Furniture of John and William Linnell', *Apollo*, August 1969. Pococke, *Travels Through England*, p. 57. Apart from the bed, the commode and one of the chairs in the Victoria and Albert Museum, there are other chairs and the stands in the Metropolitan Museum.

27. Mrs Delany, *Correspondence*, Series I, vol. III, p. 416.

28. Stowe guidebook in the Bodleian Library, Oxford. Fragments of Lady Strafford's dressing-room survive at Wentworth Castle. *Country Life*, 11 March 1993, p. 58.

29. There was also an intriguing tea room described by Arthur Young, but apparently the only survivors are a pair of mahogany and parcel-gilt chairs in a chinoiserie style convincingly attributed to William Hallett that have recently been acquired for the house. Grimsthorpe: *Country Life*, 3 December 1987, p. 140.

30. *Country Life*, 28 November 1996, p. 42. The Newhailes paper can be compared with the small piece of paper used on a firescreen at Ham House thought to have been supplied about 1732.

31. For James Mackay, see Ian Gow, 'An Aberdonian Rococo Drawing-Room' see chapter 4, n. 39.

32. Cornforth, *Country Life*, 20 February 1964, p. 392. Oman and Hamilton, *Wallpapers*, No. 69, p. 112.

33. Cornforth, *Country Life*, 7 December 1989, p. 144.

34. *Country Life*, 26 December 1931, p. 724.

35. *Country Life*, 22 December 1934, p. 666.

36. Gladys Scott Thomson, *Family Background*, p. 48.

37. For Dalemain, see Arthur Oswald, *Country Life*, 28 March 1952, p. 908. For Stretton, see Brian FitzGerald, *Correspondence of Emily Duchess of Leinster*, vol. III, p. 2. For Sudbury, see John Harris, *The Duchess of Beaufort's Observations on Places. The Georgian Group Journal*, vol. X, 2000, p. 36. For Lady Suffolk, see Julius Bryant, *Mrs Howard*, p. 53.

38. For Hampden House, see Oman and Hamilton, *Wallpapers*, No. 653 and plate 231. Oddly, the prints were reprinted in England in 1761 for John Ryall at Hogarth's Head, Fleet Street and these were used for a set of wallpapers formerly at Harrington House, Bourton-on-the-Water.

39. Margaret Jourdain and R. Soame Jenyns, *Chinese Export Art*, 1950, p. 31.

40. For Stoneleigh, see *Country Life*, 20 December 1984, p. 1934. For Saltram, see Cornforth, *Country Life*, 7 December 1989, Fig. 13, p. 149.

41. Lady Kildare, *Correspondence of Emily Duchess of Leinster*, vol. I, p. 80. For Carton, see *Country Life*, 14 November 1936, p. 514. Desmond Guinness, Carton drawing in the Irish Architectural Archive.

42. See Petworth inventory taken on the death of the Duke of Somerset, March 1749/50, Petworth House Archives and photocopy in the Furniture Department in the Victoria and Albert Museum.

43. Peter Thornton, 'The Royal State Bed', *The Connoisseur*, vol. 195, June, 1977, p. 137.

44. For Raby, see Cornforth, *Country Life*, 10 May 1990, p. 104.

45. *Correspondence of Emily Duchess of Leinster*, vol. I, pp. 82, 92, 93.

46. The valance has been remade but the curtains are made of original material that gives the scale of the design. For Milton, see *Country Life*, 7 December 1985, p. 144. For Ashburnham Place, see John Irwin and Katherine Brett, *The Origin of Chintz*, No. 7, colour plate 1.

47. Eland (ed.), *Purefoy Letters*, vol. I, pp. 104, 105.

48. Madame du Bocage, *Letters concerning England, Holland and Italy*, vol. I, 1770, letter II, p. 7. Mrs Montagu quoted in Arthur Oswald, *Country Life*, 30 April 1953, p. 1328. The reference to 'japanned in

proper colours' brings to mind the figure incorporated in the carvings formerly in the Tapestry Drawing-Room at Ditchley, which may be by the Linnells, see page 295.

49. White, *Pictorial Dictionary of British Furniture Design*.

50. Mrs Boscawen quoted in Cecil Aspinall-Oglander, *Admiral's Wife*, 1940, p. 65.

51. Blenheim inventory, 1740, British Library Add Ms 61473.

52. See the Erddig inventory of 1726 (Flintshire Record Office) and that for Canons, Huntington Library, Stowe MS 83.

53. For Giles Grendey, see Gilbert, *Furniture at Temple Newsam*, vol. I, p. 79. Christopher Gilbert, 'Furniture by Giles Grendey for the Spanish Trade', *Antiques*, April 1971, p. 544.

54. For the Osterley chairs, see *Country Life*, 12 January 1995, Fig. 6, p. 43. For Houghton, see Christies, 8 December 1994, lot 110.

55. For Shugborough, see *Country Life*, 11 March 1954, p. 676.

56. Dossie, *Handmaid of the Arts*, vol. I, p. 406.

### Chapter 10 *Planning and Sequences of Decoration, 1700–60*

1. For Blenheim, see David Green, *Blenheim Palace*, 1951. Duchess to Jennens, *Letters of Sarah Duchess of Marlborough* from the originals at Madresfield Court (1875), p. 121.

2. Charles Saumarez-Smith, *The Building of Castle Howard*, 1990. Cornforth, *Country Life*, 4 June 1992, p. 74.

3. Manchester RCHM Eighth Report 1881, Appendix II, Duke of Manchester, p. 100.

4. Alan Wace, *The Marlborough Tapestries at Blenheim Palace*, 1968.

5. See Cornforth, *Country Life*, 3 January 1991, p. 38. The hangings of the state bed supplied by Chipchase and Lambert were ornamented with embroidery that traditionally, came from a dress of Lady Portsmouth, the aunt of Lord Howard de Walden.

6. For Soldani, see *Treasure Houses* catalogue, pp. 292–3.

7. For the Corde tapestries, see Jean-Pierre Babelon, *Chantilly*, 1999, pp. 99, 100, 118, 119, 120.

8. For the Raynham bed, see *Country Life*, 21 November 1925, p. 782. The inventory lists 'a crimson damask bed the tester & head cloth made of two states one King Wm Arms the other Queen Ann This Bed is bound with Rich gold stuff that was the Duchess of Marlbrough's'.

9. For Erddig, see Martin Drury, 'Early Eighteenth-Century Furniture at Erddig', *Apollo*, July 1978, p. 46. Gervase Jackson-Stops, *Country Life*, 6 April 1978, p. 906; 13 April 1978, p. 970; 20 April 1978, p. 1070. Loveday, *Diary of a Tour in 1732*, ed. J. E. T. Loveday, Roxburghe Club, 1890.

10. The Erddig furniture can be compared with another, undocumented, set with the same pattern of velvet that survives in the state bedroom at Powis Castle. Cornforth, *Country Life*, 9 July 1987, Fig. 12, p. 110. Jeremy Cragg tells me that the pelmet cornices with silver gesso on their edges survive in store.

11. For Chicheley, see Joan Tanner, *The Building of Chicheley Hall. Records of Buckinghamshire*, vol. 17, 1961, p. 41. Arthur Oswald, *Country Life* 9 May 1936, p. 482; 16 May 1936, p. 508; 23 May 1936, p. 535. Marcus Binney, *Country Life*, 13 February 1975, p. 378; 20 February 1975, p. 434; 27 February 1975, p. 498. Cornforth, *Country Life* 2004. 1755 inventory in Buckinghamshire Record Office.

12. For Davenport, see *Country Life*, 11 July 1952, p. 114. For Mawley, see *Country Life*, 2 July 1910, p. 18. I am grateful to Adam Bowett for his

identification of the woods used in the panelling.

13. Welbeck: see pp. 230–6.

14. For Ditchley, see Cornforth, *Country Life*, 17 November 1988, p. 100; 24 November 1988, p. 82. Andor Gomm, 'Architects and Craftsmen at Ditchley', *Architectural History*, vol. 32, 1989, p. 85. Cornforth, *Country Life*, 6 January 2000, p. 52.

15. Walpole to George Montagu, 19 July 1760, *Yale Edition of Horace Walpole's Correspondence*, vol. 9, p. 289.

16. Loveday quoted in Sarah Markham, *John Loveday of Caversham 1711–1789*, 1984, p. 173.

17. For the Lock drawings, see Peter Ward Jackson, *English Furniture Designs of the Eighteenth Century*, plate 48.

18. Gilbert, *Furniture at Temple Newsam*, vol. II, p. 353. For Ditchley, see M. J. (Margaret Jourdain), *Country Life*, 20 May 1933, Fig. 7, p. 517.

19. Ditchley plan now lost but illustrated *Country Life*, 9 June 1934, Fig. 7, p. 592.

   The carvings, which were rearranged in the 1920s after the sale of the tapestry, were later removed and then divided. Some sections, including the japanned figure, were sold at Christies, New York, on 18 October 2002, lot 325, when they were fully illustrated in the catalogue. The connection between the Lichfields and the Beauforts is recalled in two of the large Wootton paintings in the hall at Badminton: the future 4th Earl appears in the stag hunt in the park at Badminton, while the 3rd Earl appears in the scene of hare hunting on Salisbury Plain.

20. For Kirtlington, see *Country Life*, 13 April 1912, p. 542. James Townsend, *The Oxfordshire Dashwoods*, 1922. Cornforth, *Country Life*, 19 April 2001, p. 100; 26 April 2001, p. 102. Roscoe, 'The Decoration and Furnishing of Kirtlington Park', *Apollo*, January, 1980, p. 22. Drawings in the house and in the Metropolitan Museum, account book in the Bodleian Library, papers in the possession of Sir Richard Dashwood. I am grateful to John Harris for discussions about John Sanderson and to Lucy Wood about the furniture.

   There are unusual comparisons to be made between the situation in England and Scotland, because Lady Dashwood's sister was married to the 5th Duke of Hamilton, Clive Aslet, *Country Life*, 13 August 1987, p. 86.

   The dining-room was sold from the house to the Metropolitan Museum, New York in 1931, but not erected until 1956.

21. Edward Lennox-Boyd (ed.), *Masterpieces of English Furniture The Gerstenfeld Collection*, 1998, No. 3, p. 192.

22. For Hagley, see Arthur Bolton, *Country Life*, 16 October 1915, p. 520. Gordon Nares, *Country Life*, 19 September 1957, p. 546; 26 September 1957, p. 608. McCarthy, 'The Building of Hagley Hall', *Burlington Magazine*, April 1976. Cornforth, *Country Life* 27 April 1989, p. 136; 4 May 1989, p. 152. Philip Yorke quoted in Godber, *The Marchioness Grey*, p. 160. Young, *Northern Tour*, p. 345.

23. Christies sale, 14 June 2001, lots 50–3.

24. Lucy Wood kindly drew my attention to Richard Joseph Sullivan's *A Tour through Parts of England, Scotland and Wales in 1778*, 2nd edition, 1785. He says that the furniture in the gallery was made by 'an artist in the neighbourhood of Hagley'. For T. F. Pritchard's book, see Harris, 'Pritchard redivivus', *Architectual History*, vol. XI, 1968, p. 17. Ionides, *Thomas Farnolls Pritchard of Shrewsbury Architect and 'Inventor of Cast Iron Bridges'*, 1999.

25. Reginald Blunt (ed.), *Mrs Montagu 'Queen of the Blues'*, vol. I, 1923, p. 385.

26. For Felbrigg, see *Country Life*, 22 December 1934, p. 666. Ketton Cremer, *Felbrigg: The Story of a House*, 1962. Cornforth, *Country Life*, 5 April 1990, p. 138; 12 April 1990, p. 102. Papers in the house and in

the Norfolk County Record Office. *The Letters of David Garrick*, edited by David M. Little and George M. Kahrl, vol. 1, letters 1–33, 1963, p. 43. Hayman, Garrick and Windham portrait painted for Garrick in Brian Allen, *Francis Hayman*, published in connection with exhibition at Kenwood, 1987, No. 10, p. 91.

27. For brackets see *Rococo* catalogue, S 55, p. 309, and plain plaster from Callaly Castle, Northumberland in Christopher Gibbs's sale catalogue of The Manor House, Clifton Campden, Christies, 25 and 26 September 2000, lot 365.

28. Another example of ready-cut hangings was in the state bedroom at Audley End in the 1780s.

29. For Holkham, see Matthew Brettingham, *Plans Elevation and Sections of Holkham in Norfolk, the Seat of the late Earl of Leicester*. C. W. James, *Chief Justice Coke, His Family and Descendants at Holkham*, 1929. Schmidt and Cornforth, *Country Life*, 24 January 1980, p. 214; 31 January 1980, p. 298; 7 February 1980, p. 359;14 February 1980, p. 427. Cornforth, *Country Life*, 4 August 1988, p. 90. *Country Life*, 13 June 1991, p. 168. Letter from John Harris, *Country Life*, 7 August 1980, p. 482. Letter from Geoffrey Beard, *Burlington Magazine*, June 1980, p. 447. James Lees Milne, *Earls of Creation*, 1962, pp. 221–61. John Kenworthy Browne, *Matthew Brettingham's Rome Account Book 1747–1754, Walpole Society*, vol. 49, 1983. Christine Hiskey, *The Building of Holkham Hall: Newly Discovered Letters Architectural History*, vol. 40, 1997. Anthony Coleridge, 'Some Mid-Georgian Cabinet-Makers at Holkham', *Apollo*, February 1964, p. 122. D. P. Mortlock, 'Thomas Coke and the family silver', *Silver Society Journal*, No. 9, Autumn 1997. Andrew Moore, *Norfolk and The Grand Tour*, catalogue of exhibition at the Castle Museum, Norwich, 1985. Mortlock, *Holkham Notes and Annals*, privately printed 2002. Mrs Powys, *Passages from the Diaries of Mrs Philip Lybbe Powys*, p. 9.

30. Angelicoussis, *The Holkham Collection of Classical Sculptures*, 2001.

31. For the Sprimont tureen, see Arthur Grimwade, *Rococo Silver*, 1974, plate 96. For the French book of ornaments, see *Country Life*, 7 February 1980, p. 362.

32. For the Vardy bed at Hardwick, see Beard, *Upholsterers*, p. 194, plates 216–17. For the Petworth beds, see ibid., p. 214, plates 334–6.

# Bibliography

The bibliography is divided into two sections. Part I is a general survey of books and articles, arranged by author. Part II is a selection covering individual houses, and is organised by house name.

I. GENERAL BOOKS AND ARTICLES

ADAM, WILLIAM, *Vitruvius Scoticus, c.* 1812, reprinted 1980.

ARCHER, CHLOE, 'Festoons of Flowers for fitting up print rooms', *Apollo*, December, 1989, p. 386.

BAMFORD, FRANCIS, 'Dictionary of Edinburgh Wrights and Furniture Makers 1600–1840', *Furniture History*, vol. XIX, 1983.

BARR, ELAINE, *George Wickes 1698–1761. Royal Goldsmith*, London 1980.

BEARD, GEOFFREY, *Georgian Craftsmen and their Work*, 1966.

——, *Decorative Plasterwork in Great Britain*, London 1975.

——, 'William Kent and the Cabinet Makers', *Burlington Magazine*, December, 1975, p. 867.

——, 'Three Eighteenth Century Cabinet Makers: Moore, Goodison and Vile', *Burlington Magazine*, July, 1977.

——, *Craftsmen and Interior Decoration in England 1660–1820*, Edinburgh 1981.

——, *Upholsterers and Interior Furnishing in England 1530–1840*, New Haven and London 1997.

——, 'Kentian Furniture by James Richard and Others', *Apollo*, January 2003, p. 37.

—— and GILBERT, CHRISTOPHER, *Dictionary of English Furniture Makers 1660–1840*, London 1986.

BINNEY, MARCUS, *Sir Robert Taylor. From Rococo to Neo-Classicism*, London 1984.

BLACKETT-ORD, CAROL, 'Letters from William Kent to Burrell Massingberd from the Continent, 1712–1719', *Walpole Society*.

BOLD, JOHN, *Wilton House and English Palladianism: Some Wiltshire Houses*, London 1988.

BOWETT, ADAM, 'The Commercial Introduction of Mahogany and Naval Stores Act of 1721', *Furniture History*, vol. XXX, 1994.

——, *English Furniture 1660–1714: From Charles II to Queen Anne*, Woodbridge 2002.

——, 'The India-Backed Chair 1715–40', *Apollo*, January 2003, p. 3.

BRISTOW, IAN C., *Architectural Colour in British Interiors 1615–1840*, New Haven and London 1996.

——, *Interior House-Painting Colours and Technology 1615–1840*, New Haven and London 1996.

BROWN, RODERICK (editor), *The Architectural Outsiders*, London 1985; including Richard Hewlings, 'Leoni' and Roger White, 'Vardy'.

BUCK, ANNE, *Dress in Eighteenth-Century England*, London 1979.

BURKE, JOSEPH, *English Art 1714–1800*, Oxford 1976.

CAMPBELL, COLEN, *Vitruvius Britannicus*, 1715, 1717, 1725, reprinted 1967.

CAMPBELL, R., *The London Tradesman*, 1747, reprinted Newton Abbot 1969.

CLIFFORD, TIMOTHY, 'The Plaster Shops of the Rococo and Neo-Classical Era in Britain', *Journal of the History of Collections*, vol. 4, no. 1, 1992.

CLIMENSON, EMILY J. (editor), *Passages from the Diaries of Mrs Philip Lybbe Powys*, London 1899.

COLERIDGE, ANTHONY, *Chippendale Furniture. The work of Thomas Chippendale and his contemporaries in the rococo taste . . . circa 1745–1765*, London 1968.

COLLINS BAKER, C.H. and BAKER, MURIEL, *The Life and Circumstances of James Brydges First Duke of Chandos, Patron of the Liberal Arts*, Oxford 1949.

COLVIN, H.M. *A Scottish Origin for Palladianism Architectural History*, 1974.

——, *A Biographical Dictionary of British Architects 1600–1840*, New Haven and London, 3rd edition 1995.

——, *Essays in English Architectural History*, New Haven and London 1999.

—— and HARRIS, JOHN (editors), *The Country Seat: Studies in the history of the British Country House presented to Sir John Summerson on his 65th birthday*, London 1970.

—— with Crooke, J. Mordaunt and Downes, Kerry, *The History of the Kings Works*, vol. V: 1660–1782, London 1976.

—— and NEWMAN, JOHN (editors), *Of Buildings. Roger North's writings on architecture*, Oxford 1981.

CORNFORTH, JOHN, *English Interiors 1790–1848: The Quest for Comfort*, London 1978.

COUTTS, HOWARD, 'Four Furniture Designs from the Circle of William Kent', *Furniture History*, vol. XXVI, 1990.

CROFT-MURRAY, EDWARD, *Decorative Painting in England*, 2 vols., 1962, 1970.

DICKINS, LILIAN and STANTON, MARY, *An Eighteenth-Century Correspondence: Letters to Sanderson Miller*, London 1910.

DOWNES, KERRY, *Hawksmoor*, London 1969

——, *English Baroque Architecture*, London 1966.

——, *Vanbrugh*, London 1977.

DUNBAR, JOHN, *The Architecture of Scotland*, London 1978.

EDWARDS, RALPH and JOURDAIN, MARGARET, *Georgian Cabinet Makers*, London 1944, 1946, 1955.

ENTWISLE, E.A., *The Book of Wallpaper*, 1954, reprinted Bath 1970.

——, *A Literary History of Wallpaper*, London 1960.

ESTERLY, DAVID, *Grinling Gibbons and the Art of Carving*, catalogue of exhibition held at the Victoria and Albert Museum, London 1998.

EUSTACE, KATHARINE, *Michael Rysbrack Sculptor 1694–1770*, catalogue of exhibition held at Bristol City Art Gallery, 1982.

FITZGERALD, BRIAN, *The Correspondence of Emily Duchess of Leinster*, Dublin, vol. 1 1949; vol. 2 1953; vol. 3 1957.

FRIEDMAN, TERRY, *James Gibbs*, New Haven and London 1984.

GIFFORD, JOHN, *William Adam 1689–1748. A life and times of Scotland's universal architect*, Edinburgh 1989.

GILBERT, CHRISTOPHER, *The Life and Work of Thomas Chippendale*, 2 vols., London 1978.

——, *Furniture at Temple Newsam and Lotherton Hall*, Leeds vol. II, 1978; vol. III, 1998.

—— and WELLS-COLE, ANTHONY, 'The Fashionable Fireplace', *Temple Newsam Country House Studies*, no. 2, published in connection with the exhibition at Temple Newsam, Leeds, 1985.

——, LOMAX, JAMES and WELLS-COLE, ANTHONY, 'Country House Floors 1660–1850', *Temple Newsam Country House Studies*, no. 3, published in connection with the exhibition held at Temple Newsam, Leeds, 1987.

—— and TESSA MURDOCH, *John Channon and brass-inlaid furniture 1730–1760*, published in connection with an exhibition at Temple Newsam and the Victoria and Albert Museum, New Haven and London 1993.

—— and TESSA MURDOCH, 'Channon Revisited', *Furniture History*, vol. XXX, 1994.

GIOMETTI, CRISTIANO 'Giovanni Battista Guelfi: New Discoveries', *The Sculpture Journal*, vol. III, 1999.

GIROUARD, MARK, *Life in the English Country House*, New Haven and London 1978.

GOMME, ANDOR, 'Smith and Rossi', *Architectural History*, vol. 35, 1992.

——, *Smith of Warwick. Francis Smith, Architect and Master-Builder*, Stamford 2001.

GOW, IAN, 'The Buffet-Niche in Eighteenth-Century Scotland', *Furniture History*, vol. XXX, 1994

——, 'William Adam: A Planner of Genius', *Journal of the Architectural Heritage Society of Scotland*, vol. I, 1990.

GRIMWADE, ARTHUR, *Rococo Silver 1727–1765*, London 1974.

GUNNIS, RUPERT, *Dictionary of British Sculptors 1660–1851*, London 1953.

HALL, MICHAEL (editor), *Gothic Architecture and Its Meanings 1550–1830*, Reading 2002.

HARRIS, EILEEN, *British Architectural Books and Writers 1556–1785*, Cambridge 1990.

HARRIS, JOHN, *Colen Campbell*, 1972 Catalogue of the Drawings Collection of the Royal Institute of British Architects, London 1968 –

——, *A Catalogue of British Drawings for architecture, decoration, sculpture and landscape gardens 1550–1900 in American collections*, Upper Saddle River, New Jersey 1971.

——, *The Artist and the Country House. A history of country house and garden view painting in Britain, 1540–1870*, London 1979.

——, *William Talman Maverick Architect*, London 1982.

——, *The Design of the English Country House 1620–1920*, catalogue of exhibition at the Octagon, Washington 1985.

——, 'William Kent's Drawings at Yale and Some Imperfect Ideas upon the Subject of his Drawing Style', in *Essays in Honor of Paul Mellon Collector and Benefactor*, edited by John Wilmerding, 1986.

——, *The Palladian Revival: Lord Burlington, his Villa and Garden at Chiswick*, catalogue of exhibition in Canada, America and England, New Haven and London 1994.

——, 'The Duchess of Beaufort's Observations on Places', *The Georgian Group Journal*, vol. X, 2000, p. 36.

HART, AVRIL and NORTH, SUSAN, *Historical Fashion in Detail: The 17th and 18th Centuries*, London 1998.

HARTOPP, CHRISTOPHER, *The Huguenot Legacy English Silver 1680–1760 from the Alan and Simone Hartmann Collection*, 1996.

HAYWARD, HELENA and HARRIS, JOHN, 'The Shoppee Album', *Furniture History*, vol. XXVI, 1990; includes notes on drawings by John Linnell and John Sanderson and the Rococo.

HAYWARD, J.F., *Huguenot Silver in England 1680–1727*, London 1959.

HEFFORD, WENDY, 'Huguenot Tapestry-Weavers in and around London 1680–1780', *Proceeding of the Huguenot Society of London*, vol. 24, 1984, p. 103.

HIND, CHARLES (editor), *The Rococo in England*, A symposium held at the Victoria and Albert Museum, London 1984.

HOSKINS, LESLEY (editor), *The Papered Wall*, London 1994; includes Anthony Wells-Cole, 'Flocks, Florals and Fancies: English Manufacture 1680–1830'.

HUSSEY, CHRISTOPHER, *English Country Houses. Early, Mid and Late Georgian*, London 1955, 1956, 1958.

JACKSON-STOPS, GERVASE (editor), *The Treasure Houses of Britain Five Hundred Years of Private Patronage and Collecting*, catalogue of the exhibition held at the National Gallery of Art, Washington, New Haven and London 1985.

—— et al., *Courts and Colonies: The William and Mary Style in Holland, England and America*, catalogue of the exhibition at the Cooper-Hewitt Museum, New York, 1989.

JACOBUS, LAURA, 'The Role of Drawings in the design of Interior Space in England, c. 1600–1800', *Architectural History*, vol. 31, 1988.

JOHNSON, BARBARA, *Album of Fashion and Fabrics*, edited by Natalie Rothstein, London 1987.

JOURDAIN, MARGARET, *The Work of William Kent*, London 1948

——, *English Interior Decoration 1500 to 1830. A study in the development of design*, London 1950

—— and SOAME JENYNS, R., *Chinese Export Art in the 18th century*, London 1950.

*A King's Feast*, published in connection with the exhibition of Danish Royal Silver at Kensington Palace, 1991; includes Philippa Glanville, 'Dining at Court, from George I to George IV' and James Lomax, 'Silver for the English Dining Room 1700–1820'.

KOLDEWEIJ, ELOY, 'Gilt Leather Hangings in Chinoiserie and other Styles: An English Speciality', *Furniture History*, vol. XXXVI, 2000, p. 61.

LAMERIE, PAUL DE, *At the sign of the Golden Ball. The Work of England's Master Silversmith, 1688–1751*, published in connection with the exhibition at Goldsmiths' Hall, London 1990.

LEACH, PETER, *James Paine*, London 1988.

LEES-MILNE, JAMES, *English Country Houses: Baroque 1685–1715*, London 1970.

LENYGON, FRANCIS [MARGARET JOURDAIN], *Decoration in England from 1660 to 1770*, London 1914.

LLANOVER, LADY (editor), *The Autobiography and Correspondence of Mary Granville, Mrs Delany*, London 1861–62.

LOMAX, JAMES, *British Silver at Temple Newsam and Lotherton Hall*, Leeds 1992.

LOVEDAY OF CAVERSHAM, JOHN, 'Diary of a Tour in 1732', *Roxburghe Club*, 1890, p. 187.

MCCARTHY, MICHAEL, *The Origins of the Gothic Revival*, New Haven and London 1987.

MCDONNELL, JOSEPH, *Irish Eighteenth-Century Stuccowork and Its European Sources*, published in connection with an exhibition held at the National Gallery of Ireland, Dublin, 1991.

MACAULAY, JAMES, *The Gothic Revival 1745–1845*, Glasgow 1975.

——, *The Classical Country House in Scotland 1660–1800*, London 1987.

MACQUOID, PERCY, *A History of English Furniture*, London 1904–1908, reprinted Woodbridge 1987.

—— and RALPH EDWARDS, *The Dictionary of English Furniture from the Middle Ages to the late Georgian period*, revised 1954, reprinted Woodbridge 1986.

MONTGOMERY, FLORENCE, *Printed Textiles. English and American Cottons and Linens 1700–1850*, Winterthur and London 1970.

MOORE, ANDREW, *Norfolk and the Grand Tour*, published in connection with the exhibition at the Castle Museum, Norwich, 1985.

——, *Family and Friends*, published in connection with the exhibition at

the Castle Museum, Norwich, 1992.

MORTIMER, MARTIN, *The English Glass Chandelier*, Woodbridge 2000.

MURDOCH, TESSA, *The Quiet Conquest: The Huguenots 1685–1985*, catalogue of the exhibition at the Museum of London, 1985.

——, 'Jean, René and Thomas Pelletier – a Huguenot family of carvers and gilders in England 1682–1726', *Burlington Magazine*, November 1997, p. 732; June 1998, p. 363.

——, 'The King's Cabinet-maker: the gilt-wood furniture of James Moore the Elder', *Burlington Magazine*, June 2002, p. 408.

NEAVE, SUSAN and DAVID, 'The Early Life of William Kent', *Georgian Group Journal*, 1996.

OMAN, CHARLES and HAMILTON, JEAN, *Wallpapers: A History and Illustrated Catalogue of the collection in the Victoria and Albert Museum*, London 1982.

PRYKE, SEBASTIAN, 'Pattern Furniture and Estate Wrights in Eighteenth Century Scotland', *Furniture History*, vol. XXX, 1994, p. 100.

RIBEIRO, AILEEN, *Dress in Eighteenth Century Europe 1715–1780*, 1984, revised edition New Haven and London 2002.

ROSCOE, INGRID, 'Andien de Clermont: Decorative Painter to the Leicester House Set', *Apollo*, February, 1986, p. 92.

ROSOMAN, TREVE, *London Wallpapers: Their Manufacture and Use 1690–1840*, published in connection with the exhibition at the RIBA Drawings Collection, London 1992.

ROTHSTEIN, NATALIE, *Silk Designs of the Eighteenth Century in the Collection of the Victoria and Albert Museum*, London 1990.

SAUMAREZ-SMITH, CHARLES, *Eighteenth-Century Decoration Design and the Domestic Interior in England*, London 1993.

SHAWE-TAYLOR, DESMOND, 'Some Aspects of Roman Baroque Architectural Decoration', *Architectural History*, vol. 36, 1993.

SHERILL, SARAH B., *Carpets and Rugs of Europe and America*, 1996.

SICCA, CINZIA MARIA, 'On William Kent's Roman Sources', *Architectural History*, vol. 29, 1986.

SIMON, JACOB, *The Art of the Picture Frame. Artists, Patrons and the Framing of Portraits in Britain*, published in connection with the exhibition at the National Portrait Gallery, London, 1996–7.

SNODIN, MICHAEL (editor), *Rococo Art and Design in Hogarth's England*, catalogue of exhibition held at the Victoria and Albert Museum, London 1984.

——, 'Thomas Bowles and Baroque Ornament', *Furniture History*, vol. XXX, 1994.

STANDEN, EDITH A., 'English Tapestries "After the Indian Manner"', *Metropolitan Museum Journal*, vol. 15, 1981.

SUMMERSON, JOHN, *Architecture in Britain 1530–1830*, 1953, revised edition New Haven and London 1993.

——, *The Unromantic Castle and other Essays*, London 1998; includes 'The Classical Country House in the 18th Century', originally given as the Cantor Lectures at the Royal Society of Arts and published in that Society's Journal in July 1959.

SWAIN, MARGARET, 'Stitching Triumphant', *Country Life*, 14 March 1991, p. 124.

——, 'Pictorial Chair Covers: Some Engraved Sources', *Furniture History*, vol. XI, 1975, p. 76.

——, 'Loose Covers or Cases', *Furniture History*, vol. 33, 1997, p. 182.

THORNTON, PETER, *Baroque and Rococo Silks*, London 1965.

——, 'The Royal State Bed', *Connoisseur*, vol. 195, June, 1977, p. 137.

——, *Seventeenth-Century Interior Decoration in England, France and Holland*, New Haven and London 1978

——, *Authentic Decor. The Domestic Interior 1620–1920*, London 1984.

WALTON, KARIN, *The Golden Age of English Furniture Upholstery 1660–1840*, the catalogue of the exhibition held at Temple Newsam, 1973.

WARD JACKSON, PETER, *English Furniture Designs of the 18th Century*, 1958 reprinted London 1984.

WATERER, JOHN, *Spanish Leather. A history of its use from 800 to 1800 for mural hangings, screens, upholstery, altar frontals, ecclesiastical vestments, footwear, gloves, pouches and caskets*, London 1971.

WEBB, M.I., *Michael Rysbrack Sculptor*, London 1954.

WELLS-COLE, ANTHONY, 'Historic Paper Hangings from Temple Newsam and other English Houses', *Temple Newsam Studies*, no. I, 1993, published in connection with exhibition at Temple Newsam.

WESTMAN, ANNABEL, 'English Window Curtains in the Eighteenth Century', *Antiques*, June, 1990.

WHINNEY, MARGARET, *Sculpture in Britain 1530–1830*, London 1964.

WHISTLER, LAURENCE, *The Imagination of Vanbrugh and his fellow artists*, London 1954.

WHITE, LISA, 'Two English State Beds in the Metropolitan Museum', *Apollo*, August 1982, p. 84.

——, *Pictorial Dictionary of British 18th century Furniture Design (The Printed Sources)*, Woodbridge 1990.

WILSON, MICHAEL, *William Kent. Architect, Designer, Painter, Gardener 1685–1748*, London 1984.

WILTON, ANDREW and BIGNAMINI, ILARIA, *The Lure of Italy in the Eighteenth Century*, catalogue of the exhibition at the Tate Gallery, 1996–97.

WOOD, LUCY, *Catalogue of Commodes*, Lady Lever Art Gallery, National Museums and Galleries on Merseyside, 1994.

II. INDIVIDUAL HOUSES

ADDERBURY, OXFORDSHIRE

*Adderbury Hall, Oxfordshire,* proceedings of a conference on the Early Eighteenth Century Great House, January 1996, edited by Malcolm Aires, with contributions by Richard Hewlings and Malcolm Baker published by the Department of Continuing Education, University of Oxford.

ALDBY HALL, YORKSHIRE

WORSLEY, GILES, 'Aldby Hall, Yorkshire', *Country Life,* 13 February 1986, p. 376; 20 February, p. 442.

ANTONY, CORNWALL (NT)

CORNFORTH, JOHN, 'Antony, Cornwall', *Country Life,* 9 June 1988, p. 252; 16 June, p. 162.

ARBURY, WARWICKSHIRE

MCCARTHY, MICHAEL, 'Sir Roger Newdigate: Drawings for Copt Hall, Essex and Arbury Hall, Warwickshire', *Architectural History,* vol. 16, 1973, p. 76.

HALL, MICHAEL, 'Needlework That Fools The Eye', *Country Life,* 24 September 1998.

——, 'Arbury, Warwickshire', *Country Life,* 7 January 1999, p. 30; 14 January, p. 40.

ARNISTON, MIDLOTHIAN

COSH, MARY, 'The Adam Family and Arniston', *Architectural History,* vol. 27, 1984, p. 214.

ARUNDEL CASTLE, SUSSEX

ROBINSON, JOHN MARTIN, *Arundel Castle guidebook,* 1994.

ASTON HALL, BIRMINGHAM

FAIRCLOUGH, OLIVER, *The Grand Old Mansion: The Holtes and Their Successors at Aston Hall 1618–1864,* 1984.

AUDLEY END, ESSEX

DRURY, P.J., 'No other palace in the kingdom will, compare with it. The evolution of Audley End 1605–1745', *Architectural History,* vol. 23, 1980, p. 24.

BADMINTON, GLOUCESTERSHIRE

COLVIN, H.M., 'Georgian Architects at Badminton', *Country Life,* 4 April 1968, p. 800.

HAYWARD, HELENA, 'Chinoiserie at Badminton: The Furniture of John and William Linnell', *Apollo,* August 1969, p. 134.

GOMME, ANDOR, 'Badminton Revisited', *Architectural History,* vol. 27, 1984, p. 150.

JACKSON-STOPS, GERVASE, 'Badminton, Gloucestershire', *Country Life,* 6 April 1987, p. 128; 16 April, p. 136.

CORNFORTH, JOHN, 'Princely Pietra Dura', *Country Life,* 1 December 1988, p. 160.

ABEL SMITH, LUCY, 'The Duke of Beaufort's Marble Room', *Burlington Magazine,* January 1996.

GERMAIN, THOMAS, 'Duke of Beaufort's Surtout', *Silver Society Journal,* no. 9, Autumn 1997.

BEDALE HALL, YORKSHIRE

LEWIS, LESLIE, 'Bedale Hall, Yorkshire', *Country Life,* 18 March 1971, p. 592.

BELTON HOUSE, LINCOLNSHIRE (NT)

JACKSON-STOPS, GERVASE, 'Belton House, Lincolnshire', *Country Life,* 29 August 1991, p. 66.

BENINGBROUGH HALL, YORKSHIRE

BINNEY, MARCUS, 'Beningbrough Hall, Yorkshire', *Country Life,* 31 December 1981, p. 1950; 10 December, p. 2098; 17 December, p. 2170.

BLAIR CASTLE, PERTHSHIRE

CORNFORTH, JOHN, 'Blair Castle', *Country Life Annual,* 1969.

COLERIDGE, ANTHONY, 'William Master and some early 18th century furniture at Blair Castle', *Connoisseur,* 1963, p. 77.

——, 'The 3rd and 4th Dukes of Atholl and the Firm of Chipchase Cabinet Makers', *Connoisseur,* February 1966, p. 96.

——, 'Chippendale, The Director and some cabinet-makers at Blair Castle', *Connoisseur,* December 1969, p. 252.

BAMFORD, FRANCIS, 'The Schaws of Edinburgh and a Bed at Blair Castle', *Furniture History,* vol. x, 1974, p. 15.

'Design by Abraham Swan for a staircase', *Leeds Art Calendar,* no. 89, 1981, p. 9.

BLENHEIM PALACE, OXFORDSHIRE

GREEN, DAVID, *Blenheim Palace,* 1951.

WACE, ALAN, 'The Marlborough Tapestries at Blenheim Palace', 1968.

BLICKLING HALL, NORFOLK

MADDISON, JOHN, 'Blickling Hall, Norfolk', *Country Life,* 17 March 1988; 24 March, p. 136.

——, 'Architectural Drawings at Blickling Hall', *Architectural History,* vol. 34, 1991, p. 75.

LAING, ALISTAIR and MADDISON, JOHN, 'Lord Hobart's Gallery', in *Family and Friends,* edited by Andrew Moore with Charlotte Crawley, the catalogue of the exhibition at the Castle Museum, Norwich, 1992, pp. 39, 225.

BOUGHTON HOUSE, NORTHAMPTONSHIRE

JACKSON-STOPS, GERVASE, 'Daniel Marot and Ist Duke of Montagu', *Nederlands Kunsthistorisch Jaarboek,* 1980, vol. 31, p. 244.

MURDOCH, TESSA, 'The Duke of Montagu as patrons of the Huguenots', *Proceedings of the Huguenot Society of London,* vol. 25, 1989–93, p. 340.

—— (editor), *Boughton House The English Versailles,* 1992.

CORNFORTH, JOHN, 'How the Boughton bed was Remade', *Country Life,* 6 February 2003, p. 56.

BURGHLEY HOUSE, LINCOLNSHIRE

HAYWARD, HELENA, and TILL, ERIC, 'A Furniture Discovery at Burghley', *Country Life,* 7 June 1973, p. 1604.

TILL, ERIC, 'Georgian Cabinet-Makers at Burghley', *Country Life,* 29 August 1974, p. 562

——'Capability Brown at Burghley', *Country Life,* 16 October 1975, p. 982.

IMPEY, OLIVER, *Four Centuries of Decorative Art From Burghley House,* catalogue for a travelling exhibition in America, 1998; the Bibliography includes references to the series of exhibitions held at Burghley or based on the Burghley collection.

BURLEY ON THE HILL, RUTLAND

FINCH, PEARL, *History of Burley on the Hill,* 1901.

HABAKKUK, H.J., 'Daniel Finch 2nd Earl of Nottingham: His House and Estate', in *Studies in Social History,* edited by J.H. Plumb, 1955.

CALKE ABBEY, DERBYSHIRE (NT)

COLVIN, H.M., 'Calke Abbey, Derbyshire', *Country Life,* 20 October 1983, p. 1062; 27 October p. 1162; 3 November p. 1242.

——, *Calke Abbey, Derbyshire: a hidden house revealed,* 1985.

'Calke Abbey, Derbyshire', *Treasure Houses of Britain,* no. 375.

CANONS ASHBY, NORTHAMPTONSHIRE

CORNFORTH, JOHN, 'Canons Ashby, Northamptonshire', *Country Life,* 9 April 1981, p. 930; 16 April p. 1026; 28 June 1984, p. 1856; 5 July p. 20.

JACKSON-STOPS, GERVASE, 'A Set of Furniture by Thomas Phill for Canons Ashby', *Furniture History,* vol. 20, 1985.

CANONS, MIDDLESEX

COLLINS BAKER, C.H. and BAKER, MURIEL, *The Life and Circumstances of James Brydges First Duke of Chandos,* 1949.

CARSHALTON HOUSE, SURREY

CORNFORTH, JOHN, 'Carshalton House, Surrey', *Country Life,* 7 September 2000, p. 174.

CASTLE HOWARD, YORKSHIRE

WORSLEY, GILES, 'Castle Howard, Yorkshire', *Country Life,* 30 January 1986, p. 274.

SAUMAREZ SMITH, CHARLES, *The Building of Castle Howard,* 1990.

CORNFORTH, JOHN, 'Castle Howard, Yorkshire', *Country Life,* 4 June 1992, p. 74.

SOTHEBY sale 11, 12, 13 November 1991.

LOMAX, JAMES, 'Silver at Castle Howard: Three Hundred Years of Investment and Fashion', *NACF Magazine,* Spring, 1992.

CASTLETOWN, CO KILDARE

CRAIG, MAURICE and GLIN, KNIGHT OF, 'Castletown, Co Kildare', *Country Life,* 27 March 1969, p. 722; 3 April p. 798.

GLIN, KNIGHT OF, and CORNFORTH, JOHN, 'Castletown, Co Kildare', *Country Life,* 10 April 1969, p. 882.

GRIFFIN, DAVID, 'Castletown, Co Kildare: The Contribution of James First Duke of Leinster', *Irish Architectural and Decorative Studies Journal of the Irish Georgian Society,* vol. 1, 1998, p. 120.

CHATSWORTH, DERBYSHIRE

THOMPSON, FRANCIS, *A History of Chatsworth,* 1949.

CORNFORTH, JOHN, 'Chatsworth', *Country Life,* 20 April 2000, p. 94.

CHICHELEY HALL, BUCKINGHAMSHIRE

TANNER, JOAN, 'The Building of Chicheley Hall', *Records of Buckinghamshire,* vol. 17, 1961, p. 41.

BINNEY, MARCUS, 'Chicheley Hall, Buckinghamshire', *Country Life,* 13 February 1975, p. 378; 20 February p. 434; 27 February p. 498.

CORNFORTH, JOHN, 'Chicheley Hall', *Country Life,* 15 April 2004, p. 124.

CHISWICK HOUSE, MIDDLESEX

ROSOMAN, T.S., 'The interior decoration and use of the state apartments of Chiswick House 1727–1770', *Burlington Magazine,* October 1985.

——'The Chiswick House Inventory', *Furniture History,* vol. XXII, 1986.

HARRIS, JOHN, *The Palladian Revival Lord Burlington, his Villa and Garden at Chiswick,* catalogue of exhibition in Canada, America and England, 1994–95.

HEWLINGS, RICHARD, 'The Link Room at Chiswick House. Lord Burlington as an Antiquarian', *Apollo,* January 1995, p. 28.

CORSHAM COURT, WILTSHIRE

LADD, F.J., *Architects at Corsham Court,* 1978.

COTEHELE, CORNWALL (NT)

CORNFORTH, JOHN, 'Cotehele, Cornwall', *Country Life,* 1 February 1990, p. 52; 8 February p. 68.

CROOME COURT, WORCESTERSHIRE

'Croome Court Tapestry Room', in *Decorative Art from the Samuel H. Kress Collection at the Metropolitan Museum,* 1964, p. 1.

HAYWARD, HELENA, 'Splendour at Croome Court. New Light on Vile and Cobb', *Apollo,* May 1974, p. 350.

LANE, JOAN, 'The Furniture at Croome Court. The Patronage of George William 6th Earl of Coventry', *Apollo,* January 1997, p. 25.

BEARD, GEOFFREY, 'Decorators and Furniture Makers at Croome Court', *Furniture History,* vol. 20, 1993. p. 88.

DALKEITH PALACE, MIDLOTHIAN

DUNBAR, JOHN, and CORNFORTH, JOHN, 'Dalkeith Palace, Midlothian', *Country Life,* 19 April 1984, p. 1092; 26 April p. 1158; 3 May p. 1230.

DITCHLEY PARK, OXFORDSHIRE

CORNFORTH, JOHN, 'Ditchley Park, Oxfordshire', *Country Life,* 17 November 1988 p 100; 24 November p. 82.

GOMME, ANDOR, 'Architects and Craftsmen at Ditchley', *Architectural History,* vol. 32, 1989, p. 85.

CORNFORTH, JOHN, 'How French Style Touched the Georgian Drawing Room', *Country Life,* 6 January 2000, p. 52.

DODDINGTON HALL, LINCOLNSHIRE

CORNFORTH, JOHN, 'A Building Baronet', *Country Life,* 3 February 1994, p. 46; 10 February p. 46.

DRAYTON HOUSE

JACKSON-STOPS, GERVASE, *Drayton House guidebook,* 1978.

THE DRUM, MIDLOTHIAN

GOW, IAN, 'The Drum, Midlothian', *Country Life,* 15 August 1991, p. 64.

DUMFRIES HOUSE, DUMFRIESSHIRE

There is no illustrated account of this house, but its building is discussed by John Fleming in *Robert Adam and his circle,* 1962, p. 94. The main source is in Christopher Gilbert, 'Thomas Chippendale at Dumfries House', *Burlington Magazine,* November, 1969, and *Thomas Chippendale,* vol. 1, p. 130; for the Scottish furniture see Francis Bamford, 'Two Scottish Wrights at Dumfries House', *Furniture History,* vol. IX, 1973, p. 80

THE HOUSE OF DUN, ANGUS

CORNFORTH, JOHN, 'The House of Dun, Angus', *Country Life,* 20 November 1986, p. 1620; 22 June 1989, p. 186.

DUNHAM MASSEY, CHESHIRE (NT)

JACKSON-STOPS, GERVASE, 'Dunham Massey, Cheshire', *Country Life,* 4 June 1981, p. 1562; 11 June p. 1664; 2 July p. 18; 9 July p. 106.

*Apollo,* July 1978.

LOMAX, JAMES, 'Lord Warrington's Silver Light Equipment', *Apollo,* April 1993, p. 244.

DYRHAM PARK, GLOUCESTERSHIRE (NT)

ARCHER, MICHAEL, 'Delft at Dyrham', *National Trust Yearbook,* 1975–76.

BRISTOW, IAN, 'The Balcony Room at Dyrham', *National Trust Studies,* 1980, p. 140.

WALTON, KARIN M., 'An Inventory of 1710 for Dyrham Park', *Furniture History,* vol. XXII, 1986, p. 25.

MCVERRY, JOHN, 'William Blathwayt at Dyrham', *Apollo,* April 2000, p. 36.

EASTON NESTON, NORTHAMPTONSHIRE

DOWNES, KERRY, 'Hawksmoor's House at Easton Neston', *Architectural History,* vol. 30, 1987, p. 50.

ERDDIG, CLWYDD (NT)

'Erddig, Clwydd', *Apollo,* July 1978.

JACKSON-STOPS, GERVASE, 'Erddig, Clwydd', *Country Life,* 6 April 1978, p. 906; 13 April p. 970; 20 April p. 1070.

ARCHER, MICHAEL, 'Stained Glass at Erddig and the work of William Price', *Apollo,* October 1985, p. 252.

CRAGG, JEREMY, 'Room for Improvement: The rearrangement of room furnishings at Erddig', *Apollo,* April 2002, p. 36.

ESHER PLACE, SURREY

HARRIS, JOHN, 'William Kent and Esher Place', *The Fashioning and Functioning of the British Country Houses,* 1989, p. 13.

FARNBOROUGH HALL, WARWICKSHIRE (NT)

CORNFORTH, JOHN, 'Farnborough Hall, Warwickshire', *Country Life,* 11 July 1996, p. 52; 18 July p. 50.

FELBRIGG HALL, NORFOLK (NT)

KETTON-CREMER, R.W., *Felbrigg. The Story of a House,* 1962.

CLATBURN, PAMELA, 'Costume at Felbrigg Hall, Norfolk', *Country Life,* 18 December 1980, p. 2344.

WATSON, MARTIN, 'Marine Pictures at Felbrigg', *Country Life,* 7 August 1986, p. 438; 18 September 1986, p. 904.

CORNFORTH, JOHN, 'Felbrigg Hall, Norfolk', *Country Life,* 5 April 1990, p. 138; 12 April p. 102.

GIBSIDE, CO DURHAM

MEDLAM, SARAH, 'William Greer at Gibside', *Furniture History,* vol. XXVI, 1990, p. 142.

WILLS, MARGARET, and COUTTS, HOWARD, 'The Bowes Family of Streatlam Castle and Gibside and Its Collections', *Metropolitan Museum Journal,* no. 93, 1998.

GILLING CASTLE, YORKSHIRE

MEDLAM, SARAH, 'Matthew Ward at Gilling Castle', *Furniture History,* vol. XXXIII, 1997, p. 109.

GRIMSTHORPE CASTLE, LINCOLNSHIRE

JACKSON-STOPS, GERVASE, 'Grimsthorpe Castle, Lincolnshire', *Country Life,* 26 November 1987, p. 72; 3 December 1987, p. 140.

LORD, JOHN, 'Sir John Vanbrugh and the Ist Duke of Ancaster', *Architectural History,* vol. 34, 1991, p. 136.

HACKWOOD, HAMPSHIRE

COLERIDGE, ANTHONY, 'John Vardy and the Hackwood Suite', *Connoisseur,* May 1962, p. 62.

HASLAM, RICHARD, 'Hackwood, Hampshire', *Country Life,* 10 December 1987, p. 56; 17 December p. 56.

CHRISTIE'S 20, 21, 22 April 1998; 8 July 1999.

HAGLEY HALL, WORCESTERSHIRE

MCCARTHY, MICHAEL, 'The Building of Hagley Hall', *Burlington Magazine,* April 1976, p. 214.

CORNFORTH, JOHN, 'Hagley Hall, Worcestershire', *Country Life,* 27 April 1989, p. 136; 4 May 1989, p. 152.

HAM HOUSE, SURREY (NT)

TOMLIN, MAURICE, '18th Century Furnishings at Ham House', *Country Life,* 10 November 1977, p. 1418.

THORNTON, PETER and TOMLIN, MAURICE, 'The Furnishing and Decoration of Ham House', *Furniture History,* vol. XVI, 1980.

HAMPTON COURT, HEREFORDSHIRE

CORNFORTH, JOHN, 'Hampton Court, Herefordshire', *Country Life,* 22 February 1973, p. 450; 1 March p. 518; 8 March p. 58.

WHITE, LISA, 'Two English State Beds in the Metropolitan Museum of Art', *Apollo,* August 1992, p. 84.

HAMPTON COURT PALACE, MIDDLESEX

ALLAN, JULIET, 'New Light on Kent at Hampton Court Palace', *Architectural History,* vol. 27, 1984, p. 50.

*Apollo,* August, 1994.

HANBURY HALL, WORCESTERSHIRE (NT)

HAWORTH, JEFFREY, 'Hanbury Hall, Worcestershire', *Country Life,* 12 December 1991, p. 48.

JACKSON-STOPS, GERVASE, 'A baroque house & its furnishings: The Hanbury Hall inventory of 1721', *Apollo,* May 1994, p. 10.

HARROWDEN HALL, NORTHAMPTONSHIRE

JACKSON-STOPS, GERVASE, 'Harrowden Hall, Northamptonshire', *Country Life,* 17 October 1974, p. 1086; 24 October p. 1190.

HARTLEBURY CASTLE, WORCESTERSHIRE

LEES-MILNE, JAMES, 'Hartlebury Castle, Worcestershire', *Country Life,* 16 September 1971, p. 672; 23 September p. 740.

HATFIELD, HERTFORDSHIRE

COLERIDGE, ANTHONY, 'English Furniture and Cabinet-Makers at Hatfield House', *Burlington Magazine,* February 1967, p. 67; April 1967, p. 201.

HERRIARD, HAMPSHIRE

JEFFRY, SALLY, 'John James and George London at Herriard: Architectural Drawings in the Jervoise of Herriard Collection', *Architectural History,* vol. 28, 1985, p. 40.

HOLKHAM, NORFOLK

BRETTINGHAM, MATTHEW, *The Plan Elevations and Sections of Holkham in Norfolk, the Seat of the late Earl of Leicester,* 1761.

LEES-MILNE, JAMES, *Earls of Creation,* 1962; essay on Thomas Coke.

COLERIDGE, ANTHONY, 'Some Mid-Georgian Cabinet-Makers at Holkham', *Apollo,* February 1964, p. 122.

SCHMIDT, LEO, and CORNFORTH, JOHN, 'Holkham, Norfolk', *Country Life,* 24 January 1980, p. 214; 31 January p. 298; 7 February p. 359; 14 February p. 427.

see also John Harris, *Country Life,* 7 August 1980, p. 482; Geoffrey Beard *Burlington Magazine,* June 1980, p. 447; John Harris, *Burlington Magazine,* September 1980.

KENWORTHY-BROWNE, JOHN, 'Matthew Brettingham's Rome Account Book 1747–1754', *Walpole Society,* vol. 49, 1983, p. 37.

CORNFORTH, JOHN, 'Augustan Vision Resumed', *Country Life,* 4 August 1988, p. 90.

CORNFORTH, JOHN, 'Subtle Sequence Reconstructed. The Landscape at Holkham', *Country Life,* 13 June 1991, p. 168.

MORTLOCK, D.P., 'Thomas Coke and the family silver', *Silver Society Journal,* no. 9 Autumn, 1997.

——, *Holkham Notes and Annuals* (privately printed) 2002.

HISKEY, CHRISTINE, 'The Building of Holkham Hall. Newly Discovered Letters', *Architectural History,* vol. 40, 1977.

ANGELICOUSSIS, ELIZABETH, *The Holkham Collection of Classical Sculpture,* 2001.

HONINGTON HALL, WARWICKSHIRE

CORNFORTH, JOHN, 'Honington Hall, Warwickshire', *Country Life,* 21 September 1978, p. 791; 28 September p. 890; 12 October p. 1082.

HOPETOUN, WEST LOTHIAN

COLERIDGE, ANTHONY, 'James Cullen Cabinet-Maker at Hopetoun House', *Connoisseur,* November 1966, p. 154 and December, p. 231.

ROWAN, ALISTAIR, 'The Building of Hopetoun', *Architectural History,* vol. 27, 1984, p. 183.

PRYKE, SEBASTIAN, 'Furniture designs for Hopetoun House', *Furniture History,* vol. 28, 1992, p. 35.

——'Hopetoun House, West Lothian', *Country Life,* 10 August 1995, p. 44.

EUSTACE, KATHERINE, 'Robert Adam, Charles Clerisseau, Michael Rysbrack and the Hopetoun chimneypiece', *Burlington Magazine,* November 1997, p. 743.

HOUGHTON HALL, NORFOLK

WARE, ISSAC, *The Plans of Houghton,* 1735 and 1760.

WALPOLE, HORACE, *Aedes Walpolianae,* 1743, 1752, 1767.

CORNFORTH, JOHN, 'Houghton Hall, Norfolk', *Country Life,* 30 April 1987, p. 124; 7 May 1987, p. 104.

HARRIS, JOHN, 'Who Designed Houghton?', *Country Life,* 2 March 1989, p. 92.

WORSLEY, GILES, 'Houghton Hall, Norfolk', *Country Life,* 4 March 1993, p. 50.

CHRISTIE'S catalogue of sale 8 December 1995.

CORNFORTH, JOHN, 'Houghton Hall, Norfolk', *Country Life,* 28 March 1996, p. 52.

MOORE, ANDREW (editor), *The Prime Minister, the Empress and the Heritage,* catalogue of the exhibition at the Castle Museum, Norwich and Kenwood, 1996.

DUKELSKAYA, LARISSA and MOORE, ANDREW, *A Capital Collection. Houghton Hall and The Hermitage,* 2002, published in connection with the exhibition of Walpole pictures from the Hermitage at Somerset House, London, 2002.

CORNFORTH, JOHN, 'Houghton Hall, Norfolk', *Country Life,* September 26, 2002, p. 94.

INVERARAY CASTLE, ARGYLLSHIRE

COLERIDGE, ANTHONY, 'English Furniture in the Duke of Argyll's Collection at Inveraray', *Connoisseur,* March 1965, p. 154.

LINDSAY, IAN G., and COSH, MARY, *Inveraray and the Dukes of Argyll,* 1973.

HAYWARD, HELENA, 'Ordered from Berkeley Square. Inveraray and the Furniture of John Linnell', *Country Life,* 5 June 1975 p. 1485.

CORNFORTH, JOHN, 'Inveraray Castle, Argyllshire' *Country Life,* 8 June 1978, p. 1619; 15 June p. 1734.

KEDLESTON HALL, DERBYSHIRE (NT)

HARDY, JOHN, and HAYWARD, HELENA, 'Kedleston Hall, Derbyshire', *Country Life,* 26 January 1978, p. 194; 2 February p. 262; 9 February p. 322.

HARRIS, LESLIE, *Robert Adam and Kedleston. The Making of a Masterpiece,* 1987, catalogue of exhibition touring in America.

CORNFORTH, JOHN, 'A Splendid Unity of Arts', *Country Life,* 13 June 1996, p. 128.

KIRTLINGTON PARK, OXFORDSHIRE

ROSCOE, INGRID, 'The Decoration and Furnishing of Kirtlington Park', *Apollo,* January 1980, p. 22.

CORNFORTH, JOHN, 'Kirtlington Park, Oxfordshire', *Country Life,* 9 April 2001, p. 100; 26 April, p. 102.

LONDON: 22 ARLINGTON STREET
CAMPBELL, PETER (editor), *A House in Town 22 Arlington Street Its Owners and Builders,* 1984.

LONDON: 44 BERKELEY SQUARE
GIROUARD, MARK, '44 Berkeley Square', *Country Life,* 27 December 1962, p. 1648.
HARRIS, JOHN, 'William Kent's 44 Berkeley Square', *Apollo,* August 1987, pp. 100–4.

LONDON: CHESTERFIELD HOUSE
WHITE, ROGER, 'Isaac Ware and Chesterfield House', in Charles Hind, *The Rococo in England,* p. 175.

LONDON: KENSINGTON PALACE
CORNFORTH, JOHN, 'Kensington Palace', *Country Life,* 5 January 1995, p. 32.
COLVIN, H.M., et al., *The History of the Kings Works,* vol. V, 1976.
—— and NEWMAN, JOHN, *The Royal Palaces,* p. 183.
HINTON, MARK, and IMPEY, OLIVER, *Kensington Palace and the Porcelain of Queen Mary II,* in connection with the exhibition, 1998.
IMPEY, EDWARD, *Kensington Palace, the Official Illustrated History,* 2003.

LONDON: NORFOLK HOUSE
*Norfolk House Survey of London,* vol. XXIX and XXX, 1960.
FITZGERALD, DESMOND, 'The Norfolk House Music Room', *Victoria and Albert Museum,* 1973.

LONDON, POMFRET CASTLE
CORNFORTH, JOHN, 'Pomfret Castle', *Country Life Annual,* 1970.
HARRIS, JOHN, 'Lady Pomfret's House: The Case for Richard Biggs', *Georgian Group Journal,* 1991, p. 45.

LONDON: SPENCER HOUSE
FRIEDMAN, JOSEPH, *Spencer House. Chronicle of a great London mansion,* 1993.

LYME PARK, CHESHIRE (NT)
CORNFORTH, JOHN, 'Lyme Park, Cheshire', *Country Life,* 5 December 1974, p. 1724; 12 December p. 1858; 19 December p. 1930; 26 December p. 1998.

MARBLE HILL, TWICKENHAM, MIDDLESEX
DRAPER, MARIE P.G., *Marble Hill House & Its Owners,* 1970.
BRYANT, JULIUS, *Mrs Howard: A Woman of Reason published in connection with the exhibition at Marble Hill,* 1988.

MAVISBANK, MIDLOTHIAN
GOW, IAN, 'Mavisbank, Midlothian', *Country Life,* 20 August 1987, p. 70.

MAWLEY HALL, SHROPSHIRE
MEDLAM, SARAH, 'The Inlaid Room at Mawley Hall' in Christopher Gilbert and Tessa Murdoch*, John Channon and brass inlaid furniture 1730–1760,* 1993.

MELVILLE HOUSE, FIFE
GENTLE, NICOLE, 'A Study of the Late Seventeenth-Century State Bed for Melville House', *Furniture History,* vol. XXXVII, 2001, p. 1.

MEREWORTH, KENT
CROMBIE, THEODORE, 'A Palladian Olympus. Mereworth's Venetian Ceilings', *Apollo,* July 1969.

MOOR PARK, HERTFORDSHIRE
CORNFORTH, JOHN, 'Moor Park, Hertfordshire', *Country Life,* 10 March 1988, p. 138.

NARFORD, NORFOLK
PARISSIEN, STEVEN, HARRIS, JOHN and COLVIN, HOWARD, 'Narford, Norfolk', *Georgian Group Report and Journal,* 1987.
KNOX, GEORGE, 'Antonio Pellegrini and Marco Ricci at Burlington House and Narford Hall', *Burlington Magazine,* vol. CXXX, November 1988, p. 846.
FORD, BRINSLEY, 'The painting of Giovanni Pellegrini at Narford Hall, Norfolk', *Apollo,* November 1985, p. 359.
—— 'Sir Andrew Fountaine', *Apollo,* November 1985, p. 352.
see also: Andrew Moore, *Norfolk and the Grand Tour,* 1985.

NEWHAILES, MIDLOTHIAN
DUNCAN, PAUL, 'Newhailes, Midlothian', *Country Life,* 29 January 1987, p. 86; 5 February p. 58.
CORNFORTH, JOHN, 'Newhailes, Midlothian', *Country Life,* 21 November 1996, p. 46; 28 November p. 42.
GOW, IAN, 'The Most Learned Drawing Room in Europe?: Newhailes and the Classical Scottish Library', *Visions of Scotland's Past. Looking to the Future. Essays in Honour of John R. Hume,* ed. Deborah C. Mays, Michael S. Moore and Miles K. Oglethorpe, 2000.
——, 'How They Brought Back the Hangings', *Country Life,* 11 March 2004, p. 84.
CORNFORTH, JOHN, 'Newhailes, Midlothian', *Country Life,* 22 August 2002, p. 62.

NOSTELL PRIORY, YORKSHIRE (NT)
BOYNTON, LINDSAY, and GOODISON, NICHOLAS, 'Thomas Chippendale at Nostell Priory', *Furniture History,* vol. IV, 1968.
GILBERT, CHRISTOPHER, 'New Light on the Furnishing of Nostell Priory', *Furniture History,* vol. XXVI, 1990, p. 53.
JACKSON-STOPS, GERVASE, 'Pre-Adam Furniture Designs at Nostell Priory', *Furniture History,* vol. X, 1974, p. 24.

ORLEANS HOUSE, TWICKENHAM, MIDDLESEX
CORNFORTH, JOHN, 'Orleans House, Twickenham, Middlesex', *Country Life,* 15 February 1996, p. 40.

PETWORTH HOUSE, SUSSEX (NT)
JACKSON-STOPS, GERVASE, 'Petworth House, Sussex, NT', *Country Life,* 28 June 1973, p. 1870; 4 September 1980 p. 798; 25 September p. 1030. *Apollo,* May 1977.
——, 'Rococo Masterpiece Restored. The Petworth State Bed', *Country Life,* 14 June 1984, p. 1698.

POWERSCOURT, CO WICKLOW
GRIFFIN, DAVID, 'Richard Castle's Egyptian Hall at Powerscourt, Co Wicklow', *Georgian Group Journal,* 1995, p. 119.

POWIS CASTLE, POWYS (NT)
LAWSON, JAMES, and WATERSON, MERLIN, 'Pritchard as Architect and Antiquary at Powis', *The National Trust Year Book,* 1975–76.
CORNFORTH, JOHN, 'Powis Castle, Powys', *Country Life,* 9 July 1987, p. 106.

RABY CASTLE, CO DURHAM
ROWAN, ALISTAIR, 'Gothick Restoration at Raby Castle', *Architectural History,* vol. 15, 1972, p. 23.
CORNFORTH, JOHN, 'Raby Castle, Co Durham', *Country Life,* 10 May 1990 p. 104; 31 May 1990, p. 148.

RAYNHAM HALL, NORFOLK
ROSENHEIM, JAMES, *The Townshends of Raynham,* 1989.

ROKEBY PARK, YORKSHIRE
WORSLEY, GILES, 'Rokeby Park, Yorkshire', *Country Life,* 19 March 1987, p. 74; 26 March 1987, p. 176; 2 April 1987, p. 116.

RUSSBOROUGH, CO WICKLOW
WYNNE, MICHAEL, 'The Milltowns as Patrons', *Apollo,* February 1974.
BENEDETTI, SERGIO, *The Milltowns a family re-union,* catalogue of an exhibition held at the National Gallery of Ireland, Dublin, 1997.

ST GILES'S HOUSE, DORSET
CHRISTIE'S 26 June 1980.

ST MICHAEL'S MOUNT, CORNWALL (NT)
CORNFORTH, JOHN, 'St Michael's Mount, Cornwall', *Country Life,* 3 June 1993, p. 84; 9 September 1993, p. 78.

SHUGBOROUGH, STAFFORDSHIRE (NT )
LAING, ALASTAIR, 'The Ruin Paintings in the Dining Room at Shugborough', *Apollo,* April 1993, p. 227.

STANDLYNCH, WILTSHIRE
JEFFEREY, SALLY, 'Standlynch, Wiltshire', *Country Life,* 13 February 1986, p. 404.

STONELEIGH ABBEY, WARWICKSHIRE

ASLET, CLIVE, 'Stoneleigh Abbey, Warwickshire', *Country Life,* 13 December 1984, p. 1844; 20 December p. 1935.

CHRISTIE's sale, 15–16 October 1981.

GOMME, ANDOR, 'Stoneleigh after the Grand Tour', *Antiquaries Journal,* 1988, part 11, pp. 265–86.

CORNFORTH, JOHN, 'Stoneleigh Abbey, Warwickshire', *Country Life,* 14 March 2002, p. 70; 9 May p. 108.

STOURHEAD, WILTSHIRE (NT)
WOODBRIDGE, KENNETH, *Landscape and Antiquity Aspects of English Culture at Stourhead 1718–1838,* 1970.

STOWE, BUCKINGHAMSHIRE (NT)
'Stowe, Buckinghamshire', *Apollo,* June 1973.

BEVINGTON, MICHAEL, *Stowe House* (guidebook), 2002.

STRAWBERRY HILL, MIDDLESEX
TOYNBEE, PAGET (editor), *Strawberry Hill Accounts,* 1927.

LEWIS, W.S., 'The Genesis of Strawberry Hill', *Metropolitan Museum Studies,* 1934, vol. V, p. 57.

CROOK, J. MORDAUNT, 'Strawberry Hill, Middlesex', *Country Life,* 7 June 1973, p. 1598; 14 June p. 1726; 21 June p. 1794.

*Horace Walpole and Strawberry Hill,* catalogue of the exhibition held at Orleans House, Autumn 1980.

WAINWRIGHT, CLIVE, 'Horace Walpole & his Collection' in *The Romantic Interior,* 1989.

EAVIS, ANNA and PEOVER, MICHAEL, 'Horace Walpole's Painted Glass at Strawberry Hill', *Journal of Stained Glass,* vol. XIX, no. 3, 1994–95.

PEOVER, MICHAEL, 'Strawberry Hill, Middlesex', *Country Life,* 26 October 1995, p. 54.

MCLEOD, BET, 'Horace Walpole and Sèvres Porcelain. The collection at Strawberry Hill', *Apollo,* January 1998, p. 42.

BROWNELL, MORRIS, *The Prime Minister of Taste A Portrait of Horace Walpole,* 2001.

STUKELEY'S HOUSE, GRANTHAM, LINCOLNSHIRE
SCOONES, FRANCESCA, 'Dr William Stukeley's House at Grantham', *Georgian Group Journal,* 1999, p. 158.

SUTTON SCARSDALE, DERBYSHIRE
GOMME, ANDOR, 'The Genesis of Sutton Scarsdale', *Architectural History,* vol. 24, 1981, p. 34.

TEMPLE NEWSAM, LEEDS
GILBERT, CHRISTOPHER, 'Newly Discovered Furniture by William Hallett', *Connoisseur,* December 1964, p. 2245.

SIMON, JACOB, 'The Long Gallery at Temple Newsam', *Leeds Art Calendar,* no. 74, 1974 p. 5.

'Temple Newsam Inventories and Sale Catalogues', *Leeds Art Calendar,* nos. 99 and 100, 1987.

CORNFORTH, JOHN, 'Temple Newsam, Leeds: A Fine Hanging Revisited. The Gallery at Temple Newsam', *Country Life,* 16 July 1992, p. 66.

LOMAX, JAMES, *British Silver at Temple Newsam and Lotherton Hall,* 1992.

WELLS-COLE, ANTHONY, 'Historic Paper Hangings from Temple Newsam and other English Houses', *Temple Newsam Studies,* no. 1, 1993, published in connection with exhibition at Temple Newsam.

GILBERT, CHRISTOPHER, *Furniture at Temple Newsam and Lotherton Hall,* vol. II 1978; vol. III, 1998.

bibliography compiled by James Lomax, 2000

TRINITY COLLEGE, DUBLIN
MCPARLAND, EDWARD, 'Trinity College, Dublin, Provost's House', *Country Life,* 14 October 1976, p. 1034; 21 October p. 1106.

UPPARK, SUSSEX (NT)
HEWLINGS, RICHARD, 'Uppark. Sir Matthew Fetherstonhaugh's First Architect', *Georgian Group Journal,* 1998.

THE VYNE, HAMPSHIRE (NT)
MCCARTHY, MICHAEL, 'John Chute's Drawings for The Vyne', *National Trust Year Book,* 1975–76, p. 70.

CORNFORTH, JOHN, 'The Vyne, Hampshire', *Country Life,* 10 April 2003, p. 76; 17 April, p. 66.

WAKEFIELD LODGE, NORTHAMPTONSHIRE
BINNEY, MARCUS, 'Wakefield Lodge, Northamptonshire', *Country Life,* 2 August 1973, p. 298.

WALLINGTON, NORTHUMBERLAND (NT)
TREVELYAN, RALEIGH, *Wallington, Northumberland,* 1994.

WELBECK ABBEY, NOTTINGHAMSHIRE
TURBERVILLE, A.S., *A History of Welbeck Abbey and Its Owners 1539–1879,* 1938–39.

SMITH, PETER, 'Lady Oxford's Alterations at Welbeck Abbey', The *Georgian Group Journal,* vol. XI, 2001, p. 133.

WENTWORTH CASTLE, YORKSHIRE
CORNFORTH, JOHN, 'Wentworth Castle, Yorkshire', *Country Life,* 11 March 1993, p. 58.

KUKE, H.J., 'Jean de Bodt Huguenot: architect and engineer', *Proceedings of the Huguenot Society of London,* vol. XXVI, 1994–97, p. 500.

WENTWORTH WOODHOUSE, YORKSHIRE
MARCUS BINNEY, 'Wentworth Woodhouse, Yorkshire', *Country Life,* 17 March 1983, p. 624; 24 March p. 708.

CHRISTIE's 8 July 1998.

WESTON HALL, NORTHAMPTONSHIRE
BAMFORD, FRANCIS, 'Weston Hall, Northamptonshire', *Country Life,* 22 January 1976, p. 174; 29 January p. 234.

WILTON HOUSE, WILTSHIRE
BOLD, JOHN, *Wilton House and English Palladianism: Some Wiltshire Houses,* 1988.

WIMPOLE HALL, CAMBRIDGESHIRE (NT)
ALLEN, BRIAN, 'Thornhill at Wimpole', *Apollo,* September 1985, p. 204.

HARRIS, JOHN, 'Harley, The Patriot Collector', *Apollo,* September 1985, p. 198.

MEYER, ARLINE, 'Wootton at Wimpole', *Apollo,* September 1985, p. 212.

ADSHEAD, DAVID, ' "A Noble Museum of Books": A View of the Interior of the Harleian Library at Wimpole Hall?', *Library History,* vol. 18, November 2002, p. 191.

WOBURN ABBEY, BEDFORDSHIRE
SCOTT THOMSON, GLADYS, *Family Background,* 1949.

*Apollo,* December 1965.

*Apollo,* June 1988 (concentrates on the 4th Duke (1710–1771)).

WORSLEY, GILES, 'Woburn Abbey, Bedfordshire', *Country Life,* 22 April 1993, p. 50.

WREST PARK, BEDFORDSHIRE
GODBER, JOYCE, 'The Marchioness Grey of Wrest Park', *The Publications of the Bedfordshire Historical Record Society,* vol. XLVII, 1968.

WRICKLEMARSH, KENT
BRUSHE, JOHN, 'Wricklemarsh and the Collections of Sir Gregory Page', *Apollo,* November 1985, p. 364.

YESTER, EAST LOTHIAN
ROWAN, ALISTAIR, 'Yester, East Lothian', *Country Life,* 9 August 1973, p. 359; 16 August p. 430; 23 August p. 490.

INDEX

and tapestry 98
*see also* Holkham Hall, Norfolk
Cole, George 127
Coleshill House, Wiltshire 37, 186
Collis, John 109
colour, use of 113–22
Combe, Henry 23
comfort, growth of 209–12
Compton Place, Sussex 41–2, *42*, 45, 61, *61*, 67, 91, *91*, 98, 99–100, *99*, 120, 121, 122, 183
Condé, Louis, 4th Prince de 279
Condy, Nicholas *225*
Coningsby, Lord 219
Conolly, Lady Louisa 67, 91, 203, 204, *206*, 207, 265
Conolly, Mrs 49
Conolly, Tom 204
Conolly, William 10, 30–1, 67
Constanzi, Placido 247
Conyers, Lady 234, 236
Conyers, Mary 3, 71
Conyers, Sophia *see* Newdigate, Lady
Copland, H. *see* Lock, Matthias
Corbett, Sir Uvedale 265
Cornbury, Oxfordshire 49
Cornwall, John Eltham, Earl of 73
Corsham Court, Wiltshire 100, 101, 105, 199, *200*
Cortese, Giuseppe 197, 199, 212
Cotehele, Cornwall 13, 106, 224–6, *224*, *225*, 234, 235
    Queen Anne's Bed 225–6, *226*, 236
    Red Bedroom 225, *225*
Cottesbrooke Hall, Northamptonshire 193
*Country Life* 24
Courtauld, Augustine 110
Courtenay, Sir William (later 1st Viscount) 70
Coypel, Antoine, *Assemblée des Dieux* 200
Cradock, Marmaduke 196
Cramillion, Barthelemij 202
Creed, Elizabeth 115–16, *115*
Crespin, Paul 112, 168, 178, 198
Croft Castle, Herefordshire 196
Crompton and Spinnage 194, *194*
Croome Court, Worcestershire 55, 93, 128, *128*, 300, *303*
Crowley, John 54
Cuenot, John *56*, 58, *126*, 127
Cullen, James 96, 196
curtains 92–5
Curzon, Sir Nathaniel 50, 95, *96*, 112, 187
Cust, Lady 40, 78
Cusworth Hall, Doncaster 101

Dacre, Lord *see* Barrett, Thomas
Dahl, Michael 4, 101, *102*, 228
Dalemain, Cumberland 265, *265*
Dalham Hall, Suffolk 196
Dalkeith Palace, Midlothian 14, *14*, 37, 44, 52, 82, 121, 227
Dalrymple, Sir David 70
Dalrymple, Sir James 6, 45–7, *45*, 70, 258
Danby, Earl of 166
*'The Dancing Master* done from the *French* of Monsieur RAMEAU by J. Esse *Dancing-Master'* 7
Dandridge, Joseph 203

Dangan, Co. Meath 38
Danson Hill, Kent 212
Danthon (weaver) 57, 98
Darlington, Grace, Countess of 207–8, *208*
Darly, Matthias
    *A New Book of Chinese, Gothic and Modern Designs* 262
    (with George Edwards), *A New Book of Chinese Designs 260*, 262
Dart, John
    *The History and Antiquities of the Cathedral Church of Canterbury* 73
    *Westmonasterium* 73
Dashwood, Alice *300*
Dashwood, Sir James 38, 296, 300
Davenant, Henry 60
Davenport House, Shropshire 35–6, 53, 116, 288
de Grey, Lady 4, 74, 95, 204, 262
Decker, Sir Matthew 30, 37, 40, 91, 124, 154, 170
Decker, Paul, *Chinese Architecture, Civil and Ornamental* 262
Deene Park, Northamptonshire 50
Defoe, Daniel 253
    *Tour through the Whole Island of Great Britain* 35
Delacour, William 66–7, 212, 247, *247*
    *First Book of Ornament* 199
Delany, Mary 204, 206
    on Bulstrode 13, 18, 208
    and busts 197
    and candlelight 130
    and case covers 105, 106
    on Castletown 44
    and chinoiserie 264
    on colour 116, 120, 121
    at Cornbury 49, 259
    on dining-rooms 43
    drawing of Chinese House, Wroxton Abbey *260*, 261
    on hangings 92, 100
    on Lady Hilsborough's drawing-room 121, 129
    on Irish halls 38
    and mohair 98
    on oriental decoration 253
    and papier mâché 193
    and picture hanging 239
    on prints 207
    on public days 50
    and textile printing 193
Delville House, Glasnevin 92, 106
Denham Place, Buckinghamshire 19
Dennis, Captain 262
deportment 7
Derby, Lady 235
Desgodetz, Antoine 66, 182
    *Les edifices antiques de Rome* 318
*Designs of Chinese Buildings, furniture, dresses etc* 262
Desportes, Alexandre-François 57, *57*
Devis, Arthur 4, 6, *70*, 71
Devonshire, 1st Duke of 24, *43*, 82
Devonshire, 4th Duke of 50
Devonshire, 5th Duke of 50
Devonshire, 6th Duke of 24, *43*
Devonshire, Duchess of 50, 253
Devonshire House, London 14, 70, 101, 104, *140*, 240

Devoto, John 247
dining-rooms 43–51
    great 51–2
Ditchley, Oxfordshire *291–6*, **291–5**
    bedrooms 92, 121
    Bradshaw and 80, 81
    chairs 55, 104
    dining-room 49, 81, *146*, 228
    drawing-rooms 53, 98
    Great Parlour 18, 35
    hall 30, 122, 124, *124*, 130, 148, 196, 287
    hall benches 37
    and heraldry 8
    and Kirtlington 296
    plan 9, 20, 44, 68, 304
    plate collection 113
    reliefs 197
    saloon 58, 116
    Smith and 29
    tables 141, 179
Dixon, Francis 195
Doddington Hall, Lincolnshire 51, 92, 120, 121, *121*, 194, *194*, 229
Doe, Robert 249
Doncaster, Mansion House 199, 211, 212
Donnington Grove, Berkshire 204
Dormer, General James *174*, 177
Dorset, 1st Duke of, London house 172, *173*
Dorset, Duchess of 6, 206
Dossie, Robert, *The Handmaid of the Arts* 127, 272
Douglas, John 18
drawing-rooms 52–8
Drayton House, Northamptonshire 6, 51, 87, 120, 217, 218–19, *218*, 253, 254
dress and decoration 4–7, *5*
The Drum, Midlothian 18, 35, 36, *37*, 45, 52, *52*, 125, 199
Drumlanrig Castle, Dumfriesshire 8, 100, 134
Drummond, John 192, 239
Dryden, Edward 41, 101, 115–16, *115*, 219
Dublin, Houses of Parliament 174
Dudmaston, Shropshire 49
Dufee, Rebekah 87
Duff, Patrick 121
Duff House, Banffshire 194, *194*
Dufour, Joseph 193
Dugdale, Sir William, *History of St Paul's* 73
Dukelskaya, Larissa, and Moore, Andrew (eds), *A Capital Collection* 151
Dumfries, Lord 58, 213
Dumfries House, Ayrshire 53, 58, 93, 98, 199, 210, 213
Dun, David Erskine, Lord 60
Duncombe Park, Yorkshire 27, 60
Dunham Massey, Cheshire 42, 50, 54, 69, *77*, 94, 99, 109, 110, 131, *131*
Dunster Castle, Somerset 194, *194*
Durham House, London 51
Dutton, Sir Thomas 171, *171*
Dyrham Park, Gloucestershire 18, 88, 94, 99, 100, 105, *112*, 113–14, 115, 123, 267
Dysart, 2nd Earl of 6
Dysart, 4th Earl of 57, *57*, 211

Earnshill, Somerset 23
Eastbury, Dorset 44, 59–60, 116, 211
Easton Neston, Northamptonshire 25

Eaton, Dan 194
Eborall, Thomas 53, 287, 289, 290
Edgcumbe, Sir Richard 224
Edgecote, Northamptonshire 64
Edinburgh, School of Design 247
Edinburgh Upholstery Company 213
Edisbury, Joshua 114
Edwards, George
    *Book of Birds* 202, 203
    and Darly, Matthias, *A New Book of Chinese Designs 260*, 262
Edwards, Ralph, and Jourdain, Margaret, *Georgian Cabinet Makers* 214
Egremont, 2nd Earl of 204, 319
Egremont House, London 204, 320
Ehret, George 203, 206
8 Clifford Street, London 35
85 St Stephen's Green, Dublin 58, 95, 199
Elizabeth I, Queen 224
Elton, Sir Abraham 223
Emerton, Alexander 119
Emerton, Joseph 195
entrance halls, double- and single-storey 23–38
Enzer, Joseph 30, *31*, *60*, 61
Epsom, house of Mr Routh 50
Erddig, Clwyd *280–4*, **281–5**
    beds *283*, 284, *284*
    chinoiserie 257, 270–1
    extension 23
    furniture 40, 82, 104
    gallery 67
    grading 291
    heraldry 8
    inventory 37, 105
    materials 79, 89, 91–3, 94, 105, 120
    painted panelling 114
    saloon 61
    silver 134
    suppliers 151
Esher Place, Surrey 138, 173, *173*, 177, 188, 211, 234, *235*, 259
Esholt Hall, Northumberland 98, *99*
Essex, James 204
Eugene, Prince, of Savoy 109
Euston, Suffolk 49, 204
Evelyn, John 51
Eworth, Hans 228
Exeter, 5th Earl of 244
Exeter, 6th and 8th Earls of 109
Exeter, 9th Earl of 82, 224
Exeter, Lady 253
Eyden, Jeremiah van der 221

Fairlawne, Kent *42*, 44, 140
    Great Room 61–2, *61*, *62*, 82
Farington, William 127, 318
Farnborough Hall, Warwickshire *196*, 197, 199, 212, 218, *241*, 242–3
Farren, Thomas 109–10
Fawley Court, Henley-on-Thames 64, 204
Felbrigg, Norfolk *308*, *311*, **307–12**
    Cabinet 95, 100, 213, 239
    and Coke 319
    dining-room 43, 47, 122, 131, 197, 244, 249
    Great Hall 37, 43
    Great Parlour 214, 218
    Green Bedchamber 90
    hangings 87, 95, 213

353

# Picture Credits

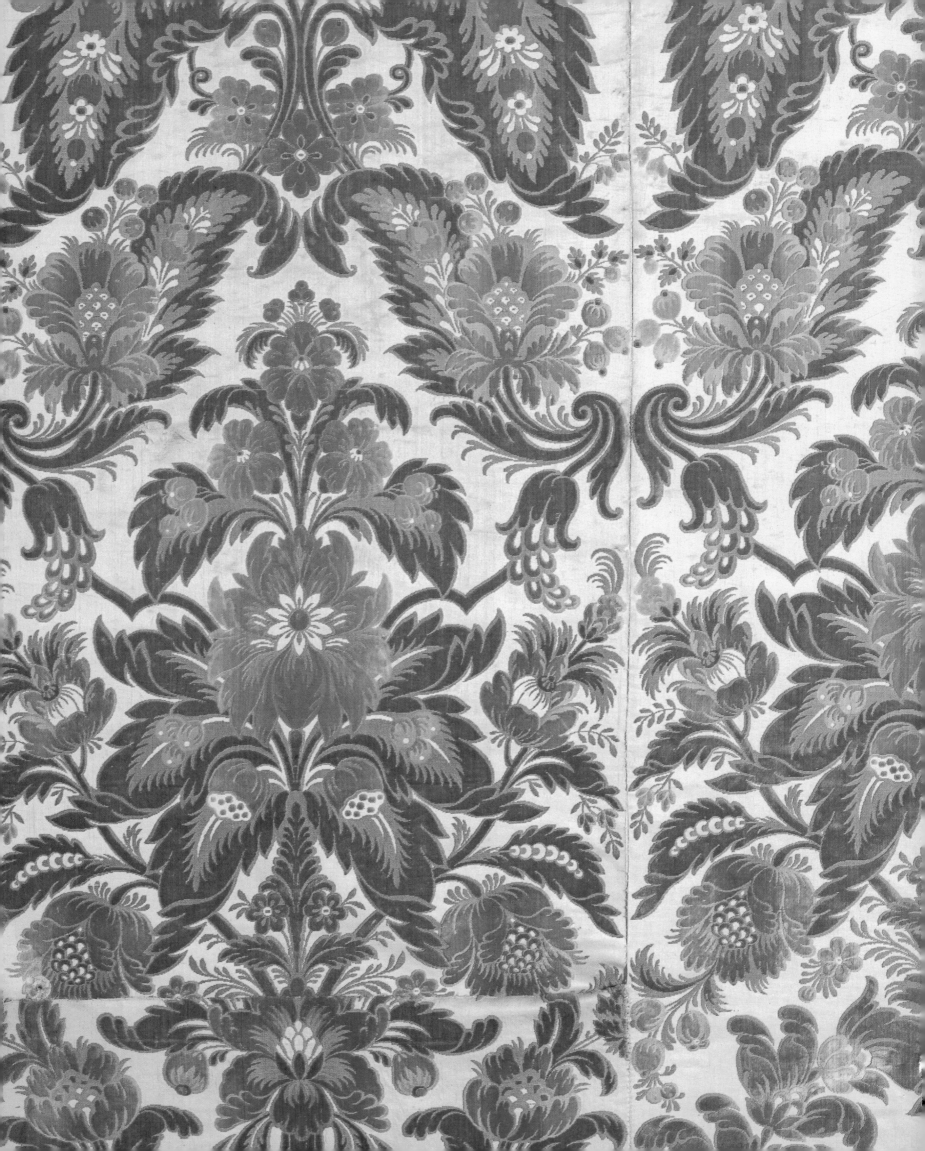